SAN FRANCISCO BALLET
THE FIRST FIFTY YEARS

Manufactured in the United States of America.
First Edition

Excerpts from *Thirty Years: The New York City Ballet*
(Alfred A. Knopf, Inc., 1978), by Lincoln Kirstein,
are reprinted on page 20 of this book by permission
of the publishers.

Excerpts from *Striking a Balance: Dancers Talk About
Dancing*, by Barbara Newman (Copyright © 1982 by
Barbara Newman) are reprinted on page 21 of this
book by permission of the publishers, Houghton
Mifflin Company.

Excerpts from "Symposium on American Dance"
(*Dance Magazine*, November 1946) are reprinted
on pages 34-35 of this book by permission of
Dance Magazine.

The synopsis of *Con Amore* that appears on pages
77-78 of this book has been adapted from *The New
Borzoi Book of Ballets* (Alfred A. Knopf, Inc; 1956), by
Rosalyn Krokover, and from *Balanchine's Stories of the
Great Ballets* (Copyright © 1953, 1968 by Doubleday
& Company, Inc.), by George Balanchine and Francis
Mason, by permission of the respective publishers.

Excerpts from "Story and Storyless Ballets" (*Dance
Magazine*, July 1956) are reprinted on pages 81-82 of
this book by permission of *Dance Magazine*.

Excerpt from *Balanchine's Stories of the Great Ballets*
(Copyright © 1953, 1968 by Doubleday & Company,
Inc.), by George Balanchine and Francis Mason,
reprinted on page 90 of this book by permission of
the publisher.

Library of Congress Cataloging In Publication Data
Steinberg, Cobbett
San Francisco Ballet: The First Fifty Years
Includes index.
1. San Francisco Ballet—History. I. Title.
GV1786.S32S73 1983 792.8'09794'61 83-4555
ISBN 0-87701-296-2 (pbk.)

Chronicle Books
870 Market Street
San Francisco

San Francisco Ballet
The First Fifty Years

Text by Cobbett Steinberg

Edited by Laura Leivick

Researched by Russell Hartley

Designed by Thomas Ingalls
with Madeleine Corson

Introduction by Lew Christensen
and Michael Smuin

Forewords by Lincoln Kirstein,
Oliver Smith, and Lucia Chase

SAN FRANCISCO BALLET ASSOCIATION ▪ CHRONICLE BOOKS

History, it has been said, is full of cunning passages and dark corridors. I would have indeed been lost in the maze of San Francisco Ballet's eventful fifty-year history were it not for the guidance of numerous individuals and organizations. The San Francisco Opera Association, California Historical Society, and San Francisco Public Library provided essential background material. The San Francisco Ballet staff—especially Dr. Richard E. LeBlond, Jr., Timothy Duncan, Craig Palmer, Denis de Coteau, Sean O'Neil, Adrienne Warren, and Virginia Riddle—graciously answered my every request. Robert Gladstein, the Company's Ballet Master and Assistant Director, revealed a knowledge of SFB history so wondrously encyclopedic that he often functioned as my one-man archives. Co-Director Lew Christensen tirelessly filled in missing facts, corrected mistaken assumptions, and lent his characteristic—and tonic—good humor to the whole enterprise. And the Board of Trustees of the SFB Association was courageous enough to approve this project in the first place.

Seiglinde Friedman and Phil Hawkins spent many long hours compiling and photocopying primary material for me. Monica Levin and Carey Charlesworth helped prepare and proofread the manuscript. As photo researcher and copy editor, Nancy Steele proved invaluable; Nancy also supplied enormous assistance in the compilation of the lists of choreographers, designers, and dancers found at the back of this book. Designers Thomas Ingalls and Madeleine Corson created a stunning format and proved themselves ideal collaborators: ceaselessly inventive, constantly understanding, not to mention repeatedly amusing. Cal Anderson, who coordinated this project, served as an oasis of rationality; his calm judgments and gentle reassurances were greatly, greatly appreciated. And as editor, Laura Leivick provided nothing less than round-the-clock answers to my every question. The structure of this book is largely her creation: it was she, for example, who devised the book's concept of "fifty themes and variations."

But even with such invaluable assistance, I would never have been able to write this book were it not for two men: SFB Co-Director Michael Smuin and Russell Hartley, founder and director of the Archives for the Performing Arts. This chronicle of San Francisco Ballet's first fifty years would not have been started, and certainly never finished, without Michael Smuin. It was Michael who conceived this project and guided it safely through every twist and turn. Michael is that rare bird: a first-rate professional who truly knows how to inspire his collaborators. He's always there for you—unshakably supportive, voraciously interested. His curiosity, dedication, and concentration are unbeatable. And energy! To paraphrase Pauline Kael's description of Tina Turner: he starts at the climax and keeps going. Quite simply, it is Michael who has been this book's driving force: he's a powerhouse of creativity.

For more than forty years, Russell Hartley has been collecting and cataloguing material on the San Francisco Ballet. Today, his SFB collection (only a fraction of his extraordinary Archives) stands unrivalled: a testament to one man's devotion to and love of history. Without his Archives, this book would have been not merely difficult, but unthinkable. Russell provided me with photographs, brochures, programs, reviews, clippings, press releases, souvenir books, magazines, journals, letters, costume designs, diaries, fliers, manuscripts . . . all meticulously dated and arranged in chronological order. The posters that grace the repertory list in this book are largely his. The checklist of dancers is extensively his. And the photographs from the Company's first forty-five years are similarly predominantly his. When I grew confused, Russell straightened me out. When I grew tired, he invigorated me with his example of unflagging dedication. When my spirits sagged, he amused me with SFB anecdotes that (fortunately? unfortunately?) never found their way into this book. To mix more than a few metaphors, Russell has been this book's muse, midwife, and *paterfamilias*: a one-of-a-kind miracle.

Finally, I should like to thank my friends Richard MacIntyre, Ted Whipple, Toby Klayman, and Larry Friedlander for keeping me sane. With great affection and patience, they provided me with pleasures that, though very different in kind, are similar in importance and wonderment to those created whenever great dancers take to the stage and so stunningly reveal the magic of the human body in motion.

Cobbett Steinberg
San Francisco, 1983

CONTENTS

Introduction by Lew Christensen and Michael Smuin viii
Foreword by Lucia Chase and Oliver Smith ix
Foreword by Lincoln Kirstein x

San Francisco Ballet: Fifty Themes and Variations

1	SFB Chronology: A Company of Firsts	2	26	Lew Christensen's 60's Ballets	96
2	Lew Christensen and Michael Smuin	8	27	Michael Smuin on Dance and Dancers	100
3	The Three Christensen Brothers	12	28	International Ballet Competition, 1979	104
4	SFB and George Balanchine	16	29	SFB Television Appearances	106
5	SFB Journal, 1933-1937	22	30	The Save Our Ballet Campaign	110
6	"Filling Station"	26	31	"A Song for Dead Warriors"	114
7	"Le Ballet Mécanique"	30	32	Robert Gladstein	118
8	Willam Christensen on Dance in America	34	33	SFB Ballerinas	122
9	SFB Journal, 1938-1942	36	34	Pas de Deux by Michael Smuin	126
10	Full-length Ballets	40	35	Edinburgh International Festival, 1981	130
11	The San Francisco Ballet School	46	36	"Shinjū"	132
12	SFB Journal, 1943-1947	50	37	SFB Danseurs	136
13	Ballerina Janet Reed	54	38	The Performing Arts Orchestra	138
14	SFB Journal, 1948-1951	56	39	SFB and Sir Frederick Ashton	140
15	The Achievement of Willam Christensen	60	40	The White House Telecast, 1982	144
16	"Nutcracker"	62	41	SFB's Five Homes	146
17	Guest Artists	66	42	SFB and Jerome Robbins	150
18	Resident Choreographers	72	43	Choreographers Workshop 1960-1973	154
19	"Con Amore"	76	44	Artists of the Company, 1982	160
20	Lew Christensen on Dance and Dancers	80	45	New York Season, 1978	164
21	Jacob's Pillow, 1956 Season	84	46	Lew Christensen's Contemporary Ballets	168
22	International Tours, 1957-1959	86	47	Checklist of SFB Designers	170
23	Music in Repertory	88	48	Checklist of SFB Dancers	174
24	Ballerina Jocelyn Vollmar	92	49	Checklist of SFB Choreographers	178
25	Ballerinas Nancy Johnson and Sally Bailey	94	50	SFB Repertory, 1933-1982	182

Letter from President Ronald Reagan 212
SFB Staff Listing 213
Illustration Credits 214

Note on the Illustrations:

The year in which a photograph or other illustration was created is given in parentheses in the caption.

San Francisco Ballet Association

San Francisco Ballet

DIRECTORS
Lew Christensen
Michael Smuin

ARTISTS OF THE COMPANY
Jo Ellen Arntz
Catherine Batcheller
Ricardo Bustamante
Val Caniparoli
Horacio Cifuentes
Evelyn Cisneros
Nigel Courtney
Laurie Cowden
Katherine Cox
Nancy Dickson
Betsy Erickson
Attila Ficzere
Michael Hazinski
Eda Holmes
David Kern
Natalie Kohn
Mark Lanham
Antonio Lopez
Grace Maduell
Tracy-Kai Maier
Dennis Marshall
John McFall
Lynda Meyer
Jonathan Miller
Linda Montaner
Victoria Morgan
Augusta Moore
Russell Murphy
Gina Ness
Anita Paciotti
Vantania Pelzer
Kristine Peary
Zoltan Peter
Kirk Peterson
Andre Reyes
Paul Russell
Tomm Ruud
Mark Silver
Jim Sohm
Robert Sund
Alexander Topciy
Paula Tracy
Wendy Van Dyck
Vane Vest
Carmela Zegarelli
Jamie Zimmerman

ASSISTANT DIRECTOR/ BALLET MASTER
Robert Gladstein

REGISSEURS
Virginia Johnson
Richard L. Cammack
Anita Paciotti
Vane Vest
Diana Weber

COMPANY INSTRUCTORS
Christine Bering
Anatole Vilzak

GUEST INSTRUCTORS
Tatiana Grantzeva
Erik Bruhn
Terry Westmoreland

MUSIC DIRECTOR/CONDUCTOR
Denis de Coteau

CONDUCTOR
Jean-Louis LeRoux

COMPOSER IN RESIDENCE
Paul Seiko Chihara

LIGHTING DIRECTOR
Sara Linnie Slocum

San Francisco Ballet School

DIRECTOR
Richard L. Cammack

SCHOOL ADMINISTRATOR
Nancy A. Dunn

ASSISTANT TO THE DIRECTOR
Yanka Valosek

FACULTY
Christine Bering
Richard Cammack
Helen Coope
Zola Dishong
Larry Grenier
Susan Parry
Mary Ruud
Marlene Fitzpatrick Swendsen
Anatole Vilzak
Diana Weber

PIANISTS
Larry Canaga
David Carter
David La Marche
Pam Martin
Timothy Murphy
Daniel Reider
Sergio Rodriguez
Barbara Russell
Ron Spicer

This book chronicles the numerous achievements of San Francisco Ballet during its first fifty years. Fifty years may sound like a long time, and indeed San Francisco Ballet is the oldest professional ballet company in America—the first to celebrate its landmark Golden Anniversary. But the Company's half century of accomplishments can only be truly understood in a larger context: the 400-year history of classical dance. Since its origins in the late sixteenth century, ballet has enjoyed uninterrupted development. It has survived wars, revolutions, and upheavals in fashion, taste, and aesthetics. Through political turmoil and social unrest, through good times and bad, its tenets have remained sound, its tradition intact. Over the past 400 years, ballet has moved from Italy to France to Russia, and, in this century, to England and America. But despite such migrations, ballet still speaks its original forceful, highly poetic language. It is an enduring art whose vision of the human spirit—large, unencumbered, extravagantly free—remains as lucid and alluring as ever.

It is this classical tradition that San Francisco Ballet has maintained for the past fifty years. Classicism has been our starting point, our driving force, our goal. The whole point of SFB is that it is not something entirely "new," but that it has picked up the torch from ballet's greatest masters—George Balanchine, Sir Frederick Ashton, Marius Petipa, August Bournonville, and those before them. Our guiding principles have been based on classical training, fine music, and good theater, and on trying to extend those principles, to perfect them: to make history by honoring history.

But SFB's adherence to classicism does not mean the Company has lacked pioneers and innovators. Tradition, it has often been said, is not merely the continuation of past practices, but the perpetual "rediscovery and reapplication" of those practices. Tradition, in other words, can be dynamic, progressive, developmental. For fifty years, San Francisco Ballet has been creating a tradition of innovation, so to speak, a tradition that innovatively blends the Continental legacy with an innate Western liveliness. Although SFB presented the first American full-length productions of such nineteenth century classics as *Swan Lake* and *Nutcracker*, the Company's functions have never been merely curatorial or custodial: we never conceived this Company as a museum of past masterworks. Rather, our intent has been to create a new repertory—a uniquely Western body of classics. Our 3000 miles' distance from the other American companies of similar caliber gave us the advantage of being able to do things our own way. We couldn't depend on what could be begged, borrowed, stolen, or revived: we had to develop our own resources. We took risks; we experimented; we gave our young choreographers considerable freedom—and considerable responsibility. And thus, a repertory was created, maintained, and developed.

The repertory list at the back of this book demonstrates our Company's sincerity. It shows that SFB has an identity, a depth, a distinct but "impersonal" point of view—like a great ballet. Thousands of people have passed through our School and Company, and although it would be impossible to tell each and every story, in the repertory list you can see how all these people (dancers, choreographers, composers, designers) connected to make things happen. Repertory *is* tradition. Repertory *is* innovation.

In many ways, 1933 was the magic year of American dance. It was the year that a foresightful Lincoln Kirstein invited George Balanchine to America to found what would one day become the New York City Ballet. It was the year that the Ballet Russe de Monte Carlo made its American debut and became the first large company of any

repute and prestige to tour America on a regular basis, paving the way for companies like American Ballet Theatre. And it was the year that Gaetano Merola, the founding director of the San Francisco Opera, weary of hiring ballet directors for each opera season, established the permanent ballet school and company today known as the San Francisco Ballet.

Of course, there was ballet in America before 1933. There were great teachers like Michel Fokine, great stars like Anna Pavlova, and there were flurries of activities across the nation—Catherina Littlefield in Philadelphia, Dorothy Alexander in Atlanta, and Serge Oukrainsky, Andreas Pavley, and Adolph Bolm in Chicago. But no continuous development, no sustained tradition existed prior to 1933, the watershed year of American ballet. 1933 marks the beginning of what could be called the "institutionalization" of dance in this country—the centering of activities about a home theater, a home school, a home audience, an institutionalization that was absolutely necessary if classical dance was to thrive in America. Within months of each other, two schools—one on the West Coast, the other in the East—opened their doors and changed the course of American ballet.

This book recounts the salient events in the institutionalization of dance here in San Francisco. It is not a full-scale, comprehensive, chronological, "official" history, but rather a kaleidoscopic view of SFB's major dancers, choreographers, ballets, and seasons. The theme of this book is taken from our Fiftieth Anniversary: there are fifty chapters, each taking its numerical designation from its topic, so that Chapter 10, for example, is about the Company's ten full-length ballets, while Chapter 35 examines the Company's season at the thirty-fifth Edinburgh Festival. This book was commissioned because we wanted the public to have information about this institution, to know the background of one of this city's foremost cultural organizations, and to realize that from its very beginnings SFB was never a small institution without point of view—it was always a large permanent company in everybody's mind.

A company doesn't get to be fifty years old without the support of countless individuals, all of whom deserve—and have—our sincerest gratitude. We should like to give special thanks to Dr. Richard E. LeBlond, Jr., President of the San Francisco Ballet Association since 1975, for providing the freedom and financial security to continue our "tradition of innovation." And most of all, we want to thank the Company's dancers: they are our life, our joy, our work, our love.

Lew Christensen and Michael Smuin
Directors, San Francisco Ballet

Michael Smuin, an American Original

Michael Smuin very quickly distinguished himself in American
Ballet Theatre as an outstanding dancer and choreographer. Follow-
ing in the tradition established by Jerome Robbins, Michael Kidd,
and John Kriza, he excelled in *demi-caractère* roles, performing with
exuberance, humor, and *élan*. When Michael performed, he took the
stage by means of the excellence of his dancing, the concentration
and depth of his interpretation.

The variety of his characterizations was outstanding: the pathetic,
mysterious Petrouchka; the fussy, prickly, affectionate Dr. Cop-
pelius; the ingenuous drummer boy in *Graduation Ball*; the innocent
young man and the cynical older Billy in *Billy the Kid*; the vacuous
Alain who defies gravity in pursuit of butterflies in *La Fille Mal
Gardée*; the suave, feline Peruvian in *Gaîté Parisienne*; the jet-
propelled sailor in *Fancy Free*. All these important roles Michael
performed with meticulous observation of the original choreography
and the added dimension of character, creating interpretations
uniquely his own. He expressed the quintessence of the American
style: its technical precision, masculine assurance, lively humor, and
vitality. He contributed generously to the mainstream of dancing in
America today.

Michael also has the extraordinary gift to create choreography;
in the four years from 1967 to 1970, he composed five ballets for
American Ballet Theatre. His first effort, *The Catherine Wheel* in
1967, although a modest beginning, definitely anticipated the talent
soon to be expressed in his wonderfully funny and ingenious
Pulcinella Variations, to a score by Igor Stravinsky. This was followed
by the lyricism and classical style of *Gartenfest* in 1968, *The Eternal
Idol* in 1969, and *Schubertiade* in 1970. These ensuing works
employed the classical vocabulary, crisply conceived, and were
distinguished forerunners of the many more complex works he later
created for San Francisco Ballet.

A ballet director must have a strong familial sense, an objectivity
of purpose, a passion for accomplishment. Michael possesses these
qualities, and had expressed them when he was a part of the family of
American Ballet Theatre. As Co-Director of San Francisco Ballet
during its financial crisis and near demise a few years ago, Michael
faced a situation not uncommon to American dance companies. His
unflagging efforts to save the company, with the help of his Board of
Trustees and Company dancers, will be remembered by all his
colleagues with gratitude. It is his sense of optimism, intense
constructive drive, discipline, ambition artistically realized that
endear Michael Smuin to all of us.

It is altogether fortuitous that Michael joined San Francisco
Ballet as Co-Director with Lew Christensen. Mr. Christensen
brought San Francisco Ballet his considerable talents as a dancer and
choreographer from Ballet Caravan and the New York City Ballet,
and Michael brings the tradition, variety, and eclectic taste of
American Ballet Theatre, to participate in the direction of the
great San Francisco Ballet.

Dear Michael: dancer, choreographer, director, we salute you.

Lucia Chase and Oliver Smith
Co-Directors, American Ballet Theatre
(1945-1980)

New York's Debt to Lew Christensen in
San Francisco: 1934–1983

It is commonly conceded that, lacking George Balanchine, there would be no School of American Ballet. It is said as often that, also, there would have been no New York City Ballet. This is true enough, with something of a proviso. As for my own part with its ups and downs, permanent growing pains of any lasting institution— failures, strikes, bankruptcies—there was, most of all, one's own weakness and doubt. Sometimes it was less than doubtful whether one could, or would, continue or survive. For more than a decade, there was the chance Balanchine might throw it all up and return to France. Here, his early reception was by no means all wine and roses. Ballets Russes de Monte Carlo, which he founded, then abandoned and which (during the War) he came back to, was always hungry. Our own fledgling American Ballet was foundering. However, for me at least, there was always the steady arm of Lew Christensen. His confidence, experience, and strength gave me the extra spine I lacked. Balanchine is not always grateful, but he said once that Lew was a man with, and through whom, he could most easily work.

It is hard after fifty years to recapture the impression Lew made on us when in January 1934 he first came to take class and afterwards to audition for a company that, likely enough, would be unable to give him a contract. And then there were two of them, Lew and Harold (I had not yet met Bill), with their girls, Gisella and Ruby. As for the two brothers, they looked more like two ex-West Pointers than dancers. Also, there was the odd fact that Gisella Caccialanza was a goddaughter of Enrico Cecchetti, the legendary *maestro* of the Milanese ballet. When Balanchine was with Diaghilev, he had taken lessons from this master who, even in advanced old age, jumped like a goat and turned like a top. In the apostolic descent of tradition, our young faculty was indeed fortunate. Italian also had been Albertieri, the Christensens' master, so our school immediately inherited a balance of Russian, Italian, and Danish strands, the last through the Scandinavian roots of these Mormon, third-generation Danish-Americans. And here in New York, half a century ago, we were given at least two male dancers as strong or stronger than any ballerinas then available.

The position of the male dancer in Western Europe and America (though not in Russia, Poland, or Denmark) had suffered years of neglect. The famous nineteenth-century ballerinas, Taglioni, Elssler, Cerrito, and Grahn, had been so greedily exploited by their managers that they were sold all the more readily without partners, who might have offered male competition. By 1855 their support in *adagio* duets and ensembles was delegated to other girls, dressed *en travestie*, and this rooted a prejudice against feminized ballet dancers which would extend to the United States, and which lasted, alas, until only about twenty-five years ago. Diaghilev's deployment of Nijinsky, Massine, and Lifar did much to restore a balance through the late Twenties, but the classic dance in America remained an anomaly. Our best professionals were popular stage performers, like Vernon Castle, Bill "Bojangles" Robinson, Fred Astaire. Ted Shawn did yeoman service with his band of men, but none of any of these was classically trained. More recently, there has been a change for the good: Edward Villella, Jacques d'Amboise, Nureyev, and Baryshnikov, through national tours and television appearances, have proved to frightened American fathers that their sons could make an honest living by dancing well.

Half a century ago, even if there had been well-trained males, there would have been little scope for them. What fine performers there were—like Adolph Bolm, Mikhail Mordkin, Andreas Pavley, Serge Oukrainsky—were refugees from the disastrous Diaghilev tour of 1917, or defectors from Anna Pavlova's world of one-night stands. At the start, and for too many years, these staffed the ballet departments of our predominantly Italian-managed opera houses, with not much chance to develop an independent art.

Our national "two-a-day" vaudeville circuits, Keith-Orpheum and others, were almost the sole opportunity for a mass audience to get a hint of what dance classicism was about. In order to cleanse what might still seem an epicene form, ballet numbers were labelled "acrobatic adagio," with emphasis on circusy fireworks. Hence vaudeville was an informal seedbed for many who would become legendary on stage and screen. Fred Astaire, Jimmy Cagney, Ray Bolger were all excellent dancers. What astonished Balanchine, together with his colleague Pierre Vladimirov (who followed Nijinsky as first dancer in the Imperial theaters, and then with Diaghilev) on their arrival in America, were the brothers Christensen's technical expertise, their Danish neatness, Italian virtuosity, American freshness and candor.

And especially, Lew. Only in the superb photographs by that camera genius George Platt Lynes is justice done to the apparition that was then Lew, posed in the studio, timed and placed for the lens by Balanchine himself. To professional aplomb was added a glowing shimmer of forthrightness and charm, a gentleness which tempered muscle, and all devoid of any trace of narcissism. Whether this was moral essence or a skillful ploy by self-discipline, Lew never seemed to know or care how his brilliance shone upon others. Today we are accustomed to hard-sell superstars veneered for TV and films in mannerisms so steely that their edited, close-cropped head-shots can't be credited as human. Lew came to us, not as an aging youth, but as a fully developed young man. Without mannerism, he had already gained that heroic high style that is the badge of the *danseur noble*, yet wholly lacked that exaggeration or affectation with which too many aspirants overload the romantic repertory.

Already as a boy in St. Petersburg, Balanchine had fallen in love with what little ragtime or early jazz filtered through in the first permissive years after the October Revolution. He idealized what he had glimpsed of American taste and manners, via Mark Twain, Jack London, and some wandering black pianists and trumpeters. He was fascinated by the syncopation and beat of our popular rhythms, and later preferred the clarity and speed of our stylized dancing to the grandiosity and "soul" (*l'âme slave*) of the elder Imperial ballerinas. This was the type of Anna Pavlova, who carried a residue of the nineteenth century all over the world. And he had seen Isadora Duncan, from San Francisco, who did her best to give ballet a bad name.

Just as Balanchine had his famous definition that "ballet was a woman" (preferably American; long legs; no bosom or behind), so I idealized a male principle. I never saw Nijinsky; this never stopped me from imagining I had. Two artists I greatly admired were Massine and Lifar, Diaghilev's last stars, but neither was schooled in the classic academy. There were others who pleased me more: Leon Woizikowsky, Yurek Shabelevsky, Andre Eglevsky, Frederic Franklin. I had loved all our Broadway and music hall performers, particularly Paul Draper and Buddy Ebsen, but tap dancing was in another category. Suddenly Lew Christensen appeared, completely endowed and equipped. As a potential "personality," he was a focus of our stripling seasons, the prize of fashion photographers from *Vogue*

and *Harper's Bazaar* even more than any girl. He surprised everyone. Pavel Tchelitchew, the painter who most enriched our repertory with color and light, designed decor and costumes for *Magic*, a small ballet to Mozart by Balanchine, in which Lew partnered Felia Doubrovska, one of the best late Diaghilev stars. Later, Tchelitchew would dress Lew as Orpheus in Gluck's opera, which we presented magnificently but disastrously at the Metropolitan. After one fitting with Lew, the painter, an internationalist who had been everywhere and seen everything, said here was a new sort of dancer, the American prince, adding, "*Beau garçon, mais vrai homme.*"

Lew's consideration for his partner was particularly appealing and expressive. This was never ostentatious, oppressively self-effacing—a manner some males lavish on supporting, in secret fury that it is the ballerinas, not they, who are spotlit. Lew's *adagio* was neat, efficient, and almost invisible, seeming to let the girl do by herself what she could not possibly have achieved alone.

Once, he was chosen to appear with Rosa Ponselle, the famous American *diva*, in *Carmen* at the Met. She wished to dance, as well as sing, her *habañera*, but flatly refused to rehearse with him. Lew could practice partnering with her own dance teacher. At their single rehearsal together on the morning of the performance, she first caught sight of him, and he was not the usual, disdained ballet boy. During their increasingly warm duet, she was to quaff a goblet of (wine) tomato juice. Incited by an armful of gorgeous manhood, she spat a mouthful in his face, pretending this was punishment for a false step. The liquor had gone to her head, rather than her feet. Afterwards, Lew, mopping his brow, tie askew, his glittering vest half-buttoned, breathed: "Honest to God, Lincoln. I thought she was trying to make me in front of God and everybody!"

Soon it was time to invent roles for himself and others toward our experimental Ballet Caravan repertory. His first work was *Encounter* to a Mozart divertimento, and later in *Pocahontas* to one of Elliot Carter's first symphonic scores he danced a valiant John Rolfe, with Gisella as a pert Indian princess. His first big success as both a dancer and choreographer was *Filling Station* to Virgil Thomson's pastiche of folk song, hymn tune, and jazz, featuring the "Big Apple," an ancestor of rock'n'roll. The blueprint backdrop and comic strip costumes by Paul Cadmus glorified Mac, the filling station mechanic, clad in see-through vinyl, who foiled the robber and saved the debutante from a fate-worse-than-death.

Lew became captain of our litle troupe. I had the dilettante's notion that a ballet company could be run by mutual consensus, every member having a democratic opinion. Fortunately for our future, Lew took the responsibility, and we would tour this continent for three seasons, and ultimately all of South America (courtesy of the United States Department of State, and Nelson A. Rockefeller). In an important way, these tours served as a post graduate course in performing and management, which was useful when Lew came to determine the fortunes of his own company, San Francisco's own great ballet.

I cannot pretend I was very happy when Lew left New York to pursue his destiny. Had I been given the same options, I would have done likewise. Balanchine has generous impulses and sharing responsibility is not least of them, as his tandem relationship with Jerome Robbins and Peter Martins has proved. But our company, thirty years ago, had its problems and limitations, while the freedom and potential of San Francisco was what Lew had clearly earned. It was a great satisfaction that in our last season's Stravinsky Centennial celebration Lew's enchanting *Four Norwegian Moods* was a triumph, and has since entered our permanent repertory.

As a final word, I'd like to affirm how I consider the essential Lew, not alone as performer, ballet master, teacher, director, but as a man. It is perhaps best expressed by something written thirty-five years ago, and it may seem to have little enough to do with Lew today. In 1946, on the German borders, just after the Rhine was crossed, we collided by chance. I discovered he had been assigned about the worst job that any army can assign. The pursuit of this duty must have been all the heavier for one accustomed to the inviolable beauty of healthy human bodies. Later he would gain a battlefield commission and administer a German town. Then in 1947, he came back to New York to help us found Ballet Society, Inc., the immediate parent of New York City Ballet whose home is now in the State Theater at Lincoln Center. Here are some rude verses written shortly after our respective jeeps split, taking our diverse directions.

Vaudeville

Pete Petersen, before this bit, a professional entertainer;
He and a partner tossed two girls on the Two-a-Day,
Swung them by their heels and snatched them in midair,
Billed as "Pete's Meteors: Acrobatic Adagio & Classical Ballet."

His vulnerable grin, efficiency, or bland physique
Lands him in Graves Registration, a slot few strive to seek.
He follows death around picking up pieces,
Recovering men and portions of men so that by dawn
Only the landscape bares its wounds, the dead are gone.

Near Echternach, after the last stand they had the heart to make
With much personal slaughter by small arms at close range
I drive for an officer sent down to look things over.
There is Pete slouched on a stump, catching his wind.

On your feet: salute. "Yes, sir?"
"Bad here, what?" "Yes, sir."

Good manners or knowing no word can ever condone
What happened, what he had to do, has done,
Spares further grief. Pete sits down.
A shimmering pulsation of exhaustion fixes him
In its throbbing aura like footlights when the curtain rises.

His act is over. Nothing now till the next show.

He takes his break while stagehands move the scenery
And the performing dogs are led up from below.

Lincoln Kirstein
General Director, New York City Ballet
President, The School of American Ballet

For Russell Hartley

San Francisco Ballet:
Fifty Themes and Variations

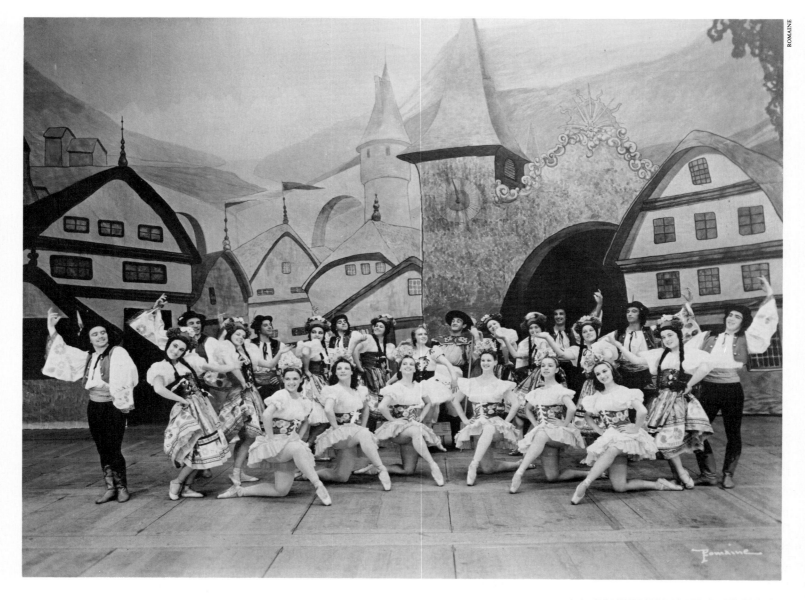

ROMAINE

Above. The *corps de ballet* in Act Two of Willam Christensen's *Coppélia* (1939).
Right. Gisella Caccialanza and Willam Christensen as the Sugar Plum Fairy and the Cavalier in SFB's landmark production of *Nutcracker* (1944).
Opposite. Jacqueline Martin and Lew Christensen in Willam Christensen's *Swan Lake* (1940).

ARCHIVES FOR THE PERFORMING ARTS

A company of *1*sts

1933. Following the opening of the War Memorial Opera House, the San Francisco Opera Association establishes the San Francisco Opera Ballet (SFOB), under the direction of ballet master Adolph Bolm. Though its primary purpose is to train dancers for operatic work, the Ballet will also present independent, "all-dance" programs: SFOB is America's first opera ballet established as an autonomous performing organization.

1937. Serge Oukrainsky replaces Bolm as ballet master. Willam Christensen, founder of the Portland Ballet, is appointed Director of SFOB's Oakland branch. Soon after his arrival, Christensen—who has brought from Portland his own repertory and a contingent of well-trained dancers—stages his first concert for the Ballet, and takes the Company on its first California tour.

1938. SFOB is reorganized: Willam Christensen becomes the Company's ballet master, and a booking department is created to supervise extensive touring. It is the first time, as *The New York Times* reports, that a Western ballet company will support itself through Western touring. After the Ballet moves into its new studios near the Opera House, Christensen begins to create a new repertoire for SFOB. The new ballets are presented in performances throughout California. Following the fall opera season, the Ballet tours the Pacific Northwest, its first venture outside California.

1939. Christensen gives SFOB its first full-length ballet: *Coppélia.* After the highly acclaimed premiere, the Ballet embarks on its second tour of the Pacific Northwest.

1940. For the first time, SFOB performs in the Midwest. Following the two-month tour, Willam's brother Harold Christensen comes to San Francisco and is appointed Director of the SFOB School. In September, Willam mounts *Swan Lake*—the first complete version of the Tchaikovsky classic ever produced by an American company. Guest Artist Lew Christensen, Willam's younger brother and America's first *premier danseur*, dances the role of Prince Siegfried. After the landmark premiere, SFOB continues its pioneering efforts to "Americanize" ballet on its third annual tour of the Northwest and its second tour of the Midwest.

1942. Because of the Second World War, the Opera Association can no longer afford to maintain SFOB. The School is sold to Willam and Harold Christensen, and the San Francisco Ballet Guild is created to support the Company—now known as San Francisco Ballet (SFB)—as a performing unit. Although SFB continues to supply the choreography and dancers for the annual fall opera seasons, the Ballet is now completely independent of the Opera Association.

1944. For SFB's Christmas Festival, Christensen mounts a full-length *Nutcracker*—the first complete version ever seen in the Western hemisphere.

1947. Following the war, a group of leading San Franciscans reconstitute the Company as the San Francisco Civic Ballet Association—America's first civic ballet. The Company presents a gala debut season, featuring the Ballet's first full-length *Giselle* and new works by Christensen and Bolm.

1948. The Civic Ballet, though a popular and critical success, cannot meet its expenses. The Association is dissolved. Christensen, supported by the Ballet Guild, reorganizes the Company as the San Francisco Ballet.

1949. Lew Christensen, working with George Balanchine as ballet master of New York City Ballet, makes the first of several visits to San Francisco to choreograph new works for SFB.

1951. The Company names Lew and Willam Christensen Co-Directors.

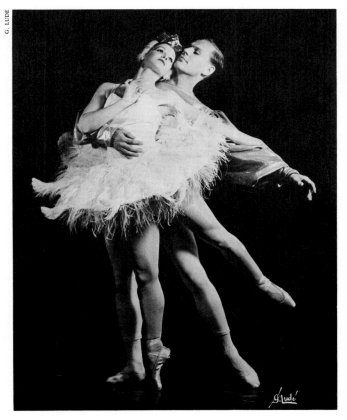

G. LUDÉ

1952. After Willam moves to Salt Lake City to found the first ballet department in an American university (at the University of Utah), Lew Christensen is appointed SFB's new Director. Under his guidance, SFB's repertory begins to build on a new foundation: Lew creates several major works and establishes an exchange policy with New York City Ballet whereby Balanchine's ballets enter the SFB repertory for the first time.

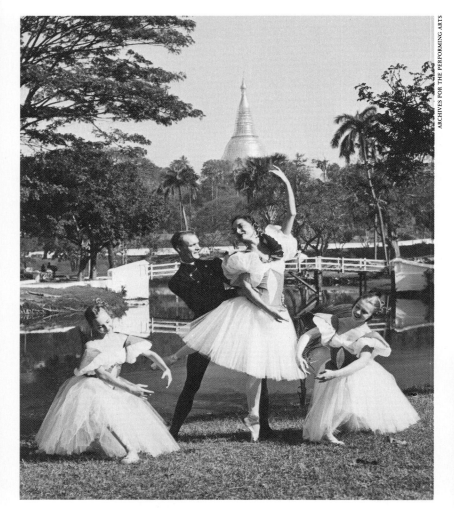

returns to San Francisco and begins to establish a stable home base. Lew Christensen wants to provide the Ballet with extended seasons in a home theater. During the next twelve years, SFB moves into several theaters in its attempt to find a home, including the Alcazar (1960-61), the Geary (1962-64), the Opera House (1965-67), and the Palace of Fine Arts (1970-72). In the summer of 1960, Company dancer Michael Smuin establishes the "Ballet '60" series, one of the first choreographers workshops in America. This series, which lasts through 1973, reflects SFB's long-standing commitment to the development of resident choreographers.

1962. SFB serves its last term as the resident dance company for the San Francisco Opera.

1963. The Ford Foundation announces its unprecedented $8 million ballet program: SFB is one of seven companies to receive first-round grants.

Left. Jocelyn Vollmar (center) with Richard Carter, Suki Schorer (left), and Tilly Abbe in Rangoon, during SFB's tour of the Far East (1957).

1954. Lew Christensen mounts his first full-length work for SFB: a new production of *Nutcracker*. This production will be in repertory for fourteen years, playing to more than 400,000 people.

1956. SFB makes its East Coast debut at Jacob's Pillow in Lee, Massachusetts. The triumphant season brings the Company its first major national exposure.

1957. The State Department sponsors SFB on a prestigious eleven-nation Asian tour. It is the first time an American ballet company performs in the Far East.

1958. To celebrate the Company's Twenty-Fifth Anniversary, Lew Christensen creates his second full-length ballet for SFB: *Beauty and the Beast*, which becomes one of SFB's most popular works during the next decade. Following the premiere, the Company embarks for Central and South America, on its second State Department-sponsored tour. The Ford Foundation establishes its innovative program, awarding promising young dancers scholarships to study either on the West Coast (at the SFB School) or in New York (at Balanchine's School of American Ballet).

1959. SFB's third State Department tour takes the Company to the Middle East.

1960. After its third international tour, the Company

1964. ABC-TV presents SFB in Lew Christensen's *Nutcracker.*

1965. The Company performs in New York City for the first time, at State Theater in Lincoln Center.

1967. Lew Christensen presents his sumptuous new version of *Nutcracker*, hailed as the most elaborate ballet production ever staged in the West.

1968. A one-hour version of Christensen's *Beauty and the Beast* is broadcast by ABC-TV.

1972. SFB is reorganized. Its various components—the School, the Company, the Guild—now come under the auspices of a single organization, the San Francisco Ballet Association.

1973. Michael Smuin returns from American Ballet Theatre in New York to accept a position as SFB's Associate Artistic Director. To celebrate the new partnership, Smuin and Christensen collaborate on the full-length *Cinderella.*

1974. The San Francisco Ballet Association faces bankruptcy. An extraordinary grassroots effort called "S.O.B." (Save Our Ballet) focuses national attention on the Company and launches a new era of creative energy.

1975. The reorganization of the Association begins with the appointment of Dr. Richard E. LeBlond, Jr., as President and General Manager. Michael Smuin creates a major new ballet, *Shinjū.* Paul Seiko Chihara's original score, the Company's first orchestral commission in over a decade, is nominated for a Pulitzer Prize. The Company creates its own resident orchestra under Music Director and Conductor Denis de Coteau. Harold Christensen, Director of the SFB School for thirty-five years, retires and is succeeded by Richard L. Cammack.

Michael Smuin's *Symphony in Jazz*, created for the Company's Choreographers Workshop (1961).

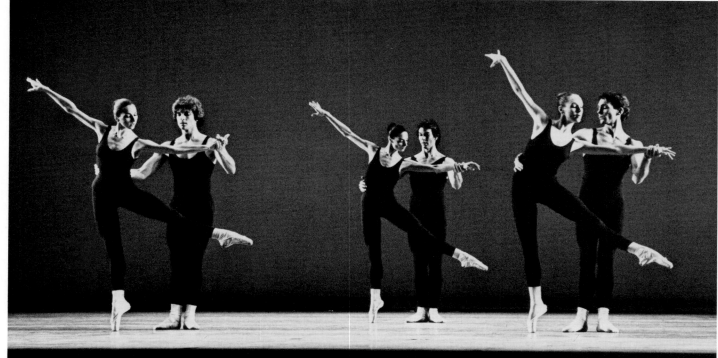

Above. (from left to right) Tracy-Kai Maier, Alexander Topciy, Laurie Cowden, Dennis Marshall, Victoria Morgan, and Jim Sohm in Robert Gladstein's *Symphony in Three Movements* (1982).

Opposite. John McFall as Alain in Sir Frederick Ashton's *La Fille Mal Gardée* (1978).

1976. Smuin is appointed Co-Director. The Company premieres his full-length *Romeo and Juliet*, a resounding success, hailed as the Company's new signature work.

1977. The international wing of the Company's repertory acquires its first ballets by Jerome Robbins, John Cranko, and Maurice Béjart.

1978. SFB becomes the first American company granted the right to perform Sir Frederick Ashton's *La Fille Mal Gardée*. Within weeks of the Ashton premiere, SFB is featured on PBS' *Dance in America* in Smuin's *Romeo and Juliet*. It is the first time the innovative television series has presented either a West Coast company or a full-length work. The broadcast wins an Emmy. In the fall, SFB debuts at the Brooklyn Academy of Music. The New York season, the Company's first in thirteen years, is a major success.

1979. SFB presents five world premieres to commissioned scores in one season, an unprecedented feat. The five new works are all by the Company's resident choreographers.

1980. SFB premieres *The Tempest* with choreography by Smuin and an original score by Chihara. It is considered the first full-length American ballet created with original choreography, music, and designs. During the first performances of *The Tempest*, the Company institutes a Dancers' Benefit Fund to assist dancers when in financial difficulties due to injury or illness. It is the first such program developed by an American ballet company. In the fall, SFB returns to the Brooklyn Academy of Music to inaugurate the "Ballet in America" series.

1981. WNET-New York and KQED-San Francisco co-produce the national telecast of Smuin's *The Tempest*, live from the Opera House on *Dance in America*. The program wins another Emmy for the Company. During the summer, SFB makes its Western European debut at the Edinburgh International Festival, playing to SRO audiences. Robert Gladstein, a former SFB School student and Company dancer, now a resident choreographer and ballet master, is named Assistant Director.

1982. The 49th season's Stravinsky Centennial showcases the Company's resident choreographers and produces an acclaimed group of new ballets, including Smuin's *Stravinsky Piano Pieces*, which is premiered on a national broadcast from the White House, and Gladstein's *Symphony in Three Movements*, which is broadcast by KQED-TV. The 49th season also features a revival of Lew Christensen's full-length *Beauty and the Beast* and the Company's first production of *Swan Lake, Act II* in twenty years. The Company's Balanchine collection continues to be expanded. The ceremonial groundbreaking is held for the Association's new home in San Francisco's Performing Arts Center. The four-level structure is the first new building in the history of American dance ever designed expressly to house a major professional dance institution.

1983. SFB, the oldest professional ballet organization in America, is the first major U.S. dance company to celebrate its Fiftieth Anniversary.

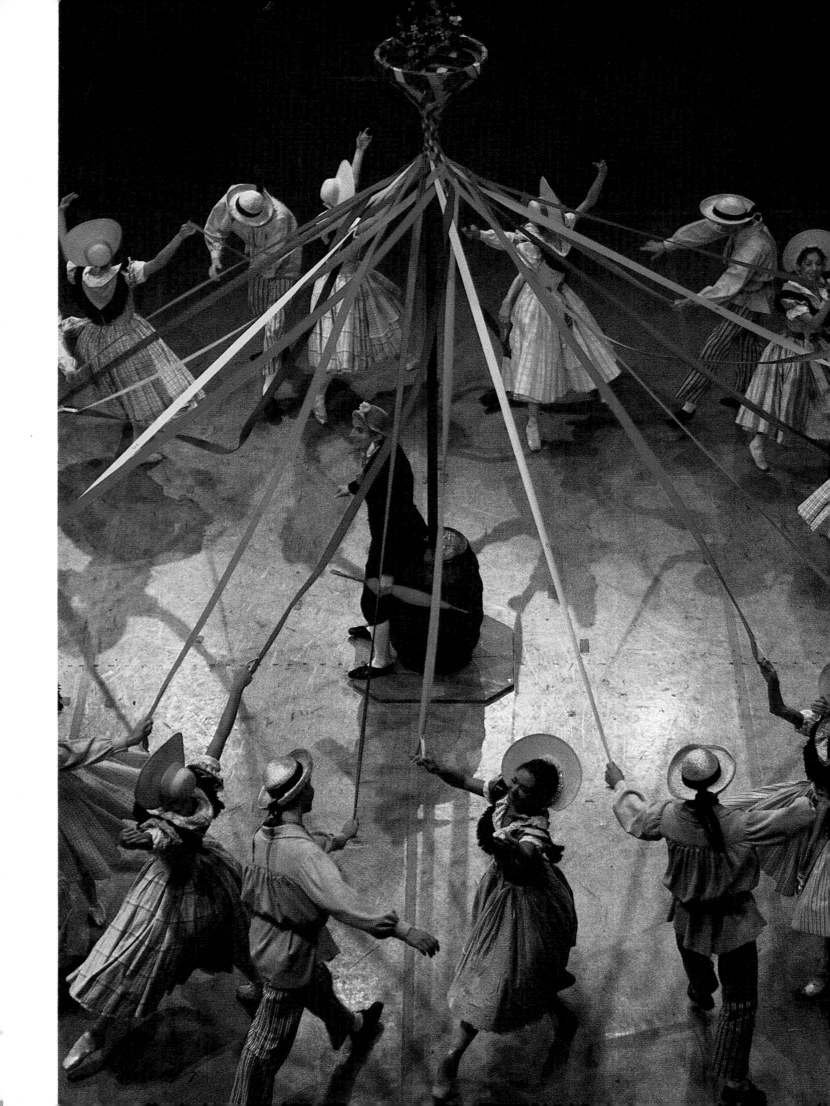

Lew Christensen and Michael Smuin

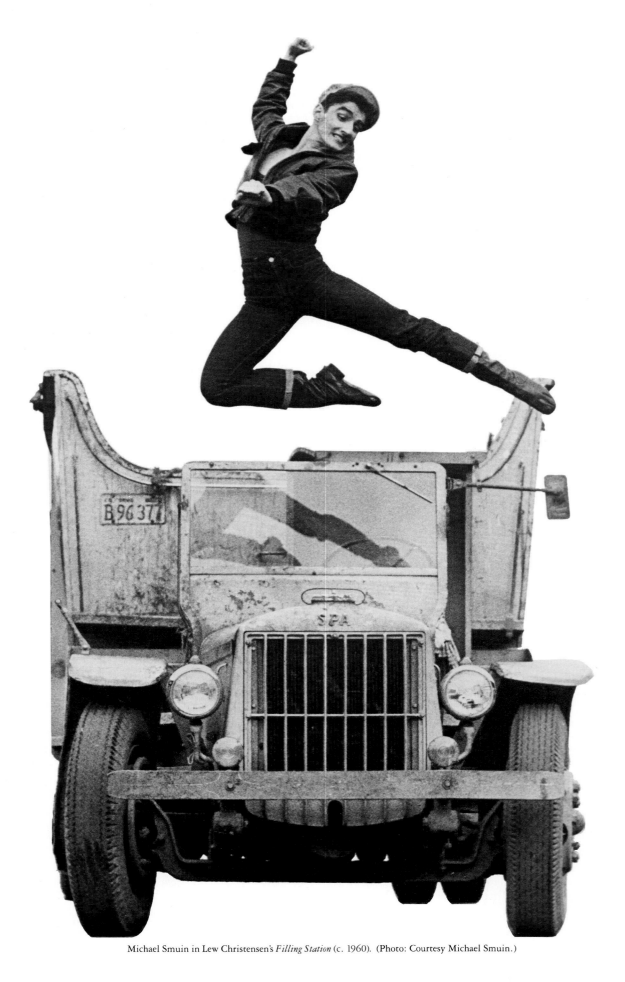

Michael Smuin in Lew Christensen's *Filling Station* (c. 1960). (Photo: Courtesy Michael Smuin.)

Since 1973, SFB has been co-directed by 2 of the leading talents in American dance—Lew Christensen and Michael Smuin. By even the most exacting standards, the Christensen-Smuin partnership has provided San Francisco Ballet with the greatest success in its fifty-year history. Since 1975, SFB's annual budget has burgeoned from two to seven million dollars, and the Company that in 1974 lay on the brink of insolvency has recently completed its eighth consecutive year in the black. If in 1970 San Francisco Ballet gave a scant forty-six performances, by 1982 the number of annual performances has climbed past 140. Three national television appearances in the last five years, and frequent national and international tours (including in 1978 the Company's first New York season in thirteen years, and in 1981 its first Western European engagement) have placed SFB at the forefront of American dance. SFB now employs forty-six dancers for a guaranteed forty-four weeks a year—longer than any other American ballet company. Whereas ten years ago San Francisco Ballet played before half-empty houses, it now draws an average attendance of 80 percent every time the curtain goes up at its home theater, the War Memorial Opera House. The Company's subscription base alone passed the 60 percent mark in 1983.

Most importantly, the SFB repertoire, which had deteriorated during the late Sixties and early Seventies, has been revitalized and replenished by Christensen and Smuin. During the past ten years, Smuin's keen negotiating skills have brought SFB its first ballets by such internationally renowned choreographers as Sir Frederick Ashton, Jerome Robbins, Maurice Béjart, John Cranko, Jiří Kylián, and Erik Bruhn. And Christensen's historic association with George Balanchine has continued to augment the core of Balanchine ballets that has graced SFB's repertory for the past thirty years: the recent additions to the Company's Balanchine collection now make it one of the largest in the world.

But in many respects, the most important additions to the SFB repertory during the decade-long Christensen-Smuin partnership have come not from Balanchine, Ashton, or Robbins, but from the Company's own group of aggressive young choreographers. Of the ninety-five ballets that have entered the repertory since 1973, fifty-nine have been created by the Company's resident artists, a fact that not only speaks of SFB's confident self-sufficiency, but that also reveals the salutary extent to which Christensen and Smuin have encouraged their fellow SFB choreographers. Because of such encouragement, SFB now has a style, a look—an identity—all its own.

Christensen and Smuin are both unique products of the American West. Christensen, born in Utah in 1909, hails from an American dance dynasty that goes back more than a hundred years to Danish émigré Lars Christensen, who, as ballet historian Olga Maynard has

written, "danced and fiddled his way across the United States," before settling in the Mormon community of Salt Lake City to teach music and dancing. Lew Christensen took his first dance classes from his uncle, Peter Christensen, and after graduating from high school, performed with his older brothers, Willam and Harold, on the vaudeville circuit. Their successful troupe survived for seven years—"a phenomenal life for a dance ensemble," says historian Maynard.

In 1935, George Balanchine and Lincoln Kirstein invited Christensen to join the American Ballet, where he quickly became the young company's *premier danseur*, winning great acclaim in the title roles of Balanchine's *Orpheus and Eurydice* (1936) and *Apollon Musagète* (1937). Christensen's success in these early Balanchine ballets, especially in *Apollon Musagète*, cannot be overestimated. Kirstein has written that Christensen's Apollo was the best he and Balanchine have ever seen. Dance scholar George Amberg has said that in *Apollo* Lew Christensen confirmed what he had promised in *Orpheus and Eurydice*: "that in him America had a magnificent classical dancer, with flawless technique and a sure grasp of noble style." And Maynard has chronicled how Christensen's masculine beauty in *Apollo*—he was tall, blond, heroically proportioned, and spectacularly good-looking—startled early American ballet audiences: "in Lew Christensen, American ballet had found a native prize for classical roles and was understandably exultant about it." In short, working with Balanchine, Christensen won the distinction of becoming America's first great *danseur noble*.

In 1936, Christensen became ballet master and principal dancer with Ballet Caravan, an experimental lyric theater founded by Kirstein to promote and encourage American talent. Christensen choreographed his first ballets for the innovative troupe—*Encounter, Pocahontas, Filling Station, Charade*—and created leading roles in many of the Company's works, including that of Pat Garrett in Eugene Loring's American masterpiece, *Billy the Kid*. According to contemporary reports, Christensen could "characterize national concepts without being pedantic because he was so patently, in looks and mien, the apotheosis of the Good Guy." He never seemed "to feel foolish" while dancing, as did so many male dancers of the English-speaking world at that time. "He danced," records Maynard, "with the kind of frankness and seriousness that foreigners used to associate with Americans. Lew Christensen was as close as American ballet ever came to producing the knight in shining armour."

Christensen's brilliant performing career, however, was interrupted by the Second World War. "The years in the Army were ruinous for me as a dancer," he remembers. "I was thirty-seven after the war and too old to start completely over again after such a long period without regular training." Nevertheless, at the war's end,

Christensen joined Balanchine's Ballet Society, and created principal roles in *The Four Temperaments*, *Renard*, and the American premiere of *Symphony in C*. When Ballet Society was reorganized as the New York City Ballet in 1948, Christensen was appointed ballet master, a member of the faculty, and a company director. These New York years, Christensen recalls, molded him into an artist. It was a period of tremendous growth and refinement: he studied, performed, taught, choreographed, and administered—mastering every aspect of the art of dance under Balanchine's and Kirstein's tutelage.

During the late Forties and early Fifties, Lew Christensen also came regularly to San Francisco to work with his brother Willam, then Director of SFB. In 1952, when Willam moved to establish a ballet department at the University of Utah, Lew assumed the SFB directorship. The Company grew immensely under Lew's guidance, making its East Coast debut in 1956 at Jacob's Pillow, and undertaking three prestigious international tours during the late Fifties under the auspices of the United States Department of State. The SFB repertoire was extensively revamped under Christensen's leadership: the Company performed its first Balanchine ballets, and Christensen choreographed nearly thirty works for SFB during his first decade as Company Director. Christensen's ballets, like Balanchine's, were choreographed with a pronounced —and intriguing—American accent. The Company's productions under Christensen's direction began to take on a new character—"a lightness, a subtlety, a whimsicality and sophistication they had never had before," says noted critic Alfred Frankenstein.

No dance company, however, enjoys uninterrupted success: "history insists on times that must be endured as well as enjoyed," as Kirstein has said. During the late Sixties and early Seventies, as Christensen's health was in jeopardy, SFB declined. The Company gave fewer performances, in smaller theaters, with fewer dancers and less success. To help him revitalize the Company, Christensen invited former SFB dancer Michael Smuin to join him as Associate Director in 1973.

Like Christensen, Michael Smuin came from a theatrical background.* He was born in 1938 in Missoula, Montana, where his parents were active in community theater. As a youth, Smuin took tap lessons, won two amateur boxing championships, and regularly entered rodeos. He was attracted to popular dance as far back as he can remember ("I grew up wanting to be Gene Kelly and

Fred Astaire—both of them"), and saw his first ballet at age eight, when his mother took him to the Ballet Russe de Monte Carlo. A superb "Bluebird" danced by Leon Danielian made Smuin an instant convert. At fifteen, he won a scholarship to study with Willam Christensen at the University of Utah. And in 1957, when San Francisco Ballet was on tour in Salt Lake City, Smuin met Lew Christensen. Christensen invited Smuin, then not yet nineteen years old, to join SFB. Smuin's mercurial stage presence and technical dexterity made him an audience favorite, and during the next several years with SFB he was cast in such major roles as the Bandit in *Con Amore*, the Juggler in *Jinx*, the Serpent in *Original Sin*, and the male soloist in *Divertissement d'Auber*, and in the third movement of Balanchine's *Symphony in C*.

Intrigued by the challenge of choreography, Smuin began making dances while still in his teens. He created *Vivaldi Concerto* for the regional Bay Area Ballet in 1958; staged the ballet in *Andrea Chenier* during the 1959 San Francisco Opera season; and in 1960 founded "Ballet '60," a summer workshop for young Bay Area choreographers. The following year, Smuin choreographed his first ballet for SFB, *La Ronde*, to an original score by Timothy Thompson. Following six months of military service (during which time he maintained his technique by doing *barre* work nightly in the barracks), Smuin rejoined the Company. He was a short, wiry, and explosively energetic performer, and when he created the role of the Jester in Christensen's smash hit *Jest of Cards*, Smuin's reputation as SFB's leading character dancer was unquestionable. "As fine as Michael Smuin ordinarily is," the *San Francisco News-Call Bulletin* said of his all-stops-out portrayal of the Jester, "he has outdone even himself this time in grace, speed, humor, and subtlety. The San Francisco Ballet sometimes loses some of its best people to Eastern companies, and . . . a separate trust fund, dedicated to freezing Smuin with the locals, might be quite a worthy philanthropic venture."

But in fact, in 1962, Smuin, like many SFB dancers before him, left for New York. In New York, Smuin hoped to work with George Balanchine, but the New York City Ballet could not use him. "Balanchine said they unfortunately had a virtuoso of my type," Smuin later told *Dance Magazine*. Instead, he and his wife, former SFB dancer Paula Tracy, embarked upon a career in the commercial theater. They danced (separately) in such Broadway musicals as *Little Me* and *No Strings*; appeared frequently on television; and were encouraged to create their own nightclub act.

As "Michael and Paula," the Smuins gained international fame in the course of extensive tours in the United States and Europe, performing with such headliners as Peggy Lee, Frank Sinatra, Maurice Chevalier, Lena Horne, Louis Armstrong, and Woody Allen. The financial security afforded by the steady work of the cabaret act allowed Smuin to continue choreographing for ballet companies. He staged *La Ronde* for the Pennsylvania

*At the turn of the century, Smuin's family managed orchestras and dance academies in Utah. In fact, at one time, the Smuins and the Christensens were rivals. To lure customers away from the Christensens, the Smuins even provided special rail transportation to their dance hall, which was reputedly "the largest, latest, and most up-to-date, with its beautiful polished maple floor with spring equipment." As an added enticement, advertisements promised, "If you miss this dance you'll miss a treat. For you must remember the Smuins are hard to beat."

Ballet, where it was renamed *The Circle*, and created *Highland Fair* for the Harkness Ballet—the first ballet to be danced on the new stage recently installed in the White House. Eventually, however, he grew weary of the nightclub circuit, and in 1966 he and Paula Tracy joined American Ballet Theatre.

Smuin quickly became one of ABT's most versatile dancers and conquered a range of works in the company's diversified repertory: in 1968, he was named principal dancer. His distinguished repertory with ABT included Alain in *La Fille Mal Gardée*; Dr. Coppelius in *Coppélia*; Billy in *Billy the Kid*; the Third Sailor in Jerome Robbins' *Fancy Free* ("working with Robbins in that ballet was the most important experience during my years with ABT"); the Boy in Green in Ashton's *Les Patineurs*; and the title role in Fokine's *Petrouchka*.

As one of the talented young choreographers developed by ABT during the late Sixties, Smuin created four works for the company: *The Catherine Wheel*, a reworking of his earlier *La Ronde*; *Eternal Idol*, for Ivan Nagy and former SFB ballerina Cynthia Gregory; *Gartenfest*;

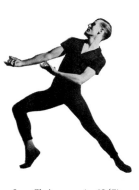

Lew Christensen (c. 1947).
(Photo: Maurice Seymour.)

and *Pulcinella Variations*, the first American ballet to have its premiere performance at the new Metropolitan Opera House, and a ballet which marked Smuin, according to *The New York Times*, "as a fresh find on the American dance scene . . . a truly original choreographer."

The success of these ballets put Smuin's talents in demand: he choreographed the revival of Leonard Bernstein's *Candide* for the opening ceremonies of the Kennedy Center in Washington, and created new works for both San Francisco Ballet (*Schubertiade*, later also staged for ABT) and Alvin Ailey's company (*Panambi*). In 1973, however, ABT declined to stage Smuin's latest ballet—*Harp Concerto*—and Smuin resigned.

"Michael Smuin's departure from the American Ballet Theatre is sad news," lamented Alan Rich in *New York Magazine*. "He was a marvelous dancer whose work was in a way an epitome of the ABT outlook: winning, inventive, and communicative. . . . The sight of Smuin as the Boy in Green, twirling amid the snow as the curtain comes down on *Les Patineurs* is another of those city landmarks we can ill afford to lose."

Smuin was thirty-four when he returned to San Francisco, and although his technical powers were still much in evidence, he returned to SFB not as a dancer, but as resident choreographer and associate director. During his first decade as Co-Director, he created twenty-four works for SFB, including three full-length works, two of which —*Romeo and Juliet* and *The Tempest*—were then produced for national television. In 1981, he directed and choreographed the smash Broadway musical *Sophisticated Ladies*, which brought him more than sixty offers to direct other

shows—he finally chose to work with Anthony Newley on a musical based on the life of Charlie Chaplin. And in 1982, Smuin directed a street dance and fight sequence for Francis Coppola's film *Rumble Fish*. Smuin's choreography during these past ten years has been characterized by incredible vitality, intense theatricality, accomplished musicality, a canny sense of showmanship, a fetching combination of lightness and speed, and a lusty and lively humor. He has that rare ability to combine classical and popular idioms with seamless virtuosity: as critic Arlene Croce has said, "Smuin, who was born in the year of *Filling Station* and *Billy the Kid*, may be the last American choreographer to deal directly in the vernacular, without the crutch of nostalgia."

Smuin's contributions to SFB, however, have not been limited to choreography. During the past decade, he has been the Company's most ardent spokesman and untiring supporter, arranging television deals, commissioning scores, organizing festivals, acquiring prestigious works from the international repertory, bringing the Company's accomplishments to the attention of the national press, serving on the Dance Advisory Panel of the national Endowment for the Arts, and travelling to the People's Republic of China as a member of the first official United States Dance Study Team. According to his supporters, Smuin's dynamic personality and spirited self-confidence are largely responsible for SFB's new-found success: he's worked miracles, they say. In recognition of his distinguished directorship of SFB, Smuin was honored with the Dance Magazine Award in 1983.

Bay Area dance enthusiasts like to contrast Christensen and Smuin. Christensen, they say, is the Company's elder statesman—a distinguished classicist who gives SFB its graciousness, elegance, and neo-Balanchinian order. Smuin, on the other hand, is said to be the impassioned romantic, whose fervent attraction to large themes and large music provides the Company with stunning showmanship and clever eclecticism. Although such distinctions are understandable (at times, Smuin *does* play Wagner to Christensen's Haydn), the "romantic" and "classical" categories tell only half the story. Throughout their careers, Christensen and Smuin have both displayed a healthy regard for popular culture. Their ballets—rich with the everyday language of Broadway musicals and Hollywood films—are dedicated to the belief that ballet can be both American *and* popular. They have given SFB a recipe for success: classical ballets that reflect both this century's and this nation's graceful athleticism, robust humor, and syncopated rhythms. Lincoln Kirstein has said that although it stretches analogy to think of every dance program as a menu, "there are certainly soup as well as salad ballets. There are *hors d'oeuvres*, second courses, and desserts." For the past ten years, SFB audiences have been feasting upon complete banquets prepared by the Company's master chefs, Lew Christensen and Michael Smuin.

Three Christensen Brothers

MAXWELL HANSHAW

From left. Lew Christensen, Mignon Lee, Wiora Stoney, and Willam Christensen in vaudeville, (c. 1932).

In Vaudeville (1927-1934)

Willam, Harold, and Lew Christensen, the 3 brothers who determined the course of San Francisco Ballet history after 1938, began their careers in the American theater on the vaudeville circuits. The Christensens' act was a quartet (originally Lew and Willam, partnering Wiora Stoney and Mignon Lee) billed at its 1927 debut as *Le Crist Revue: European Dance Novelty.* The dancers' father, Christian B. Christensen, travelled with the act and conducted the orchestra. They later called the act *Four Spirals*, the *Mascagno Four*, and *Christensen Bros. & Co.*, settling at last on *Christensen Brothers*.

Advertisements described the Christensens as "Interpretive Expressive Dancers," "A Cameo of Grace Personified," and "Dancers Par Excellence"; and one promoter was inspired by the act's finale—an accelerating display of turns of all kinds—to claim the dancers were

"Faster Than Air Mail." Mixed public image notwithstanding, the Christensens' act caught on.

Described in their self-promotion as "Creators of the Modern Ballet," the Christensens were in fact purveyors of classical dances, choreographed by Willam and packaged with appetizing simplicity for a popular audience. The women, considered "far from hard to look at" in their brief, dressy costumes, silk tights, and *pointe* shoes, rarely wore the traditional tutu. The brothers, usually costumed in trousers rather than conventional tights, were frankly admired for their "clean-cut good looks."

Booked first out of Los Angeles on the Bert Levey Circuit, then out of Chicago with the Berkhoff ballet act, they were soon on the prestigious R.K.O. (Radio-Keith-Orpheum) Circuit. R.K.O., the product of the merger between the Keith-Albee and Orpheum chains, then

owned and/or controlled 535 theatres, some 75% of the country's vaudeville houses. Reviews, which generally included reports on box office business and audience response, were favorable. "Crowd likes this act," *Variety* said. One Christensen number—a Parisian *commedia dell'arte* novelty with a gondola on the backdrop—prompted *Billboard* to observe that "this type of dancing is so successfully avoided because it is difficult that it is a refreshing thing when done well."

Other ballet dancers had worked in vaudeville, including troupes assembled by three early ballet masters of the San Francisco Opera (Theodore Kosloff, Serge Oukrainsky, and Ernest Belcher); Anna Pavlova had appeared at the Hippodrome, and Diaghilev's protégé Léonide Massine worked at the Roxy Theater. The most successful ballet entrepreneur in American show business was Viennese-born Albertina Rasch, credited with introducing professional ballet to Broadway in Florenz Ziegfield's *Rio Rita* (1927); *Variety* advertised the "units of from six to twenty-four Rasch Girls . . . appearing in vaudeville feature acts, in Broadway revues, and in [live] motion picture prologues."

The Christensens' act, it seems, was distinguished by its straightforward manner and all-dancing format. When the dancers played on a bill with headliner W. C. Fields at the legendary "Mecca of class," the New York Palace, *Billboard* noted that if they "had stooped to a coarser brand of showmanship [the Christensens] might have stopped the show. . . . But that would not have been dancing, and we have stated that this is a genuine dancing act."

Billboard further commended the Christensens for "taking a chance in trying to sell an act composed entirely of classical dancing" in the first place. The chance paid off in more than good notices and steady work: while touring the country with the act, the Christensens seized every opportunity to study classical ballet. In Los Angeles, they studied with Julietta Mendes; in Chicago, with Laurent Novikoff, who had partnered Pavlova. In New York, they worked with Enrico Cecchetti's student, Luigi Albertieri (the Metropolitan Opera ballet master whose students included Fred Astaire and Albertina Rasch), and with Diaghilev's first choreographer, Michel Fokine. Willam Christensen in particular was Fokine's protégé, and appeared with the Fokine company at the Capitol Theatre.

The young American dancers also worked extensively at the New York studio of Stefano Mascagno. It was the Italian maestro Mascagno—who was, like Cecchetti, a student of Giovanni Lepri—who had introduced the preceding generation of Christensens to classical ballet. The brothers' Danish-born grandfather, Lars Christensen, a Mormon convert who settled in Salt Lake City, was a renowned teacher of folk and ballroom dancing, music and etiquette, and the sponsor of popular public dances.

Lars Christensen's sons established similar academies in Boise, Idaho; Portland, Oregon; Seattle, Washington; and in Ogden and Brigham City, Utah. On a visit to New York, Mose Christensen, founder of the Boise and Portland schools, saw his first ballet performance and enrolled in Mascagno's classes there. When Mose's brothers Peter and Frederick joined him at Mascagno's studio, the Italian tradition had found its American champions. Willam, Harold, and Lew Christensen, who received the fundamentals of their classical training from their uncles and Mascagno, became the family's first generation of professional dancers and continued its teaching tradition. While still in his twenties, Harold Christensen established a reputation as "one of the outstanding ballet instructors of this country," teaching "The Mascagno Method" at the family schools in Brigham, Ogden, and Seattle.

Willam Christensen married his partner Mignon Lee, and in 1931 left the vaudeville act to take over the Portland school. In 1932, he founded the Willam F. Christensen Ballet—the Portland company from which he would later draw repertory and dancers for San Francisco Opera Ballet. Harold Christensen replaced his brother Willam in the act.

The vaudeville business, however, was suffering the effects of the Depression and of competition from radio and from sound films. In the huge auditoriums built during vaudeville's peak years, according to Eugene Connely who managed publicity for an established Pittsburgh theater, "some of the acts' intimate and informal tricks were missed by too many people who had to sit too

The Christensen brothers in the yard of their family home in Brigham City, Utah (c. 1912). *From top*: Guy, Willam, Harold, and Lew Christensen.

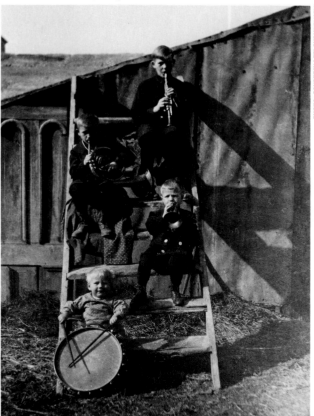

3

far away from the stage." Films bridged the gap; vaude houses converted first for mixed film and live vaudeville programs ("the pix-flesh combo"), then for the all-film format. Many performers left the stage for careers in film. In 1933, while half of New York's theaters remained dark during the season, R.K.O.'s first film pairing of Fred Astaire and Ginger Rogers ushered in the great era of Hollywood musicals, and the New York Palace—succumbing at last to the pressures of finances and fashion—converted to a movie house.

New York (1934-1938)

In 1934, when Harold's partner in the act was Ruby Asquith, a young dancer from the Portland school, the quartet was hired for *The Great Waltz*, a lavish operetta at Rockefeller Center, with dances staged by Albertina Rasch. The production briefly featured ballerina Alexandra Danilova, who had starred in the London production; but she resigned, according to her biographer A. E. Twysden, because of the ensemble emphasis in the New York version. The Christensens found little in *The Great Waltz* to satisfy their ambitions either, despite the show's success; but the schedule of performances did allow them to begin studying at the School of American Ballet.

The School was established in 1934 by American intellectual Lincoln Kirstein and Diaghilev's last choreographer, George Balanchine, to serve as the source and base of operations for a performing company. The company took several forms before its emergence in 1948 as the New York City Ballet; when Lew and Harold Christensen and Ruby Asquith (the future Mrs. Harold Christensen) joined Balanchine's company in 1936, it was called the American Ballet Ensemble, and served as the Metropolitan Opera ballet.

As members of Balanchine's company at the Metropolitan from 1936 until 1938, the Christensens worked alongside many artists with impeccable classical credentials, two of whom would later help shape San Francisco Ballet history: *premier danseur* Anatole Vilzak, a veteran of the Imperial Maryinsky and Diaghilev's Ballets Russes; and ballerina Gisella Caccialanza, who had inherited the traditions of La Scala, the Maryinsky, and the Pavlova and Diaghilev companies from her teacher Cecchetti, as well as studied with Rasch, and performed at the Roxy and Radio City Music Hall. Vilzak and his wife, ballerina Ludmilla Schollar, were to join the faculty of San Francisco Ballet School in 1966. Caccialanza would become Mrs. Lew Christensen, SFB's *prima ballerina*, and a valued instructor.

Lew Christensen's work in the principal roles of Balanchine's new production of Gluck's *Orpheus and Eurydice* (1936) and the 1937 revival of his Stravinsky ballet

Apollon Musagète, and Caccialanza's in works including the Balanchine/Stravinsky *Le Baiser de la Fée* (1937), established them as important exponents of the new classicism. But unlike the new Ballet of the San Francisco Opera, which was establishing its own repertory and identity while providing conventional services to the Opera, Balanchine's company was on a collision course at the Metropolitan. His surrealistic version of the eighteenth century Gluck opera *Orpheus*, for example, consigned the singers to the orchestra pit while only the dancers presented the action onstage. "To the general audience," Lincoln Kirstein maintains, this work's "pervasive eroticism of mime and movement smacked of Broadway or the films—which then, as now, certainly employed more imaginative approaches to sound and sense" than the usual opera ballet.

In fact, in 1936, Balanchine's choreography for the Broadway musical *On Your Toes* started a revolution in the

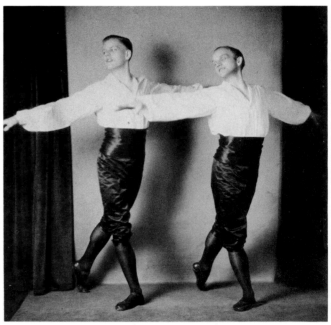

Lew and Willam Christensen in ballet class, (c. 1926).

popular theater. Ballet choreographers—from Balanchine, Agnes de Mille, and Jerome Robbins to Michael Smuin—have given musicals full access to the dramatic, expressive resources of dancing, and to its sheer stylistic force. Balanchine's collaboration with Richard Rodgers popularized ballet: *On Your Toes*, historian George Amberg wrote in 1949, "demonstrated strikingly that ballet was not the supposed museum of past glory and elusive memories, but could be as lively and vital a medium as swing and hot jazz." In return, Amberg wrote, "the gain for ballet in its conquest of Broadway is very real. Artistically it expands immensely the range of creative possibilities for imaginative choreographers and talented dancers."

It was also in 1936 that Lew and Harold Christensen, Asquith, and Caccialanza joined the advance guard of American ballet, Ballet Caravan, a touring company of

Opposite left. Billboard at the Hippodrome Theater, New York.
Left. Harold Christensen, (c. 1926).
Right. Willam, Lew, and Harold Christensen at the ceremonial groundbreaking for the San Francisco Ballet Association's new facilities.

soloists from Balanchine's company organized by Lincoln Kirstein. Renamed the American Ballet Caravan—"ABC of the American Dance"—for its final season (the 1941 foreign tour), the company had Lew Christensen's services as both dancer and Ballet Master. Christensen in fact was the principal choreographer for the Caravan's original repertory; his *Filling Station* (1938) was perhaps its most important creation.

Ballet and the West (1938-1982)

Willam Christensen began work with San Francisco Opera Ballet in 1937, as Director of its Oakland Branch School, and became Director of the School and Company in 1938. During this transition, both Lew and Harold were guest teachers for the Portland school; Harold later served as Director. At San Francisco Opera Ballet, Willam enlisted Lew, Harold, and Ruby as dancers. In 1942, the position of Director (for both School and Company) was divided between Harold (who held the new position, School Director, until his 1975 retirement) and Willam (who was Company Director until he was succeeded by Lew in 1952).

Lew Christensen, prior to his return to SFB in 1951 to serve an interim period as Co-Director with Willam, had worked for several important ballet companies. When the Caravan disbanded, Christensen worked for Dance Players, a company established by fellow Caravan veteran Eugene Loring. In St. Louis, Missouri, Christensen choreographed original versions of opera ballets and musicals including *Rio Rita, Babes in Arms* (first choreographed by Balanchine), and *East Wind* with tap dancer Al White, Jr; in Hollywood, he danced George Balanchine's choreography in two film musicals; and in New York, he choreographed the musical *Liberty Jones* (1941), directed by John Houseman. After serving in the United States Armed Forces, Christensen joined the new Balanchine/Kirstein Ballet Society, and went on to serve as Ballet Master for their New York City Ballet.

Willam, who left SFB in 1952 for Salt Lake City to work at the University of Utah, founded its ballet depart-

ment and the affiliated ballet company which later became Ballet West. Among the dancers Willam Christensen trained in Utah are Michael Smuin, SFB's current Co-Director, and Kent Stowell, who now directs Pacific Northwest Ballet—both of whom left Utah in 1957 to work for Lew Christensen at SFB.

In 1973, after almost a half century in the theater, the Christensen brothers received the Dance Magazine Award. At the presentation ceremony in New York, *Dance Magazine* editor William Como said that "in the 400-year history of ballet there have been many dynasties of dancers, teachers, and choreographers: the Vestris in France, the Taglionis in Italy, the Bournonvilles in Denmark, and, in Russia, the Karsavins (out of which Tamara Karsavina came), and the Messerers, of which Maya Plisetskaya is a member. In America we have the Christensens. When we think of 'native talent' in dance, we must begin with the Christensens." In fact, as Arlene Croce wrote in *The New Yorker* in 1980, "ballet west of the Mississippi is pretty much the creation of the Christensen brothers—Willam, Harold, and Lew—of Utah."

—Written by Laura Leivick

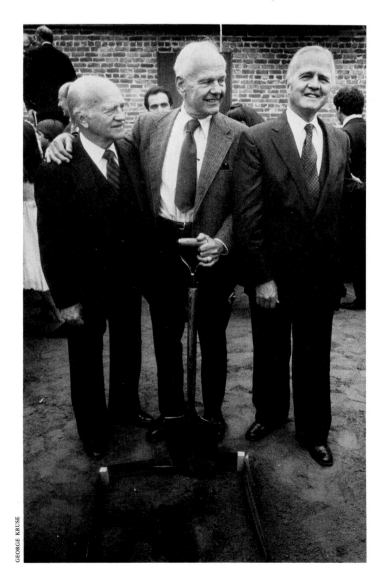

SFB *and Balanchine*

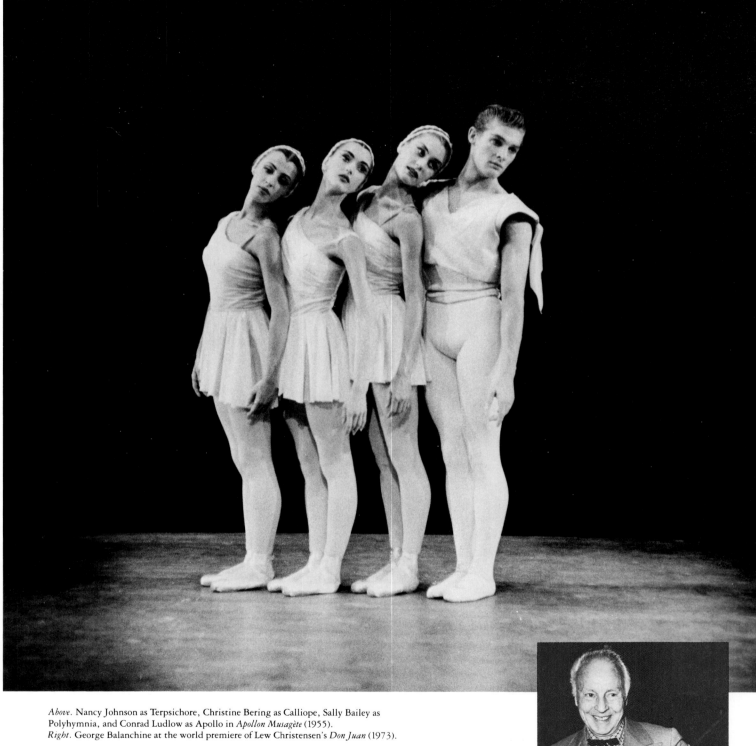

Above. Nancy Johnson as Terpsichore, Christine Bering as Calliope, Sally Bailey as Polyhymnia, and Conrad Ludlow as Apollo in *Apollon Musagète* (1955).
Right. George Balanchine at the world premiere of Lew Christensen's *Don Juan* (1973).

The *4 Temperaments*, George Balanchine's 1946 masterpiece, first entered the SFB repertoire in 1974. Set to a masterful score by Paul Hindemith, *The Four Temperaments* is a landmark work: it designates, says noted critic Arlene Croce, "one of Balanchine's several 'beginnings,'" and like *Apollo*, his first collaboration with Stravinsky, and *Serenade*, his first ballet for American audiences, it is a messianic work, which conveys to this day the sense of a brilliant and bold new understanding." Inexhaustively inventive and ineffably expressive, *The Four Temperaments* is one of Balanchine's most arresting works, his first ballet, perhaps, to be so rigorously choreographed in his "American" vein: bold, athletic, hard-edged and stripped-down—drained of life's clutter but not of its complexity.

The Four Temperaments is only one of the seminal works by Balanchine in SFB's repertoire: *Apollo, Serenade, Concerto Barocco, Symphony in C*, and *Agon* have also been performed by the Company. Since 1952 more than twenty Balanchine ballets—everything from the exquisitely elegant *Divertimento No. 15* to the unabashedly exuberant *Stars and Stripes*—have entered SFB's repertoire, which now boasts one of the largest Balanchine collections in the world. In fact, San Francisco Ballet and Balanchine's New York City Ballet have often been called "sister" companies—two companies bound by their desire to give classical dance an American accent.

The kinship began shortly after Lincoln Kirstein brought Balanchine to America in 1933 to found an academy (the School of American Ballet) and direct a company (the American Ballet Ensemble, forerunner of the New York City Ballet). In 1935 Lew Christensen, a vaudeville performer then appearing on Broadway in *The Great Waltz*, auditioned for the new Kirstein-Balanchine venture, becoming in 1937 Balanchine's first American Apollo, a role that won him unstinted praise. Kirstein, for example, wrote that Christensen's Apollo was "everything one could wish"; Balanchine was happy to say there was no male performer outside Russia who could match Christensen as a *danseur noble*; and after *Apollo*'s dress rehearsal, Stravinsky himself expressed gratitude for the heroic stature of Christensen's dancing. During the next fifteen years, Christensen not only created leading roles in Balanchine's new works (*Jeu de Cartes, The Four Temperaments, Renard, Symphony in C*), he also served first as NYCB's ballet master and then as its administrative director.

Thus, when Christensen came to San Francisco Ballet in 1951 to become SFB's Director, he brought an important Balanchine alliance: within months of Christensen's arrival, SFB and NYCB announced that the two companies would share ballets and soloists. "Any similarities between the repertory of the San Francisco Ballet and the New York City Ballet," said the April 20, 1953 issue of

Newsweek, "are not coincidental, but deliberate. For the nation's two leading civic ballet organizations have embarked on an exchange program which should add variety and freshness to each company."

The first exchange, bringing Balanchine's *Serenade* and *Concerto Barocco* into the SFB repertoire and Christensen's *Filling Station* and *Con Amore* to NYCB, was a triumph: "The New York City Ballet should circle the genial brow of Lew Christensen with a laurel," said John Martin in *The New York Times* after the City Ballet premieres of *Filling Station* and *Con Amore*, "for his two new works are both great fun and unquestionable hits, adding a definite brightness to the season."

SFB's acquisition of Balanchine ballets continued throughout the Fifties, as the Company performed Balanchine's *Swan Lake, A la Français, Sylvia Pas de Deux, Apollo, Renard* (restaged by Christensen), and *Pas de Dix*. And the SFB-NYCB alliance grew even stronger in the nation's eye when the Ford Foundation in 1958 established its innovative ballet training program: talented young dancers from across the nation were given scholarships to study either at the School of American Ballet in New York or at the San Francisco Ballet School. SFB and NYCB were the only two companies included in this initial stage of the Foundation's program: Balanchine's School of American Ballet was responsible for the eastern half of the nation, Christensen's San Francisco Ballet School for the western half.

Balanchine ballets have entered the SFB repertory regularly since the Fifties, with a noticeable acceleration in recent years: *Allegro Brillante, Divertimento No. 15, Stars and Stripes, Western Symphony*, and *Chaconne* have all been mounted by SFB since 1979. And throughout its fifty year history, San Francisco Ballet has provided dozens of dancers for Balanchine: Elise Reiman, Janet Reed, Kent Stowell, Conrad Ludlow, Frank Ohman, Roland Vasquez, Suki Schorer, Sean Lavery, Kyra Nichols, and David McNaughton are all SFB-trained dancers who have danced with New York City Ballet.

For almost fifty years, Balanchine and Christensen have maintained an active association, frequently exchanging "salutes" of support. In 1966 when SFB organized a tribute to Christensen honoring his fifteen years with the Company, Balanchine came to San Francisco to serve as guest speaker. In 1967 while Christensen was in New York to confer on the designs for SFB's new *Nutcracker*, he taught for New York City Ballet. And in 1973 when Christensen and Smuin launched their first ambitious season as Co-Directors of SFB with the world premieres of *Cinderella* and *Don Juan*, both Balanchine and Kirstein attended the San Francisco debuts.

The Christensen-Balanchine affiliation continued in 1982 when Christensen was invited to contribute a ballet to the New York City Ballet's Stravinsky Centennial

4

Festival: he was the only outside choreographer so honored. Balanchine requested *Stravinsky Pas de Deux,* a work Christensen had created in 1976 for the all-Stravinsky program marking his own Twenty-Fifth Anniversary as SFB's Director and which had survived its occasion to enter the SFB repertoire. Accordingly, Christensen's lovely *pas de deux*—renamed with its score title, *Four Norwegian Moods*—was given its New York City Ballet premiere on Saturday evening, June 12, 1982 with Christensen and his wife Gisella Caccialanza (one of Balanchine's first American ballerinas) in attendance. "Lew Christensen's *Four Norwegian Moods,*" wrote Nancy Goldner in *Dance News,* "made a big hit. The dancers really dance; they don't mark time. In *Four Norwegian*

Moods, Christensen uses Stravinsky as though he were Minkus—and the approach works." In New York as at home, Christensen's ballet outlasted the Festival and entered the repertoire.

Balanchine's contributions to San Francisco Ballet— the example of his style, the prestige of his ballets, the lessons his choreography provides for dancers—are invaluable: they defy easy summary. Christensen has said that working with Balanchine was the schooling for his own choreography. "I learned so much about ballet by working with him on brand-new ballets, just sort of by osmosis—what to do and how to do it. I was learning all the time."

Christensen learned, it would seem, several lessons

Lynda Meyer and Paul Russell in the First Movement of *Symphony in C* (1981).

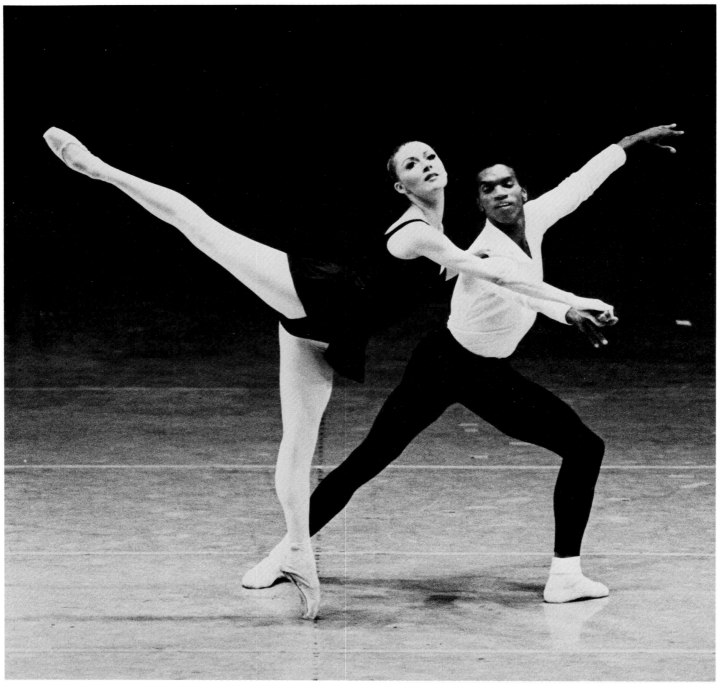

from working with Balanchine: that choreographic movement is, as Balanchine has written, "an end in itself, its only purpose to create the impression of intensity and beauty"; that in confining himself to the classical code, the choreographer "turns not away from life, but to its source"; that the more "artificial" movement becomes, unlimited by "considerations of practical, daily life," the more it gains, not loses, in spirituality; that the basic materials of classicism—the linkage of steps, the design of movement—are not a denial of emotion but an intensification of it; that the "impersonality" of the classical dancer is, in fact, the highest achievement of the personal; and that although ballet is the result of spatial and geometric thought, at its best, its "physics" imply a "metaphysics" of movement. Christensen learned, in short, the essence of ballet: that classical dance, despite its strict internal logic, its mechanical canon and prescribed movements, is paradoxically a world of countless possibilities, summing up and sometimes resolving the greatest dichotomies of Western culture—the physical and the spiritual, the real and the ideal, the temporal and the eternal.

The American critic Susan Sontag has said that ballet is the locus of all sorts of complicated ideas (ideas of pleasure, of sensuality, of civility, of order), and that wonderful reconciliations take place in classical dance. "What we experience in our lives, and even more so in our reflection, as quite opposite sometimes seems to be united in dance: a feeling for physical work as a way of

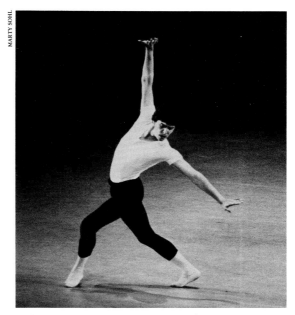

Kirk Peterson in the Melancholic Variation of *The Four Temperaments* (1981).

life, a feeling for refinement, a feeling for the nobility of the body and an intimation of what spiritual life is, and the transcendence of personality. All these things are concretely, coherently incarnated in ballet."

The exciting, almost magical, expressivity inherent in classical movement—this is what Balanchine taught to Christensen and what Christensen in turn has given so graciously, continuously, and powerfully to SFB.

Fiona Fuerstner and Virginia Johnson with *corps de ballet* in *Concerto Barocco* (1955).

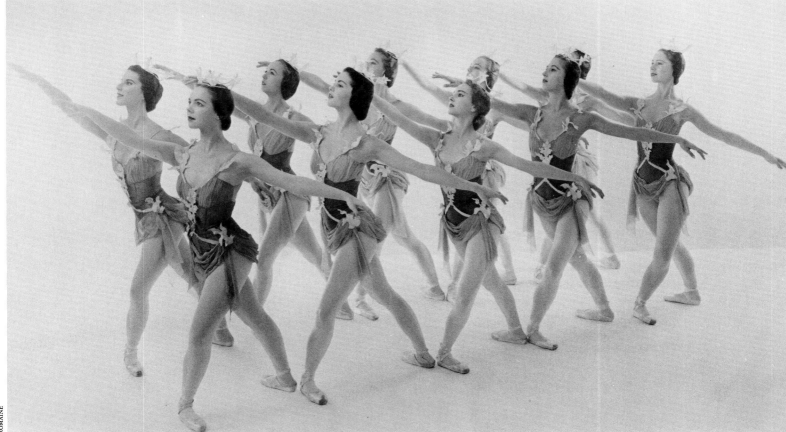

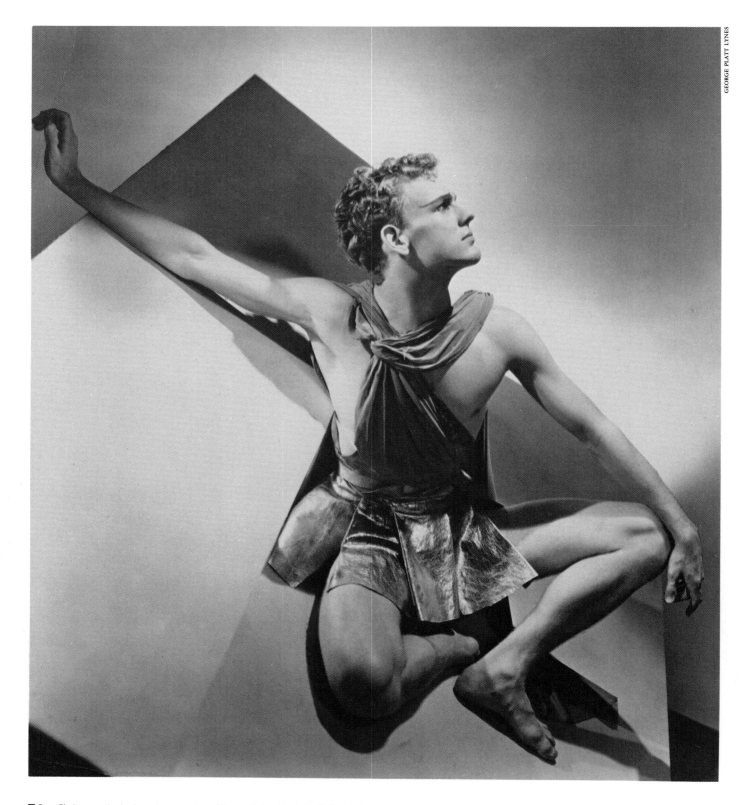

■ Lew Christensen in the American premiere of George Balanchine's *Apollo* (1937), first choreographed for Diaghilev's Ballets Russes in 1928 with Serge Lifar in the lead role. Lincoln Kirstein has written: "with Lifar, Balanchine had been given a boy who might conceivably become a young man. In America, with Lew Christensen, he found a young man who could be credited as a potential divinity. Praxitelean head and body, imperceptibly musculated but firmly and largely proportioned, blond hair and bland air recalled Greek marbles and a calm inhabitant of Nicolas Poussin's pastorals . . . [S]uch golden grace of person, and extraordinary physical endowment, is rare . . . [I]t was how Lew danced on stage and behaved off that signified to me a future, and within it a potential for American male dancers . . . Balanchine said, early on, that Lew's multiple pirouettes were the cleanest he ever saw, and years later that, as a teacher, he produced the best male aspirants on the continent. In the thirties, he danced the best *Apollo* both Balanchine and I have ever seen. His luminous clarity in life, and on stage his apparent separation from mundane consideration — indeed his sober naïveté — gave a luster to his performance which was, in the lost accuracy of the word, 'divine' . . . He combined, in one body, beauty, perfect physical endowment, musicality of a high professional level, a developed acrobatic technique, and an elegance of stage manners which was an exact reflection of his inherent morality."
—from *Thirty Years: Lincoln Kirstein's The New York City Ballet* (Alfred A. Knopf, 1978)

Opposite. (front row) Tina Santos and Elizabeth Tienken with *corps de ballet* in *Serenade* (1978).

20

Lew Christensen on George Balanchine:

"When you begin to learn Balanchine, for an outsider it's a very difficult technique. When you've been doing *Don Quixote* ballets and things like that, and then try to walk over and do *Symphony in C*, it won't work. You find you've got more feet and legs than you care to take care of."

"[In the Thirties the critics] thought everything Balanchine did was awful. Anything he did was old or old-fashioned or didn't make sense. Now his *Apollo* is a classic. They didn't think of it that way then. He had a hard time, a very hard time."

"You were taught everything, every move, by Balanchine. He demonstrated it, and then he changed it and remolded it and made it work. He would start something and then he'd put a little change here, a little change there, and it finally became something quite different and quite beautiful. You learned everything, even your finger movements and your head movements—he's that careful a choreographer."

"I never posed it as a problem, adapting to learn the style of Balanchine . . . I just did it, and I think that's the only way you can approach it. . . . You just forget everything else and do exactly what he says and it will work out well, which I think is part of his genius."

". . . In *Apollo* there is no room for acting. You dance every bit of the thing all the way through, never once a personal emotion or a grimace. You just go there and there, and you go on to the next. The story was carried very beautifully that way; it was all built in. You bring nothing personal to it, just your own feeling for the music; your response to the music, which grows as you do it."

"My relationship with [Balanchine] has been almost like brothers, just great, because we worked on solving problems together. For instance, he revived *Prodigal Son*, and we had to have little wreaths around the skullcaps for the boys, but we ran out of money. So we took the skullcaps to the top of City Center, way up high, and sat and made them, he and I, without the wardrobe department knowing about it."

". . . in Balanchine's company you are all stars and you're all corps de ballet. That's the way he worked."

". . . *Apollo* was one of my favorite roles. It was demanding, and when you'd got through it, you felt like you'd done something. Maybe you didn't have standing ovations, but who cared? You did have working with Balanchine, a very intelligent man, in a thing like that, which was a great privilege—not just the privilege of knowing him, but of learning from him. Learning was a revelation."

—from *Striking a Balance: Dancers Talk About Dancing*, by Barbara Newman (Houghton Mifflin Company, 1982)

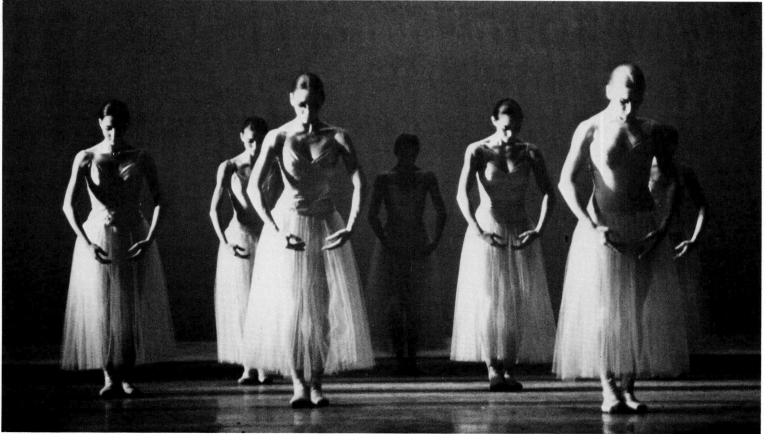

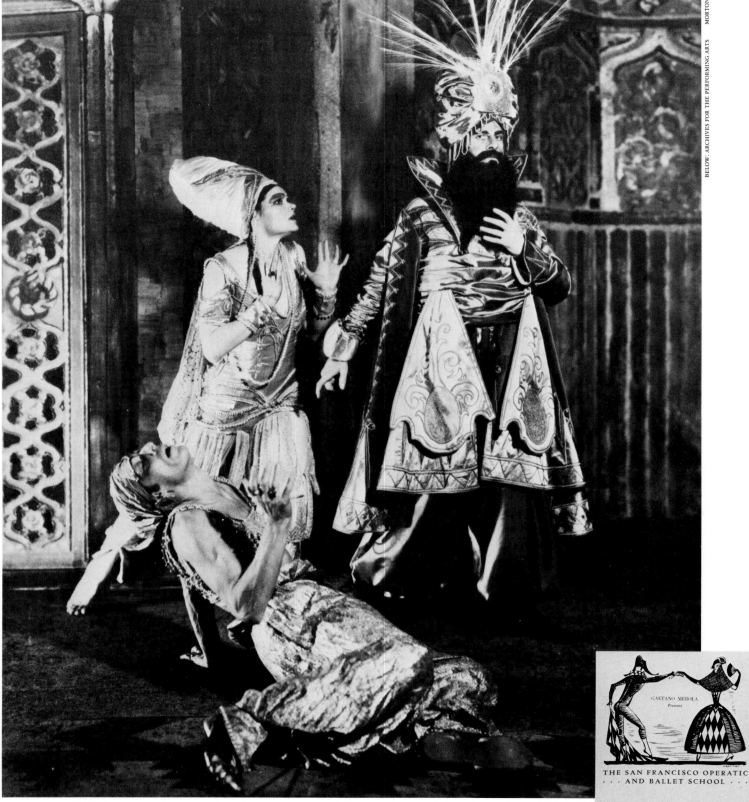

BELOW: ARCHIVES FOR THE PERFORMING ARTS MORTON

Iris de Luce as Zobeide, Guillermo Del Oro (standing) as Shahriar, and Adolph Bolm as the Favorite Slave in *Schéhérazade* (1935).

GAETANO MEROLA
Presents

THE SAN FRANCISCO OPERATIC
· · · AND BALLET SCHOOL · · ·

IN
ITS
FIRST
PERFORMANCE

Under the auspices of the
Women's Committee of
the San Francisco Opera
Association.

WAR MEMORIAL OPERA HOUSE
· · FRIDAY JUNE 2, 1933 · · ·

The first 5 years.

1933. On November 1, 1932, the San Francisco Opera finishes its fall performances. It is an historic occasion: the Company's tenth consecutive season and its first in the recently completed War Memorial Opera House— the only municipally owned opera house in America. Gaetano Merola, the Opera's founding director, is inspired by the Company's new theater and wants to solidify, and expand, the Company's resources. Though during its first decade the Opera has maintained a small ballet company, the dancers have not been associated with a permanent academy, and the ballet masters have never stayed long enough, Merola says, to impart lasting style. The Opera Ballet has seen five different ballet masters during its first ten seasons: Natale Carossio, Theodore Kosloff, Serge Oukrainsky, Ernest Belcher, and Estelle Reed.

To remedy this situation, Merola announces that starting in 1933, the Opera will establish a permanent opera and ballet school—the only such school west of New York. The San Francisco Operatic and Ballet School, Merola explains, will make possible a year-round ballet company and will, he hopes, "place San Francisco in the same high position in the realm of classical dance that it now occupies in the operatic world." Merola himself will head the opera school, while the ballet school will be directed by Adolph Bolm, the great Diaghilev dancer.

At the school's opening, Bolm explains that although the aim of the ballet school is to prepare dancers for operatic work, the ballet performances will not be confined exclusively to the Opera: a series of independent performances will start in the near future. On March 17 the school presents an informal program in its new home in the William Taylor Hotel, and on Friday evening, June 2, the Ballet presents its first all-dance performance at the Opera House. Fifty dancers take part in the program; Merola himself conducts the San Francisco Symphony; and all ballets are choreographed, staged, and to a large extent costumed by Bolm, who dances in four of the evening's eleven works.

The highlight of the evening is a full production of Bolm's "ultra-modern" factory fantasy, *Ballet Mécanique*, which had enjoyed enormous success at its 1931 Hollywood Bowl premiere. The eclectic program also includes: *Arlecchinata*, a *commedia dell'arte* ballet; *Prelude and Four-Voice Fugue*, a choreographic study in which each voice is interpreted by a dancer; *Les Précieux*, a dance of the "precious" period of Louis XIV; *Don Juan*, a choreodrama featuring Bolm as the Don; and *Reverie*, a romantic Chopin ballet fashioned after Michel Fokine's *Les Sylphides*. Tickets for the gala debut range from 50¢ (Balcony) to $2.50 (Orchestra), with an entire box costing $24. A standing-room-only audience fills the Opera House.

"By this premiere performance," the program notes announce, "San Francisco definitely takes its place as a ballet producing center with the added distinction of being the only city in the country other than New York with its Metropolitan, to boast an operatic chorus and ballet school as an auxiliary to an established grand opera company."

The hit of the fall opera season is a dance-pantomime production of Rimsky-Korsakov's *Le Coq D'Or*, in which the dancers enact the opera's story, with the cast of singers and chorus grouped at the sides of the stage. The entire production is directed by Bolm, who also staged the opera's 1918 American premiere at the Met in which he himself danced King Dodon. (The Met production was a staple of the repertoire for many years, enjoying some forty-two performances.) Russian painter Nicolas Remisoff, who had worked frequently with Bolm during their Chicago Allied Arts years, designs the elaborate— and expensive—costumes in a brilliant splash of decorative fantasy. The opera is sung in English with an "all-San Francisco" cast: one of the Opera's prime goals since its inception has been the development of American singers, and *Le Coq D'Or* is the Opera's first work performed entirely by local talent. Bolm again appears as King Dodon, with Maclovia Ruiz as Queen of Shémaka.

The premiere, with a capacity crowd, scores a success and is declared "a red-letter date" in the Opera's history— "the most important production that the San Francisco Opera has yet given us," says the *San Francisco Examiner*. "It also proves that Gaetano Merola never did a better day's work than when he brought Adolph Bolm here."

The Ballet is fifty-two dancers strong.

1934

On Friday evening, June 8, the San Francisco Opera Ballet presents its second annual gala performance before a packed, standing-room-only crowd at the War Memorial Opera House. Again, the choreography, lighting, and most of the costumes are the work of the Company's celebrated ballet master, Adolph Bolm, who also performs in three of the evening's thirteen ballets.

The program features several of last season's major hits (*Ballet Mécanique, Reverie, Carnival, Les Précieux*), as well as two noteworthy revivals from Bolm's Chicago days: *The Rivals*, a love-and-death drama based on a Chinese legend; and *Pedro the Dwarf*, a ballet-pantomime inspired by Oscar Wilde's *Birthday of Infanta*, which Bolm originally created for Ruth Page and which the Russian-born choreographer called "my first ballet in English." *Patterns*, a ballet involving the manipulation of yards and yards of webbing in complicated designs, premieres to such success that the audience demands an encore.

During the fall, the Ballet performs both at Marin's first Music Festival (at Dominican College's Forest Mead-

Above. *Corps de ballet* in Willam Christensen's *Chopinade* (1937).

Opposite. Serge Oukrainsky in *Lakme* (1937).

ows), and with the Los Angeles Grand Opera, where the resounding success of *Le Coq D'Or* is repeated. ("Films Temporarily Forgotten as Hollywood Goes to the Opera," reads an L.A. headline.)

The 12th San Francisco Opera Season is rich with dance: eight of the twelve operas call for ballet. All choreography is by Bolm, under whose guidance San Francisco is developing the only opera ballet in America organized for continuous and independent performance.

1935

Spurred by the success of its first two years, the Company undertakes its most ambitious offering to date: the third annual spring season (May 15 and 18) features the Company's first guest artist—Vincente Escudero, who stages *El Amor Brujo* for the occasion.

The season's second main offering is Bolm's restaging of Fokine's *Schéhérezade*, a ballet San Francisco has not seen for seventeen years, since the Ballets Russes' historic first American tours of 1916-17. An exotic tale whose feverish, hothouse sexuality came complete with bacchanalian orgy, women surprised with their Negro lovers, and mass execution, *Schéhérezade* had stunned—and utterly seduced—audiences at its famous 1910 Paris premiere. ("I never saw anything so beautiful," confessed Marcel Proust after the ballet's debut.) For the ballet's San Francisco revival, Bolm himself dances the Favorite Slave, a role he performed in New York on opening night of that first Ballets Russes American tour. The San Francisco

production, moreover, recreates the Léon Bakst sets and costumes, arguably the most famous ballet designs of the age. Bakst's debauched and barbaric palette of raw, riotous colors—tomato red, peacock blue, and emerald green in hitherto unseen combinations—had revolutionized Parisian tastes. (After the ballet's premiere, fashionable French women began to wear jeweled turbans; smart houses were suggestively decorated with floor pillows; and the jeweller Cartier, inspired by Bakst's orgy of blue and green, set emeralds and sapphires together for the first time in history.)

The spring gala, in honor of Bach's 250th anniversary, also includes Bolm's staging of three Bach pieces. *Lament* aspires to the condition of kinetic sculpture: three dancers perform the entire work enveloped in a single enormous costume that leaves only their heads and hands visible. *Consecration* and *Danse Noble* are elaborate, geometric abstractions full of strikingly angular, "mechanical" movements and dramatic group configurations. Costumes for *Consecration* are designed by San Francisco's internationally acclaimed artist Beniamino Buffano.

Several *divertissements*—duets for Escudero and his partner Carmita, a solo from *Firebird*, and an ensemble piece to Mendelssohn—complete the program. The program, says noted critic Alfred Frankenstein, is the most successful in the Company's history: "the principal point is that the San Francisco Opera Ballet is the only institution of its kind in the country, the only opera ballet company that is of importance in and for itself. It is far more than a

group of dancers for brief appearances in *Aida*; it is an artistic organization in its own right."

In the fall, the Ballet gives its first performances in Oakland, Berkeley, and Burlingame. Since the main focus of the current opera season is a production of Wagner's complete *Ring* cycle, the season offers little dance: only four of the thirteen operas require ballet, although the dance-filled *Le Coq D'Or* is revived from the 1933 repertory.

On December 12 the Company's Spanish dance contingent, led by Guillermo Del Oro, inaugurates a new concert series at the Opera House, a series that also features Martha Graham, Angna Enters, and the Philadelphia Orchestra with Leopold Stokowski.

1936

Bolm takes the San Francisco Opera Ballet to Los Angeles during the summer, where on three consecutive Thursdays in August, the Company performs at the Hollywood Bowl. For the first and last of these three appearances, the Company is featured in operas. But the middle program is devoted to dance: *Schéhérazade* and Bolm's Bach cycle are the main fare (or "Bach and Bakst" as one Los Angeles reviewer writes). For the first time in the Bowl's "Symphony Under the Stars" series, the orchestra sits in the pit for a dance program, yielding the entire stage to the dancers. The program receives standing ovations and rave reviews.

Following its L.A. season, the Ballet returns to San Francisco to rehearse the fall opera repertory. Although the opera season is marked by several important "firsts"—broadcasts on NBC radio, guest conducting by Fritz Reiner, and the Opera's first Mozart work, *The Marriage of Figaro*—only three operas require dancing. With no "all-ballet" spring performances in San Francisco and few fall opera-ballets, the Ballet's future is uncertain.

1937

Crisis hits the Company: Bolm's contract, due to expire in January, is not renewed, and rumors abound concerning his replacement. Both Michel Fokine (the first of Diaghilev's great choreographers) and George Balanchine (the last) are said to be likely successors, but the Opera's director Gaetano Merola declines comment and refuses to make a hasty decision. Mildred Hirsch, a local dance teacher, is appointed ballet mistress and will temporarily direct the Company.

Unlike many other opera directors, Merola is committed to dance: according to the *San Francisco Call-Bulletin*, he wants the ballet "to be expanded and developed as never before." Hence he will choose a new ballet master carefully, slowly. Months indeed pass by, and finally, pressed to find a choreographer at least for the upcoming opera season, Merola announces in July that Serge Oukrainsky—the Company's ballet master from 1928 to 1930—will once again fill that position. Oukrainsky's new contract, however, requires his services only for the

fall opera season, and it is conjectured that Merola is still searching for his "ideal" choreographer—a ballet master who will truly advance dance in San Francisco.

In August, Willam Christensen—director of the Portland Ballet and a member of one of America's leading families of dance—is appointed Director of the Oakland branch of the Opera Ballet School. The thirty-five-year-old Christensen arrives in San Francisco with his own repertory and nine of his Portland dancers.

Eager to show his directorial and choreographic talents, Christensen announces a concert soon after his arrival. His brothers Lew and Harold—principal dancers of the Balanchine/Kirstein companies, American Ballet and Ballet Caravan—will be guest artists. Thus, at the Oakland Women's City Club on September 17, three of America's foremost male dancers are featured on the same program.

Willam is the Company's principal *danseur* during the fall opera season, although the opera ballets are choreographed either by Mildred Hirsch or Oukrainsky.

In November, Christensen, rather than Oukrainsky, organizes a series of out-of-town engagements for the Ballet, performing throughout Northern California in towns that, in some instances, are seeing classical dance for the first time. (A Santa Cruz newspaper receives so many "what-is-ballet?" inquiries that it runs an article explaining the art's most elemental attributes.) The tour, which breaks audience records in certain towns, brings Christensen's talents into clear focus: Merola's long-awaited "ideal" choreographer has arrived.

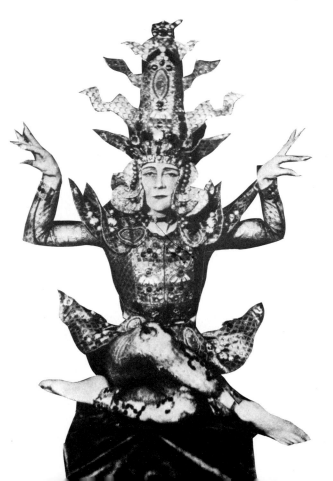

Filling Station

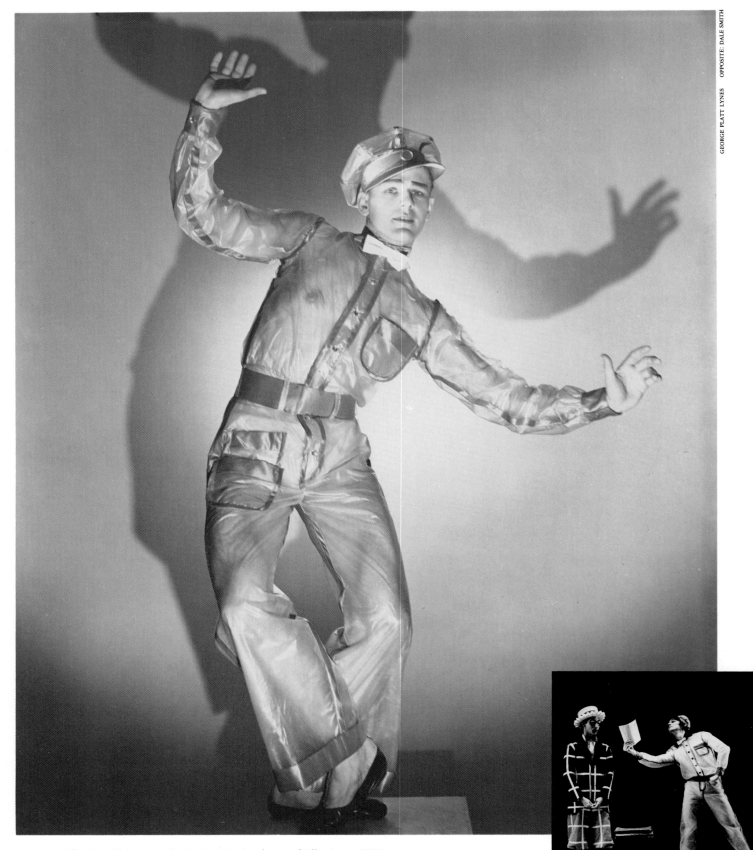

Above. Lew Christensen as Mac in the original production of *Filling Station* (1938).
Right. Dennis Marshall as Mac and Jerome Weiss as the Motorist in *Filling Station* (1978).
Opposite. Richard Carter as Mac in *Filling Station* (1959).

26

January 6, 1938 marked the world premiere of Lew Christensen's *Filling Station*, which has held, for nearly half a century, a secure place in the history of American dance. It is a seminal work: one of the first ballets on a familiar American subject; one of the first ballets to employ American music, scenery, costumes, and dancers; and the first popular hit produced by Ballet Caravan, the small American company founded in 1936 that, with the Balanchine-Kirstein ensemble American Ballet, was a precursor of the present-day New York City Ballet.

An unpretentious roadside fable about a gas station attendant whose quiet night shift is comically interrupted by a pair of truck-driving pals, a family of brassy tourists, a state trooper, a couple of tipsy socialites, and a trigger-happy gangster, *Filling Station* is unencumbered by "artiness"—it's a buoyant comic strip look at everyday life. "The music is absolutely normal, middle-class America for the time," says its composer Virgil Thomson, whose bright and witty score for *Filling Station* includes everything from hymns to honky-tonk syncopations to movie chase music to delightfully irreverent quotes from "Hail, hail, the gang's all here" and "We won't get home until morning"—all aimed, as Thomson has said, "to evoke roadside America as pop art."

The use of pop elements in *Filling Station* was programmatic, even doctrinaire—part of the movement to found a national school of American ballet and give European classicism an American accent. Lincoln Kirstein, who furnished *Filling Station* with its libretto and served as the ballet's Diaghilevian overseer, was among the first and most ardent believers in ballet's American possibilities. Shortly before *Filling Station*'s premiere, Kirstein had published his now-famous, then-infamous *Blast at Ballet*, a passionate, sweaty, impolite, noisy, contemptuous, and utterly brilliant diatribe against the "enemies" of American dance—against, that is, those people who stubbornly believed "true" ballet could be created *only* by Russians. If *Blast at Ballet* functioned as Kirstein's angry battle cry, *Filling Station* was his first taste of victory. With its cartoon costumes, madcap libretto, pop score, and athletic choreography, *Filling Station* was a paean to pop culture, immediately familiar, instantly accessible—the American answer to *Swan Lake* and *Sleeping Beauty*, with Mac the mechanic as a workaday Prince Charming.

It was thus no coincidence that in introducing American ballet to Americans, Kirstein and Christensen set their first contemporary work in the most American of all locales: the gas station, both crossroads and weigh station of U.S. mobility. Paul Cadmus designed the boldly scaled set (complete with restrooms, maps, and radio) in the neon and chromium fantasy of Thirties American pop, while his comic strip costumes were so indelibly of their time that their 1937 origins would be recognized by "the theatregoers of 2037," to quote an early program note.

The whole set, as Kirstein has said, was the kind of place "Jimmy Cagney might be at home in," and Hollywood indeed hovers over much of *Filling Station*. The bratty daughter—spoiled, ill-behaved, and as overdressed as she is undertalented—was by Kirstein's own design "the nightmare twin" of Shirley Temple, Hollywood's number one box office draw the year *Filling Station* was created. And the ballet's breakneck pace, irreverent humor, and eccentric characters shared much with Hollywood screwball comedies, which also liked to depict the antics of the irresponsible and hard-drinking rich. The whole ballet has a *Grand Hotel* slice-of-lifeness about it: characters from all walks of life—proletariat, middle class, country club set—are represented, allowing us to understand why *Filling Station* was initially subtitled "a ballet document." Part screwball comedy, part gangster melodrama, and part *Grand Hotel* omnibus, *Filling Station* aimed to prove the ballet stage could be as entertaining, and as accessible, as the silver screen.

Filling Station premiered at the Avery Memorial Theater, in Hartford, Connecticut, on a Ballet Caravan program jointly sponsored by the Wadsworth Atheneum and an organization called the Friends and Enemies of Modern Music. Christensen himself danced the virtuosic role of Mac; his brother Harold was the henpecked, befuddled, and outlandishly clad Motorist; Eugene Loring played Ray the knockabout truck driver; Erick Hawkins was the Gangster; Todd Bolender the State Trooper; and Marie-Jeanne the Rich Girl with the "vaguely F. Scott Fitzgerald" air about her. (This role was soon also danced by Gisella Caccialanza, one of Balanchine's first American ballerinas and one of the last protégées of the great Enrico Cecchetti.)

On February 18, 1938, some six weeks after the Hartford premiere, Ballet Caravan made its first New York appearance accompanied by an orchestra. The occasion was the Festival of American Music, sponsored by the WPA Federal Music Project at the Federal Music Theater. The theater, as Anatole Chujoy has recorded in his history of the New York City Ballet, was sold out to the last seat. "There were flowers, ovations, and all the other trimmings of ballet success" for a program that featured Loring's *Yankee Clipper*, Hawkins' *Show Piece*, and Christensen's *Filling Station*, the hit of the evening. According to America's great dance critic, Edwin Denby, the *Filling Station* program revealed that "an American kind of ballet is growing up, different from the nervous Franco-Russian style . . . our own ballet has an easier, simpler character, a kind of American straightforwardness that is thoroughly agreeable." And *Dance Magazine* praised the "adroit skill" with which Christensen com-

6

posed a narrative of "remarkable economy—not a single character is superfluous, nor is one missing. It must have been so tempting and easy to clutter up the stage with an ensemble of more attendants, more truck drivers, more cops, more anybody. Without losing for a moment his close connection with ballet tradition, Lew Christensen fits the separate dances to the characters and uses acrobatic and ballroom dances that deviate from the conventional *enchaînements*, yet remain within the realm of ballet."

Filling Station was given more than 300 performances during the next four years, becoming one of the most popular items touring in Ballet Caravan's repertory. Boston thought it proved that "gasoline is potentially as fragrant as the most delicate perfume in the realm of dance." Texas found it possessed "a vivid directness of experience, full of observation of details and people all of us see every time we take an automobile trip." And San Francisco noted that it "immortalizes perfect American

TONY PLEWIK

types, without a hint anywhere either of Gershwin or of that equally common and equally false Americanism that has its source in the French music hall." But when American Ballet Caravan folded after its 1941 tour of South America, *Filling Station* lapsed from the active repertory until 1951, when Christensen mounted it for San Francisco Ballet, where he had just joined his brother Willam as Co-Director.

The SFB revival was a part of the Company's Ballet Premieres series, a season of informal programs designed to try out new ballets and to cast dancers in roles new to them. Held at the Commerce High School Auditorium near the Opera House, the experimental season also included *The Nothing Doing Bar*, *Charade*, and *Le Gourmand*, a whimsically conceived ballet in which dancers portrayed a filet of sole, a breast of chicken, and a *pêche flambée*. Harold Christensen, since 1942 the director of the SFB School, recreated his original role for the *Filling Station* revival, as did Gisella Caccialanza, who had in 1941 become Mrs. Lew Christensen. Mac—whom Lincoln Kirstein once described as a "self-reliant, agreeable and frank American working-man whose acrobatic brilliance showed him capable of treating any emergency that might come up with brilliant resourcefulness"—was

played by Roland Vasquez. The stunning Paul Cadmus sets and costumes, on loan from Kirstein, were used for the revival. (The Ballet Design Exhibition at San Francisco's De Young Museum, featuring several Cadmus designs, coincided with the SFB season.) The revival was such a hit that it moved to the Opera House for the Company's May 19 Spring Gala when *Filling Station* was hailed by the *San Francisco Chronicle* as "one of the classics of modern American ballet, which dates nobly, builds to a wonderfully dramatic climax, and sets forth its assorted personalities with a hand that is as masterly in characterization as it is in choreography."

The night before the Opera House performance, San Francisco Ballet announced it had just accepted New York City Ballet's offer to exchange two works by George Balanchine for two Christensen ballets. And thus in 1953, on its fifteenth anniversary, *Filling Station* was given its NYCB debut at City Center. In a brief announcement before the curtain rose, Lincoln Kirstein, general manager of New York City Ballet, noted that *Filling Station* was being revived as a document, to give some idea of the "origins of the repertory of the New York City Ballet." But as B.H. Haggin wrote in *The Nation*, the audience knew better and responded to the piece "not with an interest in it as history but with delight in its moment-to-moment operation as a work of art. *Filling Station* takes its place with Loring's *Billy the Kid* and Robbins' *Fancy Free* as one of the classics of American ballet—brilliant in its observations, its dance invention, its organization."

Filling Station, in fact, scored one of the major successes of the NYCB season, a season that also saw the company premieres of Christensen's *Con Amore*, and the world premiere of two of Jerome Robbins' classics: *Afternoon of a Faun* and *Fanfare*. Writing in *The New York Herald Tribune*, Walter Terry called *Filling Station* "a resounding hit . . . an unpretentious, lively, thoroughly entertaining and, I believe, lovable work." And in *The New York Times*, John Martin said the ballet was a "complete surprise . . . a spirited and hilarious farce . . . a thoroughly good show . . . a big piece of vaudeville hokum."

Janet Reed, a former SFB dancer, played the stewed-to-the-gills Rich Girl to thunderous acclaim, while Mac was danced by the eighteen-year-old Jacques d'Amboise in a vibrant, vigorous performance that catapulted him into stardom. The original 1938 production ended "tragically," but for the 1953 revival Balanchine suggested that the Rich Girl, shot by the Gangster and borne off held aloft, should revive in mid-air and wave "bye-bye" to the audience just before she reached the wings, giving *Filling Station* an extra fillip of cartoon fantasy.

Filling Station was such a smash hit in New York that several oil companies even offered to film it. And on October 10, 1954, Max Liebman, the "Ziegfeld of television," presented *Filling Station* on one of his Sunday night NBC "Spectaculars," making *Filling Station* one of the first ballets aired on prime time national TV.

Vane Vest and Paula Tracy
as the Rich Couple in
Filling Station (1974).

San Francisco Ballet performed *Filling Station*, newly designed by Robin Wagner, on its 1958-59 tours of South America and the Middle East: Richard Carter and Roderick Drew alternated as Mac; Nancy Johnson and Louise Lawler shared the role of the Rich Girl; and Michael Smuin enjoyed success as the carefree and high-spirited truck driver, Roy. Although few performances of *Filling Station* were given by SFB during the Sixties, the ballet became a popular piece in the early Seventies with Robert Gladstein's accomplished portrayal of Mac; and in 1975 the Paul Cadmus sets and costumes were happily restored. For the ballet's Fortieth Anniversary in 1978, composer Virgil Thomson was in attendance: Dennis Marshall, cast from the same heroically proportioned mold as Christensen, played Mac, while the Rich Girl was danced by the Company's most gifted comedienne, Paula Tracy. Thomson and Christensen won a standing ovation at the final curtain. (The performance, and

a studio rehearsal, were taped for a PBS documentary on Thomson's life and music.) During its forty-five years, *Filling Station* has been danced by Ballet Caravan, San Francisco Ballet, New York City Ballet, Ballet West, Pacific Northwest Ballet, and Kansas City Ballet.

Lew Christensen was not yet thirty when he created *Filling Station* in 1938, striking out in largely unexplored territory: Loring's *Billy the Kid* would not come for another eight months, de Mille's *Rodeo* not until 1942, and Graham's *Appalachian Spring* and Robbins' *Fancy Free* not until 1944. Although an early work, *Filling Station* abounds with the qualities that have held Christensen in good stead throughout his long career: a wry, intriguingly eccentric comic imagination, a deft sense of characterization, an utter lack of pretension, and an ability to show that ballet can furnish first-rate theatrical entertainment without relinquishing its claim to classical dignity. As Olga Maynard has written in her pioneering overview, *The American Ballet*, it was with *Filling Station* that Christensen both "showed his distinctive style—a commingling of the playfulness and sharp clarity that seem essentially American, with a sense of design and deportment derived from the classical tradition—and emerged as an American choreographer of the first rank."

Opposite. John McFall as Mac, Robert Sund and Gardner Carlson as Roy and Ray in *Filling Station* (1978).

Below. Jerome Weiss, Janne Clement, and Allyson Deane in the Fortieth Anniversary production of *Filling Station* (1978).

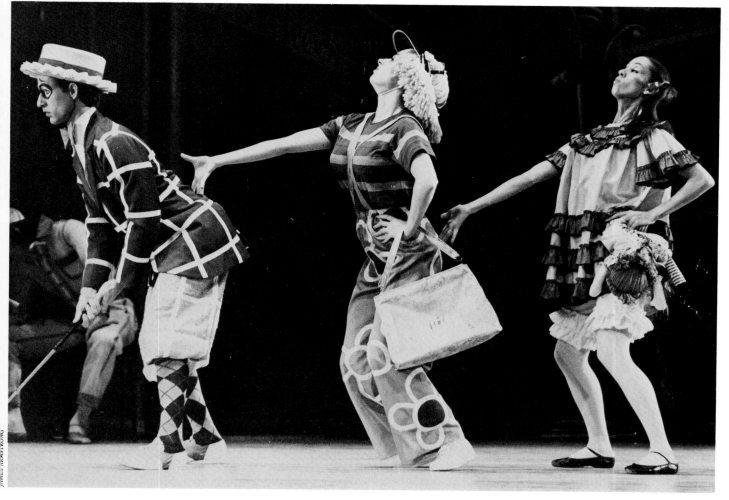

Le Ballet Mécanique

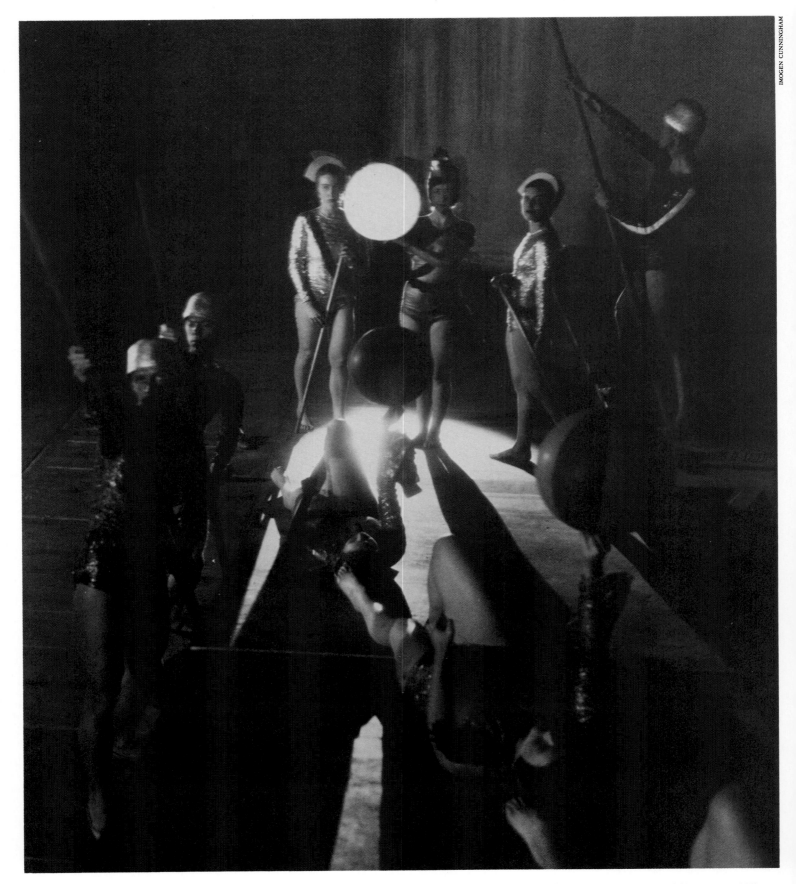

Above. Ballet Mécanique in performance at the War Memorial Opera House (1933).
Opposite. Ballet Mécanique was performed at the Hollywood Bowl in 1931 and 1932.

Some 7 groups of dancing "automatons" flanked the two principal "dynamos" in San Francisco Ballet's first major production, *Ballet Mécanique*, presented June 2, 1933 on the Company's landmark debut program. Set to a pounding score by Alexander Mossolov and choreographed by the Company's newly appointed director, Adolph Bolm, *Ballet Mécanique* embraced the machine age vigorously, and was, in fact, also known as *Spirit of the Factory* and *Iron Foundry*. Mechanistic in movement and "moderne" in design, the ballet hailed "the truly modern manner," as the program notes said, using the human body "to express the mechanical age of today." And indeed the dancers in *Mécanique* moved not as humans but as various cogs in one tremendous machine—a dynamic, throbbing, pulsating, roaring, jolting, and jerking whirl of molten-red energy. Bolm, who conceived the ballet after visits to *The New York Times* printing plant and the Ford factory in Detroit, was intrigued by the similarity of machine movements to classical ballet technique. Bolm saw, as Richard Hammond noted, the *pirouettes* of fly-wheels, the *glissades* of gears, the *battements* of levers, the *fouettés* of pendulars, and the *jetés*, *cabrioles*, and *entrechats* of spring valves. With its emphasis on novelty and innovation, his choreography here definitely followed Diaghilev's famous dictum to Cocteau, *Etonne-moi!* ("Astonish me!"), and following the fashion of so many of Diaghilev's post-1917 works, *Ballet Mécanique* was clearly—and intentionally—stamped: Made in the Twentieth Century.

Bolm had worked in Hollywood before coming to San Francisco, and *Ballet Mécanique* was originally created not for the stage but for the silver screen, for a 1931 Warner Brothers melodrama, *The Mad Genius*, in which a Svengali-like puppeteer (John Barrymore) turns a runaway boy (Donald Cook) into the world's greatest male dancer. Often thought to be loosely based on the famous Diaghilev-Nijinsky affair, *The Mad Genius* was one of Hollywood's first looks at the world of classical ballet. (In *Grand Hotel*, released a few months after *The Mad Genius*, Greta Garbo gave America another glimpse into the allegedly gloom-and-doom world of ballet.) Unfortunately, most of Bolm's *Ballet Mécanique* was deleted from the final cut of *The Mad Genius*, and even those fragments that were included are danced not to the Mossolov score, but to completely unrelated music: Warners had not wished to negotiate with the Russian composer for the film rights. Bolm was infuriated by the studio's misuse of the ballet (it was one of the most frustrating experiences of his career, he later confessed), and he decided to stage the work in its entirety for his company's 1931 summer season at the Hollywood Bowl.

And thus on July 28, 1931, *Ballet Mécanique* received its world premiere with Elise Reiman and Robert Bell as the principal "dynamos." The ballet was so successful (*The Los Angeles Times* found it "dazzling," "fascinating," and the principal dancing near "sensational"), that it was scheduled for a repeat performance on Bolm's August 7 program, with Pierre Monteux conducting a mostly Russian repertoire. This second performance, attended by a record-breaking crowd, created a furor—"a milestone in the realm of modernistic dancing," said the *Times*. Following this success, Bolm revived and enlarged

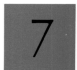

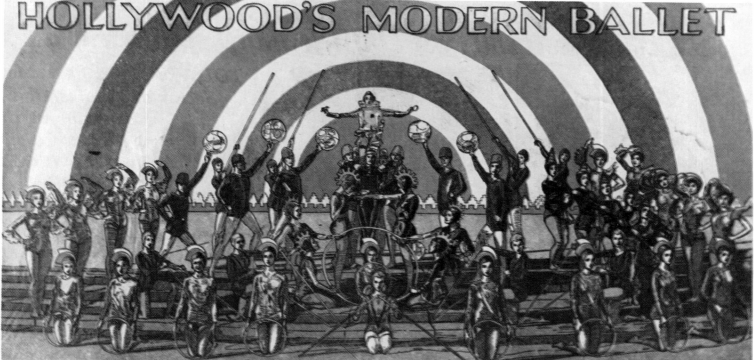

HOLLYWOOD'S MODERN BALLET

Ballet Mécanique for his 1932 Bowl season: two new groups of dancers and special lighting effects requiring iron poles fifty feet high were added. This revised production of *Ballet Mécanique* premiered August 15, 1932, and scored another instant success: "the *Mechanical Ballet* is still supreme," raved the *Times*, "and stands alone in the annals of dance presentations given in the Bowl. Were it to be offered every year from now on, audiences would

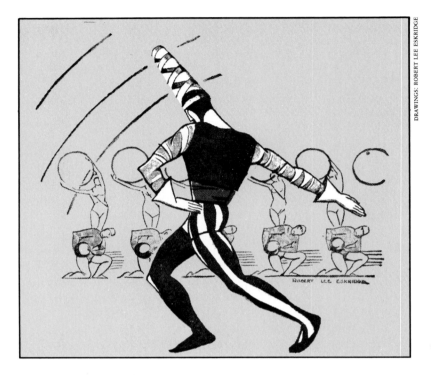

DRAWINGS: ROBERT LEE ESKRIDGE

still find new interest in its intricate workings—as evidenced last night in the insistent applause and calls for an encore. Only a short speech by Bolm, in which he explained that the dancers had already taken off their make-up, served to hush the enthusiasm—and even this was greeted by disappointed groans. . . . No ballet presented in Los Angeles in recent years possesses the ingenuity of choreography and design shown in the Bolm creation."

Four months later, Bolm was asked to direct the San Francisco Opera Ballet. Under Bolm, the Ballet was to perform not merely during the opera season but throughout the year—on independent ballet programs. For the Company's first "all-dance" gala, Bolm staged eleven solo and group dances, with a musical interlude to permit costume changes for the evening's final major production, *Ballet Mécanique*. San Francisco had read of the ballet's Los Angeles success: the local newspapers had told about the ballet "which three times attracted an audience of 20,000 to the Hollywood Bowl," and which, in San Francisco, would be danced by a large corps of fifty, "with fifteen male dancers, in itself unusual for a ballet." (It is appropriate that from its first performance, San Francisco Ballet has given the *danseur* his due.)

Elise Reiman and Robert Bell danced their original roles for the San Francisco premiere, and the ballet was, once again, a crowd pleaser. "Opera Ballet Triumphs in

Mécanique," "Dancers Thrill at Ballet Offering," "Bolm's Robots Cast Charms In Ballet at Opera House"—read the next day's headlines. Not surprisingly, *Ballet Mécanique* remained in the Company's repertoire during its first few years.

Ballet Mécanique was also produced by Ballet Theatre in 1940 for its historic New York debut season, when Viola Essen and Dimitri Romanoff danced the principal dynamo roles. (Romanoff, a former SFB dancer, had performed in *Ballet Mécanique*'s San Francisco premiere.) It was Ballet Theatre's hope that *Ballet Mécanique* would represent—at least in style and intent—the late Diaghilev era, but in 1940 *Ballet Mécanique* suited neither the audience nor the critics. "*Ballet Mécanique*," wrote John Martin in *The New York Times*, "is very minor Bolm indeed. Composed originally for the movies . . . it must be confessed that it still possesses the marks of its Hollywood background. Perhaps twenty years hence it will be revivable as a kind of period piece, representing the one-time prevalent concern of choreographers with machine movements, but it is not yet remote enough to be picturesque. As an example of its class, however, it exhibits imagination and a nice sense of form."

Today, *Ballet Mécanique* is no longer performed, and many would argue that the ballet—precisely because it dealt with the cult of the moment—would be virtually impossible to revive.* (The same charge was levelled against Massine's *Parade* and Nijinsky's *L'Après-midi d'un faune*, both of which have indeed enjoyed successful revivals in the past decade.) Certainly *Ballet Mécanique* belongs to this century's long, and fascinating, history of machine aesthetics, an aesthetics that fuelled several important movements (Italian Futurism, Russian Constructivism, the German Bauhaus), and influenced figures as diverse as Cocteau (who defined poetry as "electricity"), Henry Adams (who saw the dynamo as the principal symbol of the modern age), and Andy Warhol (who, after confessing "I want to be a machine," named his base of operations The Factory). But whether *Ballet Mécanique* was an interesting contribution to such aesthetics or merely a watered-down imitation of much more important works must remain—as is unfortunately the case with "lost" ballets—unknown. Dance, as George Balanchine has repeatedly reminded us, lives in performance and only in performance.

*An excerpt from *Ballet Mécanique* has been staged for SFB's Fiftieth Anniversary Gala (1983) by the Company's Assistant Artistic Director, Robert Gladstein, with Gina Ness and Mark Silver as the Principal Dynamos.

Above left. The male Principal Dynamo in *Ballet Mécanique*.
Opposite left. The female Principal Dynamo in *Ballet Mécanique*.
Opposite right. Elise Reiman as the female Principal Dynamo in *Ballet Mécanique* (1933).

CHARACTERS

Principal Dynamos
Switches: First Line
(9 female dancers)
Gears: Second Line
(9 male dancers)
Pendulars: Back Line
(9 female dancers)
Fly Wheel: Circle to Right
(6 female dancers)
Principal Pistons: Boys with Long
 Poles (4 male dancers)
Piston Rods: Girls with Poles
(5 female dancers)
Spring-Valves: Line to Extreme
 Right (5 female dancers)

■ A blast from a steam whistle summons the automatons to work. Clad in metallic, clinging garments, with metalized bodies, the Cog Wheels, the Piston Rods, the Balance Wheels, and other parts of the Machine enter in the midst of a red glare, as from some enormous cosmic furnace. Forming in their groups, the dancers follow the accented rhythms of the music while the Master of the Factory stands to one side marking time.

The Dynamo enters, clad in silver and cellophane, with the button controls of a robot marking the decoration of the box-shaped body, her abrupt, pleated silver skirt swirling out like a fan wheel. Holding a rod and disc in her hands, the Dynamo spins and twirls on her toes with the precision,

speed and lightness of electricity.

Following here with heavy tread comes another Dynamo, expressing the power of electricity and its grace, in a costume composed of a black foundation painted in long powerful spirals of silver, with a stripe of scarlet and with a headdress of huge spirals.

The rhythm changes. The automatons re-form new patterns on the stage. From every angle in the audience a different group is visible, working independently, yet as a perfect part of the whole dynamic group: a tremendous spectacle of concerted rhythm.

—From an account in the *San Francisco Chronicle* (May 28, 1933)

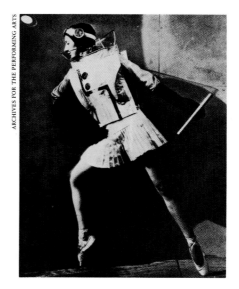

Willam Christensen on Dance in America

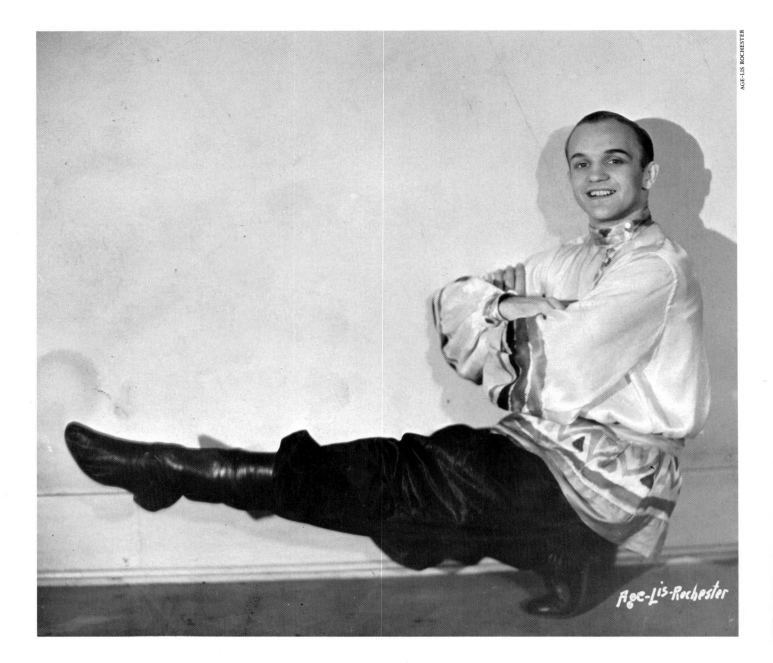

Age-Lis-Rochester

8 Selected Statements

"After a recent performance by the San Francisco Opera Ballet, a European man said that it was difficult to believe that these dancers were developed in America and that the choreography originated in America. But ballet should *not* have to wear a European label to be accepted. My dancers, mostly American born but of mixed parentage, have established a standard of performance comparable to any European company and far superior to many. And my choreography, while following classical conventions, is definitely within an American idiom." (*1939*)

"If you like to be entertained, you will like ballet. It is not a form of entertainment which must be cultivated, as a taste for green olives. It is a form of creative expression that not only tells a story, but also delights with its sheer beauty of movement and color. It is a rare bird who once views the ballet and who does not return to see more. In fact, once initiated, he tells his friends, urging them to come and see the ballet. It is no wonder that appreciation for this form of entertainment is finding increasing favor in America." (*1944*)

"Why has ballet had such a tardy success in America? The answer lies in ballet's immediate past history in America; perhaps not in the actual history, but in the layman's idea of that history—and that history contains the following items in the layman's mind:

"With Isadora Duncan all Hellas broke loose. For

decades thereafter, full-blown ladies in vaguely Greek tea gowns trailed their scarves in the breath of a sourceless but perpetual Zephyr. They contributed no more to dancing than an unflinching determination to be Grecianly aesthetic. The Greeks had no word for them.

"Another item: Butterflies à la Loie Fuller foolishly swooping with their wands, and having their public crescendi across many a high school stage in a manner that taste considered extremely classic. The passing of this vogue is mourned by the manufacturers of dyed India silk.

"More recently a misguided admiration for Pavlova produced an alarming mortality among swans. Even the most cornfed of ballerinas, determinedly moribund, teetered their last before collapsing on the auditorium floor, night after night. Pavlova's personal mannerism (exquisitely passionate in her) did not lend itself to amateurish reproduction. More or less faithful copies merely suggested a *crise de nerfs* among the hyper-thyroid.

"Item: Mary Wigman. Much water had passed under the bridge. Isadora's Greeks were older. Even so, many a Greek hostess gown, many a pince nez, was laid aside for the *tanzgruppe*. To oddly spasmodic noises, Isadora was forgotten in an effort to become *kolossal*. Some succeeded more than others.

"Final item: Contemporary groups. Girls' colleges turn out heftily thighed young ladies, darkly intense, who have gone out abroad to teach the young in their turn. Those who subscribe to the latest in revolts probably attain relief but not satisfaction.

"It is easy to satirize. In all the above cases the vogue has its inception in the individualistic performer. The poor imitator vitiates popular taste." *(1946)*

"Ballet is on an upward trend in America. Today's choreographers will mold tomorrow's repertoire, will instruct tomorrow's taste. Ballet's popularity is evident in books, magazine articles, photographs, the cinema, and in a multitude of indications that include adolescents wearing 'ballerina slippers' to their conclaves at the corner drug store. So it is high time to think of what the desirable future course will be. Those who will form the ballets of the future must today concern themselves with their responsibilities." *(1946)*

"Today's American companies are fortunate in the existence of a possible repertory that can be the means of modeling future taste for dancers, choreographers, and audience alike. Within traditional ballets, the abilities of a company's artists may be affirmed. To the choreographer, classic composition is a challenge. The repetition in performance of *Swan Lake*, *Raymonda*, *Les Sylphides*, and *Coppélia* means that audiences will eventually become able to appreciate nuance and degrees of ability. Greatness in performance is produced by the knowing audience which demands high standards." *(1946)*

"A manager's continued catering to facile taste, when a sound classical repertory is lacking, will ultimately injure ballet in America. Until audiences gain the cumulative experience that will support good ballet and, above all, good theater, the future of American ballet lies in the hands of a few. In the hands of the choreographer, then, there is a great responsibility." *(1946)*

"Let me speak then for *ballet blanc*, for the beautiful theatricality of Giselle dancing Albrecht's doom, or of the perfidious Black Swan. On classic ballet let tomorrow's American repertory be based. Then let young gentlemen anxious to express a personal experience produce the ballet of Narcissus. Taste will know how to judge them. Their popularity will be a surer one, and it will be their function to keep the dance repertory apace with the present day. For ballet tradition is as great, and as beautiful as opera tradition. Let us restore its beauty; then, if possible, let us enrich it." *(1946)*

"For America to make a contribution to dance, she must return to an understanding of classical technique. Otherwise, without a classical foundation, the result is decadence. Innovation follows foundation, and so we are constantly on watch for new choreography and new forms of expression that will make an American statement." *(1970)*

Opposite. Willam Christensen during his vaudeville career (c. 1927).
Below. Willam Christensen as Franz in *Coppélia* (1939).

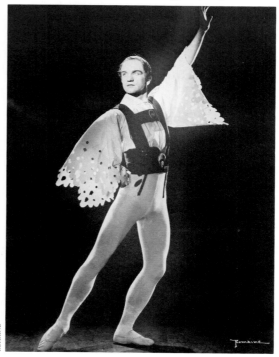

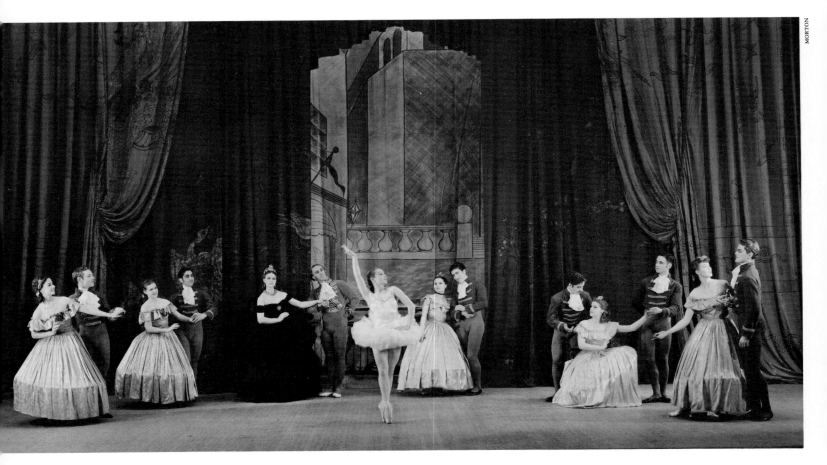

MORTON

Above. Janet Reed (center) as the Ballerina in Willam Christensen's *In Old Vienna* (1938).
Right. Janet Reed (center) as the Bride in Willam Christensen's *And Now the Brides* (1940).

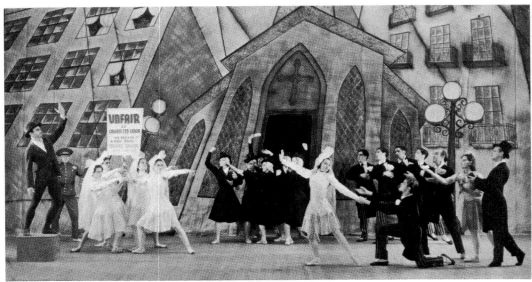

ARCHIVES FOR THE PERFORMING ARTS

1938. On January *9*, the Opera Association issues an important announcement: the San Francisco Opera Ballet has been "completely reorganized" and will start the new year "under new management, with added personnel and with a set of objectives which calls for an ambitious program during 1938."

The changes in the Ballet are indeed numerous, important, and will alter dance in the Western United States. Under the reorganization, Willam Christensen replaces Serge Oukrainsky as ballet master, and a booking department is created "to arrange tours, maintain year-round activity, and thereby attract and hold dancers of major importance." It is the first time, as John Martin writes in *The New York Times*, that "a major Western ballet has attempted to support itself by Western touring."

Within weeks, the Company is ready to perform. On March 3 a joint program with the Sacramento Municipal Orchestra is presented in the state capitol's Civic Auditorium. And on April 20 the Company gives an all-ballet performance in San Francisco's Veterans' Memorial Auditorium. Christensen choreographs several new works for these performances: *In Vienna*, a comic work to Strauss waltzes; *Romeo and Juliet*, a one-act ballet set to the Tchaikovsky overture and one of the first American dance treatments of the Shakespeare play; and *Ballet Impromptu*, a Bach suite whose program notes prefigure those for Balanchine's *Concerto Barocco* (1940). ("There has been no attempt in this ballet," says Christensen of *Ballet Impromptu*, "to 'interpret' Bach, as the word interpret is conventionally used. The music has inspired an abstract conception without consideration to any particular period.") Music for the San Francisco performance is provided by twenty musicians from the San Francisco Symphony, directed by assistant conductor Willam Van den Burg.

Although the critics realize that a major ballet company cannot be assembled overnight, and that comparisons to the international companies would thus be fruitless, the Company's first performances are deemed auspicious. "The San Francisco Opera Ballet has taken a new lease upon life," says the *San Francisco Call-Bulletin*. "A thoroughly professional performance," adds the *San Francisco News*, hoping that in the future Christensen—a "choreographer who hails from the unexplored regions of Utah and Oregon"—will employ American themes, American materials.

The Company enjoys new accomplishments during its West Coast summer tour, with performances in Santa Rosa, Guerneville, Portland, Stanford, and Santa Barbara. The Portland program, with guest artists Lew and Harold Christensen, features the Company premiere of Lew Christensen's *A Midsummer Night's Dream*, a one-act version of Shakespeare's play, set to Mendelssohn.

Following the fall opera season, the Ballet boards a bus and commences its first out-of-state tour: a four-week junket through the Pacific Northwest. San Francisco Symphony assistant conductor Willam Van den Burg travels with the Company and conducts in those towns with resident symphonies; in locales without home orchestras, the Company's two pianists provide accompaniment. The all-Christensen repertory includes *In Vienna*, *Romeo and Juliet*, *Ballet Impromptu*, and *Sketches* —a suite of *divertissements* from *Faust*, *Nutcracker*, and Schubert's *Rosamunde*.

1939

Christensen, ever ambitious, decides to choreograph the Company's first full-length work: he chooses *Coppélia*, originally produced in 1870 and often considered the last masterpiece of French Romanticism. Rehearsals for the new, full-length production are held throughout the year, as the Company continues to dance in California, performing in Sacramento (before a record-breaking audience of 4,000), Stockton, San Luis Obispo, San Francisco (both at the Opera House and at Stern Grove, where two excerpts from *Coppélia* are previewed), San Rafael, and Santa Barbara (with guest artist Lew Christensen).

Although the Ballet dances in few operas during the 1939 fall season (as Alfred Frankenstein notes in the *Chronicle*, the Ballet in recent years has been doing "about everything a ballet company can except appearing in the productions of the San Francisco Opera"), it is the opera season that provides the opportunity for *Coppélia's* debut. On Tuesday evening, October 31, the three-act *Coppélia* premieres on a double bill with *I Pagliaci*; it is the first time in this century that an American has choreographed the complete ballet.

Coppélia scores a major success. The full-length production, says the *Chronicle*, "emphatically indicates that ballet programs might well be incorporated in the opera company's future policy. For Willam Christensen's company has grown mightily since it made its debut . . . *Coppélia* is no child's play, but an intricate and difficult composition in the great tradition."

Following the close of the opera season in San Francisco, the Ballet embarks on its second tour of the Pacific Northwest. Finer costumes, new decor, the Company's first souvenir book (Janet Reed graces the cover), a larger Greyhound bus, and the addition of the full-length *Coppélia* to the repertory—are all gains over last year's tour. In Portland, the Ballet premieres Christensen's *American Interlude*, a satirical look at the present-day political scene. Set to a commissioned score (the Company's first) by Godfrey Turner, *American Interlude* tells of a Communist agitator who convinces American brides "to strike for better working conditions."

Following the Northwest tour, the Ballet performs in

9

Nevada and Utah. Salt Lake City, Christensen's home town, receives the Company warmly: "For those who believe in the American artists' right to a place in the sun," writes *The Deseret News*, "the San Francisco Opera Ballet supplies overwhelming justification."

The touring company numbers thirty-three, including twenty-seven dancers, two pianists, a wardrobe mistress, stage manager, booking director, and a salesman for the souvenir books.

1940

After the Christmas holidays, the Ballet resumes its tour, travelling for the first time to "the heart of the heart of the country"—the Midwest. In opera houses, movie theaters, and high school gymnasiums (where "thoughtful" janitors often polish the floors to a treacherous high gloss), the Company performs in Little Rock, Cedar Rapids, Omaha, Kansas City, Wichita Falls, Tulsa, Laramie, and Chicago, where *Coppélia* is a major success. "The San Francisco Opera Ballet," says the *Chicago Daily Tribune*, shows "what can happen to a museum piece like *Coppélia* when 30-odd vivacious, young west coasters get at it. . . . Willam Christensen has polished the original choreography to the point where it approaches one kind of dance ideal."

In March, upon the Ballet's return to San Francisco, the recently married Harold Christensen and Ruby Asquith join the Company. Harold becomes the school's director. Asquith joins Janet Reed as one of the Company's principal ballerinas.

During the summer the Ballet performs at the Bay Area's two major summer festivals—San Francisco's Stern Grove (where Willam's *A Midsummer Night's Dream* premieres), and the Marin Music Chest. But the Ballet directs its main energies during these months to an ambitious production of the four-act *Swan Lake*. Choreographed by Willam Christensen after the Marius Petipa-Lev Ivanov original and produced under the auspices of the Tchaikovsky Centennial Committee, *Swan Lake* debuts September 27 at the War Memorial Opera House: it is the first complete *Swan Lake* ever produced by an American company, and an undeniable success.

Swan Lake is the highlight of the Ballet's third annual Pacific Northwest tour, which continues SFOB's pioneering efforts to "Americanize" ballet. "It is no easy task," says Franklyn Smith, the Ballet's concert director, "to suit the taste of the balletomane, the dilettante, and Mr. and Mrs. America with the same dish." But that is SFOB's goal: "to bring classical dance to large numbers of Americans without sacrificing artistic standards."

1941

The Ballet begins its second tour of the South- and Midwest. The two-month junket includes the Company's first performances in Detroit (the furthest east the Ballet has played) and Topeka (where a *Coppélia* matinee for 4,000 school children, most of whom have never seen

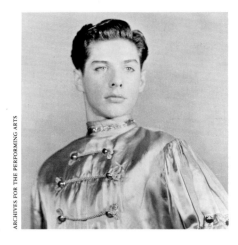

Harold Lang (1939). After dancing with SFB, Lang performed with Ballet Russe de Monte Carlo (1941-1943) and Ballet Theatre (1943-1945), where he created roles in Jerome Robbins' *Fancy Free* and *Interplay*. He then danced in a number of Broadway musicals, including *Kiss Me, Kate*, *Pal Joey*, and *Look, Ma, I'm Dancing!*

ARCHIVES FOR THE PERFORMING ARTS

classical dance, is so successful that "nothing but a basketball victory has evoked such cheering from the youngsters this season,"according to the *Kansas City Times*).

The Ballet returns to San Francisco in the spring, when for the first time in six years the Company is presented by the Opera Association in an all-dance season at the Opera House. The season's first program offers the full-length *Swan Lake*, newly designed by Helen Green, Armando Agnini, and J. Paget-Fredericks. Although the new production wins high praise from the critics ("everything a romantic ballet ought to be," says the *Chronicle*), the theater is not filled for *Swan Lake*, as it usually is for the annual winter performances of the Ballet Russe de Monte Carlo. "It is true," writes the *San Francisco News*, "that the San Francisco Opera Ballet lacks stars of the quality of Massine, Danilova, and Baronova, but it has what the Monte Carlo Ballet has never had, and that is a *corps de ballet* that knows the meaning of ensemble work. . . . This city has one of the best looking and best dancing ballets on the American stage today. Critics to the north, south, and east have so acclaimed it. Let it no longer be the prophet without honor in its own city."

The Ballet performs throughout the summer and fall, with appearances in Berkeley (part of the town's 75th Anniversary Festival of the Arts), Stern Grove (honoring the National Federation of Music Clubs), Santa Barbara, and San Francisco (the annual fall Opera Season).

December also marks the loss of two major ballerinas, the Company's Odette and Odile in Swan Lake—Jacqueline Martin (who moves to Portland) and Janet Reed (who goes to New York to join Dance Players).

The Company faces the difficult war years.

1942

Crisis again hits the Company: because of the war, the San Francisco Opera Association can no longer maintain the Opera Ballet. (There is even some question as to whether or not the opera seasons can be continued.) The Opera Association sells the Ballet School to Willam and Harold Christensen for $900, but the School cannot possibly generate enough money to maintain the Company as a performing unit. Civic and business leaders, wishing to stimulate the city's cultural life, unite to help the Ballet, and plans are made to form the San Francisco Ballet Civic Association—America's first civic ballet. In April, as the

Ballet performs for servicemen in bases around the Bay Area, the civic leaders attempt to raise a sustaining fund of $15,000 to ensure the Ballet's existence, add new works to the repertoire, and provide new scenery and costumes for a local season.

The plans for the Civic Ballet, however, are not realized: the economic pressures of the war are too severe. Nevertheless, on May 26 and 27, the Ballet—supported by fifty patrons—performs at Veterans Auditorium. The program includes the world premiere of Christensen's *Coeur de Glace*, designed by J. C. Taylor and set to Mozart's *Eine Kleine Nachtmusik.* According to its program notes, the new work is "an allegorical ballet in the pure classical style: the action takes place in a formal garden of the French court as it might have been in the late eighteenth century." Ruby Asquith, the Company's leading ballerina since Reed's departure, plays the Princess with the "heart of ice," and Christensen is her suitor, an aged and comical fop of a Prince. The perenially popular *Chopinade* and *Scènes de Ballet* (a suite of *divertissements* from *Swan Lake, Nutcracker,* and *The Sleeping Beauty*) complete the program.

During the summer, the Ballet is again reorganized. Fearful that wartime conditions might severely restrict the Company's activities, a group of San Franciscans led by Mrs. Julliard McDonald forms the San Francisco Ballet Guild, a non-profit organization created "to organize the Ballet as a complete independent entity unto itself, and to establish it as an organization which will rank with the world's greatest." Attempting to provide the Ballet with financial security during the difficult war years, the Guild will both underwrite the production of new ballets and sponsor local and touring seasons.

Under the Guild's aegis, the newly organized Company—now called San Francisco Ballet—gives its first performance at the Opera House on Friday, September 25. The program features two guest artists, Maclovia Ruiz (who danced with SFB under Adolph Bolm) and Elena Imaz (on leave from the Argentine Teatro Colon Ballet to study American dance trends). Christensen collaborates with his two guests to choreograph *Amor Espagnol.* Set to ballet music from Massenet's *Le Cid* and colorfully designed by Charlotte Rider, *Amor Espagnol* concerns the rivalry of two women (Imaz, Ruiz) for a handsome matador (Earl Riggins). The new ballet, as one critic says, "is a brilliant work of flashing skirts, flirting fans, and passionate castanets."

The program's second premiere is Christensen's *Winter Carnival*, in which the dancers—portraying vacationers at the St. Moritz Eidelweiss Inn—imitate ice skaters. (During the summer, when SFB performed in Berkeley on a joint program with an ice revue, Christensen had choreographed several numbers for the company of eighty skaters.) *Winter Carnival*, writes Alfred Frankenstein in the *Chronicle*, is a masterful variation on Léonide Massine's high-life themes. "Like *Le Beau Danube, Gaîté Parisienne, The New Yorker, Saratoga* and other ballets by

Massine, *Winter Carnival* reflects the gay life of a resort in a series of *divertissements*, has a bit of a love-triangle with officers and a girl, and an appropriate degree of nose-putty comedy. . . . Perhaps the finest feature of the work was the utterly delightful dancing of Ruby Asquith as the skating star. Miss Asquith is a magnificent character dancer, and her interpretation was as scintillant, crystalline, deft and finely modeled as the most fanatical balletomane could demand. Christensen, too, was a most acceptable Alpine officer, and the settings and costumes by Betty Bates de Mars were the finest and most appropriate the ballet company has to its credit."

Though officially separated from the Opera, SFB still provides the choreography and dancers for the fall opera series. (The annual opera seasons are a welcome source of income for the dancers.) Following the opera season, SFB briefly tours the Pacific Northwest.

Despite the Second World War, Christensen, supported by the San Francisco Ballet Guild, has thus ensured the Company's existence.

Ruby Asquith (left) and Onna White during a rehearsal for *Coppélia* (1942). White became a leading choreographer for Broadway and Hollywood. Her Broadway musicals include *The Music Man, Irma La Douce, Half a Sixpence,* and *Mame.* Among her films are *The Music Man, Mame, Bye-Bye, Birdie,* and *Oliver,* for which she won an Academy Award.

Full-Length Ballets

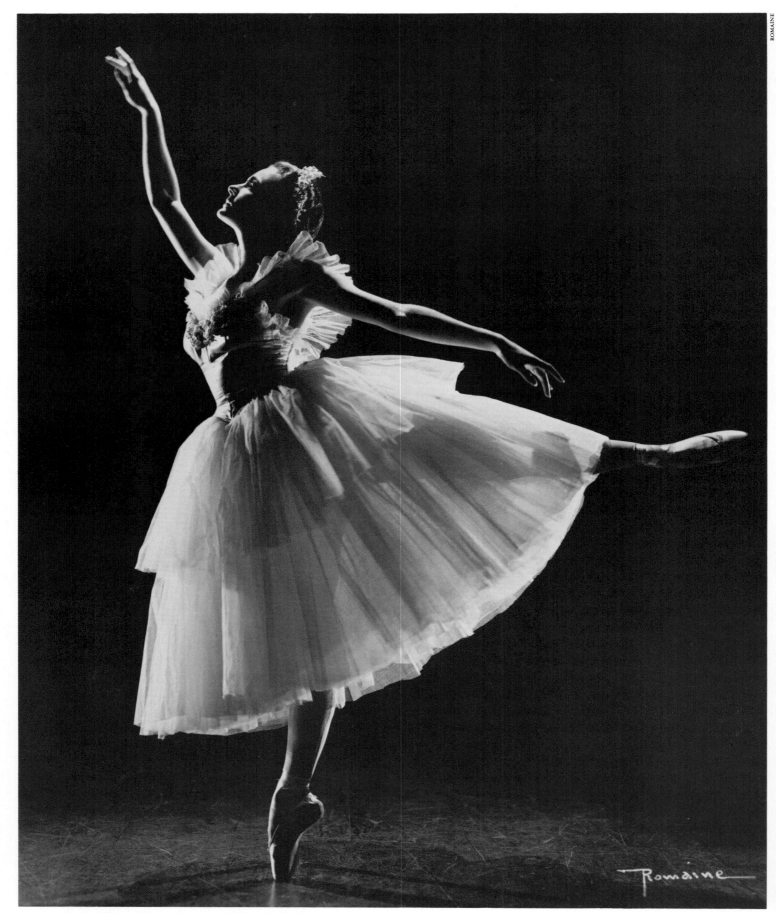

Jocelyn Vollmar as Myrtha, Queen of the Wilis, in *Giselle* (1947).

The San Francisco Ballet repertory includes *10* full-length ballets, more than that of any other American company. From 1939 when SFB presented its first evening-length ballet (*Coppélia*) to the 1981/82 season during which an unprecedented four full-length works were performed (*Nutcracker, Romeo and Juliet, The Tempest, Beauty and the Beast*), San Francisco Ballet has been a pioneer in the American presentation of multi-act ballets.

The Company's full-length works, in chronological order, are:

■ *Coppélia*, 1939. Willam Christensen had been drawn to *Coppélia*—especially to its masterful score by Delibes—ever since he first saw Pavlova's version, and he had, in 1935, created a condensed, one-act version of the work for his Portland company. But in 1939, Christensen, who had become SFB's Director the previous year, decided to mount a complete version of *Coppélia* for SFB—the Company's first full-length ballet.

Rehearsals for the new production were held throughout the year, as the Company continued its criss-cross tour of California, and on Tuesday evening, October 31, the three-act version of *Coppélia* premiered at the War Memorial Opera House on a double bill with *I Pagliacci*. (The Ballet was then officially connected to the San Francisco Opera.) It was the first time in this century that an American choreographer had produced a complete *Coppélia*, and for the gala occasion SFB was augmented by its Junior Ballet to a troupe of sixty. Willam Christensen

danced Franz, Earl Riggins played Dr. Coppelius, and Janet Reed—who, during her two years in San Francisco, had become an audience favorite—was the ballet's resourceful heroine, Swanhilda.

Coppélia was an instant hit. Writing in the *San Francisco Examiner*, Alexander Fried pronounced the ballet an "extraordinary credit" for Christensen: "by his taste, his imagination, and his skill in group leadership, he has raised the Ballet to an unprecedentedly high standard . . .*Coppélia* made everyone regret that the current opera repertory is not giving the Ballet far more to do."

Coppélia was a staple of SFB's repertoire for nearly ten years: the production was performed frequently both in San Francisco and on the Company's annual tours of the North-, South-, and Midwest.

■ *Swan Lake*, 1940. Choreographed by Willam Christensen after the Petipa-Ivanov original, SFB's *Swan Lake* premiered September 27, 1940: it was the first complete *Swan Lake* ever produced by an American company. Lew Christensen, America's *premier danseur*, arrived from New York to dance Prince Siegfried. As in the earliest Russian productions, *Swan Lake* was danced by two ballerinas: Jacqueline Martin played Odette; Janet Reed was Odile. Harold Christensen and Zoya Leporsky stopped the show in the Act Three czardas. Ruby Asquith, Onna White, and Harold Lang were also featured in the large cast. Scenery was designed by Eugene Orlovsky and Nicolas Pershin; costumes were by Charlotte Rider. The entire

The SFB *corps de ballet* in the first American production of the full-length *Swan Lake* (1940).

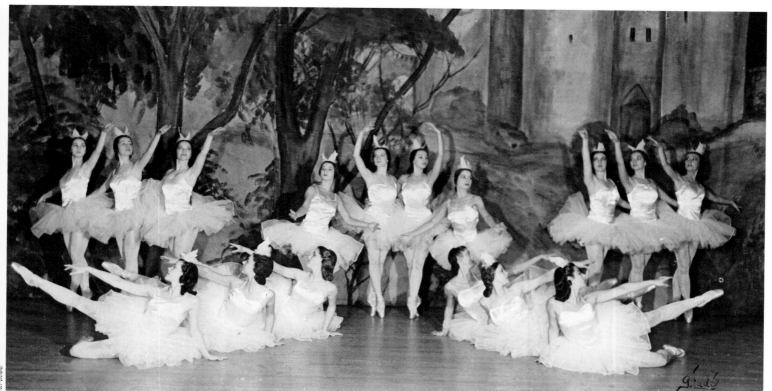

production, dedicated to the preservation of Russian culture in San Francisco, was under the patronage of the Tchaikovsky Centennial Committee, a group of Russian émigrés headed by Prince and Princess Vasili Romanoff.

"When I decided to do *Swan Lake*, I picked everyone's brains," Willam Christensen recalls. "First, I read everything I could find on the ballet and then I got San Francisco's large colony of Russian émigrés to help me. They would say, 'So-and-so goes here, and so-and-so goes there,' and I would work it out choreographically with the music. If I had not been a musician I would never have dared to stage such a large production. The main thing I wanted was the right style, and the placement of the dancers. I was lucky that my White Russian friends knew *Swan Lake* well from St. Petersburg."

According to *Dance Magazine*, Theodore Kosloff, the Moscow-born choreographer who had been SFB's ballet master from 1926 to 1927, was incensed at the "sacrilege" of an American choreographer daring to mount a complete *Swan Lake*, and fired off an indignant telegram to that effect. Christensen mollified Kosloff, and other offended parties, by inviting them to the premiere, which even his most distrustful critics called a success. The *San Francisco Call-Bulletin* pronounced the production the surprise of the season: "The music was Russian and the dancing was in the Russian idiom, but the figurants were as American as a turkey dinner. And what a performance they turned in, especially the mercurial Janet Reed and Lew Christensen. . . . If San Francisco Ballet can sustain the high order of artistry set last night at the Opera House we are independent of Messrs. S. Hurok and others who make a great ballyhoo about bringing the original 'Russian' classics to the wild west."

The four-act *Swan Lake* was the highlight of the Company's winter tour of the Midwest and Pacific Northwest. Topeka hailed the work as "a model of ballet art" that featured "a wealth of young American talent." Chicago, where "a large and enthusiastic audience took every occasion to make known its approval," called the SFB production "a delightful opportunity to see and hear the whole of the work for the first time." And in Seattle, *Swan Lake* enjoyed such a "whooping, almost hysterical success" that hundreds had to be turned away from the Moore Theater. "For all its venerable age, *Swan Lake* is a work of solid merit musically and balletistically," wrote the *Seattle Star*, "and the San Francisco organization which now presents it has become a ballet company of first importance and first-rate achievement."

When the Company returned home in the spring of 1941, a freshly designed *Swan Lake* was presented at the Opera House. Norman Thomson was Prince Siegfried, Harold Lang played Benno, and Harold Christensen was an appropriately malevolent Von Rothbart. The role of Odette-Odile was again shared by Jacqueline Martin and Janet Reed.

San Francisco Ballet performed excerpts from the Willam Christensen production throughout the next ten years. Act Three was presented independently under the title *Prince Siegfried*, and Act Two simply as *Swan Lake*. In 1953, George Balanchine's one-act recension of *Swan Lake* was mounted by the Company; the Balanchine version remained in the repertoire through 1962. In 1982, in what was considered an important, bold departure from its predominantly twentieth century repertoire, the Company presented Act Two of Kent Stowell's production. It was SFB's first *Swan Lake* in twenty years.

■ *Hansel and Gretel*, 1943. In December 1943, San Francisco Ballet presented its first annual Holiday Ballet Festival. The Festival's repertoire included several of Willam Christensen's one-act works (*Winter Carnival*, *Chopinade*, *Sonata Pathétique*, and *Romeo and Juliet*), as well as the world premiere of his third full-length ballet for SFB—*Hansel and Gretel*, a ballet pantomime with solo voices and orchestra. This novel arrangement of Humperdinck's fairy-tale opera, chosen for its obvious appeal during the season when children "take over," featured Balanchine ballerina Ruby Asquith as Gretel and Beatrice Tompkins as Hansel. Mattlyn Gevurtz—later Antony Tudor's assistant at the Metropolitan Opera Ballet—portrayed the menacing Witch, while Celena Cummings and Earl Riggins were the Mother and Father.

■ *Nutcracker*, 1944. For the second annual Holiday Ballet Festival, Willam Christensen decided to mount a complete production of *Nutcracker*—the first full-length version of the ballet ever presented in this country. *Divertissements* from the ballet had been performed by SFB as early as 1937 in *Sketches*; the 1942 *Scènes de Ballet* also included a few *Nutcracker* excerpts; and of course many other companies had performed the ballet in suite form. But a complete production was unknown in America: the full Tchaikovsky score was available only through the Library of Congress.

Gisella Caccialanza—one of Balanchine's first American ballerinas and one of the great Cecchetti's last pupils—was the Company's Sugar Plum Fairy. Willam Christensen danced the Cavalier, and Jocelyn Vollmar—an SFB-trained dancer soon to become an international star—was the Snow Queen.

Five performances of *Nutcracker* were given that year, and the reviews were ecstatic. *Nutcracker*, of course, has since become a perennial favorite and San Francisco Ballet has presented three different productions of the ballet— in 1944, 1954, and 1967.

■ *Giselle*, 1947. San Francisco Ballet produced its first— and only—full-length *Giselle* during its 1947 fall season when the Company appeared with the Markova-Dolin Ballet. Anton Dolin, who staged Ballet Theatre's first *Giselle* in 1940, oversaw the Company's production, while Willam Christensen staged the ballet's ensemble sections. Alicia Markova, one of the role's most celebrated interpreters, danced Giselle; Dolin was Albrecht; and SFB dancer Jocelyn Vollmar was Myrtha. It was the first

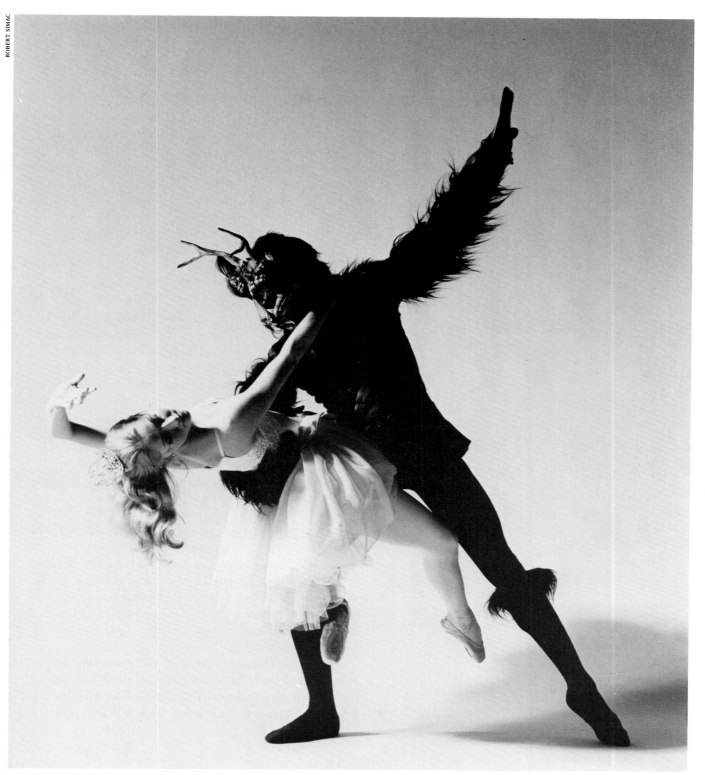

Lynda Meyer and Robert Gladstein in the title roles of Lew Christensen's *Beauty and the Beast* (1975).

time Dolin and Markova performed a complete *Giselle* with an American civic ballet. The experiment, wrote Markova in *Giselle and I*, was a "striking success. We had been able to dance *Giselle* to the Symphony Orchestras of numerous American cities, but this was the first time we had had the help of a full local company which could provide a *corps de ballet*. Alfred Frankenstein, a leading critic, wrote in the *San Francisco Chronicle:* 'They joined forces for the warmest, most richly patterned and beautifully executed *Giselle* of recent memory.'"

■ *Beauty and the Beast*, 1958. In the spring of 1958 San

Francisco Ballet celebrated its Silver Anniversary. The Company—directed by Lew Christensen since 1952 when his brother Willam left San Francisco for Salt Lake City to found what would eventually become Ballet West—had recently returned from its triumphant tour of the Far East and was soon to embark for South America on its second State Department-sponsored tour. To celebrate SFB's Twenty-fifth Anniversary and its recent successes, Lew Christensen choreographed a new full-length ballet, *Beauty and the Beast*, fancifully designed by Tony Duquette and set to an ingenious arrangement of Tchaikovsky's music by Earl Bernard Murray.

Beauty—which the *San Francisco News* praised as the "most delightful, imaginative, enchanting and accomplished ballet production ever to grace the Opera House stage"—proved to be one of the most popular of SFB's full-length works: it was presented every year from 1958 through 1967. Excepting *Nutcracker*, no other SFB full-length work has enjoyed such a long run. (For many years, *Beauty* and *Nutcracker* were so popular that they were paired as the Company's annual Christmas fare.) *Beauty* has been danced by some of SFB's most celebrated ballerinas—Cynthia Gregory, Jocelyn Vollmar, Nancy Johnson, Lynda Meyer, Diana Weber—and the ballet is steeped in SFB heritage: the Company's current Technical Director, Richard Carter, created the role of the Beast/Prince; Company Co-Director Michael Smuin was a Stag, Courtier, and led the Marmousettes at the premiere; Virginia Johnson, Regisseur, was one of the original Fireflies, Birds, and Courtiers; SFB School Instructor Christine Bering was a Magic Flower and danced the Roses' Waltz; and Assistant Director and Ballet Master Robert Gladstein danced as a Beetle and a Courtier in the 1958 production, and went on to become a celebrated Beast/Prince.

After intermittent performances during the Seventies, *Beauty* returned to the SFB repertoire in 1982 transformed: Christensen's choreography and the Tchaikovsky score were supplemented and reworked, and the whole two-act production, with five scenes and ninety-two costumes, freshly designed by José Varona. The ballet's enormous style and charm remained as vibrant—as rich in fantasy, whimsy, and deluxe stagecraft—as ever.

Christensen—who has taken many fanciful looks at love during his illustrious career—attached this note to the original production: "The old moral reads that beauty is only skin deep. So, this ballet says, is beastliness. To love is to be human, and it is no less, to humanize."

■ *Cinderella*, 1973. In 1973, Michael Smuin returned to San Francisco to join Lew Christensen as the Company's Co-Director. To celebrate their partnership, Smuin and Christensen collaborated on the Company's first full-length ballet in fifteen years: *Cinderella*. Set to the well-known Prokofiev score and designed by Robert Fletcher in the go-for-fantasy style of *trompe l'oeil* architecture and Mannerist painting, *Cinderella* opened on June 6, 1973—almost forty years to the day after the Company's very first all-ballet program (June 2, 1933), also in the War Memorial Opera House.

Cinderella was the first gem produced by the Company's 1973 "revitalization," an ambitious plan that included: Smuin's return; a month-long national audition; a new administration; the Company premiere of six ballets; and the addition of fifteen new dancers from such companies as American Ballet Theatre, Pennsylvania Ballet, Royal Winnipeg Ballet, and Harkness Ballet.

Given seven performances in San Francisco followed by six in Los Angeles, *Cinderella* was a major hit of the 1973

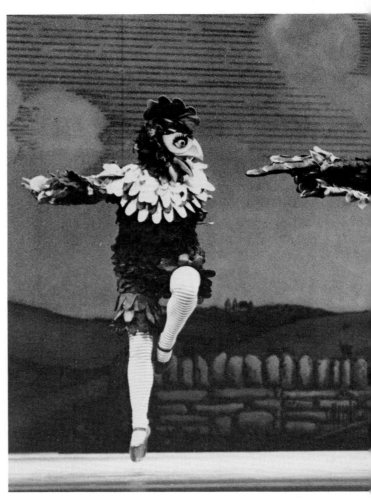

Above. The Cockerel and Hens in Sir Frederick Ashton's *La Fille Mal Gardée* (1978).

season. "It's a really stunning show," said the *San Francisco Examiner*, "handsome and very much Big Time . . . pure make-believe, but done up with enough snap, style, and just plain jollity that all types of balletomanes ought to find it hard to resist." Cinderella that first season was alternately danced by Diana Weber and Lynda Meyer; the role of the Prince by Vane Vest and Robert Gladstein.

(The Smuin-Christensen *Cinderella* was not the first American treatment of the Prokofiev score. That distinction belongs to another Christensen—Willam, who choreographed a full-length *Cinderella* for Ballet West in 1970.)

■ *Romeo and Juliet*, 1976. *Romeo and Juliet*, Michael Smuin's second full-length Prokofiev ballet, is one of the more dramatic, and impassioned, dance interpretations of Shakespeare's tragedy. The product of years of work and research, Smuin's *Romeo and Juliet* endured a rather long and difficult birth. Smuin, who had long dreamed of mounting a full-length *Romeo and Juliet*, first proposed the ballet shortly after his return to San Francisco in 1973, but the Company's finances would not immediately support such a major production. In 1975, three excerpts—the balcony, bedchamber, and tomb *pas de deux*—were presented in concert form. Then in 1976, the entire ballet was performed—with costumes, but without sets. Finally, in 1977, William Pitkin's sets were added and the ballet was at last seen in its completed form.

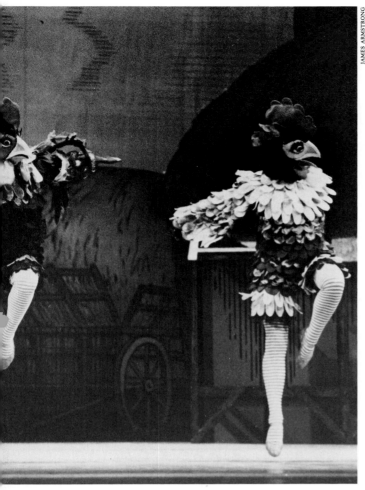

Below. Betsy Erickson as Iris in Act Two of Michael Smuin's *The Tempest* (1980).

Despite such birth pangs, *Romeo and Juliet* has since become one of the most acclaimed ballets in the Company's entire history, attracting sold-out houses and trailing glorious press notices wherever it is performed. It is both the Company's most widely toured full-length production (New York, Edinburgh, Los Angeles, Vancouver, Seattle, New Orleans, Honolulu, and a host of other cities have all seen the ballet), as well as the Company's most widely seen work (an estimated forty million people viewed the 1978 national telecast of *Romeo and Juliet*).

Admired for its clean, economical narrative and enjoyed for its bold theatricality, *Romeo and Juliet* became the Company's signature work, its flagship production—the ballet that most fully expresses SFB's youthful and high-spirited style.

■ *La Fille Mal Gardée*, 1978. Originally choreographed by innovator Jean Dauberval in 1789, *La Fille Mal Gardée* is the second oldest extant work in the ballet repertoire and one of the first to eschew mythological heroes in favor of rural, down-to-earth characters. With *Fille*, realism entered the world of ballet.

Sir Frederick Ashton staged his version of *Fille* for the Royal Ballet in 1960, and it was immediately hailed as one of the great choreographer's most charming, and felicitous, works. In 1978 San Francisco Ballet became the first and only American company granted rights to perform Ashton's bucolic masterpiece, and the ballet

marked the beginning of an important and prestigious association between SFB and Ashton.

■ *The Tempest*, 1980. *The Tempest*—Michael Smuin's third full-length ballet for SFB, his second based on Shakespeare—was the highlight of the Company's 1980 repertory season. With costumes by Willa Kim, scenery by Oscar-winner Tony Walton, and special effects by Parker Young, *The Tempest* has, ever since that premiere, astounded audiences with its vast array of visual delights —everything from magically disappearing banquets, to comical packs of wild dogs, to splendiferous gods and goddesses who descend from the heavens and arise from the sea to celebrate a young couple's betrothal.

Working in close collaboration with composer Paul Chihara (*The Tempest* is SFB's first full-length original score), Smuin based his two-act ballet on the classical Petipa model, with an elaborate and inventive suite of *divertissements* in the final act. But instead of the conventional czardas and mazurka, Smuin "Americanized" the *divertissements*. He choreographed a show-stopping series of variations derived from the fox trot, rag, beguine, and the blues. (*The Tempest*, Smuin contends, is Shakespeare's most American play: based on contemporary reports of a shipwrecking incident in the Bermudas, *The Tempest* draws upon the myths of an adventurous, magical New World.)

The Tempest is among the most happy-hearted of Smuin's recent works. After the love-and-death themes of *Romeo and Juliet*, *Shinjū*, *Medea*, *Scherzo*, and *A Song for Dead Warriors*, Smuin wanted to create a sumptuous, fantasy-filled romance, and he has done just that: like many of the great nineteenth century classics (*Sleeping Beauty*, *Nutcracker*), *The Tempest* joyously celebrates the redemptive powers of love.

The Tempest, said Clive Barnes in the *New York Post*, "makes American ballet history. It is the first full-length American classic ballet ever to be created from scratch, with new choreography, new music, scenery, and costumes. Smuin is that rare bird among American choreographers—the master showman. As a director, he has few ballet peers; Smuin is choreographic theater personified."

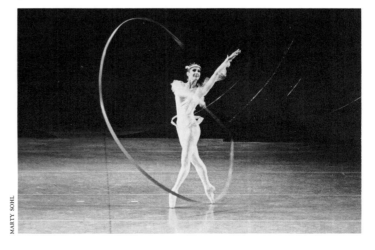

45

San Francisco Ballet School

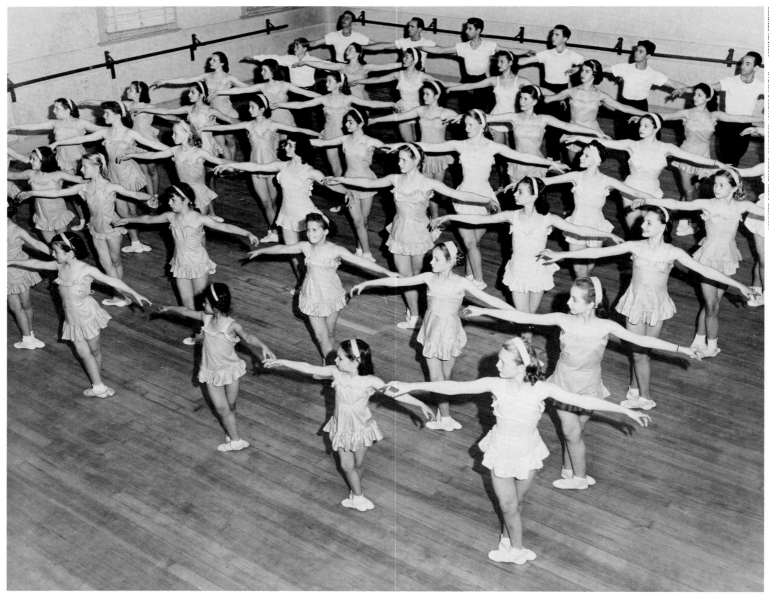

San Francisco Ballet School (1948).

Prior to its *11*th season in 1933, the San Francisco Opera employed its ballet masters and dancers on a limited seasonal basis. These opera ballet masters—Natale Carossio, Theodore Kosloff, Serge Oukrainsky, Ernest Belcher, and Estelle Reed—all maintained private commercial schools of dance, organized independent performances, and added their own recruits to the opera ballet company. In short, since 1922, the opera had relied on the independent enterprises of its ballet master, among others, for its supply of trained and seasoned ballet dancers.

In 1933, the realities of ballet production prompted Opera Director Gaetano Merola to establish the San Francisco Operatic and Ballet School. Adolph Bolm, appointed to the new post of Ballet Director, was to assume the traditional opera ballet master's duties, as

well as to stage extra ballet performances and direct the new Ballet School year round.

That summer, months before the opening of the Opera Season, the Opera presented "The San Francisco Operatic and Ballet School in its First Performance" at the War Memorial Opera House. The "school" onstage was a company of adult performers, including veterans of the Opera Ballet and dancers Bolm had brought to San Francisco. The "school" proper was The San Francisco Opera Ballet School, located in the William Taylor Hotel a few blocks from the Opera House, where classes were already underway.

Advertisements for the School quoted philosopher Havelock Ellis' contention that "if we are indifferent to the art of dancing, we have failed to understand not only the supreme manifestation of physical life, but also the

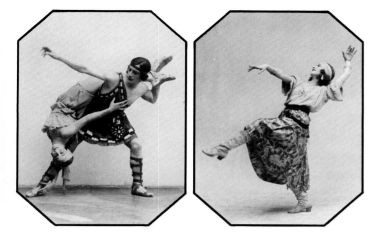

Left. Anatole Vilzak and Ludmilla Schollar.
Right. Ballerina Ludmilla Schollar.

supreme symbol of spiritual life." Consonant with this view of the universality of dance were the School's calendar ("Open All Year"), its curriculum ("Instruction in All Forms of The Dance"), and its broad base of operations: during Bolm's tenure as Director, affiliate Branch Schools were listed in Berkeley, Burlingame, Marin County, San Mateo, and Oakland.

The School's advertisements, however, also explained its specialized purpose ("Dancers for the Opera Ballet are chosen from among the students"), and Bolm established a scholarship fund to support the best students for that purpose. Along with its classical curriculum, the School under Bolm offered tap, modern, and interpretive dance, pantomime, and composition (choreography), and sponsored a dance history lecture series. Coaching in "new dance routines, adaptable to each student," was available. And Bolm, who in a 1937 radio interview expressed the belief that "America will reach into her rich history and bring forth a native American ballet," also founded a distinguished Department of Spanish Dance and its Performing Division, both under Director Guillermo Del Oro. It was, as Bolm said, "an experimental period."

Bolm left San Francisco in 1937, and the School came under the direction of Opera Ballet Mistress Mildred Hirsch, who added a fencing master and a disciple of Mary Wigman to the faculty. That year, Willam Christensen was appointed Director of the Oakland Branch School, where he offered classes in ballet, Spanish dance, character, and pantomime for "professionals, non-professionals, and beginners," and special children's classes.

In 1938, Willam succeeded interim Opera Ballet Master Serge Oukrainsky, and became full School Director. With pardonable pride, Christensen claimed the school was "first among American professional ballet schools . . . unique in policy, procedure, and ultimate aim," both as a vocational institution and as an educational resource for the community. "When the Ballet Company is not on tour," promised the brochure for a summer session, "there is a daily Company class. Arrangements may be made to attend these classes as a watcher. This is of particular value to teachers . . . [and] non-professional students of ballet as a cultural subject."

Increased touring was certainly a factor in rendering impractical the tradition of a sole Director, responsible for School and Company. Willam's brother, dancer and educator Harold Christensen, who joined SFOB as a dancer in 1940, assumed the new position of School Director as if by birthright. Harold, who had spent a year at West Point before devoting himself to the dance profession, was trained first by his uncles and their ballet mentor, Stefano Mascagno. Harold taught at several schools founded by members of the Christensen family, serving also as director of the LeCrist School in Ogden, Utah, and the Portland school, and was popularly considered "one of the outstanding ballet instructors of this country" while still in his twenties. After dancing professionally in vaudeville and at New York's Rockefeller Center in the musical *The Great Waltz*, Harold studied at the School of American Ballet, appeared with George Balanchine's American Ballet at the Metropolitan Opera, and became a founding member of Lincoln Kirstein's Ballet Caravan. With the Caravan, Harold Christensen created roles in classics like *Filling Station*, and was featured in most of the works in repertory. Throughout his dancing career, Harold worked alongside his brother Lew; at SFOB he entered into his first extensive partnership with Willam.

BILL COGAN

School Director Harold Christensen (c. 1962).

The partnership took on a new dimension in 1942, when the Opera Association, due to the economic impact of the Second World War, was forced to withdraw its support of SFOB. Harold and Willam Christensen bought the School, while Ballet patrons organized a

Guild to maintain the Company. (The School retained its independent status until 1972, when it was incorporated under the aegis of the new San Francisco Ballet Association.) SFBS continued to stress its vocational purpose: "The SFB Company, following the tradition of great European ballet companies of an earlier period, maintains its own ballet school where talented students may study in a professional atmosphere."

San Francisco Ballet School (1981).

A non-professional curriculum flourished. There was a pre-ballet program for four- to seven-year-olds that taught "deportment, rhythm, and dances." There were adult classes; one brochure explained that "business people especially have found the evening classes an excellent change from their workaday routines." But the School under Harold Christensen was a thoroughly classical academy for three decades, its graduates providing a priceless continuity through three changes in Company Directors. Class placement and entrance into the professional Classical Course were determined by the Director. Men's classes, *pas de deux* ("*adagio*," or supported double work"), and variations classes were added. The Company's Music Directors provided classes in music fundamentals, and other Company personnel led seminars in stagecraft. Student performances were staged twice a year. There was a scholarship program. The course was approved by the Veterans Administration. Summer sessions included a free course of teacher training.

In 1958, the Ford Foundation established its first ballet training program. In 1959, students selected at nationwide auditions received the first Ford grants covering expenses and tuition for one to three years' advanced study at either the School of American Ballet or SFBS. In 1963, SFBS was awarded a ten-year grant by the Ford Foundation under a new program. The School's application had stated categorically that "the cultivation of excellence in any socially acceptable form needs little justification"; and the existence of the grant program

represented a great step forward for American ballet—it acknowledged the rarity of excellence, and provided the means by which it could be schooled for professional achievement in this specialized field.

With the receipt of the grants, SFBS and the New York City Ballet's School of American Ballet, each affiliated since the Thirties with professional companies, were identified as vocational schools of national stature. Both academies, founded at a time when, as dance historian George Amberg has said, "the usual [American] ballet-school announcement promised a maximum of efficiency in a minimum of time," had insisted on the value of traditional training. Critic Nancy Goldner has pointed out that "it is not the custom in America to associate childhood with serious and hard labor;" yet this is the only foundation for classical ballet. In addition to providing institutional support and funding for a scholarship program, the Ford grants enabled the Schools to conduct auditions nationwide, with SFBS working in the Western states, while SAB toured the East.

Training at SFBS included classes with Harold and Lew Christensen, Ruby Asquith, and Gisella Caccialanza. In 1938, all four had been observed in class at the School of American Ballet by *The New Yorker*. The American dancers were working with a Russian teacher named Anatole Vilzak, who, *The New Yorker* noted in amazement, "acted with the casual assurance of a teacher writing multiplication tables on a blackboard. It was plain that he saw nothing extraordinary in what he was doing." The nonchalantly extraordinary Mr. Vilzak and his wife, ballerina Ludmilla Schollar, joined their American colleagues on the SFBS faculty in 1966. Mr. Vilzak, graduate of the Maryinsky, veteran of Serge Diaghilev's Ballets Russes, and disciple of Michel Fokine, Bronislava Nijinska, and Balanchine, continues to teach for SFBS and the Company today.

In 1975, Harold Christensen retired as School Director. He was succeeded by Richard L. Cammack, a colleague of the Company's new Co-Director, Michael Smuin. Cammack, whose performing background includes work with the Harkness Youth Dancers and American Ballet Theatre, holds a B.A. degree in dance from Butler University. During Cammack's tenure as Director, SFBS has been federally approved for foreign students, has received authorization from the California State Department of Education, and has received accreditation for student participation in federal grant programs through the Joint Commission on Dance and Theatre (through the National Associations of Schools of Art and of Music).

Since the end of the Ford program, SFBS has supported its own national audition tours, which have extended East to New York, Atlanta, and Miami since 1979. International recognition has come from Cammack's appointment to the distinguished jury for the Prix de Lausanne competition for ballet students. And roots in the local community are fortified by an extensive program

Michael Smuin with Anatole Vilzak (1982).

of free dance education and recruitment for scholarships maintained with the cooperation of area public schools. Scholarships and subsistence programs are available to students in the Professional Division; and special recruitment programs, scholarships, and classes are provided for young male students.

The tradition of non-professional courses, open to the public without audition, continues at SFBS today. Children ages five through seven are eligible for "an introduction to the dynamics of music and dance" in the Threshold Division; eight- through ten-year-olds may enroll in Basic Ballet. The Adult Division offers a full complement of ballet classes for teenagers and adults. Admission to the Professional Division today, however, whether from the School's own Basic Division or elsewhere, is by audition only.

Students in the Professional Division are periodically evaluated for continuing enrollment and advancement through its eight class levels. There is an annual Spring Performance by Professional students, who are also eligible for certain roles in Company productions. The summer sessions, a tradition for fifty years, bring many students chosen on the audition tours to SFBS for the first time. During the summer, classes in character, jazz, and modern dance, dance history, and music augment the regular curriculum.

Ballet technique, at the eight class levels of proficiency, is offered year round, as are men's classes, *pointe*, variations, and *pas de deux*—which is taught by current Company dancers Vane Vest and Lynda Meyer, and includes materials from the SFB repertory. A one-year Apprenticeship Program, designed in cooperation with the Company dancers' union (the American Guild of Musical Artists), provides five students a year with the opportunity to work under the supervision of both School and Company, helping to ensure their successful transition from student to professional dancer. Advanced students also study with SFB Co-Director Michael Smuin and the roster of international Guest Instructors he has chosen for the Company, including Erik Bruhn, Tatiana Grantzeva, and Terry Westmoreland. SFB's first decade

under Co-Directors Lew Christensen and Michael Smuin, then, has bred a new generation at SFBS, endowed with the best possible classical training, and with the spirit and expertise necessary to conquer the modern repertory.

The SFBS full-time faculty today includes—alongside the distinguished Mr. Vilzak—nine Instructors from a variety of backgrounds. They have studied at the schools of American Ballet Theatre, the National Ballet of Canada, and England's Royal Ballet, as well as SFB (where one of them held a Ford Foundation scholarship). They have also studied at the School of American Ballet, the University of Utah, the Juilliard School, Butler University, the Joffrey Ballet's American Ballet Center, and Harkness House. They are former dancers with American Ballet Theatre, Ballet West, the Grand Ballet de Marquis de Cuevas, the Joffrey Ballet, Twyla Tharp, and the Harkness Youth Dancers as well as San Francisco Ballet.

The School's graduates onstage with SFB and working as dancers and teachers all over the world have helped create an American tradition for fifty years, and staked SFBS' claim on the future.

—*Written by Laura Leivick*

The current faculty of the San Francisco Ballet School (1982). *Standing, from left:* Susan Parry, Anatole Vilzak, School Director Richard Cammack, Diana Weber, Mary Ruud, Larry Grenier. *Seated, from left:* Christine Bering, Helen Coope, Marlene Fitzpatrick Swendsen, Zola Dishong.

SFB Journal 1943-1947

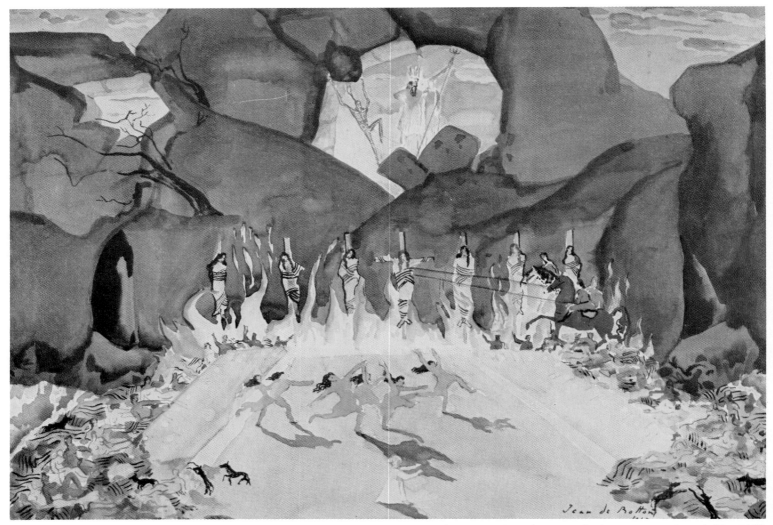

Jean de Botton's set design for Act Two of Willam Christensen's *Triumph of Hope* (1944).

1943. The *12*-member San Francisco Ballet Guild presents the Company in an innovative winter season designed to suit wartime needs — a Thursday series of "Ballet Intimes" presented at 5:15 p.m. in the Garden Court of the Palace Hotel. Each of the four programs lasts about an hour, allowing San Franciscans to return home before dim-outs. Designer Antonio Sotomayor constructs an effective stage for the series. Pianist Reina Schivo conducts members of the San Francisco Symphony for musical accompaniment. (Fritz Berens, the Company's Musical Director, is serving in the armed forces.) And for the opening program Willam Christensen creates *Sonata Pathétique*, an abstract work set to the Beethoven score that wins high praise for its principal dancers, Ruby Asquith and Frank Marasco, and which should, according to the *San Francisco Chronicle*, "become part of the Company's permanent repertoire." (*Sonata Pathétique* is indeed a staple of the SFB repertoire for the next eight years.)

The "unfailingly charming Asquith," as the *Chronicle* calls her, is the season's featured ballerina. In addition to

the new Beethoven ballet, she dazzles in *Amor Espagnol*, *The Bartered Bride*, *Nutcracker Suite*, *In Vienna*, and *Blue Bird Pas de Deux*.

Since travelling during wartime is difficult, the Company restricts its summer activities to the Bay Area, performing at the Berkeley Festival, the Marin Music Chest, and at San Francisco's Stern Grove, where Asquith is featured in all three of the program's offerings.

The thirty-two member Company appears in more than half of the thirteen operas presented during the fall season. In December SFB mounts its first Holiday Ballet Festival. The highlight of the three-performance festival is Christensen's *Hansel and Gretel*, an original and delightful adaptation, in ballet-pantomime with vocal accompaniment, of Humperdinck's opera. It is Christensen's third full-length ballet for SFB in five years. Gisella Caccialanza—who during her tenure with Balanchine's American Ballet created roles in *Serenade*, *Reminiscence*, and *Le Baiser de la Fée*—is the season's guest artist. Appearing in *Sonata Pathétique* and *Chopinade*, she is partnered by Michel Panaieff, another guest performer.

Caccialanza has moved to San Francisco while her husband, Lew Christensen, is in the Army. She begins teaching for San Francisco Ballet, and as SFB dancer Russell Hartley says, she gives the Company "an air of elegance, charm, and professionalism that are invaluable."

1944

The Company plans an ambitious five-performance spring season at the Opera House. The series' most publicized event is the world premiere of Willam Christensen's *Triumph of Hope*, set to the music of César Franck, and designed and written by Jean de Botton, the noted French muralist. Billed as "a spectacular ballet of the new world," *Triumph of Hope* is a patriotic tribute to America. The ballet, says de Botton, concerns "a titanic struggle between creative and destructive forces, and the world looking to America as the symbol of hope for all humanity."

De Botton, the official painter at the coronation of George VI, comes to San Francisco both to unveil his mural, *America at War*, at the city's Palace of the Legion of Honor, and to supervise the elaborate four-scene *Triumph of Hope*, which calls for a cast of sixty, to be headed by Ruby Asquith as Woman. Considerable attention is lavished upon the premiere: "The presentation of this original ballet in San Francisco, by San Francisco artists and dancers," says one local newspaper, "is an augury of the part America is to take in the re-juvenation of the creative arts."

Triumph of Hope, however, is hardly a spectacular success. De Botton, writes the *Chronicle*, "does not seem to have realized that large rhetorical abstractions have a way of becoming distressingly obvious, not to say ludicrous, when enacted on a stage, especially in the dance." And the *San Francisco Examiner* dismisses much of the ballet's action—the arrival of Lady Hope from the upper wings by means of wires, the similar aerial departure of Satan in a puff of smoke, the muscular Atlas upholding a scenic hemisphere—as "disconcertingly naïve and literal, or even old-fashioned." De Botton's stage designs, however, meet with approval, as does the Company's dancing, especially Christensen's portrayal of Satan, which the *San Francisco News* hails as "one of the most attractive and expertly agile Satans that ever cavorted on a local stage."

Along with *Triumph of Hope*, the spring season's all-Christensen repertoire features seven ballets, including a new version of the third act of *Swan Lake* (entitled *Prince Siegfried*), and the world premiere of *Le Bourgeois Gentilhomme*.

Following its annual summer presentations (Stern Grove, Marin Music Chest), and its yearly participation in the fall opera season, SFB undertakes its most important production in years: a full-length *Nutcracker*, the first complete version of the Tchaikovsky classic ever presented in America. Choreographed by Willam Christensen, the sumptuous production of *Nutcracker* is no easy task given wartime rations. Russell Hartley, who designs the ballet's 143 costumes, is particularly hampered by the ten-yard limitation on the purchase of fabrics: as a solution, various dancers are sent off to purchase the necessary fabric, each returning with her ten-yard piece. The South American painter Antonio Sotomayor, residing in San Francisco and well known for his caricatures of theatrical personalities, designs the lavish sets for the ballet's four scenes, including the Christmas tree that grows and grows to giant size. Principal dancers include Caccialanza (Sugar Plum Fairy), Christensen (Her Cavalier), Jocelyn Vollmar (Snow Queen), and Joaquin Felsch (Snow Prince).

The reviews are quite favorable, the *Chronicle* says: "Defying an ancient, clearly outmoded tradition which decrees a local let-down in musical affairs during the holiday season, the SFB filled the Opera House to capacity for the first full-length presentation of Tchaikovsky's *Nutcracker* ever given in the United States. . . . It is all quite charming and pleasant, and often it is more. The big ensemble dances—the snowflakes of the second act, the waltzing flowers of the third, and the finale—were admirable proof of Willam Christensen's capacities as a choreographer, and the numerous soloists . . . did splendid work." The *Examiner* agrees: "It is remarkable how Director Willam Christensen and his young troupe keep up their excellent standards. When he trains individual dancers to a high pitch, he risks losing them to the big national troupes. And the Army takes first call of his young men. Nevertheless, the *Nutcracker* production is full of color, freshness, and dancing entertainment."

The Company performs *Nutcracker* five times this season—twice in San Francisco, and three times in the nearby cities of Oakland, Stockton, and Sacramento.

A Christmas tradition has begun.

1945

"The dominating motif of the San Francisco Ballet," says the Company's new press brochure, "is to express through the medium of the ballet, moods, images, and stories which are stimulating and intelligible to the average person, to bring the ballet back to its original significance—exciting, dramatic, and beautiful entertainment."

Continuing this campaign to popularize ballet, SFB tours the West and Midwest from mid-February through mid-April. Travelling by train for the first time, the Company performs as far north as Seattle, as far south as San Diego, and as far east as Springfield, Illinois. The repertory displays the range of Christensen's choreography: included are modern plotless works (*Sonata*

Pathétique), colorful folkloric works (*Amor Espagnol, In Vienna*), and Christensen's recensions of nineteenth century classics like *Nutcracker* and *Swan Lake*. Christensen is the tour's *premier danseur*, and Caccialanza its leading ballerina. (Asquith is in San Francisco, expecting a child.) Other principal dancers are Onna White ("the comeliest of Swan Queens," says Dallas), Jocelyn Vollmar ("a crystalline classic dancer," says Muskogee), and Lois Treadwell ("a sterling actress," says Seattle).

The tour is a critical and popular success. "With its sincere desire to please, the clarity of its choreography, the prettiness and good taste of its costumes and scenery, and the considerable resources of its dancers," San Francisco Ballet is, as the *Dallas Morning News* writes, "adored" by the public.

When the Company returns to San Francisco in late April, its spring season at the Opera House must be cancelled: the theater is needed for the San Francisco Conference to found the United Nations.

During the summer, SFB performs in outdoor festivals in Oakland, San Francisco, and in Marin, where Christensen's *Pyramus and Thisbe* is premiered to a record-breaking audience celebrating the end of the war. The new ballet, a one-act satire based on the Greek myth, stars Vollmar and Robert Hansen and is set to an original score by the Company's Musical Director Fritz Berens. Costumes are by SFB dancer and designer Russell Hartley.

After the fall opera season, the Company presents its third annual Christmas Ballet Festival. Wishing to offer its audience a new treat each year, the Company performs neither of the ballets created for the first two festivals, *Hansel and Gretel* and *Nutcracker*. Rather, a freshly designed full-length *Coppélia* is presented, with Asquith in the lead role. Costumes are by Hartley, scenery by Charlotte Rider.

The festival's other offerings include *Blue Plaza*, originally scheduled for the cancelled spring series, and now premiered to high acclaim. Set to Aaron Copland's *El Salón México* and designed by Sotomayor, *Blue Plaza* is billed as the first complete ballet on a Mexican theme to be shown in San Francisco. José Manero, the famed Mexican dancer, co-choreographs the ballet with Christensen and makes a guest appearance in the ballet's leading role. Asquith plays the Sweetheart, and Onna White the Hacendado's Daughter. "This is clearly the most creative and important ballet introduced in the current series," says Alfred Frankenstein in the *Chronicle* —"a gay little Mexican fable that moves with real speed, snap, and character."

1946

Although the war is over, the Company still feels its effects: no premieres are presented this year, and the Company's performances are few and far between. A brief tour of Los Angeles and the Pacific Northwest is undertaken in the spring. During the summer, two

Rosalie Prosch, José Manero, and Lois Treadwell in Manero's *Tango* (1946).

performances are offered at Stern Grove. Lew Christensen completes his Army service, whereupon he and Caccialanza return to New York to join Balanchine's Ballet Society. The fall opera season provides SFB's only activities during the rest of the year: no Christmas Ballet Festival is offered in 1946.

In November, however, Willam Christensen quite actively speaks his mind in *Dance Magazine*'s symposium on the future of dance in America. (Other symposium participants include Jerome Robbins, Martha Graham, Anton Dolin, Frederic Franklin, Ted Shawn, and Charles Weidman.) Ballet's American popularity has been so long in coming, Christensen contends, due to the unfortunate preponderance of solo "artists" who are little more than travesties of great originals like Isadora Duncan and Anna Pavlova. Classicism, Christensen argues, is the only tradition strong enough to provide a foundation for dance in America.

1947

The 1942 plans for a civic ballet, dormant during the war, are revived. "It is easy to see how much credit a full ballet company could reflect on the city," Guild President Mrs. Julliard McDonald says at a luncheon of the San Francisco Advertising Club. "We would be known as the only city besides New York which had completed the trilogy of culture—symphony, opera, and ballet."

And thus the San Francisco Civic Ballet Association is created during the spring. George Washington Baker, the former national chairman of the March of Dimes, is secured as the Association's President; he will head a fifty-

two member board of directors whose primary function is fund raising. Noted critic and author Irving Deakin becomes the new organization's General Manager. Willam Christensen remains Artistic Director, while Mrs. Julliard McDonald retains the presidency of the San Francisco Ballet Guild.

On June 9 the new Civic Ballet presents a benefit performance at Marines' Memorial Theatre, with guest speaker Anton Dolin. Dolin, one of the world's greatest *danseurs*, enthusiastically endorses the idea of a San Francisco Civic Ballet, comparing the potential of such a troupe to the Sadler's Wells Ballet which he helped to create in London during the Thirties. After Jocelyn Vollmar dances a dazzling *Black Swan*, Dolin adds that if the newly formed Civic Ballet doesn't offer Vollmar a contract immediately, he will do so himself.

According to plans revealed at the benefit, the new Civic Ballet, although centered in San Francisco and primarily serving the West Coast, "will by no means be a purely local affair, but will employ the services of choreographers, composers, designers, and dancers of national and international reputation." The new organization will be built slowly, carefully, "with the first year devoted to membership drives and initial program work, the second season concerned with metropolitan and suburban performances on a modest scale, and the third year with full operations including repertory seasons in San Francisco, and perhaps a national tour." San Francisco Civic Ballet, says Walter Terry in *The New York Herald Tribune*, is the "new contender for the American ballet crown."

Preparations for the Civic Ballet's first season are made throughout the summer, as the Company gives two performances at Stern Grove, including a full-length *Coppélia* starring Asquith and Peter Nelson. The debut season, it is announced, will feature guest performances by Dolin and Alicia Markova in the Company's first *Giselle*. Dolin and Markova are in Mexico City, so Christensen and Jocelyn Vollmar (who will play Myrtha, Queen of the Wilis) fly to Mexico to learn Dolin's staging.

With the single exception of *Giselle*, all the works presented during the debut season will be new to San Francisco. The Dolin-Markova contingent will contribute Dolin's *The Lady of the Camellias*, Bronislava Nijinska's *Fantasia*, and Rosella Hightower's *Henry VIII*, designed by Hartley. Adolph Bolm, SFB's first director, will return to San Francisco to create *Mephisto*, to the music of Liszt with costumes by film designer Eugène Lourié. And Christensen's new ballet for the debut season will be *Parranda*, a carnival ballet lavishly designed by Sotomayor and set to the *Latin American Symphonette* of Morton Gould, who will personally conduct the premiere performance.

"The eyes of the ballet world will be upon the War Memorial Opera House the nights of November 11 and 12," says *Opera and Concert*, "when the San Francisco Civic Ballet marks its initial appearances. With the famed San Francisco Symphony Orchestra in the pit, the two gala evenings will mark the beginnings of one of the most important events in the history of ballet in the United States. For the first time, a major ballet company is being municipally sponsored and encouraged."

The debut season, under the aegis of the city's Art Commission, is a major success. "If the San Francisco Civic Ballet keeps on making productions as good as *Parranda*," writes the *Examiner*, "it will win a national reputation. *Parranda* is an absolute gem. Willam Christensen—always a tasteful and steady ballet master—rose to the occasion by putting together his best, most spirited choreography. It has flow and variety; it has rhythm; it has warmth. The cast (Ruby Asquith, Jocelyn Vollmar, Richard Burgess, José Manero) likewise achieved ballet big league status."

The Civic Ballet's debut season is such a success that a second season is planned before the first is even over. "Big things lie ahead for the San Francisco Civic Ballet," predicts an editorial in the *Examiner*. "It is now preparing to stage four more Art Commission programs with the full symphony in February. And it has plans to take its productions on tour, with due glory to its home city. Balletomanes are confident that the San Francisco Civic Ballet is destined to take its place in a triumvirate of major local cultural institutions—along with the San Francisco Symphony and the San Francisco Opera. To fulfill its plans, the Civic Ballet needs financial aid. It has proved—not merely in theory but also in the hard test of the glaring footlights—that its potentialities are brilliant and real. Its forthcoming fund-raising campaign will deserve the help of every good San Franciscan."

The new Civic Ballet ends 1947 confident that its three-year plan will be realized.

Patricia Johnston, Margaret Lloyds, Carolyn George, Vernon Wendorf, and Leo Duggan in Willam Christensen's *Parranda* (1947).

BRAUN, CHILDRESS, HALBERSTADT

Janet Reed

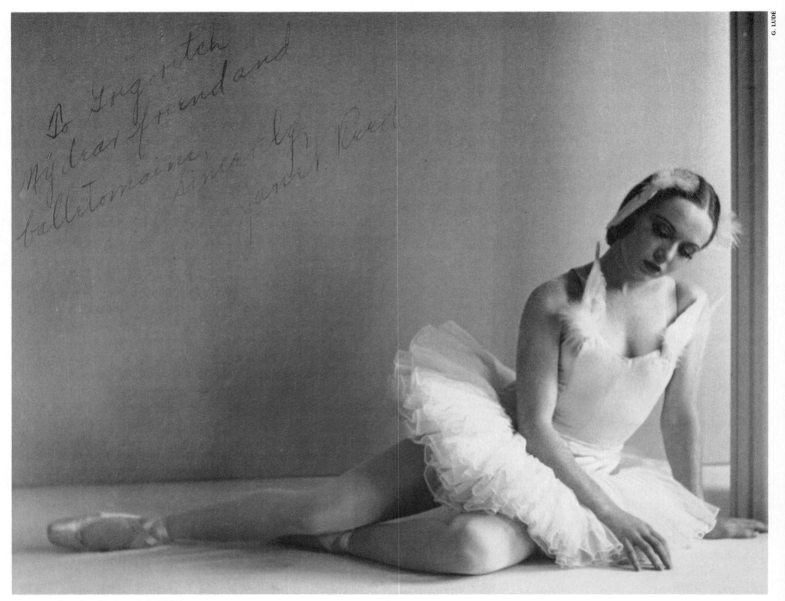

Janet Reed in *Swan Lake* (1940).

Janet Reed created roles in *13* of the seventeen ballets danced by SFB during her tenure with the Company (1937-1941), becoming one of the most popular dancers of her day in San Francisco—the first in a long line of Christensen ballerinas. Reed was a born soubrette—petite, fast, vivacious—with a superb gift for comedy. Radiating gaiety, she possessed that rare ability to spark —and capture—an audience's imagination. "When Reed came onstage," recalls former SFB dancer Russell Hartley, "something magical happened: great waves of affection—something akin to a love offering—poured across both sides of the footlights. No other SFB dancer at the time exerted such charm. Reed was in a class all by herself."

Born in 1916 in the small town of Tolo, Oregon, Reed began her training at the age of eight when her family moved to Portland. "It didn't appeal to me at all," she

later told *Dance Magazine*. "They almost had to drag me to class. But finally our class staged a pageant and once I plunged into the whirl of new costumes, make-up and the excitement of performance, I was won over completely." When she was sixteen, Reed came under the tutelage of Willam Christensen, and in 1937 when Christensen was appointed director of the Oakland branch of the San Francisco Ballet School, Reed was one of several Portland dancers who came to the Bay Area with Christensen.

Even in Christensen's first SFB concert—presented in Oakland on September 17, 1937, with guest artists Lew and Harold Christensen—Reed's prominence in the Company was already unmistakable: she danced in three of the program's four ballets, including principal roles in Willam's *Chopinade* and Lew's *Encounter* in which she was partnered by Lew in the ballet's minuet. The following

year, when Willam Christensen replaced Serge Oukrainsky as SFB's artistic director and started creating new ballets expressly for the Company, Reed was, more often than not, featured prominently in his new works. She was Juliet in *Romeo and Juliet* (1938), Titania in *A Midsummer Night's Dream* (1940), and Odile in the first full-length *Swan Lake* ever produced by an American company (1940). But it was her exuberant performance in Christensen's *Coppélia* (1939) that truly established Reed's reputation as the Company's leading *danseuse*.

Although in *Dancers of the Ballet* Reed recalls that she had never been so frightened in her life as at the premiere of *Coppélia* (during the weeks of rehearsal on the Opera House stage, the asbestos curtain had never been raised, so when the curtain slowly went up on opening night, Reed, alone on stage, was momentarily panicked by her first look into the "shadowy cavern" of the Opera House), she gave a dazzling performance. *Coppélia*, wrote Alexander Fried in the *San Francisco Examiner*, "thrust a new star in the season's foremost ranks . . . Janet Reed is a first-rate dancer." "Foremost of the innumerable soloists in *Coppélia*," agreed Alfred Frankenstein in the *Chronicle*, "was Janet Reed, who has the true ballerina's lightness, technical competence, and dominating personality. As Swanhilda, she not only charmed with her dancing but turned in a dramatic performance that realized to the full the peppery resourceful character of Delibes' heroine."

Reed's success continued on SFB's early tours of the West and Midwest. Chicago pronounced Reed "a great revelation, an artist of the top rank." Detroit declared her "an extraordinary talent, the most interesting new American dancer in years." Topeka thought Reed the affirmative "answer to the old question, Can great dancers be developed here in the United States?" And Seattle found her "dazzling, brilliant, worth going miles to see—she put a high lustre on the whole program, sweeping the large audience off its feet."

But Reed, like many of her fellow SFB dancers, wanted New York exposure (SFB did not play the East Coast until 1956), and so late in 1941 she left SFB for New York to join Dance Players, then directed by Eugene Loring in association with Lew Christensen. There she danced in the world premiere of Christensen's haunting circus ballet, *Jinx*. When Dance Players folded ("as happens to a lot of progressive ideas," Reed later recounted,"the group was an artistic success and a commercial failure"), Reed joined Ballet Theatre where she created roles in the first ballets of Jerome Robbins (*Fancy Free*) and Michael Kidd (*On Stage!*), as well as winning lead parts in *Billy the Kid*, *Tally-Ho*, *Gala Performance*, *Pillar of Fire*, *Graduation Ball*, and other works.

After her success in the Broadway musical *Look, Ma, I'm Dancing!*, Reed joined New York City Ballet in 1949. There her comedic powers were showcased in *Card Game*, *Cakewalk*, and the NYCB premiere of Lew Christensen's *Filling Station*—Reed played the deliriously tipsy Rich Girl, "a comic portrayal as perfect as any I have seen in ballet," wrote Walter Terry in *The New York Herald Tribune*. While with NYCB, Reed also created roles in several Balanchine works, including *Bourrée Fantasque*, *Pas de Deux Romantique*, *A la Françaix*, *Nutcracker*, *Western Symphony*, and *Ivesiana*. And when NYCB played London for the first time in 1950, the eminent British critic Richard Buckle wrote that "of all the female dancers in the New York City Ballet, [Reed's] is the personality which makes the most immediate appeal."

Reed has taught since retiring from dancing—she was ballet mistress of NYCB from 1959 to 1964, and since 1974 has taught for Seattle's Pacific Northwest Ballet. When asked in 1974 about the difficulties of establishing a new company in Seattle, Reed remembered her early days with SFB: the touring section of San Francisco Ballet "began with nine dancers—I was one. When we were not performing with the opera, we toured the Bay Area by bus, giving lecture-demonstrations. We grew without any big names from outside the area, extended our tours, did the whole West Coast and branched out to the Midwest. We reached this stage within two years, then eventually became full-fledged professionals. So, you see, I know this can be done."

First three photos. Janet Reed in *Swan Lake* (1940).
Fourth photo. Lew Christensen and Janet Reed.

Fifth photo. Janet Reed as Swanhilda in SFB's premiere production of Willam Christensen's *Coppélia* (1939).

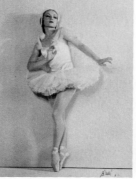

G. LUDÉ G. LUDÉ G. LUDÉ G. LUDÉ ROMAINE

SFB Journal, 1948-1951

Ludmilla Liashenko as the Strong Lady, Dolores Richardson as the Tattooed Lady, and Alton Basuino as Clown Wirewalker in SFB's 1949 revival of Lew Christensen's *Jinx*. The ballet had been originally created in 1942 for Eugene Loring's Dance Players, a small company that stressed the dramatic side of dancing. At its 1942 premiere, *Jinx* had been praised as an American *Petrouchka* —a tense, eerie piece of theater. Critic Rosalyn Krokover said the 1942 production "approached a quality that has not been otherwise achieved in contemporary ballet except in the works of Antony Tudor."

Seven months after its SFB premiere, *Jinx* was staged by New York City Ballet. The New York cast featured several former SFB dancers, including Janet Reed, Beatrice Tompkins, and Harold Lang. John Martin in *The New York Times* praised *Jinx* as "a work of inherent stature, unusual, and impressive . . . a gripping little horror piece with philosophical overtones." Martin hoped that Christensen would do further work on *Jinx* to intensify its drama. The following season, Christensen presented a revised *Jinx* to excellent effect: "a stunning, atmospheric, taut new version which holds the attention unflaggingly," wrote Martin in *The Times*.

Jinx was among the eighteen ballets presented by NYCB during its London debut in 1950, when it was highly commended by the theatrically inclined British critics. The British magazine *Ballet* praised the remarkable skill with which Christensen arranged his story so that "each incident exactly matches the moods of the contrasting sections of Britten's music."

Jinx was a staple of the SFB repertoire throughout the Fifties. It was performed during the Company's East Coast debut at Jacob's Pillow in 1956, and on all three of SFB's State Department-sponsored international tours (1957-59). The ballet has been frequently revived by the Company during the past twenty years. The role of the moody Jinx has been played by Roland Vazquez, Conrad Ludlow, Kent Stowell, Michael Smuin, Robert Gladstein, and Vane Vest. In addition to SFB and NYCB, *Jinx* has also been presented by the Joffrey Ballet.

1948. Gift of the Magi, a ballet for *14* dancers choreographed by Simon Semenoff and based on the classic O. Henry Christmas tale, opens the winter season of the San Francisco Civic Ballet. It is the Civic Ballet's second season. Like the Company's successful premiere programs the previous November, the four-performance February series is sponsored by the San Francisco Art Commission. Eleven works are presented, including the world premiere of John Taras' *Persephone*. Willam Christensen restages *Swan Lake, Act II* for the season's principal guest artist, ballerina Tamara Toumanova, who also stars in Christensen's full-length *Coppélia*. The season is a major triumph, especially for Jocelyn Vollmar, whose performances in *Persephone*, *Parranda*, and *Mephisto* mark her as the Company's rising ballerina.

The season, though a critical and popular success, is financially disastrous. The Civic Ballet Association, conceived in postwar euphoria, cannot meet its expenses: bankruptcy is declared. The Association is dissolved. Due to the generosity of Mrs. Julliard McDonald, founder and President of the San Francisco Ballet Guild, the dancers at least receive their salaries. Christensen, determined to keep SFB alive, stays in San Francisco to reorganize. The Ballet is reduced to bare essentials. Several dancers, including Jocelyn Vollmar, leave to join other companies.

During the summer, the Company—temporarily called the Willam Christensen Ballet—presents two performances at Stern Grove. In the fall SFB again provides the dancers for the opera season. But because of the Ballet's limited resources, no Christmas Festival is offered this year.

1949

In January, Lew Christensen, ballet master for the recently formed New York City Ballet, comes to San Francisco to work with his brothers Willam and Harold at SFB. For the Company's modest spring workshop series, Lew Christensen creates two new works, *Vivaldi Concerto*, a neoclassical exercise aimed to challenge the Company's young technicians, and *The Story of a Dancer*, a demonstration of ballet technique which Christensen himself narrates. This informal spring season—sponsored by the Ballet Guild and presented at the Commerce High School Auditorium near the Opera House—also features the San Francisco premiere of *Jinx*, Lew Christensen's haunting circus ballet set to Benjamin Britten's early melodramatic score *Variations on a Theme by Frank Bridge*.

The repertory for the spring season also includes the world premiere of Willam Christensen's *Danza Brillante*, a lively abstract ballet set to Mendelssohn's *Piano Concerto No. 1*. The two-performance workshop series, called "Evenings at the Ballet," is deliberately modest in scale. The Company must operate on a limited budget that

requires the use of simple sets, two-piano accompaniments, and a high school auditorium: after the Civic Ballet bankruptcy, SFB cannot afford another financial disaster.

During the summer, SFB performs in Los Angeles at the Hollywood Bowl; in Marin County at the Music Chest; and in San Francisco at Stern Grove where the *Chronicle* praises "Christensen's skill in training a company and his gift for keeping it together and finding something for it to do. 'Genius' might be a better word than 'gift' to apply to the latter aspect of Christensen's activities. Logically speaking, it isn't in the cards for San Francisco to possess a major ballet company year in and year out, but Christensen keeps it going."

In the fall, Lew Christensen, now the Company's Associate Director, temporarily returns to New York to stage *Jinx* for New York City Ballet. After its annual performances in the opera season, SFB decides to present its first full-length *Nutcracker* since the 1944 premiere.

According to plans revealed in December, San Francisco Ballet wants to establish *Nutcracker* as an annual San Francisco holiday tradition, rivalling the pantomimes of Europe and the Metropolitan Opera's production of *Hansel and Gretel*. "There is not a reason in the world why the plan should not succeed completely," concludes Alexander Fried in the *San Francisco Examiner*, for "Willam Christensen is one of the leading creative personalities in the city's world of theater. Against great difficulties, he keeps the San Francisco Ballet a going concern."

1950

The Company announces that this year's series of "Evenings at the Ballet" will be presented on a larger scale than last year's. Five performances will be given as compared with two in 1949, and a special children's matinee is being added. The series, extending over a three-month period starting in February, will culminate in a special gala performance at the Opera House—the Company's first non-Christmas appearance in the Opera House since the dissolution of the Civic Ballet.

The sensation of the season is Willam Christensen's *The Nothing Doing Bar*, a wacky satire on the Age of Jazz, bathtub gin, and machine gun mobsters. Set to Darius Milhaud's saucy score *Le Boeuf Sur Le Toit* (originally composed as a two-piano accompaniment to a Charlie Chaplin film), Christensen's new comedy, according to its program notes, "bears little, if any, resemblance to the elaborate pantomime which Jean Cocteau later wrote to this music for the clown Fratellini and presented to Parisian audiences in 1920 as a Frenchman's idea of Stateside saloon activity."

In Christensen's deliberately Americanized version, *The Nothing Doing Bar* tells the story of a raffish set of characters who patronize a Prohibition speakeasy and end

Sally Bailey (center) as the Poule Déplumée and Nancy Demmler (left) and Patricia Tribble as the Deux Champignons in the 1951 world premiere of Lew Christensen's *Le Gourmand*.

up (in a zany surprise ending) sipping milk in a celestial saloon. The ballet, a runaway hit, showcases Christensen's deft characterizations and the comedic talents of the Company's dancers.

During the workshop performances, the role of Yo-Yo the doorman is played in blackface. But the Labor Youth League, protesting that the use of such a character is racist, threatens to picket the Opera House performance. A special jury, including several representatives from the National Association for the Advancement of Colored People, convenes to consider the case. According to reports in the *Chronicle*, Christensen tells the jury that, like all figures in the ballet, Yo-Yo is a caricature based on a well-established theatrical tradition, and that no offense was intended. The jury, however, unanimously agrees that "playing the role in blackface would do no good and that playing it in whiteface would do no harm, artistic or otherwise." Christensen concurs. "Burnt cork is one item of equipment San Francisco Ballet will leave behind when it takes the stage of the War Memorial Opera House," concludes the *Chronicle*.

The spring season also features two important revivals: Willam Christensen's *Romeo and Juliet*, not seen since 1943; and Lew Christensen's *Charade*, originally created for Ballet Caravan in 1939 to Trude Rittman's arrangement of familiar American songs and social dances, including melodies by Stephen Foster and Louis Moreau Gottschalk. The libretto, concerning a debutante's coming out party in turn-of-the-century America, is by Lincoln Kirstein. Alvin Colt's costumes were said to recall "tutti-frutti ice cream, pink cake, and lace party favors."

Two of the original dancers in *Charade* repeat their roles for the San Francisco revival: Harold Christensen plays the debutante's father, and Gisella Caccialanza dances the younger sister, a role originally designed to take full advantage of Caccialanza's comic flair. (The revival of *Charade* marks Caccialanza's first local performance in two years, since she injured her Achilles tendon in 1949.) Roland Vazquez is the young suitor, a part originally danced by Lew Christensen. And Jocelyn Vollmar takes the virtuoso title role originally made for Marie-Jeanne.

For the season's Opera House gala, Lew Christensen partners Vollmar in *Swan Lake* and Celena Cummings in *Parranda*. Christensen—the first American *premier danseur* in this century—is now forty-one years old. These are his last performances as a dancer.

During the spring and summer, SFB conducts an intensive campaign to raise funds and enlarge its audience. Lecture-demonstrations are presented throughout the Bay Area; a Peninsula branch of the Ballet Guild is established; and the Guild inaugurates a drive to increase its membership of 700 to 5,000. To better understand its audience, the Company conducts a viewer survey during the spring season. (The majority of its viewers, the Company learns, attend the ballet from two to five times a year.)

And to support SFB's endeavor to establish San Francisco as the dance capital of the West Coast, several publications feature editorials about the Company. *Opera and Concert*, for example, writes: "For almost fifteen years now, ballet in San Francisco has hung on by the self-sacrifice and brute obstinacy of Willam Christensen. . . . His dream of presenting ballet continuously throughout the year—instead of once or twice during a so-called 'season'—is more than a personal whim: it is vital to the preservation of a functioning ballet troupe, whose members must rehearse continuously to stay at the peak of their technical and physical prowess. . . . As critic Edwin Denby has pointed out, ballet can never become a part of the normal cultural life of the community without a permanent home where a company can rehearse with concentration; a permanent school in which to train its dancers; expert critical advice and incorruptible artistic guidance. These priceless advantages the San Francisco Ballet already has. Can the answer be in Denby's afterthought? 'There is no substitute for artistic integrity,' he wrote. 'And integrity needs a home where it is valued.'" This, *Opera and Concert* concludes, is SFB's real problem: it lacks community support. "San Francisco Ballet, unlike New York's Ballet Theatre and New York City Ballet, has never received the major support of patrons. And due to the peculiar provincialism of a city which applauds its artists *after* they have left for greener pastures, San Francisco's balletomanes are as yet not substantial enough a public to support ballet at the box office."

To increase community support, Willam Christensen gives several interviews and speeches. Various strategies

are discussed, including a revival of the subsidy which the City extended to the Ballet in 1947. "But politics and dancing," Christensen answers, "make bad bedfellows." The most satisfactory solution, he contends, might be the formation of an Arts Council in San Francisco to solicit funds simultaneously for all of the city's major cultural institutions.

The summer finds the Company performing at Stern Grove, followed by its annual participation in the fall opera season. In December, SFB presents its second annual matinee *Nutcracker*. Russell Hartley designs new costumes. Celena Cummings is promoted to the role of Sugar Plum Fairy, while Nancy Johnson makes her debut as the Snow Queen. Sally Bailey, one of the Company's rising ballerinas, dances Rose in the Waltz of the Flowers.

1951

This year's spring workshop series, renamed "Ballet Premieres," includes four Saturday evening performances at the Commerce High School, followed by an Opera House Gala. The season features the Company premiere of *Filling Station*, Lew Christensen's groundbreaking American comedy choreographed for Ballet Caravan in 1938, and a major hit in its SFB revival. Lew Christensen, now Co-Director of SFB, also creates a new work for the season, *Le Gourmand*. Set to Mozart's *Divertimento No. 15 in F Major*, *Le Gourmand* is a wry gastronomical fantasy in which the dancers represent various foods in a *cordon bleu* menu. It's a four-course feast, including *hors d'oeuvres*, fish *entrée,* and dessert. Willam Christensen plays the grilled lobster, Caccialanza the peach in brandy, and Nancy Johnson the pheasant in love with wild rice. New York designer Leonard Weisgard's scenery and costumes are sheer imaginative whimsy. The libretto—which Christensen admits is merely a pretext for a classical suite of dances—is by Christensen, James Graham-Luján, and Paul Ferrier, *maître d'hotel* of the Mark Hopkins Hotel in San Francisco. The ballet's finale—in which the various foods return to crown the gourmand with a pig's head—is pronounced "a little masterpiece of its kind" by the *Chronicle*.

James Graham-Luján, a New York associate of Lincoln Kirstein and George Balanchine, also supplies the libretto for Willam Christensen's new ballet, *Les Maîtresses de Lord Byron*. Set to Liszt's *Concerto No. 1 in E Flat Major*, the new ballet, according to its program notes, is "an account, more balletic than authentic, about Lord Byron, embracing the principal female figures in his life. Any similarity to historical personages is probably malicious."

At the season's close, the Company announces it has established an innovative policy with New York City Ballet whereby the two organizations will exchange ballets and soloists.

During the summer, Willam Christensen, after fourteen years as the Company's Director, leaves SFB to accept a professorship of ballet at the University of Utah. Lew Christensen assumes the directorship, while James

Graham-Luján is named Artistic Director. Harold Christensen remains Director of the SFB School.

As the Company prepares for the fall opera season, it moves from its Civic Center studios to its new home on Washington Street, a mile from the Opera House. In December, Willam Christensen returns from Salt Lake City to help stage SFB's annual *Nutcracker*, this year a collaboration between Willam and Lew. Willam sets the pantomimic action of the first act, retaining some of his original second act variations, while Lew rechoreographs the Snow Scene and the Waltz of the Flowers. Nancy Johnson performs her first Sugar Plum Fairy, and Sally Bailey her first Snow Queen. "One's only criticism of this year's *Nutcracker*," says the *Chronicle*, "is that it should have been scheduled for a series of showings rather than this single performance."

Celena Cummings as Shady Sadie in the 1950 world premiere of Willam Christensen's *The Nothing Doing Bar*. Christensen's speakeasy comedy stayed in repertory only through 1954. The ballet was revived for the choreographers summer workshop in 1962 and for the main Company in 1980, when it proved a hit of SFB's season at the Brooklyn Academy of Music. "*The Nothing Doing Bar*," wrote Anna Kisselgoff in *The New York Times*, "is so good on its American terms and so different from the current usual character-style barroom ballet that it is reason enough to run down to the Academy." Noting that Christensen was "not afraid of baggy-pants humor," Kisselgoff praised the "genuine American flavor" of *The Nothing Doing Bar*, which stemmed, she said, from an irreverent American sensibility and Christensen's sense of comic timing, rooted in his early vaudeville experience. "There is a place again in American ballet for character genre," Kisselgoff concluded. And in *The New Yorker*, Arlene Croce admired the ballet's continued ability to tell us something about the popular theater it came out of and about "the tradition of synthesis in which so many saw the future of American ballet."

The Achievement of Willam Christensen

During his *15* year tenure with San Francisco Ballet, Willam Christensen was an indefatigable pioneer. Christensen came to the Bay Area in 1937 only to direct the Oakland branch of the SFB School, and instead proceeded to establish a San Francisco dance dynasty that forty-five years later still flourishes. He had the courage, vision, and sheer stamina to see the Company through the trial of the Depression and the Second World War. Within the six brief years between 1939 and 1944 he created four full-length ballets—a signal achievement. (Has any American choreographer since equalled that feat?) *Coppélia*, his first evening-length work, revealed his stature as a choreographer: as librettist James Graham-Luján later noted, Christensen's "grasp of the nature of full-length ballet, his ability to fill a stage with spectacle, and his gift for balletic humor became crystallized in *Coppélia*." *Swan Lake*, premiered within months of *Coppélia*, was another major achievement—the first complete version of the Tchaikovsky classic ever produced by an American. And Christensen's *Nutcracker*, the first full-length version presented in the Western hemisphere, provided the foundation for what has since become the most frequently produced ballet in America. Thirty one-act works and over 100 opera ballets complete Christensen's contributions to the SFB repertory.

Firmly rooted in classicism, Christensen's choreography for SFB was also infused with the values of popular culture. Although ballet was hardly a household word during the Thirties and Forties, Christensen was convinced that classical dance could become an integral part of American entertainment. His ballets for SFB were models of clarity, charm, and accessibility. Though occasionally working in an abstract mode, Christensen preferred ballets that immediately established a specific locale or nationality—eighteenth century France (*Coeur de Glace*), nineteenth century Austria (*In Vienna*), or America in the roaring Twenties (*The Nothing Doing Bar*). Christensen was a master storyteller, spinning narratives of consummate charm and lucidity. He wanted his ballets to be theatrical, colorful, entertaining—rich with "characters." His affinity for character ballets spurred him to encourage individuality in dancers: he had no one "ideal" body type, but rather played upon the variety of dancers' physiques. According to former SFB members, Chris-

tensen had the remarkable talent of knowing exactly what to draw out of each performer, from the novice to the most accomplished technician. (His adagio for Sugar Plum Fairy Gisella Caccialanza in the second act of *Nutcracker*, tailored to the brilliance of her Cecchetti-taught technique, remained in Graham-Luján's memory as something "unsurpassable," a remarkable testament to Christensen's "ability to choreograph to an individual technique.")

Christensen's choreography for men, though faithful to classical elegance, revealed a native virility that has since become a hallmark of American ballet. As principal choreographer for San Francisco Ballet during its formative years, Christensen helped forge today's American classical style. This new native style, as George Amberg wrote in his 1949 pioneer survey, *Ballet in America*, "is not aristocratic in the Imperial tradition, but it is well mannered and full of native dignity; it is not sophisticated in the Diaghilev-Kochno-Cocteau sense, but it is full of sharp comment, observation and intelligence; it is not detached and deliberate in the continental manner, but full of uninhibited rhythm and infectious joy; it is not meticulously accurate in the traditional virtuoso fashion, but it is full of bodily self-confidence and youthful stamina. And there is this other quality which Walt Whitman detects in the American common people: 'their manly tenderness and native elegance of soul.'"

During his sixty-year career, Christensen danced, choreographed, and staged ballets throughout the United States. He taught dancers who gained national and inter-

national reputations (Janet Reed, Ruby Asquith, Jocelyn Vollmar, Harold Lang, Michael Smuin), and who are now dispersed around the world as dancers and teachers carrying on the Christensen tradition. He has been instrumental in the organization of three ballet companies: in 1934 he founded the Portland Ballet; in 1938 he helped reorganize and revitalize San Francisco Ballet; and in 1963 he created the Utah Civic Ballet which in 1968 became Ballet West. In short, Christensen has been a major force in American ballet since the early Thirties—one of the few Americans able to assert his talents and win himself a leading position during the decades of Russian supremacy on the American ballet stage. As Amberg wrote, "Christensen made an invaluable contribution to the ballet in America during . . . [fifteen] years of methodical work in one place and with one group entirely composed of native dancers. In the confused and constantly shifting ballet picture in America today, the San Francisco Ballet is a telling example of what admirable results can be achieved . . . with personal and artistic integrity and singleness of purpose and direction."

In 1945, when the Company returned from its national tour, one local critic said, "Christensen is a genius in his own particular medium, and it is entirely due to his efforts that California today boasts of a major ballet company on the Pacific Coast." Thirty-eight years later, those words still ring true. Without Willam Christensen, without his dedication and unswerving belief in the eventual triumph of American dance, there would be no San Francisco Ballet.

15

Left. Willam Christensen (center) with members of Ballet West (1978).
Opposite. Willam Christensen (center) with SFB dancers Lois Treadwell and (from left to right) Celena Cummings, Peter Nelson, Betty Cuneo, Richard Burgess, Judy Nathanson, and Jocelyn Vollmar (c. 1944).

VINNIE FISH

Nutcracker

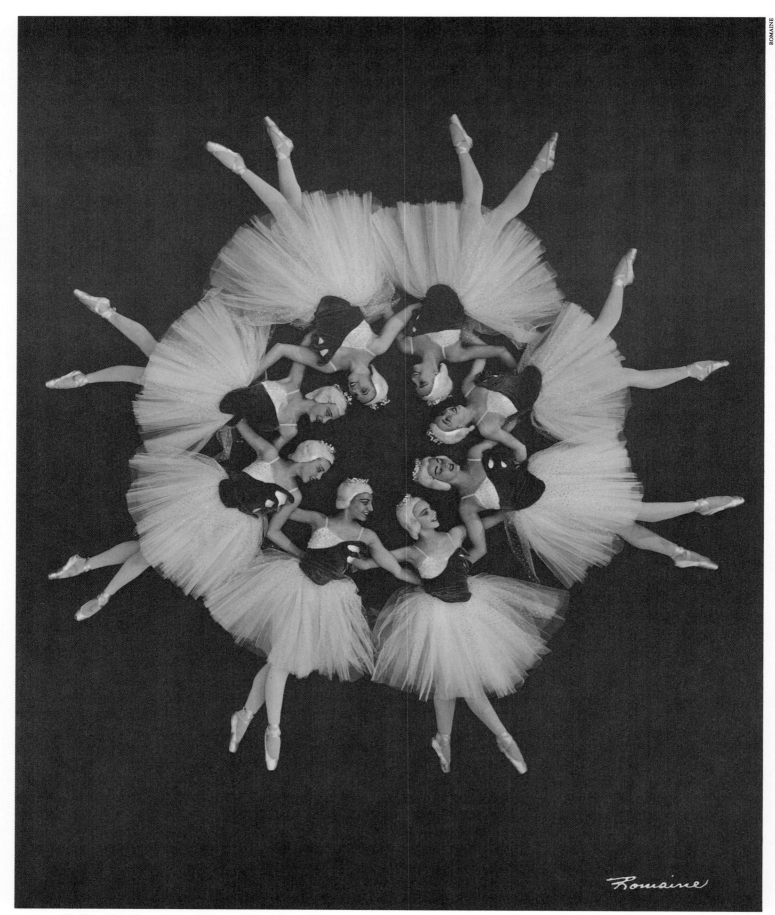

Romaine

The Waltz of the Flowers in Lew Christensen's *Nutcracker* (c. 1955).

An ensemble of *16* dancing snowflakes whirled across the stage in San Francisco Ballet's landmark 1944 production of *Nutcracker*—the first complete version of the Christmas classic ever presented in the Western hemisphere. Based on an Alexandre Dumas version of a tale by E.T.A. Hoffmann, *Nutcracker* was first produced at the Maryinsky Theatre in St. Petersburg on December 17, 1892. The libretto—a sweet, innocuous adaptation of Hoffmann's more eccentric and macabre narrative—was devised by Marius Petipa, the great nineteenth century choreographer who, for more than four decades, served as principal ballet master of the Imperial Russian Ballet. Originally assigned to choreograph *Nutcracker*, Petipa—then in his seventies—fell ill during preparations and the task passed to his assistant Lev Ivanov. The score for *Nutcracker* was composed by Peter Ilyich Tchaikovsky, whose initial reaction to the *Nutcracker* commission was not enthusiastic: Tchaikovsky had doubts about Petipa's libretto, and he believed his own creative powers to be waning.

Nutcracker was staged in the extravagant manner characteristic of the Imperial Russian Ballet. If anything, the production was, according to Tchaikovsky, "too magnificent—the eye grows tired of so much gorgeousness." Despite such "gorgeousness," the premiere was not a great success. The *St. Petersburg Gazette* said that "a more tedious work was never seen . . . the music is a long way from what is necessary for a ballet." And another critic complained that there was in general little for the dancers in *Nutcracker*, "and for art, absolutely nothing." Certain scenes, however, were acclaimed, including the grand *pas de deux* and the Dance of the Snowflakes, which required a *corps de ballet* of sixty women plus eight female soloists, all of whose headdresses featured snowflakes attached to wires that quivered whenever the women moved. According to one account, the sixty-eight women "first formed a star, then assembled into one huge snowball, and finally, as though driven by capricious winds, sank into a heap, like a snowdrift."

Despite its lukewarm reception, *Nutcracker* remained in repertory at the Maryinsky. Outside Russia, however, the complete ballet was virtually unknown. Western Europe did not see its first full-length production until 1934 when the Vic-Wells (now Royal) Ballet presented a version staged by Nicholas Sergeyev, after Ivanov. And although a one-act production of *Nutcracker* was among the most popular works performed during the Ballet Russe de Monte Carlo's annual tours of America, a complete version was not seen in the United States until SFB's 1944 production.

During the early Forties, the War Memorial Opera House, which the Ballet shared in a crowded schedule with the Opera, the Symphony, and numerous touring attractions, was almost always available during the Christmas season. Wishing to take advantage of the theater's availability, SFB Director Willam Christensen decided to produce an annual Christmas ballet festival. Christensen's *Hansel and Gretel* was the main offering for SFB's first Christmas Festival in 1943, and for the second festival, Christensen—at the suggestion of members of San Francisco's large colony of Russian émigrés—chose to produce a complete *Nutcracker*. Although he had staged excerpts from *Nutcracker* as early as 1935, Christensen had never seen or danced in a complete, traditional production of *Nutcracker*. And so, when the Ballet Russe next visited San Francisco, Christensen invited George Balanchine (whom he had known since the mid-Thirties) and Alexandra Danilova to his apartment to share with him their memories of how *Nutcracker* was danced at the Maryinsky when, as students, Danilova played Clara and Balanchine was the Mouse King one season and the Nutcracker Prince the next.

"We had something to eat and something to drink," recalls Christensen, "and then we got down to work with the score and my conductor. George described the Maryinsky production: how the big doors opened on the tree, the mime with Drosselmeyer, all the details." The discussion lasted long into the night, Balanchine growing increasingly enthusiastic about the project. According to Russell Hartley, who both designed the costumes for the SFB production and created the role of Mother Buffoon, Danilova kicked off her shoes at one point in the discussion and began dancing Clara's variation. Balanchine quickly stopped her. "No, no. Shura, don't show him the steps. Let Mr. Christensen do his own choreography."

Wartime economies and rationing restricted access to materials for the production. "One thousand dollars was

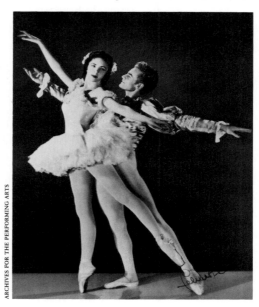

Celena Cummings and Joaquin Felsch as the Snow Queen and Prince in Willam Christensen's *Nutcracker* (1944), paired only for this publicity photograph.

the budget for the 143 costumes," remembers Hartley, "which had to include all of the material, the execution of the costumes, and my salary. The Cort Theatre, where Anna Pavlova had danced her last San Francisco seasons, had just been demolished in 1942, and somehow, the stage curtains had found their way to the Goodwill Industries store. I was able to purchase all of them for ten dollars. They provided the materials for the red velvet coats worn by the male guests in Act One, as well as providing the Company with a source of red velvet for at least the next ten years."

SFB's *Nutcracker* premiered on December 24, 1944. Antonio Sotomayor, a compatriot of sculptor Beniamino Bufano and a prominent figure in San Francisco art circles, designed the sets. Gisella Caccialanza and William Christensen were the Sugar Plum Fairy and her Cavalier. Nineteen-year-old Jocelyn Vollmar was the Snow Queen, partnered by Joaquin Felsch. Five performances were presented that year, two in San Francisco and the others in Oakland, Stockton, and Sacramento. In the *Sacramento Union*, Merrill Osenbaugh wrote: "We can't understand why a vehicle of such fantastic beauty and originality could be produced in Europe in 1892 with signal success and never be produced in its entirety in this country until 1944. Perhaps choreographers will make up for lost time from now on."

But Willam Christensen never intended *Nutcracker* to become an SFB tradition: he originally planned to produce a new ballet for each Christmas Festival. In 1949, however, he decided to revive the Tchaikovsky classic, and *Nutcracker* has been performed regularly by SFB during every Christmas season to the present day. In 1951, when Lew Christensen was appointed the Company's Co-Director, *Nutcracker* became a collaborative effort between the two brothers: Willam provided the pantomimic action of Act One, while Lew choreographed the Dance of the Snowflakes and the Waltz of the Flowers. In 1954, after Lew Christensen had succeeded his brother as SFB's Director, the Company was ready for a new, more elaborate *Nutcracker*. Leonard Weisgard, the illustrator of more than 150 children's books, designed the costumes and scenery for the new production. Nancy Johnson and Conrad Ludlow danced the Sugar Plum Fairy and the Cavalier, while Sally Bailey and Gordon Paxman led the Snowflakes. (Robert Gladstein, appointed SFB's Assistant Director in 1981, made his Company debut as Drosselmeyer's nephew.) The ballet was entirely rechoreographed by Lew Christensen, who conceived the new production in the American Victorian style of the 1850s. "I simplified *Nutcracker*," recalls Christensen, "because I wanted it to be as magical and as childlike as possible."

The ballet now opened in Drosselmeyer's workshop, where he and his nephew finished making the Nut-

cracker before setting off for the Christmas Party. The second act *divertissements*, it was said, resembled storybook illustrations come to life. In the Chocolate Variation, a Matador and his señorita fought a Licorice Bull. A Turkish magician made a dancing girl disappear during the Arabian Dance. The Mirlitons' music featured a charming number for a Candybox Shepherdess and her two lambs. The Trepak, originally three male dancers in traditional Russian dress, became a bracing Ribbon Candy Dance that in the late Fifties proved a showstopper for dancer Michael Smuin. SFB's second production of *Nutcracker* played for thirteen seasons to over 400,000 people. In the late Fifties, the Company took portions of the ballet on its State Department-sponsored tours of the Far East, Middle East, and Latin America, and, in 1964, ABC-TV filmed the entire *Nutcracker* for national television.

To celebrate the seventy-fifth anniversary of Tchaikovsky's great fairy-tale ballet, San Francisco Ballet presented its third production of *Nutcracker* in 1967. More than three years of fundraising efforts, supervised by SFB General Manager Leon Kalimos, raised the $130,000 needed to buy new costumes and scenery designed by Robert O'Hearn. "O'Hearn and I worked together to produce a full-length fantasy simple in plot, but lavish in presentation," recalls Lew Christensen. The production was indeed lavish: over 7,000 pounds of costumes, props, and scenery were crafted by hand, including 250 costumes of silk, satin, and velvet. A mechanized and electrified Christmas tree replaced the black-light tree of the previous production. Scrims were introduced to suggest falling snow and ice. And real water flowed from the fountain in the Candy Kingdom—until a leak in the fountain threatened to flood the stage.

Extensively rechoreographed by Lew Christensen, the new *Nutcracker* now opened with a picturesque street scene outside the Silberhaus home, showing a chestnut man, a toy seller, and a chimney sweep, as the guests, including Drosselmeyer and his nephew, hurried to the party. The dance of the mechanical doll and her fuzzy brown bear—among the most popular dances in the 1954 production—was retained in the new version, although both bear and doll were freshly costumed. (The doll's dress was a replica of the Ballerina's costume that Alexandre Benois created for the 1911 premiere of *Petrouchka*.) The battle of the mice and toy soldiers was made more spectacular as cannons exploded and smoked. And the second act *divertissements* were again modified; three Spanish couples replaced the Chocolate Matador and Licorice Bull; a man now tamed a paper dragon during the Chinese Dance; and Dresden Dolls were substituted for the Candybox Shepherdess and her two lambs.

SFB's sumptuous new production of *Nutcracker* received its gala premiere on December 12, 1967. Guest artists Melissa Hayden and Jacques d'Amboise danced

the opening night Sugar Plum Fairy and her Cavalier, while Virginia Johnson and David Coll were the Snow Queen and King. Lynda Meyer danced the Rose, leading the Waltz of the Flowers. *Nutcracker* was given fourteen performances that season, including five in Los Angeles. (It was the first time SFB performed *Nutcracker* in Los Angeles since 1957.) The 1967 production remains in the Company's repertoire to this day. In 1980, Robert O'Hearn created new sets for the second act Candy Kingdom, which, following a more symmetrical format, left more of the stage floor clear for dancing. The following year, the costumes for the intricate Waltz of the Flowers were freshly designed. During the 1982 season, SFB presented thirty performances of *Nutcracker* to over 85,000 people. No other full-length ballet in the Company's history has been performed as frequently.

Nutcracker is, in fact, the most popular ballet in America: more than 150 productions of *Nutcracker* are presented each year in the United States. (When asked what it was like to have started an American Christmas tradition, Willam Christensen replied, "It sometimes seems more like an epidemic than a tradition.") Despite its unprecedented popularity, *Nutcracker* has not been without its detractors. Since its 1892 premiere, there

have been complaints that the ballet is excessively sweet and blandly sentimental, that it lacks a truly developed role for a ballerina, and that its dramatic structure is weak—all the narrative is in the first act, all the dancing in the second, and neither act has any characters to speak of. "Well, we are one more *Nutcracker* nearer death," British critic Richard Buckle concluded after seeing a London production more times than he desired.

But such complaints have not diminished the ballet's appeal. Tchaikovsky's score, as Lincoln Kirstein has said, "holds a coherence and consistency unique in the literature of theatrical music." And the story line, despite its weaknesses, casts a sweet radiance. "*Nutcracker* is really a dream about Christmas," the renowned American critic Edwin Denby has said, "since it succeeds in turning envy and pain into lovely invention and social harmony." For Denby, *Nutcracker* was "the story of a child's presentiment of handsome conduct, of civilized society." It is this vision of "handsome conduct and civilized society" that San Francisco Ballet has been celebrating since 1944 when the entire Company under Willam Christensen took to the stage and presented America's first full-length *Nutcracker*.

Opposite. Costume design by Russell Hartley for SFB's first *Nutcracker* (1944).

Below. The Battle of the Mice and Toys in Lew Christensen's *Nutcracker* (c. 1955).

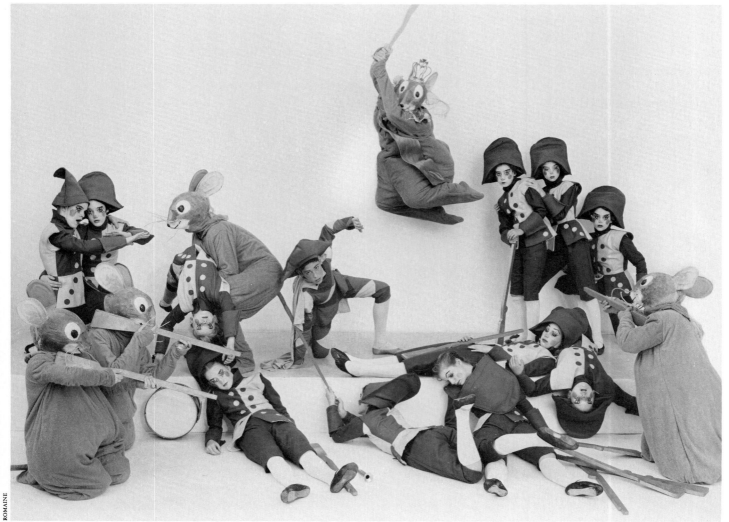

ROMAINE

Guest Artists

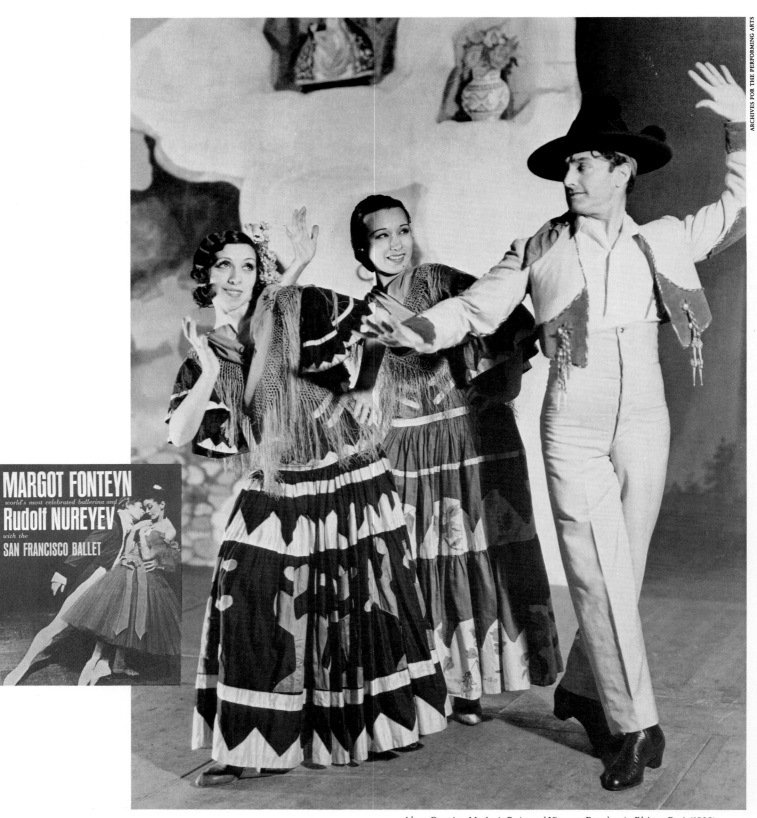

Above. Carmita, Maclovia Ruiz, and Vincente Escudero in *El Amor Brujo* (1935).
Left. Margot Fonteyn and Rudolf Nureyev (1964).
Opposite left. Leon Danielian in *Nutcracker* (1957).
Opposite right. Alexandra Danilova in SFB's first production of George Balanchine's *Serenade* (1952).

El Amor Brujo (1935) featured *17* SFB dancers and the Company's first major guest artist: Vincente Escudero, acclaimed on his world-wide tours with Pavlova in 1931 and La Argentina in 1934 as the world's most aristocratic Spanish dancer. Escudero's staging of *El Amor Brujo* had just scored a triumph at Radio City Music Hall in New York. The SFB performance marked the first time the production had been seen outside Manhattan. Set to the celebrated score by Manuel de Falla and based on an Andalusian folk tale, *El Amor Brujo* was rich with dramatic choreography for Escudero and his famous partner Carmita, "a woman of sinuous and abandoned energy," as the local press dubbed her.

Since Escudero and Carmita, nearly one hundred performers have appeared with SFB as guest artists. The Company's "guest list" includes:

■ Anton Dolin and Alicia Markova, November 11-12, 1947.

Anton Dolin and Alicia Markova, two of the great pioneer personalities of British ballet, performed with SFB during its 1947 fall season at the War Memorial Opera House. Dolin and Markova—who had danced with Diaghilev's Ballets Russes, the Royal Ballet (then called the Vic-Wells Ballet), and Ballet Theatre—had formed their own ensemble troupe in 1945, and it was this company that appeared with SFB. The Markova-

Dolin repertory that season included Bronislava Nijinska's *Fantasia*, Dolin's *Lady of the Camellias*, and Rosella Hightower's *Henry VIII*, while SFB contributed the world premiere of Willam Christensen's *Parranda*, set to a Morton Gould score (Gould himself conducted), as well as the world premiere of Adolph Bolm's *Mephisto* (the last ballet Bolm was to choreograph). Both companies, in an experimental and novel arrangement, danced together in *Giselle*: Markova, one of the most celebrated Giselles in this century, danced the title role; Dolin was Albrecht, and SFB dancer Jocelyn Vollmar made an auspicious debut as Myrtha, Queen of the Wilis. SFB also provided the all-important *corps* for the second act: it was Markova and Dolin's first full-length *Giselle* with an American civic ballet. "The corps of the San Francisco Ballet," wrote Dolin in his *Autobiography*, "gave a magnificent performance of *Giselle*, fresh, spirited, and beautifully danced." In fact, the SFB corps in *Giselle* won a curtain call all to itself.

■ Tamara Toumanova, February 5-8, 1948.

Tamara Toumanova, among the most glamorous of the Russian emigré ballerinas, first caught the attention of the ballet world in 1932 when Balanchine engaged her as one of the three "baby ballerinas" for the Ballet Russe de Monte Carlo: at the age of thirteen, Toumanova created principal roles in Balanchine's *Cotillon*, *Concurrence*, and

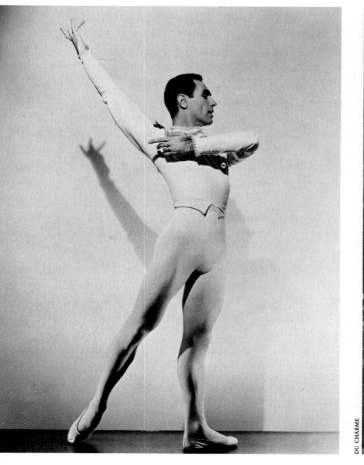

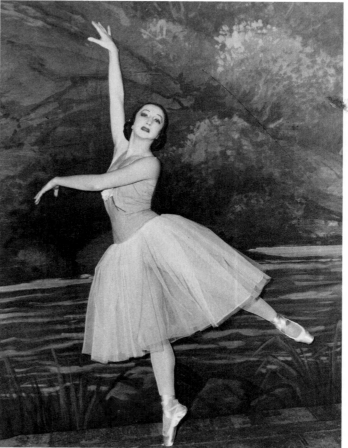

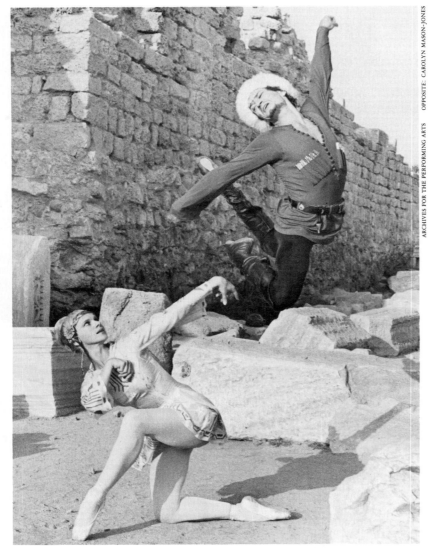

ARCHIVES FOR THE PERFORMING ARTS OPPOSITE: CAROLYN MASON-JONES

Above. Galina and Valery Panov in *Heart of the Mountain* (1976).
Opposite. Natalia Makarova in *Don Quixote Pas de Deux* (1976).

Le Bourgeois Gentilhomme, winning the praise of one of ballet's most brilliant and demanding critics, André Levinson. Toumanova performed on all four programs of SFB's 1948 spring season, her first American performances since her 1947 season with the Paris Opéra where she had created a leading role in Balanchine's *Symphony in C* (then called *Le Palais de Cristal*).

Toumanova's repertoire with SFB included Willam Christensen's full-length *Coppélia*, his *Swan Lake, Act II*, and several Petipa divertissements. Guest artist Paul Petroff, *premier danseur* with the Ballet Russe de Monte Carlo, partnered Toumanova in all ballets except *Coppélia*, in which another guest artist, Michael Panaieff, danced the role of Franz. Simon Semenoff, the season's fourth guest artist, also appeared in *Coppélia*, performing one of his most celebrated character roles, Dr. Coppelius.

■ Alexandra Danilova, April 18, 1952.

In 1951 Lew Christensen, then ballet master of Balanchine's New York City Ballet, returned to San Francisco to become SFB's Director. Soon after Christensen's arrival, SFB and NYCB initiated an exchange policy whereby works originating with one organization

were lent to the other. Thus, SFB performed its first Balanchine ballet on April 18, 1952 when Alexandra Danilova—the greatest ballerina of the Ballet Russe de Monte Carlo and among the most popular, charismatic dancers of this century—guested in *Serenade*. Danilova won an ovation for what the *San Francisco Examiner* called a "thoroughly beautiful performance."

■ Leon Danielian, April 10-21, 1953.

Leon Danielian, *premier danseur* of the Ballets Russes de Monte Carlo, first appeared with SFB during its 1953 Spring Festival. In addition to performing the *Don Quixote pas de deux*, the *pas de trois* from *Swan Lake*, and the Tennis Player in the SFB premiere of Balanchine's *A la Françaix*, that season Danielian also created the role of the Bandit in the world premiere of Lew Christensen's comic masterpiece, *Con Amore*.

Danielian's association with San Francisco Ballet continued throughout the rest of the Fifties, during which time Danielian danced in several of the Company's annual *Nutcrackers* and performed on all three of SFB's world tours (1957-1959) usually partnering Jocelyn Vollmar.

In late 1979 Danielian—after having served as director of the American Ballet Theatre School from 1968 to 1979—returned to San Francisco to work as guest instructor, at which time Michael Smuin paid a special tribute to him: "We are happy to be able to invite Leon Danielian as guest company teacher. His training and teaching suit the artistic philosophy of this School and repertory, and I've always admired him greatly as a dancer. In fact, in my early years as a performer, I modelled my dancing after his. He's a great dancer and superb teacher."

■ Maria Tallchief and André Eglevsky, April 28-May 2, 1954.
■ Maria Tallchief and Jacques d'Amboise, February 12, 1960.

The exchange agreement between SFB and NYCB allowed for an exchange of ballets *and* soloists. Among the many NYCB dancers who guested with SFB during the Fifties and Sixties were two of Balanchine's most illustrious artists, Maria Tallchief and André Eglevsky, who appeared with SFB during its 1954 spring season at the Opera House. Tallchief (then considered the most technically proficient ballerina America had ever produced) performed with Eglevsky two Balanchine works already in the SFB repertoire: the one-act version of *Swan Lake* and the *pas de deux* from *Sylvia*. Both roles were closely associated with the couple: Tallchief and Eglevsky had danced the lead roles in *Swan Lake* at its 1951 world premiere; Tallchief was also the originator of the *Sylvia pas de deux* in 1950; and Eglevsky had made his debut with NYCB in the latter ballet.

Six years later Tallchief once again danced the *Sylvia pas de deux* for SFB, this time partnered by NYCB principal dancer Jacques d'Amboise. D'Amboise and Tallchief helped to inaugurate SFB's eight-week Jubilant Series at the Alcazar Theatre—then the longest home season in the Company's history.

■ Margot Fonteyn and Rudolf Nureyev, January 14-30, 1964.

San Francisco Ballet was the first American company to engage Margot Fonteyn and Rudolf Nureyev as guest artists. Certainly among the most celebrated partnerships in the entire history of dance, Nureyev and Fonteyn appeared with SFB for five performances in San Francisco (four were planned and a fifth had to be scheduled due to popular demand), followed by two performances with the Company in St. Louis and four in Chicago. The famous pair's repertory that season included *pas de deux* from *La Sylphide*, *Swan Lake*, *Sleeping Beauty*, *Gayne*, and *Le Corsaire*, the latter being one of Nureyev's specialties. (He had danced the *Corsaire pas de deux* for his prize-winning performance in the student's competition in Moscow.)

Nureyev, needless to say, generated intense excitement: in 1964 he was still a new dancer in the West and he was breaking new ground. Just two months before his SFB performances, he had, for example, staged his first production in the West, "The Kingdom of the Shades" scene from *La Bayadère* for the Royal Ballet. And much of his SFB repertoire, though today familiar to audiences, was then quite new: he had danced the excerpts from *La Sylphide* and *Gayne* in the West for the first time just the previous summer.

■ Melissa Hayden, Jacques d'Amboise, and Conrad Ludlow, December 1967.

■ Conrad Ludlow, December 1968.

■ Violette Verdy, December 1970.

In 1967 San Francisco Ballet presented its third completely new production of *Nutcracker*: the entire ballet was restaged by Lew Christensen with spectacular new sets and costumes by Robert O'Hearn. To celebrate the occasion (billed as the most lavish ballet spectacle ever produced on the West Coast), New York City Ballet dancers Melissa Hayden, Jacques d'Amboise, and Conrad Ludlow were engaged as guest artists for the holiday season. Hayden danced the Sugar Plum Fairy to d'Amboise's Cavalier at four of the performances, while Ludlow (an SFB alumnus) danced the Cavalier role at three performances, partnering SFB ballerinas Lynda Meyer and Jocelyn Vollmar.

Ludlow returned the following year for repeat performances in SFB's *Nutcracker*, and in 1970 another NYCB principal, Violette Verdy, was engaged as the Sugar Plum Fairy, one of her "most cherished" roles. "When you dance for many years," Verdy told the *San Francisco Chronicle*, "you get to know yourself, what your 'atmosphere' is. Mine is one of joy, and the dance of the Sugar Plum is of the joy of Christmas. It's a dance of celebration, experience, and refinement—of the affirmation of keeping joy into adulthood."

■ Violette Verdy, May 15-28, 1971.

■ Violette Verdy and Edward Villella, February 29, 1972.

During the spring of 1971, San Francisco Ballet enjoyed a "double" season: the Company not only performed in the War Memorial Opera House, but also brought a variety of repertory premieres to the Palace of Fine Arts, one of San Francisco's historic landmarks. The Palace, built for the 1915 Panama-Pacific Exposition, had just been equipped with a theater, and SFB was the first professional company to perform there. As a special feature of the double season, Violette Verdy, recently returned from London, where she achieved one of the great triumphs of her career, joined SFB to dance *La Source*, which Balanchine had choreographed in 1968 especially for her. (For years at NYCB the role was exclusively Verdy's.) San Francisco Ballet was the first company besides New York City Ballet to perform *La Source*, originally created as a *pas de deux*, but expanded in 1969 to include an ensemble section for nine women. Verdy's partner here in *La Source* was SFB dancer Leo Ahonen.

During the 1971 spring season, Verdy also created a role in the world premiere of Lew Christensen's *Airs de Ballet*, a ballet for five dancers (four women and one man), set to André Grétry's *Zémire et Azor* suite. SFB dancer Philippe Arrona was Verdy's partner for the premiere of the ballet, which *San Francisco Chronicle* critic Marilyn Tucker praised as a "happy little series of divertissements —all air and bubbles whose choreography was particularly indebted to the artistry of Miss Verdy."

Verdy once again appeared with SFB in 1972 when she and NYCB star Edward Villella (one of America's most dynamic and athletic danseurs) danced Balanchine's *Tchaikovsky Pas de Deux* as part of the opening ceremonies of the new San Jose Community Theatre. It was the SFB premiere of *Tchaikovsky Pas de Deux*, one of Balanchine's most bracing "applause machines," and the audience adored it: "Villella had only to wiggle his toe," reported the *San Francisco Chronicle*, "and the audience went crazy."

■ Marcia Haydée and Richard Cragun, January 19-20, 1974.

■ Dagmar Kessler and Peter Schaufuss, February 14, 1974.

■ Patricia McBride and Jean-Pierre Bonnefous, April 25-28, 1974.

■ Natalia Makarova, May 2, 11-12, 1974.

■ Liliana Cosi, May 2, 11-12, 1974.

■ Niels Kehlet, May 11-12, 1974.

The guest roster for San Francisco Ballet's 1974 winter-spring season was unprecedented: nine internationally acclaimed stars were engaged to celebrate the longest home season in the Company's history. The four-month-long run boasted twenty-six different ballets, including nine new productions, five revivals, and the world premiere of Michael Smuin's *Mother Blues*. Danilova's staging of Fokine's *Les Sylphides*, Bournonville's *Flower Festival Pas de Deux*, and two Balanchine masterworks, *The Four Temperaments* and *La Sonnambula*, were all Company premieres that season. San Francisco Ballet's goal to present a full-fledged season in the Opera House was—at long last—realized.

The season's opening night featured Stuttgart Ballet stars Marcia Haydée and Richard Cragun in two John Cranko works: a *pas de deux* from *The Taming of the Shrew* and the West Coast debut of *Légende*, choreographed the previous spring for the Metropolitan Opera's Diamond Jubilee tribute to impresario Sol Hurok and one of the last ballets Cranko created before his untimely death in June 1973.

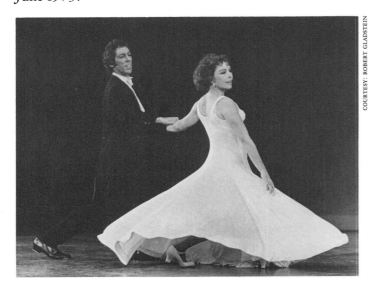

The season's next guest artists were Dagmar Kessler and Peter Schaufuss, principal dancers with the London Festival Ballet, who danced two *pas de deux* (*Don Quixote*, *Flower Festival*) before leading the Company in *Symphony in C* and *La Sonnambula*. New York City Ballet principals Patricia McBride and Jean-Pierre Bonnefous then danced Balanchine's *Tchaikovsky Pas de Deux* on April 25 and 27, and on April 28 Bonnefous partnered SFB ballerina Lynda Meyer in that bravura *pas de deux*, while McBride performed with the Company in *Serenade* partnered by Robert Gladstein. McBride and Bonnefous then danced the Sanguinic movement of *The Four Temperaments* on the April 28 matinee.

The May 2 program was, as the local press said, "an embarrassment of riches." Natalia Makarova appeared in two ballets: *The Dying Swan*, which, thanks to Pavlova, is perhaps the most famous solo in the entire ballet repertoire; and the *pas de deux* from *Don Quixote*, in which Makarova was partnered by Alexander Filipov, who had recently joined SFB. The Saint-Saëns music for *Dying Swan* was performed by famed San Francisco cellist Boris Blinder, who had played the music during Pavlova's 1924 tour. (The adoring press made much of the fact that Blinder's instrument for the May 2 performance was a priceless antique cello from the collection of San Francisco electronics wizard Edward Karkar, who was soon to marry Makarova.) If Makarova's presence were not enough, the May 2 program also featured guest artist Liliana Cosi, prima ballerina of Milan's La Scala, in the *Black Swan pas de deux*, partnered by SFB dancer Vane Vest. The three-hour program was, as the *Palo Alto Times* reported, "an 'occasion,' and the audience, riding on the

excitement, had ovations at the ready."

The excitement continued on the May 11 and 12 programs which featured Cosi, Makarova, and the return of Royal Danish principal Niels Kehlet. Cosi danced with the Company in *Les Sylphides* and *Symphony in C* partnered by Robert Gladstein. Makarova repeated her *Dying Swan* and performed the *Don Quixote pas de deux* with Kehlet, who also performed in *Symphony in C*.

The *Chronicle* hailed the season as "a festival of dance—the year the San Francisco Ballet made its astounding *grand jeté* into the front ranks. The [guest artists] were a surprising asset. Box office was obviously effected, but the larger importance was on the Company itself. Our dancers found that they could, week after week, look well and dance brilliantly on the same boards with The Big Boys. Inspiration turned to confidence. Dancers like Robert Gladstein, Vane Vest, Diana Weber, Gary Moore, Gina and Anton Ness or Nancy Dickson, Bojan Spassoff and John McFall—all of whom had proven themselves good, solid dancers—suddenly began to catch fire. Month by month, sometimes week by week, there was this sudden virtuosity popping at you from all sides."

■ Valery and Galina Panov, February 8-16, 1975.
■ Judith Jamison, February 20-March 1, 1975.
■ Cynthia Gregory, April 19-24, 1975.
■ Valery and Galina Panov, June 4-July 26, 1975.

In June 1974, Valery and Galina Panov were permitted to leave the Soviet Union for Israel after a two-year struggle which had ignited world-wide concern. San Francisco Ballet, which in 1973 had presented a benefit for the Kirov pair, was the first American company to host the Panovs. On opening night of its 1975 spring season at the Opera House, SFB presented the Panovs in the *pas de deux* from *Harlequinade*. In a special dedication to the Panovs, the program also featured SFB dancer Alexander Filipov (who also had studied at the Kirov, defecting in 1970) in Michael Smuin's dramatic 1973 benefit tribute, *For Valery Panov*. The solo, as the *Chronicle* observed, was made even "more moving when the Panovs reappeared to share the applause, embracing Filipov and Smuin, and returning the audience's love."

A few days after the Panovs' guest appearances, Judith Jamison, a leading dancer with Alvin Ailey's American Dance Theater, danced three performances with the Company. One of the most regal and stunning figures in modern dance (Clive Barnes once called her "an African goddess moving in a manner almost more elemental than human"), Jamison performed *Cry* in San Francisco, a solo that Ailey had choreographed especially for her in 1971 and which, as *Dance Magazine* noted, is to Jamison what Fokine's *Dying Swan* was to Pavlova. Jamison enjoyed a triumphant appearance with SFB. With the exception of the Panovs, she outdrew any other guest artist in the past two seasons, including all the stellar dancers of the 1974 season. (Jamison's association with the San Francisco Ballet was rekindled in 1981 when Michael Smuin choreographed and directed the Broadway hit, *Sophisticated*

Ladies, in which Jamison had a starring role.)

Cynthia Gregory, who was a soloist with San Francisco Ballet before becoming one of American Ballet Theatre's most-acclaimed ballerinas, returned to SFB as the third guest artist of the 1975 season. Partnered by SFB dancer Vane Vest, Gregory danced the first movement of Balanchine's *Symphony in C* and Michael Smuin's *Eternal Idol*—Gregory had created the female role in *Eternal Idol* when the ballet premiered with ABT in 1969.

The Panovs' February appearances with SFB were so successful that the couple joined the Company for its 1975 summer tour of the West—the first time in over a decade, since Fonteyn and Nureyev, that guest artists toured with the company. The Panovs' repertoire for the tour—which included stops in Los Angeles, Portland, Seattle, Vancouver, and El Paso—consisted of *pas de deux* from *Giselle*, *Nutcracker*, *Don Quixote*, *Le Corsaire*, *Harlequinade*, and *The Lady and the Hooligan*, the latter being one of Valery Panov's most famous roles.

- Valery and Galina Panov, February 24-28, 1976.
- Fernando Bujones and Galina Panov, March 3-5, 1976.
- Paolo Bortoluzzi and Galina Panov, March 6-9, 1976.
- Ted Kivitt and Galina Panov, March 10-15, 1976
- Carmen de Lavallade, March 21-30, 1976.
- Marge Champion, April 22-27, 1976
- Suzanne Farrell and Peter Martins, May 16, 1977.

In addition to the world premiere of Michael Smuin's full-length *Romeo and Juliet*, the 1976 SFB repertory season also featured the debut of Valery Panov's *Heart of the Mountain*, the first ballet Panov choreographed for a Western company. Unfortunately, during the second performance of *Heart of the Mountain*, Panov was injured and could not perform as scheduled on the Company's eleven-city March tour of the Southwest. Galina Panov, however, did dance on the tour, partnered by three of ABT's foremost *danseurs*—Fernando Bujones, Ted Kivitt, and Paolo Bortoluzzi—who substituted for the injured Panov.

When the Company returned from its March tour, it continued its annual spring season at the Opera House, and the guest artists also continued. First Carmen de Lavallade, one of America's most important modern dancers, performed her solo, *Les Chansons de Bilitis*. Then Marge Champion—well-known as one-half of the legendary dance team, Marge and Gower Champion, but perhaps less well-known as the daughter of Ernest Belcher, one of SFB's first ballet masters—performed with SFB in *N.R.A.*, Robert Gladstein's glittering tribute to the music and entertainment of the Thirties. Gladstein, who had retired from dancing the previous year to take on full-time responsibilities as the Company's ballet master, briefly came out of retirement to dance with Champion in his own *N.R.A.* Gladstein and Champion performed the ballet's "Rogers-Astaire" number with such "charm and sheer class," said the *San Francisco Chronicle*, that they "touched a kind of warmth and affection for the 30s that was more than mere camp. There was a special kind of grandeur to the great ballroom dancers, and this section

of *N.R.A.* came very close to matching it." (Champion and Gladstein "teamed up" once again in 1982 when Champion hosted the television broadcast of Gladstein's *Symphony in Three Movements*.)

To close—and celebrate—its 1976 repertory season, San Francisco Ballet presented a Gala Performance on May 16 at the Opera House, the first such gala in the Company's forty-three year history. In addition to excerpts from the Company's current repertoire, the Gala also featured performances by NYCB principals Suzanne Farrell and Peter Martins. Farrell and Martins, one of the great partnerships of contemporary ballet, danced Balanchine's *Tchaikovsky Pas de Deux* and Jerome Robbins' *Afternoon of a Faun*.

- Fernando Bujones and Yoko Moroshita, May 29, 1977.

A Gala Performance also closed the Company's 1977 repertory season: its guest artists were ABT principals Yoko Moroshita and Fernando Bujones (the first American to win a Gold Medal at Varna), dancing the grand *pas de deux* from *Sleeping Beauty* and the "Black Swan" *pas de deux* from *Swan Lake*.

- Gregory Hines, January 16, 1982.

After the abundance of guest artists in the mid-Seventies, San Francisco Ballet ceased to engage outside dancers: "the point," Michael Smuin has said, "was to get audiences to come, and let them see our artists right next to the stars. We waited until the public told us that we were so good we didn't need the guests." By the end of the Seventies, SFB had indeed become a true repertory company, focused on performing ballets by its own choreographers, without guest stars.

But to help kick off its 1982 repertory season, SFB did present a special guest artist, not from the world of classical dance, but from Broadway—Gregory Hines, star of the 1981 Tony Award-winning musical *Sophisticated Ladies*, directed and choreographed by Michael Smuin. At the opening of the SFB 1982 repertory season, Hines performed a number from *Sophisticated Ladies* and then, in a special surprise, invited Smuin to join him for an energetic, and touching, tap dance.

That the Company's latest guest artists have come from NYCB, ABT, and Broadway seems fitting, for San Francisco Ballet is known for its ability to draw upon three important strains of American dance: the neo-classicism of Balanchine, the dance-as-theater aesthetics of ABT, and the heady vitality of musical comedy.

GEORGE T. KRUSE

Left. Gregory Hines, Mercedes Ellington, and Michael Smuin at the opening of the 1982 Repertory Season.
Opposite. Robert Gladstein and Marge Champion in Robert Gladstein's *N.R.A.* (1976).

Resident Choreographers

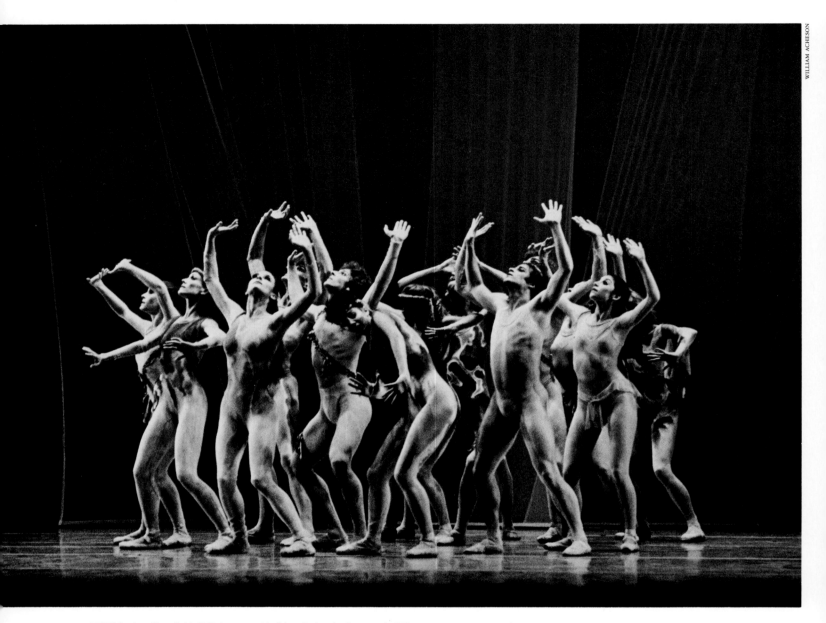

WILLIAM ACHESON

■ Val Caniparoli made his SFB choreographic debut during the Company's 1982 Stravinsky Centennial with *Love-Lies-Bleeding*. The recipient of two grants from the National Endowment for the Arts for choreography, Caniparoli has also created ballets for Pacific Northwest Ballet, Marin Ballet, and the Living Dance Company of Tucson, Arizona. Caniparoli, who received his training at the San Francisco Ballet School, is also one of the Company's most versatile dancers, excelling in classic and character roles. *Above.* The final moment from *Love-Lies-Bleeding*.

■ Betsy Erickson, who choreographed her first ballet, *Bartók Quartet No. 5*, for SFB's 1981 Summer Festival, is a product of the San Francisco Ballet School. Erickson joined the Company in 1964 and danced with SFB until 1967 when she joined American Ballet Theatre. With ABT, Erickson toured nationally and internationally, appearing in leading roles in the classical repertory and in the ballets of Alvin Ailey, Agnes de Mille, and Jerome Robbins. Since her return to SFB in 1972, Erickson has won a reputation as one of the Company's finest interpreters of the works of George Balanchine. More than ten ballets in the current SFB repertoire feature roles choreographed especially for her by the Company's resident choreographers, including Iris in Michael Smuin's *The Tempest*, which Erickson performed for the ballet's national telecast in 1981.

Erickson choreographed *Bartók Quartet No. 5* in celebration of composer Béla Bartók's Centennial. Erickson's ballets have since also been performed by Oakland Ballet. *Right.* Victoria Morgan and Vane Vest in *Bartók Quartet No. 5*.

A contingent of *18* resident choreographers has created the bulk of San Francisco Ballet's repertory during its first fifty years. Although the Company's repertory also includes ballets by such internationally acclaimed choreographers as George Balanchine, Sir Frederick Ashton, Jerome Robbins, and August Bournonville, it is the original choreography that has given SFB a repertory—and a style—very much its own. The development of resident choreography is, in fact, the core of the Company's artistic philosophy. As the *San Francisco Examiner* noted in 1982, foremost among the Company's artistic innovations has been "the encouragement of choreography from within the ranks, the building of new pieces on dancers whose skills are appreciated and understood, using all the considerable production resources of which the Company is capable. No other American ballet troupe of similar stature has fostered so much."

From its official beginnings in 1933, San Francisco Ballet has been continuously directed by a resident choreographer—first by Adolph Bolm, who, in turn, was followed by Willam Christensen, Lew Christensen, and Michael Smuin. And the Company has carefully—and innovatively—nurtured young choreographers since 1960 when Michael Smuin inaugurated, with the encouragement of Lew Christensen, the "Ballet '60" summer choreographers' series. But it has only been since the mid-Seventies that SFB has housed a *group* of resident choreographers—an unprecedented contingent of artists who provide the Company with new ballets tailored to and inspired by its dancers. During the 1982 repertory season, for example, seven resident choreographers created new works for the Ballet. In this, SFB is unique: the repertory of no other American ballet company is currently being created by as many resident choreographers.

The resident choreographers currently working for SFB are: Co-Directors Lew Christensen and Michael Smuin; Assistant Director and Ballet Master Robert Gladstein; and Company dancers Val Caniparoli, Betsy Erickson, John McFall, and Tomm Ruud.

18

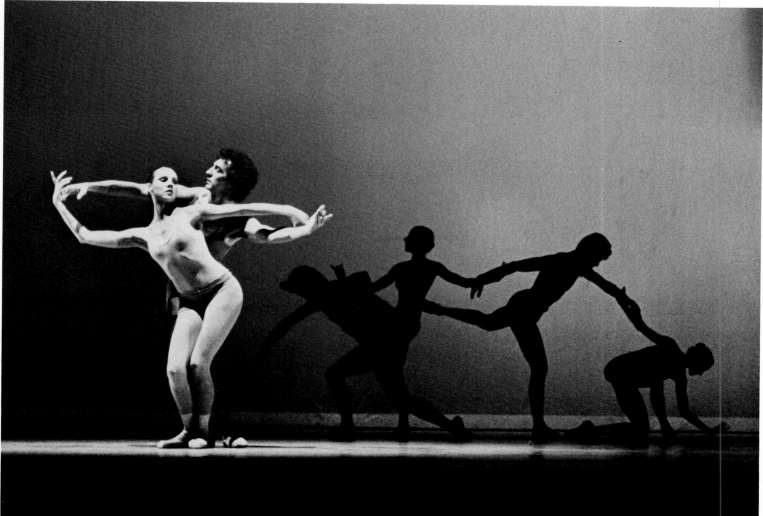

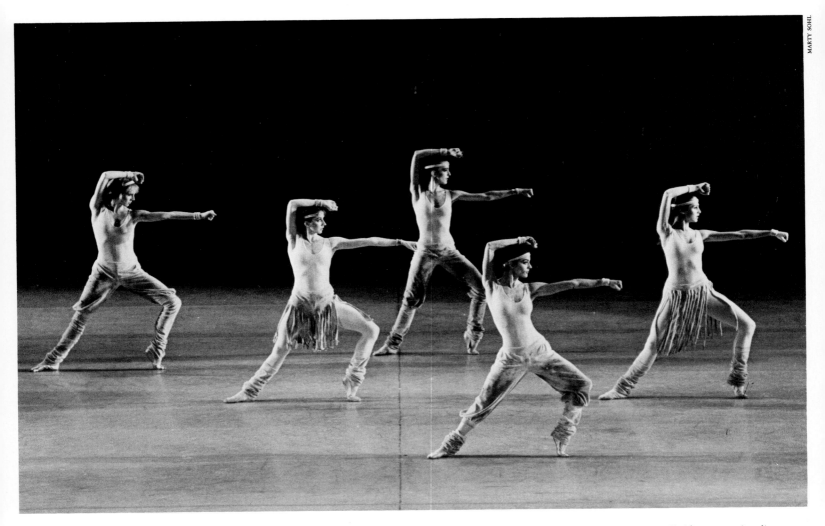

■ Discovered in Kansas City during an SFB tour of the Midwest, John McFall studied with SFB as a Ford Foundation Scholarship student, before joining the Company in 1965. As a member of SFB, he has appeared in leading solo and character roles in the ballets of Lew Christensen, Michael Smuin, and George Balanchine, and he has won wide acclaim as the delightfully dim-witted Alain in SFB's production of Sir Frederick Ashton's *La Fille Mal Gardée*. Since McFall created his first ballet in 1969 for SFB's summer workshop series, eleven of his works have been performed by the Company. A film of his 1973 ballet, *Tealia*, was awarded the U.S. Information Agency's Golden Eagle Award, and was shown at the 1977 Moscow Film Festival. In 1982, ABT Director Mikhail Baryshnikov invited McFall to create two new works for ABT's 1982/83 season, including a work for Baryshnikov himself. "John McFall's success," says Michael Smuin, "is a shining example of the success of our Resident Choreographers Program. Our intent is to give talented choreographers a forum to try their ideas and style, and then help them develop national recognition." McFall has also choreographed for opera, notably the world premiere of the San Francisco Opera's *Angle of Repose* (1977), and the Seattle Opera's production of *Aida* (1974). In addition to SFB and ABT, McFall's works are also in the repertoires of Oakland Ballet and the San Francisco Moving Company. *Above.* Victoria Morgan, Tracy-Kai Maier, Jamie Zimmerman, Anita Paciotti, and Catherine Batcheller in *Badinage* (1982).

■ Tomm Ruud trained under Willam Christensen ("he's been my teacher, director, consultant, everything," Ruud says) at Ballet West, where he danced leading roles in *Swan Lake, Coppélia,* and *Giselle* and choreographed his first ballets, *Mobile* (1969) and *Statements* (1972). Since joining SFB in 1975, Ruud has appeared in principal roles in the ballets of Lew Christensen, Michael Smuin, Robert Gladstein, John McFall, Sir Frederick Ashton, George Balanchine, Todd Bolender, John Butler, Willam Christensen, and Jerome Robbins, including the role of Ferdinand in the live national telecast of Michael Smuin's *The Tempest*. Seven of Ruud's works have been staged by SFB. *Mobile*, a staple of the Company's repertory, has been hailed by *Newsweek* as "a brilliant exercise in kinesthesia in which three dancers transform themselves into a Calder-like mobile, their interlocking limbs and torsos restlessly defining and illuminating the plasticity of the human body." In 1980 a film entitled *Balances* was made about *Mobile*. Ruud's ballets are included in the repertory of companies across the country, including American Ballet Theatre, Ballet West, the Pittsburgh and the Kansas City Ballets. *Right*. Jim Sohm (center), Deborah Zdobinski (left), and Damara Bennett in *Mobile* (1977).

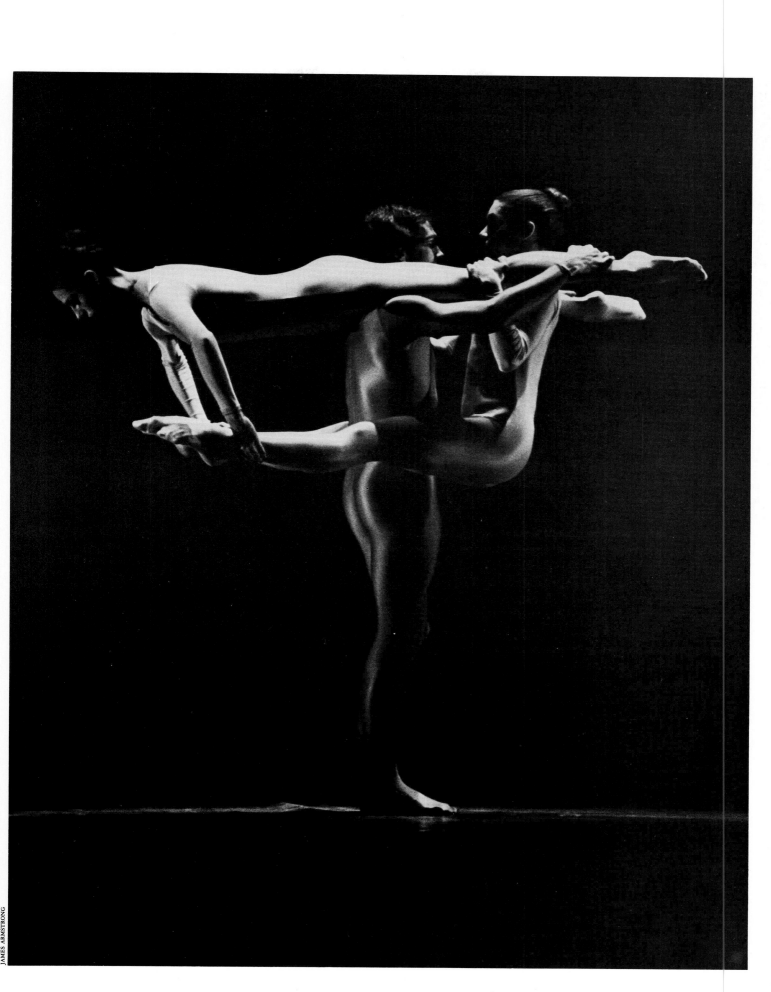

Con Amore

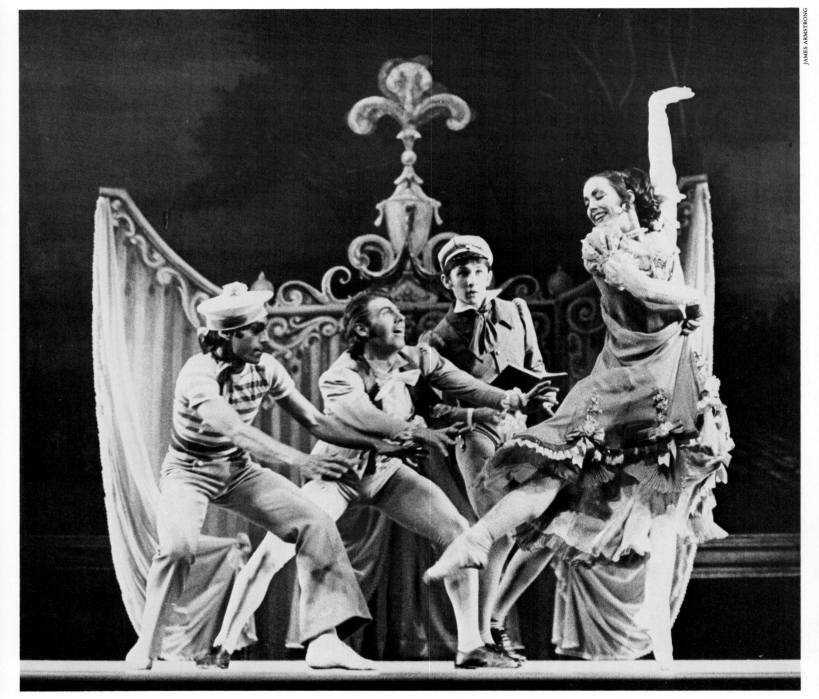

Daniel Simmons, Ted Nelson, Laurence Matthews, and Susan Williams in
Scene Two of *Con Amore* (1971).

Delightfully based upon *19*th-century dance engravings, Lew Christensen's *Con Amore* received its world premiere in April 1953 and has been performed almost every season since: no other ballet except *Nutcracker* has enjoyed such a long life in the SFB repertory. Set to three bubbling Rossini overtures and felicitously designed by James Bodrero, *Con Amore* is irresistably good-natured, a happy theater piece graced, as John Martin wrote in *The New York Times*, with "a genuinely fine and funny scenario, ingenious, theatrical, and eminently Rossinian."

The libretto—a tongue-in-cheek plot of frothy "incoherence"—was written by James Graham-Luján, who provided the book for several other colorful Christensen ballets of the early 1950s, including *American Scene*, *Heuriger*, *The Dryad*, and *Le Gourmand*. Although effective ballet libretti are notoriously rare (Théophile Gautier, the great French poet who wrote the scenario for *Giselle*, admitted it was practically impossible to "write for legs"), *Con Amore* is a model of clarity—an exemplary light narrative ballet. Rich with dance opportunities and choice comic roles, *Con Amore* keeps things spinning at a giddy pace. It's an unpretentious, witty, and effervescent romp—an out-and-out farce tempered by Christensen's characteristic affection and warmth.

The first of the ballet's three scenes—enticingly entitled "The Amazons and The Bandit"—opens on a rustic locale: a company of Amazons, handsome and robust girls in smart military uniforms, drill under the command of their captain and her lieutenants. The women move briskly and sharply (we're in the land of the "pagan" Fanny Elssler, not the "Christian" Marie Taglioni), and it is apparent from their severe military bearing that these girls have never known love and are on their guard against it.

A bandit, however, invades the woods and disrupts their patrol. At first, the women take the handsome intruder captive, but his uncontrolled gaiety and charm (he's a dashing specimen of manhood) eventually pierce their hearts. The bandit, however, will have none of them, not even the lovely captain. The Amazons, enraged by his indifference, surround the bandit: no matter where he turns, he is confronted by muskets and bayonets. Defiantly, he kneels and bares his chest to receive a fusillade. As the Amazons lift their guns and take aim, the music suddenly ends: the stage action is halted.

Scene Two of *Con Amore*, "The Master's Return," is set in the boudoir of a fashionable lady. As the scene opens, the mistress is bidding farewell to her husband, whom, we gather, she is not entirely sorry to see depart. In fact, no sooner is the husband out the door than the lady begins to primp, obviously preparing for a tryst. Sure enough, a man-about-town knocks at her door. The lady

Michael Graham, Paula Tracy, Jerome Weiss, Michael Thomas, and Val Caniparoli in Scene Two of *Con Amore* (1978).

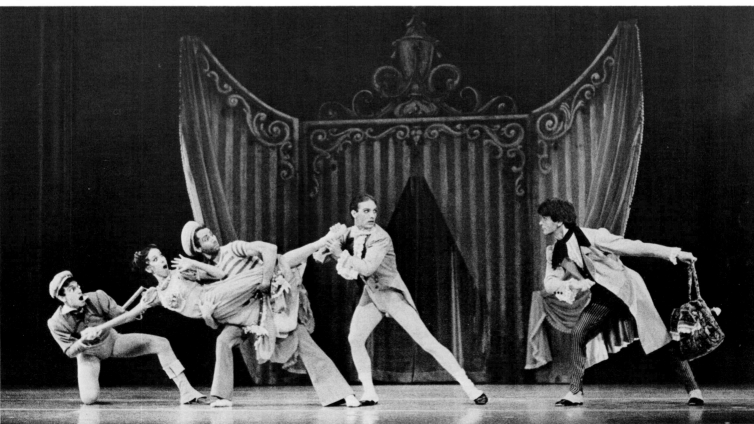

admits him with frank delight, whereupon he attempts to embrace her. The lady eludes him, although it is clear she does not wish to elude him long. But before she can succumb, there is another knock at the door (the Rossini score has several "knocking" measures which Christensen uses to full advantage). The man-about-town hastily conceals himself in a convenient closet, and the lady admits a sailor, who pursues her headlong about the apartment so heatedly, fire could stream from his nostrils. He has almost worn the elusive lady down when there is yet another knock. The lady thrusts the sailor in her closet (already occupied by the man-about-town) and then admits a young student, his nose in a book. Unlike his predecessors, the student is not eager for the lady's affections: she obligingly makes the advances, which the

RUDY LEGNAME

young man, knees quivering, just manages to escape. The man-about-town and the sailor, who have been watching all this, burst from their hiding place and demand their mistress choose among them. There is still another knock at the door: the husband returns, stunned by the sight of his wife surrounded by a few suitors too many. The scene ends.

The third and final scene, "A Triumph of Love," opens on the bandit from Scene One, still kneeling at the mercy of the angry Amazons. The women's hearts melt, and each surrenders her firearms to the bewildered bandit. As he flees the forest, we are suddenly presented with the tableau from the lady's boudoir. The errant lady begs forgiveness from her lord and master, but he, unmoved, banishes his lady and her paramours from the house. We are in the forest again: the *corps* of Amazons reappear as genial sylphs, each conveniently carrying a tree. All the lovers from Scenes One and Two enter the woods, some to hide, some to seek. Behind the sylphs' trees, they steal kisses and exchange furtive embraces. Enter Cupid. Plying her bow resourcefully, she lets fly arrows in all directions: the bandit is smitten with love for the errant lady; the husband is united with the Amazon captain; the sailor and the man-about-town embrace the Amazon lieutenants; and the timorous student, struck by love at last, rushes to claim Cupid herself. *

Con Amore was Lew Christensen's first major work after succeeding his brother Willam as SFB's Director in 1952. During his first years as the Company's new leader, Lew Christensen's strategy was clear: to create a repertoire of original ballets and to supplement that repertoire with

the best of Balanchine. (*Con Amore*, for example, opened on a program that also saw the SFB premieres of Balanchine's *Swan Lake* and *Concerto Barocco*.) *Con Amore* holds an honored place in the Company's repertoire: it was the first new work performed by New York City Ballet under the SFB-NYCB exchange program; it was danced on opening night of the Company's East Coast debut season at Jacob's Pillow in 1956; it was included on all three of SFB's international tours (1957-59); on its Silver Anniversary in 1978, it was performed during the Company's first New York season in almost fifteen years; and in 1981 *Con Amore* was among the ballets SFB brought to the Edinburgh Festival. No other one-act ballet has been performed by SFB as frequently, and no other SFB-produced ballet has entered the repertoire of so many companies: Ballet West, the Joffrey Ballet, New York City Ballet, Chicago Opera Ballet, the National Ballet, the Finnish National Opera Ballet, Kansas City Ballet, Ballet Oklahoma, and Cincinnati Ballet have all staged *Con Amore*.

Con Amore has provided San Francisco Ballet with some of its most cherished—and surefire—roles. At its premiere, Sally Bailey and Nancy Johnson enjoyed unqualified success as the Amazon Captain and the fashionable Lady, while guest artist Leon Danielian as the Bandit showed such vitality and quick humor that he was hailed in headlines. Since Danielian, many of SFB's brightest and boldest danseurs—Conrad Ludlow, Kent Stowell, Michael Smuin, Robert Gladstein, John McFall, David NcNaughton—have triumphed in the dashing role. (At New York City Ballet, the Bandit has been danced by the likes of Jacques d'Amboise and Edward Villella.) And the part of the Amazon Captain—a wry image of a ballerina's indomitable strength and independence—has proved a marvelous vehicle for SFB's Lynda Meyer and NYCB's Violette Verdy, while Paula Tracy and Anita Paciotti have sparkled as the Lady with too many paramours and too few hiding places.

Con Amore is undoubtedly a Christensen classic—"ceaselessly lively and ceaselessly inventive," as Alfred Frankenstein wrote in the *San Francisco Chronicle* after the premiere. And like many of Christensen's ballets steeped in strong comic traditions (opera buffa, vaudeville, farce), *Con Amore* is, as its very title suggests, a sweet examination of love. Beneath its robust surface, *Con Amore* gently reminds us that even those who think themselves beyond romance can still succumb, and that all dangers can be disarmed and all conflicts resolved through the irrational magic of love.

*This plot summary is gratefully adapted from *Balanchine's Complete Stories of the Great Ballets* (Doubleday & Company, 1977) and *The New Borzoi Book of Ballets* (Alfred A. Knopf, 1956).

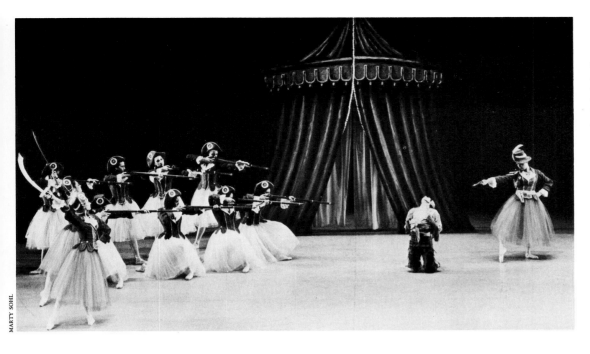

Opposite. Wendy Van Dyck as Amor in *Con Amore* (1982).
Left. Lynda Meyer as the Captain of the Amazons and John McFall as the Thief in Scene One of *Con Amore* (1981).
Below. Lynda Meyer, John McFall, and Evelyn Cisneros in Scene One of *Con Amore* (1981).

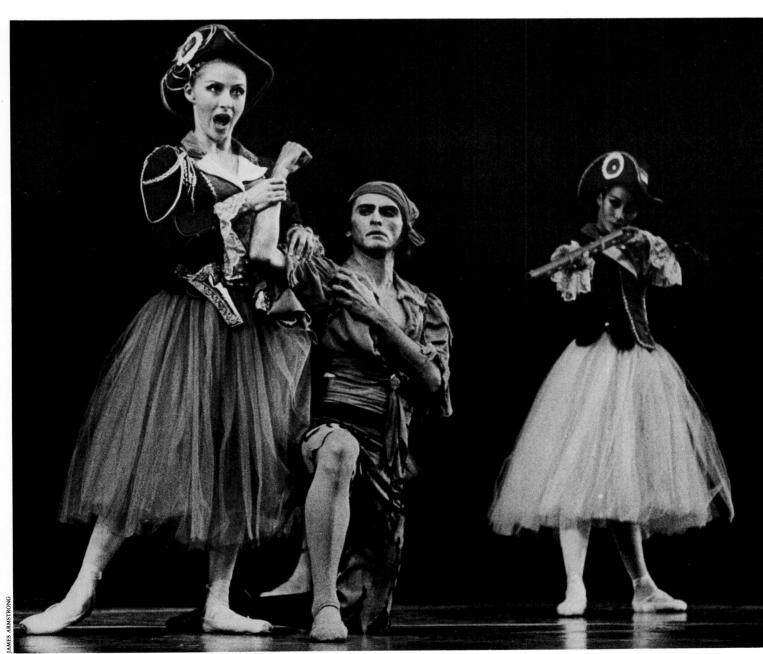

Lew Christensen on Dance and Dancers

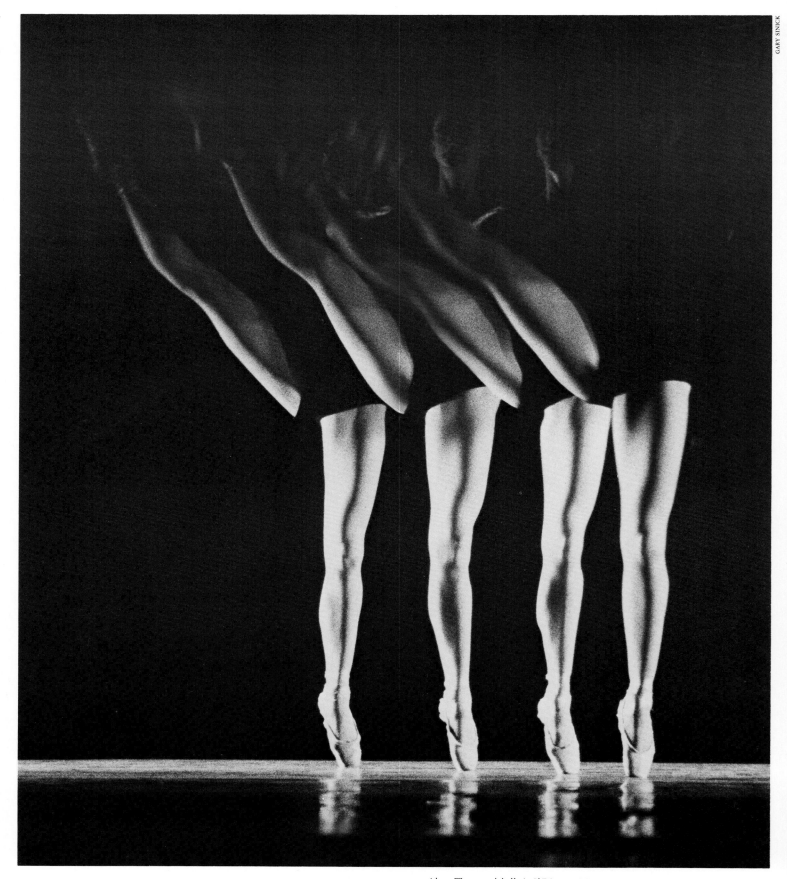

Above. The *corps de ballet* in *Il Distratto* (1979).
Opposite. David McNaughton, Diana Weber, and Elizabeth Tienken in *Divertissement d'Auber* (1979).

20 Selected Statements

"If I had a story to tell, the very last medium I would choose to tell it in would be the medium of ballet. There are, of course, wonderful story ballets, and I enjoy them very much. But, as a choreographer, I am wary of the species." (1956)

"I believe that the most important thing that ballet can say is that *movement is beautiful*. For me a ballet like Balanchine's *Concerto Barocco* is an ideal ballet. What it has to say is best expressed through dancing. It cannot be improved by story or by excellently written program notes. It is complete in itself, a balletic masterpiece." (1956)

"If a choreographer continually imposes his taste upon the public, perhaps he should allow the public to impose its taste on him." (1956)

". . . I used any choreographer's chief resource: a study of the music until its complexities and above all, its accents, became clear." (1956)

"I believe in American ballet and I must, perforce, work within it. America, thanks primarily to George Balanchine, has made an important advance in the history of ballet. That advance is American classicism. It is the criterion under which I wish to work and to be judged." (1956)

"The hardest thing about a new ballet is to find a name for it." (1956)

"Art never stands still. To advance is to make greater demands on the medium and explore new chances of expression. This is the point of view of the San Francisco Ballet. Whether the ballets are brilliant or not so brilliant is not the objective (that is personal): the objective is to leave ballet in a better condition for future choreographers than the way you found it." (1965)

"It is important for ballet companies to restage the best works of the past, but it is more important to develop the artistic and intellectual capabilities of the companies of today with a constant flow of new works if the art is to progress." (1967)

20

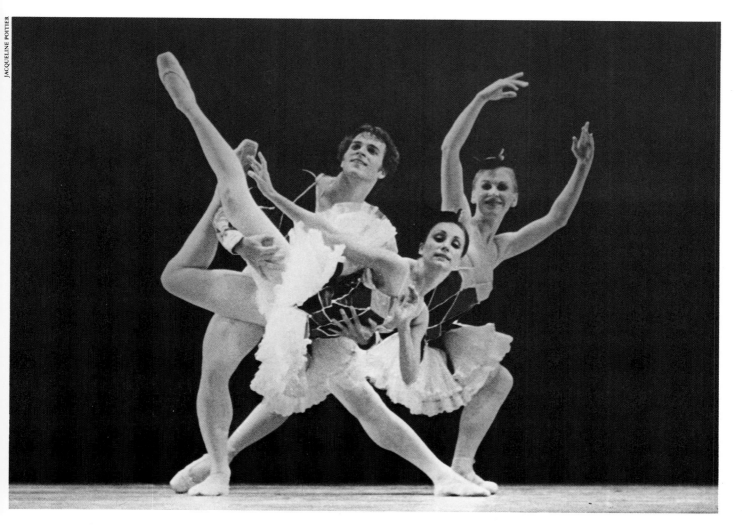

"Many of [today's choreographers] can make an impressive production every so often, with disappointments in between. Only four or five in this country can be steadily counted on for excellent productions nearly every time. One result is that companies everywhere want to use the same top men, and companies everywhere get to look more and more alike. But we want the San Francisco Ballet to stress individuality." (1972)

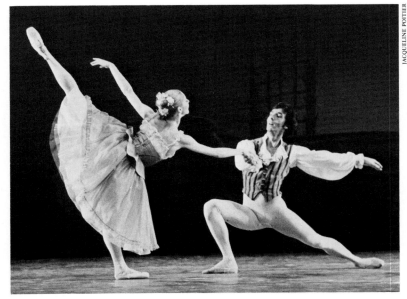

Lynda Meyer and Vane Vest in *Airs de Ballet* (c. 1977).

"I believe in the classic elegance of dancing, even in narrative ballet. I like a foundation of elegance even in the dancing of a role like that of a beggar." (1972)

"I always say a teacher doesn't teach, he coaches. Dancers actually teach themselves. . . ." (1977)

"When I came here I had to program and create different ballets for parts of the program. We had to have classic ballets, dramatic ballets, pas de deux. At that time I was the only choreographer doing it. We couldn't afford anyone else. Being at the helm of a company changed my responsibilities. Even Balanchine in New York was doing things that had to be done. That's your job as resident choreographer." (1977)

". . . a girl in a toe shoe . . . I still marvel today how they do it. That's a real technique; there's something hard on your toe, you can't feel the floor, but your balance is there and it's accurate. I just don't understand it." (1979)

"I never was conscious of making history. Dancing was just something you had to do, and you'd do everything you could to make it happen." (1979)

"Up until then [the 1937 Stravinsky Festival] I never really knew how to dance. I knew all the steps, but I didn't know how to put them together into a long movement with a feeling for the idea. That kind of training taught you how to dance: what happens between steps, how things work, how the mood works, how you interpret." (1979)

". . . my great love was not particularly ballet. It was theater, the use of theater and how to make it work. I used to build little stages when I was a kid, build them by the hundreds. And light them and go over to the theater to see how everything was proportioned, how to rig it, how to put in wings. That was my interest." (1979)

"My big flop was *Pocahontas* (1936). The material and music were way over my head. It took me weeks to get over it. Every time I'd walk out on the street, I was convinced everybody was looking at me, thinking 'There's the guy who did that stinker, *Pocahontas*.' In reality, nobody on the street had any idea of who I was. . . . Failure always hurts. I may not suffer now as I did when I made *Pocahontas*, but your choreography is a part of you, like your bones and your blood, and a failure is just like tearing out part of your body." (1982)

"I had mixed feelings [about leaving NYCB for SFB]. I was walking away from the center of dance, but at the same time I wanted to be more creative. I wanted to solidify all I had learned." (1982)

"I don't think my ballets look anything like Balanchine. I don't think about him when I choreograph, and it bothers the hell out of me when people say that. I guess it's because they don't see a story, so they figure that all abstract ballets are alike. Actually, I couldn't imitate Balanchine if I wanted to, because he's a genius. Of course, if I was going to imitate someone, can you think of a better model?" (1982)

"I don't know what happiness is. Is it a lack of sadness? Is it keeping occupied? Is it working and worrying? You explain to me what happiness is, and maybe I could tell you if I am happy or not. All I know is that work is important, and I've worked hard. And it was all fun." (1982)

Attila Ficzere in the title role of *Don Juan* (1982).

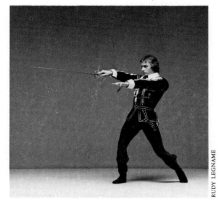

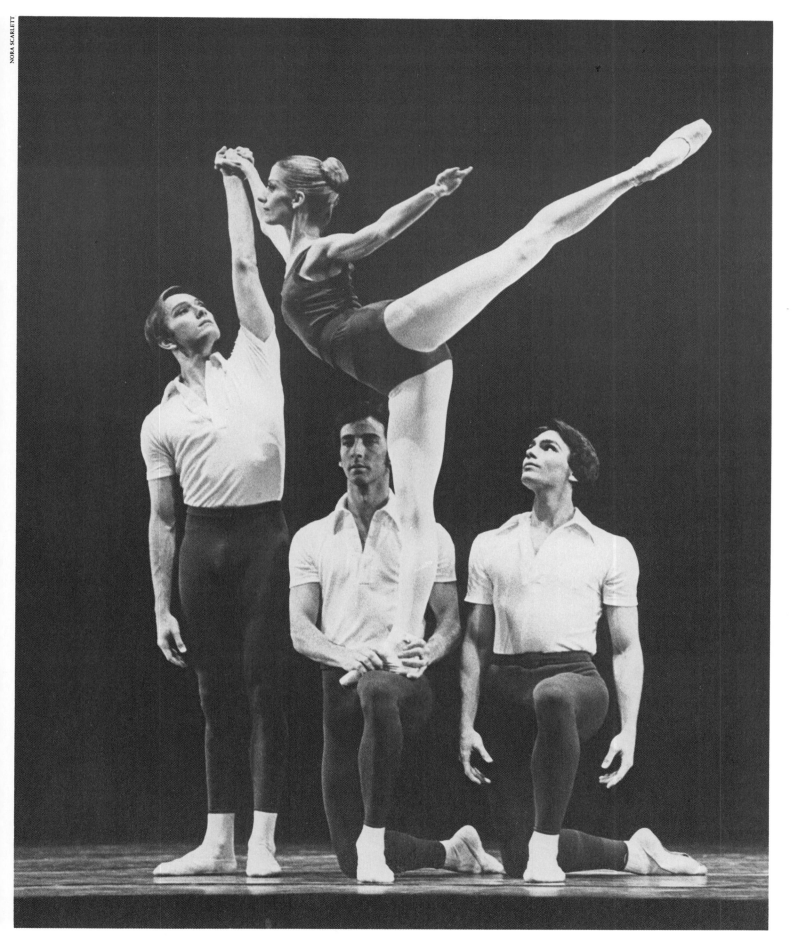

Don Schwennesen, Betsy Erickson, Vane Vest, and Jim Sohm in *Sinfonia* (1977).

Jacob's Pillow, 1956 Season

On July *21*, 1956, San Francisco Ballet arrived in Lee, Massachusetts. Three nights later, when Ted Shawn stepped to the front of the stage of the Ted Shawn Theater, he had, as *Newsweek* was later to report, "the air of a man on the verge of a momentous event." In the last three summers, Shawn told the audience, the Jacob's Pillow Dance Festival—then, as now, America's major summer dance attraction—had brought off the important U.S. debuts of the National Ballet of Canada, the Celtic Ballet of Scotland, and Ten Dancers from the Royal Danish Ballet. All three companies had enjoyed such success in the Berkshires that they were offered major American tours. (Shawn himself was later knighted by King Frederick IX of Denmark for introducing the Danish troupe and its Bournonville canon to America.) Now, Shawn continued, Jacob's Pillow had another "first" which, he said, compared with its predecessors in geographical variety and artistic impact. "History is being made here tonight," Shawn proudly said, "for the first time, an East Coast audience is to witness a performance by the San Francisco Ballet."

Although SFB had toured as early as 1936, dancing throughout the West and Midwest by 1940, the twenty-three year old company in 1956 had not performed in the East. Hailed during the Thirties and Forties as one of America's foremost dance companies, SFB remained unseen, and untested, by the all-important New York press. Without such national exposure, San Francisco Ballet, however much admired and respected in the West, would remain in the minor leagues, a "regional" troupe. The 1956 Jacob's Pillow season was the Company's bid for national stature.

The bid was won. On opening night before a capacity crowd in the 500-seat theater (reputedly the first theater in the Western hemisphere with a stage constructed expressly for dance), San Francisco Ballet conquered critics and audience alike. In *Concerto Barocco*, the evening's bold opener, soloists Christine Bering, Richard Carter, and Virginia Johnson were recalled five times to accept the crowd's unflagging enthusiasm. And when the curtain went down on Lew Christensen's *The Dryad*, the crowd demanded that Christensen himself be brought on stage

to share the ovation. "Ted Shawn guessed well when he brought the San Francisco Ballet from its California headquarters for its East Coast debut," wrote Walter Terry in *The New York Herald-Tribune*, for "the San Francisco Ballet is not to be looked upon as a little cousin from the West, but as a grownup, though youthful, company." *Newsweek* added that Shawn "had once again picked the right group at the right time. The SFB dancers had the fresh beauty of youth, a disciplined unity of style, and a remarkable technique which was apparent even in the *corps de ballet* as well as in the leading stars. The Company which had once been a source of regional pride has now matured into a national asset."

For its first major season in the East, San Francisco Ballet offered a three-program package of eight ballets, two by Balanchine (*Apollo*, *Concerto Barocco*), and the remaining six by Christensen. Since the Balanchine ballets as well as two of Christensen's (*Con Amore* and *Jinx*) were already in the repertoire of New York City Ballet, interest naturally centered upon the new works. Christensen's *The Dryad*—designed in the style of nineteenth century ballet and telling a typically romantic story of male mortals caught in a web of supernatural enchantment spun by white-clad maidens in a moonlit grove—was praised for its "gleaming *pas de deux*" and "stunning *dénouement*." And *A Masque of Beauty and the Shepherd*, premiered the previous summer and a staple of the repertoire for the rest of the decade, was called "enchanting throughout," a "first-rate" vehicle for leading dancers Nancy Johnson and Conrad Ludlow, "for the choreo-graphy disclosed Miss Johnson's loveliness of line, the real spirit of the ballerina and exquisite phrasing of action while it exploited Mr. Ludlow's spring, speed, and technical skill."

The three-week season brought the Company's youthful panache into sharp focus: the average age of the dancers was nineteen, "indecently young" according to one reviewer. San Francisco Ballet, wrote Selma Jeanne Cohen in *The New York Times*, "has the freshness and charm of youth plus many of the virtues generally associated with greater maturity." The Company's youthful exuberance, added Walter Terry, was fused "with true balletic elegance, and as a unit, the Company performs with greater exactitude than any other ballet organization of comparable size . . . indeed, they are more meticulous technically than some of our major companies have been on occasion."

Shawn, graced with a receptivity to dance in all its forms, was moved to bring SFB east by San Francisco critic Alfred Frankenstein's history of the Company which appeared in the April 1955 issue of *Dance Magazine*. After the Company's East Coast debut, Shawn wrote to Frankenstein that San Francisco's location, "far from the distracting and degenerative influences of both New York and Hollywood," had enabled the Company to develop a unique style. To Shawn, San Francisco seemed the one American city which not only had "a great tradition of culture," but whose culture was also "a living and vital force today." Because of its geographical isolation, San Francisco Ballet had "a pure style, an *esprit de corps*, a homogeneity that does not exist in any other ballet company resident in the United States. It is nearer to the quality of the Royal Danish Ballet, and because of the same reasons." (Twenty-five years later, during the Company's 1980 Brooklyn season, *The New Yorker* critic Arlene Croce also maintained that "privileged isolation may actually be the largest benefit that the Christensens' decision to stay out West has conferred" on SFB.)

Because of Shawn's love for "distant, romantic countries like San Francisco," because of his willingness to take chances, San Francisco Ballet won unprecedented attention in 1956. The Jacob's Pillow season—reviewed in international periodicals like London's *Dancing Times*, which found SFB "expertly drilled and beautifully disciplined"—exposed the Company to a new and important audience. San Francisco Ballet came into its own at Jacob's Pillow. Following the season, the State Department announced its sponsorship of an eleven-country Asian tour for SFB—the first time an American ballet company would play the Far East. That 1957 tour would in turn be followed by extensive performances in South America (1958) and the Middle East (1959). In short, the Company's bid for national stature at Jacob's Pillow brought it something more: international acclaim.

JOHN VAN LUND

Above. Constance Coler in Lew Christensen's *A Masque of Beauty and the Shepherd* (1956).
Opposite. (from left to right) Virginia Johnson, Constance Coler, Gloria Cancilla, Louise Lawler, Christine Bering, Julien Herrin, Sally Bailey, Richard Carter, Conrad Ludlow, Nancy Johnson, Glen Chadwick, Suki Schorer, Bene Arnold, Tilly Abbe, Roderick Drew, Paula Tracy, Sue Loyd, and Fiona Fuerstner at Jacob's Pillow (1956).

International Touring, 1957-1959

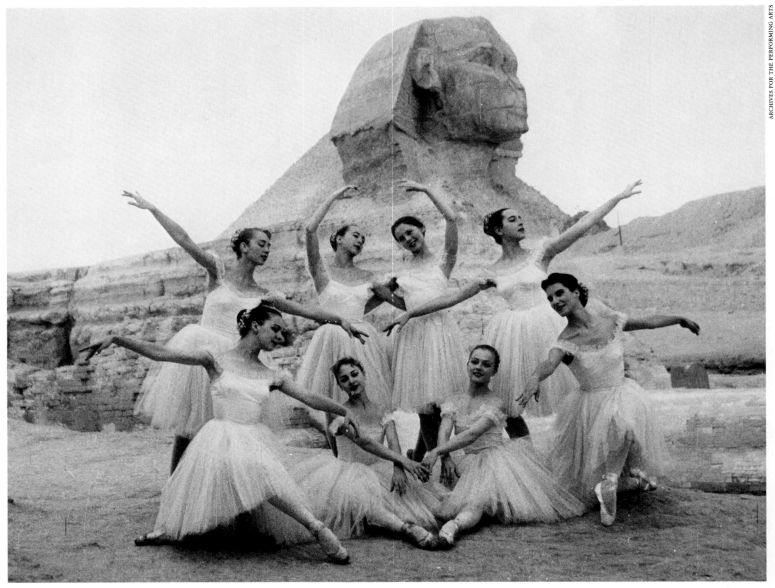

ARCHIVES FOR THE PERFORMING ARTS

(Back row) Constance Coler, Sue Loyd, Louise Lawler, Bené Arnold, (front row) Gerrie Bucher, Suki Schorer, Tilly Abbe, and Fiona Fuerstner during SFB's 1959 tour of Egypt.

On January 7, 1957, the *22* dancers of the San Francisco Ballet embarked on a major tour of the Far East. The eleven-nation tour, sponsored by the United States Department of State, marked not only the Company's international debut: it was also the first time *any* American ballet performed in the Orient. Ten ballets were presented during the two-month tour, including works by Lew Christensen and George Balanchine, as well as selections from the international repertoire such as the *Black Swan* and *Don Quixote Pas de Deux*. The dynamic Leon Danielian, principal dancer with Ballet Russe de Monte Carlo, was featured as guest artist, while SFB-trained Jocelyn Vollmar, recently returning from two years as *prima ballerina* of the Borovansky Ballet in Australia, was the leading *danseuse*. Other principal performers included Nancy Johnson, Sally Bailey, Richard Carter, and Conrad Ludlow.

Audiences were enthusiastic, occasionally even riotous. In Manila, the 3,300-seat theater (a huge quonset hut, originally an army hangar) was oversold by 4,000 tickets. "People jostled, pushed, and elbowed one another, climbed chairs and windows, hurdled enclosures, clambered up the off-limits area for the fire escape at the rear of the auditorium, and even tore the mattings from windows to see the ballet through binoculars," one journalist reported. In Burma, a troupe of Russian circus performers cancelled their performances to be able to attend performances by the Ballet. And in Cambodia, the Company drove through the jungle for two-and-a-half hours to present a show attended by the entire village of Kampong Cham. (SFB ballerina Sally Bailey remembers that chained convicts helped the Company stage managers to erect the outdoor stage for the performance.)

SFB was the third American ballet company to travel abroad under the aegis of the State Department, following the New York City Ballet and American Ballet Theatre. The International Exchange Program, directed by the American National Theatre and Academy (ANTA) in conjunction with the State Department, had its origins in 1954 when President Eisenhower, aware that the Soviet Union was sending its artists on foreign tours as a form of "cultural weaponry," asked that a similar program be created for American cultural presentations abroad. From 1955 to 1961, Congress appropriated a total of $16.2 million for the Cultural Exchange Program, which supported international tours by a variety of American performing arts organizations. "Those were the days of the Ugly American," recalls Sally Bailey, "and we were to show that Americans had something to offer besides dollars and political influence." Dance, a non-verbal art

Eugenia Van Horn and Paula Tracy during SFB's 1959 tour of the Middle East.

free from the problems of translation, was an especially popular choice of the Exchange Program. In addition to the three major American ballet companies (ABT, SFB, NYCB), the State Department also sponsored tours by the leading modern dance troupes, including the Martha Graham Dance Company, Alvin Ailey American Dance Theatre, and the José Limon Company. The international tours were, not surprisingly, political as well as artistic events. During its Far East tour, for example, SFB per-

formed for the King of Thailand, Madame Chiang Kai-shek, the King of Cambodia, the Governor-General of Hong Kong, the Prime Minister of Burma, and President Magasaysay of the Philippines.

The Company's Far East tour was so successful that it was followed by a four-month tour of Latin America in 1958, and a three-month tour of the Middle East in 1959. In Mexico City, the Company played before a sold-out house of 9,000 at the National Auditorium. In Buenos Aires, the dancers had eighteen curtain calls. And in Ethiopia, Emperor Haile Selassie awarded each dancer a gold medal. The tours, though often requiring gruelling schedules, provided the Company with invaluable experience. Michael Smuin, who joined SFB shortly before the Latin American tour, later told *Dance Magazine* that "it was mostly a series of one-nighters. We'd load the equipment into the plane, fly into town, unload the equipment into a truck, go to the theater, and we boys would unload the truck, put down the floor, put up the booms, focus the lights, hang the curtains, take out the props, get the costumes out and hang them. After the performance, the scenery and lights would go back in the crates (we even made the crates), and we'd load the truck, and then, we'd go out and have dinner and whoop it up all night, sometimes. First thing in the morning, back to the truck, off to the airplane, and the whole thing would start over again. Unions, as they are today, would never allow dancers this treasure house of experience. Because of those international tours, today, when the Company gets ready to do a lighting rehearsal, I can, for example, be of some intelligent help to a lighting designer."

In addition to conferring international status on the Company, the three State Department tours gave dancers an unprecedented chance to develop through frequent performing. Prior to the international tours, SFB had rarely enjoyed extended seasons at home or on the road. But when the Company returned to San Francisco in 1959, Lew Christensen, determined to keep the Ballet active, began to extend the Company's engagements. By the 1962/63 season, for example, SFB dancers were enjoying forty weeks of employment. "This is extraordinary in the American dance world," said *The New York Times* in 1963. James Ludwig, then President of the San Francisco Ballet Guild, told *The Times* that the United States Government deserved much of the credit for SFB's status. "It was the three Government-sponsored tours that made it possible to keep the dancers together long enough to build an effective company."

Thus, many of the Company's achievements during the early Sixties—the extended resident seasons, the choreography workshop founded by Michael Smuin, and the spate of successful Christensen ballets such as *Original Sin* and *Jest of Cards*—were the flowerings of the three international tours.

22

Music in Repertory

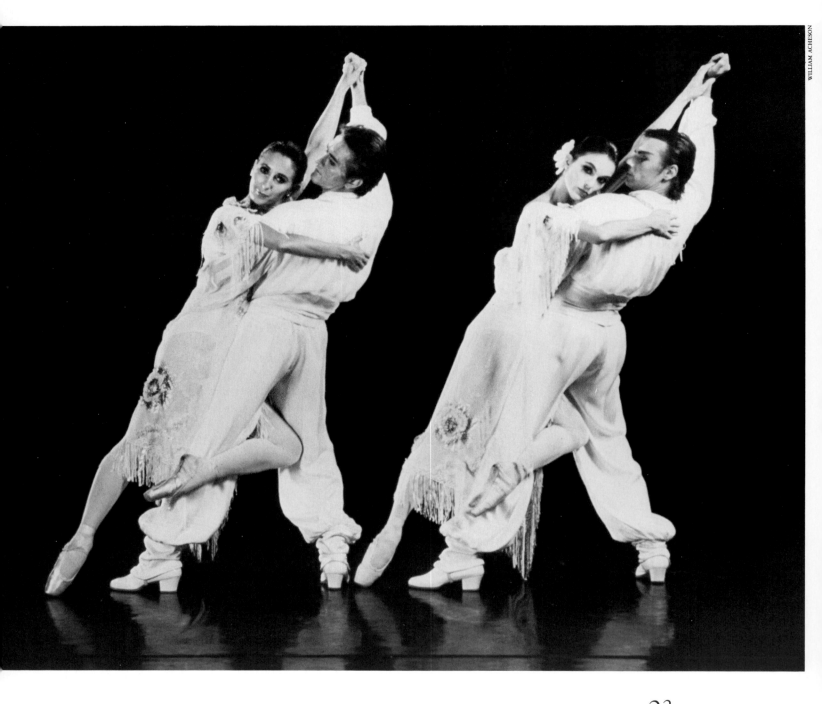

Michael Smuin on his *Stravinsky Piano Pieces:* "I never would have done *Piano Pieces* before *Sophisticated Ladies.* It's a refinement, a pure dance revue. Duke Ellington was a pianist, and oddly enough there are similarities between his music and Stravinsky's. My other piano ballets are much more legato; *Piano Pieces* is a fractured, percussive portrait of Stravinsky. The music covers so many periods in his life. You hear jazz, Liszt, Chopin, Rachmaninoff." *Above.* Paula Tracy, John McFall, Anita Paciotti, and Attila Ficzere in Michael Smuin's *Stravinsky Piano Pieces* (1982).

San Francisco Ballet presented 23 ballets to scores by Igor Stravinsky during its first fifty years: no other composer is so frequently, and handsomely, represented in the Company's repertoire. The extensive SFB Stravinsky collection contains works by more than a dozen choreographers, including Jerome Robbins, Maurice Béjart, George Balanchine, Willam Christensen, Robert Gladstein, Michael Smuin, and Lew Christensen, who has given SFB four strikingly diverse Stravinsky ballets— everything from a classic miniature like *Stravinsky Pas de Deux* (set to the exquisite *Four Norwegian Moods*), to the sumptuously mounted *The Ice Maiden* (to Stravinsky's elegant homage to Tchaikovsky, *Le Baiser de la Fée*), to the

burlesque opera-pantomime *Renard* (after Balanchine), and the inventive dance-within-a-dance version of *Danses Concertantes*.

Despite his overwhelming presence in the Company's repertoire, Stravinsky is a relative "newcomer" to SFB: not until 1955 with its performance of Balanchine's *Apollo* did SFB present a complete Stravinsky work. (As early as 1936, however, the repertory included a solo from *Firebird*, staged by Adolph Bolm after Fokine.) Stravinsky scores were especially popular with the young choreographers who created works for the Company's annual summer workshop series (1960-1973). And since 1976 the Company has presented three Stravinsky celebrations that contributed greatly to SFB's Stravinsky collection. On April 10, 1976, in celebration of his twenty-five years as SFB's director, Lew Christensen presented the premiere of his *Stravinsky Pas de Deux* on an all-Stravinsky program that also featured his *Danses Concertantes*, Michael Smuin's *Pulcinella Variations*, and the Company premiere of Balanchine's *Agon*. Then, to kick off its 1977 repertory season, SFB presented five performances of another all-Stravinsky program, which added *The Ice Maiden* and Béjart's *Firebird* to *Agon* and *Stravinsky Pas de Deux*.

San Francisco Ballet's most impressive tribute to Stravinsky came during the composer's 1982 Centennial, when the Company performed eight Stravinsky ballets, including all of the season's five world premieres: Val Caniparoli's *Love-Lies-Bleeding*, Robert Gladstein's *Symphony in Three Movements*, John McFall's *Badinage*, Tomm Ruud's *Steps for Two*, and Michael Smuin's *Stravinsky Piano Pieces*, hailed by *The New York Times* as "a sparkling suite of fourteen pieces that merged 'showbiz' and contemporary ballet conventions more persuasively than could be imagined. Stravinsky himself was not averse to marrying popular and neoclassical forms. This Smuin ballet may be the prototype for a significant direction in the San Francisco Ballet's future."

San Francisco Ballet's second favorite composer is Tchaikovsky: three of the Company's full-length works— *Swan Lake*, *Nutcracker*, and *Beauty and the Beast*—are set to music of the great nineteenth century Russian, who perhaps more than any other composer is immediately associated with classical dance. Willam Christensen's very first ballet after assuming the Company's directorship in 1938, *Romeo and Juliet*, was set to Tchaikovsky, and the close ties between SFB and NYCB have brought the Company several of Balanchine's greatest Tchaikovsky works—*Serenade*, *Swan Lake*, *Allegro Brillante*, and *Tchaikovsky Pas de Deux*. In 1958 Tchaikovsky's music provided the inspiration for a special Christmas Ballet Festival which featured *Serenade*, *Nutcracker*, and *Beauty and the Beast*. The Tchaikovsky-Christensen combination in *Nutcracker* and *Beauty and the Beast* proved so popular that for the next seven years those two ballets were the

Company's annual offerings at the Christmas season.

In addition to setting works to extant scores by such great composers as Stravinsky and Tchaikovsky, SFB began to commission music on a regular basis in 1975. That year Paul Seiko Chihara composed the music for Smuin's stunningly stark tale of love and death, *Shinjū*, and the score—an ingenious blend of ancient Japanese court music and modern Western instrumentation—won a Pulitzer Prize nomination. (Chihara received a second Pulitzer nomination in 1976 for a work he created for the Chicago Symphony.) For the 1979 repertory season, in what was an unprecedented feat for an American company, SFB premiered five new ballets to five commissioned or specially arranged scores: Charles Fox composed the music for Smuin's *A Song for Dead Warriors*; Paul Chihara for Gladstein's *The Mistletoe Bride*; Joaquin Nin-Culmell for John McFall's *Le Rêve de Cyrano*; Ron Daum for Tomm Ruud's *Richmond Diary*; and Benjamin Lees adapted seven piano sonatas of Domenico Scarlatti for Lew Christensen's wickedly funny *commedia dell'arte* ballet, *Scarlatti Portfolio*. The pairing of original choreography with original music in the five world premieres of the 1979 season fulfilled a long-held dream for SFB: to create a distinctive and original repertoire of its own, unique in the world of classical dance. "Most of the world's ballet companies are all chipping at the same musical scores," Michael Smuin explained at the onset of the 1979 season. "We want to build a unique repertoire of our own. The San Francisco Ballet will not look, or sound, like any other company."

In 1980 SFB's commitment to new music produced the Company's first commissioned score for a full-length ballet: *The Tempest*, choreographed by Smuin and composed by Paul Chihara after Henry Purcell. *The Tempest*, Chihara's third score for SFB, was his second for Smuin, and the two worked in close collaboration. As Smuin constructed *The Tempest* on the nineteenth century classical Petipa model, with an inventive series of "American" *divertissements* in the second act, so, too, did Chihara work from a classical foundation, fashioning the score after themes from Purcell, but adapting them to numerous American variations—a twentieth century view of a seventeenth century art form.

The ties between SFB and Chihara were formalized shortly after the premiere of *The Tempest*, when Chihara was named Composer-in-Residence. Today, Chihara collaborates with SFB choreographers on new works and also on new arrangements and orchestrations of works in repertory, including, for example, complete orchestral arrangements in 1980 of Smuin's *Mozart's C Minor Mass* and *Harp Concerto*. Chihara's new position with the Company is thought to be the first such ongoing relationship between an American ballet company and an American composer.

23

Above and opposite right. Sally Bailey and Richard Carter in Lew Christensen's *Danses Concertantes* (1959).

■ "I like accents and overlapping movements. But I don't think I would have been able to work with a Stravinsky score, especially *L'Histoire du Soldat*, if I hadn't studied music. With his music you can't rely on a square ¾ or ⁴⁄₄ meter or a melody." —*Val Caniparoli, 1982*

■ "Where would the ballet world be without Igor Stravinsky? The Stravinsky works commissioned by Serge Diaghilev for his Ballets Russes are classics of the modern repertory. Stravinsky's collaboration with George Balanchine is one of the art world's legendary partnerships. Delibes, Tchaikovsky, Chihara are the only composers whose contributions to ballet's musical repertory approach that of Igor Stravinsky. When you start talking about Stravinsky and his contributions to the art of ballet and his significance to us as dancers and choreographers, it's hard to know where to stop. For a choreographer, the music of Stravinsky is like the role of Giselle to a dancer—the chance of a lifetime. Some of us can't wait to jump in." —*Michael Smuin, 1982*

■ "Working with Stravinsky's music is not simply a question of emotions from melody, as with a composer like Tchaikovsky; it requires deep digging, to search out the mechanics of the score. His music is a constantly changing mathematical situation." —*Robert Gladstein, 1982*

■ "I've always found Stravinsky's music provocative and fantastic to listen to—a carnival ride. Working with his music gets you closer to the powerful, unpredictable sources of rhythm, which is the music's motion. A little like hallucinating while you ride a roller coaster. The landscape around you is always changing." —*John McFall, 1982*

"As an organizer of rhythms, Stravinsky, I have always thought, has been more subtle and various than any single creator in history. What holds me always is the vitality in the substance of each measure. Each measure has its complete, almost personal life; it is a living unit. There are no blind spots. A pause, an empty space, is never empty space between indicated sounds. It is not just nothing. It acts as a carrying agent from the last sound to the next one. Life goes on within each silence." —*George Balanchine*, Balanchine's Complete Stories of the Great Ballets, (*George Balanchine and Francis Mason, Doubleday and Company, Inc., Garden City, New York, 1977, p. 14.*)

Above. SFB Composer-in-Residence Paul Seiko Chihara and Michael Smuin (1982).
Opposite left. David McNaughton in Lew Christensen's *Stravinsky Pas de Deux* (1982).

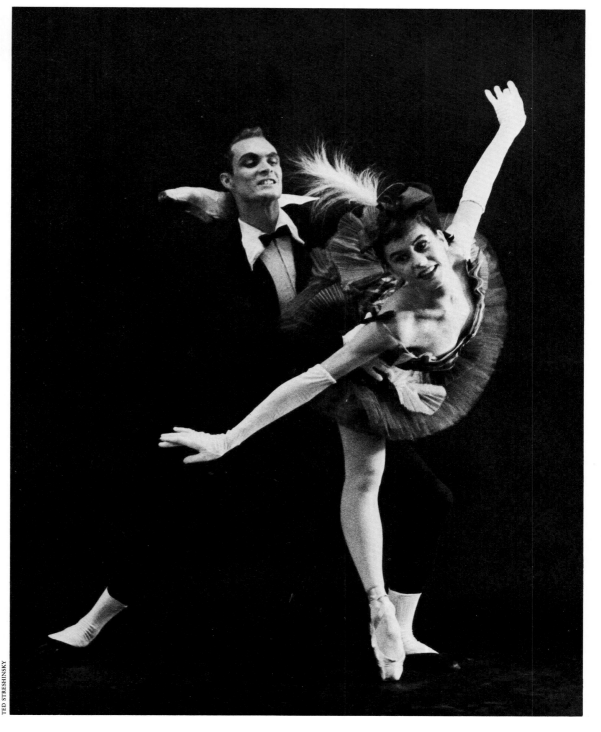

91

Jocelyn Vollmar

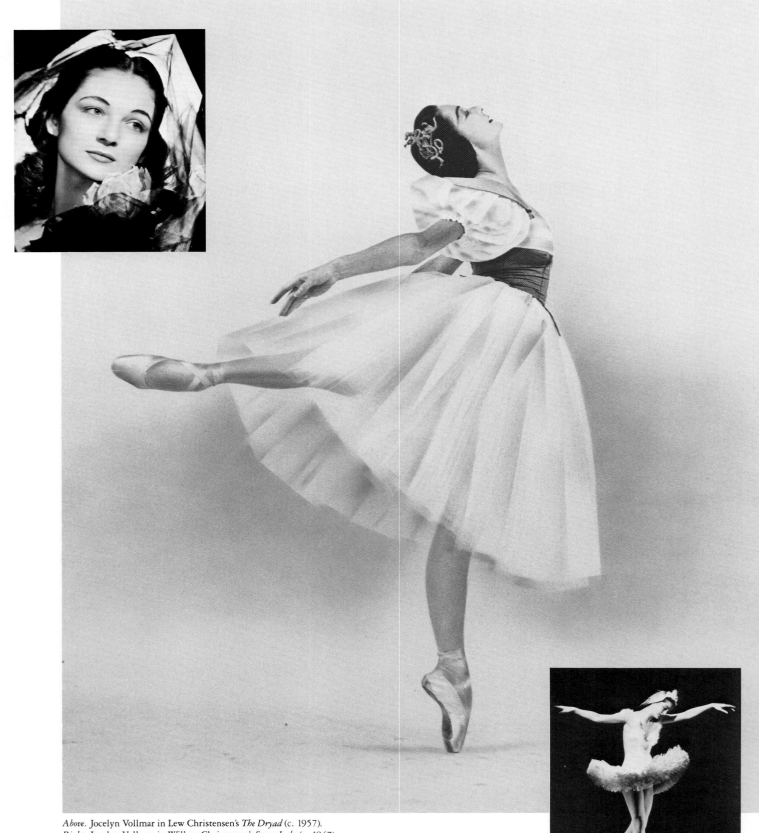

LEFT: ROMAINE ARCHIVES FOR THE PERFORMING ARTS

Above. Jocelyn Vollmar in Lew Christensen's *The Dryad* (c. 1957).
Right. Jocelyn Vollmar in Willam Christensen's *Swan Lake* (c. 1947).

ROMAINE

Jocelyn Vollmar made her debut as one of the *24* members of the *corps de ballet* in SFB's 1939 premiere production of *Coppélia*—the Company's first full-length ballet. Thirty-three years later, when she gave her farewell performance, dancing the Sugar Plum Fairy at the close of the Company's 1972 *Nutcracker* season, Vollmar had become, many said, SFB's best-known and most-loved dancer: the Company's reigning *prima ballerina*. "The name of Jocelyn Vollmar is practically synonymous with San Francisco Ballet," the Company announced at her farewell performance. As Vollmar took her bows to thunderous applause, all three Christensen brothers came onstage to present bouquets. "It was a touching moment," reported the *San Francisco Examiner*. "The Company would, quite plainly, not have been the same without her."

Vollmar's thirty-three-year career was indeed unique in SFB's history: no other dancer enjoyed such a long tenure with the Company or conquered such a large and varied repertoire. Equally at home in drama and comedy, Vollmar excelled in everything from the *Black Swan Pas de Deux* to *Filling Station*. "I've never wanted to be typed," she told a reporter in 1972. "I'm happiest when my roles are varied."

Vollmar was one of the few dancers to dance roles in all three of Willam Christensen's major full-length ballets—*Coppélia*, *Swan Lake*, and *Nutcracker*. Her clean line, sharp attack, and sure sense of characterization astonished viewers in 1947 when she danced the role of Myrtha, Queen of the Wilis, in SFB's only complete production of *Giselle*. (After performing with Vollmar in SFB's *Giselle*, the renowned British dancer Anton Dolin predicted Vollmar would become one of America's three greatest ballerinas.) She accompanied SFB on all three of its international tours, winning a reputation as a consummate technician and dynamic performer. She danced principal roles in the Company premieres of works by such diverse choreographers as George Balanchine (*Symphony in C*), Adolph Bolm (*Mephisto*), John Taras (*Persephone*), and Robert Gladstein (*N.R.A.*). And throughout the Fifties and Sixties, Vollmar was a major inspiration for Lew Christensen, who created nearly twenty ballets for her, including *Lady of Shalott*, *Sinfonia*, *Divertissement d'Auber*, *Caprice*, *Danses Concertantes*, *Danza Brillante*, *Esmeralda Pas de Deux*, *Variations de Ballet*, *Shadows*, *Prokofiev Waltzes*, *Bach Concert*, *Fantasma*, *Life*, *Pas de Six*, and *Il Distratto*. ("Anyone in ballet today couldn't be luckier than to work with Lew Christensen," Vollmar told the *Examiner* in 1965.) No other ballerina in SFB's history was, in fact, so clearly the product of all three Christensen brothers. For nearly three decades, Vollmar was the exemplary Christensen ballerina— technically strong, dramatically powerful, with an authoritative flair for comedy and lyricism alike.

Born in San Francisco in 1925, Vollmar received her first training from her mother, Wilma Wilkie, a former dancer and silent screen actress. Vollmar's formal schooling in ballet began when she was twelve, under Willam and Harold Christensen at the San Francisco Ballet School. Two years later, in 1939, she began performing with the Company as an apprentice, appearing in *Coppélia*, *Swan Lake*, *Winter Carnival*, and *Amor Espagnol*. Vollmar officially joined SFB in 1943 upon graduating from high school, and the following year danced the role of the Snow Queen in the Company's historic first complete production of *Nutcracker*. By 1947 she had become a major attraction for SFB, capturing more and more of the public's attention. "Vollmar's clean and polished technique, beauty and classic line, and fine sense of the dramatic and pictorial, made her San Francisco's discovery of the year," said the *San Francisco Chronicle* in the summer of 1947 when the display of Vollmar's "extraordinary talents" in Willam Christensen's *Sonata Pathétique* thrilled audiences. "More than ever, it is apparent that Miss Vollmar is on her way to becoming a ballerina of the first rank," added the *Examiner* during the Company's 1948 winter season. "She does more than dance nimbly and well. Her dancing distills a mood, an atmosphere. It is entrancing and it is sympathetic; it is fragile and yet firm. [The] audience was captivated by her."

Vollmar left SFB in 1948 to become a principal dancer with New York City Ballet and later a leading soloist with Ballet Theatre. In 1950 she joined the Grand Ballet de Marquis de Cuevas, touring Europe, North Africa, and South America. She was the *prima ballerina* of the Borovansky Ballet of Australia from 1954 through 1956, winning great acclaim for her performances in *Giselle*, *Swan Lake*, *Schéhérazade*, and *Petrouchka*. She returned to SFB in 1956 to dance with the Company on its State Department tours, which were, she later said, "absolutely among the highlights of my career." She choreographed eleven ballets for SFB's summer workshop series (1960-1973), as well as one work for the main Company in 1972—*Figures in F*, to music by Gian Carlo Menotti.

Since her retirement in 1972, Vollmar has won a reputation as an accomplished instructor and coach, teaching first at San Francisco Ballet School and currently with Marin Civic Ballet.

"Vollmar had a majesty that was, I think, unique among SFB ballerinas," recalls former SFB dancer Russell Hartley. "She was radiantly regal—a first-class act from start to finish, set apart by an exquisite lyricism. As a performer she was utterly dependable and professional: you could always count on her. She stayed with the Company through good times and bad times, through storm, wind, and fire. For some thirty years, she was, quite simply, the Company's Rock of Gibralter."

Sally Bailey and Nancy Johnson

Nancy Johnson in a publicity photograph (c. 1955).

To celebrate the Company's *25*th Anniversary in 1958, Lew Christensen created *Beauty and the Beast*, his second full-length ballet for SFB. At its premiere, *Beauty and the Beast* featured two of SFB's most accomplished company-trained ballerinas: Nancy Johnson, who played Beauty, and Sally Bailey, who led the Roses' Waltz in the second act *divertissements*. Throughout the Fifties, when they were among the Company's most popular—and indispensable—dancers, Johnson and Bailey frequently performed in the same ballets. They appeared together in the first Balanchine works to enter the SFB repertoire—*Serenade*, *Concerto Barocco*, and *Apollo*. And Lew Christensen created nearly a dozen ballets that featured the two ballerinas, including *Balletino*, *Con Amore*, *Nutcracker*, and *Danses Concertantes*. The ballerinas' crisp elegance, technical neatness, and signal success in Balanchine ballets marked a new SFB style: Johnson and Bailey, it was said, were the Company's first great generation of neoclassicists.

Sally Bailey, born in Oakland in 1932, started ballet classes with the San Francisco Ballet School at the age of nine, joining the Company in 1947 when she was still in her teens. During her debut year, Bailey appeared in *Coppélia*, worked with Adolph Bolm in *Mephisto*, and danced in the *corps de ballet* when SFB presented its acclaimed production of *Giselle* with guest artists Alicia Markova and Anton Dolin. Bailey's first major role, that of Odette in *Swan Lake*, came in 1952 when she was nineteen. "The charm, pathos, and skill of her performance," said Alexander Fried in the *San Francisco Examiner*, "indicate that she is now on the verge of high status as a mature, true ballerina."

By 1953, Bailey was clearly one of the Company's leading dancers, with a varied and demanding repertoire. On opening night of the 1953 spring season, Bailey danced in all three of the program's major ballets, which included nothing less than the world premiere of *Con Amore* and the Company premieres of two of Balanchine's seminal works—*Swan Lake* and *Concerto Barocco*. The week after her "triple bill" triumph, Bailey charmed audiences as the Sylph in the SFB premiere of Balanchine's comedy, *A la Françaix*. "Her grace and authority keep growing from month to month," marvelled the *Examiner*. And at the season's close, Bailey (with Johnson) flew to New York to appear as guest artist with the New York City Ballet, when *Con Amore* became the first new Christensen ballet to be staged by NYCB. "It would be a pleasure," wrote one New York critic, "to have [Johnson and Bailey] move their dancing shoes eastward and stay with us forever."

In 1955, Bailey took a three-month leave of absence to study privately with Vera Volkova at the Royal Theatre, Copenhagen, and to take classes with Olga Preobrajenska and Lubov Egorova in Paris. She returned to SFB and performed with the Company on its East Coast debut at Jacob's Pillow in 1956, and on the Company's three international tours from 1957 to 1959.

Opposite right. Sally Bailey in Willam Christensen's *Les Maîtresses de Lord Byron* (1951).
Below. Nancy Johnson in Lew Christensen's *Beauty and the Shepherd* (1954).

Sally Bailey in George Balanchine's *Swan Lake* (1953).

In 1961, Bailey created what many consider to be her signature role—Eve, in Lew Christensen's *Original Sin*. A charter member of the summer workshop founded by Michael Smuin in 1960, Bailey toured with "Ballet '63, '64, and '65," as both leading dancer and ballet mistress. In 1966, she danced the Roses' Waltz when ABC-TV filmed *Beauty and the Beast*. And in 1967 Bailey retired—as she promised she would—when she was thirty-five. She later told the *Chronicle* that she disagreed with the popular belief that once the "red shoes" were on, they couldn't be taken off. "They can come off," she wrote. "They can fall off. They can be cut off. One can bend down and take them off." Almost two decades to the day after she first joined SFB, Sally Bailey thus bent down, took off her toe shoes, and retired from the stage.

In 1971, Sally Bailey collaborated with her former teacher and fellow dancer Gisella Caccialanza (Mrs. Lew Christensen) on the publication of "Letters from the Maestro: Enrico Cecchetti to Gisella Caccialanza," a collection of letters from the legendary dancer, ballet master, and teacher to his pupil and god-daughter, published by *Dance Perspectives*.

Nancy Johnson studied at the San Francisco Ballet School where her teachers included Caccialanza and the Christensen brothers. Born in San Francisco, Johnson performed as a student in the Company's historic, first American full-length production of *Nutcracker* in 1944. In 1949, she danced the role of the Wirewalker in the SFB premiere of Lew Christensen's moody circus ballet, *Jinx*. Her first principal role was that of the Snow Queen, which came the following year, during the 1950 *Nutcracker* season. During the next decade, Johnson created leading roles in nearly a dozen of Lew Christensen's ballets, including *Con Amore*, *The Dryad*, *Beauty and the Shepherd*, *Tarot*, *Beauty and the Beast*, and *Emperor Norton*. Noted for her versatility, she passed easily from elegance to comedy to technical virtuosity. Her exquisite phrasing thrilled audiences in *Concerto Barocco* and *Apollo*. Her astute comic timing gave a droll wickedness to her portrayal of the Mistress with a roving eye in *Con Amore*. And her sensual plastique and astonishing line (Johnson was a great beauty) were perfect for the role of the world's fairest woman—Helen of Troy, in Christensen's *Beauty and the Shepherd*.

Johnson was also frequently featured with the San Francisco Opera. During the 1953 season, she danced in the American premiere of Beethoven's *The Creatures of Prometheus*, choreographed by Willam Christensen. Johnson danced the role of Woman, while Sally Bailey was featured as Aphrodite. In 1960, Johnson and her husband, SFB dancer Richard Carter, left the Company and founded the San Diego Ballet (1961). Today, Johnson is Executive Director of the Archives for the Performing Arts, after having served as Operations Director for the San Francisco Symphony.

It has often been said that a ballerina is not a woman but a concept: a poetic construct. The ballerina offers us images—stylized and abstract—of gender, sexuality, and of the human spirit. The ballerina is, as the French poet Stéphane Mallarmé once observed, "always a symbol, never a person"—a metaphor of elemental forms. Throughout the Fifties, SFB audiences were presented two different but intriguingly complementary images of the ballerina. Nancy Johnson, it was said, was the epitome of erotic allure. She was desirability, femininity, seductiveness: life in the body. Sally Bailey, on the other hand, sparkled with crystalline purity. She was refinement, transfiguration, and transcendence: life in the spirit. These two visions—of earthly appeal and heavenly purity—are among the strongest in classical dance, and were probably old long before 1838 when Théophile Gautier, in the most famous remark in the history of dance criticism, distinguished two kinds of ballerinas by labelling Marie Taglioni a "Christian" dancer, and Fanny Elssler a "pagan" one. It has been conjectured that Nancy Johnson and Sally Bailey were so frequently paired in SFB productions because their joint appearances offered audiences a stunning view of ballet's greatest dichotomy.

Christensen's Sixties Ballets

Above. Diana Nielsen as the Mountain Sheep in *Original Sin* (1961).　　*Opposite.* Costume design by John Furness. Paula Tracy as the Zebra in *Original Sin* (1961).

With an unprecedented *26* performances, the 1961 spring season at the Alcazar Theater was the Company's boldest venture to date: "the longest, costliest, and riskiest forward leap of its career," as the *San Francisco Chronicle* said, and a leap that landed SFB "closer than ever" to its long-held goal: to be a permanent repertory company with a stable home base.

For although SFB had travelled across the country and around the world, by 1961 it had yet to establish itself firmly in the Bay Area. (After returning from the Company's three highly acclaimed international tours, Lew Christensen liked to say the only places SFB had *not* been engulfed in wildly enthusiastic applause were Antarctica, Timbuktu, and San Francisco.) Christensen knew the importance of a home season in a home theater. A first-class dance company, he said, rested on three essentials: a permanent school ("continuous schooling is the soul of a company"), regular seasons ("all your schooling aims at performance, frequent performance"), and a home theater ("which, for a certain period, you can use as all your own"). Although the SFB School was in excellent shape, considered second only to Balanchine's School of American Ballet in New York, the Company itself was in urgent need of a permanent theater. The War Memorial Opera House, home to both the Opera and the Symphony, was simply unavailable for any extended season, and if SFB were to stop the flow—the flood—of dancers leaving the Company for New York, the Company would have to find a resident theater for regular seasons.

To remedy the situation, SFB moved to the Alcazar Theater (a medium-sized house in the city's theater district), where in the spring of 1960 a trial eight-weekend season was presented. Despite certain disadvantages—the orchestra pit was so treacherously small the musicians practically spilled into the audience's lap—the first season was successful enough to warrant a full-scale season the following year, when the Company booked its most extensive home season ever. In fact, the 26-performance 1961 season was unmatched by any other American company that year except New York City Ballet. Although the season offered much of interest (the Company premiere of Balanchine's *Symphony in C*, the SFB choreographic debut of Michael Smuin, repertory favorites like *Con Amore*, *Jinx*, and *Swan Lake*), almost all of the attention that season was captured by a single new work: Lew Christensen's *Original Sin*.

Set to an original jazz score by John Lewis, *Original Sin* was a modern version of the Adam and Eve story, but despite its title, primal innocence was the ballet's true theme—it radiated, as Alfred Frankenstein wrote in the *Chronicle*, "a kind of sweetness and inwardly illumined quality . . . an immensely inventive, immensely spirited work, both inspiring and entertaining at once." Christensen indeed filled *Original Sin* with a magician's

trunkload of theatrical tricks: in true Biblical style his Eve was born—onstage—from Adam's rib, and the expulsion from Paradise was marvelously—and appropriately—apocalyptic. Although Adam appeared in a simple skin-tight and flesh-colored leotard, the rest of the cast wore elaborate costumes by Hollywood designer John Furness: Eve was endowed with a knee-length and much-publicized $400 wig; the Serpent shimmered with reptilian iridescence; and Eden's other animals were, as one critic noted, magically "costumed to the last whisker." (The sets and costumes, said the *Chronicle*, "almost tell the story by themselves.")

A frenzied ovation greeted *Original Sin* on opening night. One critic called it "a huge, crashing success," another pronounced it "an unalloyed delight from start to finish," and a third was astonished by its "high-spirited explosion of brilliance." Even *Time* magazine reviewed the ballet, a rare event in those days: "As danced by San Francisco's exuberant, youthful bantam company, *Original Sin* is emotional as well as entertaining—highly successful." Lines of hopeful ticket buyers waited at the box office after the ballet's overnight success, and by the season's close, *Original Sin* had been given fourteen per-

DALE SMITH

formances instead of the originally scheduled five.

The ballet's libretto was by Kenneth Rexroth with, it was said, "liberal assistance from Jehovah." Rexroth, a leading San Francisco poet, knew the story was "potentially full of corn," but did it because "I'm kind of tired of Freud and Jung in ballet." As the curtain rose on *Original Sin*, a spinning sun swirling over a desolate landscape gave way to a lush Garden of Eden where two angels brought Adam (Roderick Drew, in a performance *Time* hailed as "magnificent") to life with their swords. Adam, according to Rexroth's libretto, "emerged, as if from clay, rose, stretched, yawned, and discovered one by one the use of his limbs." He then named Eden's various animals as they danced in pairs and trios—the walrus and the ape, the lamb and leopard, the zebra, lion, and camel. After this "ballet of the beasts," Adam, weary and alone, rested on the gnarled, raised roots of a tree. It was then that Eve (Sally Bailey) emerged from him. (Christensen confessed the birth of Eve was his biggest problem. "I sat at my desk for days, thinking—how do I do that? I even drew pictures, and all that. As it turned out, Eve has to crouch in the hollow of that tree from the beginning of the ballet until it's time for her to slip from Adam's rib.")

After Eve's birth, the pair danced a deeply affecting and highly charged love scene. According to *Time*, Adam

Roderick Drew as Adam, Sally Bailey as Eve, and Michael Smuin as Temptation in *Original Sin* (1961).

Michael Smuin (right) as the Joker in *Jest of Cards* (1962).

experimentally maneuvered Eve into exhaustively various positions—"rump to rump, shoulder to shoulder"—until at last she "twined her body around his left leg and sinuously slid up to a standing embrace." Enter Temptation in the guise of a serpent (one of Michael Smuin's most celebrated roles), and the rest, as they say, is history.

With its jazzy humor and contemporary sexiness, *Original Sin* was Christensen's vehement answer to those who urged him to choreograph romantic works in the tulle-skirt *ballet blanc* vein. "You can't indefinitely re-create ideas from an era that is long dead," he insisted. "You have to create for the future. *Original Sin* is essentially American—it's an American idea adapted to American music rather than an imported European idea."

In 1962, Christensen followed *Original Sin* with another decidedly contemporary work: *Jest of Cards*. If *Original Sin* moved to the beat of Sixties cool-cat jazz, *Jest of Cards*— set to a resolutely avant-garde score by Ernest Krenek— was more "Sixties experimental." The music thwacked, buzzed, thumped, whined, and required the pianist to beat out tone clusters on the keyboard with his forearms. (Krenek's score, appropriately titled *Marginal Sounds*, also called for three brake drums, and according to columnist Herb Caen, the Company had scoured the town's junkyards for these, looking for "just the right sound.") Like the humorous Stravinsky-Balanchine *Jeu de Cartes* which Christensen had danced at its 1937 premiere, *Jest of Cards* portrayed the lively and often bizarre fortunes of a pack of playing cards. But Christensen in 1962, unlike Balanchine in 1937, dealt his cards an "existential" hand: they were shuffled about by life, thrown into the "nothingness" of the stage wings, only to discover that death, the Joker, was the trump card. The low cards of each suit were masked and starkly depersonalized, while the forbidding kings, queens, and jacks—some as much as eighteen feet tall—were adorned in courtly, almost

Oriental splendor by designer Tony Duquette.

Jest of Cards was the centerpiece of the Company's 1962 spring season, and like *Original Sin* the year before, it met an enthusiastic reception. "A new leap forward in the Company's ever advancing creative maturity," said the *San Francisco Examiner* — "professional, expert, extraordinary, with nervy appeal to the imagination and to the sense of humor." "A remarkable feat of the imagination," echoed the *San Francisco Call-Bulletin*, "an authentic masterpiece, and as the Jester, Michael Smuin has outdone even himself this time in grace, speed, humor, and subtlety." And *Life Magazine*, in a two-page spread devoted to the ballet, called *Jest of Cards* "one of the two major ballet events of 1962."

Like many other choreographers during the Sixties, Christensen responded to the decade's go-go excitement, its heady contemporaneity and dizzying changes. "I would like today's ballets to express today's thoughts," he told *Dance Magazine* in its feature on *Jest of Cards*. "If we go on reproducing the past, we'll soon have a theater of antiques." In January 1965, Christensen created his most "right-now" ballet—*Life: A Do-It-Yourself Disaster*, credited with being the first pop art ballet. Sumptuously designed by Cal Anderson in an extravaganza of pop images, *Life* was danced before shifting panels of huge comic book characters (à la Roy Lichtenstein), colossal S&H Green Stamps (à la Andy Warhol), and towering ice cream cones (à la Wayne Thiebaud). The ballet's cast of characters included beauty queens, baton twirlers, beatniks, and a squadron of Hell's Angels. Herb Caen, San Francisco's most popular columnist, supplied the droll libretto, which reduced Shakespeare's seven ages of man to four: Incipiency ("children should be obscene but not absurd"), Virility ("fraught with sex and violence and all the other good things of life"), Maturity ("the age of anxiety has given way to the age of tranquilizers"), and Resignation ("happy is the man who can adjust to unreality, for he shall inherit the world of television").

Although the ballet's scenography was universally admired, some reviewers thought the various elements of *Life*—the pop libretto, the vanguard score by Charles Ives, and

Christensen's classical choreography—never coalesced. The ballet seemed to its critics to fall short of the "biting commentary" on the "frenzied emptiness" of modern life it purported to be. (When *Life* was presented at Lincoln Center that April during SFB's first New York season, *The New Yorker's* Winthrop Sargeant wrote, "I hate to say it, but this turned out to be West Coast avant-gardism—a special type of avant-gardism in which innocence is likely to play a large role.") Nevertheless, *Life* scored a hit with audiences and remained in the repertory for three years.

Although *Life*, *Jest of Cards*, and *Original Sin* are no longer in repertory, they remain an interesting chapter in Christensen's career. With their respective pop, avant-garde, and jazz sensibilities, they functioned, as did so much Sixties art, as up-to-the-minute "bulletins" from the frontiers of culture. These three ballets, though on the surface quite different from Christensen's best-known works, shared a goal that has attracted Christensen throughout his career: to allow classicism to speak a modern tongue. From his earliest choreographic efforts to his most recent, Christensen has tried to give the academic idiom a contemporary American accent, to infuse classicism with the values of popular entertainment—not in order to betray classicism, but to extend it. Like the rest of the Christensen oeuvre, *Original Sin*, *Jest of Cards*, and *Life* were created in the belief that the true tradition is a living tradition.

Nancy Robinson in *Life: A Do-It-Yourself Disaster* (1965).

BARON WOLMAN

Michael Smuin on Dance and Dancers

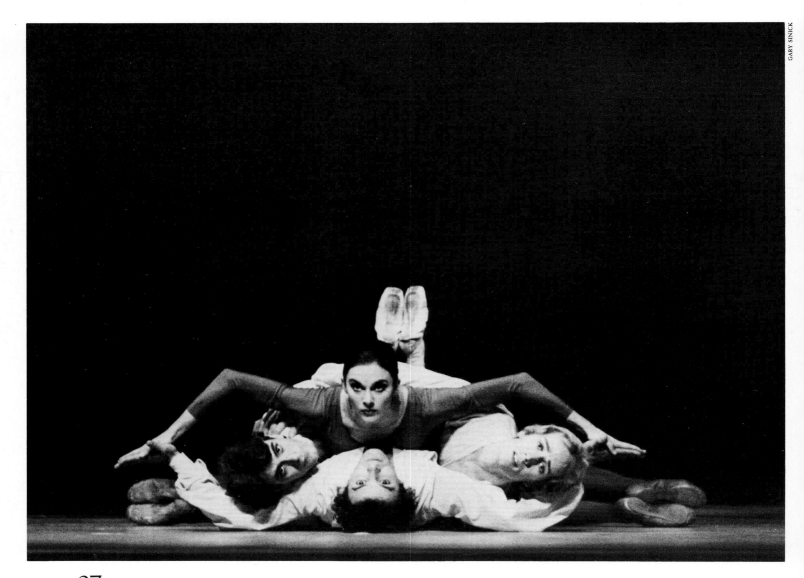

27 Selected Statements

"I will go where I know there are people who'll dance the kind of thing I want to do. A choreographer is not just steps, but taste and style. He needs a certain kind of people as much as a certain kind of music." *(1970)*

". . . the line between modern and ballet is very thin sometimes . . . movement is movement, dance is dance— we should incorporate the best of everything." *(1973)*

". . . there are no two other men I respect and admire more than Willam and Lew Christensen. Lew has put up with frustrations that would have driven anyone else mad. Now Lew and I are working hard to make this the company of the future. I believe that this could very well be *the* American ballet." *(1976)*

"What have I brought to the San Francisco Ballet? As my grandfather says, 'There has to be a ramrod.' I'm that ramrod." *(1977)*

"Casting has a great deal to do with what I do with a ballet. When I listen to the music, after a time the music takes on specific bodies and faces. When I am letting all that incubate, there are specific people that I have in mind. It comes when it's ready. You can't force it." *(1977)*

"The most democratic system of casting in ballets is done right here in this Company. A dancer will say, 'I'd like to do such and such.' I say, 'Fine, but we don't have the rehearsal time. If you want to take the videotape machine, go into Studio Four and learn the part, and show it to me, fine.' Several of our dancers have learned roles this way, on their own initiative, and we've scheduled them." *(1977)*

". . . most people don't start out in life thinking, 'One day I'm going to direct a ballet company.' But I *did*. From the time I was just a punk, I knew that one day I would have my own ballet company, so I spent my life preparing

myself for the time when it would happen. I *loved* performing, but from the very beginning I wanted to choreograph, to be in on the planning of seasons, commissioning composers, choosing designers." (*1978*)

"What I want most to achieve with my ballets is as simple as it is complex: to entertain, transport, enrapture and move people." (*1978*)

"The most important thing about San Francisco Ballet is our resident choreography. Because of this, every time we do a series there is always a new work on every program, which stimulates our box office tremendously. That there are six of us choreographing, that we're all collaborators, all friends—this is what's most significant about the Company." (*1978*)

"San Francisco Ballet is the first thing I think about when I wake up in the morning, and the last thing I think about when I go to bed at night." (*1978*)

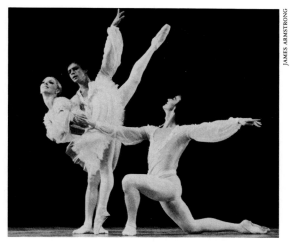

Above. Lynda Meyer, Alexander Filipov, and Dennis Marshall in *Q. a V.* (1978).
Opposite: Anita Paciotti (center, top) with Val Caniparoli (left), Zoltan Peter, and Mark Lanham in *Songs of Mahler* (1981).
Below. Allyson Deane, Diana Weber, and Lynda Meyer in *Mozart's C Minor Mass* (1978).

"I don't think I'd be equipped to run a ballet company today, if it weren't for those years in New York when I was blessed by working with the very best—the cream of the entertainment world. At ABT, for example, I worked with just about every major choreographer, top designers, composers, librettists, poets, guest stars . . . Lucia

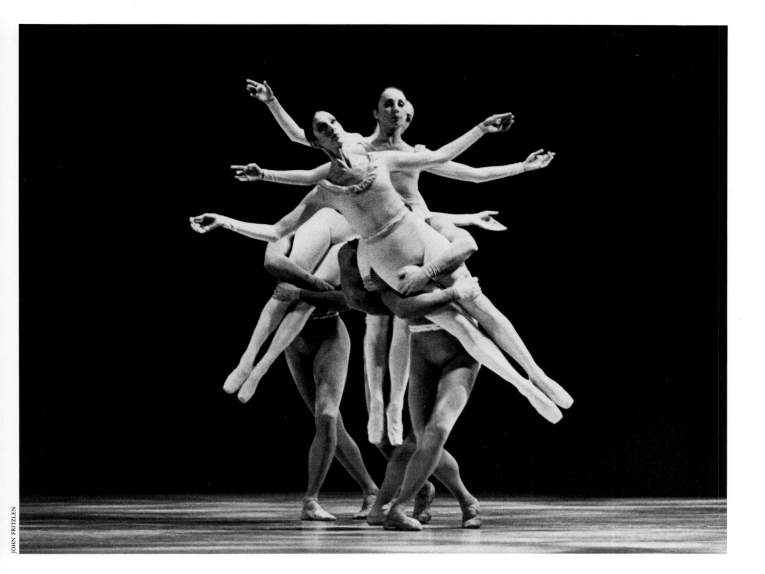

Chase and Oliver Smith were extremely generous with their time, and guidance, and love. The one thing that I missed was the fact that they could never get Martha Graham to do anything for the company, and I felt that was a horrible loss." *(1978)*

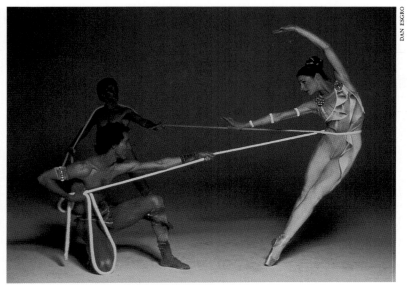

Laurie Cowden as Creusa with Jerome Weiss (front) and Gardner Carlson in *Medea* (1977).

"It was the Christensens who trained me and who influenced me hugely by giving me a tremendous respect for the art of ballet, and, most particularly, music. I think that was part of the encouragement and training that I had from Willam and Lew Christensen. They told me, 'You must be like a sponge. You have to soak up *everything*, because you never know what is going to inspire you to do a ballet, or to do anything else.'" *(1978)*

"Ballet is entertainment. You can't forget that. Dance has to move people. It should grab them in the first thirty seconds." *(1978)*

"Each of my ballets is very different from the others. When I get an idea, it takes its own directions; I just follow along." *(1980)*

"No ballet is precisely describable. Words, however carefully chosen, will conjure up slightly variable images for different people. They can recite plot and action, convey certain impressions of characterizations, reveal the structure of various dance incidents and suggest what has been revealed of human behavior, but, in the last analysis, *the seeing is all*." *(1980)*

"Lew Christensen raised all of us, practically. Lew was totally responsible for San Francisco Ballet for over twenty years. But this was never one man's ballet company. We are a city company; this city supports us. What we're doing in San Francisco is very meaningful. It's our turn. Paris, London, Leningrad, Milan, Copenhagen, New York; now San Francisco is a great

dance center. We want the whole thing. A school, a major theater, a first-rate orchestra, a full complement of dancers. This city doesn't have to settle for crumbs of talent or let its resources slip away." *(1982)*

"I think all the stuff I did before—the Broadway business, nightclub circuit, television work—all of it was geared to directing and choreographing. And that's what I always wanted to do. So it was never a wrenching, traumatic thing for me to quit dancing, as I've seen so many of my colleagues go through when they get to a certain age." *(1982)*

"I know how to make people enjoy themselves in the theater. They laugh, they cry, they squeal, they're surprised, they smile. Those things can be brought about in a kind of mechanical way. But if there's no poetry, then there's nothing to it all." *(1982)*

"That's what I enjoy most—going into the studio with the dancers every day, living with beauty, youth." *(1982)*

"The dancers that were 'great' ten years ago probably couldn't even get a job today because of the development of technique in ballet, in dance, in sports. There are all kinds of new moves that don't even have terminology. They've just evolved from choreographic sessions, from working on new ballets. The thing about dancers today is that they're generally taller, stronger, smarter, much more sophisticated. Their stamina is probably twice what it used to be. (Therefore, instead of just brief moments of splendor in a bout, they can go for much longer periods of time.) But the sad thing is, a ballet career is also over much sooner than it used to be." *(1982)*

"I just want them [my dancers] to be terribly athletic, beautiful to the point of sin, musical, intelligent, and hard-working. I don't want to have to discuss 'What's my motivation?'—you know, there's the music, there's the step—do it." *(1982)*

"You can take a 100 percent athletic male and give him the most graceful, feline type of steps—almost feminine —and it goes over the line of being either masculine or feminine and becomes simply beautiful." *(1982)*

"The duty of choreographers is to give their very best for the dancers who work so hard and sacrifice so much." *(1982)*

"San Francisco Ballet has not, in all my years here, done a big-budget ballet. Really, our productions are modest compared to ballets in the grand tradition. Our full-length ballets are very carefully streamlined, minimal— we use soft scenery, canvas, scrims. There have *not* been whole villages built onstage, with extra electrics—lights inside the scenery—and all that. People just can't believe

we did *Romeo and Juliet* with thirty-three dancers because they saw eighty people onstage. Everybody played three or four parts. We should really have eighty dancers, with our repertoire and our performing schedule. We burn people out. Then again, if we had eighty dancers, we'd probably do repertoire that'd make them look and work like one hundred and sixty." *(1982)*

"I hope touring doesn't turn into a dinosaur because of funding. Even with the best sponsor, we lose the cost of travel. But we absolutely must keep playing Hawaii, the Midwest, the Southwest, and go back to the Brooklyn Academy of Music, Wolftrap, the Edinburgh Festival—and we absolutely must go on to Manhattan, London, Paris, Milan. The recognition gives us more prestige at home, and the dancers have a vital hunger to be seen by new audiences. In the Southwest this summer, the ovations for *Beauty and the Beast* and *A Song for Dead Warriors* were like a rock concert. We also show new casts and new ballets on tour—not as much as I'd like, but we've started—like a Broadway show trying out in New Haven. It gives those audiences, which are really most sophisti-

cated, something unique. No reason not to make some history out of town. And it can take three seasons of performing and editing to get a ballet the way you want it anyway. Repertoire is always in several stages of development." *(1982)*

"I like to prepare and study, rehearse, edit, solve problems. There is something selfish, maybe, about my enjoyment of rehearsing the dancers and collaborating with composers, designers, lighting designers. I'm interested right up through dress rehearsal. But I hate the moment of giving up a work to the public for the first time—and realizing it's now free game. Anyway, after the premiere, I may like a ballet again, but it's not mine." *(1982)*

"You remember the man who thought up all of those prizes in the Cracker Jack boxes? Well, when trying to explain the incredible work behind the 'magic' of being a choreographer, I turn to his answer when asked how he managed to think up 6,543 different prizes. He replied, 'I had to. It was my job.'" *(1982)*

Anita Paciotti as Medea with Jerome Weiss (left) and Gardner Carlson in *Medea* (1977).

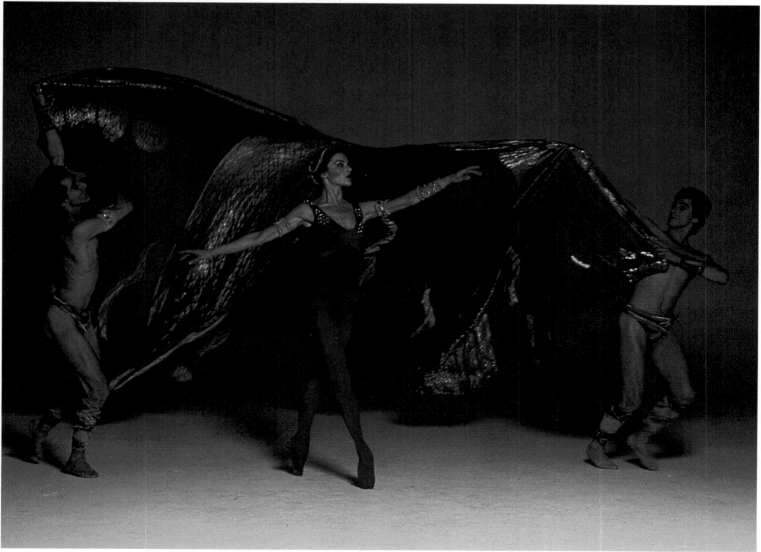

WILLIAM ACHESON

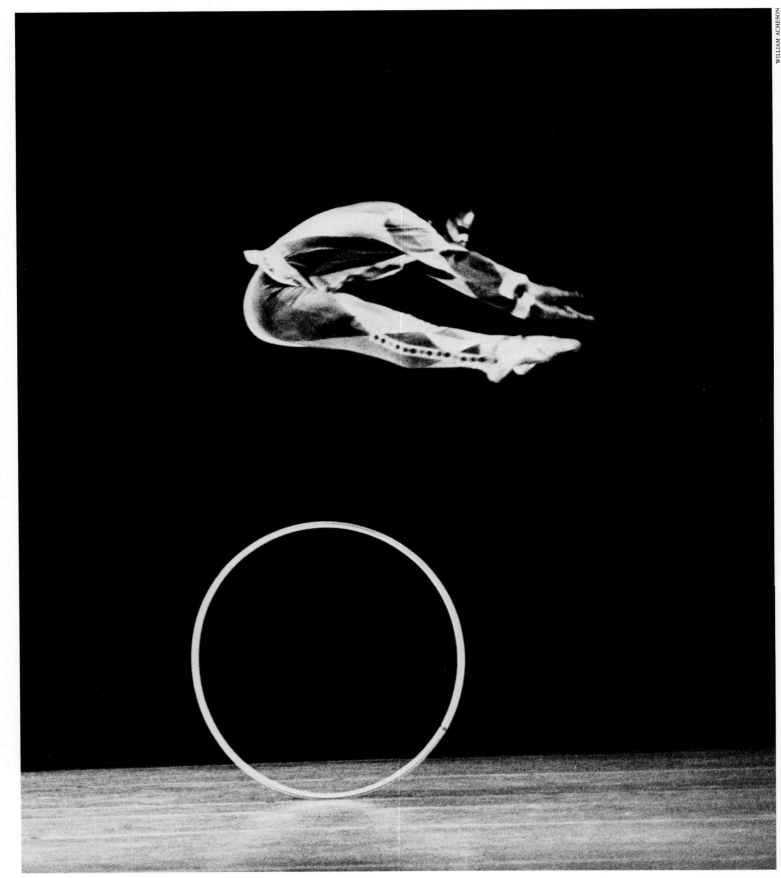

David McNaughton as Arlequin in Lew Christensen's *Scarlatti Portfolio.*

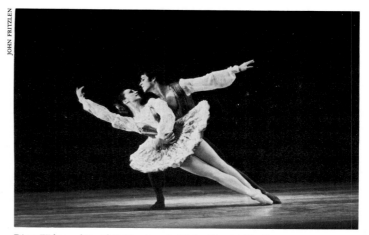

JOHN FRITZLEN

June 28 th, 1979, marked the awards presentation for the International Ballet Competition in Jackson, Mississippi. Representatives from San Francisco Ballet had captured three major prizes: in the senior men's division, David McNaughton won a silver medal, Dennis Marshall a bronze medal, and Lew Christensen's sparkling *Scarlatti Portfolio*, with its *tour de force* "hoop" solo for McNaughton, was awarded a bronze medal for choreography.

Five years in the making and the brain-child of a six-person committee chaired by *Dance Magazine* editor William Como, the Jackson event was bound to make history: it was the first international ballet competition ever held in America. Prior to Jackson, American dancers had to travel thousands of miles, spending thousands of dollars to participate in the international competitions of Moscow, Tokyo, and Varna, Bulgaria (the granddaddy of such events, where Mikhail Baryshnikov and Fernando Bujones won their gold medals). The Jackson competition, which in 1982 became the permanent U.S. host to

Diana Weber and David McNaughton in Michael Smuin's *Duettino*.

tion (the choreography awards were given in this round). And participants in the third round performed either one modern and one classical or two classical variations. The Jackson jury of fourteen judges from fourteen countries was chaired by Robert Joffrey and Sophia Golovinka.

Almost half of the sixty-four dancers participating in the 1979 Jackson competition were eliminated after the first round, and it was during the subsequent rounds that SFB dancers McNaughton and Marshall displayed their virtuosity in SFB-produced choreography—Marshall in Smuin's electrifying *Medea* and McNaughton in Christensen's bubbling *Scarlatti Portfolio*. It was a powerful display of two of SFB's strongest traditions: that of nurturing company choreography and that of producing accomplished male dancers.

In addition to the competition, Jackson also provided both an international dance school (unique to this competition) and rare performances by an eight-member group of dancers from the People's Republic of China, part of a new cultural exchange program which in 1980 sent Michael Smuin to China as a member of the first official U.S. Dance Study Team, and in 1981 saw Madame Xu Shu-Yin teaching at the SFB School at Smuin's invitation.

To honor the SFB winners upon their return from Jackson, Smuin choreographed a special *pas de deux* for the Company's 1979 summer season. Set to music from three Verdi operas, *Duettino* was a Petipa-inspired duet for McNaughton and Diana Weber, which was hailed as "a showstopper . . . meant to be brilliant and exciting, and it is exactly that."

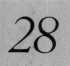

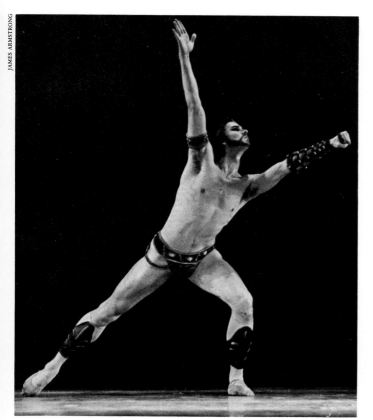

JAMES ARMSTRONG

Dennis Marshall as Jason in Michael Smuin's *Medea*.

the International Ballet Competition in a bill signed by President Ronald Reagan, has facilitated America's presence in the international circuit of competitions.

The structure of the 1979 Jackson event was similar to that of the other world-class competitions. In Round I each dancer performed one solo from the classical repertory and one choreographed after 1925. Dancers selected to continue in Round II performed a contemporary varia-

SFB on TV

Above. Gordon Paxman, Nancy Johnson, and Roland Vazquez in Lew Christensen's *commedia dell'arte* ballet for *The Standard Hour* (1952).
Right. Michael Smuin with Gene Kelly during the broadcast of *The Tempest* (1981).

Radio's award-winning *Standard Hour*, for 29 years a weekly feature of West Coast broadcasting, made its television debut in 1952. The thirteen-week experimental series, featuring selections from opera, ballet, and classical music, was hailed as "a bright new chapter" in television history—the most ambitious arts presentation ever produced in the West. "People in the industry thought we were insane to attempt anything so big here in the Bay Area, especially when we were going into it from scratch," recalls Adrian Michaelis, the executive producer who first convinced Standard Oil to sponsor the programs.

The innovative series—filmed entirely in the Bay Area—aimed to assemble a "visualized library" of San Francisco talent so rich and exciting that it would "send the Hollywood and the New York boys running for cover," according to the *San Francisco Chronicle*. The forty-member production staff tapped the best of Bay Area talent, including SFB Director Lew Christensen, who served as the series' choreographer and dance director, and SFB designer Russell Hartley, who created the costumes for the dance sequences. Intrigued by television's possibilities, Christensen worked closely with the directors and camera crew, learning the special demands of transposing dance to TV. Most of his choreography—which included excerpts from *Nutcracker*, *La Boutique Fantasque*, and *Les Sylphides*, among others—was created expressly for the TV screen. (One of Christensen's creations, the Walpurgis Night Ballet from *Faust*, was never aired: Christensen's choreography was considered too *risqué*, and the flesh-colored costumes fit so perfectly that dancers Sally Bailey and Nancy Johnson appeared nearly nude on film.) Classical dance was largely unfamiliar to television audiences in 1952, and the *Standard Hour* series, said the *Chronicle*, succeeded in removing the "mink and mothball odor" that many Americans associated with ballet and opera.

The *Standard Hour* series convinced Christensen of television's power to expand the dance audience. "Ballet is one theater art that doesn't have to worry about TV's competition," he told a reporter in 1956, during SFB's East Coast debut at Jacob's Pillow. "Television is helping dance as radio helped music. Millions, who didn't even know what it was, have discovered through television that they love ballet."

Classical dance was indeed frequently featured during television's early years. From 1950 through 1957, viewers were treated to New York City Ballet in Christensen's *Filling Station*, the Ballet Russe de Monte Carlo in *Gaîté Parisienne*, the Royal Ballet in Ashton's *Cinderella* with Margot Fonteyn, and Ballet Theatre in *Giselle*, *Rodeo*, *Billy the Kid*, and *Three Virgins and a Devil* (renamed *Three Maidens and a Devil* by the TV censors). But the companies selected for television in those years were, almost

without exception, based in New York. As Michael Smuin later said, TV executives did not think ballet existed west of the Hudson.

During the mid-Sixties, however, San Francisco Ballet was featured on several major broadcasts. In 1964, ABC-TV filmed Christensen's colorful production of *Nutcracker*. Cynthia Gregory and David Anderson were featured as the Sugar Plum Fairy and her Cavalier, while Virginia Johnson and Terry Orr danced the Snow Queen and King. Filmed at the War Memorial Opera House on December 22 (shooting began at 8:30 p.m. and did not end until 4:30 a.m.), *Nutcracker* was aired on New Year's Day in this country and was later televised in such diverse places as England, Portugal, Spain, Liberia, Bangkok, Singapore, and Kuala Lumpur.

Three months after the *Nutcracker* telecast, during the Company's New York debut at Lincoln Center, SFB dancers were featured on *The Ed Sullivan Show* in Lew Christensen's *Caprice*. In 1966, the *Bell Telephone Hour* presented SFB in Christensen's *Variations de Ballet*. And in 1968, ABC-TV aired a one-hour version of Christensen's *Beauty and the Beast*. The demanding role of Beauty was danced by SFB ballerina Lynda Meyer, while the role of the Beast who is transformed into a Prince was danced as a dual role for the first time: Robert Gladstein portrayed the Beast and David Anderson the Prince. Sally Bailey, R. Clinton Rothwell, Joan DeVere, Henry Berg, and Lee Fuller were among the principal dancers who led the cast of sixty. The San Francisco Ballet Orchestra, conducted by Gerhard Samuel, played the Tchaikovsky score. And the young British screen star Hayley Mills made five appearances during the program as the narrator. The film, originally shot in 1966, was premiered in Monaco on the opening day of American Week, part of Monaco's Tri-Centennial. It was the only film shown during the festival. Lynda Meyer flew to Monaco as the official representative of SFB.

Dance in America, the most important dance series in television's history, premiered in 1975. Despite the "America" in its title, the PBS program at first featured only East Coast-based companies: the schedule during the series' first three seasons included programs on the Joffrey Ballet, American Ballet Theatre, New York City Ballet, Pennsylvania Ballet, Dance Theatre of Harlem, Martha Graham, Paul Taylor, Merce Cunningham, and Twyla Tharp. "The line-up was unarguably innovative and impressive," says Michael Smuin, "but lopsided."

To correct the bias and lend a more "national" air to the series, producer Merrill Brockway planned a half-hour show on dance west of the Hudson: the program, however, would include only ten minutes on SFB, a fact that did not sit well with Smuin. "Both Brockway and I were then serving on the Dance Advisory Panel of the National Endowment for the Arts," Smuin recalls, "so I got to one

29

Diana Weber and Jim Sohm in Michael Smuin's *Romeo and Juliet* (1978).

projecting for the Opera House to emoting for the screen. And since costumes originally designed to be seen from the reaches of the upper balconies now had to be viewed in close-up, a certain amount of adaptation and redesign were necessary. But the major changes were those demanded by the nature of TV itself. "When you look at the ballet in a proscenium arch," Smuin explains, "it's a square. But a TV camera is like a triangle. In order to get everything in, you need distance between the dancers and the camera, and yet all this floor in the center is wasted. So, I restaged a lot of the ballet to work as a cone, as a triangle. Merrill Brockway, who directed the show, taught me everything."

Romeo and Juliet was aired in June of 1978, with Diana Weber and Jim Sohm in the title roles. SFB Co-Director Lew Christensen made a rare appearance in the non-dancing role of Friar Lawrence. The Prokofiev score was played by SFB's Performing Arts Orchestra under the direction of Denis de Coteau. TV actor Richard Thomas (whose parents danced with New York City Ballet) served as program host.

"The ballet is so meticulously paced that the absorbing acts speed by unbelievably quickly—no pauses, no distractions, just a ceaseless flow of well-regulated movement," said *Dance Magazine* of the telecast. "The whole Company dances beautifully," the review continued, "but choreographer Michael Smuin's concept of Shakespeare's tale is the star of the performance. . . . What a film director Smuin would be! The ballet pulses with more excitement than any thriller."

Three months after the telecast, William Pitkin's costumes for *Romeo and Juliet*—originally created for the stage and then adapted for television—won an Emmy Award.

"Our participation in the *Dance in America* series is recognition that San Francisco Ballet is entering a golden age," Smuin said shortly after the broadcast. "Our Ballet now has the creative force, leadership, and talent to become a company of international status. Not just a 'good regional company,' but a major force in the dance world—a company that will *set* trends, not follow them. It's all there. We just need the exposure and that's what television can provide us: mass exposure. My dream as far as TV is concerned is to do at least one presentation a year."

Smuin almost realized his dream: within two years of the *Romeo and Juliet* telecast, San Francisco Ballet was again featured on national television when *Dance in America* presented a performance of Smuin's *The Tempest*—the first ballet ever broadcast live from the War Memorial Opera House. Co-produced by KQED-San Francisco and WNET-New York, the March 1981 broadcast featured Attila Ficzere as Prospero, David McNaughton as Ariel, Tomm Ruud as Ferdinand, Evelyn Cisneros as Miranda, and Horacio Cifuentes as Caliban. Emile Ardolino directed; Gene Kelly served as host. The program—which *Dance Magazine* hailed as "a latter day Petipa spectacle,

panel meeting early, moved my placecard next to his, and talked him into coming to see the Company."

Brockway's 1977 visit coincided with SFB's presentation of Smuin's *Romeo and Juliet*—its first presentation as a completed production with sets and costumes. After seeing the ballet, Brockway was sufficiently interested in both the work and the Company to consider taping the full-length piece. When SFB took *Romeo and Juliet* on tour to New Orleans that June, Brockway was again in the audience. After this second viewing, he made a videotape of the ballet, studied it, and made the decision to present a two-hour special of *Romeo and Juliet* for *Dance in America*'s 1978 season: it would be the first time the award-winning series featured either a West Coast company or a full-length classical work.

On February 21, 1978, the Company flew to Nashville to begin fourteen days of taping at the Grand Old Opry, whose stage and television studios are among the best in the country. The initial ten days were spent shooting the street and ballroom scenes; the remaining days were used to tape the smaller, intimate sequences.

"Much of the ballet had to be reconceived for television," Smuin remembers. Acting had to be tuned from

full of theatrical and choreographic invention"—was nominated for three Emmy Awards. Smuin was nominated for achievement in choreography; Paul Chihara's original score (after Henry Purcell) was nominated for achievement in musical composition; and Willa Kim's costumes won an Emmy for outstanding costume design.

One year after *The Tempest* telecast, Smuin and Kelly once again collaborated when Kelly hosted four SFB dancers performing Smuin choreography for the TV series *Young American Artists at the White House*. (See Chapter 40.) Also in 1982, KQED-TV presented SFB in Robert Gladstein's *Symphony in Three Movements*, which Gladstein originally created for the Company's 1982 Stravinsky Centennial Celebration. KQED-TV had first collaborated with SFB in 1958, when the five-year-old station aired excerpts from Lew Christensen's *Beauty and the Beast*. That production was followed by a telecast of Christensen's *Jest of Cards* in 1962. But *Symphony in Three Movements* marked the first time the local PBS station produced an SFB dance special in KQED's studios.

Although taping a ballet for thirty-three dancers in a shallow studio without wings presented special problems (certain entrances, exits, and lifts had to be re-choreographed because cameras would catch overhead lights), the televised ballet remained true to the original. "I didn't want to change too much," notes Gladstein, who was making his television choreographic debut with *Symphony in Three Movements*. "The music said to me that it should not be costumed, that the ballet should have dancers in leotards and tights moving on an empty stage. Except for the number of dancers, I wanted this to be a sparse ballet—it's just dancing, the body moving with vitality. After all, vitality is the signature of SFB."

Symphony in Three Movements was aired in June 1982 to coincide with the Centennial of Stravinsky's birth. Marge Champion (whose father, Ernest Belcher, had been ballet master for SFB in the early Thirties) served as host.

Television, of course, has vastly enlarged the dance audience across the country since the Sixties. As Michael Smuin has noted, TV can be both a stimulant to touring ("After we did *Romeo and Juliet* on *Dance in America*, we were booked into cities where we had never been before, playing to SRO houses."), and its alternative ("The only way San Francisco Ballet can be appreciated outside of our own community is to take advantage of that kind of instant coast-to-coast visibility that only television gives us."). Video is also providing dance with what critic Arlene Croce has called "a visible past." Dance, the ephemeral art, is "rebelling against its condition," Croce says. "Like mayflies who want to be cast in bronze, dancers are putting their dances into retrieval systems. Films and videotapes preserve choreography that might otherwise have been entrusted to disputable notation or partial memory." Because of television, dance is developing, at long last, a visual archives.

"Television is simply part of the American lifestyle," Smuin concludes. "It's the medium we live with right now. I'd very much like to do ballets that are conceived totally for the camera, not a proscenium arch. SFB is very much in the forefront—we'd even like to have our own production company. Instead of twelve weeks touring, maybe we'd spend six weeks touring and six weeks producing videotape. We don't know how big the market is yet, whether it's going to be just cable, or PBS, or network, or cassettes, or discs. But whatever, we're ready."

Robert Gladstein's *Symphony in Three Movements* (1982).

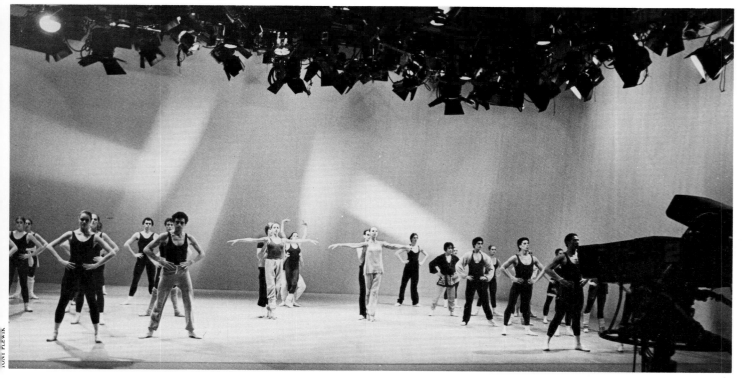

The S.O.B. Campaign

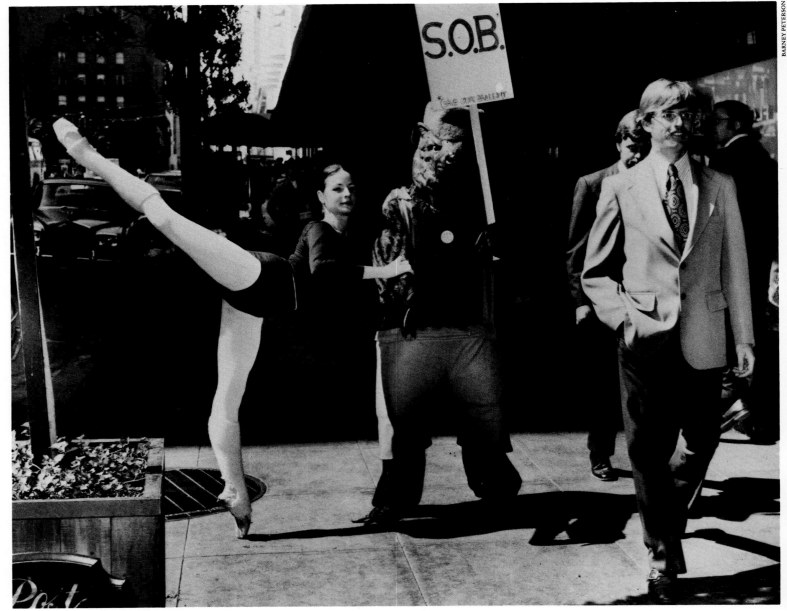

Laurie Cowden and Jerome Weiss (as bear) during "Save Our Ballet" Campaign (c. 1974).

In 1974, at the close of its *30*th annual *Nutcracker* season, San Francisco Ballet had cause for celebration: the Company had just weathered the worst financial storm in its history. On September 19 of that year, the San Francisco Ballet Association announced it faced possible dissolution and bankruptcy. Unless $500,000 could be raised within eleven days, the Company and School would be forced to close. A major survival campaign was therefore being launched, the Association announced, in an appeal to the entire Bay Area community. Some $50,000 had already been donated by the Association's board of directors. The dancers, who had started the campaign by raising $15,000, had also offered to accept thirty-six week contracts instead of forty-two, and to donate their services for five extra *Nutcracker* performances that year. In an intensive drive spearheaded by Company member Robert Gladstein, the dancers furthermore mobilized a telephone and door-to-door campaign to bring the Company's plight to the public's attention. Gladstein's community drive for public contributions was affectionately—and effectively—dubbed the S.O.B. ("Save Our Ballet") campaign.

Response to the campaign was immediate. Rudolf Nureyev cabled from Paris to lend his support. Governor Ronald Reagan urged all Californians to get behind the do-or-die campaign. Mayor Joseph Alioto issued a proclamation advocating a community-wide effort. California State Senator Milton Marks, deploring the fact that New York State appropriated $38 million for the arts while California had less than $1 million, endorsed state funding. And telegrams of concern arrived from across the country and around the world: Leontyne Price, Gene Kelly, and United States Senator John Tunney all urged support of the financially troubled Company.

Entire city blocks in San Francisco were closed to traffic and given over to fundraising block parties. "S.O.B." balloons hung from highrise balconies; the Stanford University Band marched through the streets; and for publicity, Michael Smuin entered a tricycle race, winning over a chimpanzee. As *Newsweek* later reported, the dancers not only manned the phones to potential bankrollers, but also performed in department store windows, and even danced during the half-time of a 49er football game. They appeared on the national prime time news hours and were featured in the national press. "It would be to San Francisco's everlasting shame," said SFB dancer Lynda Meyer, "if this Company folded, just as New York could never live it down if it ever let the New York City Ballet go under for want of money." Fundraising auctions were organized, and a "Fill-the-Slipper" gala was sponsored at Marine World-Africa USA, where the Company performed a special adaptation of Lew Christensen's *Beauty and the Beast* with live tigers and elephants. More than 6500 attended the special "S.O.B." day at Marine World.

All receipts from admission tickets, which ranged from $5 to $100, were donated to the campaign.

More than $350,000 was raised by September 30, encouraging the Association to extend the deadline another two weeks. Smuin went to Washington, D.C. to present the Company's plight to government officials. The National Endowment for the Arts announced a $40,000 grant to the Company, and membership in the SFB Association jumped from 300 to 2,000. By the middle of October, the Company had secured the necessary $500,000: the go-ahead was given to embark on the second annual Hawaiian tour and to begin rehearsals for *Nutcracker*. "San Francisco Ballet has come closer to dissolution than any surviving American dance company," *Dance Magazine* noted. "Its saga should be written as 'The Company that wouldn't die.'"

The Company's near demise was a shock to many, for SFB had been showing healthy advances since 1973 when Lew Christensen had asked Michael Smuin to help him revitalize the organization. More than fifteen dancers joined the Company that year, including former members of American Ballet Theatre, Harkness Ballet, Pennsylvania Ballet, and the Netherlands Dance Theatre. Audiences were definitely on the increase, and the enlarged repertory featured a popular new full-length work, *Cinderella*, as well as the Company premieres of Lester Horton's *The Beloved*, Doris Humphrey's *The Shakers*, August Bournonville's *pas de deux* from *Flower Festival at Genzano*, and George Balanchine's *La Sonnambula* and *The Four Temperaments*. The 1974 spring season was, in fact, pronounced the Company's most successful in years—"an artistic triumph," said the *San Francisco Examiner*, "which elevated the forty-one-year-old Company to a level comparable with the world's best." Following the spring series, SFB performed at the Meadow Brook Music Festival—its first engagement east of the Mississippi in a decade. The Company, in short, seemed certain to recapture its national stature when the Association suddenly revealed it faced immediate extinction. "The only thing that's stopping us from being one of the great ballets of the world," Michael Smuin told the press, "is money."

From 1957 through 1969, San Francisco Ballet had been skillfully managed by Leon Kalimos, a former SFB dancer. (At SFB, Kalimos had created the roles of Joe the Bartender in Willam Christensen's *The Nothing Doing Bar* and Von Rothbart in Balanchine's *Swan Lake*.) Kalimos knew ballet as a dancer, had a sharp managerial sense, and was, as Robert Commanday wrote in the *San Francisco Chronicle*, "a perfect complement and teammate for Lew Christensen." The Christensen-Kalimos team developed the Company throughout the late Fifties and Sixties, and was responsible for achievements that included four national and three international tours. Kalimos, the

30

President of the Association of American Dance Companies, was also instrumental in securing important grants from the Ford Foundation, the National Endowment for the Arts, and others.

After Kalimos' departure, SFB was managed—and mismanaged, many said—by a succession of stop-gap administrations. "The best that can be said of their tenure," wrote Commanday in the *Chronicle*, "is that they were short." The Ballet's real problem, Commanday concluded, was thus not artistic but administrative: the Company had been troubled by managerial turmoil since Kalimos' resignation. When San Francisco Ballet faced bankruptcy in the fall of 1974, the board of directors thus engaged a nationally recognized arts consultant, George Alan Smith, to analyze the Ballet's administrative problems. Convinced that board presidents working on a voluntary basis had not been able to perform the tasks required, and that general managers had never had the necessary status and authority, Smith urged the SFB Association to hire a full-time president—a professional arts administrator who, while mindful of artistic standards, would insist on a businesslike operation. A special steering committee was formed both to find the best candidate for the new position and to reorganize the Association. The board of directors, newly named a board of trustees, was restructured. Committees were formed, and the new board insisted it would no longer meddle unnecessarily in the artistic affairs of the Company: Michael Smuin would have "greater responsibilities and a better chance to show what he can do," according to reports in the *Chronicle*.

On January 22, 1975, the Association announced it had named Dr. Richard E. LeBlond, Jr. President and General Manager of the San Francisco Ballet Association. LeBlond, who received his doctorate in the sociology of arts from the University of Michigan, was one of the most respected arts administrators in the nation. A member of the board of the Association of American Dance Companies since its inception in 1966, he had served as its president and chairman from 1969 until 1974. He had also lent his expertise to the Advisory Panel of the New Jersey State Arts Council, the Pennsylvania State Arts Council, and the Dance Panel of the National Endowment for the Arts, of which he was co-chairman. At the time of his SFB appointment, LeBlond was General Manager and President of the Pennsylvania Ballet, where he had earned a distinguished reputation as a fundraiser and community organizer.

"I want to run SFB as professionally as possible," LeBlond said at his first SFB press conference. "We're long past the day when you can run a major performing arts organization by the seat of your pants. We'll have pros in all areas—people who know and are dedicated to their craft." Touring, in LeBlond's view, would become a major part of the Company's future. "It's the only way to stay alive, artistically, keep morale high and artistic standards up, as well as amortize the cost of new produc-tions." And a five-year plan, LeBlond said, was essential to attracting long-range financing from corporations, foundations, and private donors. "People who invest in us have a right to see how we plan to use that money."

Under LeBlond's leadership, the Association published its first five-year plan, established a development department, and finished fiscal year 1975 with a balanced budget. By the end of 1982, LeBlond had, in fact, guided SFB through eight consecutive fiscal years in the black. His meticulous management of funds vastly improved the Company's fiscal credibility: LeBlond has secured

SFB prestigious grants from the Ford Foundation, the Andrew W. Mellon Foundation, the Fidelity Savings and Loan Association, the National Endowment for the Arts, the California Arts Council, the Charles E. Merrill Trust, the San Francisco Foundation, the Rockefeller Foundation, and Atari, Inc., among many others. Since 1974, the Association's annual budget has climbed from $1.4 million to over $7 million. Earned income alone has jumped from $735,200 in 1974 to $3,871,300 in 1982.

The Company's near-bankruptcy in 1974 thus paradoxically produced an economic stability rarely enjoyed by an arts organization. The S.O.B. campaign galvanized the board into action, ignited a vital new administration, and attracted large-scale corporate and foundation funding. The drive not only saved the Company from folding, but proved it had a broad base of public support. As LeBlond has summarized, "The community said in a very tangible way, 'We want a company here.' Do you realize what an asset that is? Very few communities in this country have ever said that about a ballet company."

Lynda Meyer and Robert Gladstein in a special performance of Lew Christensen's *Beauty and the Beast* at Marine World-Africa USA (1974).

"A Song For Dead Warriors"

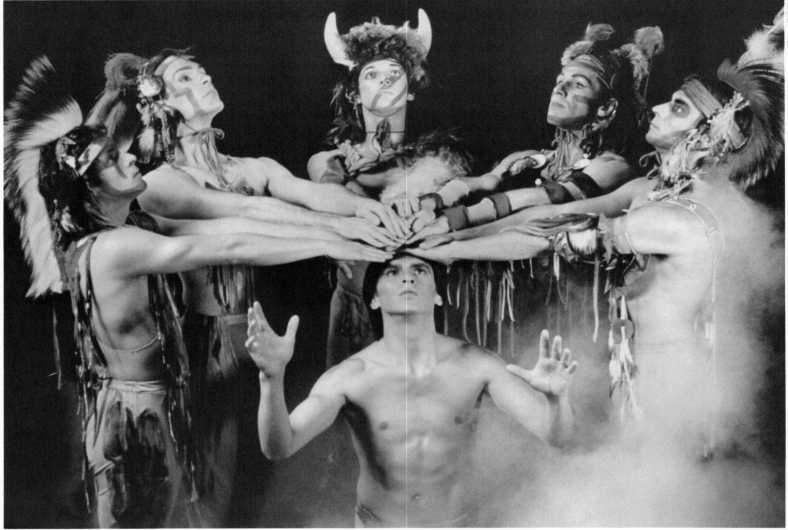

Above. David McNaughton, Jim Sohm, Alexander Topciy, Tomm Ruud, Attila Ficzere, and Antonio Lopez (center) in *A Song for Dead Warriors* (1982).
Right. Tomm Ruud in the Vision sequence from *A Song for Dead Warriors* (1982).
Opposite left. David McNaughton, Jim Sohm, Alexander Topciy, Tomm Ruud, Attila Ficzere, and Antonio Lopez (center) in *A Song for Dead Warriors* (1982).
Opposite right. David McNaughton in *A Song for Dead Warriors* (1982).

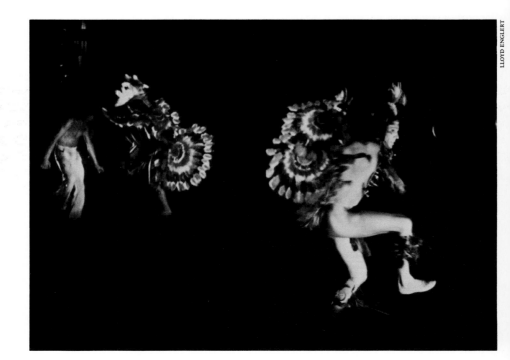

Michael Smuin's epic work for *31* dancers, *A Song for Dead Warriors*, was first performed on May 1, 1979. A searing indictment of Indian oppression, *A Song for Dead Warriors* was an overnight sensation: one of Smuin's most popular—and controversial—works. The opening night audience stood on its feet to receive this ballet. They gave the hero, newcomer Antonio Lopez, one of those a-star-is-born ovations and actually booed bad-guy Vane Vest, so complete was their involvement in Smuin's hard-hitting tale of a contemporary Indian who lives and dies under the thumb of white corruption. Dazzled by the panoply of special effects (phantasmagorical sheriffs twenty feet high, six enormous bison that take up the entire rear stage, proscenium-high photographs, cosmic clouds, and primeval trees that shoot straight for the sky), the audience cheered this ballet wildly: a thunderous ten-minute ovation roared through the War Memorial Opera House when the curtain fell on *Warriors*.

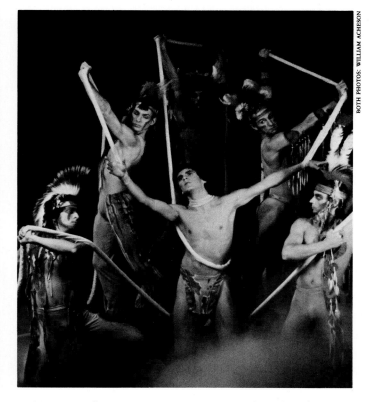

The next day, however, a controversy began to brew as many critics attacked the ballet as propagandistic, cliché-ridden, over-simplistic, over-produced, and excessively "relevant"—a melodramatic, albeit theatrically powerful, piece of agitprop. Smuin—who described the ballet simply as "a series of vignettes which traces the life of an Indian man from his birth to his death and, in so doing, reflects on the contemporary Indian situation"—had produced a full-blown *succès de scandale* worthy of Diaghilev. No other ballet in the Company's recent history, perhaps in its entire history, has aroused such heated debate or so sharply divided public and press.

Smuin had wanted to create a ballet inspired by the history, dreams, and legends of the American Indian for several years. "I think *A Song for Dead Warriors* has been in preparation for a long time," he has said. "I think this ballet has been inside me ever since I was a boy—I was raised in Montana near a large Indian community."

Over the years Smuin considered several possible sources for his Indian ballet: some friends had suggested the Hiawatha legend; others thought the Pontiac story would make a good dance; and Smuin had even considered a ballet inspired by the Iroquois constitution, which begins, as does that of the United States, with the phrase "we, the people." But none of these ideas, he has said, ever felt quite right. "Somehow the idea of taking an Indian legend or story and putting it on a proscenium stage in a European setting always bothered me. I had great respect for Indian life and I thought perhaps that their lives shouldn't even be presented as a dance piece, that it would be disrespectful. Here we go, I said to myself, it's Hollywood all over again. I didn't want to do a ballet where a lot of beautiful Indians in warbonnets and feathers prayed on a cliff during a beautiful sunset—I didn't want anything that solemn and false. I realized the ballet would have to be done differently, that I would have to find a new approach."

Smuin got glimmers of a new approach when in November 1969 he read that a group of eighty young American Indians had occupied Alcatraz Island and claimed it "free Indian land." Like many other Americans, Smuin was fascinated by the event—the occupation was to last some nineteen months—and he was particularly drawn to one of the Indians' early leaders, Richard Oakes. Oakes, a twenty-seven-year-old of Canadian Mohawk heritage, had helped to plan the occupation, becoming the group's first spokesman. Several weeks into the occupation, however, Oakes' daughter was killed in a three-story fall, and Oakes left the island, never to return.

He passed his time in San Francisco's skid row districts—a friend said that after his daughter's death, Oakes "couldn't get going again." In June 1970, he was critically injured in a fight in an Indian bar in the Mission District: two men had beaten him senseless with pool cues. During his month recuperating in a hospital, Oakes had several dreams and visions about his people's plight. When he was released from the hospital, Oakes became involved with the residents of a small Sonoma County reservation and once again became interested in Indian activism. He was about to leave on a cross-country trip to visit several other reservations when on September 20,

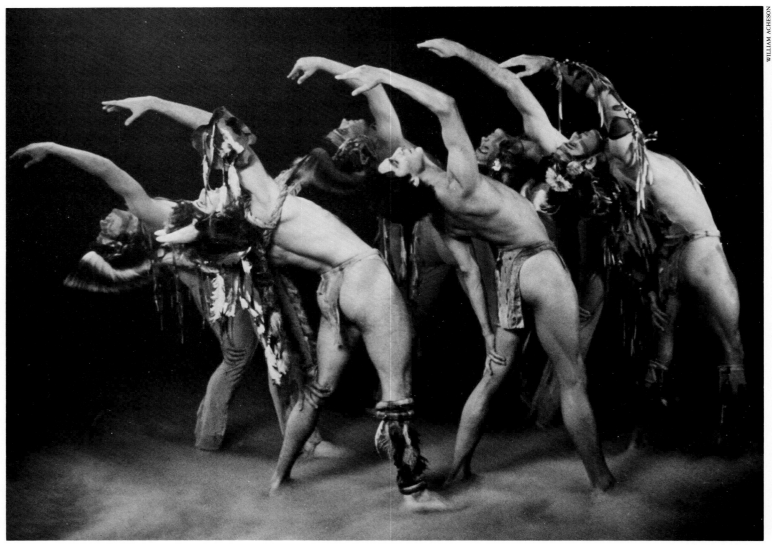

David McNaughton, Alexander Topciy, Attila Ficzere, Antonio Lopez, Jim Sohm, and Tomm Ruud in *A Song for Dead Warriors* (1982).

1970 he was shot and killed by a caretaker for a YMCA camp in Northern California, who claimed Oakes had menaced him with a hunting knife.

The more Smuin delved into Oakes' story, the more he realized that this contemporary Indian story might work as a ballet, that the disparity between the Indian's past glory and present ignominy was a powerful and appropriate theme. "I didn't want to do something too general, I didn't want to categorize and say 'All Indians do this, all Indians are like that.' The Oakes story gave me the specifics I needed."

Smuin then began a long, difficult, and at times, he has admitted, tedious process of research, collecting boxes and boxes of newsreel footage, reading dozens of books, studying hundreds of photographs, and for three consecutive summers visiting Indian reservations. At first, the overwhelming wealth of specific information seemed so essential that Smuin assigned each of the warriors in his ballet a specific name, a tribal heritage, and a detailed biography. But Smuin started eliminating this and that, trying to hone the story down to essentials, infusing it with an epic, almost mythic, quality.

His libretto complete, Smuin assembled a team of collaborators: Charles Fox (music), Ronald Chase (projections), Sara Linnie Slocum (lighting), and Willa Kim (sets and costumes). The results were undeniably bold and brash, exhilaratingly theatrical—dramatic with a vengeance. Combining film, music, dance, and drama, *A Song for Dead Warriors* may be Smuin's pop answer to Wagner's *gesamtkunstwerk*: a "total" artwork. By turns rapturous, shocking, solemn, splashy, austere, and extravagant, *Dead Warriors* showcases the range of Smuin's talents and interests: his ability, as one critic noted, "to handle the material of great popular myths as if those myths had never died"; his penchant for male variations of wall-slamming energy; and his pronounced skill at combining popular and classical idioms. ("When in the ballet's disco sequence a group of young Indians boogie their way into oblivion," wrote one reviewer, "we're dazzled by Smuin's punchy, nail-it-to-the-floor choreography—it's at moments like these when you'd swear Smuin would make a great film choreographer, that he could give celluloid a dance pulse it hasn't known in many years.")

Ballet's capacity for social commentary is notoriously slim. In her review of *The Turning Point* (1977), Pauline Kael argued that America's dance explosion stems, in part, from ballet's apolitical formalism, that ballet's freedom from "issues" has made it as popular an escape from the national mess as sports. But with *Warriors* Smuin indeed has injected a strong dose of "issues" into classical dance. In an age when ballets don't deal with causes, Smuin has given *Warriors* an unavoidable political dimension. It was in this context—as a rare grab for socio-political relevance—that *Warriors* was praised when, eighteen months after its San Francisco world premiere, the ballet was performed during SFB's 1980 New York season. Anna Kisselgoff, writing in *The New York Times*, hailed *Warriors* as "a shocker of a *ballet engagé* . . . strong stuff, courageous in its use of stereotypes." And *The New Yorker*'s Arlene Croce, overwhelmed by the ballet's last "five blinding seconds" of violence, praised *Warriors'* power to touch "our earliest and most elemental fears and joys," to vent "our loaded feelings" about the oppression of American Indians.

Michael Smuin, in short, isn't afraid to take risks, to go against the mainstream of ballet fashion. Since returning to San Francisco Ballet in 1973, he has ambitiously tackled large narratives (*Romeo and Juliet*, *Medea*) and difficult music (*Mozart's C Minor Mass*). If some artists aim for neatness and delicacy (Jane Austen once likened the world of her novels to a little bit of ivory—"two inches wide"—on which she worked with "so fine a brush"), other artists like Smuin shoot for larger game: a high-flying, hard-hitting, dramatically explosive and romantically expansive epic. Michael Smuin likes scope—he gives the Company its "big" ballets. In its mythic resonance, political intentions, and theatrical range, *A Song for Dead Warriors* is, perhaps, the biggest of Smuin's big ballets. *Warriors* speaks of an energy too passionate for the neatness of mere "good taste."

Dennis Marshall as one of the Ancestral Chiefs in *A Song for Dead Warriors* (1979).

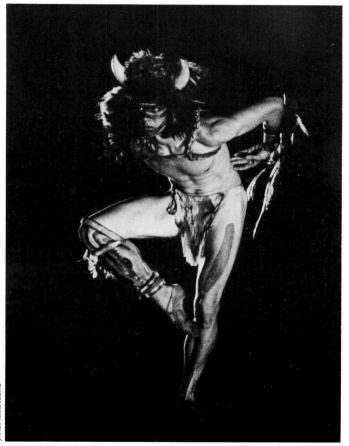

Evelyn Cisneros in *A Song for Dead Warriors* (1982).

117

Robert Gladstein

Robert Gladstein (1955).

In 1975, at the age of *32*, Robert Gladstein retired from the stage, bringing to a close one of the most distinguished and varied performing careers of any SFB *danseur*. Born in Berkeley in 1943, Gladstein began his formal training at age ten at the San Francisco Ballet School. Within months of his first SFB class in 1954, Gladstein was cast by Lew Christensen as Drosselmeyer's Nephew in the Company's new production of *Nutcracker*, Christensen's first full-length ballet for the Company. As it was also the first time in SFB's history that the Nephew was danced by a boy instead of a girl *en travestie*, Gladstein's debut was, it could be said, symbolic: it marked a new era of Company-trained *danseurs*.

During his next seven years of training with Company teachers Harold Christensen, Ruby Asquith, and Nancy Johnson, Gladstein continued to dance with SFB as a student, performing in *Nutcracker*, *Beauty and the Beast*, and Balanchine's *Swan Lake* and *Pas de Dix*. In 1961 Gladstein officially joined the Company and began his quick rise to prominence. During his debut season alone, he played Von Rothbart in *Swan Lake*, danced in all three of the Company premieres (*Symphony in C*, *Original Sin*, *St. George and the Dragon*), and performed in five other ballets by Lew Christensen—a demanding schedule for someone who had just turned eighteen.

In 1962 Gladstein danced his first Cavalier in *Nutcracker*, partnering the Company's *prima ballerina*, Jocelyn Vollmar. Two months later, Lew Christensen created *Fantasma* to showcase the Vollmar-Gladstein partnership. Gladstein's partnering skills were clearly in demand during the Company's 1963 Christmas season: he played the Cavalier to Sally Bailey's Sugar Plum Fairy in *Nutcracker*, and made an auspicious debut (opposite Cynthia Gregory) as the Beast/Prince in *Beauty and the Beast*. By 1965 Gladstein had become the Company's *premier danseur*.

His repertoire continued to expand as he took on leading roles in *Filling Station* (he played Mac, the part originally created by Lew Christensen) and *Divertissement d'Auber* ("Gladstein's broad and open style is perfect for the free quality of the opening solo," wrote Robert Commanday in the *San Francisco Chronicle*). He gained national exposure performing on *The Ed Sullivan Show* during SFB's 1965 New York season at Lincoln Center. A second national television appearance came in 1967 when Gladstein played the Beast in ABC's broadcast of *Beauty and the Beast*. That year Gladstein also created the lead role in Carlos Carvajal's *Totentanz*: Gladstein's masterful portrayal of Death became a signature role—a triumph of dramatic dancing.

Like many other SFB dancers before him, Gladstein was drawn to the East Coast, and he left the Company in 1967. "Going to New York was something that dancers had to do in those days," he later told the *Chronicle*. From 1967 through 1970, Gladstein performed with American Ballet Theatre, touring nationally and internationally, appearing in works by Antony Tudor (*Pillar of Fire*, *Jardin aux Lilas*), Agnes de Mille (*Fall River Legend*), Jerome Robbins (*Les Noces*, *Fancy Free*), and Léonide Massine (*Gaîté Parisienne*). With ABT, he appeared in *Fancy Free* in a special White House command performance for President Nixon. (ABT's Presidential performance of the Jerome Robbins classic also featured former SFB dancers Michael Smuin, Paula Tracy, and Terry Orr.)

Gladstein returned to SFB during the 1970 *Nutcracker* season, dancing the Cavalier to Virginia Johnson's Sugar Plum Fairy. "New York was not really for me," he told a reporter. "I got very anxious to come back to San Francisco." During the next four years, Gladstein remained one of SFB's most distinguished and popular dancers, performing leading roles in the Company premieres of *Don Juan*, *Cinderella*, *The Four Temperaments*, *Les Sylphides*, *Harp Concerto*, and *Pulcinella Variations*, among others.

On September 1, 1975, Gladstein retired from dancing to assume full-time responsibilities as the Company's Ballet Master, a position that requires him to oversee the training of Company dancers, supervise the rehearsal of

32

Robert Gladstein as Mac in Lew Christensen's *Filling Station* (1966).

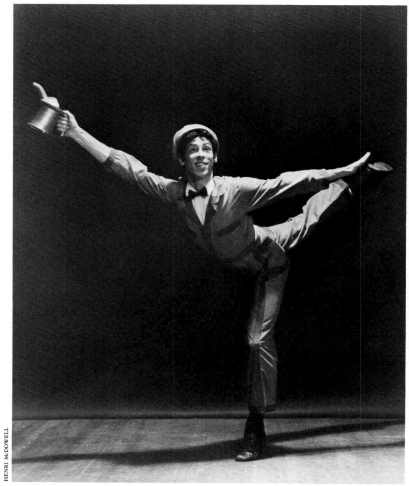

HENRI McDOWELL

the repertory, and coordinate all casting. ("He's one of the best ballet masters in the world," boasts Co-Director Michael Smuin.) In 1981, in recognition of the duties and responsibilities he had gradually assumed since his 1975 appointment as Ballet Master working with Co-Directors Lew Christensen and Michael Smuin to determine the Company's artistic philosophy and direction, Gladstein was also named the Company's Assistant Director.

Sally Bailey as the Sugar Plum Fairy and Robert Gladstein as her Cavalier in Lew Christensen's *Nutcracker* (1962).

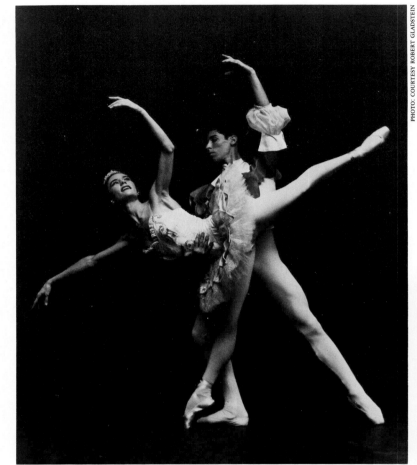

PHOTO: COURTESY ROBERT GLADSTEIN

In addition to his contributions as principal dancer, Ballet Master, and Assistant Director, Robert Gladstein has also been one of SFB's most prolific resident choreographers: twenty-four Gladstein ballets have been performed by the Company. (Only four choreographers are represented by more ballets in SFB's fifty-year repertoire —Adolph Bolm, Willam Christensen, Lew Christensen, and Michael Smuin.) When Gladstein's first ballets premiered during the Company's summer workshops, critics were quick to detect a new choreographic talent. "San Francisco Ballet may soon have one of the best choreographers if Robert Gladstein continues to develop as he has in the past year or so," said the *Chronicle* in 1965. "He has one of the keenest creative minds this Company has come up with in years, a natural way of handling bodies, line, motion, and pattern, and he has sufficient imagination to stay far ahead of his audience. Moreover, he can create humor without being grotesque or crude."

Since his first choreographic efforts, Gladstein has explored a rich range of styles. He has mined the veins of nineteenth century romanticism (*The Mistletoe Bride*), American pop (*N.R.A.*, *Gershwin*), and sacred ritual (*Psalms*). But he remains best known for his masterful interpretations of twentieth century scores. *The New Yorker* critic Arlene Croce found his *Stravinsky Capriccio for Piano and Orchestra* (1978) a "remarkable" ballet that revealed "just how far Gladstein succeeded in making his piece work." And his *Symphony in Three Movements*, a highlight of the Company's 1982 Stravinsky Centennial Celebration, proved so successful that it was chosen for a special broadcast by KQED-TV. His works are in the repertories of American Ballet Theatre Players, Ballet West, Pacific Northwest Ballet, and Sacramento Ballet.

Robert Gladstein's contributions to the Company are unique: no one else in SFB's history has served in so many capacities for so long a time. "I don't think there's another guy who can match him," says Lew Christensen. "He's been raised by us and has a natural instinct for our concept of the organization. He's also got patience beyond mine, I can tell you. And, he knows what he's doing."

Opposite. Robert Gladstein as Death in Carlos Carvajal's *Totentanz* (1967). *Below.* Laurie Cowden and Dennis Marshall in Robert Gladstein's *Stravinsky Capriccio for Piano and Orchestra* (1978).

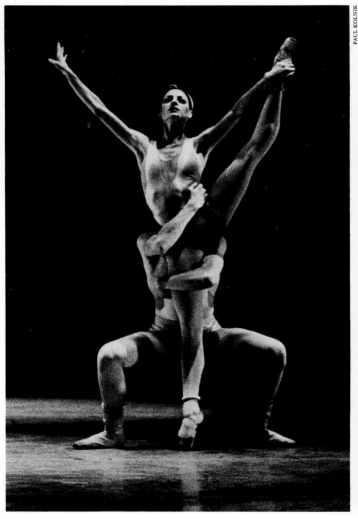

PAUL KOLNIK

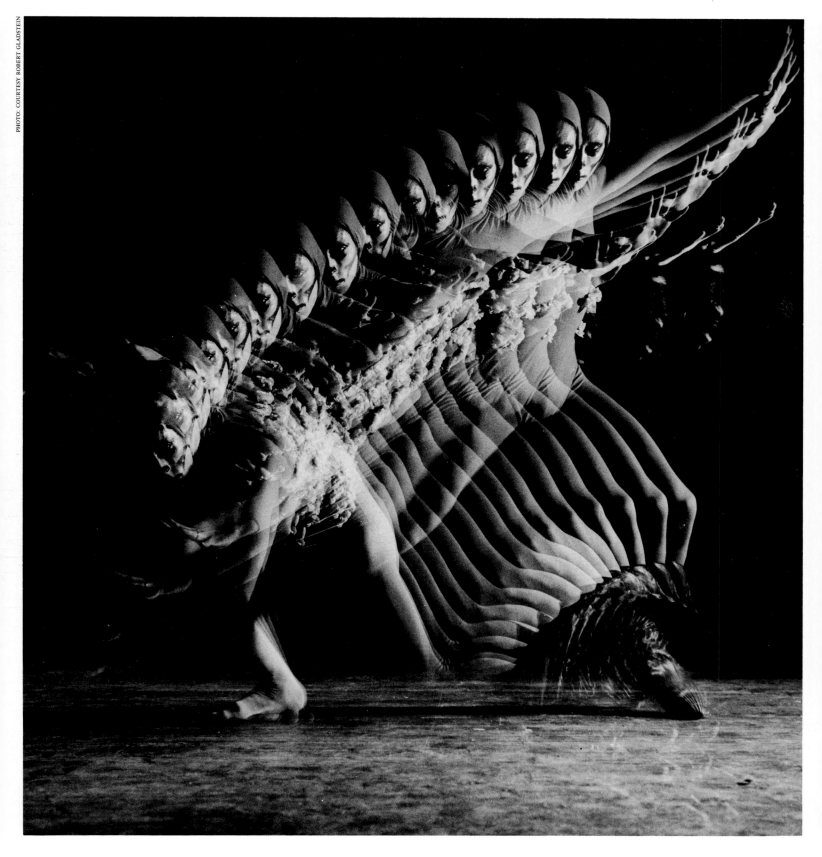

■ In 1977, *Newsweek* praised Gladstein's *Gershwin* as one of the Company's "most daring new ventures. . . . His purposeful vision is able to surmount the opera's [*Porgy and Bess*] familiar images and recast it in his own form. 'Summertime' becomes a lazily sensual dance for nine women, 'Bess, You Is My Woman Now' a sultry, loving *pas de deux*, the hurricane music a miniature Hollywood musical, and 'There's a Boat Dat's Leavin' Soon for New York' a red-hot, jazzy, shimmering trio."

■ *New York Magazine* critic Marica B. Siegel found Gladstein's *Stravinsky Capriccio for Piano and Orchestra* the highlight of SFB's 1978 New York season. "This is the music Balanchine used for *Rubies*, and Gladstein has caught the distinctive bound of Balanchine movement, the supercharged way the dancers throw their arms into positions with the same energy they use when they jump, the clean, logical floor

patterns." Another critic wrote: "The pace of *Capriccio* is furiously fast and the overall look immaculately crisp. The first two movements have that fierce, slightly competitive look of Balanchine's *Agon*: the choreography is rigorous, intense, witty at times to the point of malice. At its best (and its best is very good indeed), Gladstein's *Capriccio* captures that . . . particularly American sense of streamlined physicality—a matter of fact sensuality that's at once playful, innocent, and cruel."

■ *The New York Times* praised Gladstein's *Psalms* (1980) for its admirable "fusion of form and content. The Hebrew Psalms that Leonard Bernstein set to music in the *Chichester Psalms* are used here for a comment on the state of war in which young Israelis find themselves. . . . Gladstein uses stylized folk dances and effective tableau poses to make his points, and he achieves them every time."

SFB Ballerinas

Ruby Asquith.

In 1933, when San Francisco Ballet presented its landmark debut program under the direction of Adolph Bolm, the Company's principal ballerina was Elise Reiman. On opening night, Reiman charmed viewers in five of the program's eleven ballets: she danced leading roles in works as diverse as the neo-romantic *Reveries* (modelled on Michel Fokine's *Les Sylphides*) and Bolm's "ultra-modern" factory fantasy, *Ballet Mécanique*. Born in Terre Haute, Indiana, Reiman was one of Bolm's first American *protégées*. She created the role of Calliope in 1928 when art patron Elizabeth Sprague Coolidge commissioned Bolm to choreograph the first premiere in America of a ballet to Stravinsky music. The work was *Apollon Musagète*, and it opened the first program of ballet ever given at the Library of Congress. (Bolm himself danced Apollo.)

Reiman danced with SFOB during its first two seasons, before moving to New York to join Balanchine's first company in this country, American Ballet. There she created roles in Balanchine's *Serenade*, *Reminiscence*, *Transcendence*, and *Mozartiana*. In 1937, when Balanchine presented the American premiere of his version of Stravinsky's *Apollon Musagète*, Reiman danced the honored role of Terpsichore. (Reiman thus has the distinction of being the only dancer to have performed in both of the first two American premieres of *Apollo*.) Following work in musical comedies, films, and television, she joined Balanchine's Ballet Society (1946-1948), where she created roles in Balanchine's *The Spellbound Child*, *Divertimento*, *The Four Temperaments* (partnered by Lew Christensen), and *Symphony in C* (again partnered by Lew Christensen).

Reiman was the first of many San Francisco Ballet ballerinas. This chapter outlines the careers of some of her worthy successors.

Gisella Caccialanza in Lew Christensen's *Charade* (c. 1939).

Virginia Johnson.

■ Ruby Asquith was raised in Portland, Oregon and studied dance with Willam Christensen. She was sent by Christensen to join his brothers Harold and Lew in New York, where she appeared as principal dancer in the first production of *The Great Waltz* at Rockefeller Center. Later she danced with the American Ballet in the Metropolitan Opera, and was soloist with Ballet Caravan on its pioneering tours of America. She joined SFB in 1940 and quickly became the Company's *prima ballerina*, dancing the principal roles in most of Willam Christensen's new ballets, including *Coeur de Glace*, *Winter Carnival*, *Sonata Pathétique*, *Hansel and Gretel*, *Triumph of Hope*, *Le Bourgeois Gentilhomme*, *Blue Plaza*, and *Parranda*. She also performed leading roles in the Company premieres of *Les Sylphides* and Lew Christensen's *Jinx*. She was a superb comedienne, charming audiences as Swanhilda in *Coppélia*. Today, Asquith lives in Marin County, where she teaches with her husband, Harold Christensen.

■ Born in San Diego in 1914, Gisella Caccialanza went to Milan in 1925 to study at La Scala with Enrico Cecchetti, the renowned dancer and teacher whose former students included Anna Pavlova and Vaslav Nijinsky. Caccialanza studied with Cecchetti for three years, becoming his goddaughter before she returned to the United States in 1928. In 1934, Caccialanza became a charter member of the American Ballet, where she danced in many of George Balanchine's first American works, including *Serenade*, *Alma Mater*, and *Mozartiana*. When American Ballet presented its Stravinsky Festival at the Metropolitan Opera in 1937, Caccialanza danced the lead role in Balanchine's *Le Baiser de la Fée*. With Ballet Caravan, she performed in the first ballets of Eugene Loring, William Dollar, and Lew Christensen. And when American Ballet and Ballet Caravan merged for a 1941 tour of South America (Caccialanza and Christensen were married shortly before the tour), Caccialanza created leading roles in Christensen's *Pastorela*, Balanchine's *Ballet Imperial*, and Antony Tudor's first American ballet, *Time Table*.

Caccialanza came to San Francisco to teach at SFB when America entered the Second World War. With SFB, she created the role of the Sugar Plum Fairy in America's first full-length *Nutcracker*. After the War, she returned to New York to join Balanchine's Ballet Society where she created roles in ballets by Merce Cunningham, William Dollar, Todd Bolender, and Balanchine, including *The Four Temperaments* and *Divertimento*. Scheduled to dance in the American premiere of Balanchine's *Symphony in C*, Caccialanza slipped during a rehearsal and tore her Achilles' tendon. Doctors said she would never dance again. But she resumed her career two years later at SFB, dancing in the Company premieres of Christensen's *Charade* and *Filling Station*, as well as creating a principal role in the world premiere of his *Le Gourmand* in 1951.

Today, Caccialanza and Christensen live in San Bruno, California. Their son Chris began conducting for the SFB Orchestra in 1981.

■ Virginia Johnson, born in St. Paul, Minnesota, moved to the Bay Area as a child. At the age of ten, she began studying ballet with Harold Christensen at the San Francisco Ballet School and made her debut the following Christmas as one of the children in *Nutcracker*. Since then, Johnson has danced all three leading roles in this

ballet: Rose, which was created for her; the Snow Queen; and the Sugar Plum Fairy. Her impressive list of principal roles includes Cupid in *Con Amore*, the Wirewalker in *Jinx*, and leading roles in *Divertissement d'Auber*, *Serenade*, *Concerto Barocco*, *Symphony in C*, *Symphony in D*, *Pas de Six*, and *Variations de Ballet*. As a principal artist with the Company, Johnson has been on three international and five national tours, has appeared as a soloist in the Company's chamber group and with the San Francisco Opera. She has made numerous television appearances, including the *Ed Sullivan Show* (1965) and the ABC-TV production of San Francisco Ballet's *Nutcracker* (1964), in which she danced the role of the Snow Queen.

In 1973, Johnson became Regisseur of the San Francisco Ballet. She has staged a number of the Company's repertory works, among them: *Sinfonia*, *Il Distratto*, *Jinx*, *La Sonnambula*, *Serenade*, and *Four Norwegian Moods*.

■ Cynthia Gregory has been hailed as one of this era's greatest American ballerinas— the first American ballerina of her generation to achieve international stature. Born in Los Angeles in 1946, Gregory was awarded a Ford Foundation scholarship in 1961 to study at the San Francisco Ballet School. Within months of her arrival in San Francisco, she danced in the Company premiere of Balanchine's *Symphony in C*: she was not yet fifteen. After appearing with the Company's concert group in the

Cynthia Gregory in Lew Christensen's *Beauty and the Beast* (c. 1964).

summer of 1961 (during which she performed in the world premiere of Michael Smuin's *Ebony Concerto*), Gregory officially entered the Company's ranks during the 1961 *Nutcracker* season: her first solo role was in the Disappearance of the Turkish Delight.

The following year, Gregory's repertoire expanded as she took on roles in *Serenade*, *The Nothing Doing Bar*, and the first works of Robert Gladstein—*Opus I* and *Biography*. Most frequently, however, she was featured in Lew Christensen's ballets, including *Jest of Cards*, *Danses Concertantes*, and *Con Amore*, in which she played the Mistress.

Her first ballerina role with SFB came during the 1962 *Nutcracker* season: Gregory danced the Rose in the Waltz of the Flowers. The following year, partnered by Robert Gladstein, she was entrusted with one of the Company's most cherished roles: Beauty in Lew Christensen's *Beauty and the Beast*. Four months later, during the Company's 1964 spring season, Gregory danced the part of Anna in SFB's premiere of the Kurt Weil-Bertolt Brecht *The Seven Deadly Sins*, with choreography by Lew Christensen after Balanchine. (Anna's vocal counterpart was played by actress Nina Foch). Later that year, when ABC-TV filmed the Company's production of *Nutcracker*, Gregory danced the Sugar Plum Fairy. And during SFB's 1965 New York debut season, Gregory captured the attention of the New York press and public. "The authority of her dancing and the extensive performing experience of this tall, talented brunette are indeed exceptional," said *Dance Magazine* in a special feature on the rising ballerina.

Shortly after the Company's New York season, Gregory left SFB to join American Ballet Theatre. When ABT was in San Francisco on its 1967 tour, Gregory made her debut in the role of Odette-Odile in *Swan Lake* and, after a second performance in New York, was promoted to the rank of principal dancer. In addition to her brilliant interpretations of the nineteenth century classics, Gregory has excelled in roles created for her by contemporary choreographers such as Michael Smuin (*Eternal Idol*, *Gartenfest*) and Eliot Feld (*Harbinger*, *At Midnight*).

In 1973, she danced the ballerina role at the premiere of Peter Darrell's *Tales of Hoffmann*, the first full-evening ballet by a contemporary choreographer produced by ABT. She has appeared in theaters throughout the United States and around the world; was the recipient of the 1975 Dance Magazine Award; received the first Harkness Ballet Foundation's annual dance award in 1978; and made her debut as a choreographer at ABT's 1980 gala performance with a piece entitled *Solo*.

Antony Tudor, in whose ballets Gregory has excelled, once said that Gregory "did things that very few dancers in history have done." Gregory is indeed a glittering technician—boldly glamorous, imperiously regal. Her chiselled grandeur, technical bravura, and imperturbable presence give her dancing indisputable authority. She is, by even the most conservative estimates, one of the most accomplished technicians this country has produced.

Cynthia Gregory and Robert Gladstein in Lew Christensen's *Beauty and the Beast* (c. 1964).

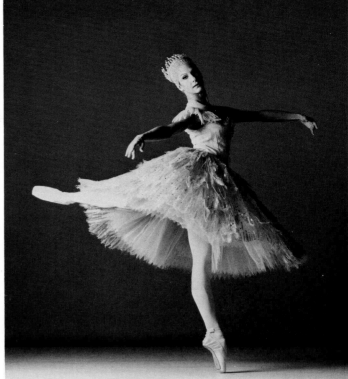

Betsy Erickson in Lew Christensen's *The Ice Maiden* (1982).

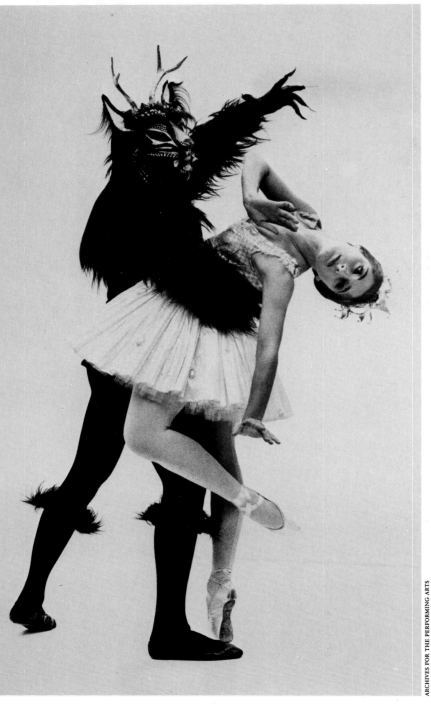

■ Betsy Erickson was born in Oakland and studied at the San Francisco Ballet School. She joined the Company in 1964, creating leading roles in Lew Christensen's *Life* and *Lucifer*, before joining American Ballet Theatre in 1967. Appearing with ABT on numerous national tours as well as tours of Japan, Europe, and Greece, Erickson became a favorite as Myrtha in *Giselle* and Lizzie Borden's mother in *Fall River Legend*, and also appeared in the film version of *Giselle* with Carla Fracci and Erik Bruhn.

Erickson returned to SFB in 1972 and soon established a reputation for the elegance and precision of her dancing in leading roles in *Symphony in C*, *Concerto Barocco*, *Serenade*, *Beethoven Quartets*, *Tealia* (both the stage and film productions), *The Ice Maiden*, *Vivaldi Concerto Grosso*, and *The Tempest* (both the stage and television productions). "She has the stabbing accuracy, the beautiful long line, and, most of all, faith in and devotion to the music," wrote one reviewer. By another critic's description, "Her dancing has the lapidary precision of cut glass—cool and clear as crystal."

Erickson choreographed her first ballet, *Bartók Quartet No. 5*, for the Company's 1981 Summer Festival. Her second ballet for SFB, *Pixellage*, was created for the 1983 Fiftieth Anniversary Season.

■ A native of New Jersey, Diana Weber began her ballet career at the age of five when her mother enrolled her in dance classes. By the age of eleven, she was attending the American Ballet Theatre School as a scholarship student. She joined ABT in 1962 and became a soloist in 1966, dancing leading roles in *Giselle*, *Coppélia*, *Theme and Variations*, *Petrouchka*, and creating roles in Michael Smuin's *Pulcinella Variations* and *Schubertiade*. She appeared at the White House in a special presentation for President Johnson and in the film of *Giselle* with Erik Bruhn.

Weber came to SFB in 1973, bringing a solid technique to principal roles in *Divertissement d'Auber*, *Serenade*, *Monotones*, and *Scherzo*, and dramatic sensitivity and depth to the roles of Doña Ana in *Don Juan*, Lise in *La Fille Mal Gardée*, Beauty in *Beauty and the Beast*, Cinderella in *Cinderella*, and Juliet in both the stage and television productions of Smuin's *Romeo and Juliet*. Weber's portrayal of Juliet was a triumph of lyric romanticism: a signature role. The *Los Angeles Herald Examiner* described her performance: "A Juliet of appealing innocence and ardent conviction, she is also a dancer of rare lyric sensibilities." Clive Barnes hailed her Juliet as "beautifully shy, fugitive, and appealing," while the *San Francisco Chronicle* praised Weber as "one of the finest lyric dancers in the country today."

Weber retired from performing in 1982. Today, she is Company Regisseur and serves on the faculty of the San Francisco Ballet School.

■ Lynda Meyer was born in Texas and joined SFB in 1963, after studying at the SFB School on a Ford Foundation scholarship. She was Beauty in the 1968 ABC-TV special of Lew Christensen's *Beauty and the Beast*, a performance which brought her a personal invitation from Prince Rainier and Princess Grace to attend a special reception following the premiere of the film in Monaco. In 1970, Meyer created leading roles in Michael Smuin's classically inspired *Schubertiade* and John Butler's abstract *Split*. As guest artist with Willam Christensen's Ballet West on that Company's first European tour, Meyer was seen as Odette in *Swan Lake*, and in Balanchine's *Serenade* and *Tchaikovsky Pas de Deux*, partnered by New York City Ballet's Jacques d'Amboise. Her command of technique has inspired many choreographers to create ballets for her: she has created principal roles in *Cinderella*, *Romeo and Juliet*, *Q. a V.*, *Songs of Mahler*, *Scarlatti Portfolio*, and *Three*, choreographed

especially for her by John Butler. Her exceptional versatility is evident in leading roles in *Agon*, *The Four Temperaments*, *Serenade*, *Symphony in C*, *Concerto Barocco*, *La Sonnambula*, *Divertimento No. 15*, *Medea*, *Con Amore*, and *Nutcracker*. In 1981, Meyer appeared as Juno in the national PBS broadcast of Smuin's *The Tempest*. The range of her talent is immense, encompassing serenely romantic portrayals, bravura showpiece roles, and intensely wrought characterizations. She is, as the *San Francisco Chronicle* has said, "a model of controlled technique and flawless line."

■ Evelyn Cisneros was born in Long Beach, California, and studied in Huntington Beach before entering the San Francisco Ballet School. She joined the Company in 1977. Her impressive debut in Michael Smuin's *Scherzo* prompted one critic to remark: "Her suppleness, quickness, and fearlessness will certainly provide more excitement in future performances. She's a girl to watch." Since then, Cisneros has indeed compiled an impressive list of performance credits, having appeared in George Balanchine's *Serenade*, *Divertimento No. 15*, *Symphony in C*, *Stars and Stripes*, and *Western Symphony*, in Michael Smuin's *Medea*, *Romeo and Juliet*, *Duettino*, and *Q.a V*, and Lew Christensen's *Nutcracker* and *Beauty and the Beast*.

In her leading female role in Smuin's *A Song for Dead Warriors*, the *San Francisco Chronicle* described her as "an incandescent Indian beauty—soft, vibrant, and telling in her struggles," and later said, "Cisneros' first solo was glorious, and the duo that followed, breathtaking." During the Company's 1980 season at the Brooklyn Academy of Music, Cisneros won repeated acclaim as an exceptional stylist. *The New York Times* sang her praises in headlines, and *The New Yorker* critic Arlene Croce said Cisneros exemplified "the bold new spirit that seems to be sweeping the Company. Cisneros has exceptional aplomb along with exceptional softness and refinement— she's not at all brash. Though her technical command is considerable, a lot of her power is still in bud. The San Francisco Ballet . . . has more vitality than most companies across the continent can claim. To have a rising ballerina, too, is a piece of luck."

In 1981, Cisneros appeared as Miranda on the nationwide PBS television broadcast of Smuin's *The Tempest*. The following year, she was featured in a live broadcast from the White House in selections from Smuin's *Q.a V.*, and in the world premiere of "Ragtime" from Smuin's *Stravinsky Piano Pieces*.

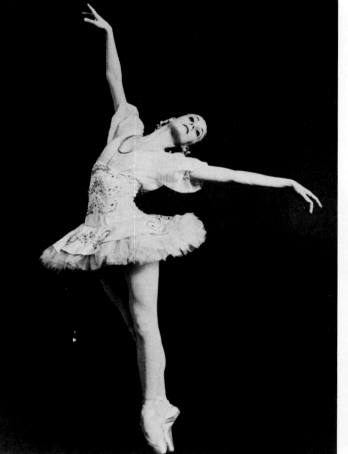

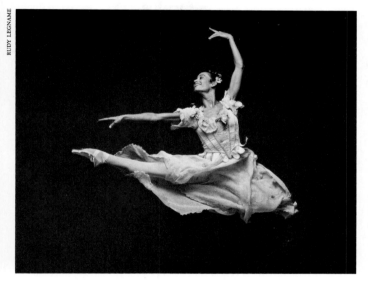

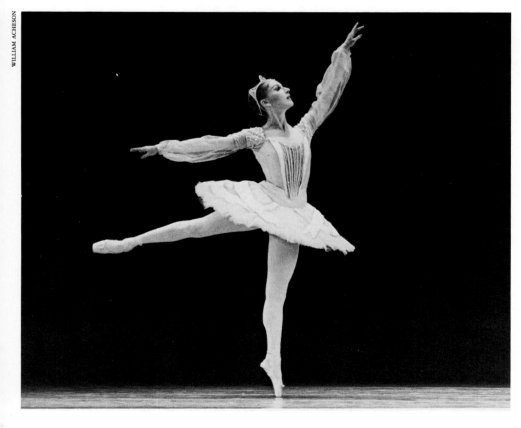

Above left. Diana Weber.
Above right. Evelyn Cisneros in Michael Smuin's *The Tempest* (1982).
Left. Lynda Meyer in Michael Smuin's *Q. a V.* (1981).

Pas de Deux by Michael Smuin

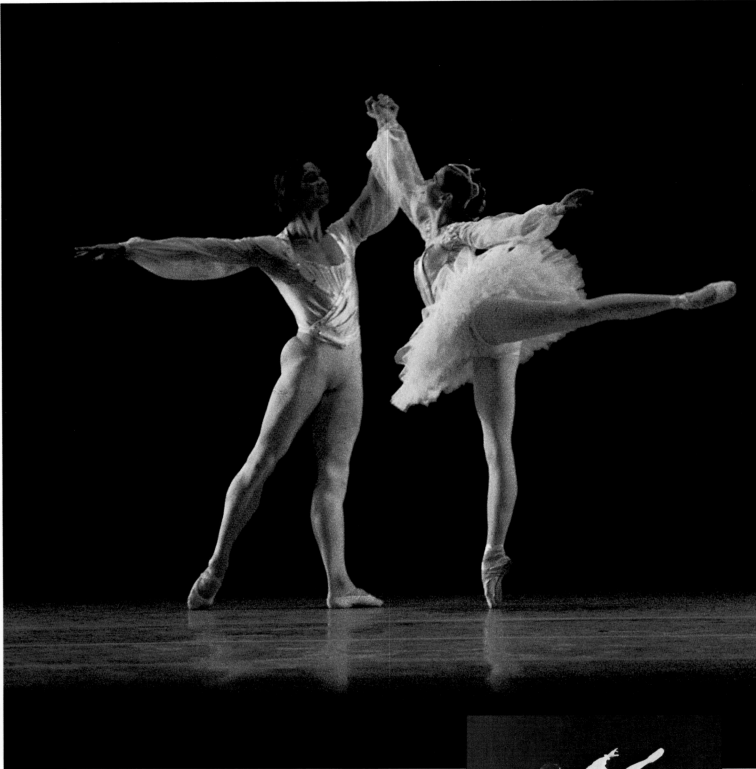

LLOYD ENGLERT

C L A S S I C A L

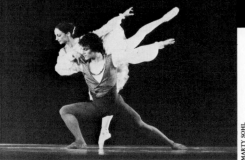

MARTY SOHL

Above. Dennis Marshall and Gina Ness
in *Q. a V.* (1978).
Right. Diana Weber and David
McNaughton in *Duettino* (1979).

126

Discussing the *34* ballets he has choreographed for the Company, Michael Smuin has said, "If I've made a technical contribution to the SFB style, it's in partnering. My *pas de deux* require a new level of expertise—sometimes dancers need to rehearse a *pas de deux* for a year in order to really master it. Every *pas de deux* I've done is different—I'm a slave to the music, for starters, and you use a couple's encounter to heighten or frame some moment in the work—but they all do generally share a sense of perpetual motion. I use off-balance motion to get the value of weight falling, the momentum of recovery. I like acrobatics and just plain wonderful physical strength, and our performers are daring."

ROMANTIC

BOTH PHOTOS: LLOYD ENGLERT

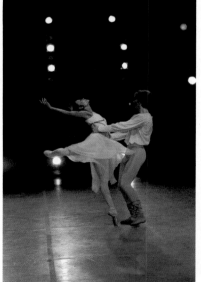

Above. Evelyn Cisneros and Alexander Topciy in *Romeo and Juliet* (1982).
Left. Vivian Little as Miranda and Jim Sohm as Ferdinand in *The Tempest* (1980).

127

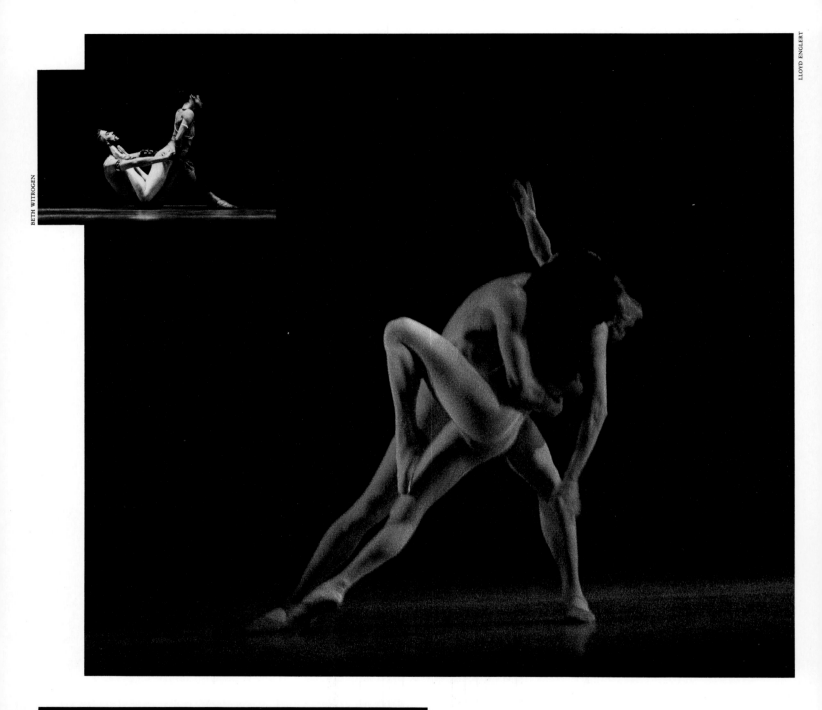

C O M I C

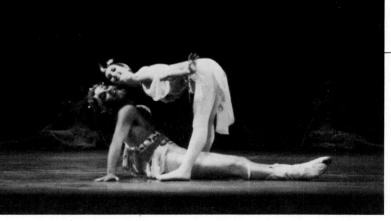

Above left. Dennis Marshall as Jason and Laurie Cowden as Creusa in *Medea* (1977).
Above right. Lynda Meyer and Vane Vest in *Eternal Idol* (1981).
Left. Paula Tracy as Ceres and Robert Sund as Bacchus in Act Two of *The Tempest* (1980).

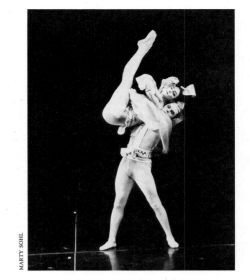

MARTY SOHL

JAMES ARMSTRONG

Above. Anita Paciotti and Attila Ficzere in *Shinjū* (1982).
Left. Anton Ness and Paula Tracy in *Shinjū* (c. 1978). (Photo: Dan Esgro)
Far left. Vane Vest as Neptune and Lynda Meyer as Juno in Act Two of *The Tempest* (1980).

129

1981 Edinburgh Festival

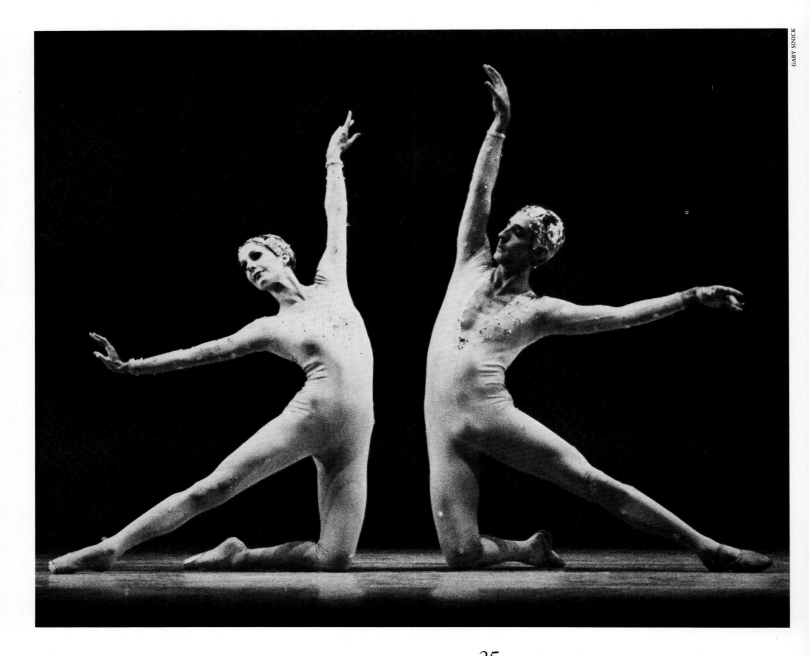

The *Glasgow Herald* hailed John McFall's *Tealia* as "a little gem—a subtly sculptured *pas de deux* which echoes the music's mystery in a series of sinuously languorous movements with marvellous hints of floating/flying. Vane Vest and Betsy Erickson danced as if boneless. Brilliant."

The 35th Edinburgh International Festival provided the occasion for San Francisco Ballet's Western European debut in 1981. A repertory of twelve ballets was transported across the Atlantic for the Company's eight-performance season at the Festival, and with the single exception of Balanchine's *Divertimento No. 15* (never before seen in Great Britain), the Company's Edinburgh repertoire was strictly its own, featuring ballets by five of the Company's resident choreographers. "You have *repertory*, your *own* repertory," Festival Director John Drummond said, explaining why he had invited SFB to Edinburgh.

Edinburgh is one of the largest and most prestigious of the European summer arts festivals. Founded in 1947 by Rudolf Bing, Director of the Metropolitan Opera from 1950 to 1972, the annual Edinburgh Festival is a three-

week display of international talent, "the festival of festivals" as it has often been called. Over 1,000 shows are presented each year, and the Festival's all-inclusive tastes run from opera, dance, theater, chamber music, and recitals to jazz and poetry readings. Besides the official events, each Festival stimulates a secondary wave of unaffiliated entertainments collectively known as "the Fringe." Most of the world's major classical dance companies—American Ballet Theatre, Britain's Royal Ballet, the New York City Ballet, and the Royal Danish Ballet—have been presented at Edinburgh, but as Festival Director Drummond noted, SFB marked a new era for dance at Edinburgh. "In our thirty years we have mined European dance rather thoroughly. All the American dance in the past has been from the New York area, but we were aware that exciting things are happening away from traditional cultural centers. I took a first look at the San Francisco Ballet and it was a quick decision to invite them to the Edinburgh Festival."

At Edinburgh's newly refurbished Playhouse Theater, San Francisco Ballet opened its season with Michael Smuin's *Romeo and Juliet*, a daring choice, many said, considering that British critics were so well versed in the MacMillan, Cranko, and Lavrovsky productions. Smuin's was, in any case, the first dance version of Shakespeare's tragedy to play the Festival in over a quarter of a century, since the Royal Danes brought Ashton's version in 1955. Despite certain unavoidable handicaps—the Playhouse stage was too small for the entire set, so the balcony scene had to be danced without the balcony—the production was boisterously acclaimed by the capacity audience. Diana Weber and Jim Sohm, the opening night Juliet and Romeo, received nine curtain calls. "Weber's deeply touching portrayal of Juliet," said the *Glasgow Herald*, "was masterly from every point of view, even to one who has seen Ulanova in the part." And Attila Ficzere's great Mercutio showed its customary brio, vigor, and devil-may-care impudence. "One had been led to expect so much from the San Francisco Ballet on its British debut at the Edinburgh Festival that complete fulfillment seemed unlikely," said the *Manchester Guardian* after the opening night of *Romeo and Juliet*. "However, the superlatives were justified. This is a splendid company of dancers; not just a handful of outstanding classical soloists, but also a reliable *corps de ballet* and a rich amalgam of crucial attributes—strength, eloquence, agility, elegance, playfulness, and verve." Overnight, San Francisco Ballet became a major hit—"the festival's prime attraction" as the *San Francisco Examiner* reported.

The three mixed programs that followed *Romeo and Juliet* featured four other Smuin ballets (it was Europe's first major look at the Smuin style), and critics were struck by the variety and scope of his work. Smuin gave them: a Petipa-inspired fireworks display, *Quattro a Verdi*;

a lyrical, intimate suite of dances, *Songs of Mahler*; a grand-scale, grand-style masque from *The Tempest*; and a visionary protest piece about the oppression of the American Indian, *A Song for Dead Warriors*, the season's most "American" and spectacularly produced ballet, which met the same fate in Scotland as it had here in the states—the audiences loved it, the critics (who called it everything from "Indian Corn" to "Hollywood kitsch") by and large did not.

Lew Christensen's festival showings—*Con Amore, Variations de Ballet, Vivaldi Concerto Grosso*—were praised as lively display pieces for the Company's neoclassical skills: brilliant showcases for Lynda Meyer's "dazzlingly effortless arabesques and cleanly elegant lines," Attila Ficzere's "bravura and style," and David McNaughton's "brilliant athleticism."

San Francisco Ballet broke attendance records at Edinburgh, and as the *Festival Times* noted, throughout its season the Company was an overwhelming audience success, winning one tumultuous ovation after another. The critics joined in the public's enthusiasm, praising the Company's "bounding vitality," "confident vigor," and "admirable legwork." But several reviewers objected to the "surfeit" of abstract ballets in SFB's repertoire. Like many other U.S. companies touring England, San Francisco Ballet learned that American and British dance tastes differ: England, steeped in one of the world's strongest theatrical traditions, sees ballet largely as an extension of drama. Confronted by SFB's abstract works (Tomm Ruud's *Introduction and Allegro*, John McFall's *Tealia*, and Robert Gladstein's *Stravinsky Capriccio for Piano and Orchestra* are all plotless), some British reviewers could only see "a string of party pieces"—even *Divertimento No. 15* was dismissed as "one of Balanchine's most sterile inventions."

Criticism and all, the Company's Edinburgh season was undeniably momentous—"the greatest odyssey of its forty-eight year existence," the *San Francisco Examiner* said in a moment of hyperbole. Expanding upon the reputation earned during the Company's successful 1978 and 1980 New York seasons, the Edinburgh Festival provided SFB with a long overdue international exposure. "This appearance at the Festival realizes a dream I've had for the Company throughout my career," Lew Christensen said. "We've performed in cities across the United States, Canada, Latin America. We were the first American dance company to tour the Far East in 1957. But we've never danced in Western Europe before. This engagement is not only a first for the San Francisco Ballet, it's a breakthrough for ballet in the Western United States, which has tended to be neglected in the past. It's wonderful that the administrators of the Edinburgh Festival realize that dance in this country doesn't happen exclusively on the East Coast."

35

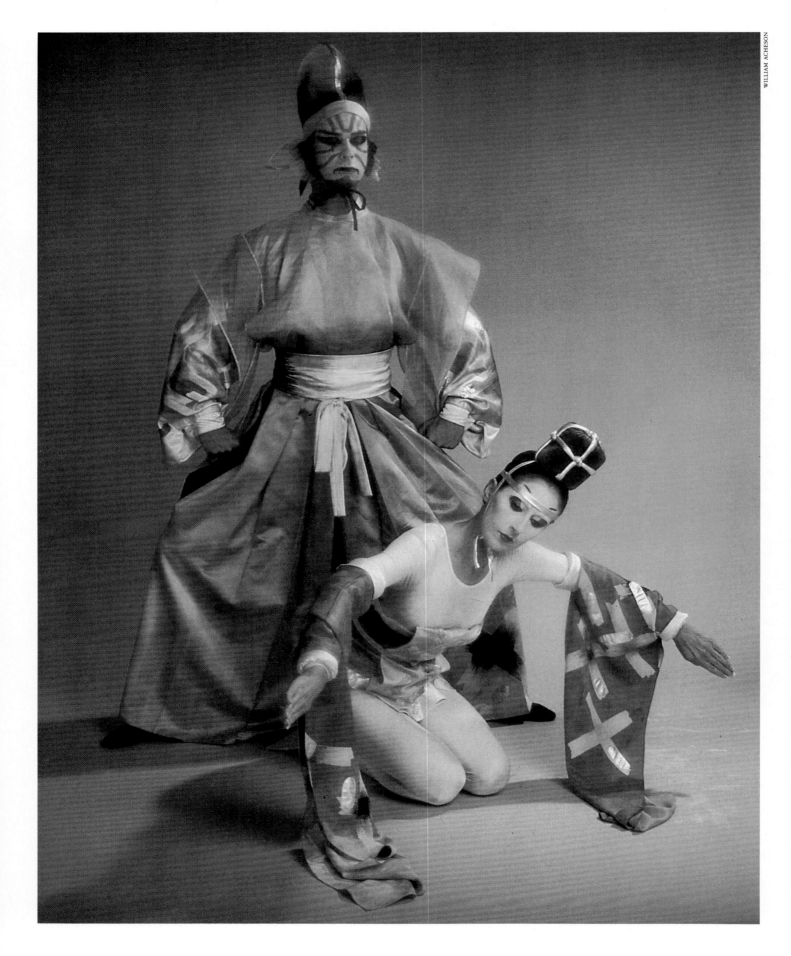

DAN ESGRO

Opposite. Paula Tracy and Robert Sund in *Shinjū* (1982).
Left. Paula Tracy in *Shinjū* (c. 1978).
Below left. Attila Fizcere (top) and John McFall in *Shinjū* (1982).

Michael Smuin was *36* when he created *Shinjū* for San Francisco Ballet's 1975 spring season. Since returning to SFB in 1973, Smuin had won a reputation as a remarkably fluent and versatile choreographer—a solid craftsman with a great flair for theatrics. In his first two years as the Company's new Associate Director, he had staged six distinctive works, ranging from the dramatic *For Valery Panov*, a stark four-minute solo, to *Cinderella*, a sumptuous full-length fairy tale ballet that he cochoreographed with Lew Christensen. *Mother Blues*, set to a jazz-inspired score by William Russo, revealed Smuin the savvy popularizer of high-energy youth. *The Eternal Idol* and *Harp Concerto*, brimming with delicate grace and shaded by the varied moods of love, featured Smuin the ardent romantic. And *Pulcinella Variations*, originally created for American Ballet Theatre in 1968 and restaged for SFB in 1974, showcased Smuin's pronounced comic talents.

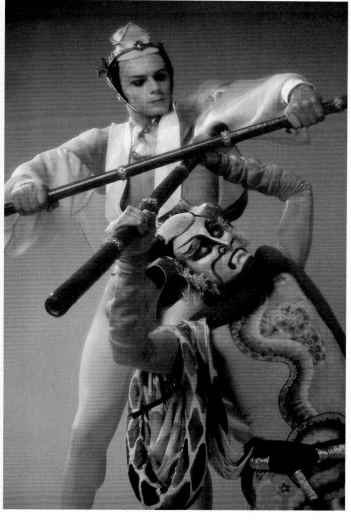

WILLIAM ACHESON

Although *Shinjū* reworked certain themes of these earlier ballets—the heightened sensuality of *The Eternal Idol*, the youthful orientation of *Mother Blues*, the social drama of *For Valery Panov*—the ballet marked a bold

new direction for Smuin. Achieving its large effects with a singular economy of means, *Shinjū* revealed a controlled, mature style. The narrative was finely honed to the edge of abstraction, the choreography stylized to an intense, poetic distillation. The entire ballet combined a severity of structure with an intensity of mood that spoke of Smuin's ability to orchestrate strikingly diverse effects with great skill and authority. *Shinjū*, it was said, marked Smuin's coming-of-age: the craftsman had become an artist.

36

Smuin first conceived *Shinjū* in 1968 while touring Japan as a principal dancer with American Ballet Theatre. "I was fascinated by Japanese theater," he later told the *San Francisco Chronicle*, "so I went to everything, nearly every day, taking in Kabuki, Nōh, and the Bunraku puppets." Smuin grew especially intrigued by the eighteenth-century playwright Chikamatsu Monzaemon, often called the Japanese Shakespeare. Noted for his emotionally tense and violent narratives that drew equally from great historical themes and the social drama of contemporary city life, Chikamatsu had written one play that came to haunt Smuin—*Shinjū-Ten-No-Amijima* (1721), which recounted the plight of two young lovers who, when thwarted by familial and social pressures, commit a ritualistic double suicide rather than endure earthly separation. During the five years following his trip to Japan, Smuin continued to research ancient Japanese theatrical and musical traditions. In 1973, Mr. and Mrs. Isaac Arnold commissioned a score for Smuin from Paul Seiko Chihara, the Japanese-American composer, then teaching at UCLA, who was to become an important force at SFB. (In 1979, Chihara composed the score for Robert Gladstein's *The Mistletoe Bride*; in 1980, he wrote the music for Smuin's *The Tempest*, the first full-length original score in SFB's history; and in 1982, he created a special processional for the groundbreaking for the Company's $11.2 million home in the Performing Arts Center. Chihara has served as SFB's composer-in-residence since 1980.)

Chihara began working on *Shinjū* by consulting Suenobu Togi and Mitsuru Yuge, both formerly of the Japanese Imperial Court Orchestra and then members of the UCLA Ethnomusicology faculty. "We all had to begin with a basic understanding of the word *shinjū* and its tradition," recalls Chihara. "To fully realize the significance of *shinjū*, though, which literally means 'lovers' suicide,' it helped us to remember the over-

whelming importance of public ritual in ancient Japan. Unlike the great ill-fated Western lovers, such as Tristan and Isolde and Romeo and Juliet, the death of the lovers in *Shinjū* is no accident. They elect their double suicide as the most powerful way to express their love, to preserve it, and to achieve ultimate togetherness. Since both Suenobu Togi and Mitsuru Yuge were very familiar with the *shinjū* tradition, and the court and theater music of the period, I asked them to perform and improvise music appropriate to the dramatic situations in the story. I then mixed ancient Japanese court music (wind instruments, wood blocks, and vocal chanting) with modern Western orchestration. From the beginning, the goal for me—and for Michael Smuin—was to be faithful to the spirit of Japanese culture, while still remaining accessible to a Western audience. We wanted to marry two traditions."

Smuin then chose Broadway and ballet designer Willa Kim to create costumes and scenery. Incorporating such traditional Japanese motifs as hanging floral strands, origami birds, and diaphanous silk canopies, Kim created an exquisite fantasy in lacquer red, silver, and white. It was Kim's first assignment for SFB, and she, like Chihara, has since become an important collaborator on SFB productions. (Kim later designed Robert Gladstein's *Stravinsky Capriccio for Piano and Orchestra* as well as four other ballets for Smuin—*A Song for Dead Warriors*, *The Tempest*, *Bouquet*, and *Stravinsky Piano Pieces*.)

Shinjū was an overwhelming success at its premiere—the hit of the 1975 season. Smuin's choreography was hailed as "one of the most extraordinary stylistic forays

Tracy-Kai Maier and Tomm Ruud as the lovers, with Grace Madwell (back left) and Kristine Peary in *Shinjū* (1982).

WILLIAM ACHESON

by any American ballet company." Kim's designs were pronounced "nothing less than important works of art." And Chihara's score was later nominated for a Pulitzer Prize. In fact, few other ballets in SFB's recent history aroused such acclaim. *San Francisco Examiner* critic Arthur Bloomfield called *Shinjū* "a stunner, a jewel, a brilliantly creative and occasionally mind-boggling, nerve-rattling ballet, a piece which the whole dance world has got to see. . . . There's a lean, hard, cold line of tension which arches over the stylized hills and valleys, the serenities and intensities—and pauses—of *Shinjū*, but there's also a human warmth which, while often stated more subliminally than directly, is very much there. . . . Smuin's choreography is a sensitive *tour de force* of Oriental-Occidental blending. Japanese theatrical attitudes and a sense of timelessness are juxtaposed, or merged, with classic and modern Western dance so artfully and communicatively that only a pedantic anti-culture-crosser would complain."

The attempted abduction sequence in *Shinjū*, which explodes into a battle among samurai warriors and mountain bandits, was called "one of the most wild, frightening things ever witnessed on the Opera House or any other stage." And the ritualistic *dénouement*, in which the ill-fated lovers, disrobed to the waist, plunge daggers into each other and writhe in pain, releasing streamers of red ribbon from their bellies, was deemed among the most stunning—and shocking—duets in SFB's history.

Since its premiere, *Shinjū* has proved one of the most durable of SFB works. In repertory every year save 1980 and 1981, it has also been performed extensively on SFB's tours, including the Company's important 1978 New York season, when it was compared (favorably and unfavorably) to Balanchine's Japanese ballet, *Bugaku*.

Smuin followed *Shinjū* with three other "love and death" ballets—*Romeo and Juliet* (1976), *Medea*, and *Scherzo* (both 1977). These four ballets, each set in a distant time and faraway land, reveal Smuin's dark romanticism—his attraction to larger-than-life passions. In this quartet of ballets, Smuin eroticizes history: the distance of the past allows him to handle the immediacy of passion. Despite their radically different settings, *Shinjū*, *Romeo and Juliet*, and *Medea* express remarkably similar themes: each overflows with the violence of romance, each is preoccupied with a sexuality of almost mythic dimensions. In these ballets, emotions take on an epic grandeur; the domesticity of love gives way to the exoticism of passion; and overwhelming desires practically defy fulfillment, as Eros and Thanatos link arms.

Shinjū also announced an important new visual style for Smuin. In 1980, during SFB's second season at the Brooklyn Academy of Music, *The New Yorker* critic Arlene Croce likened Smuin to David Belasco and Max Reinhardt, so skilled was Smuin at orchestrating various effects in a seamless spectacle and dominating them

Tracy-Kai Maier and Tomm Ruud in the dramatic climax of *Shinjū* (1982).

with his personal vision. But Croce wondered if even Reinhardt could have reconciled as many contrasts as Smuin does in a ballet like *A Song for Dead Warriors*, whose visual style, Croce said, was at once austere and extravagant. Smuin's mixing of austerity and extravagance—now a trademark of the Smuin style—began, it could be said, in *Shinjū*. In *Shinjū*, Smuin found a way to combine passages of furious, jabbing violence with sequences of near-hypnotic tranquility. (Just as Japanese composers have been said to "orchestrate" silence, so, too, can Smuin "choreograph" stillness.) Rigorous austerity and lush, highly charged eroticism exist side by side in *Shinjū*: as *San Francisco Examiner* critic Michael Walsh noted, for all its tangible carnality,

Shinjū has a "strikingly ritualized asceticism about it."

Shinjū thus was an important turning point in Michael Smuin's career. It was his first commissioned score as SFB's Associate Director, his first collaboration with Paul Chihara and Willa Kim, the first of his "love and death" dramas, and the first of his austere/extravagant ballets. It was no secret that since returning to SFB in 1973, Smuin was on the attack. His objective: to put SFB on the map as a Company of startling new ballets. With its powerful score, stunning designs, and shocking *dénouement*, *Shinjū* was everything Smuin wanted: a popular and critical success that "the whole dance world has got to see." *Shinjū*, it has been said, was Smuin's first true "SFB" ballet.

135

SFB's Male Dancers

In 19*37* Willam Christensen came to San Francisco Ballet and, in so doing, altered the course of male dancing in America. "Although more Americans now are interested in classical dancing than ever before, male dancers are still hard to find," he told the press in 1938, the year he was named SFB's Director. Male dancers, he continued, had, of course, played a large role in developing ballet during the seventeenth and eighteenth centuries, and they were still a potent force in Russia and Denmark. But in Europe and America, he explained, ballet was not deemed a suitable career for men—it was "women's work," pure and simple.

In the ensuing forty-five years, Willam Christensen and his brothers Lew and Harold ensured that dance in America could be both men's and women's work. As dancers, the three brothers provided a clear example of masculine grace, technical assurance, athletic virtuosity, and quiet dignity. As teachers, they produced some of the best male aspirants on the continent. And as choreographers, Lew and Willam created ballets that brilliantly, but undidactically, gave the *danseur* parity with the *danseuse*. The Christensens' efforts during the past half century have given SFB its strong, vital tradition of male dancing, a tradition that has won SFB repeated praise, and that is today maintained and developed by men like Michael Smuin and Robert Gladstein. This chapter chronicles the careers of but a few of the *danseurs* who have made that tradition so resplendent.

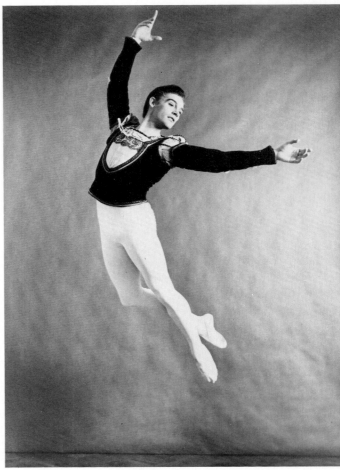

Conrad Ludlow

136

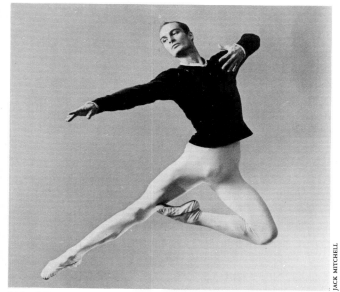

Richard Carter

■ *Opposite left.* James Starbuck and Janet Reed in the title roles of Willam Christensen's *Romeo and Juliet* (1938). Starbuck was "a pure product of the American West," as *Dance Magazine* later said. He was born in Albuquerque, spent his childhood in Denver, and was educated in California—public school in Oakland, college in Stockton. He had thoughts of becoming an actor, appeared in school plays and even toured California one summer with a repertory company. But dance was his main interest. In 1934, he joined the San Francisco Opera Ballet, then under the direction of Adolph Bolm. Three years later, when Willam Christensen joined SFOB and organized a small touring company, Starbuck was one of the company's leading dancers. He created roles in most of Christensen's first ballets for SFOB, including *Romeo and Juliet*, *In Vienna*, and *Ballet Impromptu*.

In 1939 Starbuck left SFOB to join the Ballet Russe de Monte Carlo where he won important solo roles in the ballets of Léonide Massine, including *The Three-Cornered Hat*, *The New Yorker*, and *Gaîté Parisienne*, in which he danced Massine's own role of the Peruvian. In addition to performing, Starbuck also served as rehearsal assistant for Agnes de Mille as she choreographed the American classic *Rodeo*. (Starbuck recalls that the Russian dancers, disdainful of anything "American," had to be cajoled into rehearsing.) Starbuck remained with Ballet Russe for seven years, and during his last seasons with the company, began dancing in Broadway musicals, including *Song of Norway*, *Music in My Heart* (choreographed by Ruth Page), and *Sleepy Hollow* (choreographed by Anna Sokolow).

In 1948 Starbuck embarked on what was to become his most successful endeavor: choreography for television. He worked on some of the most successful series in TV's early years, including the legendary comedy and variety series *Your Show of Shows*, starring Sid Caesar and Imogene Coca. It has been said that no TV program since *Your Show of Shows* offered its choreographer such opportunities, such material, such stars. Starbuck created wonderfully astute satires of *Swan Lake*, *Giselle*, *Sleeping Beauty*, and *Nutcracker* for himself and his "prima ballerina assoluta," comedienne Imogene Coca. These hilarious spoofs created an interest in ballet among the millions of regular viewers and allowed Starbuck to invite ballet stars like Frederic Franklin, Maria Tallchief, Tamara Toumanova, and Alicia Markova to appear as guest artists on the series. After dancing "straight," many of the ballet stars would join in comedy sequences with Coca and Starbuck. (In a rehearsal with Starbuck, Markova apologized, "I don't suppose it's much fun working with me—after all, I'm not Imogene Coca.")

After *Your Show of Shows*, Starbuck choreographed a television special for Bob Hope (in which Dinah Shore made her TV debut) and one for Maurice Chevalier (which introduced Marcel Marceau to America). He worked on two award-winning *Bell Telephone Hours*, including one featuring the American Ballet Theatre in *Billy the Kid*. His choreography during the late Fifties and Sixties included works for Hollywood (*The Court Jester* with Danny Kaye), Broadway (*Thurber's Carnival*, *Oh Captain!*) television (*The Arthur Murray Party*, *Sing Along with Mitch*), ballet (*Le Pont* for the Grand Ballet de Marquis de Cuevas, *The Comedians* for the twenty-fifth anniversary season of the Ballet Russe de Monte Carlo), and the nightclub circuit (Starbuck staged acts for Lisa Kirk, Dorothy Dandridge, and Maurice Chevalier).

Starbuck's pioneering efforts have frequently earned him the title "the father of television dance."

■ Conrad Ludlow was born in Hamilton, Montana, in 1935. He studied dance at the San Francisco Ballet School with Harold, Lew, and Willam Christensen, graduating into the Company in 1953, when he created the role of the Student in Lew Christensen's comic masterpiece, *Con Amore*. In 1955, Ludlow was appointed principal dancer, winning great success in the SFB premiere of Balanchine's *Apollo*. The *San Francisco Chronicle* hailed Ludlow's Apollo as "the perfect embodiment of lordly masculine power—an aristocratic, intellectual power symbolized in physical presence and movement." Ludlow's repertory at SFB also included principal roles in *Jinx* (the Juggler), *Beauty and the Shepherd* (Paris), *Nutcracker* (the Cavalier), *Con Amore* (the Thief), and *Dryad* (the Young Man). Ludlow was SFB's principal male dancer during the Company's East Coast debut in 1956 at Jacob's Pillow.

In 1957 Ludlow joined the New York City Ballet, but his career was soon interrupted when he was drafted into the Armed Forces. He rejoined NYCB in

1959, creating roles in Balanchine's *Monumentum pro Gesualdo* (1960), *Liebeslieder Walzer* (1960), *Tchaikovsky Pas de Deux* (1960), *A Midsummer Night's Dream* (1961), *Emeralds* (1967), and *Tchaikovsky Suite No. 3* (1970). His NYCB repertory featured leading roles in more than fifty ballets, including *Concerto Barocco*, *Symphony in C*, *Firebird*, *Divertimento No. 15*, and *Apollo*. (In 1966, noted critic B. H. Haggin praised Ludlow's Apollo as the finest since Andre Eglevsky's in 1945.)

In 1973, Ludlow and his wife, NYCB dancer Joy Feldman, were appointed co-directors of Ballet Oklahoma. Today, Ludlow directs the Grand Teton Ballet in Wyoming.

■ Richard Carter has been affiliated with San Francisco Ballet for over twenty years and, in that time, has proven his expertise in both artistic and administrative fields. At the age of sixteen, Carter was studying dance with the idea of going into musical comedy, but gradually his interest shifted to ballet. After studying at the San Francisco Ballet School, he joined the Company in 1953. Shortly afterward, however, Carter was drafted into the Army. While in the service, he was sent to Germany and there performed leading roles with the Salzburg Landes Theatre. He danced and choreographed for military shows and produced his own ballet, *Ratatuli*.

Upon his release from the Army, Carter rejoined SFB and became the Company's *premier danseur*. He created principal roles in almost all of Lew Christensen's ballets during the late Fifties, including *Beauty and the Beast*, *Sinfonia*, *Divertissement d'Auber*, *Lady of Shalott*, *Caprice*, and *Danses Concertantes*. He danced with SFB on its international tours (1957-1959), playing major roles that included Mac in *Filling Station*, Prince Siegfried in *Swan Lake*, and the Cavalier in *Nutcracker*.

In 1960, Carter assumed the post of Associate Professor of Dance at California Western University in San Diego, and a year later founded the San Diego Ballet. As the Company's Artistic Director, Carter created over twenty-five ballets. In 1968, he returned to SFB as Production Manager and four years later became Ballet Master.

Following three years as Director of the Auditorium Fairgrounds Department in the County of Marin, Carter left for Pennsylvania Ballet, where he was Artistic Administrator until 1978. After a year as Production Manager at Pacific Northwest Ballet in Seattle, he returned once again to SFB to become the Company's Technical Director in 1980.

■ Vane Vest was born in Vienna, Austria, and moved to Denver, Colorado, at an early age. He began his dance studies at the Ballet Arts Center and appeared with the Denver Civic Ballet and the Wisconsin Civic Ballet before joining American Ballet Theatre in 1968. His roles with ABT included Von Rothbart in *Swan Lake*, Hilarion in *Giselle*, and solo roles in *Etudes*, *Les Patineurs*, and *Rodeo*.

Vest joined SFB in 1972. In principal roles in the ballets of George Balanchine (*The Four Temperaments*, *Concerto Barocco*, *Symphony in C*) Michael Smuin (*Songs of Mahler*, *A Song for Dead Warriors*, *The Tempest*), and Lew Christensen (*Cinderella*, *Beauty and the Beast*, *Nutcracker*), Vest has demonstrated his extraordinary range. As Romeo in Smuin's *Romeo and Juliet*, he inspired one critic to say: "Vest is the perfect partner: with great sublety, skill, and modesty, he plays black velvet to the ballerina's diamond." Vest has also delighted and surprised audiences with his comic portrayals in *Souvenirs*, *Filling Station*, *Scarlatti Portfolio*, and *The Nothing Doing Bar*. Of his performance as the Widow Simone in Sir Frederick Ashton's *La Fille Mal Gardée*, the *Manchester Guardian* said, "he showed the same kind of three-dimensionality and warmth as his illustrious predecessor (Stanley Holden)." His versatility prompted one critic to describe him as "the kind of dancer a company can be built around." In 1982 Vest assumed the responsibilities of Company Regisseur while continuing to perform.

37

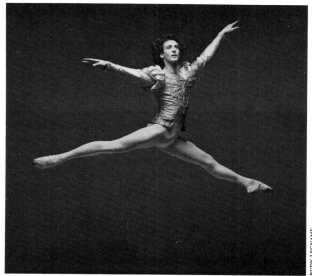

Vane Vest (1982).

The Performing Arts Orchestra

SFB Music Director and Conductor Denis de Coteau.

In 1975 San Francisco Ballet established the *38* member Performing Arts Orchestra and became one of the few American dance companies with its own permanent body of musicians. The creation of a resident orchestra that could tour with the Company was clearly an act of daring, especially given the fact that SFB had just weathered one of the worst financial crises in its history, a crisis that drove the dancers themselves to the streets (not to mention to the department store windows, football halftimes, and TV talk shows) during the Company's much-publicized "Save Our Ballet" Campaign. Despite the financial tempest, Michael Smuin realized the necessity of a permanent orchestra if SFB were to continue its renascence. Music was a dancer's floor, Balanchine said, and Smuin knew that he couldn't give his dancers a first-rate "floor" without first-rate musicians. A fine ballet company, Smuin argued, must insist on the same high artistic standards for its music that it does for its dancing and production. Without a resident orchestra, the Company's plans for an enlarged, revitalized repertory would be difficult, if not impossible, to achieve.

Smuin was right. Many of the additions to the repertoire since 1975—the five new ballets to commissioned scores during the 1979 repertory season, or the five new ballets of the 1982 Stravinsky Centennial Celebration—were musical as well as choreographic achievements. Unlike companies that treat music as a necessary evil or as a luxury, San Francisco Ballet has placed music at the very heart of its revitalization. The Company did not see the formation of the Performing Arts Orchestra only as an extra "touch of class" or as a mere decorative flourish: the presence of a resident orchestra has helped to create—and shape—a new repertoire. The support of a permanent body of musicians has allowed Smuin to act on his penchant for big scores (Prokofiev's *Romeo and Juliet*), difficult scores (Mozart's *C Minor Mass*), and new scores (Chihara's *The Tempest*). Smuin—who in 1975 instinctively followed Lincoln Kirstein's dictum that the task of an energetic

choreographer was to "uncover new noises by old composers and even commission new noises by new composers"—knew he couldn't uncover and discover such "new noises" without the day-to-day presence, knowledge, and insight of a consummate musician.

Smuin has had that consummate musician in Denis de Coteau, the musical director and conductor of the Performing Arts Orchestra since its inception in October 1975. The recipient of the Pierre Monteux Conducting Prize, the Outstanding Black American Musician Award, and the ASCAP Award for Adventuresome Programming of American Composers' Music, de Coteau had wanted to form a ballet orchestra since he began conducting for SFB in 1970. When Smuin started to make inquiries early in 1975, de Coteau seized the moment—negotiating with the musicians' union, locating an associate conductor (Jean-Louis LeRoux), and auditioning more than two hundred players. (The thirty-eight member core can be expanded to as many as sixty-five for those ballets, like Smuin's *Romeo and Juliet*, requiring fuller orchestrations.)

"The creation of a resident orchestra that could tour with the Company was a bold step," de Coteau recalls. "Very few American ballet companies have one, but the benefits were so obvious that I was certain from the beginning that ours would be a success." When the Performing Arts Orchestra made its debut during the 1975 run of *Nutcracker*, the benefits were indeed as obvious as they were immediate: after the first rehearsal, the dancers—much to de Coteau's surprise—came downstage and began applauding the musicians, as Dr. Richard E. LeBlond, Jr., President of the San Francisco Ballet Association, shouted out, "Never heard it like that!" Ever since that joyous debut, audiences and critics have echoed the Company's enthusiasm. During SFB's 1978 New York season, Byron Belt hailed the SFB orchestra as "one of the best in the business," and Dale Harris praised it as better "than any other pit orchestra heard here since the first visit of the Bolshoi Ballet back in the 1950s."

Such praise is particularly gratifying to de Coteau, for the demands of conducting for ballet are quite different from those of leading a symphony orchestra. As Edwin Denby once noted, as a performer the ballet conductor has to yield the spotlight to the dancers, and even as a musician he can't let the music take center stage. "He has to adjust the score to the rhetoric of the drama on stage," Denby explained, "and when a ballet story has been set to music composed for another purpose, the points of emphasis are often quite different ones. The ballet conductor has to take the cue for his dynamic climaxes from the theatrical moment. When the audience has become absorbed by the action, when it has grasped the situation, an increase in loudness may clinch the big effect; but if the audience is not warmed up, if it has not yet caught on

to the rhythm of the piece, a big noise will only puzzle, distress or alienate it. Most important of all, the conductor has to adjust to a speed that the dancer can use, according to the sequence she executes, according to her physical temperament; and if that speed is tough on the musical score, he has to find a way of making it sound slower or faster than it is. The fixed common term between the dancer and conductor, between the rhythm of music and the rhythm of dancing, is the beat or pulse of the music. The more steady and reliable the beat is, the more freedom for inspiration the dancer will have."

For the past thirteen years, Denis de Coteau has provided SFB's dancers with that "freedom for inspiration." A master at marrying music to dance, he skillfully coordinates the sound in the pit with both the action on the stage and the reaction in the audience. Constantly modifying his message to the musicians, he knows how to involve the orchestra so they get a sense of the stage's excitement—insuring that a downbeat will fall with a dancer's landing, or reading the complicated stage, sound, and light cues in a multi-media work like Smuin's *A Song for Dead Warriors*. "Without exact synchronization between stage and pit," de Coteau contends, "a ballet could fail to make its point—even the most brilliantly danced performance would appear disjointed."

The Orchestra's contributions to the Company have been invaluable. Although dance music was held in low esteem during the nineteenth century (with its square rhythms and bland tunes, it was considered hack work pure and simple), this century has witnessed such a vigorous rehabilitation of ballet music that music now stands at the heart of contemporary dance aesthetics. "Ballet music" may have been a term of contempt during the nineteenth century, much as "movie music" is today, but by the 1930s, many of the greatest modern composers —Stravinsky, Ravel, Debussy, Strauss, Poulenc, Prokofiev—had created for the ballet stage, revolutionizing our ideas about dance music. If critics in 1877 could find Tchaikovsky's *Swan Lake* too complicated, too symphonic, and too "good" for the ballet stage, today a complicated score like Stravinsky's *Agon* is hailed as ideal for choreography. The alliance between dance and music is simply a fact of modern ballet: as Lincoln Kirstein has noted, during the past several decades, innovations in dance have been inspired not by literature (as in the nineteenth century) nor by painting (as in the early part of this century), but by music.

SFB's focus on music—its commitment to commissioned scores, its insistence on a resident orchestra—can best be understood in this context. Like the other major dance companies that came into existence after Diaghilev's death, SFB was founded on, and fuelled by, a musical emphasis: one of the three principal architects of the Royal Ballet was the conductor-composer Constant Lambert, who gave the Royal a strong musical foundation; the New York City Ballet is practically an apotheosis of Balanchine's belief that the purpose of choreography is to allow viewers "to see the music and hear the dance"; and SFB's Christensens are, it should be remembered, a dynasty of musicians. Lew Christensen, who during his early tours would sleep with his cello in an upper berth, has made his musical credo emphatically clear: "to be a good choreographer, you have to be a good musician. I don't see how you can do without it. The music is the impetus—without it, I couldn't think of a thing." (Christensen's musical erudition is so sharp that when a conductor once called in sick at the last moment, Christensen stepped into the pit and conducted the Bach Double Violin Concerto for *Concerto Barocco* himself; and in 1981 his son Chris followed in the family's footsteps, conducting several performances of SFB's *Nutcracker*.)

SFB established the Performing Arts Orchestra in 1975 to maintain—and extend—the Company's musical heritage. The Orchestra was created in the belief that accomplished dancing requires accomplished musicians. Well-trained dancers and well-crafted choreography are, of course, the *sine qua non* of classical ballet, but both suffer without well-played music. As Denis de Coteau has said, quoting the great conductor-teacher Jean Morel: "Give the dancers only the correct tempi and they will do the steps. Give them great music with the right tempo and they will dance. It is a different experience." The difference between "steps" and "choreography" is, to a considerable extent, the only difference that counts in classical ballet: it's the difference between craft and art, prose and poetry, the ordinary and the extraordinary.

In 1983, the Performing Arts Orchestra was renamed the San Francisco Ballet Orchestra.

HANK KRANZLER

SFB Associate Conductor Jean-Louis LeRoux.

SFB *and Sir Frederick Ashton*

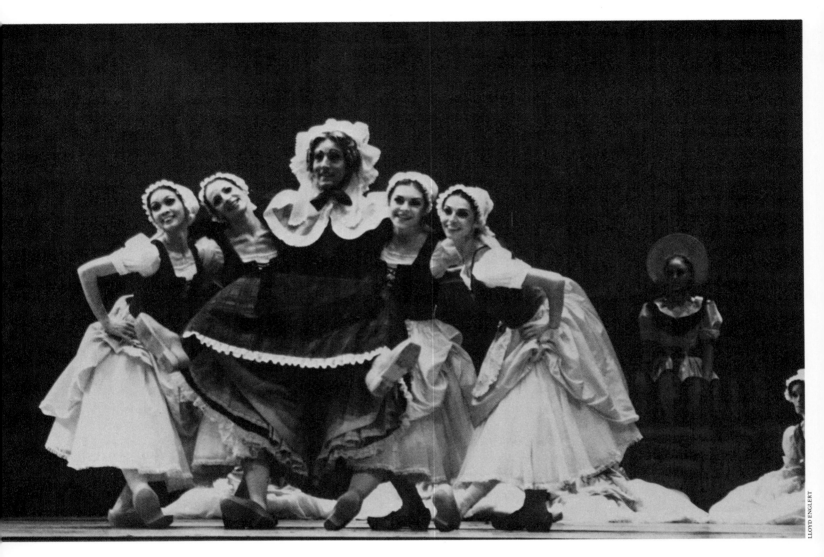

Above. Vane Vest as Widow Simone with Tina Santos, Laurie Cowden, Damara Bennett, and Deborah Zdobinski in *La Fille Mal Gardée* (1978).
Right. Anita Paciotti as Lise, John McFall as Alain, Val Caniparoli as Thomas, and Vane Vest as Widow Simone in *La Fille Mal Gardée* (1978).
Opposite. David McNaughton and Diana Weber as Colas and Lise in *La Fille Mal Gardée* (1978).

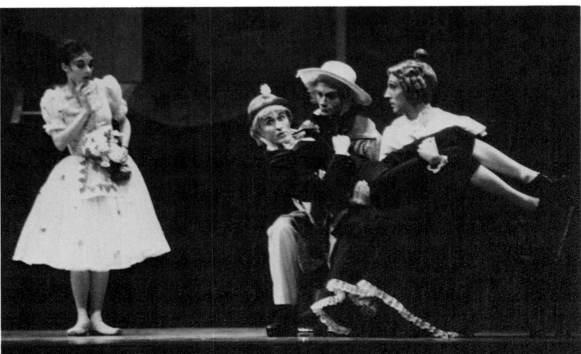

La Fille Mal Gardée, the 39th work by Sir Frederick Ashton to enter the Royal Ballet's repertoire, was an instant success at its 1960 London premiere. It's one of the great British choreographer's most charming ballets—a sweet, sunny, and profoundly good-natured portrayal of village life in the eighteenth century. Ashton has composed other tributes to country living—*Enigma Variations, A Wedding Bouquet, Tales of Beatrix Potter, A Month in the Country*—but *La Fille Mal Gardée* is in many ways his most enchanting. The ballet's choreographic inventions are infinitely delightful, full of exquisite footwork for the principal dancers and humorous eccentricities for the character roles. (*Fille*, for example, begins with a hilarious variation for a strutting rooster and his four hens, and later contains a wonderful clog dance for the Widow Simone, who is portrayed by a male dancer *en travestie*.) The two acts of *Fille* are so full of action, showmanship, and kind-hearted satire that the ballet appears seamless in construction. And its vision of romance is that rare blend of innocence and sexuality: love in *Fille* is at once silly and sublime. Ashton modestly claims that his *La Fille Mal Gardée* is merely a poor man's *Pastoral Symphony* (it was to Beethoven's symphony that Ashton constantly returned during the ballet's preparation), but *Fille* does indeed dazzle with the idyllic charm and serene simplicity of Beethoven's work. It's an undeniable masterpiece, and one which opened San Francisco Ballet's 1978 repertory season excitingly as SFB established itself as the only American company granted rights to perform *Fille*.

Fille was the Company's first sojourn into Ashton territory, and although the ballet is often said to be quintessentially British, a touchstone of the Royal school and style (at its world premiere American critic Edwin Denby conjectured that "neither an American nor a Russian company could have sustained for so long, so airy, childlike and unemphatic a good time"), SFB has indeed captured the gentle sunniness of Ashton's masterpiece. "The Company showed full mastery of the ballet's quintessential spirit," said Dale Harris in the *Manchester Guardian*, "not merely its irresistable buoyancy, but its sweetness of temper, its delight in eccentricity, its charity towards even the spoilsports of life." Even the ballet's most "British" characters—the Widow Simone and Alain, the dim-witted suitor—were superbly mastered by SFB dancers Vane Vest and John McFall.

After its success with *Fille*, San Francisco Ballet was granted permission in 1981 to stage Ashton's *Monotones 1 and 2*—a double *pas de trois* of haunting and inviolable austerity. Set to Erik Satie's *Trois Gnossiennes* and *Trois Gymnopédies*, *Monotones* is at once truly modern (stark, distilled, minimal) and purely classical ("as deeply rooted in the *danse d'école* as anything Ashton has ever composed," as David Vaughan has noted). Its six dancers—clad in unitards with glittering belts and skullcaps de-

signed by Ashton himself—powerfully evoke a celestial, other-worldly order, a world of infinite time and space. *Monotones* strikingly demonstrates Ashton's contention that abstract ballets, "though appearing to convey nothing but the exercise of pure dancing, should have a basic idea which is not necessarily apparent to the public, or a personal fount of emotion from which the choreography springs." *Monotones* unquestionably possesses such a fount, from which flows a poetry of exquisite and profound powers.

The third installment in SFB's Ashton collection arrived in 1982 when the Company presented the *pas de deux* from *The Dream*, Ashton's one-act version of *A Midsummer Night's Dream* which in 1964 catapulted dancer Antony Dowell into stardom and launched his legendary partnership with Antoinette Sibley. The *pas de deux*—hailed as "one of Ashton's most profound statements on the nature of love"—was performed by SFB in excerpt, not with reference to its original narrative context, but simply as a gorgeous duet that revealed, as Dale Harris said, "the astonishment of sensual discovery."

Ashton's ballets have brought an undeniable challenge, and prestige, to San Francisco Ballet. As director

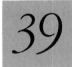

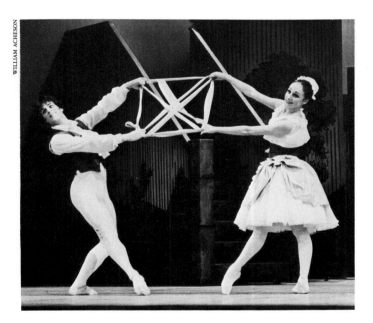

WILLIAM ACHESON

of the Royal Ballet from 1963 to 1970 and as principal choreographer for that company throughout its fifty-year history (during which time he shaped and was shaped by the career of Margot Fonteyn), Ashton is *the* seminal figure of British choreography. More than any other choreographer, he has created the English style of classic dance—lyrical, soft, fluid, musically sensitive, with a particularly British sense of "reserve." As David Vaughan has noted, Ashton is to British ballet what Balanchine is to American: the heir to Petipa whose choreography has developed and defined a national style.

For the past thirty years, San Francisco Ballet has been building one of the finest collections of Balanchine works in the world. Now it has begun to collect a similarly splendid array of Ashton ballets—to serve, in short, as the West Coast repository of the great British master's choreography.

Right. Tracy-Kai Maier and Jim Sohm in the *pas de deux* from *The Dream* (1982).
Below. Diana Weber, Linda Montaner, and Nigel Courtney in *Monotones 1* (1981).
Opposite. Robert Sund, Jamie Zimmerman, and Vane Vest in *Monotones 2* (1981).

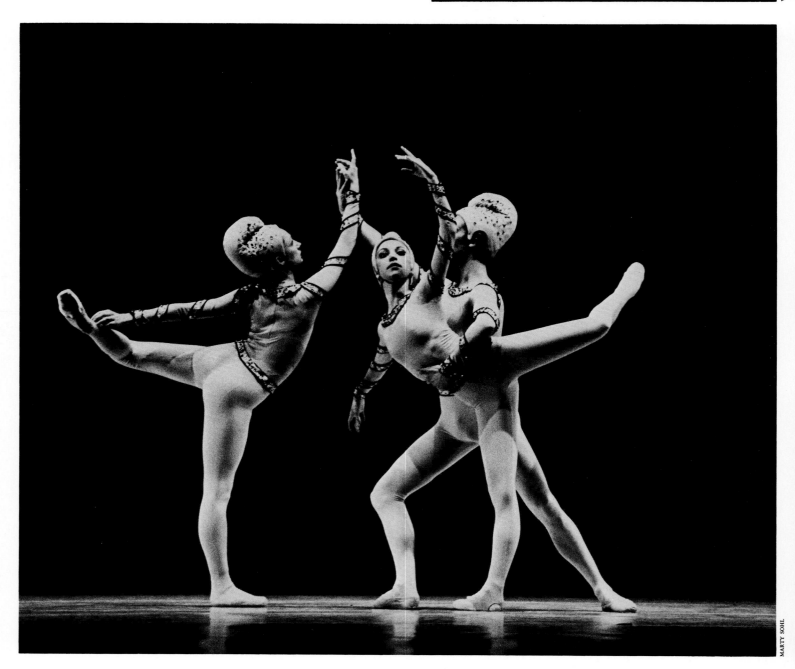

"It's not the quantity of Ashton's output that is astounding, but the variety and humanity of his work. We of my generation who try to make ballets have a debt to Ashton; we have learned from his example. He is a man gifted with taste and flair, achieved refinement and elegance of style, brilliance and an absolute clarity of expression." —*Michael Smuin*

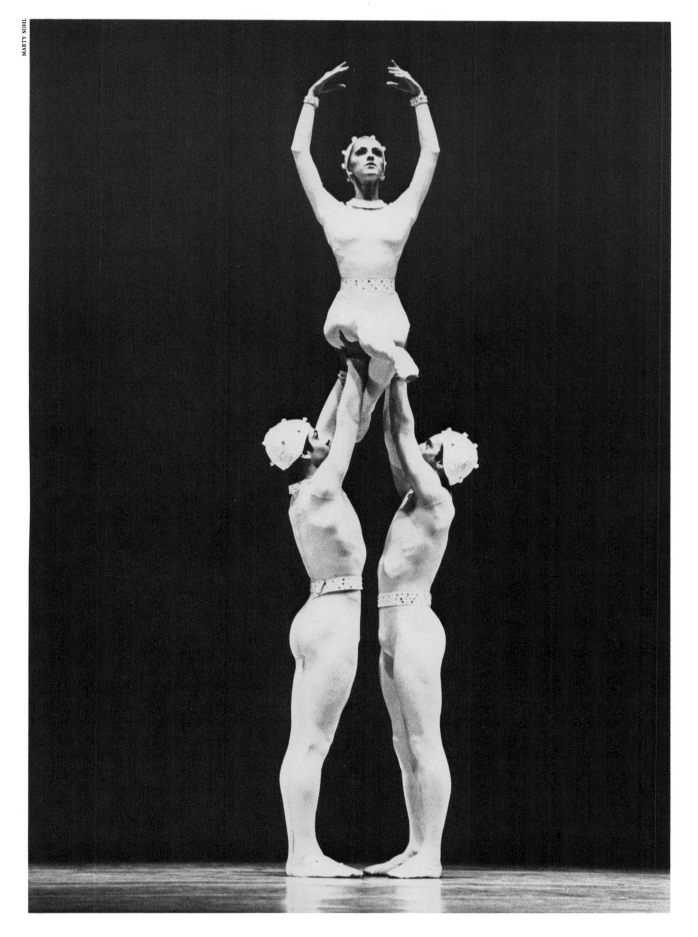

1982 White House Performance

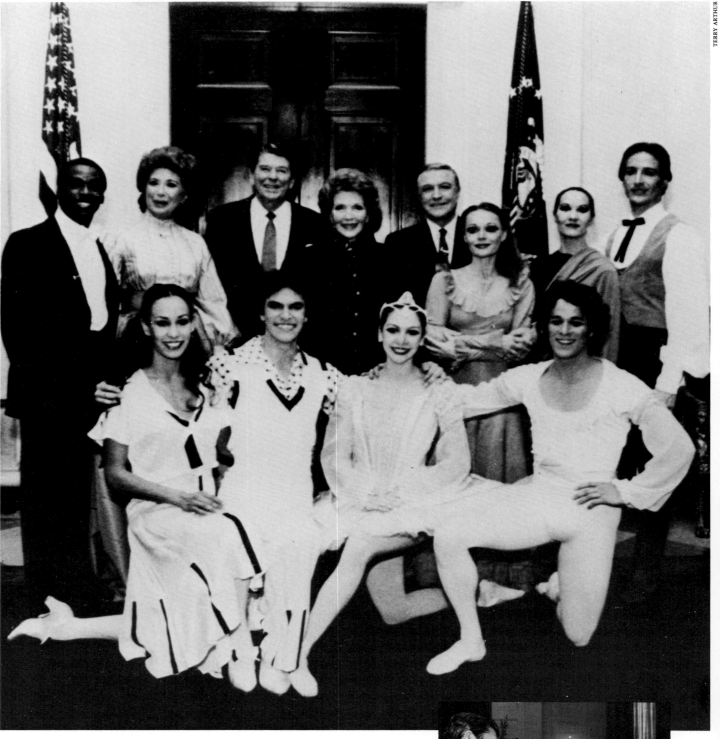

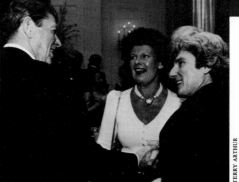

Above. (front row) SFB dancers Evelyn Cisneros, Kirk Peterson, Linda Montaner, and David McNaughton. (back row) Gregg Burge, Beverly Sills, President Ronald Reagan, First Lady Nancy Reagan, Gene Kelly, and Martha Graham dancers Christine Dakin, Joyce Herring, and Donlin M. Foreman.
Right. President Ronald Reagan, Mrs. George F. Jewett, and Michael Smuin.

At the invitation of the *40*th President of the United States, Ronald Reagan, members of San Francisco Ballet performed at the White House on March 28, 1982. The performance, taped for national broadcast the following night on PBS, was the fourth in a series of programs— "Young American Artists at the White House"—hosted by Beverly Sills. While the first three programs presented musical artists (protégés of Sills, pianist Rudolf Serkin, and country-western singer Merle Haggard), the fourth performance was devoted entirely to dance. "America has become the dance center of the world," First Lady Nancy Reagan noted in her introduction, adding that she would be saying that even if her own son—Ronald Reagan, Jr., then a member of Joffrey II—weren't "an up-and-coming dancer."

For this all-dance program, special host Gene Kelly invited choreographers Martha Graham and Michael Smuin to present performances of their work by some of America's most gifted young dancers. Smuin selected four SFB dancers (Evelyn Cisneros, Linda Montaner, David McNaughton, and Kirk Peterson) and Gregg Burge from the original Broadway cast of *Sophisticated Ladies*, the Tony-Award winning Duke Ellington revue, which Smuin had directed and choreographed to great acclaim in 1981.

The command performance took place in the East Room of the White House, on a stage notorious to dancers both for its matchbox size (34' × 30') and its low-hanging crystal chandelier, whose bottom pendant hangs a mere 6'4" above the stage. (According to a *New York Times* report, at one moment in the performance it appeared that Cisneros, held aloft by her partner Peterson, might collide with the lighting fixture. Her feet, however, just missed the pendant. When later asked by the *Washington Post* about the difficulties presented by such a small stage, Cisneros replied, "We rehearsed in an even smaller space, so when we got to the real thing, it felt luxurious by comparison.")

The SFB dancers performed two works for the gala occasion: *Q.a V.*, Smuin's 1978 classical *tour de force* set to Verdi; and an excerpt from Smuin's *Stravinsky Piano Pieces*, in which Cisneros and Peterson—costumed in black-and-white elegance by Broadway and ballet designer Willa Kim—breezily tap-danced to Stravinsky's *Ragtime*. The Stravinsky excerpt was a world premiere: the complete ballet was not revealed until April 6, when it proved to be the runaway hit of the Company's Stravinsky Centennial Celebration at the War Memorial Opera House. Herb Caen, San Francisco's best-known columnist, said of the ballet: "If you still doubt Michael Smuin is a genius of choreographers, you must have missed his *Stravinsky Piano Pieces*, one delight after another. . . ."

The White House program marked the third time the American television audience saw the San Francisco Bal-let dancing Smuin choreography: the prestigious and innovative series, *Dance in America*, had presented *Romeo and Juliet* in 1978 (the series' first full-length ballet), and *The Tempest* in 1981 (the first ballet telecast live from the War Memorial Opera House). Both programs earned the Company Emmy Awards.

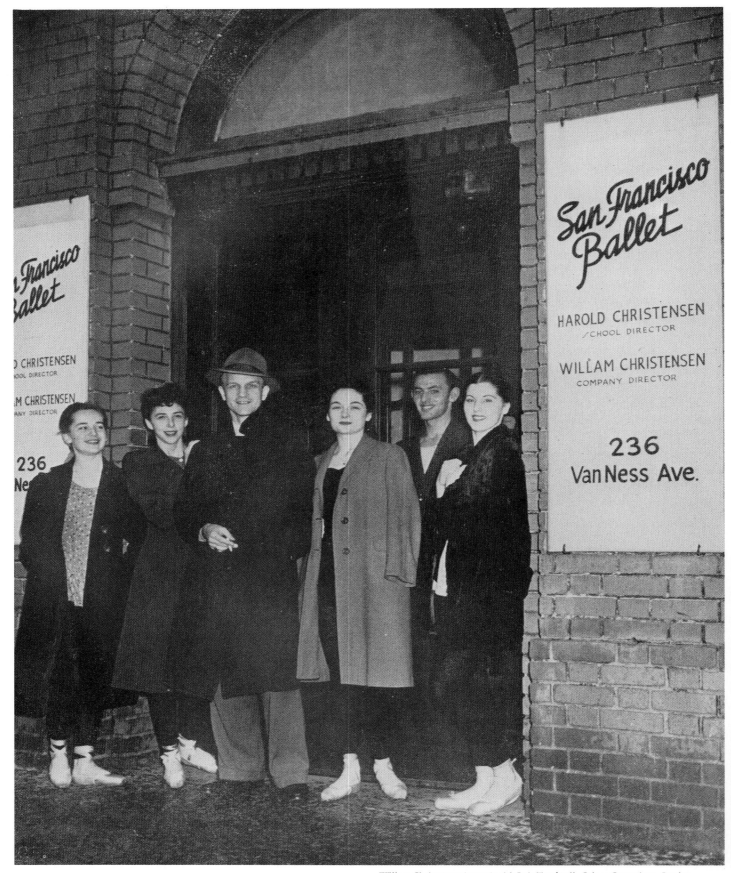

Willam Christensen (center) with Lois Treadwell, Celena Cummings, Jocelyn Vollmar, Peter Nelson, and Onna White in front of SFB's Van Ness Avenue studios (1945).

With *41* offices and conference rooms, eight vast dance studios, two libraries, three audio-visual facilities, half a dozen spacious dressing areas, a community relations headquarters, a complete physical therapy center, and space for a future "second" company, the new home of San Francisco Ballet is the first building in America created expressly to house all aspects of a major professional dance institution. Located in the Performing Arts Center directly across from the Opera House, the new four-level structure will be completed by the close of SFB's landmark Fiftieth Anniversary season. "The Company's presence in San Francisco's Performing Arts Center means that, at last, all the major art forms originally intended for residency in the Performing Arts Center—the Ballet, Opera, and Symphony—are now there," notes Dr. Richard E. LeBlond, Jr., President of the San Francisco Ballet Association and a major force behind the new building.

This fully equipped facility—designed by San Francisco's award-winning architect Beverly Willis—will be the Company's fifth home. When Gaetano Merola and the San Francisco Opera Association established the Ballet in 1933, they originally planned to house the Ballet on the lower level of the just-completed War Memorial Opera House. Although fastenings to hold the practice *barres* were installed in the Opera House basement walls, the Ballet never moved into its intended home: the ceilings were too low, the concrete floor too hard, and with the repeal of Prohibition, the space was deemed better suited for a lounge and bar. The Ballet was instead housed in the William Taylor Hotel on McAllister Street, a few blocks from the Opera House. (Advertisements for the hotel during the mid-Thirties included the proud announcement, "Our downstairs auditorium is the home of the San Francisco Opera Ballet School.") The hotel's ballroom served as the site of the Ballet's grand opening in 1933: Mary Wigman, a seminal figure of German modern dance, was guest of honor; and Adolph Bolm, SFB's first Director, revealed his plans for the Company, which included not only operatic work, but a series of independent, "all-ballet" presentations.

Before SFB made its official debut in June at the Opera House, an informal studio program was presented on March 17 at the hotel. Bolm screened his 1922 film, *Danse Macabre*, and a small contingent of dancers led by Elise Reiman, Evelyn Wenger, and Irene Flyzik danced eight excerpts from Bolm's ballets. Several other informal performances were given at the hotel during the next five years.

In 1937, shortly after Willam Christensen joined the Company, SFB moved to the second floor of a lodge hall, conveniently located across from the Opera House at 236 Van Ness Avenue, in the heart of San Francisco's Civic Center. (The Opera House in San Francisco faces City Hall and other government buildings.) The larger of the two studios in the Company's new home was used for Company class and rehearsals. Wood floors in both studios were wonderfully resilient, and high ceilings allowed partners to practice overhead lifts. Each of the two dressing rooms was small, only accommodating seven or eight dancers. The women's included a second "loft" dressing area, used by the Company's ballerinas. The ample office featured both an anteroom for the Director and some storage space. Eventually the vacant first-floor storefront was leased for the Company's costumes and scenery.

"The feeling of energy was everywhere," recalls former dancer and designer Russell Hartley about the Van Ness facility. "During a rehearsal, the studio doorway was crowded with people, the older students looking over the heads of the younger ones. Everywhere you looked, something was happening. Even when not rehearsing, the dancers frequently stayed in the studios: a few read, *all* gossiped, and the boys practiced turns and generally horsed around. The girls often knitted tights—there was no nylon in those days, so practice tights were usually woolen and performance tights silk. There was remarkable camaraderie at 236 Van Ness Avenue. We were a small group of dancers inspired by Willam Christensen—or 'Mr. C.' as the dancers called him."

In 1951 the Civic Center site had to be vacated when the building was sold to the City and the Ballet lost its lease. The Company moved to a new location a mile away: the Theatre Arts Colony, a small theater on Washington Street, between Polk Street and Van Ness Avenue. The new home—occupied by the Ballet as Lew Christensen succeeded his brother Willam as Company Director—came complete with courtyard, statues, and garden. The Company leased both floors. "It was artsy," remembers Robert Gladstein, then an SFB student, now the Company's Ballet Master and Assistant Director. "It reminded one of the classic, older New York rehearsal spaces complete with old photographs and trophies, large cabinets and hardwood floors. It smelled of theater!"

With the continued growth of the Company and School, the Washington Street studio soon became inadequate. In 1956 SFB moved to its fourth home—a converted two-story parking garage on Eighteenth Avenue in the city's Richmond District, a quiet residential neighborhood miles from the Opera House. At its opening, the new home garnered national attention as an outstanding dance facility. The second floor boasted of three new studios, while the ground level housed the Company's administrative offices. In the early Sixties, a fourth studio was added downstairs to accommodate expanding classes. But space became a problem by the mid-Seventies. As the Company continued to enlarge its administrative staff, three adjacent apartments were leased to provide more offices. During the summers when schedules for Company rehearsals and the School's inten-

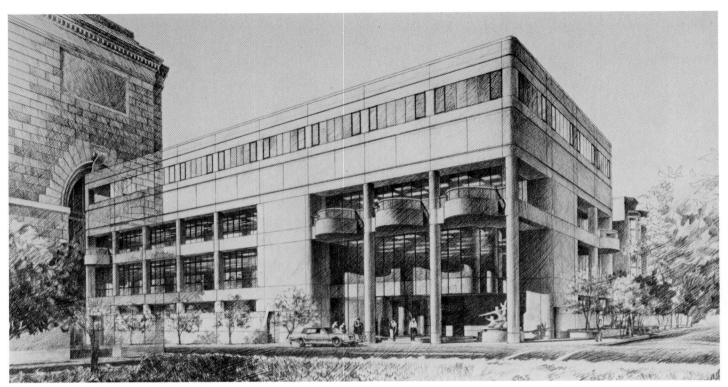

The new home of the San Francisco Ballet Association, designed by Willis & Associates, Inc., and scheduled for occupancy in late 1983.

sive summer programs grew too difficult to reconcile, additional space had to be rented across town, further dispersing the Company's activities.

"Everywhere you turned," says Michael Smuin, "we were cramped. In our rehearsals, we were climbing the walls. I could watch a performance of our Company on stage in the Opera House, and sometimes I was sure I saw dancers duck from habit, after rehearsing in our upstairs studio where the beams were so low that we couldn't even do the full lift for the Sugar Plum Fairy in the grand *pas de deux* from *Nutcracker*."

The trustees of the San Francisco Ballet Association began wrestling with the Company's space problem. "It was obvious something had to be done," says Dr. LeBlond. "When the Ballet moved into the Eighteenth Avenue studios in 1956, the Company only numbered eighteen dancers, as opposed to the forty-four it has now. And the School had about 250 students then, compared to its current enrollment of 650. We've been bursting at the seams for years."

After studies determined that enlargement of the existing Eighteenth Avenue structure would be unfeasible, the trustees considered the options for converting a wide variety of existing structures, including automobile showrooms, abandoned piers, a warehouse, a dry cleaning plant, and an old Masonic temple. "But we had an unusual list of requirements as a potential tenant," LeBlond says. "Foremost, we needed large, unobstructed spaces. Ultimately, we realized that the best solution for our facility problem, economically as well as aesthetically, was to build it ourselves."

A suitable location for the new building had to be found. After what the *San Francisco Examiner* later called

"a unique saga of dollars and determination" involving Mayor Dianne Feinstein, Chief Administrative Officer Roger Boas, the San Francisco Redevelopment Agency, the San Francisco Parking Authority, the Western Addition Project Area Committee, and the Bank of America, the Ballet finally obtained rights to an ideal site at Franklin and Fulton streets. The 206' x 88' piece of land enjoyed a privileged location: directly across the street from the stage entrance of the Opera House.

Two of the Association's trustees, both excellent architects in their own rights, made an extraordinary contribution in laying the foundation for the landmark project. Peter Bolles, Chairman of the Facilities Committee, has been instrumental to the success of the project from its inception. He has represented the Association in the development and implementation of the plans for the new building as well as working with the contractor in its erection. And Charles Rueger, who also served on the Facilities Committee, organized a fact-finding mission to study dance facilities in Stuttgart, Paris, New York, and Toronto. "We wanted to find out about every detail," Reuger says. "The construction of the floors, the height of the *barres* from the floor, the best diameter of the *barre* itself, whether or not to have air conditioning, whether or not to have curtains in front of rehearsal mirrors, what dancers most want in a studio, and what they most don't want."

Meeting these various needs was no easy task. The Company's dancers, the School's students, and the Association's administrators each required tailor-made facilities, and each floor of the new building had to be designed accordingly. "The School, with its twelve-foot-high ceilings," explains architect Willis, "is located on

148

the first and second floors to provide easy access for the children. The Company's artistic and administrative offices, and lounge and locker areas are located on the third floor with nine-foot ceilings. We wanted administrative and artistic staffs on the same floor because, as General Manager Timothy Duncan emphasized, it would greatly facilitate communication. And the rehearsal studios for the Company, with their requisite fifteen-foot ceilings, are located on the fourth floor. Two of the fourth-floor studios can be combined to accommodate videotaping or complete dress rehearsals, with a dancing area equal to the Opera House stage plus enough room for observers and a full orchestra as well."

May 26, 1982, marked the ceremonial groundbreaking for the new building. Lew Christensen, with his brothers Harold and Willam in attendance, turned the first shovelful with the "Golden Spade," used for the groundbreaking of the Golden Gate Bridge in 1933, the same year SFB was founded. Paul Chihara, the Company's resident composer, wrote a new processional for the occasion. City and state officials welcomed the Ballet back to the Civic Center after its thirty-one-year absence. As the *Examiner* reported, the ribbons were cut, the speeches delivered, the hands shaken, the backs patted: a new chapter in the Company's history had begun.

More than $7.5 million of the $10 million proposed fundraising goal had been secured before the ceremonial groundbreaking. (Certain increased costs and additions to the project later made it necessary to increase the goal to $11.5 million.) The Building Fund Campaign, chaired by L. Jay Tenenbaum, had created what the *Examiner* later hailed as "nothing less than the master scenario for massive arts fundraising endeavors for at least the next decade." Virtually all the secured funds came from the private sector. "There are things better done without government," LeBlond told the press at a conference preceding the groundbreaking. "The government's not going to build this and the government's not going to run it. We want a Tijuana Trolley, not another BART."

By opening night of the Company's Fiftieth Anniversary Season in January 1983, over $9.6 million had been raised. The Building Fund had the full support of the Association's Board of Trustees: all forty-two trustees donated sums ranging up to $1 million, for a total of $3.5 million, with generous contributions by Trustees Mr. and Mrs. George F. Jewett, Jr., Mr. and Mrs. Rudolph W. Driscoll, Mrs. G. W. Douglas Carver, and Mrs. Gorham Knowles. Foundations contributed $2.6 million, with most of that figure deriving from major grants from the James Irvine Foundation, the S. H. Cowell Foundation, the Kresge Foundation, the William Randolph Hearst Foundation, and the William and Flora Hewlett Foundation. Corporate contributions totalled $1.8 million, with large donations by Standard Oil of California (Chevron, U.S.A.), Atari, Inc., Foremost-McKesson, Inc., and the Bank of America Foundation. Prominent individuals and families have donated more than $1.7 million, including

generous contributions by the Haas family and Mrs. Phyllis Wattis.

"Ten years ago, if you had told fundraisers the Ballet needed its own multi-million dollar building, they would have laughed at you," notes LeBlond. "In those years the Ballet, lacking economic stability, simply did not have that kind of fiscal credibility in the community. In the mid-Seventies when the Performing Arts Center was being planned, the Ballet was unfortunately suffering one of the worst economic trials in its entire history—the near bankruptcy that led to the 'Save Our Ballet' campaign. So, not surprisingly, when the Performing Arts Center was being planned, the Ballet was given very little—no permanent rehearsal rooms, office space, etc. As it turns out, the planners did us a favor, because it eventually became evident that we would have to build our own facility, one that would be run by us and not by the City. Our Board of Trustees, chaired by Philip S. Schlein, courageously took on a $10 million project. Although some people thought that kind of money simply was not available after the community had just given more than $35 million to build the Louise M. Davies Symphony Hall, we found out that the wells were far from dry. The Building Fund's success is, I think, proof of the community's faith in the Ballet—a testimony to the achievement of our Co-Directors, resident choreographers, and superb dancers. We've entered a new era."

The new era will not merely provide the Company with more comfortable surroundings, but, more importantly, with expanded services. Company dancers, for example, will now be able to take classes in subjects such as character, jazz, and modern dancing, which in the past were relegated to summer months.

New courses, higher morale, improved communications between artistic and administrative personnel, the possibility of a second, "junior" company—these are obvious advantages of the Association's new home in the Civic Center. But perhaps the true significance of the new building has been best summarized by Lew Christensen. With an air of finality, he declares, "It says in concrete: 'San Francisco Ballet is here to stay.'"

San Francisco Ballet Association President Dr. Richard E. Le Blond, Jr. (left) and Lew Christensen at the 1982 groundbreaking for the Association's new home.

GEORGE T. KRUSE

SFB *and Jerome Robbins*

Michael Smuin in *Fancy Free* in front of John F. Kennedy Center for the Performing Arts in Washington, D.C. (1972).

In 1944, when Ballet Theatre was 42 dancers strong, the company presented Jerome Robbins' first ballet, *Fancy Free*. It was one of the most auspicious choreographic debuts in the history of American dance. A hot and sexy contemporary ballet about three sailors on shore leave, *Fancy Free* was so big a hit on opening night that its young dancers, as Edwin Denby noted, "all looked a little dazed as they took their bows." Quickly adapted into the smash Broadway musical *On the Town* (1944), which in 1949 became a smash Hollywood film, *Fancy Free* was merely the first of many triumphs for Robbins, who has since created a string of balletic masterpieces, directed and choreographed several huge successes on Broadway (including *West Side Story* and *Fiddler on the Roof*), won one of the few Oscars ever awarded for choreography (for *West Side Story*), and founded his own company (Ballets USA), before returning to the New York City Ballet in 1969 as assistant artistic director, where he has become, by common consensus, America's greatest native-born choreographer of classical dance.

Some twenty-five years after the premiere of *Fancy Free*, American Ballet Theatre began presenting several young

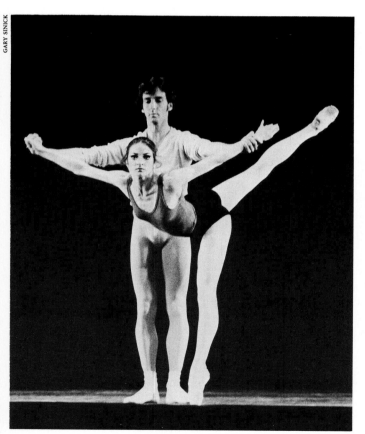

Vane Vest and Laurie Cowden in *Moves* (1977).

choreographers who were collectively hailed as heirs to Robbins—the next generation of American choreographers. Michael Smuin was among this group of bold new choreographers (Eliot Feld was the other notable mem-

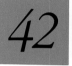

ber), and since their debuts in the late Sixties, it is Smuin who has most successfully mined the rich Robbins vein. Like Robbins, Smuin effortlessly combines classical and colloquial idioms, mixing ballroom, Broadway, and ballet in a way that grasps, to borrow a phrase from Arlene Croce, what is "American" in ballet and what is "classical" in popular dance—eclecticism flows as naturally in Smuin's work as it does in Robbins'. Both Smuin and Robbins, moreover, reveal a true range of styles, moving from comedies to dramas to plotless works with great ease. And whether working in narrative or abstract modes, both choreographers are repeatedly drawn to similar themes—the vitality of American youth, the competitive spirit of dance, the sidewalk *savoir-faire* of male camaraderie. (When Robbins said his three sailors in *Fancy Free* were "full of animal exuberance and boisterous spirits," he could have been describing the men in any number of Smuin ballets.) Fuelled by a strong sense of theater, both Smuin and Robbins connect with their audiences immediately, intimately: their ballets justify Lincoln Kirstein's contention that American choreographers work to "establish a direct connection approaching personal intimacy, or its theatrical equivalent, with their audiences;" that whereas "Russians keep their audience at arm's length, we almost ask ours to dance with us."

After his seven-year tenure with ABT, Smuin returned to San Francisco Ballet in 1973, joining Lew Christensen as Co-Director, and given the similarities between Smuin and Robbins, it's not surprising that Smuin wanted Robbins represented in the SFB repertoire. Since 1977, three distinctive Robbins ballets have been staged by the Company: *Moves* (which, danced entirely in silence, is Robbins' most uniquely "scored" work), *Circus Polka* (which, danced by forty-eight baby ballerinas, is Robbins' most unusually cast ballet), and *Requiem Canticles* (which, danced to Stravinsky's "celebration of death," is Robbins' most austere religious work).

San Francisco Ballet revealed an immediate affinity for the inventive Robbins style. *Moves*, first presented at the 1959 Spoleto Festival and entering the SFB repertory in 1977, captured the Company's "no stars" ensemble spirit. It's a ballet about dancers: self-assured, physically beautiful creatures who ritualistically perform difficult feats before their acknowledged audience. As the ballet begins, the dancers move toward the audience in single file from the back of the stage: stretching across the footlights, they strike a pre-*Chorus Line* chorus line, before breaking up into various groups to dance a series of duets, quartets, quintets, sextets. At the end, the dancers file off as they had entered. Although the ballet explores certain tensions between dancers (the first *pas de deux* is fevered, aggressive, almost brutal in its combativeness), *Moves* is essentially a ballet about company spirit, about the relationships in an *ensemble* of performers, and as such,

is a perfect vehicle for SFB's all-corps, all-star dancers.

Circus Polka, mounted by SFB in 1979, also explores the common heritage of a group of dancers, but in this case the dancers are four dozen student ballerinas, each dozen younger—and smaller—than its predecessor. (The smallest group, as one critic said, are really "tots in tutus.") Set to the Stravinsky score that Balanchine used for his famous 1942 Ringling Brothers *Ballet of the Elephants*, Robbins' *Circus Polka* retains a Big Top setting: a whip-cracking ringmaster (played by Robbins himself during City Ballet's 1972 Stravinsky Festival) puts four successive groups of baby ballerinas through their paces. For the finale, at the ringmaster's command, the children form the Stravinsky initials, *I.S.*, complete with punctuation. Although the ballet is undeniably light ("a splash of color and sweetness," one reviewer said), *Circus Polka* nevertheless reminds us that the lifeblood of any major company is its school, that ballet more than any other is an art of succession—one generation passing its knowledge to the next. SFB's production of *Circus Polka* also reminds us that the Company's School is, in several respects, a sister academy to City Ballet's School of American Ballet. (As early as 1943, *Dance Magazine* noted that the Christensens had admirably modelled the SFB School along the lines of Balanchine's institution.)

Like *Circus Polka*, Robbins' *Requiem Canticles* was created for City Ballet's 1972 Stravinsky Festival (it was the Festival's final ballet), and SFB performed it during its own 1982 Stravinsky Centennial Celebration. Stravinsky wanted this score, his last major composition, to be played "in memory of a man of God, a man of the poor, a man of peace," and Robbins' stark and strong choreogra-

phy is, as Clive Barnes has remarked, an appropriately "abstract and transfigured view of death." *Requiem Canticles*, with its black-clad dancers and their clenches, spasms, and open-mouthed silent cries, is "an anatomy of loss." In its agonized tautness, *Requiem Canticles* is an interesting companion piece to Smuin's "physical celebration of life," his *Mozart's C Minor Mass*.

Since the mid-Seventies, SFB's artistic policy regarding repertoire has been clear: to create, first and foremost, a unique body of resident choreography, and secondly to complement that house choreography with the best of the international repertoire. Although John Cranko, Maurice Bejart, and Jiří Kylián are represented in SFB's international wing, it is dominated by the works of three geniuses: George Balanchine, Sir Frederick Ashton, and Jerome Robbins. Balanchine gives the Company's international wing its modernity, Ashton its lyricism, and Robbins, as Michael Smuin has said, its eclectic vitality.

Students from the San Francisco Ballet School with School Director Richard L. Cammack as the Ringmaster in the final tableau of *Circus Polka* (1979).

"Robbins is a man of intense concentration and is extremely demanding—however, no more demanding on the artist than he is on himself. He is craft but, more important, he is theater. I've learned a great deal from Robbins. He is one of the great creative artists of our time. With George Balanchine, Frederick Ashton, Igor Stravinsky, Leonard Bernstein, Tennessee Williams, Ingmar Bergman, and Pablo Picasso, Jerome Robbins is a man of staggering accomplishments."—*Michael Smuin*

Nancy Dickson, Horacio Cifuentes, Damara Bennett, and Paul Russell in *Requiem Canticles* (1982).

Choreographers Workshop

Shari White, Lynda Meyer, and Sue Loyd in Ron Poindexter's *The Set* (1963).

154

Works by *43* choreographers were premiered in the "new choreographers" series that San Francisco Ballet presented from 1960 through 1973. The annual summer series, among the first choreography workshops ever sponsored by an American ballet company, was the brainchild of Michael Smuin, who in 1960 was quickly winning a reputation as one of SFB's most dynamic and enterprising young dancers. Smuin had choreographed a dance sequence for *Andrea Chenier* during the 1959 opera season; the dance, an inventive gavotte, had been well received, and Smuin was eager to continue to choreograph. Together with SFB Director Lew Christensen and General Manager Leon Kalimos, Smuin conceived the idea of a workshop for SFB dancers who also wanted to choreograph. To provide the novice choreographers with a market for their first works, sixteen SFB dancers were enlisted to form an independent "chamber" troupe, and a modest two-performance series was planned. Though the series had the support and encouragement of the parent Company (Christensen donated his proven hit *Divertissement d'Auber*), the troupe's debut would not be officially sponsored by SFB. Instead, Smuin was the series' artistic director, ballet master, principal choreographer (he created four of the six ballets performed during the premiere season), as well as one of its leading dancers. Another dancer, Jeffreys Hobart, served as business manager, while dancer Maurine Simoneau designed the costumes. Everyone sewed, worked on sets, hung the lights, and took crash courses in stage management.

"It was a case of ignorance is bliss," recalls Smuin. "We knew absolutely nothing about such things as unions or insurance or business management. We had to find out pretty fast. I think if we had known how complicated running a ballet company—even a small one—is, we'd never have started at all."

Following the example of George Balanchine, one of whose first dance companies, "Les Ballets 1933," was named after its calendar year debut, Smuin christened the workshop series "Ballet '60." The contemporary emphasis of the name reflected the young troupe's intentions: "Ballet '60" aimed to produce works with a decidedly "new" look. Smuin contributed two "right-now" jazz ballets, *Symphony in Jazz* and *Session* (danced to onstage bongo drums plus catcalls and whistles from the cast), while Jeannde Herst, the workshop's second principal choreographer, took a wickedly satiric look at modern day American society in *By the Side of the Freeway*.

Because the main Company had no extended engagements directly following its spring season, "Ballet '60" premiered during the summer—on July 8, 1960, at the Contemporary Dancers Center. As *The New York Times* later reported, "to the surprise of nearly everyone involved in the project, ['Ballet '60'] quickly captured the attention of the press and as much of the public as could

squeeze into the theater." The debut program was indeed so popular that two additional performances were presented that season. One reviewer hailed the experiment as "a sparkling success which calls for more of the same." Another critic pronounced Smuin "a choreographer with a future." And a third writer found the new troupe's "choreographic approach fresh, its chamber ballet atmosphere intimately appealing, and its general attitude typified by heel-kicking high jinks and unrestrained balletic fun."

The success of the debut season ensured the workshop's continued existence. Now under the official aegis of SFB, "Ballet '61" was presented the following summer and enjoyed several advances over its predecessor. The extended run covered six consecutive weekends of performances; there were eleven premieres as compared to five the previous season; and the troupe was enlarged to twenty-two dancers. (Cynthia Gregory, today one of the world's most accomplished ballerinas, made her workshop debut in "Ballet '61.") The Contemporary Dancers Center was forsaken in favor of the main Company's rehearsal studios, dubbed, for the occasion, "The San Francisco Ballet Theatre." As one writer later commented, "although the space was limited (300 seats), the stage inadequate and the audience cramped, the rent was more than reasonable."

Smuin—though serving in the Army at nearby Fort Ord, where he succeeded in obtaining weekend passes to rehearse ballets set before his induction—remained the director of the series, which was now billed as "the West Coast's first summer stock ballet theater." Smuin's assistant for "Ballet '61" was SFB dancer Kent Stowell, who choreographed five new works in the season's most auspicious choreographic debut. The troupe's outlook remained resolutely contemporary: "See experiments in ballet, ballet that's strictly 'in,' ballet that's 'way out.' Enjoy the ballets of the future *now*," urged the brochures for "Ballet '61."

The contemporary emphasis was, in fact, one of the young troupe's most frequently admired qualities throughout its second season. "Where most companies have a repertory of standard favorites, occasionally spiced by a new production, it is exactly the opposite with 'Ballet '61,'" wrote Dean Wallace in the *San Francisco Chronicle*. "Here the emphasis is on new ideas, novel approaches, and a deliberate extension of the vocabulary of dance." Noted critic Alfred Frankenstein agreed: "The main thing is that a very creative, experimental, and daring attitude to theatrical dancing holds sway at 'Ballet '61,' and that is a great stimulus after the timidity and commercialism displayed by all the touring companies that have come to San Francisco in recent seasons. It reinforces an attitude toward ballet on which I have always insisted—that the vocabulary of ballet is infinite,

need be limited to no special type of expression, and so limits itself at its peril."

To illustrate his point, Frankenstein enumerated the variety and range present in a single night of "Ballet '61": "ballet as psychological drama in Kent Stowell's *The Crucible* after Arthur Miller's play; ballet as acrobatics in Lew Christensen's *Divertissement d'Auber*; ballet as fluff and gossamer in Stowell's *Elysium*; ballet as finger-snapping, rump-wiggling insouciance in *Session* by Michael Smuin; ballet as crisp and sparkling mathematics in Smuin's *Ebony Concerto*; and ballet as fluency, fluidity, and delicacy in Christensen's *Prokofiev Waltzes*."

Christensen, seldom afraid to temper his deep regard for classicism with a touch of novelty and experiment, contributed a second new work to "Ballet '61"—*Shadows*, an ingenious me-and-my-shadow number starring Stowell and Jocelyn Vollmar which, later entering the main Company's repertory, was performed for more than a decade.

This second season was even more successful than the first. As *Dance Magazine* editor Lydia Joel reported, San Francisco and its tourists flocked to "Ballet '61." "Obviously, audiences liked what they saw, but perhaps the really important thing here is what the Company and Administration saw: a brand new audience of well-seasoned non-balletomanes—the young professionals and students, the working girls, the man on the street. This is the audience so desperately needed to keep ballet alive and thriving, season after season, in cities all over the country. It is expected that summer stock ballet will prove a valuable training ground for artists. Unexpectedly, it may also prove to be an enormously important training ground for audiences who will freely support ballet and demand of it far more than is being offered in the theater and on television today."

As a training ground for artists and audiences alike, the workshop received a boost the following year when "Ballet '62" began touring California. Because Smuin

Below. Kent Stowell (left) and Terry Orr with Diana Nielsen, Patricia Prager, Sue Loyd, and Paula Tracy in Michael Smuin's *Symphony in Jazz* (1960).

Opposite. Lee Fuller and Lynda Meyer in Robert Gladstein's *Psychal* (1967).

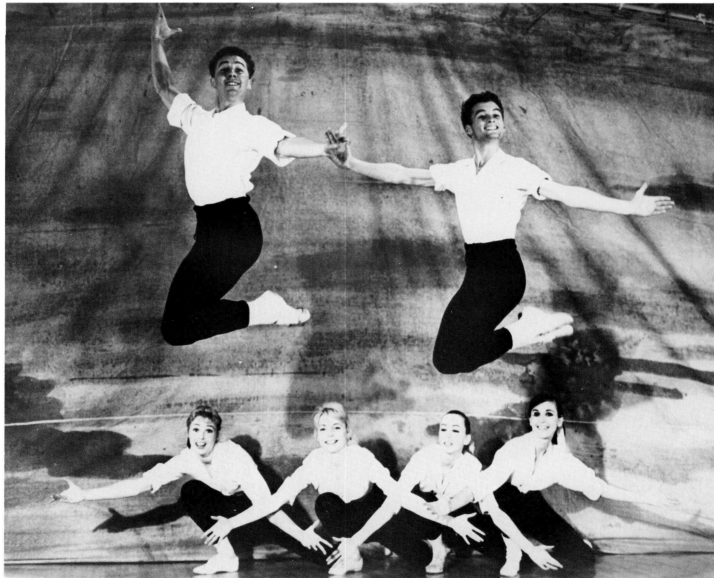

had moved to New York, the workshop came under the direction of Michael Rubino, Terry Orr, and Robert Gladstein, who made his choreographic debut during "Ballet '62" with a work called *Opus I*. The sold-out resident season and subsequent California tour, applauded as "the most exciting new concept in dance programming in many decades," gave "Ballet '62" considerable exposure: national booking companies grew interested in SFB's innovative chamber company. The following year, "Ballet '63," now under the management of Columbia Artists, took to the road on an ambitious and strenuous nine-week tour that played forty-eight towns in seventeen states. The troupe travelled in one bus —together with their luggage, costumes, props, and sound equipment—to small-town auditoriums across the country. The Columbia Artists-sponsored tours continued through 1965. In the course of these three fall tours, "Ballet '63, '64, and '65" presented 125 performances in thirty-two states, Mexico, and Canada.

The annual summer seasons in San Francisco also continued to expand as more and more Company dancers tested their choreographic talents. "Ballet '65," for example, featured works by a dozen choreographers. The eclectic repertory included story ballets, folkloric ballets, "think" pieces, conceptual works which reflected very contemporary concerns, and ballets in the classical vein. R. Clinton Rothwell, for example, a British-born dancer trained at the Royal Ballet School in London, staged a traditional *pas de deux* from *Giselle* for "Ballet '65," while Frank Ordway created his surrealistic *Real Games* in which the dancers wore white skullcaps painted to show the various areas of the brain. And in Jeannde Herst's off-beat comedy, *Highway 101*, the dancers represented cars on a crowded freeway. (According to the *San Francisco Chronicle*, "the young gentleman in a tweed cap was obviously a sports car; the lady in the flowered bonnet was a sedate sedan; the burly fellow was a ten-ton truck; another was a hot-rodder; and so on.")

The series grew so popular that "Ballet '68" was enlarged to include two local seasons—a spring series at the 500-seat Presentation Theater, and a summer season at the large Nourse Auditorium near the Opera House. For the first time, choreographers outside the Bay Area were invited to contribute works: Dennis Carey, director of the Ballet Nacional de Chile, introduced four of his ballets to American audiences, while Stuart Hodes, a soloist with the Martha Graham Company for twelve years, staged *Prima Sera*, an adaptation of Tennessee Williams' *The Roman Spring of Mrs. Stone*. The repertory grew even more eclectic as the spirit of the late Sixties took hold of the young choreographers. Carlos Carvajal, the choreographer most influenced by San Francisco's "flower child" era, created the season's celebrated "blow-your-mind" ballet, *Voyage Interdit II*, featuring a live rock band and a light show courtesy of the Garden of Delights. "A phantasmagoric odyssey into the inner mind, a revelation of a personal discovery of self, a discovery achieved within the

ambience of a psychedelic shower, not one that inundates and destroys, but one that purifies," is how one Berkeley critic described the new Carvajal ballet, which played to sold-out houses.

A new dimension was added to the workshop series when SFB and San Francisco State University co-produced "Ballet '71." The collaboration was part of a pilot project sponsored by the University's School of Creative Arts: a special summer course in Ballet Appreciation was offered by the school, with members of "Ballet '71" as artists-in-residence. University students were thus given the rare opportunity to observe the choreographic process from conception, through rehearsals, to professional performance: the full-credit course culminated in three weekends of public performances in the University's main theater. The University residence was part of SFB's attempt to develop a wider and more serious understanding of classical dance in schools and colleges: from 1966 through 1968, for example, SFB had worked closely with the Merced County School System, giving lecture-demonstrations, performances, and gymnasium concerts. And in 1969 the Company began its Caravan Concerts program, specifically tailored to state and community colleges. The campus residency of "Ballet '71" was so successful that San Francisco State University also sponsored "Ballet '72 and '73."

In 1973 Michael Smuin returned to San Francisco to become SFB's Associate Director. Once again he took charge of the workshop he had introduced fourteen years earlier, which was now "Ballet '73." That season Smuin created *For Valery Panov* in tribute to the Russian dancer whose request to emigrate to Israel had been denied by the Soviet government. "Ballet '73" was the last of its

line, bringing to a close the choreographers workshop summer series. The main Company, guided by the ambitious "revitalization" program Smuin and Christensen devised in 1973, began to perform too frequently during the summer months to allow for the workshop. In the summer of 1974, for example, SFB toured the West extensively with guest artists Valery and Galina Panov. Beginning in 1977 the Company's local spring repertory season was expanded to include a summer series. And by the end of the decade, SFB was performing in summer festivals across the nation and around the world, including the Blossom Music Festival in Cleveland, the Ravinia Festival in Chicago, and the Edinburgh International Festival in Scotland.

In the fourteen years of "Ballet '60" to "Ballet '73," the workshop presented almost 400 performances. Variety was the keynote of each program. Music ranged from Bach to Black spirituals to electronic taped scores. And the repertory included everything from a biography of Eva Peron to Dadaist collages to psychedelic extravaganzas to excerpts from Petipa's *The Sleeping Beauty*. The workshop produced 150 new works—classical tutu ballets alongside Kabuki-inspired dramas. Of course, only a handful of these premieres entered the repertory of the main Company, and of those few, only three are performed today—Christensen's *Il Distratto*, Tomm Ruud's *Mobile*, and John McFall's *Tealia*.

But the series was never intended to produce an uninterrupted string of new masterpieces. It was designed as a *workshop*—a place to experiment with new choreography, new music, new staging, and new lighting effects. Dedicated to the proposition that the Company's dancers might have something to say as choreographers and that

they deserved the chance to say it and develop, "Ballet '60 to '73" was, as one critic later noted, "a unique setting for fledgling choreographers, providing a training ground and outlet for dancers to discover if they could cross over into the area of choreography. It provided a chance found in few other places to develop choreographic ideas in a pressure-free and informal setting, and to experiment with the vocabulary of dance, introducing contemporary elements and indulging passing fancies."

The workshop, in short, continued SFB's long-standing policy to develop resident choreography. (As early as 1939, Willam Christensen told a reporter that although well-trained dancers were of course essential, a ballet company would never be first-rate without a resident choreographer.) One measure of the workshop's success can be found in the fact that four of SFB's current resident choreographers—Michael Smuin, Robert Gladstein, John McFall, and Tomm Ruud—received their start in the summer series. In its attempt to discover and develop choreographers, "Ballet '60 to '73" was dedicated to the belief that choreography is not simply one element; it is, to quote Lincoln Kirstein, "that without which ballet cannot exist. As aria is to opera, words to poetry, color to painting, so sequences in steps—their syntax, idiom, vocabulary—are the stuff of stage dancing." Choreography of course is not *all* there is to dance; the sensual specificity of an individual dancer's style cannot be denied. But choreography is the primary organizing force behind dance, and it is the choreographer, more than the dancer, who can and has changed the direction of ballet, extending, transcending, and subverting the accepted idiom to provide us with new visions of the human body in motion.

Below. Susan Williams and Bruce Bain in Bain's *Structures* (1971). (Photo: Pat Quinlan)

Opposite. John Engstrom (left) and David Coll in Lew Christensen's *Three Movements for the Short Haired* (1968). (Photo: Archives for the Performing Arts)

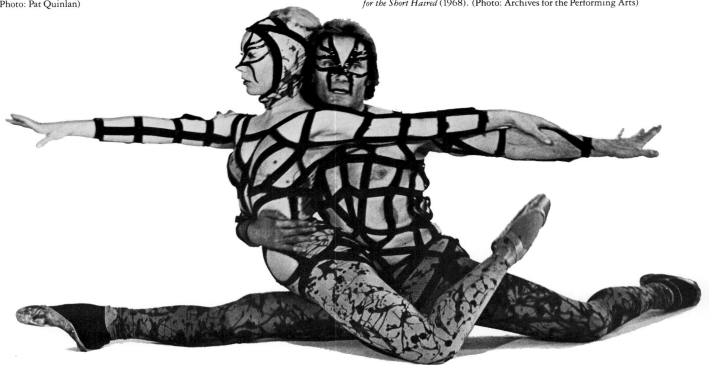

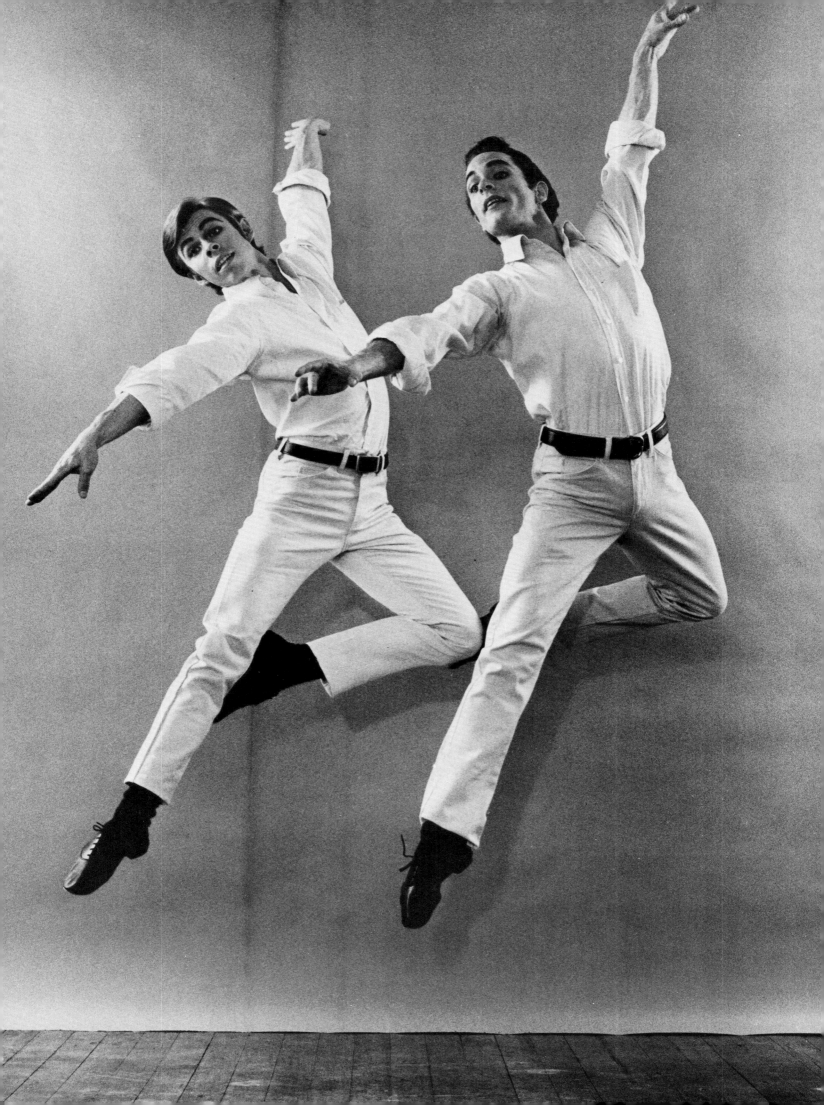

The Current Company

With 44 dancers on its 1982 roster, San Francisco
Ballet is the largest dance company outside New York.
It is, in fact, the nation's third largest company, exceeded
in size only by New York City Ballet and American
Ballet Theatre.

Laurie Cowden

Catherine Batcheller

Val Caniparoli

Katherine Cox

Ricardo Bustamante

Horacio Cifuentes

Nancy Dickson

Evelyn Cisneros

Betsy Erickson

Nigel Courtney

Natalie Kohn

Attila Ficzere

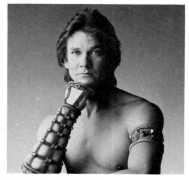

Dennis Marshall

Mark Lanham

Michael Hazinski

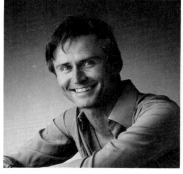

John McFall

Antonio Lopez

Eda Holmes

Lynda Meyer

Tracy-Kai Maier

David Kern

Vantania Pelzer

Russell Murphy

Jonathan Miller

Zoltan Peter

Gina Ness

Linda Montaner

Kirk Peterson

Anita Paciotti

Victoria Morgan

Andre Reyes

Kristine Peary

Paul Russell

Robert Sund

Vane Vest

Tomm Ruud

Alexander Topciy

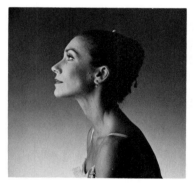

Carmela Zegarelli

Mark Silver

Paula Tracy

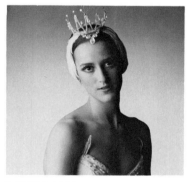

Jamie Zimmerman

Not pictured: Augusta Moore
Photos: Rudy Legname

Jim Sohm

Wendy Van Dyck

The 1978 New York Season

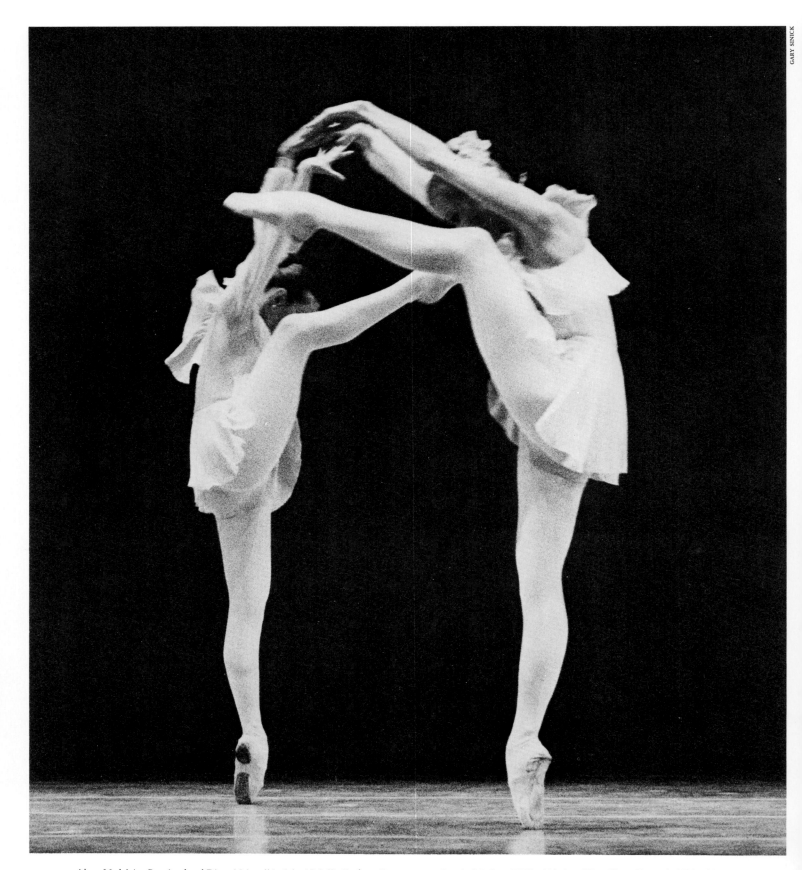

Above. Madeleine Bouchard and Diana Meistrell in John McFall's *Beethoven Quartets*, among "the best of the Company's new works," said *Newsweek*. "Without trivializing the profound music, McFall manages to find a playfulness that he translates into inventive, high-spirited movement."

Opposite left. Gary Wahl as Tybalt and Vane Vest as Romeo in Michael Smuin's *Romeo and Juliet*.
Opposite right. Laurie Cowden and Dennis Marshall in Robert Gladstein's *Stravinsky Capriccio for Piano and Orchestra*.

San Francisco Ballet was *45* years old in 1978, but it looked more like America's newest ballet company than its oldest, radiating, as one critic after another noted, the boundless, vital energy of youth. For the Company had entered an era of intensive, and unprecedented, revitalization in 1973. Long the homeless orphan among Bay Area arts organizations, SFB had finally found a permanent theater in the War Memorial Opera House, allowing the Company to extend its season, expand its audience, and enlarge its contingent of dancers— becoming, in fact, the largest employer of union dancers west of the Hudson. By 1977 the Association's board of trustees had been revamped, the coffers replenished, and the repertory greatly enlarged. Works by international choreographers like Jerome Robbins, Maurice Béjart, John Cranko, and Sir Frederick Ashton were acquired. The Company's Balanchine collection was restored and expanded. Resident choreographers like Robert Gladstein, John McFall, Tomm Ruud, and Jerome Weiss were encouraged to make their own unique contributions to the repertoire. And Michael Smuin—who had returned from ABT to SFB in 1973 to spearhead the Company's revitalization with Lew Christensen—was in the middle of a prolific sprint that would produce, by the end of his first decade as Co-Director, an impressive body of twenty-four works that ranged from bold dramas to sparkling *divertissements* to three full-length ballets. Guided by the able hands of Association President Dr. Richard E. LeBlond, Jr., SFB ended 1977 as its third consecutive year in the black, a rare feat among performing arts organizations in the less-than-healthy economy of the late Seventies. The Company's audiences had grown loyal, its reviews laudatory, and its dancers—who for decades had defected to New York—stayed put. In fact, the Company, reversing the exodus from West to East, had begun attracting dancers from across the nation and around the world. San Francisco Ballet, once the poor stepsister to the Opera and Symphony, had achieved equal status, and the city's long-held dream of "three pillars of culture," each as solid as the next, was realized. In short, by 1977 the first stage of SFB's revitalization was complete: the Company was firmly established in the city's cultural, artistic, and financial life.

In 1977 SFB thus pushed toward its next goal: national recognition. In February, *The New York Times* critic Clive Barnes came west to see the Company, writing a series of glowing reviews that piqued New York's curiosity about SFB. "The San Francisco Ballet," said the influential Barnes, "is going to be one of the emerging international companies of the next decade. This is a company of enormous potential . . . with a style very much its own and a vitality all its own. The impression the company gives is one of joyous youth. They are beautifully trained dancers. The men have a buoyant elegance, with big, broad jumps, and an attractive stylistic openness. The women have something of the same directness and power."

Within weeks, Barnes' valentine was followed by Hubert Saul's equally enthusiastic feature story in *Newsweek*. The two-page tribute—appropriately titled "Cinderella Story"—maintained that "San Francisco Ballet has achieved an artistic excellence that now places it in the front rank of American dance companies. Instead of bemoaning their company's geographic isolation, Christensen and Smuin have made a virtue of necessity, imbuing their organization with a pioneering spirit that can only be called Western in its adventurousness and self-reliance. The unexpected range of subject and style [of the Company's repertory] is astonishing. . . . Its dancers are polished and versatile and they perform with elegance. The way [SFB] is going at it, they're writing a whole new book. They could call it *Manifest Destiny*."

The Company's "manifestations" of its national stature continued: in the summer, *Saturday Review*'s Walter Terry profiled SFB's "unprecedented success," praising the Company's "fast-paced, varied, something-for-everyone" programming; and the following spring the prestigious PBS-TV series *Dance in America* featured SFB in Michael Smuin's *Romeo and Juliet*—the first time the Emmy Award-winning series had showcased a West Coast company. As Smuin himself said, the broadcast gave the Company vast national exposure: "after one showing of the ballet on TV we reached the same number of people we would have if we performed the ballet in our opera house in San Francisco every night, to a full house, for thirty-two years."

The national telecast and the glowing notices in major American publications led to the next step in the Company's campaign for national recognition: a New York season. Shortly after the Company taped *Romeo and Juliet*, SFB announced it had been invited to perform in the

45

opera house at the Brooklyn Academy of Music—its first New York appearance since its (less-than-triumphant) 1965 season at Lincoln Center. And thus, in 1978, from October 26 through November 5, the Company danced eleven works in Brooklyn, all by resident choreographers and eight of them New York premieres. (Following a

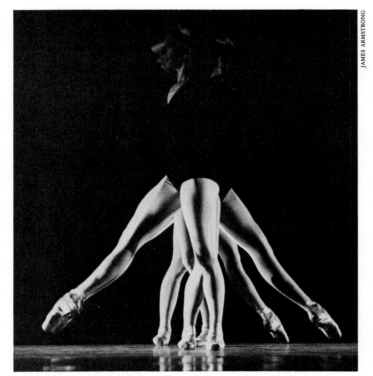

The *corps de ballet* in Lew Christensen's *Il Distratto*.

why-bring-coals-to-Newcastle philosophy, SFB left its Balanchine ballets behind.) The large and varied repertory was dominated by Co-Directors Smuin and Christensen (represented by four works apiece), with other works by each of the Company's other choreographers—Robert Gladstein, John McFall, and Tomm Ruud.

In honor of the twelve-performance series, Mayor Koch renamed the Brooklyn Bridge the Golden Gate for one day, and in a curtain speech on opening night, National Endowment for the Arts Chairman Livingston L. Biddle Jr. welcomed the West to the East, calling the Seventies "the decade of the dance." As Anna Kisselgoff reported in *The New York Times*, an unusually large number of dancers and other prominent figures in the dance world attended the debut performance, evidence of the sharp interest awakened by the Company. The opening night program included five works, four of them new to New York, but as *Newsweek* reported, there were no opening-night jitters: "this troupe has developed on its own into a first-rate dance company—and a specifically Western one. Behind the San Franciscans' speed, agility, and musicality is a strong sense of teamwork, an air of fellow adventurers on a hazardous mission. There is a freshness and an innocence in their dancing: these are well-loved children, sure of their welcome."

The welcome SFB received during its 1978 New York

season was indeed hearty, vociferous, and perhaps a bit surprising to San Franciscans and New Yorkers alike. Despite a newspaper strike, word of the Company's success spread and drew capacity crowds. When the strike ended, *The New York Times* ran a "San Francisco Ballet Conquers New York" headline, noting that during its Brooklyn series, SFB had enjoyed an unusually warm reception: "the appealing young company has won many friends in a town that likes to think of itself as the major progenitor of the best in dance. . . . It is plain that New York has taken the San Francisco Ballet to its heart." *Newsday*'s Bob Micklin said the troupe "hit the stage with an irresistible *élan* and a crisp precision that any important dance company might well envy." Clive Barnes called SFB "a company that must be seen," and virtually every notice saluted the Company's ensemble polish. "No one here with any interest in dance," concluded Dale Harris, "is ignorant any longer of the fact that nowadays San Francisco has a ballet company of genuine distinction, pure in style, versatile, thoroughly professional, yet engaging in manner. . . . The country's oldest classical ballet company has become animated with a new sense of artistic purpose."

The season gave New York its first glimpse of Smuin's post-ABT style, and in New York Smuin was—as he so often has been in San Francisco—the focus of much attention. His *Romeo and Juliet*, presented on half of the Company's twelve performances, was both praised and criticized for its boisterous theatricality, full-blooded sexiness, and aggressive pace. His other works—*Shinjū*, *Songs of Mahler*, and *Quattro a Verdi*—were similarly caught in a cross-fire, lauded as "beautifully crafted, ambitious, sensitive, and lyrical," and dismissed as "flamboyant, lurid, toney, and vulgar." But in the season's most extended and penetrating review, *The New Yorker*'s Arlene Croce argued that Smuin's choreography, whatever its excesses, "always has a sunny vigor; it is cleanly modelled and spacious in design. With all his use of acrobatics, he doesn't torture the rhetoric—he dares to be simple."

The season's most consistent praise was captured by Lew Christensen's four ballets, two of which (*Con Amore* and *Il Distratto*) had been performed by the New York City Ballet or the Joffrey Ballet, and hence were familiar to New York audiences. Croce—who called Christensen's one New York premiere, *Stravinsky Pas de Deux*, "choreographically the most distinguished work of the season"—said that Christensen's ballets held "a provocative secret" and should be better known. And *Dance News* critic Nancy Goldner found "the best numbers by far were by Lew Christensen," noting that *Con Amore* was "expertly paced," *Divertissement d'Auber* "a solid virtuoso piece," and *Il Distratto* a clever, "whole-hearted satire."

Of course the season was not without critical reservations, but even the cautious judgments evinced respect for the Company's achievements and faith in its future. Croce found SFB flourishing, easily persuading an au-

dience of its seriousness and the seriousness of ballet, but she thought the Company still lacked a fully realized style: "when the company learns to project itself with the continuous and coherent force it lacks now, it will have learned the beginnings of style, and that could make it a company of national importance."

Despite such reservations, the Company's 1978 New York season was, by even the most conservative of estimates, a major success. Reviewing the 1978 dance scene, the *San Francisco Chronicle*'s Heuwell Tircuit maintained that "if there were a single major event for the local dance world, it was ironically an out-of-town one: the first New York appearance of the San Francisco Ballet in thirteen years. During the great rebirth of the company in the Seventies, there had been national notice of the company's stature. Magazine articles, reviews by visiting critics and that wonderful telecast of Michael Smuin's *Romeo and Juliet* had spread the word. There had been successful American tours to the Midwest and Southeast, not to forget Hawaii and even Alaska. These were wildly, unbelievably successful—including last summer's triumphs at the Cleveland Orchestra's Blossom Festival. But here lay another irony: New York, which considers itself the

communications center of the United States, was the last to know. . . . It has been perfectly obvious that we had a ballet of international stature for the past three or four years. The New York appearances amounted to an unofficial coronation."

Crowned with its New York success, the Company continued its campaign for national recognition: in 1980 SFB returned to Brooklyn to inaugurate the ambitious "Ballet in America" series, and the following year the Company was once again featured on national TV when *Dance in America* presented a live broadcast of Smuin's *The Tempest*. While preparing for that telecast, the Company announced it had been invited to perform at the 1981 Edinburgh Festival: the Company's bid for national recognition thus provided the chance for international exposure and acclaim.

Returning from the 1978 New York season, Smuin, in his characteristic straightforward style, best summed up the season's importance: "We were taken very seriously in New York, we were a success, and now the Company's over a big psychological hurdle. We've cleared our 'inferiority complex.' We're free to do what we're here to do: create more and better ballets."

Roberta Pfeil, Deborah Zdobinski, Jerome Weiss, Damara Bennett, and Mariana Alvarez in Lew Christensen's *Il Distratto* (1978).

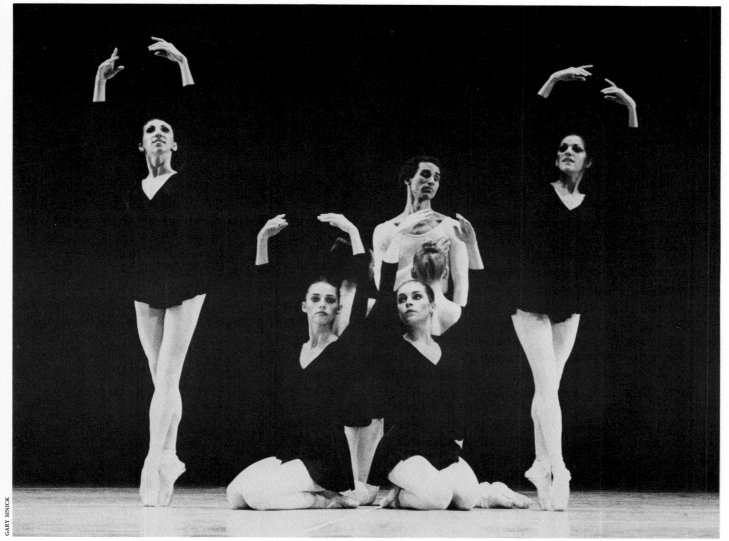

Lew Christensen's Contemporary Ballets

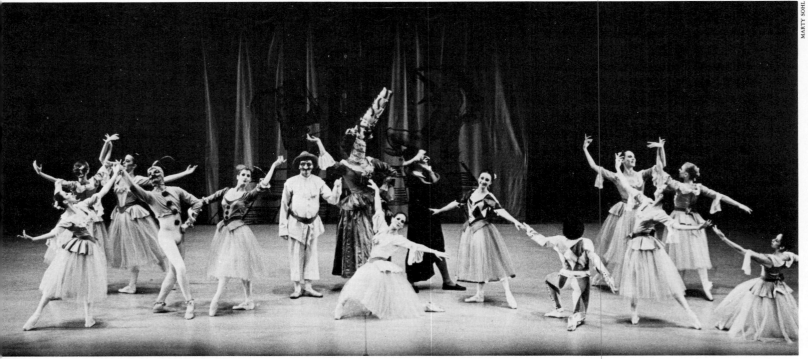

The final tableau of *Scarlatti Portfolio* (1979).

Scarlatti Portfolio was the 46th ballet Lew Christensen choreographed expressly for San Francisco Ballet, and being both bawdy and sweet, it ranks among Christensen's most masterfully whimsical works—a remarkably good-humored exercise in sexual and social frivolity. Set to Benjamin Lees' commissioned arrangement of seven sonatas by Domenico Scarlatti and inspired by the raucously "unbuttoned" tradition of *commedia dell'arte*, *Scarlatti Portfolio* covers the full panoply of Christensen trademarks: it's a fast-paced, delightfully quirky series of vignettes that for all its earthy physical comedy manages to include passages of movingly pure classicism. *The New Yorker* critic Arlene Croce could have had *Scarlatti* in mind when she praised the "eclectic Christensen tradition—a bold yet somehow impeccable combination of classical-academic and popular dance." *Scarlatti*, choreographed in 1979, draws on two of the strongest strains in Christensen's choreography—the comic and the classic. It's a craftsman's review of his career, a summing up and distillation of Lew Christensen's strong belief that classic ballet is compatible with the values of popular entertainment.

Scarlatti Portfolio wasn't Christensen's first assay of the *commedia dell'arte* style. "I've always been interested in *commedia*," he has confessed. Indeed, as early as 1952 Christensen choreographed a *commedia dell'arte* scene for television's *Standard Hour,* and his 1973 *Don Juan*—which Lincoln Kirstein hailed as "one of the finest pieces of theater I have ever seen either in Europe or America"—also took its structure from the *commedia* tradition. "The

whole style of *commedia dell'arte* still seems very modern today," Christensen has noted. "The idea of the different characters assuming similar roles in various dramatic situations, doing them in shifts, while their companions change backstage, it comes right down to twentieth century vaudeville. That same kind of structure—with small scenes inserted between larger scenes—is actually very typical of vaudeville."

True to the wacky incongruity of *commedia* and vaudevillian narrative, the seven sections of *Scarlatti Portfolio* are not a continuous story but are rather a batch of sketches full of cunning twists and wickedly exquisite timing. In one scene, the rich, elderly Franceschina—efficiently equipped with a mobile bosom that she manipulates by pulling strings on her back—searches for a husband with resolute, and resourceful, determination. Unfortunately, Franceschina (played by a man *en travestie*) is so ill-featured that whenever Pantalone or Pulcinella peek under her veil, they either swoon or attempt suicide. In another vignette, Arlequin and Columbine perform an oddly affecting "fetish" dance (Christensen wryly called it an "off-the-beaten-path" *pas de deux*), the focal point of which is Columbine's long, luxuriant, and all-too-easy-to-pull hair. And in the ballet's most celebrated sequence, Arlequin tosses off a spectacular virtuoso "duet" with a white hoop that provided SFB, as one critic said, "with four of the most exciting minutes it has enjoyed in years." It was this *tour de force* hoop dance that won Christensen a bronze medal for choreography at the 1979 International Ballet Competition in Jackson, Mississippi; David

McNaughton, who created the Arlequin role, captured a silver medal in the senior men's division—the highest prize won by an American that year.

Although some have found the ribaldry of *Scarlatti* offensive ("if we had presented the *real commedia*," Christensen contends, "we would have been censored off the stage"), most reviewers have been charmed by the ballet's broad, bold humor which has, as Anna Kisselgoff said in *The New York Times*, "a good dose of humanity about it." Praised as "vintage Christensen" and "first-rate dance theater," *Scarlatti Portfolio* has taken its place beside *Filling Station* and *Con Amore* as one of Christensen's comic masterworks—an amiable, larky romp that reveals a comic imagination unique in American dance.

In 1981 Christensen followed *Scarlatti Portfolio* with another ballet set to a baroque Italian score, *Vivaldi Concerto Grosso*. Shortly after *Vivaldi*'s premiere, Christensen explained why his two latest works employed baroque music. "Like everybody else, I went through a period where I tried to make ballets to modern music, but I got disgusted with the toot, whack, squeak, honk after awhile, and my tastes have reverted to the baroque. That music has body, construction, shape. Baroque music is all rooted in dance terms."

With its fleet footwork and boldly shifting patterns, *Vivaldi Concerto Grosso* is indeed one of Christensen's danciest ballets in years—perhaps the most vigorous, compressed, and "high-density" work of his entire career. "This music ain't dainty," Christensen insisted during rehearsals, "it drives like a train, makes the cello work

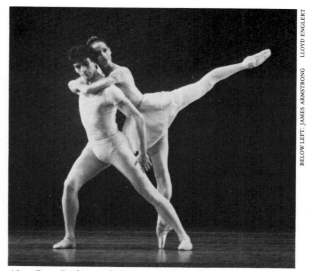

Above. Betsy Erickson and Val Caniparoli in the Second Movement of *Vivaldi Concerto Grosso* (1981).
Below left. Lynda Meyer as Isabella in *Scarlatti Portfolio* (1979).

like hell, and I want to see it really move." *Vivaldi* is indeed fuelled by a persistent drive, a heady briskness, as if, *Vivaldi*'s principal ballerina Betsy Erickson has said, Christensen were "getting to the very basis of movement itself." Like *Scarlatti*, which achieves its diverse effects with a small troupe of sixteen, *Vivaldi* does not require a large cast: the three movements of *Vivaldi* are performed by fourteen dancers—a *corps* of twelve and a solo couple. Alert to contrapuntal possibilities, Christensen works groups of dancers against each other with immaculate craftsmanship. Throughout the exhilarating first and third movements, the dancers spin intricate floor patterns: lines become pinwheels, circles, and spirals as duets, trios, and quartets quickly assemble and just as quickly disperse. Even the langorous duet of the second movement, rich with "extreme imagery" as *The New York Times* has said, is not a diminution of energy, but an intensification of it. This duet ("I've had this *pas de deux* in mind for a long time," Christensen has confessed) has the same capacious strength as the presto movements—the entire ballet moves with a consistent drive, a pulse, a sweep that are hard to resist.

If *Scarlatti Portfolio* is, as one reviewer has remarked, a "fitting bookend" to *Filling Station*, then *Vivaldi Concerto Grosso* also harks back to an earlier model: Christensen's very first ballet, *Encounter* (1936), which by his own account was a neo-classical exercise dictated primarily by its music. Throughout his career—from *Filling Station* to *Scarlatti*, from *Encounter* to *Vivaldi*—Christensen has been a master of the comic and the classic, and a master at mixing the two. His most raucous romps have been unerringly graced by the dignified spirit of the *danse d'école*, just as his most crystalline abstractions have been enlivened with a wickedly wry wit. Astute musicality, bold comedy, neo-classical craftmanship—these are Christensen's gifts to SFB. As the *San Francisco Examiner* has said, when the curtain goes down on *Vivaldi Concerto Grosso*, "no one can doubt the taste, wit, and musicality" of the Christensen legacy.

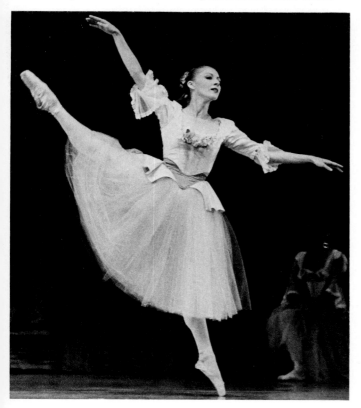

The Company's Designers

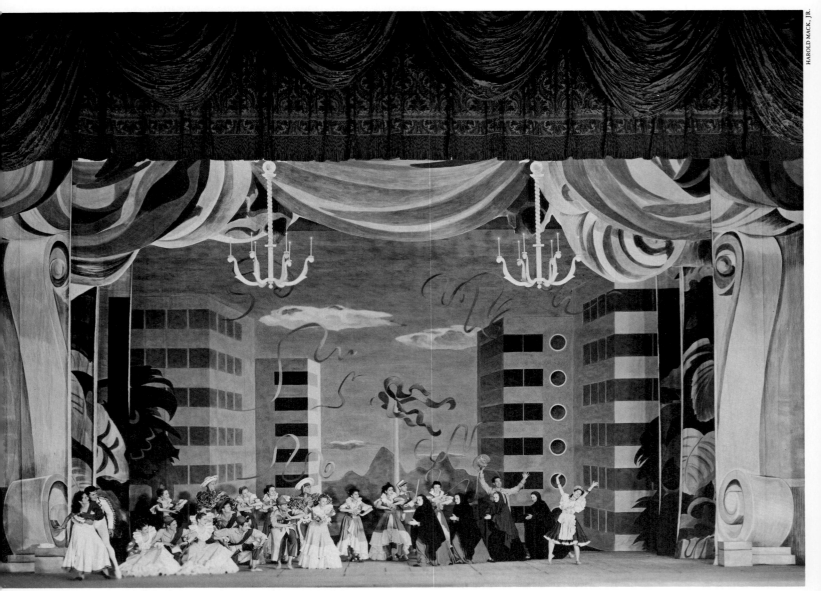

Antonio Sotomayor's scenery for Willam Christensen's *Parranda* (1947).

The 47 costumes for the *corps de ballet* in *Ballet Mécanique*, San Francisco Ballet's first major production, were designed by Adolph Bolm, the ballet's choreographer. It was one of the few times in the Company's fifty-year history that an artist functioned both as choreographer and designer. Since *Ballet Mécanique*, more than 100 designers have worked for SFB. Although the list of Company designers includes such internationally acclaimed figures as Rouben Ter-Arutunian, Willa Kim, and Tony Walton, the majority of SFB designers have been West Coast artists like Russell Hartley, Antonio Sotomayor, Cal Anderson, and Sandra Woodall. The Company's policy of developing resident choreographers has been complemented by its policy of supporting local designers.

The following is an alphabetical listing of SFB designers and an inventory of their work for the Company's premiere productions. The list does not include opera ballets or works created for the summer choreographers' workshops that SFB sponsored between 1960 and 1973.

Abbreviations:
- S Scenery
- C Costumes
- S,C Scenery and Costumes
- P Projections
- SE Special Effects

Tony Duquette's costume designs for Lew Christensen's *Lady of Shalott* (1958).

ANDERSON, Cal
1965 Life: A Do-It-Yourself
Disaster (*S,C*)
1967 Totentanz (*S,C*)
1972 N.R.A. (*C,P*)
1977 Peter and the Wolf (*S,C*)
1978 Orpheus—Return to the
Threshold (*C*)
1979 Scarlatti Portfolio (*S*)
1982 Love-Lies-Bleeding (*S,P*)

ARIEL
1976 Garden of Love's Sleep (*C*)

ARMISTEAD, Horace
1966 Scotch Symphony (*S*)

ARNETT, Chuck
1967 Kromatika (*C*)
1970 Joyous Dance (*C*)
1972 New Flower (*C*)

ARNOLD, Eloise
1953 A La Françaix (*C*)
The Festival (*C*)
1954 Heuriger (*C*)
1955 The Tarot (*C*)
1957 Mendelssohn Concerto (*C*)

ARONOVICI, Marjorie
1947 Giselle (*C*, with Rose Schogel)

ASHTON, Sir Frederick
1981 Monotones: Nos. 1 and 2 (*C*)

BAKST, Leon
1935 Firebird: A Solo (*C*,
adapted from original
designs)
Schéhérazade (*C*,
adapted from original
designs)

BATTLE, Richard
1974 The Four Temperaments (*C*)
The Beloved (*C*)
Flower Festival at Genzano:
Pas de Deux (*C*)

BERLANDIA, Jeanne
1935 Danse Noble (*C*)

BERMAN, Eugene
1953 Concerto Barocco (*S,C*)

BIBBINS, Patricia
1972 Figures in F (*C*, with
Virginia Tracy)

BODRERO, James
1950 Prelude: To Performance (*S*)
1953 Con Amore (*S,C*)

BOLM, Adolph
1933 Reverie (*C*)
Passacaglia (*C*)
Don Juan (*C*)
Au Jardin des Tuileries (*C*)
Roundelay (*C*)
Prelude and Four-Voice
Fugue (*C*)
Perpetuum Mobile (*C*)
Voices of Spring (*C*)
Le Ballet Mécanique (*C*, with
Nicolas Remisoff)

1934 Wiener Blut (*C*)
Hopak (*C*)
Abnegation (*C*)
Pedro the Dwarf (*S,C*)
Patterns (*S,C*)
Faunesque (*C*)
Hyde Park Satire (*C*)
Lament (*C*)

1935 Country Dance (*C*)
Juris Fanatico (*C*)

BOYT, John
1982 Western Symphony (*S*)

BUFANO, Beniamino
1935 Consecration (*C*)

CADMUS, Paul
1951 Filling Station (*S,C*)

CARRETERO, Angel
1935 Cordoba (*C*)
El Amor Brujo (*S,C*)

CHALON, A.E.
1973 Pas De Quatre (*C*, adapted
from original designs)

CHASE, Ronald
1979 A Song for Dead Warriors (*P*)

CHRISTENSEN, LEW
1960 Variations de Ballet

COLT, Alvin
1950 Charade or The Debutante (*C*)

Cal Anderson's costumes and scenery for Lew Christensen's *Life* (1965).

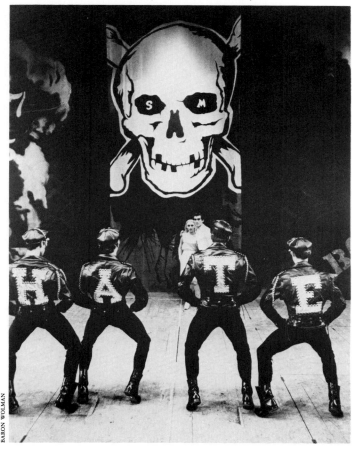

CRESCI, Geraldine
1947 Dr. Pantalone (*C*)

CROWLEY, Paul
1970 Joyous Dance (*S*)
Genesis '70 (*S*)

DALTON, Elizabeth
1974 Taming of the Shrew:
Pas de Deux (*C*)

DARLING, Robert
1970 Split (*S*)
1971 Jon Lord—Both Sides Now (*S*)
1972 Tingel-Tangel-Taenze (*S*)

DE BOTTON, Jean
1944 Triumph of Hope (*S,C*)

DE MARS, Betty Bates
1942 Winter Carnival (*S,C*)

DUBOIS, Raoul Pène
1948 Gift of the Magi (*S,C*)

DUQUETTE, Tony
1958 Lady of Shalott (*S,C*)
Beauty and the Beast (*S,C*)
1959 Sinfonia (*S,C*)
Divertissement d'Auber (*I*)
(*C*)
Caprice (*S,C*)
Danses Concertantes (*S,C*)
1960 Danza Brillante (*C*)
1961 Symphony in C (*S,C*)
1962 Jest of Cards (*S,C*)
1963 Divertissement d'Auber (*II*)
(*C*)
Fantasma (*S,C*)
1965 Octet (*C*)

FLETCHER, Robert
1973 Cinderella (*S,C*)

FRANCES, Esteban
1955 Renard (*S,C*)

FURNESS, John
1961 Original Sin (*S,C*)

GILMORE, Read
1978 Chi Mai (*C*)

GLADSTEIN, Robert
1982 Symphony in Three
Movements

GOLDSTEIN'S
1943 Hansel and Gretel (*C*)
1944 Le Bourgeois Gentilhomme
(*C*)

GRASHOW, James
1977 The Referee (*C*)

GREEN, Helen
1938 Romeo and Juliet (*C*)
In Vienna (*C*)
1939 Coppélia (*C*)
American Interlude (*C*)
1940 And Now the Brides (*C*)

GUTHRIE, David
1977 Gershwin (*S,C*)

GYORFI, Victoria
1977 Beethoven Quartets (*C*)
1978 Quanta (*C*)
1979 We, The Clown (*C*)

HARTLEY, Russell
 1944 Nutcracker (C)
 1945 Pyramus and Thisbe (C)
 1947 Henry VIII (S,C)
 1948 Les Sylphides (C)
 1949 Jinx (C)
 1950 Charade or The Debutante (S)
 1951 Divertimenti (C)
 Les Maîtresses de
 Lord Byron (S,C)
 1952 Serenade (C)
 American Scene (S,C)
 1953 Swan Lake (C)
 1954 The Dryad (SE)
 Beauty and the Shepherd (C)
 1957 Emperor Norton (C, with
 Antonio Sotomayor)

HICKS, Jimmy
 1949 Danza Brillante (C)

HODGE, Ron
 1978 Trilogy (C)

HOLDER, Geoffrey
 1976 Les Chansons de Bilitis (C,SE)

HOLLIS, Jesse
 1979 The Mistletoe Bride (S)

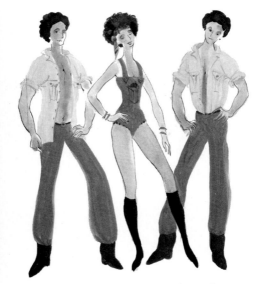

Tony Walton's costume designs for
Michael Smuin's *Mother Blues* (1974).

HUDSON, Dennis
 1972 Figures in F (P)
 1979 The Mistletoe Bride (P)

IZBINSKY, Natasha
 1976 Heart of the Mountain (S,C)

JOHN, Tom
 1977 Scherzo (S)
 Three (S)
 1980 The Nothing Doing Bar (S)

JONES, Betsy
 1980 The Nothing Doing Bar (S)

JONES, Cliff
 1943 Sonata Pathétique (C)

KALIMOS, Athena
 1966 Way Out (II) (S,C)

KARINSKA, Barbara
 1947 Black Swan Pas de Deux (C)
 1954 Sylvia: Pas de Deux (C)
 1966 Scotch Symphony (C)
 1981 Stars and Stripes (C)
 1982 Western Symphony (C)

KAY, Andy
 1977 Medea (C)

KERSH, Henry
 1966 Wajang (C)

KIM, Willa
 1975 Shinjū (S,C)
 1978 Stravinsky Capriccio for
 Piano and Orchestra (C)
 1979 A Song for Dead Warriors
 (S,C)
 1980 The Tempest (C)
 1981 Bouquet (C)
 1982 Stravinsky Piano Pieces (C)

KREMPETZ, Ronald
 1979 Le Rêve de Cyrano (S,C)

LANCASTER, Osbert
 1978 La Fille Mal Gardée (S,C)

LEE, Ming Cho
 1973 Don Juan (S)

LOURIE, Eugène
 1947 Mephisto (S,C)
 1948 Persephone (S,C)
 1953 Swan Lake (S)

MACOUILLARD, Grace
 1950 The Nothing Doing Bar (C)

NORTH, Robert
 1978 David and Goliath (C)

O'DANIEL, Higby
 1973 The Shakers (C)

O'HEARN, Robert
 1966 Pas de Six (C)
 1967 Symphony in D (S,C)
 Nutcracker (S,C)
 1969 Night in the Tropics (C)
 1971 Airs de Ballet (C)
 1972 Tingel-Tangel-Taenze (C)

ORLOVSKY, Eugene
 1940 Swan Lake (S, with
 Nicolas Pershin)

PAREDES, Marcos
 1970 Schubertiade (C)
 1971 Jon Lord—Both Sides Now
 (C)
 1973 Harp Concerto (C)
 Eternal Idol (C)
 1974 Pulcinella Variations (S,C)
 1977 Harp Concerto Pas de Deux
 (C)
 1978 Mozart's C Minor Mass (S,C)
 Bach Duet (C)

PERSHIN, Nicolas
 1940 Swan Lake (S, with
 Eugene Orlovsky)

Russell Hartley's costume designs for the Wirewalkers in Lew Christensen's
Jinx (1949).

PITKIN, William
 1970 Schubertiade (S)
 1975 Romeo and Juliet:
 A Study in Three Scenes (C)
 1976 Romeo and Juliet (S,C)

POLEN, Patricia
 1976 Stravinsky Pas de Deux (C)

REMISOFF, Nicolas
 1933 Carnival (C)
 Arlecchinata (C)
 Les Précieux (C)
 Le Ballet Mécanique (C, with
 Adolph Bolm)
 1934 Raymonda: Grand Pas
 Espagnol Classique (C)
 The Rivals (S,C)
 Bumble-Bee (C)
 1935 Rondo Capriccioso (C)

REQUET, Jacques
 1952 The Carnival of the
 Animals (S,C)
 1955 Apollon Musagète (C)

RIDER, Charlotte
 1938 Romeo and Juliet (S)
 In Vienna (S)
 1939 Coppélia (S)
 American Interlude (S)
 1940 A Midsummer Night's Dream
 (C, with J. C. Taylor)
 Swan Lake (C)
 And Now the Brides (S)
 1942 Amor Espanol (S,C)

RIZZI, Norman
 1977 Medea (S, after Gustav Klimt)

RODRIQUEZ (S), Louis
 1971 Classical Symphony (C)

ROSS, Elizabeth
 1982 Steps for Two (C)

ROUSTAN, Joelle
 1977 Firebird (C)

RUBIN, Steven
 1977 Metamorphoses (C)
 1979 Richmond Diary (S,C)

RUIZ, Antonio
 1947 The Lady of the Camellias
 (S,C)

ST. AMAND, Joseph
 1954 The Dryad (C)

SAN FRANCISCO OPERA
STAFF COSTUMERS
 1938 Ballet Impromptu (C)

SANJUST, Filippo
 1982 Swan Lake: Act II (S)

SCHOGEL, Rose
 1947 Fantasia (C)
 Giselle (C, with
 Marjorie Aronovici)

SHARP, Kenneth
 1980 Canti (C)

SIMONEAU, Maurine
 1961 St. George and the Dragon
 (S,C)

SMUIN, Michael
 1976 Songs of Mahler (C)

SOTOMAYOR, Antonio
 1944 Nutcracker (S)
 1945 Blue Plaza (S,C)
 1947 Parranda (S,C)
 1957 Emperor Norton (S,C, with
 Russell Hartley)
 1960 Esmeralda: Pas de Deux (C)

TANNING, Dorothea
 1954 The Dryad (S)

TAYLOR, J.C.
 1937 Chopinade (C)
 Rumanian Wedding (S,C)
 Capriccio Espagnol (C)
 1938 The Bartered Bride: Three
 Dances (C)
 1939 L'Amant Rêve (C)
 1940 A Midsummer Night's Dream
 (C, with Charlotte Rider)
 1942 Coeur de Glace (C)

TER-ARUTUNIAN, Rouben
 1964 The Seven Deadly Sins (S,C)
 1965 Lucifer (S,C)
 1974 La Sonnambula (S,C)
 1976 Souvenirs (S,C)

THAYR, Forest Jr.
 1937 Encounter (C)

THOMPSON, Frank
 1977 The Referee (C)
 Three (C)

TOUMANOVA, Eugenia
 1948 Don Quixote: Pas de Deux (C)

TRACY, Virginia
 1972 Figures in F (C, with
 Patricia Bibbins)

TRAVIS, Warren
 1982 Badinage (C)

VARDEMAN, Lynne
 1967 Kromatika (SE)

VARONA, José
 1973 Don Juan (C)
 1977 The Ice Maiden (S,C)
 1982 Beauty and The Beast (S,C)

WALTON, Tony
 1973 Harp Concerto (S)
 1974 Mother Blues (S,C)
 1980 The Tempest (S)
 1982 Stravinsky Piano Pieces (S)

WEISGARD, Leonard
 1951 Le Gourmand (S,C)
 1954 Nutcracker (S,C)

WEST, David
 1955 Apollon Musagète (S)

WOODALL, Sandra
 1977 Scherzo (C)
 1978 Quattro a Verdi (C)
 1979 The Mistletoe Bride (C)
 Scarlatti Portfolio (C)
 Allegro Brillante (C)
 Duettino (C)
 1980 Introduction and Allegro (C)
 Psalms (C)

 1981 Vivaldi Concerto Grosso (C)
 Bartok Quartet No. 5 (C)
 1982 Vilzak Variations (C)
 Swan Lake: Act II (C)
 Love-Lies-Bleeding (C)

YOUNG, Parker
 1973 Cinderella
 1980 The Tempest (SE)

Right. José Varona's costume design
for Lew Christensen's *Beauty and the
Beast* (1982).
Far right. Leonard Weisgard's costume
design for the Café Royale in Lew Chris-
tensen's *Le Gourmand* (1951).

Willa Kim's costume design for Michael Smuin's *A Song for Dead Warriors* (1979).

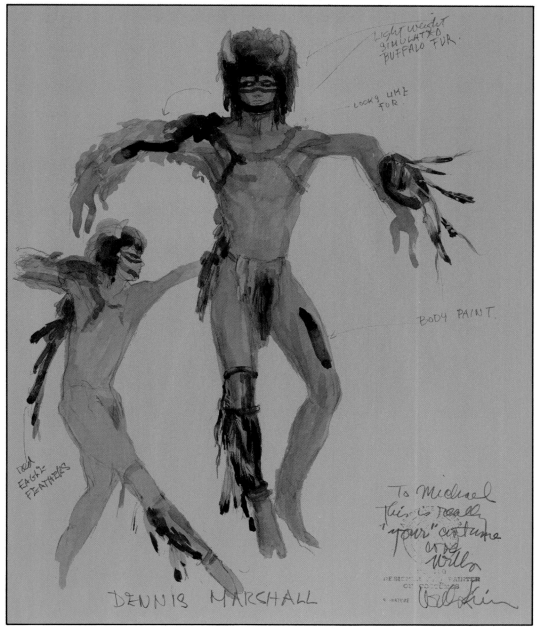

173

The Company's Dancers

The Company numbered *48* dancers at its premiere performance on June 2, 1933. Since that landmark debut, more than 970 performers have danced with San Francisco Ballet. The following is an alphabetical list of those artists.

NOTES:

■ The date following each name indicates the calendar year in which the dancer first joined the Company or appeared in the capacity indicated in parentheses.

■ The abbreviation "g.a." in parentheses following a dancer's name designates a guest artist.

■ The abbreviation "app." in parentheses following a dancer's name designates a Company apprentice.

■ The abbreviation "aux." in parentheses following a dancer's name designates an auxiliary Company member. Included are dancers who performed as Company members in *Nutcracker* only, and advanced students of the San Francisco Ballet School.

ABBE, Tilly/Matilda	1956
ABBOTT,	1933
Betty Scoble/Elizabeth	
ACKERMAN, Maile	1967
ADAMS, Barbara	1953
a.k.a. JOHNSTON, Barbara	
ADAMS, Holli (aux.)	1977
ADAMSON, Sandra	1968
ADLER, Louise	1937
AGNESE, Rita	1962
AHONEN, Leo	1968
AITKEN, Peter	1943
ALBERTSEN, Victoria	1934
ALDEN, Guy	1933
ALDEN, Walter	1934
ALLAN, Edward	1936
ALLEN, Dennis	1964
ALLEN, Willette	1937
ALSER, Jamie (aux.)	1977
ALVAREZ, Mariana	1973
ANDERSON, David	1962
ANDREWS, Jon	1947
ANDROS, Gus	1948
ANTISDEL, Karen	1979
ANTONIA, Ms.	1935
ARKATOV, Gloria	1939
ARKATOV, Victoria	1939
ARNOLD, Bené	1949
ARNTZ, Jo Ellen	1983
ARRONA, Philippe	1969
ARVOLA, Soili	1968
ASONOVICH, Genevieve	1944
ASQUITH, Ruby	1940
AUTRAND, Claire	1945
AVILA, Ms.	1935
AYERS, Kristi (aux.)	1971
AYRES, Judith (aux.)	1959
BACHICH, Annette	1962
BADERTSCHER, Barbara	1944
BAILEY, Francis	1939
BAILEY, Sally	1947
BAIN, Bruce	1960
BAKOVA, Pega	1936
a.k.a. BATES, Peggy	
BALKE, Karl (aux.)	1955
BANCROFT, Wallace	1933
BARALLOBRE, Raymond	1949
a.k.a. BARA, Ray	
BARBOUR, Joan	1942
BARTH, Carmen	1980
BASUINO, Alton	1948
BATCHELLER, Catherine	1982
BATCHELOR, Lorene	1953
BATES, Peggy	1936
a.k.a. BAKOVA, Pega	
BEATTIE, Katherine	1944
BECKWITH, Barbara	1939
BEGANY, Barbara	1964
BELERUE, Mary	1936
BELL, Bonnie	1944
BELL, Robert E.	1933
BENNET, Joan	1941
BENNETT, Christine	1966
BENNETT, Damara	1970
BENNETT, Ruth	1937
BERCI, Vadja	1936
a.k.a. DEL ORO, Vadja	
BERG, Henry	1963
BERGMAN, Alan	1966
BERING, Christine	1951
BERKINS, Cosette	1936
BERNAL, Tina	1962
BERNARD, Lois	1940
BERRY, Lynda	1962
BERTCH, Bonnie	1940
BIALOBLOCKI, Patricia	1968

BIBBINS, Patricia	1947
a.k.a. JOHNSTON, Patricia	
BICKMORE, Rex	1964
BILZ, Nell	1933
BLACK, Sherron	1974
BLISS, Barbara	1933
BLISS, Olive	1947
BLOCK, Arnold/Arron/Yonkel	1935
BODINE, Lori	1980
BOHM, Cecilia	1942
BOLM, Adolph	1933
BONNEFOUS, Jean-Pierre (g.a.)	1974
BOOTH, Velerie	1946
BORJA, Claudia	1934
BORTOLUZZI, Paolo (g.a.)	1962
BOSEMAN, Beverly	1943
BOUCHARD, Madeleine	1973
BOVARD, Jean (aux.)	1954
BOWEN, Jane	1944
BRADLEY, Carla	1934
BRADLEY, Julie	1952
BRADSHAW, Isobel	1933
BRADY, Joan	1957
BRANDNER, Eildon	1935
BRANNIN, Jerome	1957
BRATOFF, Anatole	1934
BRATOFF, George	1933
BREEDLOVE, Bill	1965
BRENNAN, Wayne	1955
BRIGHT, Brantly	1972
BRODERICK, Maureen	1973
BRODY, Lori	1969
BROULETTE, Julienne	1936
BROWNING, Virginia	1934
BROX, Gerard	1971
BRUCE, Bob	1964
BRUCE, Cheryl (aux.)	1976
BRUDOWSKY, John (aux.)	1976
BRUNETTE, Ms.	1943
BRUMBLEY, June	1933
BUCHER, Gerrie	1957
BUCK, Webster	1950
BUGBEE, Donna	1934
BUJONES, Fernando (g.a.)	1976
BURGESS, Richard	1943
BURGESS, Walter	1949
BURNETT, Jackie	1943
BURR, Mary	1937
a.k.a. CARRUTHERS, Mary;	
TOVANYA, Maria	
BUSCH, Christine	1973
BUSTAMANTE, Ricardo	1981
BUTLER, Daryl	1971
BUTT, Miriam	1935
CACCIALANZA, Gisella	1943
CALLAGHAN, Kathleen (aux.)	1972
CALLOW, Charlene	1955
CAMERON, James (aux.)	1979
CANCILLA, Gloria	1952
CANE, Jean	1935
a.k.a. DALZIEL, Jean	
CANIPAROLI, Val	1973
CANNON, Larry (aux.)	1961
CAPPARA, Michael	1970
CARLISLE, Eldon	1951
CARLSON, Deirdre	1972
CARLSON, Gardner	1970
CARLTON, Janet	1939
CARLYLE, David	1937
CARMASSI, Joseph	1943
CARMITA (g.a.)	1935
CARPENTER, Jan	1952
CARR, Natalie/Natasha	1941
CARRUTHERS, Mary	1937
a.k.a. BURR, Mary;	
TOVANYA, Maria	
CARSON, Shirley	1952

Name	Year
CARTER, Francis	1955
CARTER, Richard	1952
CARTT, Susan	1963
CARVAJAL, Carlos	1951
CASSIDY, Joan	1943
CATE, Nicholas	1973
CEDERWALL, Susan (aux.)	1963
CHADWICK, Glen	1953
CHAMPION, Marge (g.a.)	1976
CHAPPELL, Gina	1942
CHARISSE, Nico	1933
CHETWOOD, Ronald	1937
CHISHOLM, Milton	1936
CHRISTENSEN, Harold (g.a.)	1937
CHRISTENSEN, Lew (g.a.)	1937
CHRISTENSEN, Willam	1937
CHUN, Gilbert (aux.)	1977
CIFUENTES, Horacio	1979
CISNEROS, Evelyn	1977
CLARK, Alice	1936
CLARK, Susan Barbara	1936
CLARKE, Thatcher	1963
CLEMENT, Janne	1975
CLINE, J.	1933
COCHRAN, Warren	1947
COFFMAN, Vernon	1965
COHN, Wilma	1944
COLER, Constance	1950
COLL, David	1966
COLTRON, Evelyn	1943
CONNOLY, Patricia	1933
CONROY, Pamela	1953
CONVERSE, Payne	1940
COOK, Ms.	1935
COOKE, Allan	1933
CORTAZ, Joan	1942
COSI, Liliana (g.a.)	1975
COTTON, Dorothy	1933
COURTNEY, Nigel	1979
COWDEN, Laurie	1971
COX, Katherine	1981
CRABTREE, Cornell (aux.)	1976
CRAGUN, Richard (g.a.)	1974
CRAIG, E.	1934
CRAWFORD, Jane	1933
CRISTEN, Grant	1937
CROCKER, Virginia	1941
CROCKETT, Deane	1936
CROCKETT, Leslie	1975
CROWELL, Ann	1949
CULBERTSON, Barbara	1959
CUMMINGS, Celena	1939
CUNEO, Betty	1943
CUNNINGHAM, Genevieve	1933
CURRY, Jere	1947
CURTEZ, Joan	1942
CURTIS, James	1947
DALE, Anne	1972
DAL SANTO, Yvonne	1947
DALZIEL, Jean	1935
a.k.a. CANE, Jean	
D'AMBOISE, Jacques (g.a.)	1960
DAMSGAARD, Lars (app.)	1983
DANIELIAN, Leon (g.a.)	1953
DANILOVA, Alexandra (g.a.)	1952
DANO, Lazar	1967
DAVID, Mercedes (app.)	1983
DAVIS, Diana	1969
DAYHOFF, Donald (aux.)	1974
DEANE, Allyson	1966
a.k.a. SEGELER, Allyson	
DE ANGELO, Ann Marie (aux.)	1971
DE GARCIA, Ralph	1934
DE GRAF, Anne	1936
DE HEURTAMONT, Illiana	1966
DE LAVALLADE, Carmen (g.a.)	1976
DELICHTENBERG, Marianne	1963
DEL LANTIS, Zoe	1939
DEL MOTTE, Madeline	1937
DEL ORO, Guillermo	1934
DEL ORO, Vadja	1936
a.k.a. BERCI, Vadja	
DELOS, Donald	1953
DE LUCE, Iris	1934
DEMMLER, Nancy	1950
DE RUIZ, Albert	1936
DE SOSA, Emita	1937
DETTLING, Aileen	1951
DE VERE, Joan	1964
DEVINCENZI, Susan	1949
DE VITA, Marilyn	1950
DE WITTE, Odile	1971
DIAMOND, Ms.	1939
DICKSON, Nancy	1971
DI GIOVANNA, Joanna	1962
DIMPHEL, Elva	1933
DISHONG, Zola	1962
DODGE, Marcella	1943
DODSON, Betty Joan	1935
DOHERTY, Kathleen	1961
DOLIN, Anton (g.a.)	1947
DOMINE, Eric	1941
DONALD, Geralyn	1964
DONNE, Dieu	1937
DOOLIN, Genevieve	1939
DOUGLAS, Scott	1948
a.k.a. HICKS, Jimmy	
DOUTHIT, Donald (aux.)	1969
DOWNING, Andrea	1939
DREW, Roderick	1954
DUCLOS, Lisa	1971
DUFFUS, Barrie	1967
DUFFY, Patrick (aux.)	1981
DUGAN, Kathleen (aux.)	1976
DUGGAN, Leo	1949
DUNN, Patricia	1948
DWYER, Michael	1973
DUNNIGAN, Joseph	1944
EAMES, Janet	1936
EDGECUMBE, Lodena (g.a.)	1937
EDGERTON, Joan	1946
EDWARDS, Charles	1953
EGLEVSKY, Andre (g.a.)	1954
ELLIOTT, Patricia	1953
ELLISON, Heidi	1973
EMPEY, Glenda	1953
ENDERS, Uta	1964
ENGSTROM, Jon	1966
ENMAN, Marion	1936
ERICKSON, Betsy	1964
ERYCK, Donald	1969
ESCUDERO, Vicente (g.a.)	1935
EVANS, Helen	1939
FAGUNDES, Christina (app.)	1983
FANEUF	1942
FARRELL, Suzanne (g.a.)	1979
FAULKNER, Ralph	1936
FEALY, Dan	1936
FEINBERG, Ronald	1950
FELSCH, Joaquin	1942
FERGUSON, Margaret	1933
FERGUSON, Mildred	1939
FERNANDEZ, Royes (g.a.)	1959
FERRIER, André (g.a.)	1944
FICZERE, Attila	1973
FILIPOV, Alexander	1974
FINLAY, Mary Barbara	1949
FISHEL, Winifred	1935
FITZELL, Roy (g.a.)	1948
FITZGERALD, Marion	1933
FLANDRO, Ronnie	1943
FLEMING, Mela (aux.)	1967
FLYZIK, Irene	1933
FNICK, Virginia	1941
FOCH, Nina (g.a.)	1964
FOLEY, Ann	1981
FONTEYN, Margot (g.a.)	1964
FORD, Katherine	1955
FRALEY, Ingrid	1968
FRANCE, Joe	1960
FRANCESCA,	1934
(Guigni-Romanoff)	
a.k.a. GUIGNI, Francesca;	
LEDOVA, Francesca;	
ROMANOFF, Francesca	
FRANK, Deanne (aux.)	1976
FRANKLIN, Robert	1938
FREEMAN, Charles	1938
FREEMAN, Claire	1938
FREEMAN, Wendla (aux.)	1967
FRELLSON, Robert	1945
FRICK, Pearl	1940
FUERSTNER, Fiona	1950
FUJINO, Koishi	1969
FULLER, Lee	1963
FUNK, Linda (aux.)	1958
FUSHILLE, Celia (app.)	1982
GAIR, Joan	1972
GALE, Florence	1937
GALLYOT, Raul (aux).	1971
GANN, Rudolph	1938
GARDE, Greta	1933
GARLAND, Patricia (aux.)	1967
GARVER, Dorothy	1935
GEARY, Gladys	1939
GEIPEL, Robert	1951
GEORGE, Carolyn	1948
GERLACH, Betty Jean	1937
GEVURTZ, Mattlyn	1937
GIAGNI, Daniel (aux.)	1972
GIBSON, Diane	1963
GIBSON, Elizabeth	1943
GIBSON, Richard	1964
GILARDI, Andrew	1943
GILLENWATER, Carleton (app.)	1983
GIRARD, Aaron	1951
GLADSTEIN, Robert	1960
GLEASON, Michael (aux.)	1974
GLIMIDAKIS, Anastasia (app.)	1980
GODKINS, Paul	1936
GOLD, Vera	1943
GORBOUNOFF, Gregory	1933
GORDON, Emmaleen	1936
GOSHEN, Harriet	1940
GRADY, Claire	1936
GRAHAM, Michael	1973
GREENLEY, Audrey	1944
GREGORY, Cynthia	1961
GREY, Jim	1949
GRIFFEN, Tonia	1943
GRIZZLE, Terrence (aux.)	1971
GROSSENBACHER, Judith (aux.)	1963
GUHLKE, Antoinette	1944
GUIGNI, Francesca	1934
a.k.a. FRANCESCA,	
(Guigni-Romanoff);	
LEDOVA, Francesca;	
ROMANOFF, Francesca	
GYORFI, Victoria/Marolyn	1964
HALL, George	1947
HAMILTON, Carol (aux.)	1971
HAMILTON, Michelle (aux.)	1976
HAMILTON, Roberta	1950
HAMMONS, Suzanne	1959
HAMPTON, Thomas	1950
HANF, Mary	1971
HANLON, Scott	1970
HANNA, Jean (aux.)	1971
HANNER, Thomas	1973
HANSEN, Robert	1943
HANSON, Marvin (aux.)	1963
HARDIE, David	1956
HARGRAVES, Lou Anne	1951
HARRIS, Donna	1960
HARRIS, Maria (aux.)	1979
HARRIS, William (aux.)	1974
HARROUN, Ann (aux.)	1958
HARSHBARGER, Joan	1953
HART, Phillipp	1940
HARTLEY, Russell	1943
HARWEST, Harry	1945
HASSTEDT, Glen	1971
HAY, William	1946
HAYDEE, Marcia (g.a.)	1974
HAYDEN, Melissa (g.a.)	1967
HAYES/HAYS, Jeanne	1935
HAZINSKI, Michael	1980
HEAVERLO, James (aux.)	1969
HEINEMANN, Kristine	1963
HELMS, Caroline	1953
HENDERSON, Helena	1942
HENDERSON, Howard	1958
HERNANDEZ, Letitia (aux.)	1978
HERNDON, Jerry	1958
HERRIN, Julien	1956
HERST, Jeannde	1934
a.k.a. TAYLOR, Jeannde	
HERTZELL, Edward	1948
HESS, Susan (aux.)	1976
HEVENOR, Douglas	1970
HICKS, Janet	1944
HICKS, Jimmy	1948
a.k.a. DOUGLAS, Scott	
HILDEBRAND, Carol	1953
HILKOVSKY, Valentina (aux.)	1967
HILL, Marjorie	1933
HILLIARD, Riette	1933
HINES, Gregory (g.a.)	1982
HINK	1939
HOAGLAND, Helen	1934
HOBART, Jeffreys	1958
HOCTOR, Daniel	1938
HOFFSCHNEIDER, Lois	1937
HOLLAND, Thomas	1938
HOLMAN, Nina	1953
HOLMES, Eda	1980
HOLT, Wendy	1966
HOOPER, Corinne	1934
HOUSER, Carolyn	1968
HOUY, John	1968
HOWARD, Marlan	1952
HSEUH, Polly	1967
HUNTER, Katherine (aux.)	1978
HUNTER, Kathleen	1977
HUNTRESS, Patricia	1954
HUTELIN, Lynne	1971
HUTTEN, Lee (aux.)	1979
IGLESIAS, Roberto	1949
IMAZ, Elena	1942
IRWIN, Elizabeth (aux.)	1979
IRWIN, Jane	1958
IRWIN, Robert	1938
ISHAM, Irene	1933
ISHIKAWA, Tokuko	1962
JACOBS, Nancy	1945
JACOBSEN, Marion	1942
JACOBSON, Nancy	1943
JAMES, Beverly	19xx
JAMES, Evelyn	1933
JAMES, Marie	1935
JAMISON, Judith (g.a.)	1975
JANES, Howell	1943
JARNAC, Dorothy	1936

JEPPSON, Pat 1955
JHUNG, Finis 1961
JIMINEZ, Marie 1958
JOHNSON, Juanita 1935
JOHNSON, Nancy 1944
JOHNSON, Virginia 1953
JOHNSON, Walter 1938
JOHNSON, William 1962
JOHNSTON, Barbara 1953
 a.k.a. ADAMS, Barbara
JOHNSTON, Patricia 1947
 a.k.a. BIBBINS, Patricia
JONES, Cliff 1942
 a.k.a. JONS, Kurt
JONES, Kurt 1948
JONES, Stephanie 1974
JONS, Kurt 1942
 a.k.a. JONES, Cliff

KALIMOS, Leon 1947
KALININ, Nika 1934
KEEVER, Robert 1938
KEHLET, Niehls (g.a.) 1973
KEITH, Hal 1942
KEITH, Robert 1945
KELLY, Jane 1971
KERN, David 1981
KERSH, Henry 1964
KESSLER, Dagmar (g.a.) 1974
KESSLER, John 1953
KIESOV, Deborah 1971
KILMURRAY, Jay (aux.) 1979
KIMMERLE, Milo 1937
KITAIN, Michel (aux.) 1977
KITCHENS, Frank 1941
KIVITT, Ted (g.a.) 1976
KLAKOWICZ, Roberta 1944
KLOSKI, Paige (aux.) 1976
KNEIPER, Dorothy 1938
KNEISS, Gloria 1943
KNICK, Virginia 1941
KNIGHT, Pat 1960
KOERBER, Betty 1949
KOGAN, Ellen 1969
KOHN, Natalie 1981
KOLODIN, Michael 1933
KOOLISH, Deborah 1967
KOOVSHINOFF, Natasha 1944
KOPELS, Beverly (aux.) 1971
KOSTALKI, Linda 1974
KOSTIK, Jirjana 1969
KOTCHIK, Alice 1940
KRAUKLIS, Vera 1937
KRAUTER, Marvin 1942
KRISMAN, Kim 1962
KRUSE, Lois B. 1935
KUBES, Mary Alyce 1949

LA FETRA, Jacqueline 1943
LAGIOS, Penelope 1966
LANG, Harold 1939
LANHAM, Mark 1980
LAUCHE, Clare 1933
LAUERMANN, Margaret 1969
LAUNSPACH, Roberta 1948
LAVEAU, Carolyn 1939
LAVELLE, Rene 1934
LAVERY, Leslie 1944
LAVERY, Sean 1973
LAWLER, Louise 1953
LAWLER, Phyllis 1933
LAWRENCE, Houston (aux.) 1963
LEAVITT, Gerard 1964
LE CRONE, Arlend 1946

LEDOVA, Francesca 1934
 a.k.a. FRANCESCA,
 (Guigni-Romanoff);
 GUIGNI, Francesca;
 ROMANOFF, Francesca
LEITCH, Patricia 1948
LEMUS, Maurice 1958
LENNARD, Paul 1941
LEPORSKY, Zoya 1938
 a.k.a. LIPORSKA, Zoya
LEVY, Ruth 1937
LEWIS, Curt Conner 1933
LIASHENKO, Ludmilla 1949
LICHTENSTEIN, Manya (aux.) 1976
LIND, P. 1934
LINTZ, Hope 1939
LINTZ, Mark 1942
LIPITZ, Kenneth 1966
LIPORSKA, Zoya 1938
 a.k.a. LEPORSKY, Zoya
LIPPI, Tosca 1939
LITTLE, Vivian 1978
LLOYDS, Margaret 1947
LONGTIN, Ann Marie 1965
LOOPER, Ted 1960
LOPEZ, Antonio 1979
LORDON, Daniel 1971
LORRAINE, Serrita 1936
LOSWICK, Sonia 1944
LOUIS, Robert 1952
LOWE, Donna (aux.) 1962
LOWELL, Ellen 1936
LOYD, Sue 1956
LUCIER, Sara (aux.) 1979
LUDLOW, Conrad 1953
LUTHI, Alice/Alys 1933
LYNN, Dana (aux.) 1980
LYNN, Mari 1940
LYON, James 1958

MACEJUNAS, Deborah 1970
MAC RITCHIE, Norman 1950
MADSDEN, Dagmar 1953
MADUELL, Grace 1983
MAGNO, Susan 1975
MAIER, Tracy-Kai 1980
MAKAROVA, Natalia (g.a.) 1975
MALLOZZI, John 1953
MALM, Shirley 1933
MAMALES, George 1954
MANCATO, Rafael 1936
MANERO, José 1945
MANN, Grace 1941
MANNERS, Joseph 1945
MANNING, Joyce 1939
MANSFELDT, Irene 1945
MARASCO, Frank 1938
MARISCHE, Louise 1933
MARKOVA, Alicia (g.a.) 1947
MARKS, Diana 1966
MARLOW, Pamela 1958
MARSHALL, Dennis 1976
MARTIN, Barbarajean 1969
MARTIN, Jacqueline 1937
MARTIN, Keith 1975
MARTINS, Peter (g.a.) 1977
MARVIN, Ronald 1940
MARX, Linda 1970
MASCAGNO, Ernest 1938
MASIS, Jose (aux.) 1979
MATTHEWS, C. 1934
MATTHEWS, Laurence 1969
MATTY, Jane (aux.) 1979
MAULE, Sara 1968
MAY, Elizabeth (aux.) 1979
MAYES, Lucille 1933

McALLISTER, Lisa (aux.) 1979
McBRIDE, Patricia (g.a.) 1974
McCONNELL, Billy 1933
McCOY, L. Harlan 1944
McDONNELL, Diane 1953
McFALL, John 1965
McINTYRE, Barbara 1939
McLAUGHLIN, Gaby 1933
McLAUGHLIN, Margaret 1972
McMILLAN, Lois 1935
McNAUGHTON, Daniel (aux.) 1969
McNAUGHTON, David 1976
MEHRKINS, Ms. 1935
MEISTRELL, Diana 1977
MEYER, Lynda 1963
MEYER, Roberta 1950
MEYERS, Cynthia 1971
MILLER, Cynthia (aux.) 1979
MILLER, Eduardo 1951
MILLER, Gwendolyn (aux.) 1979
MILLER, Jonathan 1979
MILLER, Sharon Lee 1944
MITCHELL, Kathleen (app.) 1983
MITOFF, Janice 1948
MONDONVILLE, J.G. 1935
MONTANER, Linda 1980
MOORE, Augusta 1982
MOORE, Gary 1972
MOORE, Genie (aux.) 1962
MOORHEAD, Kristi 1972
MORAN, Consuelo 1969
MORAN, Eccleston 1933
MOREY, Norman 1956
MOREY, Zelda 1937
 a.k.a. NERINA/
 NORINA, Zelda
MORGAN, Victoria 1979
MOROSHITA, Yoko (g.a.) 1977
MORTIMER, Zelda 1936
MOSER, Molly 1936
MOURELATOS, John 1978
MOURELATOS, Mina (aux.) 1974
MRAZ, Fiala 1943
MURPHY, Russell 1980
MURRAY, Ed (aux.) 1961
MUSANTE, Muriel 1933

NABESHINA, Irene 1951
NACHTSHEIM, Gigi 1968
NAGLE, Sharon (aux.) 1979
NARI, Mr. 1935
NASSIE, Georgia 1943
NATHANSON, Judy 1945
NEILSEN, Norma 1938
NEIPER, Dorothy 1938
NELSON, Frank 1941
 a.k.a. NELSON, Peter
NELSON, Marcus 1947
NELSON, Mark 1942
NELSON, Peter 1941
 a.k.a. NELSON, Frank
NELSON, Ted 1941
NELSON, Ted 1970
NERINA/NORINA, Zelda 1937
 a.k.a. MOREY, Zelda
NESS, Anton 1972
NESS, Gina 1972
NIELSEN, Diana 1959
NOBLE, Edwina 1942
NOE, Susan 1935
NORLANDER, Sven 1968
NORMAN, Patricia 1963
NORTON, Janyce 1937
NOYES, Betina 1937
NUREYEV, Rudolf (g.a.) 1964
NUYTS, Jan 1979

ODHNER, Ellen 1944
OGILVIE, Richard 1972
OHMAN, Frank 1959
OLIVA, Mary Alice 1951
OLIVER, Edward 1935
ORDWAY, Frank 1963
O'ROURKE, Kevin 1969
ORR, Terry 1959
OSTAGGI, Elizabeth 1951
OTIS, Billie/Willa 1937
OUKRAINSKY, Serge 1937

PACE, Loraine 1940
PACIOTTI, Anita 1970
PANAIEFF, Michel (g.a.) 1943
PANOV, Galina (g.a.) 1975
PANOV, Valery (g.a.) 1975
PARADES, Betty 1939
PARADES, Nemesio 1940
PARELLO, Leila 1970
PARIN, Andrew 1933
PARKER, James 1940
PARKER, Margo 1947
PARKER, Mary 1951
PARKER, Suzanne 1933
PATTERSON, John 1966
PATTERSON, Ralph 1944
PATZELT, Lydia 1933
PAUL, Henry 1940
PAUL, Virginia 1940
PAULINI, Philippa 1933
PAUSCH, Adea 1953
PAXMAN, Gordon 1951
PEARY, Kristine 1981
PELZER, Vantania 1982
PEMBERTON, Terri Lee (aux.) 1960
PENROD, Jim 1958
PEREGO, Marguerite 1943
PERKINS, Cosette 1937
PERRI, Ms. 1935
PERRY, Joy 1953
PESINA, Victor 1980
PETER, Zoltan 1978
PETERSON, Kirk 1981
PETERSON, Marianne 1944
PETRILLO, Rosemary 1958
PETRO, Rudolph 1933
PETRUSICH, John 1937
PFEIL, Roberta 1973
PHILLIPS, Michael (aux.) 1974
PHILLIPS, Pam (aux.) 1976
PINEDA, Carlos 1933
PINER, Bruce (app.) 1976
PLATO, Ms. 1935
POINDEXTER, Ron 1963
POLINSKI, Betty 1942
PONS, Denise 1980
POOLE, Virginia 1943
POST, Janet 1947
POST, Laura 1935
POSTON, Eileen 1933
POWELL, Marilyn 1944
PRAGER, Patricia 1959
PRICE, Deborah 1971
PRING, George 1933
PROSCH, Rosalie 1939
PRUD'HOMME, Kay 1973
PULFORD, Marti 1969

QUEEN, Clyde 1955
QUICK, Cynthia 1968

RABU, Renald 1969
RADDING, Celene 1936
RAISBECK, Virginia 1935
RAISCH, Leila 1934
RAMACIOTTI, Julio 1933

RAMEY, Valla	1943	
RAMOS, David	1969	
RANDALL, Julia	1938	
RAUB, Marcianne	1944	
RAYBURN, Nada	1938	
REED, Janet	1937	
REESE, Doral	1947	
REIKMAN, Ruth	1939	
REIMAN, Elise	1933	
RENOV, Ramon	1933	
RETLE, Jean	1958	
REYBURN, Josephine	1940	
REYES, Andre	1981	
REYES, Benjamin	1967	
REYES, Genie	1949	
RICHARDSON, Dolores	1946	
RICHIE, Joyce	1939	
RICHTER, Gertrude	1934	
RIEDEL, Jymmi	1943	
RIGGINS, Earl	1938	
RIOS, Mauricio	1949	
RIOS, Michael (aux.)	1955	
RITCHIE, Linda (aux.)	1963	
RITTER, Laurie	1974	
ROBINSON, Christine	1958	
ROBINSON, Nancy	1961	
ROCHE, Aurora	1936	
ROCK, Richard (aux.)	1973	
ROGERS, Dawn (aux.)	1953	
ROGERS, Margaret	1933	
ROMANOFF, Dimitri	1933	
ROMANOFF, Francesca	1934	
a.k.a. FRANCESCA,		
(Guigni-Romanoff);		
GUIGNI, Francesca;		
LEDOVA, Francesca		
ROOF, Leone	1935	
ROSENBURG, Ronald	1973	
ROSS, Ms.	1939	
ROSS, Ron	1953	
ROSSO, Ralph	1947	
ROTHWELL, Maureen	1971	
ROTHWELL, R. Clinton	1965	
ROWLAND, Deanne	1965	
RUBINO, Michael	1963	
RUDNICK, Lia	1969	
RUGE, Ron (aux.)	1971	
RUIZ, Alex	1952	
RUIZ, Maclovia	1933	
RUIZ, Marie	1933	
RUMBERGER, Edward (aux.)	1966	
RUSS, Virginia	1933	
RUSSELL, Joe (aux.)	1970	
RUSSELL, Paul	1980	
RUUD, Tomm	1975	
SACHS, L.	1934	
SAGE, Russell	1953	
SAKAJIAN	1942	
SAKOWSKY, Juliana	1964	
SALANO (g.a.)	1945	
SALAZAR, Constance	1937	
SANDERS, Tom	1963	
SANTOS, Tina	1973	
SASSOON, Janet	1944	
SCHAEFER, Karen (app.)	1976	
SCHAEFFER, Keith (app.)	1983	
SCHAUFUSS, Peter (g.a.)	1974	
SCHILLER, Jean	1951	
SCHNEIDER, Phyliss (aux.)	1977	
SCHOLTER, Krista (aux.)	1968	
SCHORER, Suki	1956	
SCHROEDER, Royal B.	1933	
SCHROETER, Ruth	1935	
SCHUELER, Ruth Louise	1933	
SCHULTE, Ms.	1935	
SCHWARTZ, Daniel (aux.)	1976	

SCHWENNESEN, Don	1976	
SEALANDER, Carla (aux.)	1967	
SEGELER, Allyson	1966	
a.k.a. DEANE, Allyson		
SELLMAN, Bernice	1933	
SEMOCHENKO, Irene	1933	
SHAEFFER, Rosalind	1936	
SHAPIRO, Muriel	1953	
SHARP, Christie	1961	
SHARPE, Richard	1945	
SHEEREN, Susan	1971	
SHEPARD, Ada	1960	
SHEPARD, Kay	1935	
SHIMONAUFF, Alexis	1933	
SHORE, Sharon	1944	
SHWAB, Fred	1955	
SIKES, Richard	1971	
SILVA, Rodolfo	1943	
SILVER, Mark	1982	
SIMMONS, Daniel	1970	
SIMONEAU, Maurine	1958	
SIPRELLE, Richard	1934	
SKINNER, Patricia	1943	
SLATER, Josephine	1936	
SLAZER, Constance	1937	
SMART, Eldon	1951	
SMITH, Belva	1953	
SMITH, Charles	1936	
SMITH, Duncan	1942	
SMITH, Nicki	1971	
SMITH, Salicia	1965	
SMUIN, Michael	1957	
SMYTH, Edward (aux.)	1966	
SNIDER, Sharon	1946	
SNODGRASS, Ernest	1933	
SNYDER, Alice	1933	
SNYDER, Evelyn	1933	
SOHM, Jim	1975	
SORKIN, Naomi	1973	
SORVO, Salli	1947	
SPAIGHT, Dennis (aux.)	1978	
SPASSOFF, Bojan	1973	
SPOTTSWOOD, Donald	1947	
STALLEY, Suzanne	1961	
STANTON, Thomas	1971	
STAPLETON, Virginia	1961	
STARBUCK, James	1934	
STAVER, Frederick	1938	
STEIMLE, Michael (aux.)	1976	
STEMBER, Tim (aux.)	1976	
STEPHANS, Marsha	1975	
STEPICK, Wanda	1945	
STERBA, Natalie	1977	
STEWART, Lee	1952	
STODDARD, Jud	1966	
STOLZE, Lisa (aux.)	1979	
STONEY, Wiora	1937	
STOREY, Edward	1943	
STORM, Carol	1970	
STOWELL, Kent	1957	
STREETER, Patricia	1957	
STURGES, Lee	1933	
SULLIVAN, John	1969	
SUMINSBY, Barbara	1940	
SUND, Robert	1978	
SWANSON, Britt (aux.)	1967	
SWIFT, Peggy	1940	
SWIFT, Virginia	1941	
SWING, Roberta	1962	
SYKES, Richard	1970	
SYLVESTER, Patricia	1971	
SYNDON, Ruth	1935	
TALLCHIEF, Maria (g.a.)	1954	
TAMON, Arnold	1936	
TAYLOR, Jeannde	1934	
a.k.a. HERST, Jeannde		

THOMAS, Geoffrey	1970	
THOMAS, Ms. L	1935	
THOMAS, Michael	1973	
THOMPSON, Norman	1939	
THOMPSON, Ralph	1936	
THORSON, Robert	1943	
TIENKEN, Elizabeth	1971	
TIKANNEN, Matti (g.a.)	1970	
TJOMSLAND, Eloise	1964	
TOEPLEMAN, Edward	1947	
TOMLINSON, Nadine	1973	
TOMPKINS, Beatrice	1943	
TOPCIY, Alexander	1979	
TOSCANO, Synde	1933	
TOUMANOVA, Tamara (g.a.)	1948	
TOVANYA, Maria	1937	
a.k.a. BURR, Mary;		
CARRUTHERS, Mary		
TRACY, Paula	1957	
TREADWELL, Lois	1942	
TREEN, Virginia	1934	
TRIBBLE, Patricia	1951	
TRUE, Sallie	1972	
TRUETTE, Victor (aux.)	1971	
TUCKER, Jeannette	1939	
TUCKER, Robert	1943	
TULIX, Michael	1970	
TUMKOVSKY, Timothy	1972	
TURETZKY, Michele	1972	
TURNER, Margaret	1933	
UPTEGROVE, Richard	1971	
VALDEZ, Arnoldo	1935	
VAN DER KAMP, Walter	1933	
VAN DYCK, Wendy	1979	
VAN HORN, Eugenia	1957	
VAN PATTEN, Dolores	1935	
VAN WINKLE, Rick	1970	
VAR, Danya	1933	
VARJAN, Stephan	1972	
VASILIEFF, Nicolai	1933	
VAZQUEZ, Geraldine	1948	
VAZQUEZ, Roland	1947	
VERCHININA, Nina (g.a.)	1938	
VERDY, Violette (g.a.)	1970	
VESSELOFZOROV, Roman	1933	
VEST, Vane	1972	
VICKERS, Joan	1943	
VICKREY, Robert	1961	
VILLANUEVA, Josepha	1967	
VILLELLA, Edward (g.a.)	1972	
VISENTIN, Gail	1960	
VITALE, Adriano (g.a.)	1959	
VOLLMAR, Jocelyn	1939	
VUKSICH, Gordanna (aux.)	1952	
WAHL, Gary	1973	
WALKER, Dorothy	1935	
WALKER, George (aux.)	1956	
WALKER, Laura	1973	
WALLACE, Mimi	1960	
WARNER, Catherine	1968	
WARNER, Robert (app.)	1977	
WARREN, Larry	1958	
WARWICK, Alyan	1937	
WAXMAN, Gina	1959	
WEBB, June (aux.)	1967	
WEBER, Bill	1941	
WEBER, Diana	1973	
WEBER, Sam (g.a.)	1972	
WEBER, Tony	1958	
WEBER, William	1942	
WEICHARDT, Eric	1976	
WEINGARTEN, Judy	1971	
WEISBARTH, Bonnie	1971	
WEISELMAN, Laura (aux.)	1969	

WEISS, Jerome	1973	
WELCH, Laurie (aux.)	1974	
WENDORF, Vernon	1948	
WENGER, Evelyn	1933	
WENK, Emily (aux.)	1975	
WENNERHOLM, Wana	1938	
WEST, Golden	1935	
WESTLAKE, Rachel (app.)	1979	
WHALEN, Sally	1943	
WHIPPLE, Ed (aux.)	1953	
WHISTLER, Doris	1940	
WHITE, Gabrilla	1937	
WHITE, Josephine	1936	
WHITE, Onna/Anna	1938	
WHITE, Shari	1960	
WHITED, Ms. E.	1935	
WHITNEY, Margaret	1936	
WHITSON, Eileen	1949	
WICKMAN, Wendy (app.)	1980	
WIEMAN, Virginia	1935	
WILLIAMS, Caroline	1944	
WILLIAMS, Christina	1970	
WILLIAMS, Julie (aux.)	1966	
WILLIAMS, Kerry	1966	
WILLIAMS, Merle	1937	
WILLIAMS, Susan	1970	
WILLIAMS, Wana	1942	
WILSON, Bobbie	1940	
WILSON, June	1944	
WILSON, Marjorie	1936	
WING, Lita/Lyda	1935	
WINTERS, Dan	1957	
WISEMAN, Maureen/Anne	1965	
WITT, Diana	1951	
WOLF, Stephanie	1973	
WOLLENBERG, M.	1934	
WOOD, Barbara	1937	
WOODS, Deane	1943	
WOODS, Robert (app.)	1973	
WOODWORTH, Julia	1935	
WORTHINGTON, Ann (aux.)	1963	
WRIGHT, Gabriella	1937	
WYNN, Billy	1953	
YAMAGUCHI, Suzanne (aux.)	1974	
YAZOLINO, Felice	1934	
YOUNG, Eleanor	1935	
YOUNGER, Judith	1951	
ZDOBINSKI, Deborah	1973	
ZEGARELLI, Carmela	1979	
ZIEHR, Jean	1942	
ZIMMERMAN, Jamie	1977	
ZONN, Eugenia	1934	

The Company's Choreographers

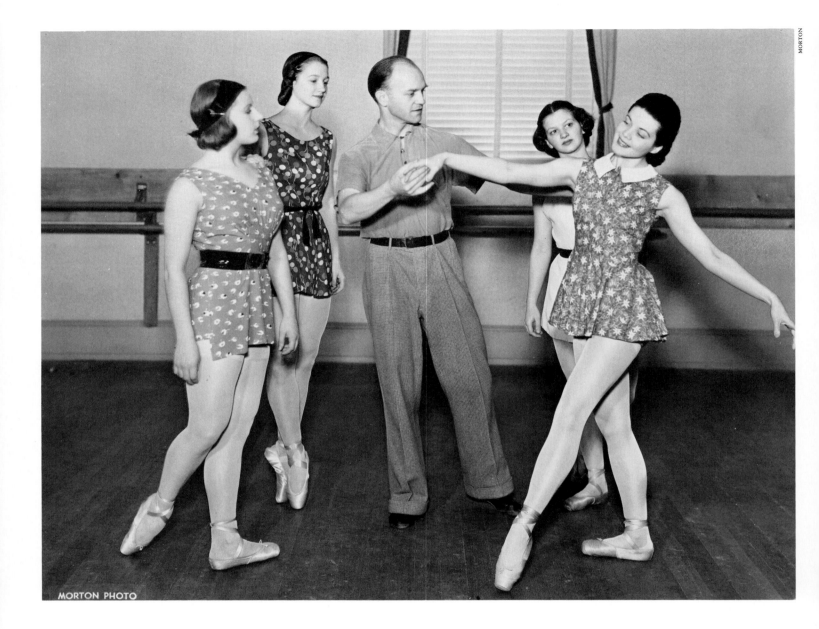

Above. Willam Christensen (center) with Mary Carruthers, Jacqueline Martin, Merle Willams, and Zoe del Lantis (1938).
Opposite. Lew Christensen (center) rehearsing Lynda Meyer and Vane Vest in *Beauty and the Beast* (1982).

By the end of its *49*th year in 1982, San Francisco Ballet had presented works by more than 90 choreographers. Included among the Company's choreographers are nineteenth-century masters (August Bournonville, Marius Petipa, Lev Ivanov), innovators from the Diaghilev era (Michel Fokine, Adolph Bolm, Bronislava Nijinska), pioneers of American classicism (George Balanchine, Lew Christensen, Willam Christensen, Jerome Robbins, Michael Smuin), and contemporary choreographers of international stature (Sir Frederick Ashton, John Cranko, Maurice Béjart).

The following is a complete alphabetical listing of SFB choreographers and an inventory of their works for the Company. The date given for each ballet is the year the work entered the SFB repertoire. This list does not include opera ballets, lecture-demonstrations, or performances by the San Francisco Ballet School.

AHONEN, Leo
1969 Minkus Pas de Deux
The Sun Did Not Rise
1970 Le Corsaire: Pas de Deux
(after Alexander Gorsky)
Tanssinen
1971 Classical Symphony

AILEY, Alvin
1975 Cry

ALLEN, Dennis
1964 Buji

ANDERSON, David
1965 Hungarica
1966 Thème Variée

ANISIMOVA, Nina
1964 Gayne: Pas de Deux
(reproduced by Rudolf
Nureyev)

ARENAL, Julie
1977 The Referee

ARRONA, Philippe
1972 Pas de Decors

ARVOLA, Soili
1969 Valse Triste
1971 A.C.—615
La Favorita

ASHTON, Sir Frederick
1978 La Fille Mal Gardée
1981 Monotones: Nos. 1 and 2
1982 The Dream: Pas de Deux

BAIN, Bruce
1969 The Encounter
Scherzo Mechanique
Fusion
1970 Firebird: Pas de Deux
1971 Structures

BALANCHINE, George
1952 Serenade
1953 Concerto Barocco
Swan Lake, Act II
(after Lev Ivanov)
A La Françaix
1954 Sylvia: Pas de Deux
1955 Apollon Musagète or Apollo
Renard (staged by
Lew Christensen)
1959 Danses Concertantes (staged
by Lew Christensen)
1960 Pas de Dix
Variations de Ballet
(with Lew Christensen)
1961 Symphony in C
1964 The Seven Deadly Sins
(revised by Lew
Christensen)
1966 Scotch Symphony
1971 La Source
1972 Tchaikovsky Pas de Deux
1974 The Four Temperaments
La Sonnambula
1976 Agon
1979 Allegro Brillante
Divertimento No. 15
1981 Stars and Stripes
1982 Western Symphony

BARNARD, David
1967 Winter Etchings

BEJART, Maurice
1977 L'Oiseau de Feu (Firebird)

BERG, Henry
1965 Pas de Trois
1966 Danza

BOLENDER, Todd
1976 Souvenirs

BOLM, Adolph
1933 Reverie
Passacaglia
Don Juan
Au Jardin des Tuileries
Roundelay
Carnival
Arlecchinata
Prelude and Four-Voice Fugue
Perpetuum Mobile
Voices of Spring
Les Précieux
Le Ballet Mécanique
1934 Wiener Blut
Hopak
Raymonda: Grand Pas
Espagnol Classique (after
Marius Petipa)
The Rivals
Abnegation
Pedro the Dwarf
Patterns
Faunesque
Lament
Bumble-Bee
1935 Rondo Capriccioso
Firebird: A Solo (after
Michel Fokine)
Danse Noble
Consecration
Schéhérazade (after
Michel Fokine)
Country Dance
Juris Fanatico
1947 Mephisto

BOURNONVILLE, August
1964 La Sylphide: Excerpts from
Act II (reproduced by
Rudolf Nureyev)
1974 Flower Festival at Genzano:
Pas de Deux

BOYARSKY, Konstantin
1975 Lady and the Hooligan: Pas de
Deux (staged by Valery
Panov)

BUTLER, John
1970 Split
1977 Three

CANIPAROLI, Val
1982 Love-Lies-Bleeding

CAREY, Denis
1968 La Péri
Sensemaya
Flight
Almost Lazarus

CARTER, Richard
1971 American Dance Overture
1972 Two Romantic Pas de Deux

CARVAJAL, Carlos
1962 Voyage à Reims
1965 Siempre Bach
Reflections
1966 Alpenfest
Wajang
Three Diversions
Kama Sutra
Voyage Interdit: A Nōh Play
1967 Totentanz
Kromatika
Facets
Shapes of Evening
1968 Giocoso
The Awakening
Wind Songs
Changes
1969 The Way
1970 Joyous Dance
Genesis '70
Matinée Dansante
1972 New Flower

CHETWOOD, Ronald
1965 Showoff
1966 The Adolescents

CHRISTENSEN, Lew
1937 Encounter (Excerpts)
1938 A Midsummer Night's Dream
1949 The Story of a Dancer
Vivaldi Concerto or Balletino
Jinx
1950 Prelude: To Performance
Charade or The Debutante
1951 Filling Station
Divertimenti (with Willam
Christensen, after Marius
Petipa and Lev Ivanov)
Le Gourmand

1954 Nutcracker
1955 Renard (after George
Balanchine)
The Tarot
1957 Emperor Norton
1958 Lady of Shalott
Beauty and The Beast
1959 Sinfonia
Divertissement d'Auber (I)
Caprice
Danses Concertantes (after
George Balanchine)
1960 Danza Brillante
Esmeralda: Pas de Deux
Variations de Ballet (with
George Balanchine)
1961 Original Sin
St. George and the Dragon
Shadows
Prokofiev Waltzes
1962 Jest of Cards
Bach Concert
1963 Divertissement d'Auber (II)
Fantasma
Dance Variations
1964 The Seven Deadly Sins (after
George Balanchine)
1965 Life: A Do-It-Yourself Disaster
Lucifer, or Concert Music for
Strings and Brass
Instruments
1966 Pas de Six
1967 Symphony in D
Nutcracker
Il Distratto
1968 Three Movements for the
Short Haired
The Magical Flutist
1971 Airs de Ballet
1972 Tingel-Tangel-Taenze

LLOYD ENGLERT

1952 American Scene
1953 Con Amore
The Festival
1954 Heuriger
The Dryad
Beauty and the Shepherd or
A Masque of Beauty and
the Shepherd

1973 Cinderella (with Michael
Smuin)
Don Juan
1976 Stravinsky Pas de Deux
1977 The Ice Maiden
1979 Scarlatti Portfolio
1981 Vivaldi Concerto Grosso

CHRISTENSEN, Willam
1937 Chopinade (after
Michel Fokine)
Dance Divertissements
Rumanian Wedding Festival
or Rumanian Rhapsody
Sketches
Capriccio Espagnol
1938 Romeo and Juliet
Ballet Impromptu
In Vienna or In Old Vienna
The Bartered Bride:
Three Dances
1939 L'Amant Rêve
Coppélia
American Interlude
A Midsummer Night's Dream
1940 Swan Lake (after Marius
Petipa and Lev Ivanov)
And Now the Brides
1942 Coeur de Glace
Scènes de Ballet
Winter Carnival
Amor Español (with Elena
Imaz and Maclovia Ruiz)
1943 Sonata Pathétique
Nutcracker: Divertissements
Hansel and Gretel
1944 Triumph of Hope
Le Bourgeois Gentilhomme
(with Earl Riggins and
André Ferrier)
Nutcracker
1945 Pyramus and Thisbe
Blue Plaza (with José Manero)
1947 Dr. Pantalone
Parranda
1949 Danza Brillante
1950 The Nothing Doing Bar
1951 Divertimenti (with Lew
Christensen, after Marius
Petipa and Lev Ivanov)
Les Maîtresses de Lord Byron
1965 Octet

CLARKE, Thatcher
1963 Triptych
1964 Sancho
Anagnorisis
Gentians in His House

CLIFFORD, John
1969 Night in the Tropics

COLL, David
1967 Balalaika

CORALLI, Jean
1947 Giselle (with Jules Perrot,
staged by Anton Dolin)
1975 Giselle: Pas de Deux (with
Jules Perrot, staged by
Olga Vinogradov)

CRANKO, John
1974 Legende
Taming of the Shrew:
Pas de Deux
1976 Opus I

DANILOVA, Alexandra
1974 Les Sylphides (after
Michel Fokine)

DE LAVALLADE, Carmen
1976 Les Chansons de Bilitis

DEL ORO, Guillermo
1934 Jota Aragonaise

1935 Jota Aragonesa
Cuadro Flamenco

DE LUCE, Iris
1934 Hyde Park Satire

DOLIN, Anton
1947 The Lady of the Camellias
Giselle (after Jean Coralli and
Jules Perrot)
1973 Pas de Quatre (with Keith
Lester, after Jules Perrot)

DOLLAR, William
1957 Mendelssohn Concerto

ERICKSON, Betsy
1981 Bartók Quartet No. 5

ERYCK, Donald
1969 The Music Box
1970 Dance Dvořák

ESCUDERO, Vicente
1935 Cordoba
El Amor Brujo

FERRIER, André
1944 Le Bourgeois Gentilhomme
(with Willam Christensen
and Earl Riggins)

FOKINE, Michel
1933 Reverie (staged by Adolph
Bolm after Les Sylphides)
1934 Caprice Viennoise
1935 Firebird: A Solo (staged by
Adolph Bolm)
Schéhérazade (staged by
Adolph Bolm)
1937 Chopinade (staged by Willam
Christensen after Les
Sylphides)
1948 Les Sylphides (staged by John
Taras)
1974 Les Sylphides (staged by
Alexandra Danilova)
Dying Swan

GIBSON, Richard
1964 Adagio for Ten and Two
1965 Souvenir

GIRARD, Aaron
1952 The Carnival of the Animals

GLADSTEIN, Robert
1962 Opus One
Biography
1963 Vivaldi Concerto
1964 Concertare
Les Desirables
1965 Way Out (I)
Face of Death
1966 Way Out (II)
Variations for Violin and
Orchestra
The Saga of Silver Creek
1967 Divertissement
Psychal
1968 Impressions in Black
and White
1971 Jon Lord—Both Sides Now
The Mistletoe Bride
1972 N.R.A. or If You Remember
Cats, Canaries and Kicking
Out, Then I'm Talking to
the Right Person
Celebration
1973 Preludium

1977 Gershwin
1978 Stravinsky Capriccio for Piano
and Orchestra
Chi Mai
1979 The Mistletoe Bride
1980 Psalms
1982 Symphony in Three
Movements

GORSKY, Alexander
1970 Le Corsaire: Pas de Deux
(reproduced by Leo
Ahonen)

GUIDI, Ronn
1968 Sun Music

HERST, Jeannde
1960 By the Side of the Freeway
1961 Buy
Questionnaire
Eva
1965 Highway 101

HIGHTOWER, Rosella
1947 Henry VIII

HODES, Stuart
1968 Prima Sera

HORTON, Lester
1974 The Beloved

HUMPHREY, Doris
1973 The Shakers

IMAZ, Elena
1942 Amor Español
(with Willam Christensen
and Maclovia Ruiz)

IVANOV, Lev
1940 Swan Lake (with Marius
Petipa, staged by Willam
Christensen)
1951 Divertimenti (with Marius
Petipa, staged by Willam
and Lew Christensen)
1953 Swan Lake, Act II (staged by
George Balanchine)
1982 Swan Lake, Act II (staged by
Kent Stowell)

KERSH, Henry
1964 Princess Aurora (from Sleeping
Beauty, after Marius Petipa)
1965 Libation: A Morality Play

LESTER, Keith
1973 Pas de Quatre (with Anton
Dolin, after Jules Perrot)

LITTIG, Marina
1969 Dances for the King

MANERO, José
1945 Blue Plaza (with Willam
Christensen)

McFALL, John
1969 Concerto in Four Movements
1970 Coup d'Essai
1972 Symphonic Impressions
1973 Tealia
1976 Garden of Love's Sleep
1977 Beethoven Quartets
1978 Quanta
1979 Le Rêve de Cyrano
We, The Clown
1980 Canti
1982 Badinage

MOORE, Gary
1973 Portrait

NELSON, Ted
1971 W.O.O.

NIJINSKA, Bronislava
1947 Fantasia

NOLAND, Ann
1972 First Time Out

NORTH, Robert
1978 David and Goliath (with
Wayne Sleep)

NUREYEV, Rudolf
1964 La Sylphide: Excerpts from
Act II (after August
Bournonville)
Le Corsaire: Pas de Deux
(after Marius Petipa)
Gayne: Pas de Deux (after
Nina Anisimova)

ORDWAY, Frank
1964 A Dream Work
1965 Concertino
Real Games

ORR, Terry
1962 Session III

PANOV, Valery
1975 Harlequinade: Pas de Deux
(after Marius Petipa)
Lady and the Hooligan:
Pas de Deux (after
Konstantin Boyarsky)
1976 Heart of the Mountain

PASQUALETTI, John
1972 Flaming Angel

PERROT, Jules
1947 Giselle (with Jean Coralli,
staged by Anton Dolin)
1973 Pas de Quatre (staged by
Anton Dolin and Keith
Lester)
1975 Giselle: Pas de Deux (with
Jean Coralli, staged by
Olga Vinogradov)

PETIPA, Marius
1934 Raymonda: Grand Pas
Classique (staged by
Adolph Bolm)
1940 Swan Lake (with Lev Ivanov,
staged by Willam
Christensen)
1943 Blue Bird: Pas de Deux
(from Sleeping Beauty)
1947 Black Swan Pas de Deux
(from Swan Lake)
1948 Don Quixote: Pas de Deux
1951 Divertimenti (with Lev
Ivanov, staged by Willam
and Lew Christensen)
1964 Le Corsaire: Pas de Deux
(reproduced by Rudolf
Nureyev)
Sleeping Beauty: Grand Pas
de Deux
Princess Aurora
(from Sleeping Beauty,
staged by Henry Kersh)
1975 Harlequinade: Pas de Deux
(staged by Valery Panov)

1982 Vilzak Variations (staged by
 Anatole Vilzak)

POINDEXTER, Ron
1963 The Set

REYES, Benjamin
1967 Mindanao

RIGGINS, Earl
1944 Le Bourgeois Gentilhomme
 (with Willam Christensen
 and André Ferrier)

ROBBINS, Jerome
1976 Afternoon of a Faun
1977 Moves
1979 Circus Polka
1982 Requiem Canticles

ROTHWELL, R. Clinton
1965 Giselle: Peasant Pas de Deux
 Defeat

RUIZ, Maclovia
1942 Amor Español (with Willam
 Christensen and Elena
 Imaz)

RUUD, Tomm
1969 Mobile
1972 Statements
1977 Metamorphoses
1978 Trilogy
1979 Richmond Diary
1980 Introduction and Allegro
1982 Steps for Two

SEMENOFF, Simon
1948 Gift of the Magi

SHOWALTER, Gordon
1962 Elijah
 Shore Leave

SLEEP, Wayne
1978 David and Goliath (with
 Robert North)

SMUIN, Michael
1960 Accent
 Session I
 Trois Couleurs
 Symphony in Jazz
1961 La Ronde
 Ebony Concerto
 Session II (with Kent Stowell)

1970 Schubertiade
1973 Cinderella (with Lew
 Christensen)
 Harp Concerto
 Eternal Idol
 For Valery Panov
1974 Mother Blues
 Pulcinella Variations
1975 Shinjū
 Romeo and Juliet: A Study in
 Three Scenes
1976 Romeo and Juliet
 Songs of Mahler
 Scott Joplin Rag: A Gala
 Finale
1977 Harp Concerto: Pas de Deux
 Medea
 Scherzo
 Sousa March: A Gala Finale
1978 Mozart's C Minor Mass
 Q. a V., or Quattro a Verdi
 San Francisco Tango:
 A Gala Finale
 Bach Duet, or Puppenspiel
1979 A Song for Dead Warriors
 Duettino
 The Tempest: Three Dances
1980 The Tempest

1981 Debut
 Bouquet
1982 Stravinsky Piano Pieces

STOWELL, Kent
1961 Session II (with Michael
 Smuin)
 The Crucible
 Shostakovich Pas de Deux
 Apologue
 Elysium
1982 Swan Lake: Act II
 (after Lev Ivanov)

TARAS, John
1948 Persephone
 Les Sylphides
 (after Michel Fokine)

VALDOR, Antony
1969 Masquerade
 Andante Spianato et Grande
 Polonaise
 Dark Vigil
1970 Dialogues in Jazz

VAN WINKLE, Rick
1970 Afternoon Revival
1972 The Trial

VASILIEFF, Nicolai
1935 Russian Peasant Scene

VEST, Vane
1973 Tangents

VILZAK, Anatole
1982 Vilzak Variations (after Marius
 Petipa)

VINOGRADOV, Olga
1975 Giselle: Pas de Deux (after
 Jean Coralli and
 Jules Perrot)

VOLLMAR, Jocelyn
1963 Sonnet
1964 Scherzando
1965 Song Without Words
1966 Pygmalion
1967 Much Ado About Nothing
 Eclipse
1968 Games in 4/4 Time
1969 Trios Con Brio
1970 Tapestry
1971 Autumn Dances
1972 Figures in F
 Tarantella for Ten

WEISS, Jerome
1973 Dance!!!
1977 Peter and the Wolf
1978 Orpheus—Return to the
 Threshold

WILDE, Marc
1966 Lilith

WILLIAMS, Susan
1970 Introspections
1972 Synapse

JAMES ARMSTRONG

Paula Tracy and Michael Smuin rehearsing Willam Christensen's *The Nothing Doing Bar* (1980).

The Repertory

For *50* years, San Francisco Ballet has been assembling a large and varied repertory. Some 579 works have been produced by SFB during its first five decades, including 248 works for the main Company, 181 opera ballets, and 150 works for the Company's choreographers' summer workshops SFB sponsored from 1960 through 1973.

The following is a complete chronological list of premiere performances of this repertory.

NOTES:

■ Lecture-demonstrations and performances by the San Francisco Ballet School are not included in this compilation.

■ Through 1962, San Francisco Ballet provided the choreography and dancers for the San Francisco Opera. These "Opera Ballets" are included as a separate category at the end of each year's listings. Unless otherwise noted, all opera ballets were performed at the War Memorial Opera House in San Francisco.

■ From 1960 through 1973, San Francisco Ballet sponsored an annual series of workshop performances called Ballet '60, Ballet '61, Ballet '62, etc. Works presented in this series are included in a separate category at the end of the respective year's listings.

■ A single asterisk (*) beside a ballet's title indicates a choreographic World Premiere. A double asterisk (**) is used whenever the ballet's choreography *and* its music were being presented for the first time anywhere.

■ The abbreviation "g.a." is placed in parentheses after a dancer's name if that dancer was a guest artist with the Company.

■ In listing the various years each ballet has been in repertory, the calendar year—and not the seasonal year— has been employed.

■ If a work was in the repertory of the workshop series (Ballet '60, etc.) but not in that of the main Company, then a "B" is used to indicate such: thus, Lew Christensen's *Bach Concert* is listed as having been in repertory in B1962, B1963, and B1964.

■ If no principal dancers are listed under a particular ballet, it is because the work was an ensemble piece, that is, without principal roles.

■ For reference purposes, an alphabetical listing follows the chronological repertory.

1933

REVERIE

Choreography: Adolph Bolm (after Michel Fokine's *Les Sylphides*).
Music: Frédéric Chopin (*Nocturne*, Op. 27, No. 2; *Prelude*, Op. 28, No. 1; *Prelude*, Op. 28, No. 19; *Mazurka*, Op. 33, No. 3; *Mazurka*, Op. 17, No. 1).
Costumes: Adolph Bolm
Premiere: June 2, 1933. War Memorial Opera House, San Francisco.
Number of Dancers: 11
Principal Dancers: Elise Reiman, Evelyn Wenger, Irene Flyzik.
In Repertory: 1933, 1934, 1935.
Note: Other San Francisco Ballet versions of *Les Sylphides* listed under 1937 (*Chopinade*), 1948, and 1974.

PASSACAGLIA

Choreography: Adolph Bolm
Music: Cyril Scott
Costumes: Adolph Bolm
Premiere: June 2, 1933. War Memorial Opera House, San Francisco.
Number of Dancers: 1
Principal Dancer: Adolph Bolm.
In Repertory: 1933, 1934, 1935.

DON JUAN
(A Choreodrama)

Choreography: Adolph Bolm
Music: Isaac Albéniz
Costumes: Adolph Bolm
Premiere: June 2, 1933. War Memorial Opera House, San Francisco.
Number of Dancers: 9
Principal Dancers: Adolph Bolm (Don Juan), Elise Reiman (The Doña).
In Repertory: 1933.

AU JARDIN DES TUILERIES
(As Children Used to Play)

Choreography: Adolph Bolm
Music: Johann Strauss
Costumes: Adolph Bolm
Premiere: June 2, 1933. War Memorial Opera House, San Francisco.
Number of Dancers: 2
Principal Dancers: Gaby McLaughlin, Irene Semochenko.
In Repertory: 1933, 1934.

ROUNDELAY
(Russian Village Scene)

Choreography: Adolph Bolm
Music: Folk music arranged by Kurt Schindler
Costumes: Adolph Bolm
Premiere: June 2, 1933. War Memorial Opera House, San Francisco.
Number of Dancers: 2
Principal Dancers: Betty Scoble Abbott, Dimitri Romanoff.
In Repertory: 1933, 1934.

CARNIVAL
(Russian Village Scene)

Choreography: Adolph Bolm
Music: Nicolai Rimsky-Korsakov
Costumes: Nicolas Remisoff

Premiere: June 2, 1933. War Memorial Opera House, San Francisco.
Number of Dancers: 26
Principal Dancers: Irene Isham, Nico Charisse.
In Repertory: 1933, 1934.

ARLECCHINATA
(A Choreocomedie)

Choreography: Adolph Bolm
Music: Jean Joseph Cassanea de Mondonville (from *Le Carnaval du Parnasse*).
Costumes: Nicolas Remisoff
Premiere: June 2, 1933. War Memorial Opera House, San Francisco. (World Premiere: Society of Chamber Music, Library of Congress, Washington, D.C., 1928.)
Number of Dancers: 3
Principal Dancers: Adolph Bolm (Arlecchino), Elise Reiman (Flamina), Allan Cooke (El Capitan).
In Repertory: 1933; 1935.

PRELUDE AND FOUR-VOICE FUGUE

Choreography: Adolph Bolm
Music: Johann Sebastian Bach ("Prelude and Four-Voice Fugue" from *The Well-Tempered Clavier*).
Costumes: Adolph Bolm
Premiere: June 2, 1933. War Memorial Opera House, San Francisco.
Number of Dancers: 4
Principal Dancers: Irene Isham, Evelyn Wenger, Irene Flyzik, Eileen Poston.
In Repertory: 1933; 1935.

PERPETUUM MOBILE

Choreography: Adolph Bolm
Music: Franz Ries
Costumes: Adolph Bolm
Premiere: June 2, 1933. War Memorial Opera House, San Francisco.
Number of Dancers: 1
Principal Dancer: Elise Reiman.
In Repertory: 1933.

VOICES OF SPRING

Choreography: Adolph Bolm
Music: Robert Schumann and Franz Liszt.
Costumes: Adolph Bolm
Premiere: June 2, 1933. War Memorial Opera House, San Francisco.
Number of Dancers: 4

Principal Dancers: Irene Isham, Nell Bilz, Irene Flyzik, Eileen Poston.
In Repertory: 1933, 1934, 1935.

LES PRECIEUX

Choreography: Adolph Bolm
Music: Sergei Prokofiev
Costumes: Nicolas Remisoff
Premiere: June 2, 1933. War Memorial Opera House, San Francisco.
Number of Dancers: 2
Principal Dancers: Adolph Bolm, Evelyn Wenger.
In Repertory: 1933, 1934, 1935.

LE BALLET MECANIQUE
(The Iron Foundry)

Choreography: Adolph Bolm
Music: Alexander Mossolov (*The Spirit of the Factory*)
Costumes: Nicolas Remisoff (for principal female dancer) and Adolph Bolm (for all other dancers).
Premiere: June 2, 1933. War Memorial Opera House, San Francisco. (World Premiere: Bolm Ballet, 1931. Also performed in the film *The Mad Genius*, Warner Brothers, 1931.)
Number of Dancers: 50
Principal Dancers: Elise Reiman, Robert E. Bell.
In Repertory: 1933, 1934.

Opera Ballets

The Ballet appeared in four of the twelve operas presented during the 1933 San Francisco Opera season, November 3 through December 2:

SAMSON ET DALILA

Choreography: Adolph Bolm
Music: Camille Saint-Saëns
Opening Night: November 3, 1933.
Principal Dancers: Elise Reiman, Evelyn Wenger, Irene Isham, Dimitri Romanoff.

LE COQ D'OR

Choreography: Adolph Bolm
Music: Nicolai Rimsky-Korsakov
Costumes and Decor: Nicolas Remisoff
Opening Night: November 6, 1933.
Principal Dancers: Adolph Bolm (King Dodon), Maclovia Ruiz (Queen of Shémaka), Nikolai Vasilieff (General Polkan), George Bratoff (The Astrologer).

AIDA

Choreography: Adolph Bolm
Music: Giuseppe Verdi
Opening Night: November 8, 1933.
Principal Dancers: Elise Reiman, Evelyn Wenger, Irene Isham, Maclovia Ruiz.

LA TRAVIATA

Choreography: Adolph Bolm
Music: Giuseppe Verdi
Opening Night: November 24, 1933.
Principal Dancers: Elise Reiman, Dimitri Romanoff, Nico Charisse.

1 9 3 4

WIENER BLUT

Choreography: Adolph Bolm
Music: Johann Strauss
Costumes: Adolph Bolm
Premiere: March 10, 1934. War Memorial Opera House, San Francisco.
Number of Dancers: 8
Principal Dancers: Irene Isham, Nico Charisse.
In Repertory: 1934.

HOPAK

Choreography: Adolph Bolm
Music: Modest Mussorgsky (from *Sorochintzky Fair*).
Costumes: Adolph Bolm
Premiere: March 10, 1934. War Memorial Opera House, San Francisco.
Number of Dancers: 2
Principal Dancers: Betty Scoble Abbott, Nikolai Vasilieff.
In Repertory: 1934, 1935.

RAYMONDA: GRAND PAS ESPAGNOL CLASSIQUE

Choreography: Adolph Bolm (after Marius Petipa).
Music: Alexander Glazounov (from *Raymonda*).
Costumes: Nicolas Remisoff
Premiere: March 10, 1934. War Memorial Opera House, San Francisco.
Number of Dancers: 1
Principal Dancer: Elise Reiman.
In Repertory: 1934.

THE RIVALS
(A Choreodrama)

Choreography: Adolph Bolm
Music: Henry Eichheim (*The Rivals*).
Costumes and Scenery: Nicolas Remisoff
Premiere: March 10, 1934. War Memorial Opera House, San Francisco. (World Premiere: Chicago Allied Arts, 1925.)
Number of Dancers: 6
Principal Dancers: Adolph Bolm (General Houang), Dimitri Romanoff (General Yu), Maclovia Ruiz (General Yu's Wife).
In Repertory: 1934.

ABNEGATION

Choreography: Adolph Bolm
Music: Isaac Albéniz
Costumes: Adolph Bolm
Premiere: June 8, 1934. War Memorial Opera House, San Francisco.
Number of Dancers: 2
Principal Dancers: Maclovia Ruiz, Dimitri Romanoff.
In Repertory: 1934.

PEDRO THE DWARF
(From *Birthday of the Infanta*, a ballet-pantomime)

Choreography: Adolph Bolm

Music: John Alden Carpenter (*Birthday of the Infanta*).
Book: Based on the story by Oscar Wilde.
Costumes and Scenery: Adolph Bolm
Premiere: June 8, 1934. War Memorial Opera House, San Francisco. (World Premiere: Chicago Opera Company, 1919. With sets and costumes by Robert Edmond Jones.)
Number of Dancers: 4
Principal Dancers: Adolph Bolm (Pedro), Dorothy Cotton (Infanta).
In Repertory: 1934.

PATTERNS*

Choreography: Adolph Bolm
Music: Alexander Tcherepnin (*Bagatelle No. 7*; *Pièces sans titres Nos. 5 and 8*).
Costumes and Scenery: Adolph Bolm
Premiere: June 8, 1934. War Memorial Opera House, San Francisco.
Number of Dancers: 7
Principal Dancers: Elise Reiman, Irene Isham, Irene Flyzik.
In Repertory: 1934.

FAUNESQUE
(La Danse de Puck)

Choreography: Adolph Bolm
Music: Claude Debussy
Costumes: Adolph Bolm
Premiere: June 8, 1934. War Memorial Opera House, San Francisco.
Number of Dancers: 2
Principal Dancers: Evelyn Wenger, Nikolai Vasilieff.
In Repertory: 1934, 1935.

HYDE PARK SATIRE

Choreography: Iris de Luce
Music: Alexander Tcherepnin (*Bagatelle No. 1*).
Costumes: Adolph Bolm
Premiere: June 8, 1934. War Memorial Opera House, San Francisco.
Number of Dancers: 1
Principal Dancer: Iris de Luce.
In Repertory: 1934.

LAMENT*

Choreography: Adolph Bolm
Music: Johann Sebastian Bach (*Prelude No. 8*).
Costumes: Adolph Bolm
Premiere: June 8, 1934. War Memorial Opera House, San Francisco.
Number of Dancers: 3
Principal Dancers: Clare Lauché, Irene Isham, Irene Flyzik.
In Repertory: 1934, 1935, 1936.

BUMBLE-BEE

Choreography: Adolph Bolm
Music: Nicolai Rimsky-Korsakov
Costumes: Nicolas Remisoff
Premiere: June 8, 1934. War Memorial Opera House, San Francisco.
Number of Dancers: 1
Principal Dancer: Elise Reiman.
In Repertory: 1934.

JOTA ARAGONAISE

Choreography: Guillermo Del Oro
Music: Camille Saint-Saëns

Premiere: September 22, 1934. Forest Meadows, Dominican College; San Rafael, California.
Number of Dancers: 10
Principal Dancers: Guillermo Del Oro, Maclovia Ruiz.
In Repertory: 1934.

CAPRICE VIENNOISE

Choreography: Michel Fokine
Music: Fritz Kreisler (*Caprice Viennoise*).
Premiere: September 22, 1934. Forest Meadows, Dominican College; San Rafael, California.
Number of Dancers: 1
Principal Dancer: Carla Bradley.
In Repertory: 1934.

Opera Ballets

The Ballet appeared in eight of the twelve operas during the 1934 San Francisco Opera season, November 14 through December 8:

THE BARTERED BRIDE

Choreography: Adolph Bolm
Music: Bedřich Smétana
Opening Night: November 14, 1934.
Principal Dancers: Carla Bradley, Irene Flyzik, Nikolai Vasilieff.

WILLAM CHRISTENSEN
ARTISTIC DIRECTOR

SAN FRANCISCO OPERA Ballet

CARMEN

Choreography: Adolph Bolm
Music: Georges Bizet
Opening Night: November 17, 1934.
Principal Dancers: Maclovia Ruiz, Betty Scoble Abbott, Irene Flyzik, Irene Isham.

TANNHÄUSER

Choreography: Adolph Bolm
Music: Richard Wagner
Opening Night: November 26, 1934.
Principal Dancers: Irene Isham, Carla Bradley, Irene Flyzik, Nikolai Vasilieff. Three Graces: Clare Lauché, Iris de Luce, Victoria Albertson.

LA TRAVIATA

Choreography: Adolph Bolm
Music: Giuseppe Verdi
Opening Night: November 28, 1934.
Principal Dancers: Frances Giugni,
Dimitri Romanoff, Allan Cooke.

FAUST

Choreography: Adolph Bolm
Music: Charles Gounod
Opening Night: November 30, 1934.

LA RONDINE

Choreography: Adolph Bolm
Music: Giacomo Puccini
Opening Night: December 3, 1934.
Principal Dancers: Irene Isham,
Dimitri Romanoff.

LAKME

Choreography: Adolph Bolm
Music: Léo Delibes
Opening Night: December 4, 1934.
Principal Dancers: Maclovia Ruiz,
Dimitri Romanoff.

MIGNON

Choreography: Adolph Bolm
Music: Ambroise Thomas
Opening Night: December 7, 1934.
Principal Dancers: Eccleston Moran,
Betty Scoble Abbott, Dimitri
Romanoff.

1 9 3 5

RONDO CAPRICCIOSO*

Choreography: Adolph Bolm
Music: Felix Mendelssohn
Costumes: Nicolas Remisoff
Premiere: May 15, 1935. War
Memorial Opera House, San
Francisco.
Number of Dancers: 6
Principal Dancers: Margaret Rogers,
Nicolai Vasilieff.
In Repertory: 1935.

FIREBIRD: A SOLO

Choreography: Adolph Bolm
(after Michel Fokine).
Music: Igor Stravinsky
Costumes: After Leon Bakst
Premiere: May 15, 1935. War
Memorial Opera House, San
Francisco.
Number of Dancers: 1
Principal Dancer: Irene Flyzik.
In Repertory: 1935.

CORDOBA

Choreography: Vicente Escudero
Music: Isaac Albéniz
Costumes: Angel Carretero
Premiere: May 15, 1935. War
Memorial Opera House, San
Francisco.
Number of Dancers: 2
Principal Dancers: Vicente Escudero
(g.a.), Carmita (g.a.).
In Repertory: 1935.

DANSE NOBLE*

Choreography: Adolph Bolm
Music: Johann Sebastian Bach
(*G Minor Fugue*).
Costumes: Jeanne Berlandina
Premiere: May 15, 1935. War
Memorial Opera House, San
Francisco.
Number of Dancers: 19
Principal Dancers: Evelyn Wenger,
Arron Block, Nikolai Vasilieff.
In Repertory: 1935, 1936.

CONSECRATION*

Choreography: Adolph Bolm
Music: Johann Sebastian Bach
(*Toccata and Fugue in D Minor*).
Costumes: Beniamino Bufano
Premiere: May 15, 1935. War
Memorial Opera House, San
Francisco.
Number of Dancers: 30
Principal Dancers: Iris de Luce,
Raoul Pausé.
In Repertory: 1935, 1936.

EL AMOR BRUJO

(The Phantom Lover)
Choreography: Vicente Escudero
Music: Manuel de Falla (*El Amor
Brujo*).
Costumes and Scenery: Angel Carretero
Premiere: May 15, 1935. War
Memorial Opera House, San
Francisco.
Number of Dancers: 20
Principal Dancers: Vicente Escudero
(g.a.) (Carmelo), Carmita (g.a.)
(Candelas), Guillermo Del Oro
(Phantom), Maclovia Ruiz (Lucia).
In Repertory: 1935.

SCHEHERAZADE

Choreography: Adolph Bolm
(after Michel Fokine).
Music: Nicolai Rimsky-Korsakov
Costumes: After Leon Bakst
Scenery: Armando Agnini (after Leon
Bakst)
Premiere: May 15, 1935. War
Memorial Opera House, San
Francisco.
Number of Dancers: 48
Principal Dancers: Iris de Luce
(Zobeide), Adolph Bolm (Favorite
Slave), Guillermo Del Oro (Sultan).
In Repertory: 1935, 1936.

COUNTRY DANCE

Choreography: Adolph Bolm
Music: Ludwig van Beethoven
Costumes: Adolph Bolm
Premiere: October 15, 1935. Country
Concert Association, Burlingame
High School Auditorium;
Burlingame, California.
Number of Dancers: 1
Principal Dancer: Clare Lauché.
In Repertory: 1935.

RUSSIAN PEASANT SCENE

Choreography: Nicolai Vasilieff
Music: Anatole Liadov
Premiere: October 15, 1935. Country
Concert Association, Burlingame

High School Auditorium;
Burlingame, California.
Number of Dancers: 3
Principal Dancers: Virginia Browning,
Margaret Rogers, Nicolai Vasilieff.
In Repertory: 1935.

JURIS FANATICO

Choreography: Adolph Bolm
Music: Johann Sebastian Bach
(*Variations Nos. 10 and 19*).
Costumes: Adolph Bolm
Premiere: October 15, 1935. Country
Concert Association, Burlingame
High School Auditorium;
Burlingame, California.
Number of Dancers: 1
Principal Dancer: Adolph Bolm
In Repertory: 1935.

JOTA ARAGONESA

Choreography: Guillermo Del Oro
Music: Louis Moreau Gottschalk
Premiere: October 15, 1935. Country
Concert Association, Burlingame
High School Auditorium;
Burlingame, California.
Number of Dancers: 2
Principal Dancers; Lucille Mayes,
Arnoldo Valdez.
In Repertory: 1935.

CUADRO FLAMENCO

Choreography: Guillermo Del Oro
Music: Popular
Premiere: November 20, 1935.
Women's City Club; Oakland,
California.
Number of Dancers: 5
Principal Dancers: Elva Dimpfel,
Arnoldo Valdez, Vadja Berci.
In Repertory: 1935.

Opera Ballets

The Ballet appeared in four of the
thirteen operas presented during the
1935 San Francisco Opera season,
November 1 through December 2:

AIDA

Choreography: Adolph Bolm
Music: Giuseppe Verdi
Opening Night: November 11, 1935.
Principal Dancers: Frances Giugni,
Evelyn Wenger, Eccleston Moran,
Elva Dimpfel.

LA JUIVE

Choreography: Adolph Bolm
Music: Jacques Halévy
Opening Night: November 18, 1935.
Principal Dancers: Margaret Rogers,
Elva Dimpfel, Eccleston Moran,
Nicolai Vasilieff.

RIGOLETTO

Choreography: Adolph Bolm
Music: Giuseppi Verdi
Opening Night: November 29, 1935.

LE COQ D'OR

Choreography: Adolph Bolm
Music: Nicolai Rimsky-Korsakov
Costumes and Scenery: Nicolas
Remisoff
Opening Night: December 2, 1935.
Principal Dancers: Adolph Bolm (King
Dodon), Maclovia Ruiz (Queen of
Shémaka), Nikolai Vasilieff (General
Polkan), George Bratoff (The
Astrologer).

1 9 3 6

Opera Ballets

The Ballet appeared in three of the
fifteen operas presented during the
1936 San Francisco Opera season,
October 30 through November 22:

LA JUIVE

Choreography: Adolph Bolm
Music: Jacques Halévy
Opening Night: October 30, 1936.
Principal Dancers: Nicolai Vasilieff,
Margaret Rogers.

CARMEN

Choreography: Adolph Bolm
Music: Georges Bizet
Opening Night: November 4, 1936.
Principal Dancers: Guillermo Del Oro,
Vadja Berci.

RIGOLETTO

Choreography: Adolph Bolm
Music: Giuseppe Verdi
Opening Night: November 6, 1936.

1 9 3 7

CHOPINADE

Choreography: Willam Christensen
(after Michel Fokine's *Les Sylphides*).
Music: Frédéric Chopin (*Nocturne*,
Op. 32, No. 2; *Mazurka*, Op. 33,
No. 3; *Waltz*, Op. 64, No. 2;
Mazurka, Op. 67, No. 3; *Prelude*,
Op. 28, No. 7; *Waltz*, Op. 18, No. 1).
Costumes: J. C. Taylor
Premiere: September 17, 1937.
Women's City Club; Oakland,
California. (World Premiere:
Willam Christensen Ballet, 1935.)
Number of Dancers: 15
Principal Dancers: Janet Reed, Willam
Christensen, Merle Williams, Zelda
Morey.

In Repertory: 1937; 1939, 1940, 1941, 1942, 1943, 1944; 1946.

Note: Other San Francisco Ballet versions of *Les Sylphides* listed under 1933 (*Reverie*), 1948, and 1974.

DANCE DIVERTISSEMENTS

Choreography: Willam Christensen
Music: Helen Green, Arthur Honegger, Folk Music, Johannes Brahms.
Premiere: September 17, 1937. Women's City Club; Oakland, California.
Number of Dancers: 6
Principal Dancers: "Nightingale's Dance"—Virginia Russ; "Hayden"—Betina Noyes; "Fandanguillo De Aracena"—Laura Post; "Czardas"—Zoya Leporsky, Peggy Bates, Ronald Chetwood.
In Repertory: 1937.

ENCOUNTER
(Excerpts)

Choreography: Lew Christensen
Music: Wolfgang Amadeus Mozart (*Haffner Serenade*).
Costumes: Forest Thayr, Jr.
Premiere: September 17, 1937. Women's City Club; Oakland, California. (World Premiere: Ballet Caravan, 1936.)
Number of Dancers: 8
Principal Dancers: Janet Reed, Lew Christensen (g.a.), Harold Christensen (g.a.), Zelda Morey.
In Repertory: 1937.

RUMANIAN WEDDING FESTIVAL or RUMANIAN RHAPSODY
(A Comedy Ballet in One Act)

Choreography: Willam Christensen
Music: Georges Enesco (*First Rhapsody*).
Costumes and Scenery: J. C. Taylor
Premiere: September 17, 1937. Women's City Club; Oakland, California. (World Premiere: Willam Christensen Ballet, 1936.)
Number of Dancers: 16
Principal Dancers: Merle Williams (Bride), Willam Christensen (Bridegroom), Jacqueline Martin (A Rumanian Mother), Lois Hoffschneider, Constance Slazer (Her Children).
In Repertory: 1937; 1939; 1945, 1946; 1950.

SKETCHES
(A Suite of Divertissements)

Choreography: Willam Christensen
Music: Charles Gounod (from *Faust*) and Franz Schubert (from *Rosamunde*).
Premiere: November 12, 1937. Santa Rosa High School Auditorium; Santa Rosa, California. San Francisco Premiere: April 20, 1938. Veterans Memorial Auditorium.
Number of Dancers: 9
Principal Dancers: Janet Reed, Willam Christensen.

In Repertory: 1937 (*divertissements* to Tchaikovsky's *Nutcracker* and Russian Folk Music added), 1938 (*divertissements* to Respighi's *Rossiniana* and Delibes' *Coppélia* added), 1939 (*divertissement* to Bizet's *L'Arlésienne* added), 1940, 1941.

Note: Other versions listed under *Scènes de Ballet* (1942), *Divertimenti* (1951).

CAPRICCIO ESPAGNOL

Choreography: Willam Christensen
Music: Nicolai Rimsky-Korsakov (*Capriccio Espagnol*).
Costumes: J. C. Taylor
Premiere: December 13, 1937. Santa Cruz High School Auditorium; Santa Cruz, California. (World Premiere: Willam Christensen Ballet, 1935.)
Number of Dancers: 10
Principal Dancers: Deane Crockett (The Smuggler), James Starbuck (Toreador), Merle Williams, Zelda Morey, Laura Post (Gypsy Girls).
In Repertory: 1937.

Opera Ballets

The Ballet appeared in seven of the thirteen operas during the 1937 San Francisco Opera season, October 15 through November 11:

AIDA

Choreography: Serge Oukrainsky
Music: Giuseppe Verdi
Opening Night: October 15, 1937.
Principal Dancer: Willette Allen.

THE MASKED BALL

Choreography: Serge Oukrainsky
Music: Giuseppe Verdi
Opening Night: October 20, 1937.

FAUST

Choreography: Serge Oukrainsky
Music: Charles Gounod
Opening Night: October 23, 1937.
Principal Dancers: Willette Allen, Janet Reed.

LAKME

Choreography: Serge Oukrainsky
Music: Léo Delibes
Opening Night: October 29, 1937.
Principal Dancers: Serge Oukrainsky, Willette Allen, Deane Crockett, James Starbuck.

LA TRAVIATA

Choreography: Serge Oukrainsky
Music: Giuseppe Verdi
Opening Night: October 30, 1937
Principal Dancers: Janet Reed, Laura Post, Willam Christensen.

ROMEO AND JULIET

Choreography: Mildred Hirsch
Music: Charles Gounod
Opening Night: November 1, 1937.

RIGOLETTO

Choreography: Mildred Hirsch
Music: Giuseppe Verdi
Opening Night: November 6, 1937.

1 9 3 8

ROMEO AND JULIET*
(Ballet in Three Scenes)

Choreography: Willam Christensen
Music: Peter Ilyich Tchaikovsky
Scenery: Charlotte Rider
Costumes: Helen Green
Premiere: March 3, 1938. Memorial Auditorium, Sacramento. San Francisco Premiere: April 20, 1938.
Number of Dancers: 28
Principal Dancers: Janet Reed (Juliet), Willam Christensen (Romeo), James Starbuck (Mercutio), Deane Crockett (Paris), Ronald Chetwood (Tybalt), Grant Cristen (Benvolio), Zoya Leporsky (Nurse).
In Repertory: 1938, 1939, 1940 (revised as Ballet in Two Scenes), 1941, 1942, 1943; 1950.

BALLET IMPROMPTU*
(A Bach Suite)

Choreography: Willam Christensen
Music: Johann Sebastian Bach (*Suite No. 2 in B Minor*).
Costumes: San Francisco Opera Staff Costumers
Premiere: April 20, 1938. Veterans Memorial Auditorium, San Francisco.
Number of Dancers: 16
Principal Dancers: Janet Reed, Merle Williams, Deane Crockett, James Starbuck, Ronald Chetwood.
In Repertory: 1938, 1939, 1940.

IN VIENNA or IN OLD VIENNA

Choreography: Willam Christensen
Music: Johann Strauss (from *Die Fledermaus*)
Scenery: Charlotte Rider
Costumes: Helen Green
Premiere: April 20, 1938. Veterans Memorial Auditorium, San Francisco. (Premiere of Scene One: March 3, 1938. Memorial Auditorium, Sacramento.)
Number of Dancers: 22
Principal Dancers: Jacqueline Martin (The Ballerina), Robert Franklin (A Young Huzzar), James Starbuck (Waiter), Ronald Chetwood (A Boulevardier), Deane Crockett (A Huzzar), Laura Post (His Love of the Moment).
In Repertory: 1938, 1939, 1940, 1941, 1942, 1943, 1944, 1945, 1946.

THE BARTERED BRIDE: THREE DANCES

Choreography: Willam Christensen
Music: Bedřich Smétana
Costumes: J. C. Taylor
Premiere: June 4, 1938. Stern Grove, San Francisco. Prior to the official premiere, *The Bartered Bride* was

presented April 9, 1938 at the War Memorial Opera House on the San Francisco Symphony's Young People's Concert. (World Premiere: Willam Christensen Ballet, 1936.)
Number of Dancers: 22
Principal Dancers: Janet Reed, Ronald Chetwood, Deane Crockett, Jeanne Hays, James Starbuck, Jacqueline Martin.
In Repertory: 1938, 1939, 1940; 1943.

A MIDSUMMER NIGHT'S DREAM*
(A Ballet Fantasy in One Act)

Choreography: Lew Christensen
Music: Felix Mendelssohn (*A Midsummer Night's Dream*).
Book: Based on the play by William Shakespeare.
Premiere: July 18, 1938. Multnomah Civic Stadium, Portland.
Number of Dancers: 47
Principal Dancers: Janet Reed (Titania), Lew Christensen (Oberon), Natalie Lauterstein (Puck), Ronald Chetwood (Lysander), Harold Christensen (Demetrius), Zelda Morey (Hermia), Jacqueline Martin (Helena), Willam Christensen (Bottom).
In Repertory: 1938.

Opera Ballets

The Ballet appeared in six of the thirteen operas presented during the 1938 San Francisco Opera season, October 7 through November 3:

ANDREA CHENIER

Choreography: Willam Christensen
Music: Umberto Giordano
Opening Night: October 7, 1938.

DON GIOVANNI

Choreography: Willam Christensen
Music: Wolfgang Amadeus Mozart
Opening Night: October 10, 1938.

MARTHA

Choreography: Willam Christensen
Music: Friedrich von Flotow
Opening Night: October 12, 1938.

DIE MEISTERSINGER

Choreography: Willam Christensen
Music: Richard Wagner
Opening Night: October 14, 1938.

LA FORZA DEL DESTINO

Choreography: Willam Christensen
Music: Giuseppe Verdi
Opening Night: October 28, 1938.
Principal Dancer: Janet Reed.

LE COQ D'OR

Choreography: Willam Christensen
Music: Nicolai Rimsky-Korsakov
Opening Night: November 3, 1938.

1939

L'AMANT REVE

Choreography: Willam Christensen
Music: Carl Maria von Weber
(*Invitation to the Dance*).
Costumes: J. C. Taylor
Premiere: September 2, 1939. Santa
 Barbara County Drama and Music
 Festival; Santa Barbara, California.
Number of Dancers: 2
Principal Dancers: Jacqueline Martin
 (The Maid), Willam Christensen
 (The Man).
In Repertory: 1939, 1940.

COPPELIA*

Choreography: Willam Christensen
Music: Léo Delibes (*Coppélia*).
Costumes: Helen Green
Scenery: Charlotte Rider
Premiere: October 31, 1939. War
 Memorial Opera House, San
 Francisco.
Number of Dancers: 55
Principal Dancers: Janet Reed
 (Swanhilda), Willam Christensen
 (Frantz), Earl Riggins (Dr.
 Coppelius), Deane Crockett
 (Burgomeister).
In Repertory: 1939, 1940, 1941, 1942,
 1943 (Act III); 1945 (new
 production), 1946 (Act III), 1947,
 1948.

AMERICAN INTERLUDE**

Choreography: Willam Christensen
Music: Godfrey Turner
Costumes: Helen Green
Scenery: Charlotte Rider
Premiere: November 16, 1939.
In Repertory: 1939.

Note: *American Interlude*,
 rechoreographed to new music in
 1940, was retitled *And Now the
 Brides*. See listing under 1940.

Opera Ballets

Opera Ballets

The Ballet appeared in two of the
 thirteen operas presented during the
 1939 San Francisco Opera season,
 October 13 through November 4:

RIGOLETTO

Choreography: Willam Christensen
Music: Giuseppe Verdi
Opening Night: October 23, 1939.

LA TRAVIATA

Choreography: Willam Christensen
Music: Giuseppe Verdi
Opening Night: October 30, 1939.
Principal Dancers: Merle Williams,
 Willam Christensen.

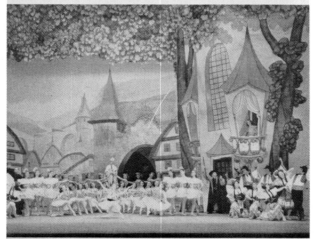

The San Francisco Opera Association
— presents —
SAN FRANCISCO OPERA BALLET

With Members of the

San Francisco Symphony Orchestra

TWO PERFORMANCES
WAR MEMORIAL OPERA HOUSE APRIL 24 - APRIL 26, 1941

1940

A MIDSUMMER NIGHT'S DREAM*

Choreography: Willam Christensen
Music: Felix Mendelssohn
 (*A Midsummer Night's Dream*).
Costumes: J. C. Taylor and Charlotte
 Rider
Book: Based on the play by William
 Shakespeare.
Premiere: June 23, 1940. Stern Grove,
 San Francisco.
Number of Dancers: 27
Principal Dancers: Willam Christensen
 (Oberon), Janet Reed (Titania),
 Ruby Asquith (Puck), Norman
 Thomson (Bottom), Harold
 Christensen (Lysander).
In Repertory: 1940, 1941.

SWAN LAKE*

(Ballet in Four Acts)

Choreography: Willam Christensen
 (after Marius Petipa and Lev Ivanov).
Music: Peter Ilyich Tchaikovsky
Costumes: Charlotte Rider
Scenery: Eugene Orlovsky and Nicolas
 Pershin.
Premiere: September 27, 1940. War
 Memorial Opera House, San
 Francisco. (The Petipa-Ivanov *Swan
 Lake* was first presented in 1895 at
 the Maryinsky Theatre in St.
 Petersburg.)
Number of Dancers: 41
Principal Dancers: Lew Christensen
 (g.a.) (Prince Siegfried), Jacqueline
 Martin (Odette), Janet Reed (Odile),
 Ronald Chetwood (Von Rothbart).

In Repertory: 1940, 1941. Excerpts:
 1942, 1943, 1944, 1945, 1946,
 1947, 1948; 1950, 1951, 1952,
 1953.

Note: Other San Francisco Ballet
 versions of *Swan Lake* listed under
 1947 (*Black Swan*), 1953, and 1982.

AND NOW THE BRIDES**

(Ballet in Three Episodes)

Choreography: Willam Christensen
Music: Fritz Berens
Costumes: Helen Green
Scenery: Charlotte Rider
Premiere: November 15, 1940.
 Burlingame High School
 Auditorium; Burlingame,
 California. San Francisco Premiere:
 April 26, 1941. War Memorial
 Opera House.

Number of Dancers: 23
Principal Dancers: Janet Reed (The
 Bride), Ronald Chetwood
 (Bridegroom), Harold Christensen
 (Agitator), Willam Christensen
 (Drunk).
In Repertory: 1940, 1941; 1944; 1946.

Note: *And Now the Brides* was a
 reworking of *American Interlude*. See
 1939 listings.

Opera Ballets

Opera Ballets

The Ballet appeared in six of the ten
 operas presented during the 1940
 San Francisco Opera season, October
 12 through November 2:

LAKME

Choreography: Willam Christensen
Music: Léo Delibes
Opening Night: October 14, 1940.
Principal Dancers: Janet Reed,
 Norman Thomson, Frank Marasco.

DON GIOVANNI

Choreography: Willam Christensen
Music: Wolfgang Amadeus Mozart
Opening Night: October 21, 1940.

THE MASKED BALL

Choreography: Willam Christensen
Music: Giuseppe Verdi
Opening Night: October 23, 1940.

CARMEN

Choreography: Willam Christensen
Music: Georges Bizet
Opening Night: October 25, 1940.
Principal Dancers: Emita De Sosa, Lew
 Christensen.

RIGOLETTO

Choreography: Willam Christensen
Music: Giuseppe Verdi
Opening Night: October 28, 1940.

AIDA

Choreography: Willam Christensen
Music: Giuseppe Verdi
Opening Night: October 30, 1940.
Principal Dancers: Janet Reed, Lew
 Christensen.

1941

Opera Ballets

Opera Ballets

The Ballet appeared in four of the
 eleven operas presented during the
 1941 San Francisco Opera season,
 October 13 through November 1:

RIGOLETTO

Choreography: Willam Christensen
Music: Giuseppe Verdi
Opening Night: October 4, 1941.
 Municipal Auditorium, Portland.
 San Francisco Premiere: October 19,
 1941.

TANNHAUSER

Choreography: Willam Christensen
Music: Richard Wagner

Opening Night: October 8, 1941. Municipal Auditorium, Portland. San Francisco Premiere: October 24, 1941.
Principal Dancer: Janet Reed.

THE DAUGHTER OF THE REGIMENT

Choreography: Willam Christensen
Music: Gaetano Donizetti
Opening Night: October 16, 1941.

CARMEN

Choreography: Willam Christensen
Music: Georges Bizet
Opening Night: October 27, 1941.
Principal Dancer: Maclovia Ruiz.

1 9 4 2

COEUR DE GLACE

Choreography: Willam Christensen
Music: Wolfgang Amadeus Mozart (*Eine Kleine Nachtmusik*).
Costumes: J. C. Taylor
Premiere: May 26, 1942. Veterans Auditorium, San Francisco. (World Premiere: Willam Christensen Ballet, 1936.)
Number of Dancers: 17
Principal Dancers: Ruby Asquith (Princess), Willam Christensen (The Old Prince), Clair Freeman, Marvin Krauter (Gentlemen), Zoya Leporsky, Barbara Wood (Their Ladies).
In Repertory: 1942, 1943.

SCENES DE BALLET*
(A Suite of Divertissements)

Choreography: Willam Christensen
Music: Ludwig van Beethoven (from *Ecossaises*); Peter Ilyich Tchaikovsky (from *Swan Lake, Nutcracker,* and *Sleeping Beauty*); Franz Schubert (from *Rosamunde*); Modest Mussorgsky (from *Sorochintzky Fair*).
Premiere: May 26, 1942. Veterans Auditorium, San Francisco.
Number of Dancers: 43
Principal Dancers: Zoya Leporsky, Earl Riggins, Ruth Riekman, Deane Crockett, Ruby Asquith, Norman Thomson, Willam Christensen.
In Repertory: 1942.

Note: Other versions listed under *Sketches* (1937) and *Divertimenti* (1951).

WINTER CARNIVAL*

Choreography: Willam Christensen
Music: Johann and Josef Strauss, arranged by Fritz Berens.
Scenery and Costumes: Betty Bates de Mars
Premiere: September 25, 1942. War Memorial Opera House, San Francisco.
Number of Dancers: 35
Principal Dancers: Willam Christensen (Officer of the Alpine Guards), Ruby Asquith (A Skating Star), Earl Riggins (The General).
In Repertory: 1942, 1943, 1944, 1945.

AMOR ESPANOL*

Choreography: Willam Christensen, Elena Imaz, Maclovia Ruiz.
Music: Jules Massenet (ballet music from *Le Cid*).
Scenery and Costumes: Charlotte Rider
Premiere: September 25, 1942. War Memorial Opera House, San Francisco.
Number of Dancers: 30
Principal Dancers: Elena Imaz (g.a.) (Dolores), Earl Riggins (The Matador), Maclovia Ruiz (g.a.) (Marcarena).
In Repertory: 1942, 1943, 1944, 1945, 1946; 1948.

Opera Ballets

The Ballet appeared in nine of the twelve operas presented during the 1942 San Francisco Opera season, October 9 through October 31:

AIDA

Choreography: Willam Christensen
Music: Giuseppe Verdi
Opening Night: October 9, 1942.
Principal Dancer: Ruby Asquith.

THE DAUGHTER OF THE REGIMENT

Choreography: Willam Christensen
Music: Gaetano Donizetti
Opening Night: October 12, 1942.
Principal Dancers: Ruby Asquith, Ronn Marvin.

LA TRAVIATA

Choreography: Willam Christensen
Music: Giuseppe Verdi
Opening Night: October 14, 1942.
Principal Dancers: Ruby Asquith, Willam Christensen.

THE BARTERED BRIDE

Choreography: Willam Christensen
Music: Bedřich Smétana
Opening Night: October 16, 1942.
Principal Dancers: Ruby Asquith, Barbara Wood, Alice Kotchik, Earl Riggins.

LUCIA DI LAMMERMOOR

Choreography: Willam Christensen
Music: Gaetano Donizetti
Opening Night: October 18, 1942.

CARMEN

Choreography: Willam Christensen
Music: Georges Bizet
Opening Night: October 19, 1942.
Principal Dancer: Maclovia Ruiz.

FAUST

Choreography: Willam Christensen
Music: Charles Gounod
Opening Night: October 21, 1942.

DIE FLEDERMAUS

Choreography: Willam Christensen
Music: Johann Strauss
Opening Night: October 26, 1942.
Principal Dancer: Ruby Asquith.

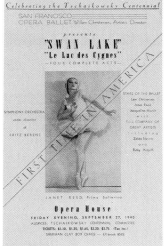

LE COQ D'OR

Choreography: Willam Christensen
Music: Nicolai Rimsky-Korsakov
Opening Night: October 30, 1942.

1 9 4 3

SONATA PATHETIQUE*

Choreography: Willam Christensen
Music: Ludwig von Beethoven
Costumes: Cliff Jones
Premiere: February 18, 1943. Garden Court, Palace Hotel; San Francisco.
Number of Dancers: 12
Principal Dancers: Ruby Asquith, Frank Marasco.
In Repertory: 1943, 1944, 1945, 1946, 1947, 1948; 1950.

NUTCRACKER: DIVERTISSEMENTS*

Choreography: Willam Christensen
Music: Peter Ilyich Tchaikovsky
Premiere: March 4, 1943. Garden Court, Palace Hotel; San Francisco.
Number of Dancers: 11
Principal Dancers: Ruby Asquith, Mattlyn Gevurtz, Earl Riggins, Rosalie Prosch, Lois Treadwell, Frank Marasco.
In Repertory: 1943.

Note: Full-length productions of *Nutcracker* listed under 1944, 1954, and 1967.

BLUE BIRD: PAS DE DEUX
(from *Sleeping Beauty*)

Choreography: Marius Petipa
Music: Peter Ilyich Tchaikovsky (from *Sleeping Beauty*).
Premiere: March 11, 1943. Garden Court, Palace Hotel; San Francisco. (Petipa's *Sleeping Beauty* was first presented in 1890 at The Maryinsky Theatre in St. Petersburg.)
Principal Dancers: Ruby Asquith, Frank Marasco.
Number of Dancers: 2
In Repertory: 1943; 1946.

Note: "Blue Bird: Pas de Deux" is also included in *Scènes de Ballet* (see 1942 listings), *Divertimenti* (see 1951 listings), and *Princess Aurora* (see 1964 listings).

HANSEL AND GRETEL*
(A Ballet Pantomime with Solo Voices and Symphony Orchestra)

Choreography: Willam Christensen
Music: Engelbert Humperdinck
Scenery: San Francisco Opera Company
Costumes: Goldstein and Company
Premiere: December 26, 1943. War Memorial Opera House, San Francisco.
Number of Roles: 67
Principal Dancers: Beatrice Tompkins (Hansel), Ruby Asquith (Gretel), Celena Cummings (Mother), Earl Riggins (Father), Mattlyn Gevurtz (Witch).
Principal Singers: Mary Helen Markham (Hansel and Sandman), Lois Hartzell (Gretel), Claire Mae Turner (Mother), Edward Wellman (Father), Jeannette Hopkins (Dew Fairy and Witch).
In Repertory: 1943.

Opera Ballets

The Ballet appeared in seven of the thirteen operas presented during the 1943 San Francisco Opera season, October 7 through October 30:

SAMSON ET DALILA

Choreography: Willam Christensen
Music: Camille Saint-Saëns
Opening Night: October 7, 1943.
Principal Dancer: Beatrice Tompkins.

LA TRAVIATA

Choreography: Willam Christensen
Music: Giuseppe Verdi
Opening Night: October 10, 1943.
Principal Dancers: Beatrice Tompkins, Willam Christensen.

LA FORZA DEL DESTINO

Choreography: Willam Christensen
Music: Giuseppe Verdi
Opening Night: October 11, 1943.

LUCIA DI LAMMERMOOR

Choreography: Willam Christensen
Music: Gaetano Donizetti
Opening Night: October 18, 1943.

CARMEN

Choreography: Willam Christensen
Music: Georges Bizet
Opening Night: October 24, 1943.
Principal Dancers: Betty Parades, Mattlyn Gevurtz, Earl Riggins, Joseph Carmassi.

RIGOLETTO

Choreography: Willam Christensen
Music: Giuseppe Verdi
Opening Night: October 25, 1943.

DON GIOVANNI

Choreography: Willam Christensen
Music: Wolfgang Amadeus Mozart
Opening Night: October 27, 1943.

TRIUMPH OF HOPE*

Choreography: Willam Christensen
Music: César Franck (from *Symphony in D Minor, Les Eolides*, and *Le Chasseur Maudit*).
Costumes and Scenery: Jean de Botton
Premiere: May 18, 1944. War Memorial Opera House, San Francisco.
Number of Dancers: 48
Principal Dancers: Earl Riggins (Man), Ruby Asquith (Woman), Willam Christensen (Satan), Joaquin Felsch (Icarus).
In Repertory: 1944.

LE BOURGEOIS GENTILHOMME*

(A Ballet Pantomime)

Choreography: Willam Christensen, Earl Riggins, André Ferrier.
Music: Jean-Baptiste Lully (*Le Bourgeois Gentilhomme*) and André Grétry.
Costumes: Goldstein and Company.
Premiere: May 19, 1944. War Memorial Opera House, San Francisco.
Number of Dancers: 30
Principal Dancers: Ruby Asquith, Willam Christensen (The Lovers), André Ferrier (Monsieur Jordan), Earl Riggins (Tailor), Joaquin Felsch (Ballet Master), L. Harlan McCoy (Muphti).
In Repertory: 1944.

PHOTO: JOHN BLACK

NUTCRACKER*

Choreography: Willam Christensen
Music: Peter Ilyich Tchaikovsky
Costumes: Russell Hartley
Scenery: Antonio Sotomayor
Premiere: December 24, 1944. War Memorial Opera House, San Francisco. (Lev Ivanov's *Nutcracker* was first presented in 1892 at the Imperial Maryinsky Theatre.)
Number of Roles: 126
Principal Dancers: Lois Treadwell (Clara), Robert Thorson

(Drosselmayer), Earl Riggins (King of the Mice), Jocelyn Vollmar (Snow Queen), Joaquin Felsch (Snow Prince), Gisella Caccialanza (Sugar Plum Fairy), Willam Christensen (Her Cavalier), Russell Hartley (Mother Buffoon), Celena Cummings (Ballerina, Waltz of the Flowers), Mattlyn Gevurtz (Chocolate), Onna White (Arabian), Lois Treadwell (Merliton).
In Repertory: 1944, 1945 (suite), 1946 (suite), 1947 (suite), 1948 (suite), 1949, 1950, 1951 (with some new choreography by Lew Christensen), 1952, 1953.
Note: In 1954, San Francisco Ballet presented a new production of the complete *Nutcracker* choreographed by Lew Christensen. See 1954 listings. Also see 1967 listings for third San Francisco Ballet version of *Nutcracker*. Excerpts from *Nutcracker* also listed in *Sketches* (1937), *Scènes de Ballet* (1942), *Nutcracker Divertissements* (1943), and *Divertimenti* (1951).

Opera Ballets

The Ballet appeared in nine of the fifteen operas presented during the 1944 San Francisco Opera season, September 29 through October 28:

AIDA

Choreography: Willam Christensen
Music: Giuseppe Verdi
Opening Night: September 29, 1944.
Principal Dancer: Ruby Asquith.

LA FORZA DEL DESTINO

Choreography: Willam Christensen
Music: Giuseppe Verdi
Opening Night: October 1, 1944.

MARTHA

Choreography: Willam Christensen
Music: Friedrich von Flotow
Opening Night: October 3, 1944.

LAKME

Choreography: Willam Christensen
Music: Léo Delibes
Opening Night: October 6, 1944.
Principal Dancers: Ruby Asquith, Earl Riggins, Frank Nelson.

LUCIA DI LAMMERMOOR

Choreography: Willam Christensen
Music: Gaetano Donizetti
Opening Night: October 11, 1944.

RIGOLETTO

Choreography: Willam Christensen
Music: Giuseppe Verdi
Opening Night: October 17, 1944.

FAUST

Choreography: Willam Christensen
Music: Charles Gounod
Opening Night: October 18, 1944.

A MASKED BALL

Choreography: Willam Christensen
Music: Giuseppe Verdi
Opening Night: October 20, 1944.

CARMEN

Choreography: Willam Christensen
Music: Georges Bizet
Opening Night: October 27, 1944.
Principal Dancers: Ruby Asquith, Mattlyn Gevurtz, Earl Riggins.

PYRAMUS AND THISBE**

Choreography: Willam Christensen
Music: Fritz Berens
Costumes: Russell Hartley
Premiere: September 2, 1945. Marin Music Chest, Forest Meadows, Dominican College; San Rafael, California. (Premiere title: *Once Upon a Time*, or *Why Mulberries are Purple*.) San Francisco Premiere: December 27, 1945.
Number of Dancers: 9
Principal Dancers: Jocelyn Vollmar (Thisbe), Robert Hansen (Pyramus), Willam Christensen (The Lion).
In Repertory: 1945.

BLUE PLAZA*

Choreography: Willam Christensen and José Manero.
Music: Aaron Copland (*El Salón México*).
Scenery and Costumes: Antonio Sotomayor
Premiere: December 26, 1945. War Memorial Opera House, San Francisco.
Number of Dancers: 24
Principal Dancers: José Manero (g.a.) (El Pelado), Ruby Asquith (The Flower Vendor), Robert Thorson (El Hacendado), Onna White (His Daughter).
In Repertory: 1945; 1948.

Opera Ballets

The Ballet appeared in seven of the seventeen operas presented during the 1945 San Francisco Opera season, September 25 through October 27:

CARMEN

Choreography: Willam Christensen
Music: Georges Bizet
Opening Night: September 25, 1945.
Principal Dancers: Ruby Asquith, Solana.

LA TRAVIATA

Choreography: Willam Christensen
Music: Giuseppe Verdi
Opening Night: September 30, 1945.
Principal Dancers: Ruby Asquith, Willam Christensen.

THE TALES OF HOFFMANN

Choreography: Willam Christensen
Music: Jacques Offenbach
Opening Night: October 4, 1945.

LUCIA DI LAMMERMOOR

Choreography: Willam Christensen
Music: Gaetano Donizetti
Opening Night: October 13, 1945.

DON GIOVANNI

Choreography: Willam Christensen
Music: Wolfgang Amadeus Mozart
Opening Night: October 16, 1945.

RIGOLETTO

Choreography: Willam Christensen
Music: Giuseppe Verdi
Opening Night: October 26, 1945.

AIDA

Choreography: Willam Christensen
Music: Giuseppe Verdi
Opening Night: October 27, 1945.
Principal Dancer: Ruby Asquith.

Opera Ballets

The Ballet appeared in six of the sixteen operas presented during the 1946 San Francisco Opera season, September 17 through October 20:

CARMEN

Choreography: Willam Christensen
Music: Georges Bizet
Opening Night: September 7, 1946. Portland Auditorium, Portland. San Francisco Premiere: September 19, 1946.
Principal Dancers: Lois Treadwell, José Manero, Rosalie Prosch.

LA TRAVIATA

Choreography: Willam Christensen
Music: Giuseppe Verdi
Opening Night: September 8, 1946. Portland Auditorium, Portland. San Francisco Premiere: September 20, 1946.
Principal Dancers: Jocelyn Vollmar, Peter Nelson.

BORIS GODOUNOFF

Choreography: Willam Christensen
Music: Modest Mussorgsky
Opening Night: September 27, 1946.

LAKME

Choreography: Willam Christensen
Music: Léo Delibes
Opening Night: October 1, 1946.
Principal Dancers: Onna White, Joaquin Felsch, Peter Nelson.

LA FORZA DEL DESTINO

Choreography: Willam Christensen
Music: Giuseppe Verdi
Opening Night: October 3, 1946.

RIGOLETTO

Choreography: Willam Christensen
Music: Giuseppe Verdi
Opening Night: October 19, 1946.

DR. PANTALONE*
(Pierrot's Allergies)

Choreography: Willam Christensen
Music: Domenico Scarlatti, arranged by Fritz Berens.
Costumes: Geraldine Cresci
Premiere: August 10, 1947. Stern Grove, San Francisco.
Number of Dancers: 7
Principal Dancers: Marcus Nelson (Dr. Pantalone), Joan Vickers (Columbine), James Curtis (Pierrot), William Hay (Harlequin).
In Repertory: 1947, 1948, 1949, 1950, 1951.

THE LADY OF THE CAMELLIAS

Choreography: Anton Dolin
Music: Giuseppe Verdi (from *La Traviata*), arranged by Robert Zeller.
Costumes and Scenery: Antonio Ruiz
Book: Based on the story by Alexandre Dumas, *fils*.
Premiere: November 11, 1947. War Memorial Opera House, San Francisco. (World Premiere: The Markova-Dolin Ballet, 1947.)
Number of Dancers: 10
Principal Dancers: Alicia Markova (g.a.) (Camille), Anton Dolin (g.a.) (Armand).
In Repertory: 1947.

BLACK SWAN PAS DE DEUX

Choreography: Marius Petipa
Music: Peter Ilyich Tchaikovsky (from *Swan Lake*).
Costumes: Barbara Karinska
Premiere: November 11, 1947. War Memorial Opera House, San Francisco. (Petipa's *Swan Lake* premiered in 1895.)
Principal Dancers: Bettina Rosay (g.a.), Oleg Tupine (g.a.).
In Repertory: 1947, 1948; 1950; 1957, 1958, 1959; 1964; 1974; 1977.
Note: Other San Francisco Ballet versions of *Swan Lake* listed under 1940, 1942 (*Scènes de Ballet*), 1951 (*Divertimenti*), 1953, and 1982.

MEPHISTO*
(Choreographic Poem in Two Scenes)

Choreography: Adolph Bolm
Music: Franz Liszt (from *Mephisto Waltzes*).
Costumes and Scenery: Eugène Lourié
Premiere: November 11, 1947. War Memorial Opera House, San Francisco.
Number of Roles: 61
Principal Dancers: Richard Burgess (Mephisto), Peter Nelson (The Poet), Jocelyn Vollmar (The Beloved), James Curtis (Poet's Rival).
In Repertory: 1947, 1948.

HENRY VIII

Choreography: Rosella Hightower
Music: Gioacchino Rossini (from *William Tell, Semiramide*, and *Cenerentola*), adapted and arranged by Robert Zeller.
Costumes and Scenery: Russell Hartley
Premiere: November 11, 1947. War Memorial Opera House, San Francisco. (World Premiere: The Markova-Dolin Ballet, 1947.)
Number of Dancers: 10
Principal Dancers: Anton Dolin (g.a.) (Henry VIII), Natalie Conlon (g.a.) (Catherine of Aragon), Alicia Markova (g.a.) (Anne Boleyn).
In Repertory: 1947.

FANTASIA

Choreography: Bronislava Nijinska
Music: Franz Schubert and Franz Liszt.
Costumes: Rose Schogel
Premiere: November 12, 1947. War Memorial Opera House, San Francisco.
Number of Dancers: 6
Principal Dancers: Bettina Rosay (g.a.), Oleg Tupine (g.a.).
In Repertory: 1947.

GISELLE
(Romantic Ballet in Two Acts)

Choreography: Anton Dolin (after Jean Coralli and Jules Perrot).
Music: Adolphe Adam
Costumes: Marjorie Aronovici and Rose Schogel.
Ensembles Staged By: Willam Christensen
Premiere: November 12, 1947. War Memorial Opera House, San Francisco. (Revival of Dolin's production for Ballet Theatre, 1940. *Giselle* was first presented in 1841 at the Paris Opéra.)
Number of Roles: 51
Principal Dancers: Alicia Markova (g.a.) (Giselle), Anton Dolin (g.a.) (Albrecht), Peter Nelson (Hilarion), Jocelyn Vollmar (Myrtha).
In Repertory: 1947.
Note: Other San Francisco Ballet versions of *Giselle* listed under 1965 and 1975.

PARRANDA*

Choreography: Willam Christensen
Music: Morton Gould (*Latin American Symphonette*).
Book: Antonio Sotomayor
Costumes and Scenery: Antonio Sotomayor
Premiere: November 12, 1947. War Memorial Opera House, San Francisco.
Number of Dancers: 25
Principal Dancers: Jocelyn Vollmar (A Young Woman), Richard Burgess (A Young Man), José Manero (El Colonel Toribio), Ruby Asquith (A Confetti Vendor).
In Repertory: 1947, 1948, 1949, 1950; 1952.

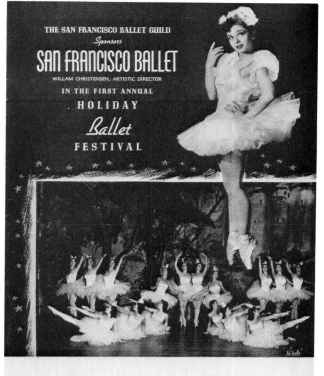

Opera Ballets

The Ballet appeared in eight of the seventeen operas presented during the 1947 San Francisco Opera season, September 16 through October 19:

AIDA

Choreography: Willam Christensen
Music: Giuseppe Verdi
Opening Night: September 11, 1947. Seattle Civic Auditorium, Seattle. San Francisco Premiere: September 25, 1947.
Principal Dancer: Ruby Asquith.

FAUST

Choreography: Willam Christensen
Music: Charles Gounod
Opening Night: September 13, 1947. Seattle Civic Auditorium, Seattle. San Francisco Premiere: September 21, 1947.

LA TRAVIATA

Choreography: Willam Christensen
Music: Giuseppe Verdi
Opening Night: September 16, 1947.
Principal Dancers: Ruby Asquith, José Manero.

ROMEO AND JULIET

Choreography: Willam Christensen
Music: Charles Gounod
Opening Night: September 18, 1947.

MARRIAGE OF FIGARO

Choreography: Willam Christensen
Music: Wolfgang Amadeus Mozart
Opening Night: October 5, 1947.

DON GIOVANNI

Choreography: Willam Christensen
Music: Wolfgang Amadeus Mozart
Opening Night: October 8, 1947.

RIGOLETTO

Choreography: Willam Christensen
Music: Giuseppe Verdi
Opening Night: October 12, 1947.

LUCIA DI LAMMERMOOR

Choreography: Willam Christensen
Music: Gaetano Donizetti
Opening Night: October 17, 1947.

GIFT OF THE MAGI

Choreography: Simon Semenoff
Music: Lukas Foss (*Gift of the Magi*).
Book: Based on the story by O. Henry.
Scenery and Costumes: Raoul Pène DuBois
Premiere: February 5, 1948. War Memorial Opera House, San Francisco. (World Premiere: Ballet Theatre, 1945.)
Number of Dancers: 14
Principal Dancers: Ruby Asquith (Della), Roy Fitzell (Jim).
In Repertory: 1948.

DON QUIXOTE: PAS DE DEUX

Choreography: Marius Petipa
Music: Léon Minkus (from *Don Quixote*).
Costumes: Eugenia Toumanova
Premiere: February 5, 1948. War Memorial Opera House, San Francisco. (World Premiere: Petipa's full-length *Don Quixote*, Moscow, 1869. Revised version, St. Petersburg, 1871.)
Principal Dancers: Tamara Toumanova (g.a.), Paul Petroff (g.a.).
In Repertory: 1948; 1950; 1953; 1955; 1957, 1958, 1959; 1971; 1974, 1975, 1976.

PERSEPHONE*

Choreography: John Taras
Music: Robert Schumann (*Symphony No. 1 in B flat Major*).
Scenery and Costumes: Eugène Lourié
Premiere: February 6, 1948. War Memorial Opera House, San Francisco.
Number of Dancers: 24
Principal Dancers: Jocelyn Vollmar (The Woman), Richard Burgess (The Man).
In Repertory: 1948.

LES SYLPHIDES

Choreography: Michel Fokine (restaged by John Taras).
Music: Frédéric Chopin (*Nocturne*, Op. 32, No. 2; *Mazurka*, Op. 33, No. 3; *Mazurka*, Op. 67, No. 3; *Prelude*, Op. 28, No. 7; *Waltz*, Op. 64, No. 2; *Waltz*, Op. 18, No. 1; *Waltz*, Op. 70, No. 1).
Costumes: Russell Hartley
Premiere: September 5, 1948. Stern Grove, San Francisco. (World Premiere: Serge Diaghilev's Ballets Russes, Paris, 1909; excerpt of "Chopiniana," St. Petersburg, 1908.)
Number of Dancers: 22
Principal Dancers: Ruby Asquith, Joan Vickers, Sally Whalen, James Curtis.
In Repertory: 1948, 1949.

Note: Other San Francisco Ballet versions of *Les Sylphides* listed under 1933 (*Reverie*), 1937 (*Chopinade*), and 1974.

Opera Ballets

The Ballet appeared in nine of the nineteen operas presented during the 1948 San Francisco Opera season, September 14 through October 17 :

DON GIOVANNI

Choreography: Willam Christensen
Music: Wolfgang Amadeus Mozart
Opening Night: September 19, 1948.

DIE MEISTERSINGER VON NÜRNBERG

Choreography: Willam Christensen
Music: Richard Wagner
Opening Night: September 21, 1948.

LA FORZA DEL DESTINO

Choreography: Willam Christensen
Music: Giuseppe Verdi
Opening Night: September 24, 1948.

RIGOLETTO

Choreography: Willam Christensen
Music: Giuseppe Verdi
Opening Night: September 26, 1948.

BORIS GODOUNOFF

Choreography: Willam Christensen
Music: Modest Mussorgsky
Opening Night: October 1, 1948.
Principal Dancers: Rosalie Prosch, Peter Nelson.

FALSTAFF

Choreography: Willam Christensen
Music: Giuseppe Verdi
Opening Night: September 14, 1948.

LA TRAVIATA

Choreography: Willam Christensen
Music: Giuseppe Verdi
Opening Night: September 16, 1948.
Principal Dancers: Ruby Asquith, Peter Nelson.

LA GIOCONDA

Choreography: Lew Christensen
Music: Amilcare Ponchielli
Opening Night: October 3, 1948.
Principal Dancer: Sally Whalen.

CARMEN

Choreography: Willam Christensen
Music: Georges Bizet
Opening Night: October 5, 1948.
Principal Dancers: Ruby Asquith, Vadja Del Oro, José Manero.

1949

THE STORY OF A DANCER*

(Demonstration of Ballet Technique)

Choreography: Lew Christensen
Music: George Frederick Handel (*Water Music Suite*).
Premiere: April 4, 1949. Commerce High School Auditorium, San Francisco.
Number of Dancers: 22
Principal Dancer: Ruby Asquith.
Narrated By: Lew Christensen.
In Repertory: 1949.

Note: In 1950, *The Story of a Dancer* was revised as *Prelude*. See 1950 listings.

VIVALDI CONCERTO*

(later called *Balletino*)

Choreography: Willam Christensen
Music: Antonio Vivaldi (*Piano Concerto in B Minor*).
Premiere: April 4, 1949. Commerce High School Auditorium, San Francisco.
Number of Dancers: 15
Principal Dancers: Janet Sassoon, Nancy Johnson, Sally Bailey, Jane Bowen, Alton Basuino.
In Repertory: 1949, 1950; 1953 (as *Balletino*); 1957, 1958, 1959, 1960; 1964, B1965, 1966.

JINX

Choreography: Lew Christensen
Music: Benjamin Britten (*Variations on a Theme of Frank Bridge*).
Costumes: Russell Hartley
Premiere: April 25, 1949. Commerce High School Auditorium, San Francisco. (World Premiere: The Dance Players, 1942.)
Number of Dancers: 11
Principal Dancers: Roland Vasquez (Jinx), Dolores Richardson (Tattooed Lady), Sally Whalen (Strong Lady), Mattlyn Gevurtz (Bearded Lady),

Richard Burgess (Ringmaster), Ruby Asquith, Nancy Johnson, Alton Basuino (Wirewalkers).
In Repertory: 1949, 1950; 1955, 1956, 1957, 1958, 1959, 1960, 1961; B1966; 1972, 1973, 1974; 1978, 1979.

DANZA BRILLANTE*

Choreography: Willam Christensen
Music: Felix Mendelssohn (*Piano Concerto No. 1*).
Costumes: Jimmy Hicks
Premiere: April 25, 1949. Commerce High School Auditorium, San Francisco.
Number of Dancers: 13
Principal Dancers: Celena Cummings, Joan Vickers, Sally Whalen, Carolyn George, Rosalie Prosch.
In Repertory: 1949, 1950, 1951.

Opera Ballets

The Ballet appeared in eight of the twelve operas presented during the 1949 San Francisco Opera season, September 20 through October 23:

FAUST

Choreography: Willam Christensen
Music: Charles Gounod
Opening Night: September 22, 1949.

CARMEN

Choreography: Willam Christensen
Music: Georges Bizet
Opening Night: September 24, 1949.
Principal Dancers: Geraldine Vasquez, Joan Vickers, Roland Vasquez.

DON GIOVANNI

Choreography: Willam Christensen
Music: Wolfgang Amadeus Mozart
Opening Night: September 27, 1949.

AIDA

Choreography: Willam Christensen
Music: Giuseppe Verdi
Opening Night: October 13, 1949.
Principal Dancer: Celena Cummings.

THE TALES OF HOFFMANN

Choreography: Willam Christensen
Music: Jacques Offenbach
Opening Night: October 14, 1949.

SAMSON ET DALILA

Choreography: Willam Christensen
Music: Camille Saint-Saëns
Opening Night: October 18, 1949.
Principal Dancer: Joan Vickers.

LUCIA DI LAMMERMOOR

Choreography: Willam Christensen
Music: Gaetano Donizetti
Opening Night: October 21, 1949.

RIGOLETTO

Choreography: Willam Christensen
Music: Giuseppe Verdi
Opening Night: October 26, 1949.

1950

PRELUDE: TO PERFORMANCE*

Choreography: Lew Christensen
Music: George Frederick Handel (*Water Music Suite*).
Scenery: James Bodrero
Premiere: February 1, 1950. Commerce High School Auditorium, San Francisco.
Number of Dancers: 23
Principal Dancers: Jocelyn Vollmar, Roland Vasquez.
Narrator: Lew Christensen
In Repertory: 1950.

Note: Original title: *The Story of a Dancer*. See 1949 listings.

THE NOTHING DOING BAR*

Choreography: Willam Christensen
Music: Darius Milhaud (*Le Boeuf sur le Toit*).
Costumes: Grace MacOuillard
Scenery: Louis MacOuillard
Premiere: March 11, 1950. Commerce High School Auditorium, San Francisco.
Number of Dancers: 10
Principal Dancers: Leon Kalimos (Joe the Bartender), Robert Frellson (Punchie), Carolyn George, Vernon Wendorf (The Van Snoopers), Joan Vickers (Fannie Flapper), Alton Basuino (Joe College).
In Repertory: 1950, 1951; 1954; B1962 (revised by Lew Christensen); 1980 (new production), 1981.

CHARADE, or THE DEBUTANTE

Choreography: Lew Christensen
Music: American Melodies, arranged by Trude Rittman.
Costumes: Alvin Colt
Scenery: Russell Hartley
Book: Lincoln Kirstein
Premiere: April 25, 1950. Commerce High School Auditorium, San Francisco. (World Premiere: Ballet Caravan, 1939.)
Number of Dancers: 15
Principal Dancers: Jocelyn Vollmar (Blanche Johnson, the Debutante), Gisella Caccialanza (Trixie, Her Younger Sister), Harold Christensen (Mr. Johnson), Roland Vasquez (Wilmer J. Smith).
In Repertory: 1950, 1951.

Opera Ballets

The Ballet appeared in four of the fourteen operas presented during the 1950 San Francisco Opera season, September 26 through October 29:

AIDA

Choreography: Willam Christensen
Music: Giuseppe Verdi
Opening Night: September 26, 1950.
Principal Dancer: Celena Cummings.

LUCIA DI LAMMERMOOR

Choreography: Willam Christensen
Music: Gaetano Donizetti
Opening Night: September 28, 1950.

MARRIAGE OF FIGARO

Choreography: Willam Christensen
Music: Wolfgang Amadeus Mozart
Opening Night: September 29, 1950.

ANDREA CHENIER

Choreography: Willam Christensen
Music: Umberto Giordano
Opening Night: October 6, 1950.

1951

FILLING STATION

Choreography: Lew Christensen
Music: Virgil Thomson (*Filling Station*).
Scenery and Costumes: Paul Cadmus
Book: Lincoln Kirstein
Premiere: February 17, 1951. Commerce High School Auditorium, San Francisco. (World Premiere: Ballet Caravan, 1938).
Number of Dancers: 10
Principal Dancers: Roland Vasquez (Mac), Gisella Caccialanza (Rich Girl), Leo Duggan (Rich Boy), Harold Christensen (Motorist), Gordon Paxman (State Trooper).
In Repertory: 1951; 1958, 1959, 1960; 1966; 1969, 1970, 1971, 1972; 1974; 1978.

DIVERTIMENTI*

Choreography: Willam and Lew Christensen (after Marius Petipa and Lev Ivanov).
Music: Peter Ilyich Tchaikovsky (from *Swan Lake*, *Sleeping Beauty*, and *Nutcracker*).
Costumes: Russell Hartley
Premiere: March 3, 1951. Commerce High School Auditorium, San Francisco.
Number of Dancers: 33
Principal Dancers: Sally Whalen, Peter Nelson (Czardas, *Swan Lake*); Nancy Johnson, Richard Burgess (Black Swan Pas de Deux, *Swan Lake*); Joan Vickers, Peter Nelson (Blue Bird Pas de Deux, *Sleeping Beauty*).
In Repertory: 1951, 1952.

Note: Other San Francisco Ballet productions of Tchaikovsky *divertissements* listed under *Sketches* (1937), *Scènes de Ballet* (1942), *Blue Bird Pas de Deux* (1943), *Princess Aurora* (1964), and *Sleeping Beauty* (1964).

LES MAITRESSES DE LORD BYRON*

Choreography: Willam Christensen
Music: Franz Liszt (*Concerto No. 1 in E flat Major*).
Scenery and Costumes: Russell Hartley
Book: James Graham-Luján
Premiere: March 17, 1951. Commerce High School Auditorium, San Francisco.
Number of Dancers: 8
Principal Dancers: Richard Burgess (Lord Byron), Joan Vickers (Countess Guiccioli), Leo Duggan (Count Guiccioli), Carolyn George (Caroline Lamb).
In Repertory: 1951.

LE GOURMAND*

Choreography: Lew Christensen
Music: Wolfgang Amadeus Mozart (*Divertimento No. 10 in F Major*).
Scenery and Costumes: Leonard Weisgard
Book: Lew Christensen and James Graham-Luján.
Premiere: March 31, 1951. Commerce High School Auditorium, San Francisco.
Number of Dancers: 15
Principal Dancers: Alton Basuino (M. Le Gourmand), Willam Christensen (Un Vieil Homard Grillé), Carolyn George (Un Filet de Sole), Sally Bailey (Une Poule Déplumée), Gisella Caccialanza (La Pêche Flambée).
In Repertory: 1951, 1952, 1953; 1955, 1956.

Opera Ballets

The Ballet appeared in six of fourteen operas presented during the 1951 San Francisco Opera season, September 18 through October 21:

CARMEN

Choreography: Lew Christensen
Music: Georges Bizet
Opening Night: September 20, 1951.
Principal Dancers: Joan Vickers, Geraldine Vasquez, Roland Vasquez.

ROMEO AND JULIET

Choreography: Lew Christensen
Music: Charles Gounod
Opening Night: September 21, 1951.

BORIS GODOUNOFF

Choreography: Lew Christensen
Music: Modest Mussorgsky
Opening Night: October 2, 1951.

LA FORZA DEL DESTINO

Choreography: Lew Christensen
Music: Giuseppe Verdi
Opening Night: September 28, 1951.

LA TRAVIATA

Choreography: Lew Christensen
Music: Giuseppe Verdi
Opening Night: October 5, 1951.
Principal Dancers: Joan Vickers, Aaron Girard.

RIGOLETTO

Choreography: Lew Christensen
Music: Giuseppe Verdi
Opening Night: October 20, 1951.

The Ballet also appeared with the Pacific Opera Company:

HANSEL AND GRETEL

Choreography: Lew Christensen
Music: Engelbert Humperdinck
Premiere: December 30, 1951. War Memorial Opera House, San Francisco.
Number of Dancers: 14
In Repertory: 1951.

1952

SERENADE

Choreography: George Balanchine
Music: Peter Ilyich Tchaikovsky (*Serenade in C for Strings*).
Costumes: Russell Hartley
Premiere: April 18, 1952. War Memorial Opera House, San Francisco. (World Premiere: American Ballet, 1934).
Number of Dancers: 25
Principal Dancers: Alexandra Danilova (g.a.), Sally Bailey, Nancy Johnson, Roland Vasquez, Leo Duggan.
In Repertory: 1952, 1953, 1954; 1958, 1959, 1960; 1962; 1970; 1972; 1974, 1975, 1976; 1978, 1979; 1981.

THE CARNIVAL OF THE ANIMALS*

Choreography: Aaron Girard
Music: Camille Saint-Saëns (*Carnaval des Animaux*).
Scenery and Costumes: Jacques Requet
Premiere: April 20, 1952. War Memorial Opera House, San Francisco. (Preview performance at Youth Concerts Series, February 3, 1952. Palo Alto Community Center; Palo Alto, California.)
Number of Dancers: 13
Principal Dancers: Nancy Demmler (A Little Girl), Roberta Meyer (Lioness), Judy Younger (Chicken), Mary Alyce Kubes (Donkey), Christine Bering (Turtle).
In Repertory: 1952.

AMERICAN SCENE*

Choreography: Lew Christensen
Music: Carter Harman
Scenery and Costumes: Russell Hartley
Book: James Graham-Luján
Premiere: September 14, 1952. Stern Grove, San Francisco.
Number of Dancers: 12
Principal Dancers: Patricia Johnston (Mamma), Leon Kalimos (Papa), Virginia Johnson (Sister), Nancy Demmler (Sister).
In Repertory: 1952.

Opera Ballets

The Ballet appeared in five of the sixteen operas presented during the 1952 San Francisco Opera season, September 16 through October 19:

RIGOLETTO
Choreography: Willam Christensen
Music: Giuseppe Verdi
Opening Night: September 17, 1952.

MEFISTOFELE
Choreography: Willam Christensen
Music: Arrigo Boito
Opening Night: September 20, 1952.

AIDA
Choreography: Willam Christensen
Music: Giuseppe Verdi
Opening Night: September 23, 1952.
Principal Dancer: Sally Bailey

THE DAUGHTER OF THE REGIMENT
Choreography: Willam Christensen
Music: Gaetano Donizetti
Opening Night: October 7, 1952.

DON GIOVANNI
Choreography: Willam Christensen
Music: Wolfgang Amadeus Mozart
Opening Night: October 14, 1952.

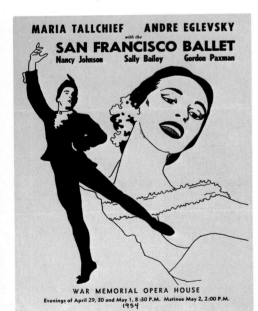

MARIA TALLCHIEF ANDRE EGLEVSKY
with the
SAN FRANCISCO BALLET
Nancy Johnson Sally Bailey Gordon Paxman

WAR MEMORIAL OPERA HOUSE
Evenings of April 29, 30 and May 1, 8:30 P.M. Matinee May 2, 2:00 P.M.
1954

1953

CONCERTO BAROCCO
Choreography: George Balanchine
Music: Johann Sebastian Bach (*Concerto in D Minor for Two Violins.*)
Scenery and Costumes: Eugene Berman
Premiere: April 10, 1953. Veterans Auditorium, San Francisco. (World Premiere: American Ballet Caravan, 1941.)
Number of Dancers: 11
Principal Dancers: Nancy Johnson, Sally Bailey, Gordon Paxman.
In Repertory: 1953, 1954, 1955, 1956, 1957, 1958, 1959, 1960, 1961, 1962; 1976, 1977, 1978, 1979, 1980, 1981.

SWAN LAKE
(Ballet in One Act)
Choreography: George Balanchine (after Lev Ivanov).
Music: Peter Ilyich Tchaikovsky
Scenery: Eugène Lourié
Costumes: Russell Hartley
Premiere: April 10, 1953. Veterans Auditorium, San Francisco. (World Premiere: The New York City Ballet, November 20, 1951.)
Number of Dancers: 23
Principal Dancers: Sally Bailey (Odette), Gordon Paxman (Prince Siegfried), Ray Barallobre (Benno), Leon Kalimos (Von Rothbart), Constance Coler, Nancy Demmler, Louise Lawler, Virginia Johnson (Cygnets).
In Repertory: 1953, 1954; 1960, 1961, 1962 (new production).
Note: Other San Francisco Ballet versions of *Swan Lake* listed under 1940 (*Ballet in Four Acts*), 1947 (*Black Swan*), and 1982 (Act II).

CON AMORE*
Choreography: Lew Christensen
Music: Gioacchino Rossini (Overtures to *La Gazza Ladra*, *Il Signor Bruschino*, and *La Scala di Seta*).
Scenery and Costumes: James Bodrero
Book: James Graham-Luján
Premiere: April 10, 1953. Veterans Auditorium, San Francisco.
Number of Dancers: 18
Principal Dancers: Sally Bailey (Captain of the Amazons), Leon Danielian (The Bandit), Nancy Johnson (The Lady).
In Repertory: 1953, 1954, 1955, 1956, 1957, 1958, 1959, 1960, 1961, 1962, 1963; 1971 (new production), 1972, 1973, 1974, 1975; 1978, 1979; 1981.

A LA FRANÇAIX
Choreography: George Balanchine
Music: Jean Françaix (*Serenade for Small Orchestra*).
Costumes: Eloise Arnold
Premiere: April 17, 1953. Veterans Auditorium, San Francisco. (World Premiere: The New York City Ballet, 1951.)
Number of Dancers: 5
Principal Dancers: Ruby Asquith (The Girl), Gordon Paxman, Ray Barallobre (Two Boys), Leon Danielian (Tennis Player), Sally Bailey (A Sylph).
In Repertory: 1953, 1954.

THE FESTIVAL*
Choreography: Lew Christensen
Music: Wolfgang Amadeus Mozart
Costumes: Eloise Arnold
Premiere: September 5, 1953. Marin Music Chest, Forest Meadows, Dominican College; San Rafael, California. San Francisco Premiere: September 13, 1953. Stern Grove.
Number of Dancers: 21
Principal Dancers: Sally Bailey, Gordon Paxman, Nancy Demmler, Virginia Johnson, Conrad Ludlow.
In Repertory: 1953, 1954.

Opera Ballets
The Ballet appeared in eight of the fifteen operas presented during the 1953 San Francisco Opera season, September 15 through October 18:

MEFISTOFELE
Choreography: Willam Christensen
Music: Arrigo Boito
Opening Night: September 15, 1953.

LA TRAVIATA
Choreography: Willam Christensen
Music: Giuseppe Verdi
Opening Night: September 22, 1953.
Principal Dancers: Sally Bailey, Gordon Paxman.

DON GIOVANNI
Choreography: Willam Christensen
Music: Wolfgang Amadeus Mozart
Opening Night: September 23, 1953.

THE CREATURES OF PROMETHEUS
Choreography: Willam Christensen
Music: Ludwig van Beethoven (*Creatures of Prometheus*).
Scenery: Armando Agnini
Book: Salvatore Viganò, adapted by James Graham-Luján.
Premiere: September 25, 1953. War Memorial Opera House, San Francisco.
Number of Roles: 41
Principal Dancers: Gordon Paxman (Prometheus), Virginia Johnson (Fire), Nancy Johnson (Woman), Ray Barallobre (Man), Patricia Johnston (Athena), Bené Arnold (Terpsichore), Sally Bailey (Aphrodite), Conrad Ludlow (Bacchus).
In Repertory: 1953

CARMEN
Choreography: Willam Christensen
Music: Georges Bizet
Opening Night: September 26, 1953.
Principal Dancers: Sally Bailey, Gordon Paxman.

BORIS GODOUNOFF
Choreography: Willam Christensen
Music: Modest Mussorgsky
Opening Night: September 29, 1953.
Principal Dancer: Gordon Paxman.

TURANDOT
Choreography: Willam Christensen
Music: Giacomo Puccini
Opening Night: October 11, 1953.

A MASKED BALL
Choreography: Willam Christensen
Music: Giuseppe Verdi
Opening Night: October 16, 1953.

1954

HEURIGER*
Choreography: Lew Christensen
Music: Wolfgang Amadeus Mozart (*Les Petits Riens, German Dances*).
Costumes: Eloise Arnold
Book: James Graham-Luján
Premiere: April 10, 1954. Memorial Auditorium, Stanford University; Stanford, California. San Francisco Premiere: April 30, 1954.
Number of Dancers: 22
Principal Dancers: Sally Bailey (Bride), Gordon Paxman (Bridegroom), Nancy Demmler (Uncomfortable Conscience), Constance Coler (Temptation).
In Repertory: 1954, 1955.

THE DRYAD*
Choreography: Lew Christensen
Music: Franz Schubert (*Fantasy in F Minor*, Opus 103), orchestrated by Felix Mottl.
Costumes: Joseph St. Amand
Scenery: Dorothea Tanning
Additional Effects: Russell Hartley
Book: James Graham-Luján
Premiere: April 28, 1954. Berkeley Community Theater; Berkeley, California. San Francisco Premiere: April 29, 1954.
Number of Dancers: 21
Principal Dancers: Nancy Johnson (The Dryad), Glen Chadwick (A Murdered Boy), Gordon Paxman (A Young Man).
In Repertory: 1954; 1956 (new production), 1957, 1958, 1959.

SYLVIA: PAS DE DEUX
Choreography: George Balanchine
Music: Léo Delibes (from *Sylvia*).
Costumes: Barbara Karinska
Premiere: April 30, 1954. War Memorial Opera House, San Francisco. (World Premiere: The New York City Ballet, 1950.)
Number of Dancers: 2
Principal Dancers: Maria Tallchief (g.a.), Andre Eglevsky (g.a.).
In Repertory: 1954

BEAUTY AND THE SHEPHERD*
(Later called *A Masque of Beauty and the Shepherd*)
Choreography: Lew Christensen
Music: Christoph Willibald von Gluck

THE INTERNATIONALLY ACCLAIMED
San Francisco Ballet
SILVER ANNIVERSARY

Costumes: Russell Hartley
Premiere: August 29, 1954. Stern Grove, San Francisco.
Number of Dancers: 20
Principal Dancers: Constance Coler (Hera), Bené Arnold (Athena), Louise Lawler (Aphrodite), Conrad Ludlow (Paris), Nancy Johnson (Helen).
In Repertory: 1954, 1955, 1956, 1957, 1958, 1959, 1960.

NUTCRACKER*

Choreography: Lew Christensen
Music: Peter Ilyich Tchaikovsky
Costumes and Scenery: Leonard Weisgard
Book: James Graham-Luján, based on the E.T.A. Hoffmann story.
Premiere: December 18, 1954. War Memorial Opera House, San Francisco.
Number of Roles: 122
Principal Dancers: Gordon Paxman (Drosselmeyer), Suki Schorer (Clara), Carlos Carvajal (King of the Mice), Sally Bailey (Snow Queen), Gordon Paxman (Snow Prince), Nancy Johnson (Sugar Plum Fairy), Conrad Ludlow (The Cavalier), Sally Bailey (Rose, Waltz of the Flowers).
In Repertory: 1954, 1955, 1956, 1957, 1958, 1959, 1960, 1961, 1962, 1963, 1964, 1965, 1966.
Note: Other San Francisco Ballet productions of *Nutcracker* listed under 1943, 1944, and 1967.

Opera Ballets

The Ballet appeared in eight of the sixteen operas presented during the 1954 San Francisco Opera season, September 17 through October 21:

RIGOLETTO

Choreography: Lew Christensen
Music: Giuseppe Verdi
Opening Night: September 17, 1954.

LA FORZA DEL DESTINO

Choreography: Willam Christensen
Music: Giuseppe Verdi
Opening Night: September 21, 1954.
Principal Dancers: Sally Bailey, Nancy Johnson, Gordon Paxman, Conrad Ludlow.

LUCIA DI LAMMERMOOR

Choreography: Lew Christensen
Music: Gaetano Donizetti
Opening Night: September 23, 1954.

THE PORTUGUESE INN

Choreography: Lew Christensen
Music: Luigi Cherubini
Opening Night: September 24, 1954.

MANON

Choreography: Lew Christensen
Music: Jules Massenet
Opening Night: September 28, 1954.
Principal Dancers: Nancy Johnson, Sally Bailey, Gordon Paxman, Conrad Ludlow.

TURANDOT

Choreography: Willam Christensen
Music: Giacomo Puccini
Opening Night: October 8, 1954.

THE MARRIAGE OF FIGARO

Choreography: Lew Christensen
Music: Wolfgang Amadeus Mozart
Opening Night: October 12, 1954.

JOAN OF ARC AT THE STAKE

Choreography: Willam Christensen and Lew Christensen.
Music: Arthur Honegger
Opening Night: October 15, 1954.

1955

APOLLON MUSAGETE
(Later called *Apollo*)

Choreography: George Balanchine
Music: Igor Stravinsky (*Apollon Musagète*).
Costumes: Jacques Requet
Scenery: David West
Premiere: May 26, 1955. War Memorial Opera House, San Francisco. (World Premiere: Serge Diaghilev's Ballets Russes, 1928. American Premiere: American Ballet, 1937.)
Number of Dancers: 7
Principal Dancers: Conrad Ludlow (Apollo), Christine Bering (Calliope), Sally Bailey (Polyhymnia), Nancy Johnson (Terpsichore).
In Repertory: 1955, 1956.

RENARD
(The Fox)

Choreography: Lew Christensen (after George Balanchine).
Music: Igor Stravinsky (*Renard*).
Book: Igor Stravinsky
Scenery and Costumes: Esteban Francés
Premiere: May 19, 1955. Ventura High School Auditorium; Ventura, California. San Francisco Premiere (with voices): May 28, 1955. War Memorial Opera House. (World Premiere: Ballet Society, 1947.)
Number of Performers: 4 dancers, 4 singers.
Principal Dancers: Conrad Ludlow (The Fox), Carlos Carvajal (The Rooster), Christine Bering (The Cat), Fiona Fuerstner (The Ram).
In Repertory: 1955; 1957.

THE TAROT*

Choreography: Lew Christensen
Music: Peter Ilyich Tchaikovsky (*Mozartiana*).
Costumes: Eloise Arnold
Premiere: August 7, 1955. Stern Grove, San Francisco.
Number of Dancers: 11

Principal Dancers: Virginia Johnson, Fiona Fuerstner, Bené Arnold, Constance Coler, Nancy Johnson, Conrad Ludlow, Richard Carter, Carlos Carvajal.
In Repertory: 1955, 1956, 1957.

Opera Ballets

The Ballet appeared in eight of the thirteen operas presented during the 1955 San Francisco Opera season, September 15 through October 20:

AIDA

Choreography: Willam Christensen
Music: Giuseppe Verdi
Opening Night: September 15, 1955.
Principal Dancers: Nancy Johnson, Conrad Ludlow.

CARMEN

Choreography: Willam Christensen
Music: Georges Bizet
Opening Night: September 17, 1955.
Principal Dancers: Nancy Johnson, Conrad Ludlow.

LOUISE

Choreography: Lew Christensen
Music: Gustave Charpentier
Opening Night: September 23, 1955.
Principal Dancer: Nancy Johnson.

MACBETH

Choreography: Willam Christensen
Music: Giuseppe Verdi
Opening Night: September 27, 1955.

DON GIOVANNI

Choreography: Lew Christensen
Music: Wolfgang Amadeus Mozart
Opening Night: September 30, 1955.

ANDREA CHENIER

Choreography: Lew Christensen
Music: Umberto Giordano
Opening Night: October 4, 1955.
Principal Dancers: Nancy Johnson, Conrad Ludlow.

FAUST

Choreography: Willam Christensen
Music: Charles Gounod
Opening Night: October 18, 1955.

LE COQ D'OR

Choreography: Willam Christensen
Music: Nicolai Rimsky-Korsakov
Opening Night: October 11, 1955.
Principal Dancer: Carlos Carvajal (Cockerel).

1956

Opera Ballets

The Ballet appeared in five of the fourteen operas presented during the 1956 San Francisco Opera season, September 13 through October 17:

IL TROVATORE

Choreography: Willam Christensen
Music: Giuseppe Verdi
Opening Night: September 16, 1956.
Principal Dancers: Sally Bailey, Conrad Ludlow.

DELI

FALSTAFF

Choreography: Willam Christensen
Music: Giuseppe Verdi
Opening Night: September 21, 1956.

BORIS GODOUNOFF

Choreography: Willam Christensen
Music: Modest Mussorgsky
Opening Night: September 25, 1956.

THE ELIXIR OF LOVE

Choreography: Willam Christensen
Music: Gaetano Donizetti
Opening Night: October 12, 1956.

AIDA

Choreography: Willam Christensen
Music: Giuseppe Verdi
Opening Night: October 17, 1956.
Principal Dancers: Nancy Johnson, Conrad Ludlow.

1957

MENDELSSOHN CONCERTO*

Choreography: William Dollar
Music: Felix Mendelssohn (*Concerto in G Minor for Piano*).
Costumes: Eloise Arnold
Premiere: July 21, 1957. Stern Grove, San Francisco.
Number of Dancers: 12
Principal Dancers: Nancy Johnson, Christine Bering, Fiona Fuerstner, Richard Carter.
In Repertory: 1957, 1958.

EMPEROR NORTON**
(Ballet in One Act and Four Scenes)

Choreography: Lew Christensen
Music: Vernon Duke (based in part on Jacques Offenbach).
Scenery and Costumes: Antonio Sotomayor
Special Costume Effects: Russell Hartley
Premiere: November 8, 1957. War Memorial Opera House, San Francisco.
Number of Dancers: 22
Principal Dancers: Gordon Paxman (The Emperor), Matilda Abbe (Bummer), Suki Schorer (Lazarus).
In Repertory: 1957, 1958.

Opera Ballets

The Ballet appeared in six of the twelve operas presented during the 1957 San Francisco Opera season, September 17 through October 24:

TURANDOT

Choreography: Willam Christensen
Music: Giacomo Puccini
Opening Night: September 17, 1957.

LA TRAVIATA

Choreography: Willam Christensen
Music: Giuseppe Verdi
Opening Night: September 19, 1957.
Principal Dancers: Sally Bailey, Richard Carter, Roderick Drew.

A MASKED BALL

Choreography: Willam Christensen
Music: Giuseppe Verdi
Opening Night: September 24, 1957.

LUCIA DI LAMMERMOOR

Choreography: Willam Christensen
Music: Gaetano Donizetti
Opening Night: September 27, 1957.

MACBETH

Choreography: Willam Christensen
Music: Giuseppe Verdi
Opening Night: October 11, 1957.

AIDA

Choreography: Willam Christensen
Music: Giuseppe Verdi
Opening Night: October 18, 1957.
Principal Dancers: Nancy Johnson, Richard Carter.

1 9 5 8

LADY OF SHALOTT**

Choreography: Lew Christensen
Music: Arthur Bliss
Scenery and Costumes: Tony Duquette
Book: Arthur Bliss, after the poem by Alfred, Lord Tennyson.
Premiere: May 2, 1958. Hertz Hall, University of California; Berkeley, California. San Francisco Premiere: May 24, 1958.
Number of Dancers: 20
Principal Dancers: Jocelyn Vollmar (Lady of Shalott), Richard Carter (Sir Lancelot), Fiona Fuerstner (Village Belle), Kent Stowell (Red Knight).
In Repertory: 1958, 1959, 1960, 1961, 1962, 1963, 1964, 1965; 1967.

BEAUTY AND THE BEAST*

Choreography: Lew Christensen

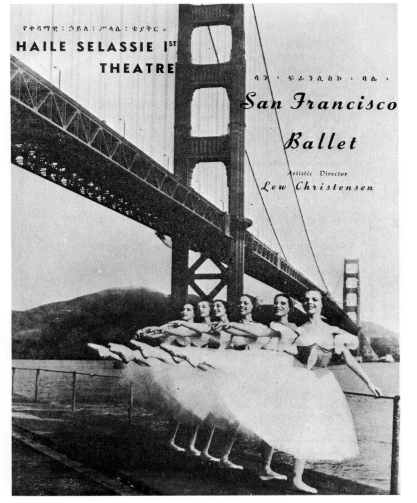

Music: Peter Ilyich Tchaikovsky, arranged and orchestrated by Denis de Coteau and Earl Bernard Murray (from *Symphonies Nos. 1, 2, and 3; Orchestral Suites Nos. 1, 2, 3; The Storm*, Opus 76; *Theme and Variations for Piano*, Opus 19, No. 6 added 1982).
Scenery and Costumes: Tony Duquette
Premiere: May 23, 1958. War Memorial Opera House, San Francisco.
Number of Roles: 100
Principal Dancers: Nancy Johnson (Beauty), Richard Carter (Beast-Prince), Julien Herrin (Beauty's Father), Bené Arnold, Gerrie Bucher (Beauty's Sisters), Sally Bailey, Kent Stowell (Rose Waltz), Virginia Johnson (Bird), Jerome Brannin, Michael Smuin, Kent Stowell (Stags).
In Repertory: 1958, 1959, 1960, 1961, 1962, 1963, 1964, 1965, 1966, 1967; 1970, 1971; 1975; 1982 (new production designed by José Varona; *Pas de Six* added, Act II; Robert Gladstein, Assistant Choreographer).

Opera Ballets

The Ballet did not appear with the San Francisco Opera during the 1958 season as the Ballet was touring Central and South America.

1 9 5 9

SINFONIA*

Choreography: Lew Christensen
Music: Luigi Boccherini (*Symphony in A Major*).
Scenery and Costumes: Tony Duquette
Premiere: January 6, 1959. Hogan Junior High School Auditorium; Vallejo, California. San Francisco Premiere: December 19, 1959. War Memorial Opera House.
Number of Dancers: 20
Principal Dancers: Fiona Fuerstner, Sally Bailey, Jocelyn Vollmar, Richard Carter.
In Repertory: 1959, 1960, 1961, 1962, 1963, 1964, 1965, 1966, 1967; 1972; 1977, 1978, 1979, 1980.

DIVERTISSEMENT D'AUBER (I)*

(Pas de Trois)

Choreography: Lew Christensen
Music: François Esprit Auber (from Overtures to *Bronze Horse, Crown Diamonds, Fra Diavolo, Black Domino*).
Costumes: Tony Duquette
Premiere: January 6, 1959. Hogan Junior High School Auditorium; Vallejo, California. San Francisco Premiere: February 19, 1960. Alcazar Theatre.
Number of Dancers: 3
Principal Dancers: Jocelyn Vollmar, Richard Carter, Fiona Fuerstner.

In Repertory: 1959, 1960, 1961, 1962; 1967; 1969; B1970; 1972; 1974; 1977, 1978, 1979.
Note: In 1963, *Divertissement d'Auber* was expanded into a ballet for eighteen dancers, with the *pas de trois* as the second movement. See 1963 listings.

CAPRICE*

Choreography: Lew Christensen
Music: Franz von Suppé (from Overtures to *The Beautiful Galatea, Boccaccio*, and *Tantalusqualen*).
Scenery and Costumes: Tony Duquette
Premiere: January 6, 1959. Hogan Junior High School Auditorium; Vallejo, California. San Francisco Premiere: February 12, 1960. Alcazar Theatre.
Number of Dancers: 25
Principal Dancers: Virginia Johnson, Jocelyn Vollmar, Richard Carter.
In Repertory: 1959, 1960, 1961, 1962, 1963, 1964, 1965; 1967; 1969; 1972.

DANSES CONCERTANTES*

Choreography: Lew Christensen (after George Balanchine).
Music: Igor Stravinsky (*Danses Concertantes*).
Scenery and Costumes: Tony Duquette
Premiere: October 13, 1959. War Memorial Opera House, San Francisco.
Number of Dancers: 22
Principal Dancers: Nancy Johnson, Roderick Drew, Sally Bailey, Kent Stowell, Jocelyn Vollmar, Richard Carter, Virginia Johnson, Michael Smuin, Fiona Fuerstner, Julien Herrin.
In Repertory: 1959, 1960, 1961, 1962, 1963; 1970; 1976.

Opera Ballets

The Ballet appeared in seven of the fourteen operas presented during the 1959 San Francisco Opera season, September 11 through October 22:

AIDA

Choreography: Willam Christensen
Music: Giuseppe Verdi
Opening Night: September 11, 1959.
Principal Dancers: Nancy Johnson, Sally Bailey, Richard Carter, Roderick Drew.

ORFEO ED EURIDICE

Choreography: Willam Christensen
Music: Christoph Willibald von Gluck
Opening Night: September 15, 1959.

CARMINA BURANA

Choreography: Ghita Hager
Music: Carl Orff
Opening Night: September 19, 1959.
Principal Dancers: Sally Bailey, Roderick Drew.

SAN FRANCISCO BALLET

ANDREA CHENIER
Choreography: Michael Smuin
Music: Umberto Giordano
Opening Night: September 25, 1959.

DON GIOVANNI
Choreography: Willam Christensen
Music: Wolfgang Amadeus Mozart
Opening Night: October 3, 1959.

DIE MEISTERSINGER VON NÜRNBERG
Choreography: Willam Christensen
Music: Richard Wagner
Opening Night: October 6, 1959.

CARMEN
Choreography: Willam Christensen
Music: Georges Bizet
Opening Night: October 23, 1959.
Principal Dancers: Nancy Johnson, Richard Carter.

1960

DANZA BRILLANTE*
Choreography: Lew Christensen
Music: Felix Mendelssohn (*Octet in E Flat for Strings*, Op. 20).
Costumes: Tony Duquette
Premiere: February 26, 1960. Alcazar Theatre, San Francisco.
Number of Dancers: 20
Principal Dancers: Jocelyn Vollmar, Sally Bailey, Roderick Drew, Kent Stowell.
In Repertory: 1960, 1961.

ESMERALDA: PAS DE DEUX*
Choreography: Lew Christensen
Music: Césare Pugni (from *Esmeralda*).
Costumes: Antonio Sotomayor
Premiere: March 11, 1960. Alcazar Theatre, San Francisco.
Principal Dancers: Jocelyn Vollmar, Richard Carter.
In Repertory: 1960, 1961.

PAS DE DIX
Choreography: George Balanchine
Music: Alexander Glazounov (from *Raymonda*).
Premiere: May 6, 1960. Alcazar Theatre, San Francisco. (World Premiere: The New York City Ballet, 1955.)
Number of Dancers: 10
Principal Dancers: Sally Bailey, Richard Carter.
In Repertory: 1960.
Note: See 1960, *Variations de Ballet*.

LA RONDE**
Choreography: Michael Smuin
Music: Timothy Thompson
Book: Based on the film by Max Ophuls, itself based on the play by Arthur Schnitzler.
Costumes: Maurine Simoneau
Premiere: April 15, 1961. Alcazar Theatre, San Francisco.
Number of Dancers: 6
Principal Dancers: Julien Herrin (Husband), Fiona Fuerstner (Wife), Frank Ohman (Young Man), Paula Tracy (Sweetheart), Roderick Drew (Soldier), Eugenia Van Horn (Young Man).
In Repertory: 1961

VARIATIONS DE BALLET*
Choreography: George Balanchine and Lew Christensen
Music: Alexander Glazounov (from *Raymonda*).
Premiere: October 11, 1960. War Memorial Opera House, San Francisco.
Number of Dancers: 20
Principal Dancers: Jocelyn Vollmar, Roderick Drew, Sally Bailey, Julien Herrin.
In Repertory: 1960, 1961, 1962, 1963, 1964, 1965, 1966, 1967; 1969; 1972; 1974 (new production), 1975, 1976; 1981 (new production with added variation to Glazounov's *Chant de Ménèstrel*), 1982.
Note: *Variations de Ballet* is a reworking of *Pas de Dix*, first presented by the San Francisco Ballet in May 1960.

"Ballet '60"

ACCENT*
Choreography: Michael Smuin
Music: Antonio Vivaldi
Costumes: Maurine Simoneau
Premiere: July 8, 1960. Contemporary Dancers Center, San Francisco.
Number of Dancers: 6
In Repertory: B1960.

SESSION I**
Choreography: Michael Smuin
Music: Kaye Dunham (drums).
Costumes: Maurine Simoneau
Premiere: July 8, 1960. Contemporary Dancers Center, San Francisco.
Number of Dancers: 3
Principal Dancers: Sally Bailey, Roderick Drew, Zack Thompson.
In Repertory: B1960.

TROIS COULEURS*
Choreography: Michael Smuin
Music: Jacques Offenbach
Costumes: Maurine Simoneau
Premiere: July 8, 1960. Contemporary Dancers Center, San Francisco.
Number of Dancers: 3
Principal Dancers: Roderick Drew, Sally Bailey, Frank Ohman.
In Repertory: B1960.

SYMPHONY IN JAZZ*
Choreography: Michael Smuin

Music: Rolf Leibermann
Costumes: Maurine Simoneau
Premiere: July 8, 1960. Contemporary Dancers Center, San Francisco.
Number of Dancers: 9
In Repertory: B1960, B1961.

BY THE SIDE OF THE FREEWAY**
Choreography: Jeannde Herst
Sound: Jack Sweeny and John Tomaschke
Costumes: Maurine Simoneau
Premiere: July 8, 1960. Contemporary Dancers Center, San Francisco.
Number of Dancers: 10
Principal Dancers: Part I—"Obstacle Course": Paula Tracy, Robert Gladstein, Zack Thompson, Maurine Simoneau, Frank Ohman. Part II—"I Live By the Side of the Freeway": Diana Nielsen. Part III—"Cocktail Party": Paula Tracy, Terry Orr, Robert Gladstein.
In Repertory: B1960. "Cocktail Party": B1961, B1962, B1963, B1964.

Opera Ballets
The Ballet appeared in four of the fourteen operas presented during the 1960 San Francisco Opera season, September 16 through October 27:

AIDA
Choreography: Lew Christensen
Music: Giuseppe Verdi
Opening Night: September 30, 1960.
Principal Dancers: Jocelyn Vollmar, Sally Bailey, Roderick Drew, Julien Herrin.

LA TRAVIATA
Choreography: Ghita Hager
Music: Giuseppe Verdi
Opening Night: October 20, 1960.
Principal Dancers: Jocelyn Vollmar, Sally Bailey, Roderick Drew.

CARMEN
Choreography: Lew Christensen
Music: Georges Bizet
Opening Night: October 16, 1960. Greek Theatre, University of California; Berkeley.
Principal Dancers: Jocelyn Vollmar, Sally Bailey, Roderick Drew.

COSI FAN TUTTE
Choreography: Lew Christensen
Music: Wolfgang Amadeus Mozart
Opening Night: November 9, 1960.

1961

ORIGINAL SIN**
(Ballet in Two Scenes)
Choreography: Lew Christensen
Music: John Lewis
Scenery and Costumes: John Furness
Book: Kenneth Rexroth
Premiere: March 10, 1961. Alcazar Theatre, San Francisco.
Number of Dancers: 17

Principal Dancers: Roderick Drew (Adam), Sally Bailey (Eve), Michael Smuin (Temptation), Robert Gladstein (Raphael), Robert Vickrey (Lucifer).
In Repertory: 1961, 1962, 1963; 1966.

SYMPHONY IN C
Choreography: George Balanchine
Music: Georges Bizet (*Symphony in C Major*).
Scenery and Costumes: Tony Duquette
Premiere: March 17, 1961. Alcazar Theatre, San Francisco. (World Premiere as *Le Palais de Cristal*: Paris Opéra, 1947; as *Symphony in C*: Ballet Society, 1948.)
Number of Dancers: 36
Principal Dancers: First Movement: Jocelyn Vollmar, Roderick Drew; Second Movement: Sally Bailey, Julien Herrin; Third Movement: Fiona Fuerstner, Michael Smuin; Fourth Movement: Virginia Johnson, Kent Stowell.
In Repertory: 1961, 1962; 1973, 1974, 1975, 1976, 1977; 1980, 1981.

ST. GEORGE AND THE DRAGON*
Choreography: Lew Christensen
Music: Paul Hindemith (*Kammermusik No. 1 for Wind Quintet*).
Scenery and Costumes: Maurine Simoneau
Premiere: March 31, 1961. Alcazar Theatre, San Francisco.
Number of Dancers: 9
Principal Dancers: St. George: Kent Stowell, Frank Ohman, Robert Gladstein; The Princess: Fiona Fuerstner, Virginia Johnson, Eugenia Van Horn; The Dragon: Michael Smuin, Terry Orr, Finis Jhung.
In Repertory: 1961; B1964.

"Ballet '61"

EBONY CONCERTO*
Choreography: Michael Smuin
Music: Igor Stravinsky (*Ebony Concerto*).
Costumes: Maurine Simoneau
Premiere: July 14, 1961. San Francisco Ballet Theatre, San Francisco.
Number of Dancers: 10
Principal Dancers: Virginia Johnson, Robert Gladstein, Paula Tracy, Robert Vickrey, Cynthia Gregory, Terry Orr.
In Repertory: B1961, B1962, B1963.

SESSION II**
Choreography: Michael Smuin and Kent Stowell
Percussion: Kaye Dunham
Premiere: July 14, 1961. San Francisco Ballet Theatre, San Francisco.
Number of Dancers: 4
Principal Dancers: Diana Nielsen, Terry Orr, Paula Tracy, Sue Loyd.
In Repertory: B1961.

THE CRUCIBLE*
Choreography: Kent Stowell
Music: Morton Gould
Costumes: John Furness

Premiere: July 14, 1961. San Francisco Ballet Theatre, San Francisco.
Number of Dancers: 9
Principal Dancers: Fiona Fuerstner (Abigail Williams), Robert Gladstein (John Proctor), Christine Bering (Elizabeth Proctor).
In Repertory: B1961, B1962.

san francisco ballet

SPRING SEASON 1962 APRIL 17-MAY 5
THE PLAYGOER *Geary Theatre*

CAL ANDERSON

SHOSTAKOVICH PAS DE DEUX*

Choreography: Kent Stowell
Music: Dimitri Shostakovich
Premiere: July 14, 1961. San Francisco Ballet Theatre, San Francisco.
Principal Dancers: Sally Bailey, Kent Stowell.
In Repertory: B1961.

BUY**

Choreography: Jeannde Herst
Sound: John Tomaschke and Jack Sweeny.
Costumes: Maurine Simoneau
Premiere: July 14, 1961. San Francisco Ballet Theatre, San Francisco.
Number of Dancers: 1
Principal Dancer: Maurine Simoneau
In Repertory: B1961.

QUESTIONNAIRE**

Choreography: Jeannde Herst
Sound: John Tomaschke and Jack Sweeny.
Costumes: Maurine Simoneau
Premiere: July 14, 1961. San Francisco Ballet Theatre, San Francisco.
Number of Dancers: 7
Principal Dancers: Terry Orr, Robert Vickrey, Robert Gladstein.
In Repertory: B1961, B1962, B1963, B1964.

EVA**

Choreography: Jeannde Herst
Music: Jerome Rosen
Costumes: Maurine Simoneau
Premiere: July 21, 1961. San Francisco Ballet Theatre, San Francisco.
Number of Dancers: 11

Principal Dancers: Fiona Fuerstner (Eva), Robert Gladstein (Peron).
In Repertory: B1961.

APOLOGUE*

Choreography: Kent Stowell
Music: Darius Milhaud
Costumes: John Furness
Premiere: July 21, 1961. San Francisco Ballet Theatre, San Francisco.
Number of Dancers: 3
Principal Dancers: Robert Gladstein, Diana Nielsen, Robert Vickrey.
In Repertory: B1961.

SHADOWS*

Choreography: Lew Christensen
Music: Paul Hindemith (*Educational Music for Instrumental Ensembles*, Op. 44, and *Trauermusik*).
Premiere: San Francisco Ballet Theatre, San Francisco. Entered company repertory 1964.
Number of Dancers: 10
Principal Dancers: Jocelyn Vollmar, Kent Stowell.
In Repertory: B1961, B1962, B1963, 1964, 1965, 1966; B1969; B1971, 1972.

ELYSIUM*

Choreography: Kent Stowell
Music: Georges Bizet (from *The Fair Maid of Perth*).
Costumes: Maurine Simoneau
Premiere: August 4, 1961. San Francisco Ballet Theatre, San Francisco.
Number of Dancers: 9
Principal Dancers: Virginia Johnson, Finis Jhung.
In Repertory: B1961, B1962.

PROKOFIEV WALTZES*

Choreography: Lew Christensen
Music: Sergei Prokofiev
Costumes: Maurine Simoneau
Premiere: August 4, 1961. San Francisco Ballet Theatre, San Francisco.
Number of Dancers: 8
Principal Dancers: Jocelyn Vollmar, Sally Bailey, Fiona Fuerstner, Virginia Johnson, Kent Stowell, Robert Gladstein, Finis Jhung, Terry Orr.
In Repertory: B1961, B1962, B1963, B1964, B1965, B1966.

Opera Ballets

In 1961 the San Francisco Opera inaugurated a spring season. The Ballet appeared in three of the six operas presented between May 2 and May 19:

ROMEO AND JULIET

Choreography: Lew Christensen
Music: Charles Gounod
Opening Night: May 2, 1961.

LA TRAVIATA

Choreography: Lew Christensen and Michael Smuin.
Music: Giuseppe Verdi

Opening Night: May 13, 1961.
Principal Dancers: Jocelyn Vollmar, Roderick Drew.

CARMEN

Choreography: Lew Christensen and Michael Smuin.
Music: Georges Bizet
Opening Night: May 19, 1961.

Opera Ballets

The Ballet appeared in eleven of the twelve operas presented during the 1961 San Francisco Opera season, September 15 through October 26:

LUCIA DI LAMMERMOOR

Choreography: Lew Christensen
Music: Gaetano Donizetti
Opening Night: September 15, 1961.

TURANDOT

Choreography: Ghita Hager
Music: Giacomo Puccini
Opening Night: September 16, 1961.

BLOOD MOON

Choreography: Lew Christensen
Music: Norman Dello Joio
Opening Night: September 18, 1961.
Principal Dancer: Roderick Drew.

BORIS GODOUNOFF

Choreography: Lew Christensen
Music: Modest Mussorgsky
Opening Night: September 21, 1961.

THE MARRIAGE OF FIGARO

Choreography: Ghita Hager
Music: Wolfgang Amadeus Mozart
Opening Night: September 29, 1961.

RIGOLETTO

Choreography: Lew Christensen
Music: Giuseppe Verdi
Opening Night: September 30, 1961.

NABUCCO

Choreography: Ghita Hager
Music: Giuseppe Verdi
Opening Night: October 6, 1961.

UN BALLO IN MASCHERA

Choreography: Lew Christensen
Music: Giuseppe Verdi
Opening Night: October 12, 1961.

DIE MEISTERSINGER VON NÜRNBERG

Choreography: Ghita Hager
Music: Richard Wagner
Opening Night: October 17, 1961.

AIDA

Choreography: Lew Christensen
Music: Giuseppe Verdi
Opening Night: November 3, 1961.
Principal Dancers: Sally Bailey, Jocelyn Vollmar, Kent Stowell, Roderick Drew.

A MIDSUMMER NIGHT'S DREAM

Choreography: Ghita Hager
Music: Benjamin Britten
Opening Night: October 10, 1961.

1 9 6 2

JEST OF CARDS*

Choreography: Lew Christensen
Music: Ernest Křenek (*Marginal Sounds*).
Scenery and Costumes: Tony Duquette
Premiere: April 17, 1962. Geary Theatre, San Francisco.
Number of Dancers: 25
Principal Dancers: Michael Smuin (Joker), Fiona Fuerstner, Kent Stowell, Sally Bailey, Jocelyn Vollmar, Cynthia Gregory, Terry Orr, Virginia Johnson, Robert Gladstein.
In Repertory: 1962, 1963, 1964; 1967; 1974.

"Ballet '62"

OPUS ONE*

Choreography: Robert Gladstein
Music: Sergei Prokofiev
Costumes: Virginia Stapleton
Premiere: July 13, 1962. San Francisco Ballet Theatre, San Francisco.
Number of Dancers: 6
Principal Dancers: Ada Shepard, Gail Visentin, Nancy Robinson, Cynthia Gregory, Shari White, Sue Loyd.
In Repertory: B1962, B1963.

ELIJAH*

Choreography: Gordon Showalter
Music: Mahalia Jackson
Premiere: July 13, 1962. San Francisco Ballet Theatre, San Francisco.
Number of Dancers: 10
Principal Dancers: Gail Visentin, Michael Rubino.
In Repertory: B1962, B1963.

SESSION III**

Staged By: Terry Orr
Premiere: July 20, 1962. San Francisco Ballet Theatre, San Francisco.
Number of Dancers: 3
Principal Dancers: Robert Vickrey, Sally Bailey, David Anderson.
In Repertory: B1962.

BIOGRAPHY*

Choreography: Robert Gladstein
Music: Ernest Bloch
Costumes: Ken Howard
Premiere: July 27, 1962. San Francisco Ballet Theatre, San Francisco.
Number of Dancers: 8
Principal Dancers: Cynthia Gregory, Robert Vickrey, Terry Orr, David Anderson.
In Repertory: B1962.

SHORE LEAVE*

Choreography: Gordon Showalter
Music: Henry Mancini
Premiere: July 27, 1962. San Francisco
 Ballet Theatre, San Francisco.
Number of Dancers: 3
Principal Dancers: Sally Bailey, David
 Anderson, Suzanne Stalley.
In Repertory: B1962.

VOYAGE A REIMS*

Choreography: Carlos Carvajal
Music: Gioacchino Rossini
Costumes: Eloise Arnold
Premiere: July 27, 1962. San Francisco
 Ballet Theatre, San Francisco.
Number of Dancers: 2
Principal Dancers: Sally Bailey, Robert
 Gladstein.
In Repertory: B1962.

BACH CONCERT*

Choreography: Lew Christensen
Music: Johann Sebastian Bach (*Partita
 No. 2 in C Minor, Prelude for Lute,
 "Courante" from Suite No. 2 for
 Cello, "Adagio" and "Toccata" from
 Toccata in C Major*).
Premiere: August 10, 1962. San
 Francisco Ballet Theatre, San
 Francisco.
Number of Dancers: 15
Principal Dancers: Sue Loyd, Cynthia
 Gregory, Jocelyn Vollmar, Robert
 Gladstein, Nancy Robinson.
In Repertory: B1962, B1963, B1964.

Opera Ballets

The Ballet appeared in five of the
fourteen operas presented during the
1962 San Francisco Opera season,
September 14 through October 25:

CARMEN

Choreography: Lew Christensen
Music: Georges Bizet
Opening Night: September 20, 1962.
Principal Dancers: Sally Bailey, Robert
 Gladstein.

FAUST

Choreography: Lew Christensen
Music: Charles Gounod
Opening Night: September 25, 1962.

THE DAUGHTER OF
THE REGIMENT

Choreography: Lew Christensen
Music: Gaetano Donizetti (ballet
 music interpolated from Donizetti's
 La Favorita).
Opening Night: October 18, 1962.
Principal Dancers: Jocelyn Vollmar,
 Robert Gladstein, Terry Orr.

DON GIOVANNI

Choreography: Lew Christensen
Music: Wolfgang Amadeus Mozart
Opening Night: October 16, 1962.

FALSTAFF

Choreography: Lew Christensen

Music: Giuseppe Verdi
Opening Night: October 23, 1962.

1963

DIVERTISSEMENT
D'AUBER (II)*

Choreography: Lew Christensen
Music: François Esprit Auber (from
 overtures to *Bronze Horse, Crown
 Diamonds, Fra Diavolo, Black
 Domino*).
Costumes: Tony Duquette
Premiere: February 4, 1963. Phoenix
 Union High School Auditorium;
 Phoenix, Arizona.
Number of Dancers: 18
Principal Dancers: Virginia Johnson,
 Terry Orr, Cynthia Gregory.
In Repertory: 1963, 1964, 1965, 1966.
Note: For *pas de trois* version of
 Divertissement d'Auber, see 1959
 listings.

FANTASMA*

Choreography: Lew Christensen
Music: Sergei Prokofiev (*Waltzes*, Opus
 101), arranged by Lew Christensen.
Scenery and Costumes: Tony Duquette
Premiere: February 5, 1963. University
 of Arizona Auditorium; Tucson,
 Arizona.
Number of Dancers: 21
Principal Dancers: Robert Gladstein
 (Wanderer), Jocelyn Vollmar
 (Mistress of the Mansion).
In Repertory: 1963, 1964, 1965; 1967;
 1969, 1970; 1975, 1976.

"Ballet '63"

VIVALDI CONCERTO*

Choreography: Robert Gladstein
Music: Antonio Vivaldi
Costumes: Kathleen Gee
Premiere: June 7, 1963. San Francisco
 Ballet Theatre, San Francisco.
Number of Dancers: 6
Principal Dancers: Sue Loyd, Nancy
 Robinson, Cynthia Gregory, Ron
 Poindexter, David Anderson, Henry
 Berg.
In Repertory: B1963, B1964, B1965,
 B1966.

DANCE VARIATIONS*

Choreography: Lew Christensen
Music: Vittorio Rieti
Premiere: June 14, 1963. San Francisco
 Ballet Theatre, San Francisco.
Number of Dancers: 8
Principal Dancers: Sally Bailey, Lynda
 Meyer, Joan DeVere, Robert
 Gladstein, Henry Berg, Frank
 Ordway.
In Repertory: B1963, B1964.

TRIPTYCH**

(Ballet in Three Movements)

Choreography: Thatcher Clarke
Music: Robert Phillips
Book: Kenneth Pitchford
Costumes: Art Fine

Premiere: June 21, 1963. San Francisco
 Ballet Theatre, San Francisco.
Number of Dancers: 12
Principal Dancers: David Anderson
 (The Man), Cynthia Gregory (The
 Woman).
In Repertory: B1963.

SONNET*

Choreography: Jocelyn Vollmar
Music: Gioacchino Rossini
Costumes: Art Fine
Premiere: June 21, 1963. San Francisco
 Ballet Theatre, San Francisco.
Number of Dancers: 6
Principal Dancers: Jocelyn Vollmar,
 Robert Gladstein.
In Repertory: B1963, B1964, B1965,
 B1966.

THE SET*

Choreography: Ron Poindexter
Music: Dave Brubeck
Premiere: June 28, 1963. San Francisco
 Ballet Theatre, San Francisco.
 Entered main Company repertory,
 1964.
Number of Dancers: 8
Principal Dancers: Shari White, Nancy
 Robinson, David Anderson, Henry
 Berg.
In Repertory: B1963, 1964, 1965.

SCHOENBERG
VARIATIONS*

Choreography: Frank Ordway
Music: Arnold Schoenberg
Premiere: July 5, 1963. San Francisco
 Ballet Theatre, San Francisco.
In Repertory: B1963.

THE COLORISTS*

Choreography: Robert Gladstein
Music: Manuel Palau
Premiere: July 12, 1963. San Francisco
 Ballet Theatre, San Francisco.
Principal Dancers: Tina Bernal, Henry
 Berg.
In Repertory: B1963.

1964

LA SYLPHIDE: EXCERPTS
FROM ACT II

Choreography: After August
 Bournonville (reproduced by Rudolf
 Nureyev).
Music: Herman Løvenskjold (from *La
 Sylphide*).
Premiere: January 14, 1964. War
 Memorial Opera House, San
 Francisco. (World Premiere: Royal
 Danish Ballet, 1836. Excerpts of
 Nureyev staging: 1963.)
Number of Dancers: 2
Principal Dancers: Margot Fonteyn
 (g.a.), Rudolf Nureyev (g.a.).
In Repertory: 1964.

LE CORSAIRE:
PAS DE DEUX

Choreography: After Marius Petipa
 (reproduced by Rudolf Nureyev).

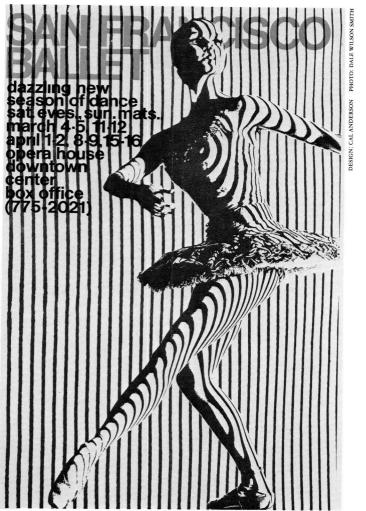

DESIGN: CAL ANDERSON PHOTO: DALE WILSON SMITH

SAN FRANCISCO BALLET

dazzling new
season of dance
sat. eves. sun. mats.
march 4-5 11-12
april 1-2, 8-9 15-16
opera house
downtown
center
box office
(775-2021)

Music: Riccardo Drigo and Léon
Minkus (from *Le Corsaire*).
Premiere: January 14, 1964. War
Memorial Opera House, San
Francisco. (Nureyev first staged the
Corsaire pas de deux in 1962. The
full-length ballet had been
presented in 1856 with
choreography by Joseph Mazilier
and music by Adolphe Adam.
Marius Petipa restaged the ballet in
1899 with additional music. World
Premiere: 1899, the Maryinsky
Theatre, St. Petersburg.)
Principal Dancers: Margot Fonteyn
(g.a.), Rudolf Nureyev (g.a.).
In Repertory: 1964; 1975 (with Valery
and Galina Panov and various guest
artists, 1976).

Note: Also see San Francisco Ballet
production of *Corsaire pas de deux*,
1970 listings.

GAYNE: PAS DE DEUX

Choreography: Nina Anisimova
(reproduced by Rudolf Nureyev).
Music: Aram Khachaturian (from
Gayne).
Premiere: January 18, 1964. War
Memorial Opera House, San
Francisco. (World Premiere: Full-
length ballet: 1942, Kirov Ballet,
Leningrad.)
Principal Dancers: Margot Fonteyn
(g.a.), Rudolf Nureyev (g.a.).
In Repertory: 1964.

SLEEPING BEAUTY: GRAND PAS DE DEUX

Choreography: Marius Petipa
Music: Peter Ilyich Tchaikovsky (from
Sleeping Beauty).
Premiere: January 20, 1964. War
Memorial Opera House, San
Francisco. (World Premiere of
Sleeping Beauty: 1890, the Maryinsky
Theatre, St. Petersburg.)
Principal Dancers: Margot Fonteyn
(g.a.), Rudolf Nureyev (g.a.).
In Repertory: 1964; 1977 (with
Fernando Bujones and Yoko
Morishita).

Note: For another San Francisco Ballet
production of this *pas de deux*, see
listings for *Princess Aurora*, 1964.

THE SEVEN DEADLY SINS

Choreography: George Balanchine
(revised by Lew Christensen).
Music: Kurt Weill
Scenery and Costumes: Rouben Ter-
Arutunian
Book: Bertholt Brecht, translated by
W. H. Auden and Chester Kallman
Premiere: April 9, 1964. Geary
Theater, San Francisco. (World
Premiere: The New York City
Ballet, 1958.)
Principal Dancer: Cynthia Gregory
(Anna II).
Principal Singers: Nina Foch (Anna I),
Sam Resnick, bass (Mother), Milton
Williams, bass (Father), Thomas
Hageman, tenor (Brother I), Patrick
Dougherty, tenor (Brother II).

Total Performers: 26 dancers and 5
singers.
In Repertory: 1964.

"Ballet '64"

CONCERTARE*

Choreography: Robert Gladstein
Music: César Franck (*Symphonic
Variations*).
Premiere: June 19, 1964. San Francisco
Ballet Theatre, San Francisco.
Number of Dancers: 20
Principal Dancers: Virginia Johnson,
Sue Loyd, Nancy Robinson, Gail
Visentin.
In Repertory: B1964.

PRINCESS AURORA*

(A Suite of Dances from *Sleeping Beauty*)

Choreography: Henry Kersh (after
Marius Petipa).
Music: Peter Ilyich Tchaikovsky (from
Sleeping Beauty).
Premiere: June 19, 1964. San Francisco
Ballet Theatre, San Francisco.
Number of Dancers: 20
Principal Dancers: Jocelyn Vollmar
(Princess Aurora), Henry Kersh
(Prince Desiré), Sue Loyd, Thatcher
Clarke (Blue Bird).
In Repertory: B1964.

Note: Other San Francisco Ballet
productions of the "Blue Bird" *pas de
deux* listed under *Scènes de Ballet*
(1942), *Blue Bird* (1943), and
Divertimenti (1951). Other San
Francisco presentations of the Grand
Pas de Deux from *Sleeping Beauty*
listed under 1964.

SANCHO*

Choreography: Thatcher Clarke
Music: Robert Hughes
Premiere: June 26, 1964. San Francisco
Ballet Theatre, San Francisco.
Number of Dancers: Unknown
Principal Dancers: Unknown
In Repertory: B1964.

SCHERZANDO*

Choreography: Jocelyn Vollmar
Music: Edouard Lalo
Premiere: June 26, 1964. San Francisco
Ballet Theatre, San Francisco.
Number of Dancers: Unknown
Principal Dancers: Unknown
In Repertory: B1964, B1965.

ADAGIO FOR TEN AND TWO*

Choreography: Richard Gibson
Music: Samuel Barber
Costumes: Suzanne Gibson
Premiere: July 3, 1964. San Francisco
Ballet Theatre, San Francisco.
Number of Dancers: 12
Principal Dancers: Zola Dishong,
David Anderson.
In Repertory: B1964, B1965.

A DREAM WORK*

Choreography: Frank Ordway
Music: Alban Berg
Scenery: Frank Ordway

Premiere: July 3, 1964. San Francisco
Ballet Theatre, San Francisco.
Number of Dancers: 8
Principal Dancers: Nancy Robinson,
Zola Dishong, Gerald Leavitt, Lee
Fuller, Richard Gibson.
In Repertory: B1964, B1965.

ANAGNORISIS**

Choreography: Thatcher Clarke
Music: Robert Hughes
Premiere: July 9, 1964. San Francisco
Ballet Theatre, San Francisco.
Number of Dancers: 1
Principal Dancer: Thatcher Clarke.
In Repertory: B1964.

LES DESIRABLES*

Choreography: Robert Gladstein
Music: Benjamin Britten
Premiere: July 9, 1964. San Francisco
Ballet Theatre, San Francisco.
Number of Dancers: 7
Principal Dancers: Sally Bailey, Sue
Loyd.
In Repertory: B1964.

BUJI*

Choreography: Dennis Allen
Music: Bulent Arel, Alan Hovhaness,
Lopresti.
Premiere: July 16, 1964. San Francisco
Ballet Theatre, San Francisco.
In Repertory: B1964.

GENTIANS IN HIS HOUSE**

Choreography: Thatcher Clarke
Music: Robert Hughes
Premiere: July 23, 1964. San Francisco
Ballet Theatre, San Francisco.
In Repertory: B1964.

1965

LIFE: A DO IT YOURSELF DISASTER*

(A Pop Art Ballet)

Choreography: Lew Christensen
Music: Charles Ives (*Halloween* and *The
Pond*).
Scenery and Costumes: Cal Anderson
Book: Herb Caen
Premiere: January 30, 1965. War
Memorial Opera House, San
Francisco.
Number of Dancers: 28
Principal Dancers: Incipiency: Barbara
Begany, Salicia Smith; Virility:
Lynda Meyer, David Anderson;
Maturity: Jocelyn Vollmar, Gerald
Leavitt; Resignation: Gerald Leavitt .
In Repertory: 1965, 1966, 1967.

OCTET

Choreography: Willam Christensen
Music: Igor Stravinsky (*Octet*).
Costumes: Tony Duquette
Premiere: February 6, 1965. War
Memorial Opera House, San
Francisco (World Premiere: The
New York City Ballet, 1958.)
Number of Dancers: 8

Principal Dancers: Sue Loyd, Terry
Orr, Virginia Johnson, Lee Fuller,
Joan DeVere, David Anderson,
Cynthia Gregory, R. Clinton
Rothwell.
In Repertory: 1965.

LUCIFER*

(later known as *Concert Music for Strings
and Brass Instruments*)

Choreography: Lew Christensen
Music: Paul Hindemith (*Concert Music
for Strings and Brass*, Op. 50).
Scenery and Costumes: Rouben Ter-
Arutunian
Premiere: February 20, 1965. War
Memorial Opera House, San
Francisco.
Number of Dancers: 18
Principal Dancers: R. Clinton
Rothwell (Lucifer), David Anderson
(St. Michael).
In Repertory: 1965, 1966.

"Ballet '65"

CONCERTINO*

Choreography: Frank Ordway
Music: Giovanni Battista Pergolesi
Premiere: July 9, 1965. San Francisco
Ballet Theatre, San Francisco.
Number of Dancers: 9
Principal Dancer: Virginia Johnson.
In Repertory: B1965.

GISELLE: PEASANT PAS DE DEUX*

Staged By: R. Clinton Rothwell
Music: Adolphe Adam
Premiere: July 9, 1965. San Francisco
Ballet Theatre, San Francisco.
Principal Dancers: Maureen Wiseman,
Henry Berg.
In Repertory: B1965.

Note: Other San Francisco Ballet
versions of *Giselle* listed under 1947
and 1975.

SIEMPRE BACH*

Choreography: Carlos Carvajal
Music: Johann Sebastian Bach
Premiere: July 9, 1965. San Francisco
Ballet Theatre, San Francisco.
Number of Dancers: 8
Principal Dancers: Virginia Johnson,
Zola Dishong, Victoria Gyorfi,
Barbara Begany, Lee Fuller, Frank
Ordway, Bill Breedlove, Carlos
Carvajal.
In Repertory: B1965, B1966, B1967.

WAY OUT (I)*

Choreography: Robert Gladstein
Music: Jacques Ibert (*Concertino da
Camera for Saxophone and Orchestra*),
Georg Reidel (*Conversation
Symphonette*: Second Movement).
Premiere: July 16, 1965. San Francisco
Ballet Theatre, San Francisco.
Number of Dancers: 4
Principal Dancers: Nancy Robinson,
Eloise Tjomsland, David Anderson,
Lee Fuller.
In Repertory: B1965, B1966, B1967,
B1968.

Note: See *Way Out* (II) under 1966 listings.

LIBATION: A MORALITY PLAY**

Choreography: Henry Kersh
Music: Percussion
Scenery: Henry Kersh
Premiere: July 16, 1965. San Francisco Ballet Theatre, San Francisco.
Number of Dancers: 6
Principal Dancers: Henry Kersh (King), Nancy Robinson (Nymph), Tina Kalimos (Demon-Child).
In Repertory: B1965.

PAS DE TROIS*

Choreography: Henry Berg
Music: Georges Bizet
Costumes: Sue Loyd
Premiere: July 23, 1965. San Francisco Ballet Theatre, San Francisco.
Principal Dancers: Zola Dishong, R. Clinton Rothwell, Victoria Gyorfi.
In Repertory: B1965.

SONG WITHOUT WORDS*

Choreography: Jocelyn Vollmar
Music: Gabriel Fauré
Costumes: Henry Kersh
Premiere: July 23, 1965. San Francisco Ballet Theatre, San Francisco.
Number of Dancers: 13
Principal Dancers: Robert Gladstein (The Youth), Jocelyn Vollmar (The Mute), Eloise Tjomsland, Betsy Erickson, Kerry Williams (The Affliction).
In Repertory: B1965, B1966.

DEFEAT*

Choreography: R. Clinton Rothwell
Music: Hector Villa-Lobos
Premiere: July 23, 1965. San Francisco Ballet Theatre, San Francisco.
Number of Dancers: 2
Principal Dancers: Maureen Wiseman, R. Clinton Rothwell.
In Repertory: B1965.

HIGHWAY 101**

Choreography: Jeannde Herst
Sound: John Tomaschke
Projection: Louis Bennett
Premiere: July 30, 1965. San Francisco Ballet Theatre, San Francisco.
Number of Dancers: 9
Principal Dancers: Joan DeVere, Barbara Begany, Ann Worthington, Wendy Holt.
In Repertory: B1965, B1966.

SOUVENIR*

Choreography: Richard Gibson
Music: Sir Edward Elgar
Premiere: July 30, 1965. San Francisco Ballet Theatre, San Francisco.
Number of Dancers: 15
Principal Dancers: Jocelyn Vollmar (Elizabeth), Henry Kersh (Her Betrothed), David Anderson (Her Lost Love).
In Repertory: B1965.

HUNGARICA*

Choreography: David Anderson
Music: Ernst von Dohnányi
Costumes: Zola Dishong
Premiere: August 13, 1965. San Francisco Ballet Theatre, San Francisco.
Number of Dancers: 2
Principal Dancers: Virginia Johnson, David Anderson.
In Repertory: B1965, B1966.

REAL GAMES*

Choreography: Frank Ordway
Music: Gunther Schuller
Premiere: August 13, 1965. San Francisco Ballet Theatre, San Francisco.
Number of Dancers: 16
Principal Dancers: Joan DeVere, Victoria Gyorfi, Eloise Tjomsland, Barbara Begany.
In Repertory: B1965.

REFLECTIONS*

Choreography: Carlos Carvajal
Music: Wayne Peterson (*Free Variations*).
Premiere: August 13, 1965. San Francisco Ballet Theatre, San Francisco.
Number of Dancers: 5
Principal Dancers: Carlos Carvajal (The Man), Lee Fuller (His Reflection), Virginia Johnson (The Woman), Zola Dishong (Her Reflection), Joan DeVere (Destiny).
In Repertory: B1965, B1966.

FACE OF DEATH*

Choreography: Robert Gladstein
Music: Belá Bartók and Otto Klemperer.
Premiere: August 20, 1965. San Francisco Ballet Theatre, San Francisco.
Number of Dancers: 12
Principal Dancers: Jocelyn Vollmar (Widow), David Anderson (Deceased).
In Repertory: B1965.

SHOWOFF*

Choreography: Ronald Chetwood
Music: Dimitri Kabalevsky
Premiere: August 20, 1965. San Francisco Ballet Theatre, San Francisco.
Number of Dancers: 7
Principal Dancers: Jocelyn Vollmar, Zola Dishong, Victoria Gyorfi, Deanne Rowland.
In Repertory: B1965, B1966.

1 9 6 6

ALPENFEST*

Choreography: Carlos Carvajal
Music: Wolfgang Amadeus Mozart (*German Dances*: K605, No. 3; K600, No. 2; K606, No. 1; K571, No. 2; *A Musical Joke*: last movement).

Premiere: February 12, 1966. War Memorial Opera House, San Francisco.
Number of Dancers: 9
Principal Dancer: Jocelyn Vollmar.
In Repertory: 1966.

SCOTCH SYMPHONY

Choreography: George Balanchine
Music: Felix Mendelssohn (*Symphony No. 3 in A*, Op. 56, "Scottish": Second, Third, and Fourth Movements).
Scenery: Horace Armistead.
Costumes: Barbara Karinska
Premiere: February 12, 1966. War Memorial Opera House, San Francisco. (World Premiere: The New York City Ballet, 1952.)
Number of Dancers: 19
Principal Dancers: Lynda Meyer, R. Clinton Rothwell, Henry Berg, Lee Fuller, Sue Loyd.
In Repertory: 1966.

WAJANG*

Choreography: Carlos Carvajal
Music: Colin McPhee (*Tabuh Tabuhan*: Prelude, Pastorale, Finale).
Costumes: Henry Kersh
Premiere: February 19, 1966. War Memorial Opera House, San Francisco.
Number of Dancers: 11
Principal Dancers: Joan DeVere, Henry Berg, Zola Dishong, Robert Gladstein.
In Repertory: 1966.

WAY OUT (II)*

Choreography: Robert Gladstein
Music: Igor Stravinsky (*Orchestral Suite No. 2, Scherzo à la Russe, Circus Polka*) and George Reidel (*Conversation Symphonette*: Second Movement).
Scenery and Costumes: Athena Kalimos
Premiere: April 2, 1966. War Memorial Opera House, San Francisco.
Number of Dancers: 4
Principal Dancers: Nancy Robinson, David Anderson, Eloise Tjomsland, Lee Fuller.
In Repertory: 1966.

Note: See version of *Way Out* listed under 1965.

PAS DE SIX*

Choreography: Lew Christensen
Music: Hans Christian Lumbye (*Fredrick VII March, Britta Polka, Columbine Polka Mazurka, Concerto Polka for Two Violins, Salute for August Bournonville Galop*).
Costumes: Robert O'Hearn
Premiere: May 1, 1966. Hilmar High School Auditorium; Merced, California. San Francisco Premiere: April 8, 1967, War Memorial Opera House.
Number of Dancers: 6
Principal Dancers: Sue Loyd, Jocelyn Vollmar, Sally Bailey, Robert Gladstein, David Anderson, Lee Fuller.

In Repertory: 1966, 1967, B1968, 1969, 1970, 1971.

"Ballet '66"

THREE DIVERSIONS*

Choreography: Carlos Carvajal
Music: Dimitri Shostakovich (from *Second Piano Concerto*).
Premiere: July 8, 1966. San Francisco Ballet Theatre, San Francisco.
Number of Dancers: 16
Principal Dancers: Sally Bailey, Sue Loyd, Henry Berg, Carlos Carvajal.
In Repertory: B1966; B1969, B1970.

VARIATIONS FOR VIOLIN AND ORCHESTRA*

Choreography: Robert Gladstein
Music: Max Bruch (*Fantasy on Scottish Folk Tunes*, Op. 46).
Costumes: Henry Kersh
Premiere: July 15, 1966. San Francisco Ballet Theatre, San Francisco.
Number of Dancers: 11
Principal Dancers: Nancy Robinson, David Anderson, Sue Loyd.
In Repertory: B1966.

PYGMALION*

Choreography: Jocelyn Vollmar
Music: Gioacchino Rossini
Scenery and Costumes: Henry Kersh
Premiere: July 15, 1966. San Francisco Ballet Theatre, San Francisco.
Number of Dancers: 10
Principal Dancers: Robert Gladstein (Pygmalion), Jocelyn Vollmar (Galatea), Joan DeVere (Muse), David Coll (Servant).
In Repertory: B1966.

THE ADOLESCENTS*

Choreography: Ronald Chetwood
Music: Francis Poulenc
Costumes: Henry Kersh
Premiere: July 29, 1966. San Francisco
 Ballet Theatre, San Francisco.
In Repertory: B1966.

LILITH*

Choreography: Marc Wilde
Music: Karl-Birger Blomdahl
Premiere: July 29, 1966. San Francisco
 Ballet Theatre, San Francisco.
Number of Dancers: 6
Principal Dancers: Penelope Lagios
 (First Woman), Edward Smyth (The
 Man), Sue Loyd (The Second
 Woman), Henry Berg (The
 Medium), Joan DeVere, John McFall
 (The Forces).
In Repertory: B1966.

THEME VARIEE*

Choreography: David Anderson
Music: Ernst von Dohnányi
Costumes: Zola Dishong and David
 Barnard
Premiere: August 5, 1966. San
 Francisco Ballet Theatre, San
 Francisco.
In Repertory: B1966.

KAMA SUTRA**

Choreography: Carlos Carvajal
Music: Robert Hughes
Costumes: Craig Hampton
Premiere: August 5, 1966. San
 Francisco Ballet Theatre, San
 Francisco.
In Repertory: B1966.

DANZA*

Choreography: Henry Berg
Music: Gustav Mahler
Premiere: August 5, 1966. San
 Francisco Ballet Theatre, San
 Francisco.
In Repertory: B1966.

THE SAGA OF SILVER CREEK*

Choreography: Robert Gladstein
Music: Aaron Copland
Scenery: Jud Stoddard
Premiere: August 5, 1966. San
 Francisco Ballet Theatre, San
 Francisco.
Number of Dancers: 18
Principal Dancers: Alan Bergman
 (Gambler), Jud Stoddard (Bandit),
 Henry Berg (Sheriff), Jocelyn
 Vollmar (Senorita Spitfire), Betsy
 Erickson (Bride).
In Repertory: B1966.

VOYAGE INTERDIT: A NOH PLAY*

Choreography: Carlos Carvajal
Music: Love, Mimaroglu, Auni, and
 the Fugs.
Projections: John Patterson and David
 Barnard
Premiere: August 19, 1966. San
 Francisco Ballet Theatre, San
 Francisco.
Number of Dancers: 15

Principal Dancers: Carlos Carvajal (The
 Voyager), Zola Dishong (The
 Oracle), Betsy Erickson (Truth).
In Repertory: B1966; B1968 (new
 production).

1 9 6 7

SYMPHONY IN D*

Choreography: Lew Christensen
Music: Luigi Cherubini
Scenery and Costumes: Robert
 O'Hearn
Premiere: March 4, 1967. War
 Memorial Opera House, San
 Francisco.
Number of Dancers: 32
Principal Dancers: Lynda Meyer,
 Henry Berg, Sue Loyd, David Coll.
In Repertory: 1967; 1970.

TOTENTANZ**

(Ballet in Four Scenes)

Choreography: Carlos Carvajal
Music: Warner Jepson
Scenery and Costumes: Cal Anderson
Props: Jud Stoddard
Premiere: April 1, 1967. War
 Memorial Opera House, San
 Francisco.
Number of Dancers: 32
Principal Dancers: Robert Gladstein
 (Death), Virginia Johnson, David
 Coll (Lovers), Nancy Robinson
 (Young Woman), Henry Berg, Lee
 Fuller (Young Men).
In Repertory: 1967; 1969; 1972.

KROMATIKA*

Choreography: Carlos Carvajal
Music: William Walton (Variations on a
 Theme of Paul Hindemith).
Costumes: Chuck Arnett
Visual Effects: Lynne Vardeman
Premiere: April 15, 1967. War
 Memorial Opera House, San
 Francisco.
Number of Dancers: 20
Principal Dancers: Sally Bailey, Robert
 Gladstein, Virginia Johnson, David
 Coll, Sue Loyd, Lee Fuller, Joan
 DeVere, Henry Berg.
In Repertory: 1967.

NUTCRACKER*

Choreography: Lew Christensen
Music: Peter Ilyich Tchaikovsky
Scenery and Costumes: Robert
 O'Hearn
Premiere: December 12, 1967. War
 Memorial Opera House, San
 Francisco.
Number of Roles: 191
Principal Dancers: Henry Kersh
 (Drosselmeyer), Harold Christensen,
 Jr. (His Assistant), Bridget Mullins
 (Clara), William Johnson (King of
 the Mice), Virginia Johnson (Queen
 of Snow), David Coll (King of
 Snow), Melissa Hayden (g.a.) (Sugar
 Plum Fairy), Jacques d'Amboise
 (g.a.) (Cavalier), Lynda Meyer (Rose,
 Waltz of the Flowers).

In Repertory: 1967, 1968, 1969, 1970,
 1971, 1972, 1973, 1974, 1975,
 1976, 1977, 1978, 1979, 1980,
 1981, 1982.
Note: Other San Francisco Ballet
 productions of Nutcracker listed
 under 1943, 1944, and 1954.

"Ballet '67"

FACETS*

Choreography: Carlos Carvajal
Music: Francis Poulenc (Harpsichord
 Concerto).
Premiere: July 14, 1967. San Francisco
 Ballet Theatre, San Francisco.
Number of Dancers: 22
Principal Dancers: Virginia Johnson,
 Lynda Meyer, Lee Fuller, David
 Coll.
In Repertory: B1967, B1968.

WINTER ETCHINGS**

Choreography: David Barnard
Music: Malcolm Smith and Joel
 Schwartz.
Scenery and Costumes: David Barnard
Premiere: July 14, 1967. San Francisco
 Ballet Theatre, San Francisco.
Number of Dancers: 6
Principal Dancers: Jocelyn Vollmar,
 Eloise Tjomsland, Christine
 Bennett.
In Repertory: B1967.

BALALAIKA*

Choreography: David Coll
Music: Folk music
Costumes: David Barnard
Premiere: July 14, 1967. San Francisco
 Ballet Theatre, San Francisco.
Number of Dancers: 2
Principal Dancers: Lynda Meyer, David
 Coll.
In Repertory: B1967.

MUCH ADO ABOUT NOTHING*

Choreography: Jocelyn Vollmar
Music: Béla Bartók
Scenery: John Patterson
Premiere: July 14, 1967. San Francisco
 Ballet Theatre, San Francisco.
Number of Dancers: 15
Principal Dancers: Nancy Robinson,
 David Coll, John McFall, Barbara
 Begany, Lee Fuller.
In Repertory: B1967, B1968.

ECLIPSE*

Choreography: Jocelyn Vollmar
Music: Antonín Dvořák
Scenery: Jud Stoddard
Premiere: July 21, 1967. San Francisco
 Ballet Theatre, San Francisco.
Number of Dancers: 3
Principal Dancers: Nancy Robinson,
 Robert Gladstein, Jocelyn Vollmar.
In Repertory: B1967.

MINDANAO*

Choreography: Benjamin Reyes
Music: Traditional Philippine folk
 music
Costumes: Henry Kersh
Scenery: Jud Stoddard

Premiere: July 21, 1967. San Francisco
 Ballet Theatre, San Francisco.
Number of Dancers: 18
Principal Dancers: Sally Bailey
 (Sultana), Carlos Carvajal (Sultan).
 Fan Dance: Nancy Robinson, Lynda
 Meyer, Virginia Johnson, Eloise
 Tjomsland. Warrior Dance: David
 Coll, Alan Bergman, John McFall,
 Jon Engstrom.
In Repertory: B1967.

IL DISTRATTO*

Choreography: Lew Christensen
Music: Franz Josef Haydn (Symphony
 No. 60 in C: Il Distratto).
Costumes: David Barnard
Premiere: August 4, 1967. San
 Francisco Ballet Theatre, San
 Francisco. Entered main Company
 repertory April 5, 1969.
Number of Dancers: 15
Principal Dancers: Jocelyn Vollmar,
 Ingrid Fraley, Patricia Garland,
 Cynthia Quick, Krista Scholter,
 Wendy Holt, Gina Ness, Allyson
 Segeler, Catherine Warner, Sally
 Bailey.
In Repertory: B1967, B1968, 1969;
 1971, 1972; 1977, 1978, 1979,
 1980.

DIVERTISSEMENT*

Choreography: Robert Gladstein
Music: Jacques Ibert (Divertissement).
Scenery and Costumes: Jud Stoddard
Premiere: August 4, 1967. San
 Francisco Ballet Theatre, San
 Francisco.
Number of Dancers: 8
Principal Dancer: Nancy Robinson.
In Repertory: B1967.

SHAPES OF EVENING*

Choreography: Carlos Carvajal
Music: Claude Debussy (from Danse
 Sacrée et Danse Profane).
Costumes: Illana de Heurtamont
Premiere: August 4, 1967. San
 Francisco Ballet Theatre, San
 Francisco.
Number of Dancers: 6
Principal Dancers: Virginia Johnson,
 Lee Fuller, Lynda Meyer, Nancy
 Robinson, Sven Norlander, William
 Johnson.
In Repertory: B1967, B1968, B1969,
 B1970.

PSYCHAL*

Choreography: Robert Gladstein
Music: Béla Bartók
Scenery and Costumes: Kageyama
Premiere: August 18, 1967. San
 Francisco Ballet Theatre, San
 Francisco.
Number of Dancers: 26
Principal Dancers: Nancy Robinson
 (Intruder), Lynda Meyer, Lee Fuller
 (Insects).
In Repertory: B1967.

"Ballet '68"

LA PERI

Choreography: Denis Carey
Music: Paul Dukas (from *La Péri*).
Costumes and Scenery: Chuck Arnett
Premiere: April 1, 1968. Presentation Theater, San Francisco. (World Premiere: Ballet Nacional de Chile, 1967.)
Number of Dancers: 3
Principal Dancers: Lynda Meyer, John McFall, Sven Norlander.
In Repertory: B1968.

GIOCOSO*

Choreography: Carlos Carvajal
Music: Nicolai Lopatnikoff (*Concertina*, Op. 30).
Costumes: Chuck Arnett
Scenery: Claus Heppner
Premiere: April 1, 1968. Presentation Theater, San Francisco.
Number of Dancers: 10
Principal Dancers: Victoria Gyorfi, Barbara Begany, Sven Norlander.
In Repertory: B1968.

SENSEMAYA

Choreography: Denis Carey
Music: Silvestre Revueltas (*Sensemaya*).
Scenery: Denis Carey
Premiere: April 16, 1968. Presentation Theater, San Francisco. (World Premiere: Ballet Nacional de Chile, 1967.)
Number of Performers: 7 dancers and 1 narrator.
Principal Dancers: Virginia Johnson, Sven Norlander (The Serpent), John McFall, Christine Bennett (The Hunters).
Narrator: Bill Johnson
In Repertory: B1968.

SUN MUSIC*

Choreography: Ronn Guidi
Music: Peter Sculthorpe (*Sun Music*).
Costumes: Chuck Arnett
Premiere: April 30, 1968. Presentation Theater, San Francisco.
Number of Dancers: 8
Principal Dancers: Lynda Meyer, Victoria Gyorfi, Diana Marks, Salicia Smith, William Johnson, John McFall, Jon Engstrom, Sven Norlander.
In Repertory: B1968.

IMPRESSIONS IN BLACK AND WHITE*

Choreography: Robert Gladstein
Music: Paul Hindemith (*Symphonic Metamorphosis*).
Costumes: Kageyama
Premiere: April 30, 1968. Presentation Theater, San Francisco.
Number of Dancers: 8
Principal Dancers: Lynda Meyer, John McFall, Jon Engstrom, Virginia Johnson, Kenneth Lipitz, Victoria Gyorfi, David Coll, Diana Marks.
In Repertory: B1968.

THREE MOVEMENTS FOR THE SHORT HAIRED*

Choreography: Lew Christensen
Music: John Lewis (*Sketch, England's Carol*, and *Golden Striker*).
Costumes: Kageyama
Premiere: May 14, 1968. Presentation Theater, San Francisco.
Number of Dancers: 10
Principal Dancers: Jon Engstrom, David Coll, Kenneth Lipitz, Sven Norlander.
In Repertory: B1968, B1969, B1970.

THE AWAKENING*

Choreography: Carlos Carvajal
Music: Warner Jepson
Costumes: Chuck Arnett
Projection: Bill Ham
Premiere: May 14, 1968. Presentation Theater, San Francisco.
Number of Dancers: 18
In Repertory: B1968.

FLIGHT*

Choreography: Denis Carey
Music: Bohuslav Martinu (*Concerto for Two String Orchestras, Piano, and Percussion*).
Costumes: Kageyama
Scenery: Michael Caffee
Premiere: May 21, 1968. Presentation Theater, San Francisco.
Number of Dancers: 9
Principal Dancers: Virginia Johnson (The Woman), Lynda Meyer (Her Younger Sister), Kenneth Lipitz (A Man).
In Repertory: B1968.

THE MAGICAL FLUTIST*

Choreography: Lew Christensen
Music: Amilcare Ponchielli (*Quartet in B Flat for Winds with Piano*).
Costumes: Kageyama
Premiere: July 10, 1968. Norse Auditorium, San Francisco.
Number of Dancers: 3
Principal Dancers: Virginia Johnson, David Coll, Lynda Meyer.
In Repertory: B1968.

ALMOST LAZARUS

Choreography: Denis Carey
Music: Igor Stravinsky (*Octet*).
Scenery and Costumes: Kageyama, based on original designs by Bruna Contreras.
Premiere: July 10, 1968. Norse Auditorium, San Francisco. (World Premiere: Ballet Nacional de Chile, 1964).
Number of Dancers: 10
Principal Dancers: Sven Norlander (Lazarus), Patricia Bialoblocki (Wife), William Johnson (Lover).
In Repertory: B1968.

WIND SONGS*

Choreography: Carlos Carvajal
Music: Charles Griffes (*White Peacock* and *Clouds*).
Scenery and Costumes: Kageyama
Premiere: July 24, 1968. Norse Auditorium, San Francisco.
Number of Dancers: 4

Principal Dancers: Virginia Johnson, Gina Ness, Jon Engstrom, William Johnson.
In Repertory: B1968, B1969, B1970.

PRIMA SERA*

Choreography: Stuart Hodes
Music: Tadeusz Baird (*Four Essays for Orchestra*).
Book: Based on Tennessee Williams' *The Roman Spring of Mrs. Stone*.
Costumes: Kageyama
Premiere: July 24, 1968. Norse Auditorium, San Francisco.
Number of Dancers: 4
Principal Dancers: Patricia Bialoblocki (Woman), John McFall (Gigolo), Sven Norlander (Memory of Husband), David Coll (Ragged Man of Future).
In Repertory: B1968.

GAMES IN 4/4 TIME*

Choreography: Jocelyn Vollmar
Music: Ernst Křenek (*Three Merry Marches*); Eric Korngold (*March of the Sentinel*); and Alban Berg (March from *Wozzeck*).
Costumes: Kageyama
Premiere: July 24, 1968. Norse Auditorium, San Francisco.
Number of Dancers: 10
Principal Dancers: Jocelyn Vollmar, David Coll.
In Repertory: B1968, B1969; B1971.

CHANGES*

Choreography: Carlos Carvajal
Music: Arthur Honegger (*Second Symphony for Strings*).
Costumes: Kageyama
Premiere: August 21, 1968. Norse Auditorium, San Francisco.
Number of Dancers: 16
Principal Dancers: Lynda Meyer, Sven Norlander, Virginia Johnson, Kenneth Lipitz.
In Repertory: B1968, B1969; B1972.

NIGHT IN THE TROPICS*

Choreography: John Clifford
Music: Louis Moreau Gottschalk (*A Night in the Tropics*).
Costumes: Robert O'Hearn
Premiere: April 5, 1969. Opera House; Seattle, Washington. San Francisco Premiere: June 20, 1969, San Francisco Ballet Theatre.
Number of Dancers: 17
Principal Dancers: Lynda Meyer, Bruce Bain, Leo Ahonen.
In Repertory: 1969, 1970.

"Ballet '69"

MASQUERADE*

Choreography: Antony Valdor
Music: Aram Khachaturian
Premiere: May 16, 1969. San Francisco Ballet Theatre, San Francisco.
Number of Dancers: 19

Principal Dancers: Lynda Meyer, John McFall, Sandra Adamson, Leo Ahonen.
In Repertory: B1969.

TRIOS CON BRIO*

Choreography: Jocelyn Vollmar
Music: Robert Russell Bennett
Costumes: Kageyama
Scenery: Searl Tavares and Norman Trafton
Premiere: May 10, 1969. San Francisco Ballet Theatre, San Francisco.
Number of Dancers: 9
Principal Dancers: Jocelyn Vollmar, Bruce Bain, Donald Eryck; Victoria Gyorfi, Susan Williams, John Houy; Christine Bennett, Sandra Adamson, Daniel Simmons.
In Repertory: B1969.

DANCES FOR THE KING*

Choreography: Marina Littig
Music: Igor Stravinsky
Costumes: Marina Littig
Premiere: May 23, 1969. San Francisco Ballet Theatre, San Francisco.
Number of Dancers: 8
Principal Dancers: Soili Arvola, Christine Bennett, Wendy Holt, Ellen Kogan, Cynthia Quick, Daniel Simmons, Catherine Warner.
In Repertory: B1969.

CONCERTO IN FOUR MOVEMENTS*

Choreography: John McFall
Music: Howard Hanson
Costumes: Kageyama
Premiere: June 6, 1969. San Francisco Ballet Theatre, San Francisco.
Number of Dancers: 19
Principal Dancers: Susan Williams, Bruce Bain, Sandra Adamson, Leo Ahonen.
In Repertory: B1969.

THE ENCOUNTER*

Choreography: Bruce Bain
Music: Béla Bartók (from *The Miraculous Mandarin*).
Costumes: Bruce Bain
Scenery: Norman Trafton
Premiere: June 6, 1969. San Francisco Ballet Theatre, San Francisco.
Number of Dancers: 3
Principal Dancers: John Houy (Leader of the Thieves), Susan Williams (His Girlfriend), Bruce Bain (The Mandarin).
In Repertory: B1969.

FACETS*

Choreography: Carlos Carvajal
Music: Francis Poulenc (*Harpsichord Concerto*).
Premiere: July 14, 1967. San Francisco Ballet Theatre, San Francisco.
Number of Dancers: 22
Principal Dancers: Virginia Johnson, Lynda Meyer, Lee Fuller, David Coll.
In Repertory: B1967, B1968.

WINTER ETCHINGS*

Choreography: David Barnard
Music: Malcolm Smith and Joel Schwartz
Scenery and Costumes: David Barnard
Premiere: July 14, 1967. San Francisco Ballet Theatre, San Francisco.
Number of Dancers: 6
Principal Dancers: Jocelyn Vollmar, Eloise Tjomsland, Christine Bennett.
In Repertory: B1967.

BALALAIKA*

Choreography: David Coll
Music: Folk music
Costumes: David Barnard
Premiere: July 14, 1967. San Francisco Ballet Theatre, San Francisco.
Number of Dancers: 2
Principal Dancers: Lynda Meyer, David Coll.
In Repertory: B1967.

MUCH ADO ABOUT NOTHING*

Choreography: Jocelyn Vollmar
Music: Béla Bartók
Scenery: John Patterson
Premiere: July 14, 1967. San Francisco Ballet Theatre, San Francisco.
Number of Dancers: 15
Principal Dancers: Nancy Robinson, David Coll, John McFall, Barbara Begany, Lee Fuller.
In Repertory: B1967, B1968.

ECLIPSE*

Choreography: Jocelyn Vollmar
Music: Antonín Dvořák
Scenery: Jud Stoddard
Premiere: July 21, 1967. San Francisco Ballet Theatre, San Francisco.
Number of Dancers: 3
Principal Dancers: Nancy Robinson, Robert Gladstein, Jocelyn Vollmar.
In Repertory: B1967.

MINDANAO*

Choreography: Benjamin Reyes
Music: Traditional Philippine Folk Music
Costumes: Henry Kersh
Scenery: Jud Stoddard
Premiere: July 21, 1967. San Francisco Ballet Theatre, San Francisco.
Number of Dancers: 18
Principal Dancers: Sally Bailey (Sultana), Carlos Carvajal (Sultan). Fan Dance: Nancy Robinson, Lynda Meyer, Virginia Johnson, Eloise Tjomsland. Warrior Dance: David Coll, Alan Bergman, John McFall, Jon Engstrom.
In Repertory: B1967.

VALSE TRISTE*

Choreography: Soili Arvola
Music: Jean Sibelius (*Valse Triste*, Op. 44).
Premiere: June 20, 1969. San Francisco Ballet Theatre, San Francisco.
Number of Dancers: 7
Principal Dancers: Krista Scholter (Girl), John McFall (Boy).
In Repertory: B1969.

MOBILE

(Moving Objects Behaving in Linear Equipose)
Choreography: Tomm Ruud
Music: Aram Khachaturian ("Gayne's Adagio" from *Gayne*).
Premiere: June 20, 1969. San Francisco Ballet Theatre, San Francisco. Entered main Company repertory May 2, 1976. (World Premiere: Ballet West, 1969.)
Number of Dancers: 3
Principal Dancers: Sara Maule, Roderick Drew, Krista Scholter.
In Repertory: B1969, B1970, B1971; 1976, 1977, 1978; 1980.

Note: In 1978 *Mobile* became the second movement of *Trilogy*; see 1978 listings.

ANDANTE SPIANATO ET GRANDE POLONAISE*

Choreography: Antony Valdor
Music: Frédéric Chopin
Premiere: June 20, 1969. San Francisco Ballet Theatre, San Francisco.
Number of Dancers: 6
Principal Dancers: Lynda Meyer, Virginia Johnson, Victoria Gyorfi, Bruce Bain, Leo Ahonen, John McFall.
In Repertory: B1969.

SCHERZO MECHANIQUE*

Choreography: Bruce Bain
Music: Igor Stravinsky (*Scherzo à la Russe*).
Premiere: July 25, 1969. San Francisco Ballet Theatre, San Francisco.
In Repertory: B1969.

THE WAY*

Choreography: Carlos Carvajal
Music: Toru Takemitsu (*Coral Island. Water Music*, and Vocals).
Costumes: Kageyama
Premiere: July 25, 1969. San Francisco Ballet Theatre, San Francisco.
Number of Dancers: 15
Principal Dancers: Kerry Williams, Roderick Drew, Christine Bennett.
In Repertory: B1969.

MINKUS PAS DE DEUX*

Choreography: Leo Ahonen
Music: Léon Minkus (from *Paquita*).
Premiere: July 25, 1969. San Francisco Ballet Theatre, San Francisco.
Principal Dancers: Soili Arvola, Leo Ahonen.
In Repertory: B1969.

THE MUSIC BOX*

Choreography: Donald Eryck
Music: Alessandro Marcello (*Concerto in C Minor for Oboe and Strings*).
Costumes: Kageyama and Angene Feves
Premiere: August 8, 1969. San Francisco Ballet Theatre, San Francisco.
Number of Dancers: 7
Principal Dancers: Christine Bennett, William Johnson.
In Repertory: B1969, B1970.

FUSION*

Choreography: Bruce Bain
Music: Béla Bartók (*Piano Concerto for Two Pianos, Percussion, and Orchestra*).
Costumes: Bruce Bain
Premiere: August 8, 1969. San Francisco Ballet Theatre, San Francisco.
Number of Dancers: 2
Principal Dancers: Susan Williams, Bruce Bain.
In Repertory: B1969, B1970.

DARK VIGIL*

(A Dance Pantomime in Three Movements)
Choreography: Antony Valdor
Music: Samuel Barber (*Quartet No. 1*, Op. 11)
Costumes: Kageyama
Scenery: Norman Trafton
Premiere: August 8, 1969. San Francisco Ballet Theatre, San Francisco.
Number of Dancers: 7
Music: Sandra Adamson, John Houy, Bruce Bain.
In Repertory: B1969.

THE SUN DID NOT RISE*

Choreography: Leo Ahonen
Music: Ludwig van Beethoven (*Sonata in C Minor*, Op. 13, "Pathétique").
Costumes: Kageyama
Premiere: August 15, 1969. San Francisco Ballet Theatre, San Francisco.
Number of Dancers: 9
Principal Dancers: Nancy Hanna (Lost Child), Jocelyn Vollmar, Roderick Drew (Parents).
In Repertory: B1969.

1 9 7 0

JOYOUS DANCE*

Choreography: Carlos Carvajal
Music: Johann Sebastian Bach (*Concerto for Three Violins, Strings, and Continuo*).
Costumes: Chuck Arnett
Scenery: Paul Crowley
Premiere: April 25, 1970. War Memorial Opera House, San Francisco.
Number of Dancers: 18
Principal Dancers: Virginia Johnson, Lynda Meyer, Christine Bennett, Diana Davis.
In Repertory: 1970.

GENESIS '70*

Choreography: Carlos Carvajal
Music: Terry Riley (*In C*).
Scenery: Paul Crowley
Premiere: April 25, 1970. War Memorial Opera House, San Francisco.
Number of Dancers: 31
In Repertory: 1970.

SCHUBERTIADE*

Choreography: Michael Smuin
Music: Franz Schubert

Costumes: Marcos Paredes
Scenery: William Pitkin
Premiere: May 16, 1970. War Memorial Opera House, San Francisco.
Number of Dancers: 16
In Repertory: 1970, 1971, 1972; 1974, 1975.

SPLIT*

Choreography: John Butler
Music: Morton Subotnick (*Silver Apples of the Moon*).
Scenery: Robert Darling
Premiere: October 1, 1970. Alan Hancock College Auditorium; Santa Maria, California. San Francisco Premiere: May 12, 1971. Palace of Fine Arts Theater.
Number of Dancers: 17
Principal Dancers: Lynda Meyer, Sandra Adamson, Ted Nelson, Leo Ahonen.
In Repertory: 1970, 1971, 1972.

LE CORSAIRE: PAS DE DEUX

Choreography: After Alexander Gorsky (reproduced by Leo Ahonen).
Music: Riccardo Drigo—Léon Minkus (from *Le Corsaire*).
Premiere: October 7, 1970. Los Angeles Harbor College Auditorium; Los Angeles. San Francisco Premiere: May 9, 1971.
Principal Dancers: Leo Ahonen, Soili Arvola.
In Repertory: 1970, 1971, 1972.

Note: For another San Francisco Ballet production of the *Corsaire pas de deux*, see 1964 listings.

MATINEE DANSANTE*

Choreography: Carlos Carvajal
Music: Gioacchino Rossini—Benjamin Britten (*Soirées musicales*).
Premiere: June 21, 1970. Stern Grove, San Francisco.
Number of Dancers: 4
Principal Dancers: Lynda Meyer, Victoria Gyorfi, Philippe Arrona, John McFall.
In Repertory: 1970; 1972.

"Ballet '70"

INTROSPECTIONS*

Choreography: Susan Williams
Music: Edgar Varèse
Costumes: Bruce Bain
Premiere: July 24, 1970. San Francisco Ballet Theatre, San Francisco.
Number of Dancers: 2
Principal Dancers: Susan Williams, Bruce Bain.
In Repertory: B1970.

DIALOGUES IN JAZZ*

Choreography: Antony Valdor
Music: Howard Brubeck
Costumes: David Barnard
Premiere: July 24, 1970. San Francisco Ballet Theatre, San Francisco.
Number of Dancers: 12
Principal Dancers: Susan Williams, Donald Eryck, Victoria Gyorfi, John McFall, Jocelyn Vollmar.
In Repertory: B1970.

TAPESTRY*

Choreography: Jocelyn Vollmar
Music: Peter Ilyich Tchaikovsky
Costumes: Donald Eryck and
 E. Andreina
Premiere: July 24, 1970. San Francisco
 Ballet Theatre, San Francisco.
Number of Dancers: 12
Principal Dancers: Jocelyn Vollmar,
 Bruce Bain, Sandra Adamson, Leo
 Ahonen.
In Repertory: B1970.

DANCE DVOŘÁK*

Choreography: Donald Eryck
Music: Antonín Dvořák (*Piano Quintet
 in A Major*, Op. 81).
Costumes: E. Andreina
Premiere: August 7, 1970. San
 Francisco Ballet Theatre, San
 Francisco.
Number of Dancers: 10
Principal Dancers: Carolyn Houser,
 Kevyn O'Rourke, Lynda Meyer,
 Steven Wistrich, Virginia Johnson,
 Donald Eryck.
In Repertory: B1970.

TANSSINEN*

Choreography: Leo Ahonen
Music: Léon Minkus
Premiere: August 7, 1970. San
 Francisco Ballet Theatre, San
 Francisco.
Number of Dancers: 8
Principal Dancers: Soili Arvola, John
 McFall.
In Repertory: B1970.

Note: *Tanssinen* is a reworking of
 Minkus Pas de Deux. See 1969
 listings.

AFTERNOON REVIVAL*

Choreography: Rick van Winkle
Music: Erik Satie (*Trois Gymnopédies*).
Costumes: David Barnard
Premiere: August 7, 1970. San
 Francisco Ballet Theatre, San
 Francisco.
Number of Dancers: 3
Principal Dancers: Deborah
 Macejunas, Cynthia Quick,
 Geoffrey Thomas.
In Repertory: B1970.

COUP D'ESSAI*

Choreography: John McFall
Music: Maurice Ravel (*Piano Concerto
 in G*).
Costumes: Victoria Gyorfi
Premiere: August 7, 1970. San
 Francisco Ballet Theatre, San
 Francisco.
Number of Dancers: 15
Principal Dancers: Sandra Adamson,
 Leo Ahonen, Victoria Gyorfi, Bruce
 Bain.
In Repertory: B1970.

FIREBIRD: PAS
DE DEUX*

Choreography: Bruce Bain
Music: Igor Stravinsky
Costumes: Bruce Bain

CAL ANDERSON

*Spring Season
Opera House
Saturday Evenings
Sunday Matinees
April 11,12-25,26
May 2,3-16,17
Sherman Clay
Box Office
(397-0717)*

San Francisco Ballet

Premiere: August 14, 1970. San
 Francisco Ballet Theatre, San
 Francisco.
Principal Dancers: Susan Williams,
 Bruce Bain.
In Repertory: B1970.

1971

LA SOURCE

Choreography: George Balanchine
Music: Léo Delibes (from *La Source* and
 Naïla).
Premiere: May 15, 1971. War
 Memorial Opera House, San
 Francisco. (World Premiere: The
 New York City Ballet, 1969).
Number of Dancers: 11
Principal Dancers: Violette Verdy
 (g.a.), Leo Ahonen, Soili Arvola.
In Repertory: 1971, 1972.

JON LORD—
BOTH SIDES NOW*

Choreography: Robert Gladstein
Music: Jon Lord (*Concerto for Group and
 Orchestra*).
Costumes: Marcos Paredes
Scenery: Robert Darling
Premiere: May 19, 1971. Palace of Fine
 Arts Theater, San Francisco.
Number of Dancers: 23
Principal Dancers: Kerry Williams,
 Sara Maule, Geoffrey Thomas,
 Lynda Meyer, Anita Paciotti,
 Barbarajean Martin, Daniel
 Simmons.
In Repertory: 1971, 1972.

AIRS DE BALLET*

Choreography: Lew Christensen
Music: André Grétry (from *Zémire et
 Azor*).
Costumes: Robert O'Hearn
Premiere: May 26, 1971. Palace of Fine
 Arts Theater, San Francisco.
Number of Dancers: 5
Principal Dancers: Violette Verdy
 (g.a.), Philippe Arrona, Sara Maule,
 Laurence Matthews, Susan
 Williams.
In Repertory: 1971, 1972; 1974, 1975,
 1976, 1977, 1978.

CLASSICAL SYMPHONY

Choreography: Leo Ahonen
Music: Sergei Prokofiev (*Symphony
 No. 1 in D*, Op. 25, "Classical").
Costumes: Louis Rodriguez
Premiere: May 26, 1971. Palace of Fine
 Arts Theater, San Francisco.
Number of Dancers: 28

Principal Dancers: Virginia Johnson,
 Sandra Adamson, Soili Arvola,
 Robert Gladstein, Lynda Meyer.
In Repertory: 1971.

"Ballet '71"

W.O.O.*

Choreography: Ted Nelson
Music: Lalo Schifrin (from *Bullitt*).
Premiere: August 5, 1971. Creative
 Arts Auditorium; San Francisco
 State College, San Francisco.
Number of Dancers: 2
Principal Dancers: Kerry Williams,
 Ted Nelson.
In Repertory: B1971.

THE MISTLETOE BRIDE*

Choreography: Robert Gladstein
Music: Francis Poulenc (*Aubabe:
 Choreographic Concerto for Piano and
 18 Instruments*).
Book: Based on T. H. Bayly's poem,
 "The Mistletoe Bough."
Scenery: Dennis Hudson
Premiere: August 5, 1971. Creative
 Arts Auditorium; San Francisco
 State University, San Francisco.
Number of Dancers: 9
Principal Dancers: Sandra Adamson
 (Mistletoe Bride), Daniel Simmons
 (Lord Lovell as a Youth), Robert
 Gladstein (Lord Lovell in Later
 Years).
In Repertory: B1971.

Note: See 1979 listings for new
 production of *The Mistletoe Bride*.

AUTUMN DANCES*

Choreography: Jocelyn Vollmar
Music: Sergei Rachmaninoff (*Symphonic
 Dances*, Op. 45).
Costumes: Louis Rodriguez
Premiere: August 5, 1971. Creative
 Arts Auditorium; San Francisco
 State University, San Francisco.
Number of Dancers: 15
Principal Dancers: Robert Gladstein,
 Jocelyn Vollmar, Geoffrey Thomas.
In Repertory: B1971.

A.C.—615*

Choreography: Soili Arvola
Music: Folk music by Myric, Moss,
 Briggs, and Putnam.
Costumes: Louis Rodriguez
Premiere: August 12, 1971. Creative
 Arts Auditorium; San Francisco
 State University, San Francisco.
Number of Dancers: 5
Principal Dancers: Anita Paciotti,
 Cynthia Meyers, Lori Brody, Daniel
 Simmons, Ted Nelson.
In Repertory: B1971.

STRUCTURES*

(A Balletic Impression Inspired by the
 Life Cycle of Insects)

Choreography: Bruce Bain
Music: Béla Bartók (*Sonata for Two
 Pianos and Four Percussion*).
Costumes: Bruce Bain
Projection: James Armstrong

Premiere: August 12, 1971. Creative
 Arts Auditorium; San Francisco
 State University, San Francisco.
Number of Dancers: 15
Principal Dancers: Jocelyn Vollmar
 (Queen), Bruce Bain (Lookout),
 Anita Paciotti (First Sentry), Kerry
 Williams (Second Sentry), Susan
 Williams (Third Sentry).
In Repertory: B1971.

AMERICAN DANCE
OVERTURE*

Choreography: Richard Carter
Music: Paul Creston
Costumes: Louis Rodriguez
Premiere: August 19, 1971. Creative
 Arts Auditorium; San Francisco
 State University, San Francisco.
Number of Dancers: 8
Principal Dancers: Spanish: Sara
 Maule, Michael Cappara; English:
 Virginia Johnson, Gardner Carlson;
 French: Kerry Williams, Philippe
 Arrona; American: Susan Williams,
 Richard Sikes.
In Repertory: B1971.

LA FAVORITA*

Choreography: Soili Arvola
Music: Gaetano Donizetti (from
 La Favorita).
Premiere: August 19, 1971. Creative
 Arts Auditorium; San Francisco
 State University, San Francisco.
 Entered main Company repertory
 March 10, 1972.
Number of Dancers: 2
Principal Dancers: Soili Arvola, Leo
 Ahonen.
In Repertory: B1971, 1972.

1972

TCHAIKOVSKY
PAS DE DEUX

Choreography: George Balanchine
Music: Peter Ilyich Tchaikovsky (from
 Swan Lake).
Premiere: February 29, 1972. San Jose
 Community Theater; San Jose,
 California. (World Premiere: The
 New York City Ballet, 1960.)
Principal Dancers: Edward Villella
 (g.a.), Violette Verdy (g.a.).
In Repertory: 1972; 1974 with Jean-
 Pierre Bonnefous (g.a.), Patricia
 McBride (g.a.), and Lynda Meyer;
 1976 with Peter Martins (g.a.) and
 Suzanne Farrell (g.a.).

TINGEL-TANGEL-
TAENZE*

Choreography: Lew Christensen
Music: Johann Strauss, Jr. & Sr., Josef
 Strauss, and Hans Christian
 Lumbye.
Costumes: Robert O'Hearn
Scenery: Robert Darling
Premiere: March 8, 1972. Palace of
 Fine Arts Theater, San Francisco.
Number of Dancers: 14
Principal Dancers: Lynda Meyer,
 Philippe Arrona, Victoria Gyorfi,
 John McFall.
In Repertory: 1972.

FIGURES IN F*
(An Abstract Ballet with a Motif of Figures)
Choreography: Jocelyn Vollmar
Music: Gian Carlo Menotti (*Piano Concerto in F*).
Costumes: Patricia Bibbins and Virginia Tracy.
Projections: Dennis Hudson
Premiere: March 17, 1972. Palace of Fine Arts Theater, San Francisco.
Number of Dancers: 21
Principal Dancers: Leo Ahonen, Sandra Adamson, Tina Bernal, Jocelyn Vollmar, Bruce Bain.
In Repertory: 1972.

N.R.A.**
or, If You Remember Cats, Canaries, and Kicking Out, Then I'm Talking to the Right Person.
(An Entertainment of Music and Dance of the 1930s)
Choreography: Robert Gladstein
Collage of Words and Music: Warner Jepson
Costumes and Projections: Cal Anderson
Premiere: April 7, 1972. Palace of Fine Arts Theater, San Francisco.
Number of Dancers: 35
Principal Dancers: John McFall, Jocelyn Vollmar, Antony Valdor, Beverly Kopels, Sandra Adamson, Laurence Matthews.
In Repertory: 1972; 1975, 1976.

NEW FLOWER*
(A Choreographic Fantasy)
Choreography: Carlos Carvajal
Music: Traditional Indonesian music
Costumes: Chuck Arnett
Premiere: April 21, 1972. Palace of Fine Arts Theater, San Francisco.
Number of Dancers: 19
Principal Dancers: Kerry Williams, Robert Gladstein.
In Repertory: 1972.

CELEBRATION*
(A Gala Appearance of Four Ballerinas)
Choreography: Robert Gladstein
Music: Alexandre Luigini (from *The Egyptian*).
Premiere: July 16, 1972. Windsor Vineyards Amphitheater; Sonoma, California. San Francisco Premiere: August 10, 1972. McKenna Theater, San Francisco State University; San Francisco.
Number of Dancers: 8
Principal Dancers: Virginia Johnson, Lynda Meyer, Damara Bennett, Victoria Gyorfi.
In Repertory: 1972, 1973.

"Ballet '72"

FLAMING ANGEL*
Choreography: John Pasqualetti
Music: Sergei Prokofiev (*Symphony No. 3, Op. 44*).
Costumes: John Pasqualetti
Premiere: July 20, 1972. McKenna Theater, San Francisco State University; San Francisco.

Number of Dancers: 16
Principal Dancers: Gary Moore (God), Anita Paciotti (The Girl, A Mystic), John McFall (The Boy), Michael Cappara (The Angel), Robert Gladstein (The Devil), Gina Ness (The Seductress).
In Repertory: B1972.

STATEMENTS
Choreography: Tomm Ruud
Music: Aaron Copland (*Statements for Orchestra*).
Costumes: L. F. Shultz
Premiere: July 20, 1972. McKenna Theater, San Francisco State University; San Francisco. (World Premiere: Ballet West, 1972.)
Number of Dancers: 17
Principal Dancers: Christine Bennett, Laurence Matthews, Victoria Gyorfi, Geoffrey Thomas.
In Repertory: B1972.

PAS DE DECORS*
Choreography: Philippe Arrona
Music: Sylvestre Revueltas and Dimitri Shostakovich.
Premiere: July 27, 1972. McKenna Theater, San Francisco State University; San Francisco.
Number of Dancers: 10
Principal Dancers: Sara Maule, Anton Ness.
In Repertory: B1972.

SYNAPSE**
Choreography: Susan Williams
Music: Tape by Dennis Hudson
Costumes: Michael Cookinham
Premiere: July 27, 1972. McKenna Theater, San Francisco State University; San Francisco.
Number of Dancers: 2
Principal Dancers: Susan Williams, Christine Bennett.
In Repertory: B1972.

TARANTELLA FOR TEN*
Choreography: Jocelyn Vollmar
Music: Louis Moreau Gottschalk
Costumes: Sandra Woodall
Scenery: Dennis Hudson
Premiere: July 27, 1972. McKenna Theater, San Francisco State University; San Francisco.
Number of Dancers: 10
Principal Dancers: Jocelyn Vollmar, Robert Gladstein.
In Repertory: B1972.

THE TRIAL*
Choreography: Rick Van Winkle
Music: Benjamin Britten (*Four Sea Interludes*, Op. 33a).
Costumes: Sandra Woodall
Book: Based on the novel by Franz Kafka.
Premiere: July 27, 1972. McKenna Theater, San Francisco State University; San Francisco.
Number of Dancers: 8
Principal Dancers: Deborah Macejunas.
In Repertory: B1972.

SYMPHONIC IMPRESSIONS*
Choreography: John McFall
Music: Dimitri Shostakovich (*Symphony No. 9*).
Costumes: Victoria Gyorfi
Premiere: July 20, 1972. McKenna Theater, San Francisco State University; San Francisco.
Number of Dancers: 12
Principal Dancers: Victoria Gyorfi, Anita Paciotti, Geoffrey Thomas.
In Repertory: B1972, B1973.

FIRST TIME OUT**
Choreography: Ann Noland
Music and Words: Debra Quinn, arranged by Tom Barger.
Premiere: August 17, 1972. McKenna Theater, San Francisco State University; San Francisco.
Number of Dancers: 2
Principal Dancers: Michele Turetzky, Gary Moore.
In Repertory: B1972.

TWO ROMANTIC PAS DE DEUX*
Choreography: Richard Carter
Music: Franz Liszt (*Consolation No. 3* and *Concert Etude No. 3 in E Flat*).
Premiere: August 17, 1972. McKenna Theater, San Francisco State University; San Francisco.
Number of Dancers: 4
Principal Dancers: Gina Ness, Daniel Simmons, Lynda Meyer, Robert Gladstein.
In Repertory: B1972.

1 9 7 3

CINDERELLA*
Choreography: Lew Christensen and Michael Smuin.
Music: Sergei Prokofiev
Scenery and Costumes: Robert Fletcher
Premiere: June 6, 1973. War Memorial Opera House, San Francisco.
Number of Roles: 88
Principal Dancers: Lynda Meyer (Cinderella), Vane Vest (Prince), Gary Moore (Father), Anita Paciotti (Mother), Paula Tracy (Fairy Godmother), John McFall (Jester), Anton Ness and Daniel Simmons (Sisters).
In Repertory: 1973, 1974, 1975, 1976, 1977.

DON JUAN*
Choreography: Lew Christensen
Music: Joaquin Rodrigo (*Concierto de Aranjuez, Fantasia para un Gentilhombre*).
Costumes: José Varona
Scenery: Ming Cho Lee
Premiere: June 10, 1973. War Memorial Opera House, San Francisco.
Number of Dancers: 30
Principal Dancers: Attila Ficzere (Don Juan), Daniel Simmons (Catalinon), Diana Weber (Doña Ana), Robert Gladstein (Commander).

In Repertory: 1973, 1974, 1975, 1976; 1980.

ETERNAL IDOL
(A Tribute to Rodin)
Choreography: Michael Smuin
Music: Frédéric Chopin (*Piano Concerto No. 2, Second Movement*).
Costumes: Marcos Paredes
Premiere: June 13, 1973. War Memorial Opera House, San Francisco. (World Premiere: American Ballet Theatre, 1969.)
Number of Dancers: 2
Principal Dancers: Madeleine Bouchard, Attila Ficzere.
In Repertory: 1973, 1974, 1975, 1976; 1981.

PAS DE QUATRE
Choreography: Keith Lester and Anton Dolin (after Jules Perrot).
Music: Cesare Pugni
Costumes: After A. E. Chalon
Premiere: July 29, 1973. Windsor Vineyards Amphitheater; Sonoma, California. San Francisco Premiere: January 31, 1974. War Memorial Opera House. (Perrot first created *Pas de Quatre* in London in 1845. Dolin's staging was premiered in 1941 by Ballet Theatre.)
Number of Dancers: 4
Principal Dancers: Diana Weber (Marie Taglioni), Cynthia Meyers (Carlotta Grisi), Gina Ness (Fanny Cerrito), Mariana Alvarez (Lucille Grahn).
In Repertory: 1973, 1974, 1975.

"Ballet '73"

PORTRAIT*
Choreography: Gary Moore
Music: Erik Satie
Costumes: Gary Moore
Premiere: August 15, 1973. McKenna Theater, San Francisco State University; San Francisco.
Number of Dancers: 3
Principal Dancers: Laurie Cowden, Maureen Broderick, Margaret McLaughlin.
In Repertory: B1973.

TEALIA*
Choreography: John McFall
Music: Gustav Holst ("Neptune" from *The Planets*).
Costumes: Victoria Gyorfi
Premiere: August 15, 1973. McKenna Theater, San Francisco State University; San Francisco.
Number of Dancers: 2
Principal Dancers: John McFall, Victoria Gyorfi.
In Repertory: 1973; 1975, 1976; 1981.

FOR VALERY PANOV*
Choreography: Michael Smuin
Music: Sergei Rachmaninoff (*Across the Wild River*).
Premiere: August 15, 1973. McKenna Theater, San Francisco State University; San Francisco.
Number of Dancers: 1
Principal Dancer: Laurence Matthews.
In Repertory: B1973; 1975.

HARP CONCERTO*

Choreography: Michael Smuin
Music: Carl Reinecke (Concerto for Harp with Orchestral Accompaniment in E Minor, Op. 182).
Costumes: Marcos Paredes
Scenery: Tony Walton
Premiere: June 13, 1973. War Memorial Opera House, San Francisco.
Number of Dancers: 21
Principal Dancers: Diana Weber, Vane Vest, Paula Tracy, Robert Gladstein, John McFall, Naomi Sorkin.
In Repertory: 1973, 1974, 1975, 1976.

Note: See 1977 listings for *Harp Concerto: Pas De Deux*.

THE SHAKERS

Choreography: Doris Humphrey
Music: Doris Humphrey
Costumes: Higby-O'Daniel
Premiere: June 13, 1973. War Memorial Opera House, San Francisco. (World Premiere: Dance Repertory Theater, 1931.)
Number of Dancers: 13
Principal Dancers: Naomi Sorkin (Eldress), Daniel Simmons (Elder).
In Repertory: 1973.

TANGENTS*

Choreography: Vane Vest
Music: Béla Bartók (*Dance Suite for Orchestra*).
Premiere: August 22, 1973. McKenna Theater, San Francisco State University; San Francisco.
Number of Dancers: 12
Principal Dancers: Lynda Meyer, Vane Vest.
In Repertory: B1973.

DANCE!!!*

Choreography: Jerome Weiss
Music: Maurice Ravel
Premiere: August 22, 1973. McKenna Theater, San Francisco State University; San Francisco.
Number of Dancers: 7
Principal Dancer: Gardner Carlson.
In Repertory: B1973.

PRELUDIUM*

Choreography: Robert Gladstein
Music: Dag Wiren (*Serenade for Strings*, Op. 11).
Premiere: August 22, 1973. McKenna Theater, San Francisco State University; San Francisco.
Number of Dancers: 20
Principal Dancers: Betsy Erickson, Michael Dwyer, Gina Ness, Gary Moore, Paula Tracy, Mariana Alvarez, Daniel Simmons.
In Repertory: B1973.

1974

LES SYLPHIDES

Choreography: Michel Fokine (staged by Alexandra Danilova).

Music: Frédéric Chopin (*Nocturne*, Op. 32, No. 2; *Mazurka*, Op. 33, No. 3; *Mazurka*, Op. 67, No. 3; *Prelude*, Op. 28, No. 7; *Waltz*, Op. 64, No. 2; *Waltz*, Op. 18, No. 1; *Waltz*, Op. 70, No. 1).
Premiere: January 19, 1974. War Memorial Opera House, San Francisco. (First presented under title *Chopiniana* in St. Petersburg, 1908. Performed as *Les Sylphides* in Paris, 1909.)
Number of Dancers: 20
Principal Dancers: Diana Weber, Lynda Meyer, Betsy Erickson, Robert Gladstein.
In Repertory: 1974.

Note: Other San Francisco Ballet versions of *Les Sylphides* listed under 1933 (*Reverie*), 1937 (*Chopinade*), and 1948.

MOTHER BLUES*
(For Michele)

Choreography: Michael Smuin
Music: William Russo (*Three Pieces for Blues Band and Symphony Orchestra*).
Scenery and Costumes: Tony Walton
Premiere: January 19, 1974. War Memorial Opera House, San Francisco.
Number of Dancers: 27
In Repertory: 1974, 1975.

LEGENDE

Choreography: John Cranko
Music: Henri Wienawski
Premiere: January 19, 1974. War Memorial Opera House, San Francisco. (World Premiere: Stuttgart Ballet, 1973.)
Number of Dancers: 2
Principal Dancers: Marcia Haydée (g.a.), Richard Cragun (g.a.).
In Repertory: 1974.

TAMING OF THE SHREW: PAS DE DEUX

Choreography: John Cranko
Music: Kurt-Heinz Stolze (after Domenico Scarlatti).
Costumes: Elizabeth Dalton
Premiere: January 20, 1974. War Memorial Opera House, San Francisco. (World Premiere: Stuttgart Ballet, 1969.)
Principal Dancers: Marcia Haydée (g.a.), Richard Cragun (g.a.).
In Repertory: 1974.

THE FOUR TEMPERAMENTS
(A Dance Ballet without Plot)

Choreography: George Balanchine
Music: Paul Hindemith (*The Four Temperaments*).
Costumes: Richard Battle
Premiere: January 27, 1974. Hawaii International Center, Honolulu. San Francisco Premiere: January 31, 1974. War Memorial Opera House. (World Premiere: Ballet Society, 1946.)
Number of Dancers: 25

Principal Dancers: Robert Gladstein (Melancholic), Diana Weber, Attila Ficzere (Sanguinic), Vane Vest (Phlegmatic), Lynda Meyer (Choleric).
In Repertory: 1974, 1975, 1976; 1981.

PULCINELLA VARIATIONS

Choreography: Michael Smuin
Music: Igor Stravinsky (from *Pulcinella*).
Scenery and Costumes: Marcos Paredes
Premiere: January 27, 1974. Honolulu International Center, Honolulu. San Francisco Premiere: February 7, 1974. War Memorial Opera House. (World Premiere: American Ballet Theatre, 1968.)
Number of Dancers: 24
Principal Dancers: Madeleine Bouchard, Paula Tracy, Robert Gladstein, Victoria Gyorfi, John McFall, Betsy Erickson, Vane Vest, Michael Dwyer.
In Repertory: 1974, 1975, 1976.

THE BELOVED

Choreography: Lester Horton
Music: Judith Hamilton
Costumes: Richard Battle
Premiere: January 31, 1974. War Memorial Opera House, San Francisco. (World Premiere: Dance Theatre, 1948).
Number of Dancers: 2
Principal Dancers: Paula Tracy, Vane Vest.
In Repertory: 1974.

LA SONNAMBULA
(Ballet in One Act)

Choreography: George Balanchine
Music: Vittorio Rieti, orchestrated and arranged from operas by Vincenzo Bellini (*La Sonnambula, I Puritani, I Capuletti ed i Montecchi*).
Scenery and Costumes: Rouben Ter-Arutunian
Premiere: February 14, 1974. War Memorial Opera House, San Francisco. (World Premiere: As *Night Shadow*; Ballet Russe de Monte Carlo, 1946.)
Number of Dancers: 30
Principal Dancers: Diana Weber (A Sleepwalker), Attila Ficzere (A Poet), Paula Tracy (A Coquette), Michael Dwyer (The Baron).
In Repertory: 1974, 1975.

FLOWER FESTIVAL AT GENZANO: PAS DE DEUX

Choreography: August Bournonville
Music: Edvard Helsted
Costumes: Richard Battle
Premiere: February 16, 1974. War Memorial Opera House, San Francisco. (World Premiere: One-act ballet, *Flower Festival*, The Royal Danish Ballet, 1858.)
Principal Dancers: Peter Schaufuss (g.a.), Diana Weber.
In Repertory: 1974.

DYING SWAN

Choreography: Michel Fokine
Music: Camille Saint-Saëns ("The Swan," from *Carnival of the Animals*).
Premiere: May 2, 1974. War Memorial Opera House, San Francisco. (World Premiere: St. Petersburg, 1905.)
Principal Dancer: Natalia Makarova (g.a.).
In Repertory: 1974.

1975

HARLEQUINADE: PAS DE DEUX

Choreography: Valery Panov (after Marius Petipa)
Music: Riccardo Drigo (from *Les Millions d'Arlequin*).
Premiere: February 8, 1975. War Memorial Opera House, San Francisco. (Petipa's *Les Millions d'Arlequin* premiered in St. Petersburg, 1900.)
Principal Dancers: Valery Panov (g.a.), Galina Panov (g.a.).
In Repertory: 1975.

CRY

Choreography: Alvin Ailey
Music: Alice Coltrane ("Something About John Coltrane"), Laura Nyro ("Been on a Train"), The Voices of East Harlem ("Right On, Be Free").
Premiere: February 20, 1975. War Memorial Opera House, San Francisco. (World Premiere: American Dance Theater, 1971.)
Number of Dancers: 1
Principal Dancer: Judith Jamison
In Repertory: 1975.

SHINJŪ**

Choreography: Michael Smuin
Music: Paul Seiko Chihara
Scenery and Costumes: Willa Kim
Book: Based on Chikamatsu, version of an ancient Japanese legend.
Premiere: March 20, 1975. War Memorial Opera House, San Francisco.
Number of Dancers: 13
Principal Dancers: Tina Santos, Gary Wahl.
In Repertory: 1975, 1976, 1977, 1978, 1979; 1982.

ROMEO AND JULIET: A STUDY IN THREE SCENES*

Choreography: Michael Smuin
Music: Sergei Prokofiev
Costumes: William Pitkin
Premiere: April 5, 1975. War Memorial Opera House, San Francisco.
Principal Dancers: Lynda Meyer, Vane Vest.
In Repertory: 1975.

Note: See 1976 listings for full-length production.

GISELLE: PAS DE DEUX

Choreography: After Jules Perrot and Jean Coralli (staged by Oleg Vinogradov)
Music: Adolphe Adam
Premiere: June 4, 1975. San Jose Center for the Performing Arts; San Jose, California. (First performed 1841, Paris.)
Principal Dancers: Valery Panov (g.a.), Galina Panov (g.a.).
In Repertory: 1975.

Note: Other San Francisco Ballet productions of *Giselle* listed under 1947 and 1965.

LADY AND THE HOOLIGAN: PAS DE DEUX

Choreography: Valery Panov (after Konstantin Boyarsky).
Music: Dimitri Shostakovich (from *The Lady and the Hooligan*).
Premiere: June 17, 1975. Portland Civic Theatre, Portland. (World Premiere: Leningrad, 1962.)
Principal Dancers: Valery Panov (g.a.), Galina Panov (g.a.).
In Repertory: 1975.

1 9 7 6

ROMEO AND JULIET*
(Ballet in Three Acts)

Choreography: Michael Smuin
Music: Sergei Prokofiev
Scenery and Costumes: William Pitkin
Premiere: January 27, 1976. War Memorial Opera House, San Francisco.
Number of Roles: 78

Principal Dancers: Lynda Meyer (Juliet), Vane Vest (Romeo), Attila Ficzere (Mercutio), John McFall (Benvolio), Jim Sohm (Paris), Michael Dwyer (Lord Capulet), Anita Paciotti (Lady Capulet), Gary Wahl (Tybalt), Elizabeth Tienken (Nurse), Val Caniparoli (Lord Montague), Gina Ness (Lady Montague), Anton Ness (Friar Laurence), Susan Magno, Keith Martin (Street Dancers).
In Repertory: 1976, 1977, 1978, 1979; 1981, 1982.

Note: See *Romeo and Juliet* excerpts listed under 1975.

SOUVENIRS

Choreography: Todd Bolender
Music: Samuel Barber (*Souvenirs*).
Scenery and Costumes: Rouben Ter-Arutunian
Premiere: February 3, 1976. War Memorial Opera House, San Francisco. (World Premiere: The New York City Ballet, 1955.)
Number of Dancers: 36
Principal Dancers: Vane Vest (Man About Town), Paula Tracy (A Wife), John McFall (Her Husband), Tina Santos (A Woman), Attila Ficzere (A Man), Tomm Ruud (A Lifeguard), Allyson Deane (Girl with Umbrella).
In Repertory: 1976, 1977; 1979.

HEART OF THE MOUNTAIN*
(Ballet in One Act)

Choreography: Valery Panov
Music: Murad Kozhlayev
Scenery and Costumes: Natasha Izbinsky
Book: Natasha Izbinsky
Premiere: February 24, 1976. War Memorial Opera House, San Francisco.
Number of Dancers: 18
Principal Dancers: Valery Panov (g.a.) (Young Man), Galina Panov (g.a.) (Young Woman).
In Repertory: 1976.

ADAGIO CELEBRE

Choreography: Valery Panov
Music: Thommaso Albinoni
Premiere: February 24, 1976. War Memorial Opera House, San Francisco.
Number of Dancers: 2
Principal Dancers: Valery Panov (g.a.), Galina Panov (g.a.).
In Repertory: 1976.

LES CHANSONS DE BILITIS
(Twelve Poems by Pierre Loüys)

Choreography: Carmen de Lavallade
Music: Claude Debussy (*Chansons de Bilitis*).
Costumes and Special Effects: Geoffrey Holder
Premiere: March 21, 1976. War Memorial Opera House, San Francisco.
Number of Dancers: 1

Principal Dancer: Carmen de Lavallade (g.a.).
In Repertory: 1976.

AGON

Choreography: George Balanchine
Music: Igor Stravinsky (*Agon*).
Premiere: April 10, 1976. Orpheum Theater, San Francisco. (World Premiere: The New York City Ballet, 1957.)
Number of Dancers: 12
Principal Dancers: Betsy Erickson, Lynda Meyer, Laurie Cowden, Nancy Dickson, Vane Vest, Gary Wahl, Anton Ness, Jim Sohm.
In Repertory: 1976, 1977.

STRAVINSKY PAS DE DEUX*

Choreography: Lew Christensen
Music: Igor Stravinsky (*Four Norwegian Moods*).
Costumes: Patricia Polen
Premiere: April 10, 1976. Orpheum Theater, San Francisco.
Principal Dancers: Susan Magno, Keith Martin.
In Repertory: 1976, 1977, 1978, 1979; 1982.

GARDEN OF LOVE'S SLEEP*

Choreography: John McFall
Music: Aram Khachaturian (*Concerto for Violin and Orchestra*: Second Movement).
Costumes: Ariel
Premiere: April 22, 1976. War Memorial Opera House, San Francisco.
Number of Dancers: 2
Principal Dancers: Betsy Erickson, Gary Wahl.
In Repertory: 1976.

OPUS I

Choreography: John Cranko
Music: Anton von Webern (*Passacaglia*, Op. 1).
Premiere: April 22, 1976. War Memorial Opera House, San Francisco. (World Premiere: The Stuttgart Ballet, 1965.)
Number of Dancers: 14
Principal Dancers: Diana Weber, Attila Ficzere.
In Repertory: 1976, 1977.

SONGS OF MAHLER*

Choreography: Michael Smuin
Music: Gustav Mahler (from *Des Knaben Wunderhorn* and *Songs of a Wayfarer*).
Costumes: Michael Smuin
Premiere: May 2, 1976. War Memorial Opera House, San Francisco.
Number of Dancers: 21
Principal Dancers: Betsy Erickson, Keith Martin, Anita Paciotti, Laurie Cowden, Jim Sohm, Elizabeth Tienken, Susan Magno, Gary Wahl, Paula Tracy, Vane Vest, Nancy Dickson, Anton Ness, Tina Santos, Gardner Carlson, Tomm Ruud, Jerome Weiss.
In Repertory: 1976, 1977, 1978, 1979; 1981.

AFTERNOON OF A FAUN

Choreography: Jerome Robbins
Music: Claude Debussy (*Prélude à L'Après-midi d'un Faune*).
Premiere: May 16, 1976. War Memorial Opera House, San Francisco. (World Premiere: The New York City Ballet, 1953.)
Number of Dancers: 2
Principal Dancers: Suzanne Farrell (g.a.), Peter Martins (g.a.).
In Repertory: 1976.

SCOTT JOPLIN RAG*
(A Gala Finale)

Choreography: Michael Smuin
Music: Scott Joplin ("Maple Leaf Rag")
Premiere: May 16, 1976. War Memorial Opera House, San Francisco.
Number of Dancers: Entire Company.
In Repertory: 1976.

1 9 7 7

L'OISEAU DE FEU (FIREBIRD)

Choreography: Maurice Béjart
Music: Igor Stravinsky
Costumes: Joelle Roustan
Premiere: January 6, 1977. War Memorial Opera House, San Francisco. (World Premiere: The Ballet of the Twentieth Century, 1970.)
Number of Dancers: 26
Principal Dancers: Gary Wahl (The Bird), Tomm Ruud (The Phoenix).
In Repertory: 1977, 1978.

THE ICE MAIDEN*
(Ballet in Four Scenes)

Choreography: Lew Christensen
Music: Igor Stravinsky (*Le Baiser de la Fée*).
Scenery and Costumes: José Varona
Premiere: January 6, 1977. War Memorial Opera House, San Francisco.
Number of Dancers: 38
Principal Dancers: Betsy Erickson (Ice Maiden), Tomm Ruud (Groom), Susan Magno (Bride).
In Repertory: 1977, 1978.

THE REFEREE**
(A Pre-Rock Dance Suite)

Choreography: Julie Arenal
Music: Galt McDermot
Costumes: Frank Thompson
Scenery: James Grashow
Premiere: February 15, 1977. War Memorial Opera House, San Francisco.
Number of Dancers: 18
Principal Dancer: Paula Tracy (The Referee).
In Repertory: 1977.

METAMORPHOSES*

Choreography: Tomm Ruud
Music: Paul Creston (*Metamorphoses*, Op. 84).
Costumes: Steven Rubin

Premiere: March 31, 1977. War
Memorial Opera House, San
Francisco.
Number of Dancers: 7
Principal Dancers: Michael Graham,
Diana Weber, Gary Wahl, Susan
Magno, Victoria Gyorfi, Vane Vest,
Betsy Erickson.
In Repertory: 1977.

HARP CONCERTO: PAS DE DEUX

Choreography: Michael Smuin
Music: Carl Reinecke (*Concerto for Harp with Orchestral Accompaniment in E Minor*, Op. 182: Second Movement).
Costumes: Marcos Paredes
Premiere: March 31, 1977. War
Memorial Opera House, San
Francisco.
Principal Dancers: Madeleine
Bouchard, Attila Ficzere.
In Repertory: 1977, 1978, 1979, 1980.

Note: See 1973 listings for full-length version of *Harp Concerto*.

BEETHOVEN QUARTETS*

Choreography: John McFall
Music: Ludwig van Beethoven (from "Theme and Variations": *Quartet No. 5*, Op. 18; from "Presto"; *Quartet No. 13*, Op. 130; from "Adagio": *Quartet No. 8*, Op. 59).
Costumes: Victoria Gyorfi
Premiere: April 14, 1977. War
Memorial Opera House, San
Francisco.
Number of Dancers: 16
Principal Dancers: Victoria Gyorfi,
Michael Graham, Michael Thomas,
Tina Santos, David McNaughton.
In Repertory: 1977, 1978.

MEDEA*

Choreography: Michael Smuin
Music: Samuel Barber (*Medea Suite*, Op. 23).
Costumes: Andy Kay
Scenery: Norman Rizzi after Gustav Klimt.
Premiere: April 14, 1977. War
Memorial Opera House, San
Francisco.
Number of Dancers: 5
Principal Dancers: Anita Paciotti
(Medea), Dennis Marshall (Jason),
Laurie Cowden (Creusa), Gardner
Carlson, Jerome Weiss (Sons of
Medea and Jason).
In Repertory: 1977, 1978, 1979.

GERSHWIN*
(A Suite of Dances)

Choreography: Robert Gladstein
Music: George Gershwin (*Porgy & Bess*, arranged by Robert Russell Bennett as *A Symphonic Picture*, 1942).
Costumes and Scenery: David Guthrie
Premiere: April 14, 1977. War
Memorial Opera House, San
Francisco.
Number of Dancers: 20
Principal Dancers: Susan Magno,
David McNaughton, Anita Paciotti,
Vane Vest, Laurie Cowden, Gary
Wahl, Tina Santos.
In Repertory: 1977, 1978.

SCHERZO*

Choreography: Michael Smuin
Music: Gustav Mahler (*Symphony No. 5: Second Movement*).
Costumes: Sandra Woodall
Scenery: Tom John
Premiere: April 28, 1977. War
Memorial Opera House, San
Francisco.
Number of Dancers: 8
Principal Dancers: Michael Dwyer
(Death), Allyson Deane (Death's
Apparition).
In Repertory: 1977, 1978, 1979, 1980.

THREE*

Choreography: John Butler
Music: Alberto Ginastera (*String Quartet No. 2*).
Costumes: Frank Thompson
Scenery: Tom John
Premiere: April 28, 1977. War
Memorial Opera House, San
Francisco.
Number of Dancers: 3
Principal Dancers: Lynda Meyer, Vane
Vest, Dennis Marshall.
In Repertory: 1977, 1978; 1981.

PETER AND THE WOLF*

Choreography: Jerome Weiss
Music: Sergei Prokofiev
Scenery and Costumes: Cal Anderson
Premiere: April 28, 1977. War
Memorial Opera House, San
Francisco.
Number of Dancers: 9
Principal Dancers: Michael Graham
(Peter), Gary Wahl (The Wolf),
Allyson Deane (The Bird), Damara
Bennett (The Duck), Madeleine
Bouchard (The Cat), John McFall,
Tomm Ruud, Jim Sohm (The
Stagehands).
Narrator: Willie Brown
In Repertory: 1977, 1978, 1979.

MOVES
(A Ballet in Silence about
Relationships)

Choreography: Jerome Robbins
Premiere: May 5, 1977. War Memorial
Opera House, San Francisco. (World
Premiere: Ballets U.S.A., 1959.)
Number of Dancers: 12
Principal Dancers: Tina Santos, Tomm
Ruud.
In Repertory: 1977, 1978.

SOUSA MARCH
(A Gala Finale)

Choreography: Michael Smuin
Music: John Philip Sousa (from *Stars and Stripes*).
Premiere: May 29, 1977. War
Memorial Opera House, San
Francisco.
Number of Dancers: Entire Company.
In Repertory: 1977.

1 9 7 8

LA FILLE MAL GARDEE
(Ballet in Two Acts)

Choreography: Sir Frederick Ashton
Music: Ferdinand Hérold (*La Fille Mal Gardée*), freely adapted and arranged by John Lanchbery from the 1828 version.
Scenery and Costumes: Osbert Lancaster
Book: After Jean Dauberval for 1789 production.
Premiere: January 10, 1978. War
Memorial Opera House, San
Francisco. (World Premiere: The
Royal Ballet, London, 1960.)
Number of Roles: 47
Principal Dancers: Diana Weber (Lise),
Jan Nuyts (Colas), Vane Vest
(Widow Simone), John McFall
(Alain).
In Repertory: 1978, 1979, 1980; 1982.

MOZART'S C MINOR MASS*

Choreography: Michael Smuin
Music: Wolfgang Amadeus Mozart
(*Mass in C Minor*: Kyrie, Gloria).
Scenery and Costumes: Marcos Paredes
Premiere: January 26, 1978. War
Memorial Opera House, San
Francisco.
Number of Dancers: 48
Principal Dancers: Paula Tracy,
Michael Graham, Damara Bennett,
Anita Paciotti, Betsy Erickson,
Attila Ficzere, Gary Wahl, Dennis
Marshall, Jan Nuyts, Victoria
Gyorfi, John McFall, Vane Vest,
Lynda Meyer, Diana Weber, Jim
Sohm, Laurie Cowden, Tomm
Ruud.
In Repertory: 1978, 1979, 1980, 1981.

TRILOGY*

Choreography: Tomm Ruud
Music: Béla Bartók (*Music for Strings, Percussion, and Celeste* and *Concerto for Orchestra*: Third Movement) and
Aram Khachaturian (*Gayne*, adagio).
Costumes: Ron Hodge
Premiere: February 14, 1978. War
Memorial Opera House, San
Francisco.
Number of Dancers: 20
Principal Dancers: Damara Bennett,
Jim Sohm, Deborah Zdobinski,
Gardner Carlson.
In Repertory: 1978, 1979.

Note: Second Movement performed as
Mobile; see 1969 listings.

QUANTA*

Choreography: John McFall
Music: Dimitri Shostakovich (*String Quartet No. 6*).
Scenery and Costumes: Victoria Gyorfi
Premiere: April 11, 1978. War
Memorial Opera House, San
Francisco.
Number of Dancers: 29
Principal Dancers: Michael Graham,
Victoria Gyorfi, Lynda Meyer,
Tomm Ruud.
In Repertory: 1978, 1979, 1980.

DAVID AND GOLIATH

Choreography: Robert North and
Wayne Sleep
Music: Carl David (*David and Goliath*).
Costumes: Robert North
Premiere: April 18, 1978. War
Memorial Opera House, San
Francisco. (World Premiere: London
Contemporary Dance Theatre,
1975.)
Number of Dancers: 12
Principal Dancers: David McNaughton
(David), Dennis Marshall (Goliath).
In Repertory: 1978.

Q. a V.*
(Quattro a Verdi)

Choreography: Michael Smuin
Music: Giuseppe Verdi (selections from
ballet music for *Il Trovatore* and *I Vespri Siciliani*).
Costumes: Sandra Woodall
Premiere: May 9, 1978. War Memorial
Opera House, San Francisco.
Number of Dancers: 4
Principal Dancers: Lynda Meyer, Gina
Ness, Dennis Marshall, Alexander
Filipov.
In Repertory: 1978, 1979, 1980, 1981,
1982.

STRAVINSKY CAPRICCIO FOR PIANO & ORCHESTRA*

Choreography: Robert Gladstein
Music: Igor Stravinsky (*Capriccio for Piano & Orchestra*).
Costumes: Willa Kim
Premiere: May 9, 1978. War Memorial
Opera House, San Francisco.
Number of Dancers: 16
Principal Dancers: Gina Ness,
Alexander Filipov, Laurie Cowden,
Dennis Marshall.
In Repertory: 1978, 1979, 1980 (*pas de deux*), 1981.

SAN FRANCISCO TANGO
(A Gala Finale)

Choreography: Michael Smuin
Music: Gus Kahn
Premiere: May 21, 1978. War
Memorial Opera House, San
Francisco.
Number of Dancers: Entire Company.
In Repertory: 1978.

BACH DUET*
(Puppenspiel)

Choreography: Michael Smuin
Music: Johann Sebastian Bach (*Italian Concerto in F*—Second Movement; *Toccata in D Minor*; *French Suite in D minor*—Gigue).
Costumes: Marcos Paredes
Premiere: July 20, 1978. Geary
Theater, San Francisco.
Number of Dancers: 2
Principal Dancers: Paula Tracy, Tomm
Ruud.
In Repertory: 1978, 1979.

ORPHEUS—RETURN TO THE THRESHOLD*

Choreography: Jerome Weiss
Music: Alan Hovhaness (*Meditation on Orpheus for Orchestration*, Op. 155)
Costumes: Cal Anderson
Premiere: July 27, 1978. Geary Theater, San Francisco.
Number of Dancers: 4
Principal Dancers: Vane Vest (Orpheus), Anita Paciotti (Death), Jim Sohm (Younger Orpheus), Diana Weber (Eurydice).
In Repertory: 1978.

CHI MAI*

Choreography: Robert Gladstein
Music: Ennio Morricone (*Chi Mai*).
Costumes: Read Gilmore
Premiere: July 27, 1978. Geary Theater, San Francisco.
Number of Dancers: 3
Principal Dancers: Vane Vest, Anita Paciotti, Jim Sohm.
In Repertory: 1978.

1 9 7 9

RICHMOND DIARY**

Choreography: Tomm Ruud
Music: Ron Daum
Book: Ron Daum, from a story by Tom Carlin.
Costumes and Scenery: Steven Rubin
Premiere: January 9, 1979. War Memorial Opera House, San Francisco.
Number of Dancers: 32
Principal Dancers: Paula Tracy (Jenny), Vane Vest (The General, Her Husband), Diana Weber (The Daughter), David McNaughton (The Young Lieutenant).
Narrator: Phyllis Courtney (Voice of Jenny).
In Repertory: 1979.

THE MISTLETOE BRIDE**

Choreography: Robert Gladstein
Music: Paul Seiko Chihara
Book: Based on the poem, "The Mistletoe Bough," by Thomas Haynes Bayly.
Costumes: Sandra Woodall
Scenery: Jesse Hollis
Premiere: January 30, 1979. War Memorial Opera House, San Francisco.
Number of Dancers: 29
Principal Dancers: Vane Vest (Lord Lovell), Susan Magno (The Bride), Jim Sohm (Lord Lovell as a Young Man).
In Repertory: 1979, 1980.

Note: For first version of *The Mistletoe Bride*, see 1971 listings.

SCARLATTI PORTFOLIO*

Choreography: Lew Christensen
Music: Domenico Scarlatti (*Sonatas*, L.58, L.465, L.382, L.104, L.64, L.282, L.499.), transformed for orchestra by Benjamin Lees.

Costumes: Sandra Woodall
Scenery: Cal Anderson
Premiere: March 15, 1979. War Memorial Opera House, San Francisco.
Number of Dancers: 16
Principal Dancers: David McNaughton (Arlequin), Diana Weber (Columbine), Vane Vest (Franceschina), Lynda Meyer (Isabella), Tina Santos (Lucretia), John McFall (Pulcinella), Anton Ness (Pantalone), Jerome Weiss (Coviello).
In Repertory: 1979, 1980, 1981.

CIRCUS POLKA

Choreography: Jerome Robbins
Music: Igor Stravinsky (*Circus Polka*).
Premiere: May 1, 1979. War Memorial Opera House, San Francisco. (World Premiere: The New York City Ballet, 1972).
Number of Dancers: 48 children and 1 adult.
Principal Dancer: Richard Cammack (Ringmaster).
In Repertory: 1979; 1982.

A SONG FOR DEAD WARRIORS**

Choreography: Michael Smuin
Music: Charles Fox
Costumes and Scenery: Willa Kim
Projections: Ronald Chase
Indian Singers and Drummers: Tootoosis Family
Premiere: May 1, 1979. War Memorial Opera House, San Francisco.
Number of Dancers: 31
Principal Dancers: Antonio Lopez, Evelyn Cisneros, Vane Vest, Gary Wahl, David McNaughton, Jerome Weiss, Dennis Marshall, Tomm Ruud.
In Repertory: 1979, 1980, 1981, 1982.

LA RÊVE DE CYRANO**

Choreography: John McFall
Music: Joaquin Nin-Culmell
Book: After the play *Cyrano de Bergerac* by Edmond Rostand.
Costumes and Scenery: Ronald Krempetz
Premiere: May 10, 1979. War Memorial Opera House, San Francisco.
Number of Dancers: 12
Principal Dancers: Attila Ficzere (Cyrano), Jim Sohm (Christian de Neuvillette), Allyson Deane (Roxane).
In Repertory: 1979.

ALLEGRO BRILLANTE

Choreography: George Balanchine
Music: Peter Ilyich Tchaikovsky (*Piano Concerto No. 3*—"The Unfinished"—Op. 75 in E Flat).
Costumes: Sandra Woodall
Premiere: July 24, 1979. Geary Theater, San Francisco. (World Premiere: The New York City Ballet, 1956.)
Number of Dancers: 10

Principal Dancers: Deborah Zdobinski, Vane Vest.
In Repertory: 1979, 1980, 1981.

DUETTINO*

Choreography: Michael Smuin
Music: Giuseppe Verdi (from *I Lombardi, Gerusalemne, Il Trovatore,* and *I Vespri Siciliane*).
Costumes: Sandra Woodall
Premiere: July 24, 1979. Geary Theater, San Francisco.
Number of Dancers: 2
Principal Dancers: David McNaughton, Diana Weber.
In Repertory: 1979, 1980, 1981.

WE, THE CLOWN

Choreography: John McFall
Music: Victor Charles (*Harlequin*).
Costumes: Victoria Gyorfi
Premiere: July 31, 1979. Geary Theater, San Francisco. (World Premiere: Oakland Ballet, 1978.)
Number of Dancers: 2
Principal Dancers: Victoria Gyorfi, Anita Paciotti.
In Repertory: 1979.

DIVERTIMENTO NO. 15

Choreography: George Balanchine
Music: Wolfgang Amadeus Mozart (*Divertimento No. 15* in B Flat Major, K.287).
Premiere: October 5, 1979. Pasadena Civic Auditorium; Pasadena, California. San Francisco Premiere: January 15, 1980. War Memorial Opera House, San Francisco. (World Premiere: The New York City Ballet, 1956).
Number of Dancers: 16
Principal Dancers: Allyson Deane, Lynda Meyer, Gina Ness, Roberta Pfeil, Deborah Zdobinski, Anton Ness, Don Schwennesen, Jim Sohm.
In Repertory: 1979, 1980, 1981.

THE TEMPEST: THREE DANCES*

(Preview of a Work in Progress)
Choreography: Michael Smuin
Music: Paul Seiko Chihara (after Henry Purcell).
Premiere: August 7, 1979. Geary Theater, San Francisco.
Number of Dancers: 5
Principal Dancers: Jonathan Miller, Alexander Topciy, Betsy Erickson, Madeleine Bouchard, Jim Sohm.
In Repertory: 1979.

Note: For full-length *The Tempest*, see listing under 1980.

1 9 8 0

INTRODUCTION AND ALLEGRO*

Choreography: Tomm Ruud
Music: Sir Edward Elgar (*Introduction and Allegro for Quartet and String Orchestra*, Op. 47).
Costumes: Sandra Woodall
Premiere: April 8, 1980. War Memorial Opera House, San Francisco.

Number of Dancers: 14
Principal Dancers: Betsy Erickson, Anton Ness.
In Repertory: 1980, 1981.

CANTI*

Choreography: John McFall
Music: Henri Lazarof (*Canti*).
Costumes: Kenneth Sharp
Premiere: April 15, 1980. War Memorial Opera House, San Francisco.
Number of Dancers: 16
In Repertory: 1980, 1981.

PSALMS*

Choreography: Robert Gladstein
Music: Leonard Bernstein (*Chichester Psalms*).
Costumes: Sandra Woodall
Premiere: April 22, 1980. War Memorial Opera House, San Francisco.
Number of Dancers: 18
In Repertory: 1980, 1981.

THE TEMPEST**

Choreography: Michael Smuin
Music: Paul Seiko Chihara (after Henry Purcell).
Electronic Music: Paul Seiko Chihara and Craig Hundley.
Book: Michael Smuin, Philip Semark, and Paul Seiko Chihara, based on the play by William Shakespeare.
Costumes: Willa Kim
Scenery: Tony Walton
Special Effects: Parker Young
Premiere: May 13, 1980. War Memorial Opera House, San Francisco.
Number of Roles: 67
Principal Dancers: Attila Ficzere (Prospero), David McNaughton (Ariel), Evelyn Cisneros (Miranda), Tomm Ruud (Ferdinand), Horacio Cifuentes (Caliban), Zoltan Peter (Antonio), Antonio Lopez (Trinculo), John McFall (Stephano), Roberta Pfeil (Juno), Anton Ness (Neptune), Gina Ness (Corn), Victoria Morgan (Wheat), Vivian Little (Barley), Damara Bennett (Rye), Paula Tracy (Ceres), Robert Sund (Bacchus), Alexander Filipov (Centaur), Betsy Erickson (Iris), Jonathan Miller, Alexander Topciy (Tarantella).
In Repertory: 1980, 1981, 1982.

Note: Preview excerpts from *The Tempest* listed under 1979.

1 9 8 1

STARS AND STRIPES

(Ballet in Five Campaigns)
Choreography: George Balanchine
Music: John Philip Sousa (*Corcoran Cadets, Rifle Regiment, Thunder and Gladiator, Liberty Bell, El Capitan, Stars and Stripes*), adapted and orchestrated by Hershy Kay.
Costumes: Barbara Karinska

Premiere: January 19, 1981. War Memorial Opera House, San Francisco. (World Premiere: The New York City Ballet, 1958.)
Number of Dancers: 41
Principal Dancers: First Campaign—Madeleine Bouchard; Second Campaign—Victoria Morgan; Third Campaign—Mark Lanham; Fourth Campaign—Evelyn Cisneros, David McNaughton.
In Repertory: 1981, 1982.

DEBUT*

Choreography: Michael Smuin
Music: Alessandro Scarlatti (*Preambulo and Allegro Vivo*).
Premiere: January 27, 1981. War Memorial Opera House, San Francisco.
Number of Dancers: 1
Principal Dancer: Kirk Peterson
In Repertory: 1981.

MONOTONES: NOS. 1 AND 2

Choreography: Sir Frederick Ashton
Music: Erik Satie (from *Trois Gymnopédies* and *Trois Gnossiennes*), orchestrated by Claude Debussy, Roland Manuel, and John Lanchbery.
Costumes: Sir Frederick Ashton
Premiere: January 27, 1981. War Memorial Opera House, San Francisco. (World Premiere: The Royal Ballet, 1966 and 1965.)
Number of Dancers: 6
Principal Dancers: Madeleine Bouchard, Allyson Deane, Zoltan Peter, Betsy Erickson, Don Schwennesen, Jim Sohm.
In Repertory: 1981, 1982.

VIVALDI CONCERTO GROSSO*

Choreography: Lew Christensen
Music: Antonio Vivaldi (*Concerto Grosso*, Op. 3, No. 11).
Costumes: Sandra Woodall
Premiere: February 27, 1981. Blaisdell Concert Hall, Honolulu. San Francisco Premiere: April 14, 1981. War Memorial Opera House.
Number of Dancers: 14
Principal Dancers: Betsy Erickson, Jim Sohm.
In Repertory: 1981, 1982.

BOUQUET*

Choreography: Michael Smuin
Music: Dimitri Shostakovich (*Concerto No. 2*: Second Movement, and *Concerto No. 1*: Second Movement).
Costumes: Willa Kim
Premiere: April 28, 1981. War Memorial Opera House, San Francisco.
Number of Dancers: 6
Principal Dancers: Tracy-Kai Maier, Vane Vest, Madeleine Bouchard, Alexander Filipov, Zoltan Peter, Kirk Peterson.
In Repertory: 1981.

BARTÓK QUARTET NO. 5*

Choreography: Betsy Erickson
Music: Béla Bartók (*String Quartet No. 5*: Second, Third, and Fourth Movements).
Costumes: Sandra Woodall
Premiere: February 28, 1981. Blaisdell Concert Hall, Honolulu. San Francisco Premiere: July 23, 1981. War Memorial Opera House.
Number of Dancers: 10
In Repertory: 1981, 1982.

1982

VILZAK VARIATIONS*

Choreography: Anatole Vilzak (after Marius Petipa).
Music: Peter Ilyich Tchaikovsky (from *Swan Lake, Sleeping Beauty,* and *Eugene Onegin*); Léon Minkus (from *Paquita* and *Don Quixote*); Léo Delibes (from *Coppélia*); and Gioacchino Rossini (from *La Boutique Fantasque*).
Costumes: Sandra Woodall
Premiere: January 16, 1982. War Memorial Opera House, San Francisco.
Number of Dancers: 16
In Repertory: 1982.

SYMPHONY IN THREE MOVEMENTS*

Choreography: Robert Gladstein
Music: Igor Stravinsky (*Symphony in Three Movements*).
Premiere: January 16, 1982. War Memorial Opera House, San Francisco.
Number of Dancers: 33
Principal Dancers: Laurie Cowden, Dennis Marshall, Tracy-Kai Maier, Alexander Topciy, Victoria Morgan, Jim Sohm.
In Repertory: 1982.

WESTERN SYMPHONY

Choreography: George Balanchine
Music: Hershy Kay (*Western Symphony*).
Costumes: Barbara Karinska
Scenery: John Boyt
Premiere: January 16, 1982. War Memorial Opera House, San Francisco. (World Premiere: The New York City Ballet, 1954.)
Number of Dancers: 36
Principal Dancers: First Movement: Evelyn Cisneros, Jim Sohm; Second Movement: Linda Montaner, Kirk Peterson; Third Movement: Tracy-Kai Maier, Robert Sund; Fourth Movement: Carmela Zegarelli, John Mourelatos.
In Repertory: 1982.

THE DREAM: PAS DE DEUX

Choreography: Sir Frederick Ashton
Music: Felix Mendelssohn (from *A Midsummer Night's Dream*), arranged by John Lanchbery.
Premiere: February 9, 1982. War Memorial Opera House, San Francisco. (World Premiere: The Royal Ballet, 1964.)
Principal Dancers: Tracy-Kai Maier, Jim Sohm.
In Repertory: 1982.

SWAN LAKE: ACT II

Choreography: Kent Stowell (after Lev Ivanov).
Music: Peter Ilyich Tchaikovsky
Costumes: Sandra Woodall
Scenery: Filippo Sanjust
Premiere: February 9, 1982. War Memorial Opera House, San Francisco. (World Premiere of full-length Stowell production: Frankfurt Ballet, 1976.)
Number of Dancers: 27
Principal Dancers: Laurie Cowden (Odette), Dennis Marshall (Prince Siegfried).
In Repertory: 1982.

Note: Other San Francisco Ballet productions of *Swan Lake* listed under 1940, 1947 (*Black Swan*), and 1953.

REQUIEM CANTICLES

Choreography: Jerome Robbins
Music: Igor Stravinsky (*Requiem Canticles*).
Premiere: February 9, 1982. War Memorial Opera House, San Francisco. (World Premiere: The New York City Ballet, 1972.)
Number of Dancers: 19
Principal Dancers: Damara Bennett, Horacio Cifuentes, Lynda Meyer, Paul Russell.
In Repertory: 1982.

STRAVINSKY PIANO PIECES*

Choreography: Michael Smuin
Music: Igor Stravinsky (from *Four Etudes for Piano, Eight Easy Pieces for Piano Duet, Les Cinque Doigts, Serenade in A for Piano, Pulcinella*; and *Valse, Polka, Tango,* and *Ragtime*), edited by Isidor Philipp, Soulima Stravinsky, and Roy Bogas.
Costumes: Willa Kim
Scenery: Tony Walton
Premiere: April 6, 1982. War Memorial Opera House, San Francisco. (World Premiere: "Ragtime" movement: The White House, Washington, D.C., March 28, 1982.)
Number of Dancers: 18
In Repertory: 1982.

Note: "Serenata" originally part of 1968 *Pulcinella Variations*; see 1974 listings.

LOVE-LIES-BLEEDING*

Choreography: Val Caniparoli
Music: Igor Stravinsky (from *L'Histoire du Soldat, Four Etudes for Orchestra, First Suite for Small Orchestra, Pastorale, Double Canon in D, Epitaphium*, and *Preludium for Jazz Ensemble*).
Costumes: Sandra Woodall
Scenery and Projections: Cal Anderson
Premiere: April 6, 1982. War Memorial Opera House, San Francisco.
Number of Dancers: 15
Principal Dancers: Victoria Morgan, Antonio Lopez, Linda Montaner, David McNaughton, Anita Paciotti, Jim Sohm.
In Repertory: 1982.

STEPS FOR TWO*

Choreography: Tomm Ruud
Music: Igor Stravinsky (*Eight Miniatures for Fifteen Players*).
Costumes: Elizabeth Ross
Premiere: April 20, 1982. War Memorial Opera House, San Francisco.
Number of Dancers: 2
Principal Dancers: Tomm Ruud, Eda Holmes.
In Repertory: 1982.

BADINAGE*

Choreography: John McFall
Music: Igor Stravinsky (*Concerto in D for String Orchestra*).
Costumes: Warren Travis
Premiere: April 20, 1982. War Memorial Opera House, San Francisco.
Number of Dancers: 10
Principal Dancers: Tracy-Kai Maier, Russell Murphy.
In Repertory: 1982. ■

SAN FRANCISCO BALLET

NUTCRACKER and REPERTORY SEASON 1978/79 War Memorial Opera House

JACLOW, KELLEY, MILLER, AND ORR, INC. PHOTO: RONDAL PARTRIDGE

Repertory II

(ALPHABETICAL)

Abnegation (1934)
A.C.—615 (1971)
Accent (1960)
Adagio Célèbre (1976)
Adagio for Ten and Two (1964)
The Adolescents (1966)
Afternoon of a Faun (1976)
Afternoon Revival (1970)
Agon (1976)
Airs de Ballet (1971)
Allegro Brillante (1979)
Almost Lazarus (1968)
Alpenfest (1966)
L'Amant Rêve (1939)
American Dance Overture (1971)
American Interlude (1939)
American Scene (1952)
El Amor Brujo (1935)
Amor Espagnol (1942)
Anagnorisis (1964)
Andante Spianato et Grande Polonaise (1969)
And Now the Brides (1940)
Apollo (1955)
Apollon Musagète (1955)
Apologue (1961)
Arlecchinata (1933)
Autumn Dances (1971)
The Awakening (1968)

Bach Concert (1962)
Bach Duet (1978)
Badinage (1982)
Balalaika (1967)
Ballet Impromptu (1938)
Balletino (1949)
Le Ballet Mécanique (1933)
The Bartered Bride: Three Dances (1938)
Bartók Quartet No. 5 (1981)
Beauty and the Beast (1958)
Beauty and the Shepherd (1954)
Beethoven Quartets (1977)
The Beloved (1974)
Biography (1962)
Birthday of the Infanta (1934)
Black Swan: Pas de Deux (1947)
Blue Bird: Pas de Deux (1943)
Blue Plaza (1945)
Bouquet (1981)
Le Bourgeois Gentilhomme (1944)
Buji (1964)
Bumble-Bee (1934)
Buy (1961)
By the Side of the Freeway (1960)

Canti (1980)
Capriccio Espagnol (1937)
Caprice (1959)
Caprice Viennoise (1934)
Carnival (1933)
The Carnival of the Animals (1952)
Celebration (1972)
Changes (1968)
Les Chansons de Bilitis (1976)
Charade (1950)
Chi Mai (1978)
Chopinade (1937)
Cinderella (1973)
Circus Polka (1979)
Classical Symphony (1971)
Coeur de Glace (1942)

The Colorists (1963)
Con Amore (1953)
Concertare (1964)
Concertino (1965)
Concert Music for Strings and Brass Instruments (1965)
Concerto Barocco (1953)
Concerto in Four Movements (1969)
Consecration (1935)
Coppélia (1939)
Cordoba (1935)
Le Corsaire: Pas de Deux (1964, 1970)
Country Dance (1935)
Coup d'Essai (1970)
The Crucible (1961)
Cry (1975)
Cuadro Flamenco (1935)

Dance!!! (1973)
Dance Divertissements (1937)
Dance Dvořák (1970)
Dances for the King (1969)
Dance Variations (1963)
Danse Noble (1935)
Danses Concertantes (1959)
Danza (1966)
Danza Brillante (1949, 1960)
Dark Vigil (1969)
David and Goliath (1978)
Debut (1981)
The Debutante (1950)
Defeat (1965)
Les Desirables (1964)
Dialogues in Jazz (1970)
Il Distratto (1967)
Divertimenti (1951)
Divertimento No. 15 (1979)
Divertissement (1967)
Divertissement d'Auber (I) (1959)
Divertissement d'Auber (II) (1963)
Dr. Pantalone (1947)
Don Juan (1933, 1973)
Don Quixote: Pas de Deux (1948)
The Dream: Pas de Deux (1982)
A Dream Work (1964)
The Dryad (1954)
Duettino (1979)
Dying Swan (1974)

Ebony Concerto (1961)
Eclipse (1967)
Elijah (1962)
Elysium (1961)
Emperor Norton (1957)
The Encounter (1969)
Encounter (Excerpts) (1937)
Esmeralda: Pas de Deux (1960)
Eternal Idol (1973)
Eva (1961)

Face of Death (1965)
Facets (1967)
Fantasia (1947)
Fantasma (1963)
Faunesque (1934)
La Favorita (1971)
The Festival (1953)
Figures in F (1972)
La Fille Mal Gardée (1978)
Filling Station (1951)
Firebird (1977)
Firebird: Pas de Deux (1970)
Firebird: A Solo (1935)
First Time Out (1972)
Flaming Angel (1972)
Flight (1968)
Flower Festival at Genzano: Pas de Deux (1974)

For Valery Panov (1973)
The Four Temperaments (1974)
A La Françaix (1953)
Fusion (1969)

Games in 4/4 Time (1968)
Garden of Love's Sleep (1976)
Gayne: Pas de Deux (1964)
Genesis '70 (1970)
Gentians in His House (1964)
Gershwin (1977)
Gift of the Magi (1948)
Giocoso (1968)
Giselle (1947)
Giselle: Pas de Deux (1975)
Giselle: Peasant Pas de Deux (1965)
Le Gourmand (1951)

Hansel and Gretel (1943)
Harlequinade: Pas de Deux (1975)
Harp Concerto (1973)
Harp Concerto: Pas de Deux (1977)
Heart of the Mountain (1976)
Henry VIII (1947)
Heuriger (1954)
Highway 101 (1965)
Hopak (1934)
Hungarica (1965)
Hyde Park Satire (1934)

The Ice Maiden (1977)
Impressions in Black and White (1968)
In Old Vienna (1938)
Introduction and Allegro (1980)
Introspections (1970)
In Vienna (1938)
Iron Foundry (1933)

Au Jardin des Tuileries (1933)
Jest of Cards (1965)
Jinx (1949)
Jon Lord—Both Sides Now (1971)
Jota Aragonaise (1934)
Jota Aragonesa (1935)
Joyous Dance (1970)
Juris Fanatico (1935)

Kama Sutra (1966)
Kromatika (1967)

Lady and the Hooligan: Pas de Deux (1975)
Lady of Shalott (1958)
The Lady of the Camellias (1947)
Lament (1934)
Legende (1974)
Libation: A Morality Play (1965)
Life: A Do-It-Yourself Disaster (1965)
Lilith (1966)
Love-Lies-Bleeding (1982)
Lucifer (1965)

The Magical Flutist (1968)
Les Maîtresses de Lord Byron (1951)
A Masque of Beauty and the Shepherd (1954)
Masquerade (1969)
Matinée Dansante (1970)
Medea (1977)
Mendelssohn Concerto (1957)
Mephisto (1947)
Metamorphoses (1977)
A Midsummer Night's Dream (1938, 1940)
Mindanao (1967)
Minkus Pas de Deux (1969)
The Mistletoe Bride (1971, 1979)
Mobile (1969)

Monotones: Nos. 1 and 2 (1981)
Mother Blues (1974)
Moves (1977)
Mozart's C Minor Mass (1978)
Much Ado About Nothing (1967)
The Music Box (1969)

New Flower (1972)
Night in the Tropics (1969)
The Nothing Doing Bar (1950)
N.R.A. (1972)
Nutcracker (1944, 1954, 1967)
Nutcracker: Divertissements (1943)

Octet (1965)
L'Oiseau de Feu (1977)
Opus I (1976)
Opus One (1962)
Original Sin (1961)
Orpheus—Return to the Threshold (1978)

Parranda (1947)
Pas de Décors (1972)
Pas de Dix (1960)
Pas de Quatre (1973)
Pas de Six (1966)
Pas de Trois (1965)
Passacaglia (1933)
Patterns (1934)
Pedro the Dwarf (1934)
La Péri (1968)
Perpetuum Mobile (1933)
Persephone (1948)
Peter and the Wolf (1977)
Portrait (1973)
Les Précieux (1933)
Prelude and Four-Voice Fugue (1933)
Prelude: To Performance (1950)
Preludium (1973)
Prima Sera (1968)
Princess Aurora (1964)
Prokofiev Waltzes (1961)
Psalms (1980)
Psychal (1967)
Pulcinella Variations (1974)
Puppenspiel (1978)
Pygmalion (1966)
Pyramus and Thisbe (1945)

Q. a V. (1978)
Quanta (1978)
Quattro a Verdi (1978)
Questionnaire (1961)

Raymonda: Grand Pas Espagnol Classique (1934)
Real Games (1965)
The Referee (1977)
Reflections (1965)
Renard (1955)
Requiem Canticles (1982)
Le Rêve de Cyrano (1979)
Reverie (1933)
Richmond Diary (1979)
The Rivals (1934)
Romeo and Juliet (1938, 1976)
Romeo and Juliet: A Study in Three Scenes (1975)
Rondo Capriccioso (1935)
Roundelay (1933)
Rumanian Rhapsody (1937)
Rumanian Wedding Festival (1937)
Russian Peasant Scene (1935)

The Saga of Silver Creek (1966)
St. George and the Dragon (1961)
Sancho (1964)
San Francisco Tango (1978)
Scarlatti Portfolio (1979)
Scènes de Ballet (1942)
Schéhérazade (1935)
Scherzando (1964)
Scherzo (1977)
Scherzo Mechanique (1969)
Schoenberg Variations (1963)
Schubertiade (1970)
Scotch Symphony (1970)
Scott Joplin Rag (1976)
Sensemaya (1968)
Serenade (1952)
Session I (1960)
Session II (1961)
Session III (1962)
The Set (1963)
The Seven Deadly Sins (1964)
Shadows (1961)
The Shakers (1973)
Shapes of Evening (1967)
Shinjū (1975)
Shore Leave (1962)
Shostakovich Pas de Deux (1961)
Showoff (1965)
Siempre Bach (1965)
Sinfonia (1959)
Sketches (1937)
Sleeping Beauty: Blue Bird Pas de
 Deux (1943)
Sleeping Beauty: Grand Pas de Deux
 (1964)
Sleeping Beauty: Princess Aurora
 (1964)
Sonata Pathétique (1943)
A Song for Dead Warriors (1979)
Songs of Mahler (1976)
Song Without Words (1965)
La Sonnambula (1974)
Sonnet (1963)
La Source (1971)
Sousa March (1977)
Souvenir (1965)
Souvenirs (1976)
Split (1970)
Stars and Stripes (1981)
Statements (1972)
Steps for Two (1982)
The Story of a Dancer (1949)
Stravinsky Capriccio for Piano and
 Orchestra (1978)
Stravinsky Pas de Deux (1976)
Stravinsky Piano Pieces (1982)
Structures (1971)
The Sun Did Not Rise (1969)
Sun Music (1968)
Swan Lake (1940)
Swan Lake: Act II (1953, 1982)
Swan Lake: Black Swan Pas de Deux
 (1947)
La Sylphide: Excerpts from Act II
 (1964)
Les Sylphides (1948, 1974)
Sylvia: Pas de Deux (1954)
Symphonic Impressions (1972)
Symphony in C (1961)
Symphony in D (1967)
Symphony in Jazz (1960)
Symphony in Three Movements (1982)
Synapse (1972)

Taming of the Shrew: Pas de Deux
 (1974)
Tangents (1973)
Tanssinen (1970)
Tapestry (1970)
Tarantella for Ten (1972)
The Tarot (1955)
Tchaikovsky Pas de Deux (1972)
Tealia (1973)
The Tempest (1980)
The Tempest: Three Dances (1979)
Thème Variée (1966)
Three (1977)
Three Diversions (1966)
Three Movements for the Short Haired
 (1968)
Tingel-Tangel-Taenze (1972)
Totentanz (1967)
The Trial (1972)
Trilogy (1978)
Trios Con Brio (1969)
Triptych (1963)
Triumph of Hope (1944)
Trois Couleurs (1960)
Two Romantic Pas de Deux (1972)

Valse Triste (1969)
Variations de Ballet (1960)
Variations for Violin and Orchestra
 (1966)
Vilzak Variations (1982)
Vivaldi Concerto (1949, 1963)
Vivaldi Concerto Grosso (1981)
Voices of Spring (1933)
Voyage à Reims (1962)
Voyage Interdit: A Nōh Play (1966)

Wajang (1966)
The Way (1969)
Way Out (I) (1965)
Way Out (II) (1966)
Western Symphony (1982)
We, The Clown (1979)
Wiener Blut (1934)
Wind Songs (1968)
Winter Carnival (1942)
Winter Etchings (1967)
W.O.O. (1971)

DESIGN: TONY WALTON

Tony Walton's illustration of Michael Smuin's *Stravinsky Piano Pieces* for SFB's Fiftieth Anniversary Gala.

THE WHITE HOUSE

WASHINGTON

December 21, 1982

Nancy and I take great pleasure in sending our
congratulations to the San Francisco Ballet on
its 50th Anniversary and our special greetings
to all those who are helping to celebrate this
important occasion.

As the oldest ballet company in America, the
San Francisco Ballet has led the way, setting
an example for others to follow during the
phenomenal growth of dance in our nation. We
are grateful to all those who have worked so
diligently to bring the Company to its place
of eminence and especially commend the dancers
and choreographers who have given of their
energies and talents with wholehearted dedica-
tion throughout the years.

It is certainly fitting to acknowledge the
contributions of the San Francisco Ballet
Company to our dance heritage through these
gala festivities. We send our best wishes
for continued success.

Ronald Reagan

STAFF

ADMINISTRATION
President and Chief Executive Officer
Richard E. LeBlond, Jr.

General Manager
Timothy Duncan

Company Manager
Michael Alexander

Executive Secretaries
Rowena Newton
June Carr

Receptionists
Barbara Boffi
Garland Jones
Jennifer Sweeting
Lisa Takeyama

ACCOUNTING
Controller
O. Robert Conkey

Bookkeeper
Kirsten Hansen

Accounting Clerk
Diana Dubash

Accounting Assistant
Alicia Snow

BUILDING
Project Manager
M.C. Abramson

COMMUNICATIONS SERVICES
Communications Services Manager
Craig Palmer

Marketing Manager
Valerie J. Kosorek

Marketing Associate
Tom Gulick

Communications Services Associate
Jon Roberson

Publications Associate
Sean O'Neil

Design Associate
Mark Coleman

Media Relations Associate
Sandy Stumbaugh

San Francisco Ballet Box Office

Treasurer
Elizabeth Lindsey

1st Assistant Treasurer
Blair Conklin

Assistant Treasurers
Ann Cashen
Debra Pollock

Staff
Margo Aparicio
Krischa Mayben

COMMUNITY RELATIONS
Community Relations Manager
Meg Madden

Dance-in-Schools

Director/Instructor
Leni Siegel

Associate Instructor
Charles McNeal

Accompanist
David Frazier

Elective-Scholarship Program

Director/Instructor
Mary Ruud

Associate Instructor
Charles McNeal

Classroom Assistant
Lynda Schlittler

Accompanist
Barbara Russell

DEVELOPMENT
Development Manager
Ernest Phinney

Assistant Development Manager
Kathleen Craig

Development Coordinator
Margaret L. Cowan

Development Secretary
Cindy Reynolds

MUSIC
Music Director and Conductor
Denis de Coteau

Conductor
Jean-Louis LeRoux

Orchestra Personnel Manager
Danny Montoro

Music Librarian
David Bartolotta

Company Pianists
Eugene Babo
James Lees
Timothy Murphy

San Francisco Ballet Orchestra is the official orchestra of the San Francisco Ballet. Roy Malan, Concertmaster.

PRODUCTION
Technical Director
Richard Carter

Stage Manager
S. Randolph Post

Assistant Stage Manager
Paula Williams

Artistic Research Coordinator
Laura Leivick

Directors' Secretary
Nancy Sarabale

Master Carpenter
Michael Kane

Master Electrician
Lawrence Poggetti

Master of Properties
Robert Kirby

Assistant Electrician
Dennis Hudson

Sound Technician
Kevin Kirby

Wardrobe and Make-up Department

Costume Supervisor
Patricia Bibbins

Wardrobe Master
George Elvin

Make-Up Artist
Richard Battle

Photographs and Illustrations

The editor, the author, and the publisher would like to thank Russell Hartley and the Archives for the Performing Arts for providing most of the photographs and illustrations for this book. The names of all the individual photographers and artists who could be identified are listed, with an index to their works, below; the year in which each listed work was created, when known, is indicated in parentheses.

© William Acheson: p. 6 (1982); p. 49 bottom right (1982); p. 72 (1982); p. 73 (1981); p. 88 (1982); p. 114 top (1982); p. 115 (1982); p. 116 (1982); p. 125 bottom left (1981); p. 132 (1982); p. 133 bottom (1982); p. 134 (1982); p. 135 (1982); p. 141 (1978); p. 142 top (1982); pp. 152-153 (1982); dustjacket, back (1983).

© Age-Lis Rochester: p. 34 (1927).

© Cal Anderson: SFB 50 logo, front dustjacket and p. iii (1982); p. 196 (1962); p. 197 (1967); p. 199 (1964); p. 203 (1970).

© James Armstrong: p. 26 bottom right (1978); p. 29 top (1974) and bottom (1978); pp. 44-45 (1978); p. 75 (1977); p. 76 (1971); p. 79 (1981); p. 101 top (1978); p. 105 left (1979); p. 117 right (1982) and left (1979); p. 129 left (1980); p. 166 (ca. 1978); p. 169 left (1979); p. 181 (1980).

©Terry Arthur: p. 144 left and right (1982).

© Balon: p. 58 (1951).

© John Black: p. 188 (1941).

© Jean de Botton: p. 50 (1944).

© Ernest Braun: p. 59 (1950).

© Braun, Childress, Halberstadt: p. 53 (1947); p. 56 (1949).

© Bill Cogan Photography: p. 47 (ca. 1962).

© Attributed to Imogen Cunningham: p. 30 (1933).

© Deli: p. 193 (1959).

© DuCharme: p. 67 (1952).

© Tony Duquette: p. 171 top (1958).

© Lloyd Englert: p. 7 (1978); p. 21 (1978); p. 114 bottom (1982); p. 126 left (1978); p. 127 (1980); p. 128 center (1981) and left (1980); p. 140 top and bottom (1978); p. 169 right (1981); p. 179 (1982); p. 216.

© Dan Esgro: p. 102 (1977); p. 103 (1977); p. 129 center (1978); p. 133 top (1978).

© Robert Lee Eskridge: p. 31 (1933); p. 32 (1933); p. 33 (1933).

© Charlotte Fairchild: p. 25 (1937).

© Vinnie Fish: p. 61 (1978).

© John Fritzlen: p. 101 bottom (1978); p. 105 right (1979).

© John Furness: p. 97 right (1961).

© Maxwell Hanshaw: p. 12 (ca. 1932); p. 15 top (ca. 1926).

© Russell Hartley: p. 64 (1944); p. 172 right (1949).

© Willa Kim: p. 173 center (1979).

© Paul Kolnik: p. 120 right (1978).

© Hank Krantzler: p. 139.

© George T. Kruse: p. 15 right (1982); p. 71 (1982); p. 149 (1982).

© Rudy Legname: p. 78 (1982); p. 82 bottom (1982); p. 124 right (1982); p. 125 top right (1982); p. 137 bottom right (1982); p. 138 (1982); pp. 160-163 (1982).

© John Lindquist: p. 84 (1956).

© G. Ludé: p. 3 (1940); p. 41 (1940); p. 54 (1940); p. 55 bottom (1940); p. 187 (1940); p. 189 (1940).

© George Platt Lynes: p. 20 (1937); p. 26 (1938).

© Harold Mack, Jr.: p. 170 (1947).

© Carolyn Mason-Jones: p. 69 (1976).

© Henri McDowell: p. 119 (1966).

© Jack Mitchell: p. 137 top.

© Morton: p. 22 (1935); p. 36 top (1938); p. 136 top (1938); p. 178 (1938).

© Moulin Studios: p. 46 center (1948).

© Rondal Partridge: p. 209 (1977).

© Pete Peters: p. 98 right (1962).

© Barney Peterson: p. 110 (ca. 1974).

© Jacqueline Poitier: p. 81 (1979); p. 82.

© Tony Plewik: p. 28 (1978); p. 109 (1982).

© Pat Quinlan: p. 158 (1971).

© Romaine: p. 2 top (1939); p. 19 bottom (1955); p. 35 (1939); p. 40 (1947); p. 52 (1946); p. 55 right (1939); p. 62 (1955); p. 65 (1955); p. 92 lower right (1947) and upper left; p. 94 top (1951) and bottom (1955); p. 95 left (1954) and right (1955); p. 122 left.

© Romaine-Skelton: p. 118 (1955).

© Nora Scarlett: p. 83 (1977).

© Nancy Rica Schiff: p. 49 top left (1982).

© Maurice Seymour: p. 11 (1947); p. 122 right (1939).

© Robert Simac: p. 43 (1975).

© Gary Sinick: p. 80 (ca. 1977); p. 100 (1981); p. 130 (1981); p. 151 (1977); p. 164 (ca. 1978); p. 167 (1978).

© Dale Smith: p. 27 (1959); p. 98 left (1961); p. 96 (1961); p. 97 left (1961).

© Dale Wilson Smith: p. 108 (1978); p. 197 (1967); p. 199 (1964).

© Marty Sohl: p. 18 (1981); p. 19 top (1981); p. 45 (1980); p. 48 (1981); p. 74 (1982); p. 79 (1981); p. 90 (1982); p. 129 right (1982); p. 142 bottom (1981); p. 143 (1981); p. 152 (1979).

© Ted Streshinsky: p. 90 right (1959).

© Martha Swope: p. 108 (1978).

© John VanLund: p. 16 top (1955); p. 85 (1956).

© Jose Varona: p. 173 left (1982).

© Tony Walton: p. 172 left (1974); p. 211 (1982).

© Leonard Weisgard: p. 173 top right (1951).

© Willis & Associates, Inc.: p. 148 (1982).

© Beth Witrogen: p. 77 (1978); p. 128 top left (1977).

© Baron Wolman: p. 99 (1965).

San Francisco Ballet: The First Fifty Years

This book was composed by Mackenzie-Harris Corporation in Garamond No. 3 with Garamond Oldstyle Italic for display on the Mergenthaler Linotron 202 and printed by Hooper Printing Company on Warren's #70 Patina Matte. Color separations were scanned by Solzer & Hail with black and white and duotone reproductions by Hooper Printing Company. Editions were bound in Roxite Vellum by Hiller Industries, Salt Lake City. Dust jackets were printed by Hooper Printing Company. Production and manufacturing were directed by Marianne Hinckle with assistance from Derek Hooper and Virginia Chapman. Book design by Thomas Ingalls with Madeleine Corson. Production assistance by Holly Douglas and Loretta Staples. This book was produced by Thomas Ingalls + Associates.

LLOYD ENGLERT